Art &
Civilization

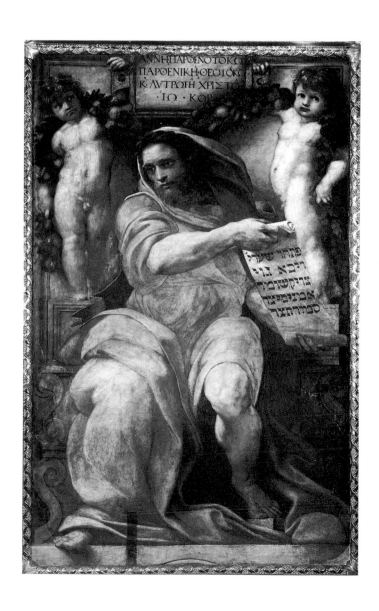

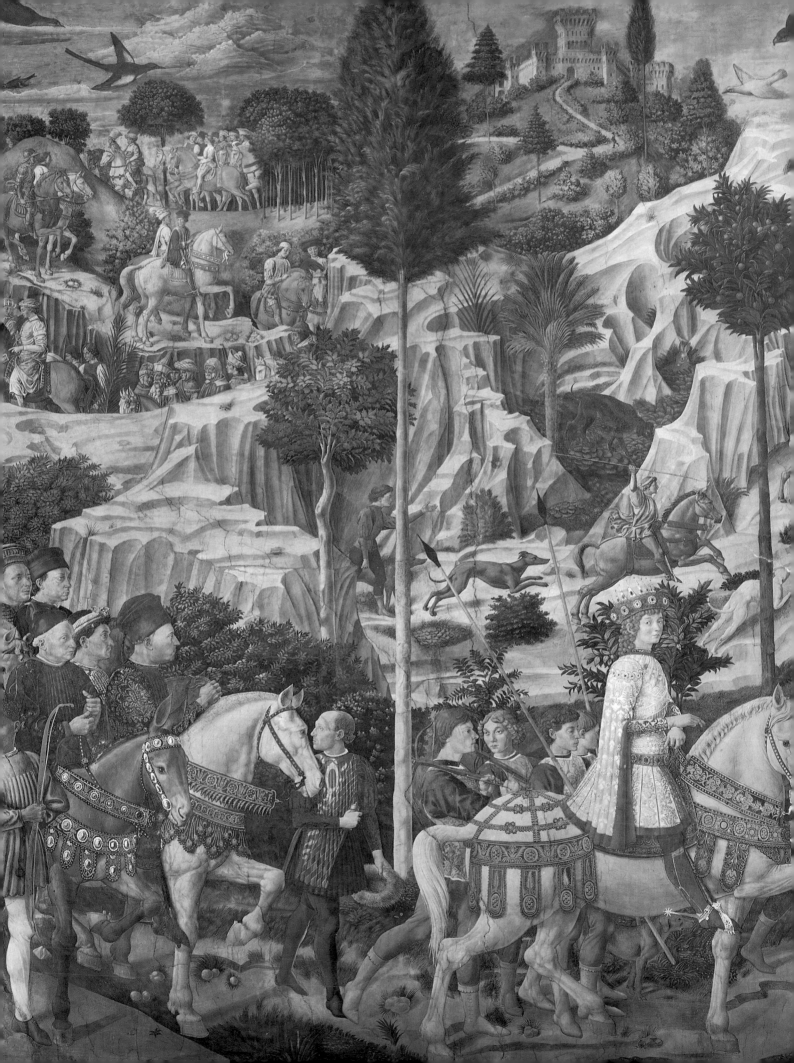

Art & Civilization

Edward Lucie-Smith

Laurence King

for Shaunagh Heneage
an education in herself

Published 1992 by Laurence King

A catalogue record for this book is available from the British
Library.

ISBN 1–85669–027–X

Designed by Barbara Mercer
Picture research by Visual Arts Library/Suzanne Green
Maps by Euromap

Typeset by Fakenham Photosetting Ltd., Norfolk
Printed and bound in Singapore

Half-title: **Raphael**, *The Prophet Isaiah* 1511–12. Fresco,
98½ × 61 ins (250 × 155 cm). Sant'Agostino, Rome.

Frontispiece: (detail) **Benozzo Gozzoli**, *The Journey of the Magi*
1459. Fresco. Medici Riccardi Palace, Florence.

Contents

Acknowledgments

It is impossible to write a book as large and as ambitious in its coverage and timescale as this one without considerable help and input from other people. There are a small number who have perhaps had to do more than their share in helping me bring the project to completion. I would like to thank my editors, Melanie White and Rosemary Bradley, for their patience and practical assistance, and for putting up with my occasional bouts of bad temper. I owe a great debt to Tim Barringer for reading the manuscript at a crucial stage. Many of his suggestions are now incorporated in the final text. Finally, I should like to thank my agent, Pat White, for her encouragement.

Credits

Calmann & King Ltd., the author, and the picture researcher wish to thank the institutions and individuals who have kindly provided photographic material for use in this book. Museums and galleries are given in the captions; other sources are listed below.

Accademia Americana (Fototeca Unione): 4.8
© ADAGP, Paris/DACS, London, 1992: 26.22, 26.27, 27.14, 27.15, 27.17, 28.7, 28.17, 29.4, 29.6, 29.11, 29.12
Alinari, Florence: 5.1, 5.3, 5.4, 5.5, 5.8, 5.9, 7.8, 8.14, 8.18, 8.19, 8.20, 8.21, 8.22, 8.27, 8.28, 10.4, 10.5, 10.9, 10.10, 10.13, 10.14, 10.15, 10.16, 10.17, 10.20, 11.20, 13.2, 13.3, 13.4, 13.5, 13.6, 13.23, 14.1, 14.4, 14.15, 20.3
Ancient Art & Architecture Collection, London: 2.5, 2.17, 3.3, 3.8, 3.17, 3.18
© Carl Andre/DACS, London/VAGA, NY, 1992: 30.8
Wayne Andrews, Chicago: 26.3
Arcaide, London: 29.2
Architectural Association: 27.6, 29.1, 30.3, 30.4
Prof. Andronikos: 3.18
James Austin: 7.10, 8.25
Tim Benton: 25.2
Biblioteca Apostolica Vaticana: 7.13
Bibliotheque Nationale, Paris: 20.2
Oswaldo Böhm, Venice: 11.16, 13.4, 13.17
Bridgeman Art Library, London: 11.5, 20.4, 24.13, page 360
Caisso Nationale des Monuments Historiques et des Sites: page 115
Lady Juliet de Chair: 19.6
Conway Library, London: 10.20
Country Life Magazine, London: 21.2
© DACS, London, 1992: PERRET 26.4, 26.5, 26.8, 26.16, 26.17, 26.18, 26.19, 26.21, Le CORBUSIER 27.2, 27.3, 27.9, 27.11, 27.12, 27.13, 27.18, 29.1, 29.5, 29.7, 30.14
© DEMART/PRO ARTE/BV/DACS, London/VAGA, NY, 1992: 28.5
Deutsches Archäologisches Institut, Rome: 4.7, 5.7
J. Dieuzaide: 15.5
Edimedia, Paris: page 134, 27.10
Elio Ciol: 18.9
Esto Photographics © 1958 Ezra Stoller: 28.2
E. T. Archive/Elek, London: page 111
Werner Forman Archive, London: page 39, page 46, 4.6, 6.5
Galleria Gian Ferrari: 27.7
Giraudon, Paris: 2.11, 2.12, page 114, 7.22, 7.24, 8.4, 8.24, 11.10, 14.5, page 263, 15.13, page 276, 16.10, 18.10, 20.5, 20.9, 21.4, 22.3, 24.10, 25.3, 25.11, 25.13, 26.9
Sonia Halliday, Buckinghamshire: 3.24, 6.8, 6.9, 8.9, 8.10
Colorphoto Hans Hinz, Allschwil, Switzerland: page 14, 1.5, 1.7, 28.12
Lucien Hervé © SPADEM: 27.2
Hirmer Fotoarchiv, Munich: 2.3, 2.4, 2.6, 2.8, 2.9, 3.16, 3.23, 26.11

Michael Holford/Clyde: 10.1
© Jasper Johns/DACS, London/VAGA, NY, 1992: 28.11
A. F. Kersting, London: 1.9, 7.5
Studio Kopperman, Munich: 3.21
Ralph Lieberman: 6.3, 11.1
Mansell Collection, London: 4.5, 13.24, page 336
Ampliaciones y Reproducciones MAS: 1.10, 9.10, 13.11, 13.21, 15.3, 15.4, 15.9, 15.10, 15.14, 25.1
Bildarchiv Foto Marburg: 4.10, 7.1, 7.6, 7.7, 8.3, 9.1, 9.13, 10.11, 12.6, 12.7, 13.10, 18.1, 18.4, 18.8, 18.10, 23.2, 23.12, 23.13, 27.1
Novosti, London: 18.12
Novosti, Paris: 24.7
© 1992 The Georgia O'Keeffe Foundation/ARS, NY. Photo Malcolm Varon NYC © 1987: 28.4
Oronoz Madrid: 13.20
Photo J. Powell: 6.1
Polish Cultural Institute, London: 9.12
© 1992 The Pollock-Krasner Foundation/ARS, NY: 28.9
Prestel Verlag, Munich: 26.5
© Robert Rauschenberg/DACS, London/VAGA, NY, 1992: 28.10
Réunion des Musée Nationaux, Paris: 16.2, 16.11, 21.3, 23.9, 25.12
Rheinischer Bildarchiv, Ludwig Museum, Köln: page 444, 26.11
Royal Commission of Historical Monuments: 7.3, 7.12, 7.21, 7.23, 8.5, 8.6, 8.7, 8.8, 9.2, 17.1, 17.4, 17.5, 17.6, 19.2, 19.3, 20.1, 24.2
Royal Institute of British Architects, London: 27.3
Scala, Florence: 3.9, 6.7, 7.25, 8.15, 8.17, 8.23, 9.5, 9.7, page 170, page 177, 10.6, 10.7, 10.8, 10.14, 11.2, 11.3, 11.4, 11.6, 11.7, 11.9, 11.11, 11.15, 11.17, 11.19, 13.1, 13.6, 13.7, 13.8, 13.18, page 242, 14.3, 14.6, 14.7, 14.8, 14.11, 14.13, 14.16, 15.1, 16.1, 16.3, 26.6, 26.21
© David Smith/DACS, London/VAGA, NY, 1992: 28.16
Soprintendenza, Florence: 13.22
South American Pictures, Suffolk: 28.1
State Archive of Italy: 4.1
Still Moving Picture Company, Edinburgh: 1.8
Stockholm National Museum: page 308
© Succession H. Matisse/DACS, London, 1992: 26.9, 26.10, 26.25
Duke of Sutherland Collection, on loan to the National Gallery of Scotland: 16.7
Topham Picture Library: 13.12, 15.15, 25.4
Trinity College, Dublin: page 104
Visual Arts Library, London: 7.16, 8.16, 11.13, 13.13, page 262, 15.12, 16.8, page 298, 20.7, 21.6, 21.7, 23.1, 23.4, 24.1, 24.8, 24.14, 24.15, 24.17, 24.21, 24.25, page 434, 26.12, 26.13, 26.16, page 464, 26.22, 26.23, 26.25, 27.9, 27.12, 28.14, 29.3, 29.4, 29.8
Roger Wood, London: 2.9
F. R. Yerbury: 26.4
Zodiaque: 7.4, 7.9, 7.17, 7.18, 7.19, 8.1, 8.26, 9.3

Preface

One of the fascinating aspects of the human quest for creative achievement and self-improvement is the enormous variety of ways of thinking which it has produced. Equally important are the wide variety of ways of building, painting, sculpting, writing, and composing that it has also fostered. The purpose of this book, therefore, is to describe these ideas and arts and to give a basic, simple explanation of how the phenomenon we now call "Western civilization" has developed.

The framework of *Art and Civilization* is not universal. It does not attempt to describe all the civilizations which have existed, but only those that have been called "Western." What does "Western civilization" mean? Essentially this concept began life as a geographical term—developments rooted in, or centered upon, the continent of Europe. It has now been enlarged to mean something else: the fusion of the ancient Greek and Roman and Judaeo-Christian traditions and the impact made by this hybrid upon people all over the world. Paradoxically, it is essential to recall that Western civilization itself does not have its deepest roots in Europe. It owes its origins to ideas borrowed from cultures which were outside the European sphere—from ancient Egypt and most of all from the ancient Near East. The influence of the latter was crucial. The origins of Christianity were not European but Near Eastern, and Christianity and its influence have been one of the distinguishing marks of the civilization of the West.

It is also important to remember that, even if we insist on looking at Western civilization in purely geographical terms, what we call "the West" has continually redefined itself. The civilization of the Greco-Roman world, which we undoubtedly think of as "Western," affected all the lands surrounding the Mediterranean, and was powerfully entrenched in Anatolia. However, it reached only areas of Germany, and was unknown in Scandinavia. The first two parts of this book examine the civilizations of the prehistoric and ancient worlds, looking in depth at their ideas, their art forms, and the influence these were to have on the civilizations that were to follow.

With the collapse of the Roman Empire, the barbarian invasions and the first Islamic conquests the balance of power and culture was completely altered and the focus of Western civilization became France, Germany and later Italy. Parts 3 and 4 of this book describe this shift by looking at the philosophies and arts of the Middle Ages and the early and "High" Renaissance.

In the late fifteenth and early sixteenth centuries, with the increase in trade between countries and numerous voyages of discovery, it could be argued that the term "Western civilization" ceased to be a purely geographical description and became a descriptive label for a certain mental attitude. Parts 5 and 6 of *Art and Civilization* examine this premise through a detailed look at the ideas, visual arts, literature, and music of the sixteenth, seventeenth, and eighteenth centuries in Europe.

The final two parts of this book cover the arts and ideas of the nineteenth and twentieth centuries, focusing on Europe but also paying attention to the rapid cultural development of North America within the Western tradition.

While primarily concerned with Western culture, this book does also look, from the sixteenth century onward, at the influence exercised by the West on other cultures, and on reciprocal influences from civilizations which are not Western.

Art and Civilization focuses its attention on specific personalities, buildings, paintings, sculptures, literary works, and musical compositions, which may be considered especially representative of their times. Each chapter covers a range of topics, and as far as possible these are discussed in the same order:

Ideas/Philosophy/Religion
Architecture
Painting
Sculpture
Literature
Drama
Music

A general introduction to each part outlines the historical background and important influences of every era, and stimulating focus boxes in many chapters provide an intimate insight into the lives and works of influential men and women, and important places and events. Every building, painting, or sculpture discussed is illustrated and there are also extracts and quotations from significant literary works to complement those writers included in the text.

Art and Civilization can thus be read as either a continuous narrative following the development of the arts from prehistory to the twentieth century, or as a series of intertwined accounts, each devoted to a particular theme.

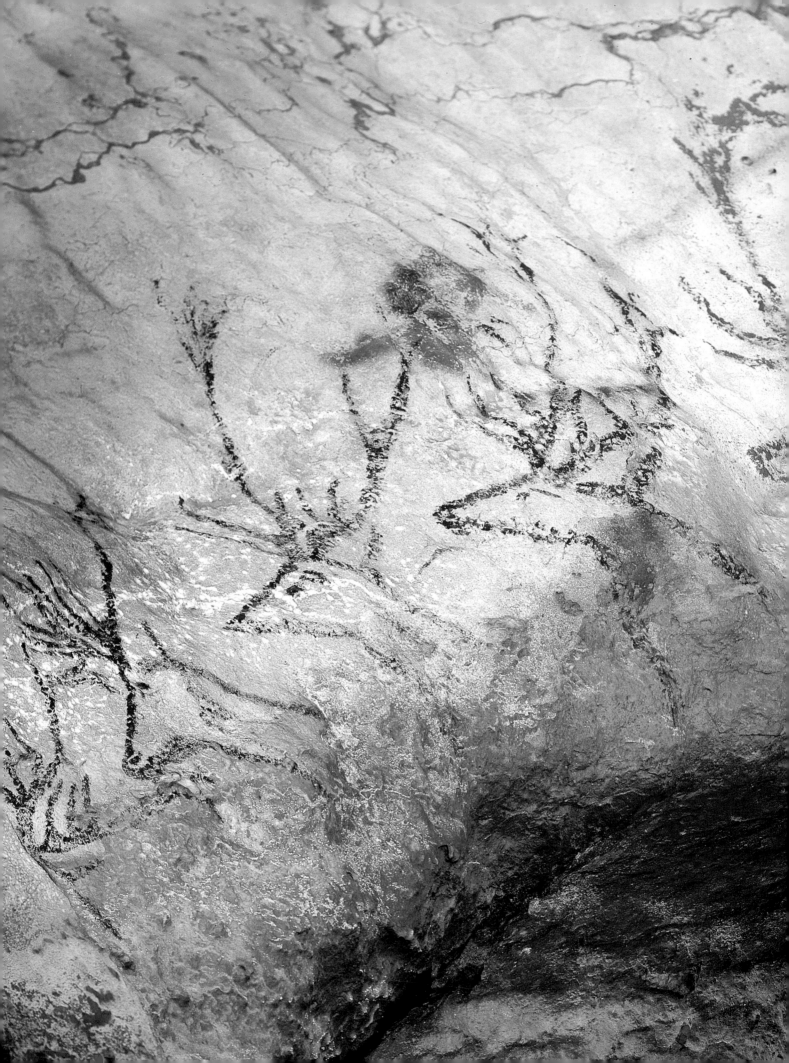

Part
1

Beginnings

Chapter 1

European Prehistory

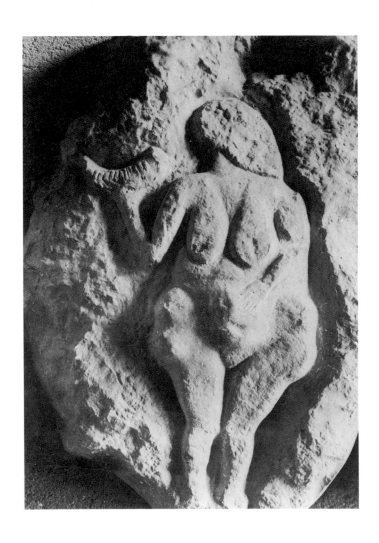

1.1 Relief of a woman from Laussel, Dordogne, France, c. 19,000 B.C. Stone. Musée de l'Homme, Paris.

The nature of prehistory

Any assessment of what is "prehistoric"—that is to say, without any form of written records—can be only fragmentary, and must contain a large element of guesswork. The evidence is always purely circumstantial. It consists of objects—the bones of humans and animals, the tools and domestic objects men and women made and used, the works of art and architecture they created. Sometimes this material has been discovered as the result of scientific excavation, which supplies it with a context, allowing us to relate one piece of evidence to another. Often, however, it is the result of chance finds. This evidence must always be regarded as incomplete, and our evaluation of it can at any moment be altered decisively by some new discovery.

The study of prehistory is itself a new science. The development of sophisticated archeological techniques belongs to the late nineteenth and the twentieth centuries. It stems from a change in attitude toward human beings from that taken by earlier generations. Basically, we have learned to think of people, together with their greatest and most complex creation, civilization, as emerging very slowly from the past. There was a period when men and women were only creatures who had the possibility of becoming human. Later they possessed the elements of material culture, such as the ability to make fire, to create increasingly sophisticated tools and weapons, and to make pottery, without being what we should now think of as "civilized."

The difficulty with this rational and gradualist approach is that it somehow fails to cope with certain great achievements whose quality we are forced to recognize, while at the same time acknowledging their isolation. The best cave paintings are as beautiful, in their own way, as the great art of any more recent period. Stonehenge, however primitive its method of construction, remains a harmonious architectural creation. These examples highlight the fact that artistic creativity is itself not subject to scientific laws. The division between art and science has been widened, not narrowed, by recent developments in art. In the Renaissance, as we shall see, it was possible to feel that artists could build upon the explorations and discoveries of their predecessors (which is exactly what the scientist still does). Today, we assume that every artist is forced to begin anew, without guidelines.

The great achievements of prehistoric Europe are impersonal, in the sense that we know nothing at all about the people who made them beyond what we can learn from a scrutiny of the works themselves. Yet by contrast they have a deeply personal meaning, not only because they speak directly from one individual mind to another, across an immense gulf of time, but because they exist in isolation from other kinds of information—the only secure meaning they can have is one which is subjective and personal to the spectator. The legends which a monument like Stonehenge collects around itself disclose the importance and indeed the nature of that subjectivity.

	30,000	25,000	15,000	10,000	5000	0 B.C.
		UPPER PALEOLITHIC			MESOLITHIC	NEOLITHIC
HISTORICAL BACKGROUND	Tool making Human notation system	Last Ice Age *c.* 18,000–15,000	Human migration from Asia to America begins *c.* 12,000	Domestication of animals *c.* 9000–8000 "Neolithic Revolution" in Near East Discovery of metals *c.* 7000		
VISUAL ARTS	"Venus" of Willendorf (**1.4**) Animals from the Vogelherd cave (**1.5**)	Laussel relief (**1.1**) Lascaux cave paintings (**1.7**)		Remisia cave paintings (**1.10**)		
ARCHITECTURE						Development of architecture Maes Howe, Scotland (**1.8**) Stonehenge, England (**1.9**)

Paleolithic culture

Paleolithic society—the earliest known to us—belongs to a period between about 30,000 B.C. and about 8000 B.C. Our imperfect knowledge of this culture comes not from written records of any kind—writing still lay far in the future—but from human and animal remains, from tools and weapons, and most of all from a surprisingly rich heritage of works of art. The surviving evidence tells us that the men and women of the Old Stone Age (Paleo = old; lithos = stone) belonged to loosely organized communities of hunter-gatherers. Agriculture was still unknown. So too were nearly all the basic crafts—not merely metalworking, but weaving and making pottery.

There is obviously a close connection between Paleolithic art and the basic economy of the time—the means by which these primitive men and women survived. The chief, but not the only, subject of their art is the prey they hunted— deer, wild cattle, horse, mammoth, and buffalo. The distribution of subject matter varies according to the location of the various sites where paintings and other artefacts have been found. Usually at each site there is a marked preponderance of one species. It is likely that this was a function of the prevalent climatic conditions at the time the paintings were done, and the ecology of the immediate neighborhood. Paleolithic groups had not yet tamed horses and other beasts of burden—they might perhaps travel far over a period of time but could not travel speedily.

Until quite recently Paleolithic art was considered to be a western European phenomenon, largely confined to an area of France and Spain lying on either side of the Pyrenees. Recent discoveries, however, at sites as far afield as Siberia and Antalya in Anatolia have disproved this theory.

If the geographical framework of Paleolithic culture is still somewhat uncertain, its chronology is even more so. Attempts have been made to rectify the situation using climatic and other sorts of information, some of it the product of modern scientific techniques, such as radiocarbon dating. But the sequence remains extremely vague and shaky, and could be altered at any moment by a new discovery. In this connection one has to remember that while Paleolithic culture is in absolute terms very old, in historiographical terms it is still young. Historians have had only just over a century to get used to the fact of its existence.

The cave paintings in particular, hidden in darkness for many millennia, and perhaps unseen previously by any but their original creators, give us a new perspective on the story of human culture taken as a whole. They seem to supply confirmation of the fact that the activity of making art, prompted by whatever impulse, is central to the existence of our species. The story of humankind now begins unequivocally with men's and women's activity as artists, and it is art which supplies the strongest thread of continuity as the tale develops.

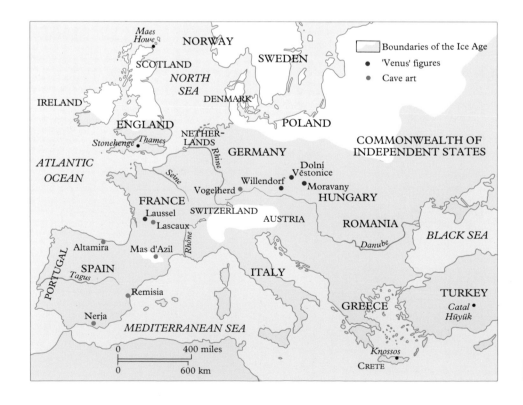

1.2 Prehistoric Europe.

Paleolithic religion

Since they provide our main evidence, artistic representations naturally bear directly on speculations about Paleolithic religion, and therefore about the attitudes that Paleolithic people had toward the largely hostile environment that surrounded them. In general, it seems unlikely that Paleolithic art was made for its own sake. However, if it had an ulterior purpose, what precisely was this? Are the plump female figurines goddesses, or amulets designed to insure the fertility of the tribe? Are the paintings to be regarded as acts of "hunting magic"? In some cases the artists seem to have had no respect for their own creations, to the extent that they put one design on top of another (Fig. **1.3**). It has been argued from this that painting and drawing were purely ritual activities—that it was the making which counted, rather than the finished product. This hypothesis is supported by an eyewitness account of a hunting ritual used by Bushmen in South Africa. Their custom was to draw the animal to be hunted on the bare earth, to wound it ritually before the hunt, and then to efface the drawing after the kill had been made, so as to give no refuge to the dead animal's spirit, which might seek to revenge itself upon the hunters.

There are also a large number of abstract signs of different types associated with representational images in Paleolithic art. These are known as tectiforms, claviforms, scutiforms, penniforms, and aviforms, because of real or fancied resemblances to huts, clubs, shields, feathered objects, and birds in flight. These signs have proven stubbornly resistant to interpretation, though a large number of different explanations have been put forward. For example, tectiforms have been seen as primitive shelters, devices for trapping animals, and representations of the female genital organs. This dispute about a simple diagram arises chiefly from the lack of an agreed context to give it meaning. It serves as a warning against any confident or elaborate interpretation of the nature of Paleolithic thought.

1.3 General view of cave chamber at Lascaux, France, *c.* 16,000–10,000 B.C.

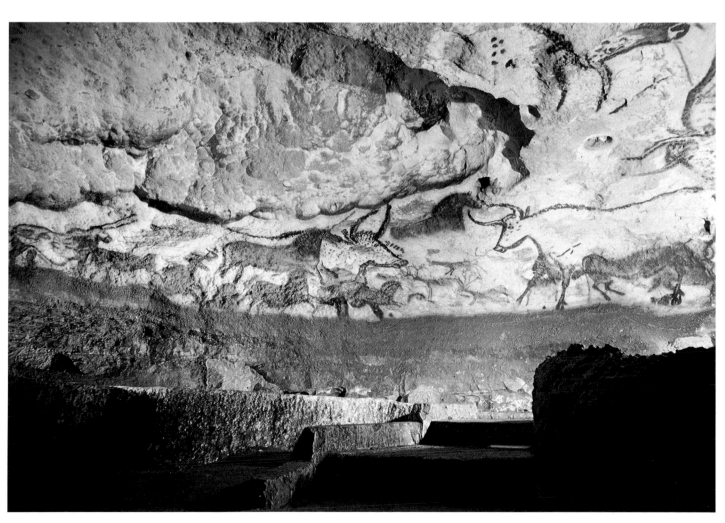

Paleolithic sculpture

While the earliest-known Paleolithic sculptures apparently predate any Paleolithic paintings which have so far been discovered, they are not the things upon which the fame of Paleolithic art primarily rests.

The sculptures fall into four categories. There are small carvings of human figures in stone, ivory, and bone, plus one or two modeled in clay. There are three-dimensional figures of animals. There are carvings, also of animals, which form part of useful or ceremonial objects—so-called *art mobilier*. Finally, there are large-scale reliefs, carved from stone or modeled in natural clay deposits. Of these, the small human figures are the most important. While not all are female, the majority are, and they seem to be the precursors of the images of the Mother Goddess made in many later cultures. The most typical are plump, often with vastly developed breasts and buttocks. The features are generally not marked, and the heads are slightly downcast. The hands rest on the breasts, and the feet are vestigial. Among the most familiar carvings of this type is the so-called Venus of Willendorf (Fig. **1.4**). Radiocarbon dates for the site in Austria where the figure was found suggest that it was made between 30,000 and 25,000 B.C. Its naturalism is unusual, but it shows characteristics which typify a whole class of such statuettes.

The animal carvings were probably portable amulets. A comparison has been made with the walrus ivory carvings created by modern Eskimos, to be taken with them on their journeys. A very early group of such carvings has been found in the Vogelherd cave near Württemberg in Germany (Fig. **1.5**). Not all were found in the same stratum, so it is clear that they were produced over a long period of time. They can be compared not only to Eskimo carvings but to the amulets in animal form which were made later on in the ancient Near East, though these are generally more stylized.

The carvings which adorn various useful or ceremonial objects are considerably more vivid. These can be compared directly to the representations of animals found in cave paintings. The objects they adorn include throwing sticks, spear-throwers (Fig. **1.6**), and what were once called *bâtons de commandement* (scepters)—now recognized as devices for

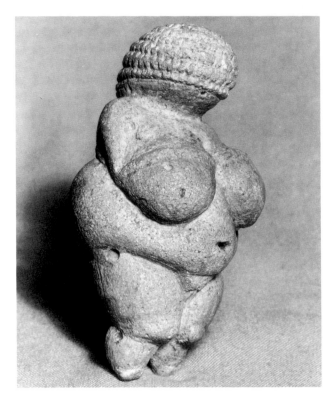

1.4 Venus of Willendorf, Austria, *c.* 30,000–25,000 B.C. Limestone, 4½ ins (11.5 cm) high. Naturhistorisches Museum, Vienna.

1.5 Animals from the Vogelherd cave, Germany, *c.* 26,000 B.C. Bone and ivory. Institut für Urgeschichte, Universität Tübingen, Germany.

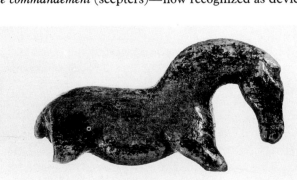

straightening the points of wooden spears. There is here no distinction between the concept of art and the concept of craft—a situation which will persist until the end of the Middle Ages.

The reliefs are the only sculptures which are large in scale. Most can be related directly to cave paintings. One or two have links with fully three-dimensional work—for example, the impressive figure of a woman found at Laussel in the Dordogne in France, which dates from about 19,000 B.C. (Fig. **1.1**). This is a larger version of the Venus of Willendorf. It has been suggested that the figure is more complex than it first appears to be; that it is in fact an attempt to combine three different viewpoints—two side views, a left and a right, plus a fully frontal one. This would account for the broadening and flattening of the form, and also for the markedly knock-kneed stance. The horn the figure holds may be a prefiguration of the allegorical cornucopia, or "horn of plenty," so often found in classical Greek and Roman art. If this is the case, the emphasis is once again on the idea of fertility.

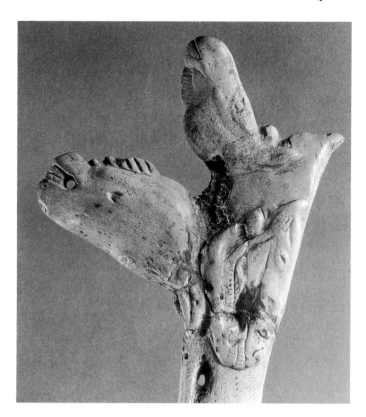

1.6 Spear-thrower carved with three horse-heads from Mas d'Azil, Ariège, France. Bone. Saint Germain-en-Laye, Musée des Antiquités Nationales.

Paleolithic painting

Though the Paleolithic paintings now known to us are probably somewhat later than the earliest Paleolithic sculptures, there are far more of them, and in aesthetic terms they are more important. Most have survived in caves, preserved by the absence of light and also by even temperature and humidity. Animals play the largest part, but they do not totally dominate the repertoire of subjects, which includes human beings and monsters (mostly but not invariably humanoid), together with the abstract signs already described. As well as being the most numerous of the representations, animals are also the ones that have most impressed modern observers with their delicacy and truth. Paleolithic artists relied primarily on the power of outline. Though they tended to present what they depicted in its "completest" form—that is, viewed sideways on, so all important physical features would be apparent—they were by no means indifferent to the idea of volume, and stressed this in various ways: by making the outline thicker or thinner and, in more elaborate examples, by making use of colored infilling which was carefully wiped away at various points to increase the illusion of roundness. There was no attempt at naturalism in the coloring, since the necessary resources were not available. The colors used are naturally occurring earth

colors, such as ocher and a black derived from manganese.

The methods by which such colors were applied are, like many things to do with Paleolithic art, a matter of speculation. Modern experiments, and the parallels offered by primitive rock paintings made in historical times, lead to the belief that techniques may have been surprisingly sophisticated. In addition to painting with the tip of the finger, Paleolithic artists used well-chewed twigs, and perhaps even real brushes tipped with animal hair. As negative handprints show, they must also have made use of color blown from the mouth, probably through a pipe; in this instance the pigment would fairly certainly have been waterborne—experiments have shown that earth pigments filled with water will bind quite satisfactorily to the surfaces Paleolithic artists used. In addition to these methods of painting, it seems likely that they drew with a lump of natural material sharpened to a point.

It is easy to appreciate the brilliance of individual representations of animals in Paleolithic painting but often less easy to see how one such representation relates to another. There has been controversy for many years, and opinions are still divided, about the nature of pictorial composition in the art of this very early period, and indeed about whether

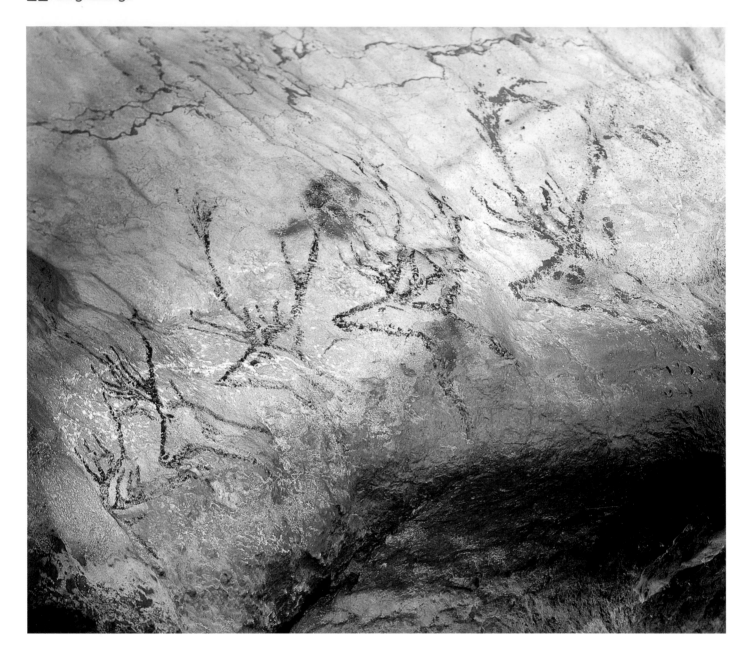

1.7 Five stags swimming. Painting from the caves at Lascaux, France, c. 16,000–14,000 B.C.

the modern understanding of "composition"—the aesthetic arrangement of line and color on a surface—can be said to be relevant at all. Very occasionally it *is* possible to say that certain things seem to have been deliberately grouped together, and are meant to be read as a whole. This is the case with five stags shown apparently swimming a river in the Lascaux caves, France (Fig. **1.7**). Even here, though, the action represented is not absolutely certain. Paleolithic painters had a habit of abbreviating figures. Human beings are quite often shown as mere torsos; animals are painted without their legs, or in extreme cases are indicated by little more than the characteristic curves of back and belly. Something else which the modern spectator finds disconcerting is the consistent absence of a ground line, unless this is provided by some already existing natural feature, such as a fissure in the rock.

Students of Paleolithic painting have repeatedly tried to find evidence not only of deliberate grouping but of actual narrative. However, proof that any narrative impulse existed has been difficult to find, and this is surprising, because it is always assumed that oral story-telling is a basic human cultural activity, found in even the most primitive tribes.

Paleolithic painting is thus a curious mixture of the extremely immediate and the ambiguous and distant. The modern audience can enjoy the keen response of these early artists to what they saw; but it is difficult for even the most expert to fathom any deeper meanings which may lie concealed within these startlingly accomplished representations. It is not even quite certain that our response, which is an aesthetic one, has any relevance to them at all.

Mesolithic to Bronze Age

The Mesolithic (Middle Stone Age), Neolithic (New Stone Age), and Bronze Age in mainland Europe represent a steady progress toward a settled society. Yet there also seems to have been a cultural regression. The paintings and sculptures produced by Mesolithic and Neolithic peoples are not nearly as impressive as the best of those made by their Paleolithic ancestors. The art of architecture is, however, a Neolithic invention.

One of the surprising things about this architecture is that the great monuments are to be found at such peripheral sites—for example, at Maes Howe on Orkney, in Scotland (Fig. 1.8), and New Grange in Ireland. Even Stonehenge (Fig. 1.9), the greatest Neolithic and Bronze Age monument in Europe, is not on the continental mainland. Earlier this century there was a theory that the great tombs and religious centers of northern Europe were created in response to an impulse that traveled northward from the Mediterranean, and specifically from Mycenae, but this has been challenged by radiocarbon datings, which show that Stonehenge is in fact older than Mycenae itself. Some inventions do, however, seem to have been imported from the Middle East. The most important of these is the wheel used for making pottery.

The terms Mesolithic and Neolithic were initially coined because progress was measured with reference to increasing skill in the making of stone artefacts. At first the basic material was flint, just as it had been in Paleolithic times. A characteristic of flint is that it can be shaped by flaking. By Neolithic times people had discovered that the best material for this purpose came not from surface finds but from deposits underground, where the flint had been protected from air and changes of temperature and humidity. This led to the appearance of something resembling industry. Flint mines were dug deep underground. One of the best known sites is once again in England, at Grime's Graves, near Cambridge.

An even more significant innovation in Neolithic times was the change from an economy based on hunting and gathering to one in which plants were cultivated for food. The Paleolithic hunters had been nomadic, and certainly the invention of agriculture did not necessarily tie groups down to one spot, or at least not at first. Europe was still very underpopulated, and there was little or no competition for land. The custom was to clear a suitable piece of ground, plant it, stay long enough to harvest it, and then move on. Methods of cultivation were not very efficient—there were no plows as yet, only sharpened digging sticks, weighted with a stone. There were also wooden hoes made from forked sticks.

Paleolithic populations had been able to prepare and sew together skins, and to make baskets, which were used both for gathering berries and other edibles, and for carrying possessions from place to place, as the hunter-gatherers migrated. The first baskets were probably *ad hoc* containers, roughly made from whatever stems or leaves were available, often wrapping designed for a particular object, destined to be destroyed when what was carried was unwrapped again. However, as basketry skills improved, they led in two directions: first, toward weaving (which was originally undertaken without a loom), and secondly, toward pottery. It had long been known that clay was hardened by fire—baked-clay figurines, including some Paleolithic examples, long predate the appearance of ceramic vessels. These may have evolved from the practice of covering a basket with clay in order to make it waterproof—the basketry support could later be burnt away in a fire.

The next step was the discovery of metals. The first to make their appearance were copper and gold, both of which are regularly found in nature. In contrast, iron, which appeared much later, is found only very rarely, in the form of meteorites. Paleolithic people discovered that copper could be shaped by hammering, and that this process served to harden it. The discovery that copper could be smelted from copper ores may have been connected with the making of pottery, and in particular with the introduction of glazes, in which malachite, a compound of copper, was used as a coloring agent.

Copper soon came to be combined with tin, to produce bronze, which is a harder and more practical material for tools and weapons of all kinds. Tin occurs in comparatively few localities, and there are fewer still where copper and tin are found together. These naturally tended to become centers for producing tools and weapons. Total production was very small. It has been estimated, for example, that the consumption of copper in the whole of the ancient world (not just Europe alone) between 2800 and 1300 B.C., did not exceed 10,000 tons. Throughout the European Bronze Age, metal tools and weapons were scarce and expensive.

The introduction of metals had a profound effect on the structure of European society. Smiths were not the main beneficiaries. They were regarded as set apart, associated with the dangerous as well as the positive qualities of the materials they handled, and often linked to witchcraft and the uncanny by the secret nature of the processes they used. In some communities at least, smiths were treated as feared and respected outcasts. The situation was very different for those who could afford to make use of their services. The ownership of metal tools, and especially weapons made of metal, gave certain individuals the ability to dominate their fellows. The Bronze Age saw the emergence of a warrior class, and, with it, the growth of more aggressive attitudes between different communities.

Neolithic architecture

The origins, and sometimes even the purpose, of the megalithic (meaning large stone) structures of Britain and Ireland, some of the most impressive of their type in Europe, have long been in dispute. The large passage grave at Maes Howe in the remote Orkneys was apparently built as a collective burial place by a small local community of fishermen and farmers, though there is also evidence that the Orkneys were at that time regarded as sacred ground by people who did not live there.

The construction of Maes Howe (Fig. **1.8**) required immense physical effort and a highly developed degree of skill. Some of its lintel stones—the horizontal crossbars laid across an opening—are 18 feet (5.5 m) long, and probably weigh around 3 tons. The monument consists of a mound 25 feet (7.6 m) high and 115 feet (3.5 m) in diameter, built on a specially leveled platform. Within the mound a long passage leads to a walled chamber about 15 feet square (1.4 m²), built of stone. The walls, at first vertical, then sloping slightly inward, are roofed by a square vault, or arched roof, created by corbeling out successive layers of stone blocks. (The principle of the true vault, where each part of the structure supports the other, had yet to be discovered.) The walls of the main chamber have square openings leading to cells of different sizes. When the tomb was thoroughly looted in the twelfth century by Viking raiders, accounts claim that it took them "three days and three nights" to carry away all the gold contained there.

The basic purpose of Maes Howe is not in doubt, and its date is also reasonably well established—it was built around 2600 B.C. The situation is very different with Stonehenge, one of the most celebrated megalithic monuments in Europe.

In its present form, Stonehenge (Fig. **1.9**) is the ruin of a complex structure which seems to have been added to and rebuilt several times. It is surrounded by a bank and ditch, and used to be approached by a long ceremonial avenue. It consists of an outer circle of immense squared uprights made of sarsen, a variety of sandstone, some of which still

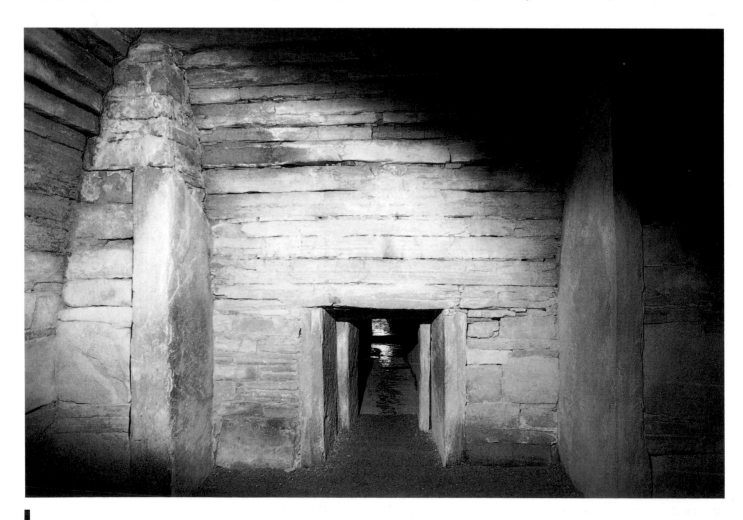

1.8 Maes Howe (interior), Orkney Islands, Scotland, *c.* 2600 B.C.

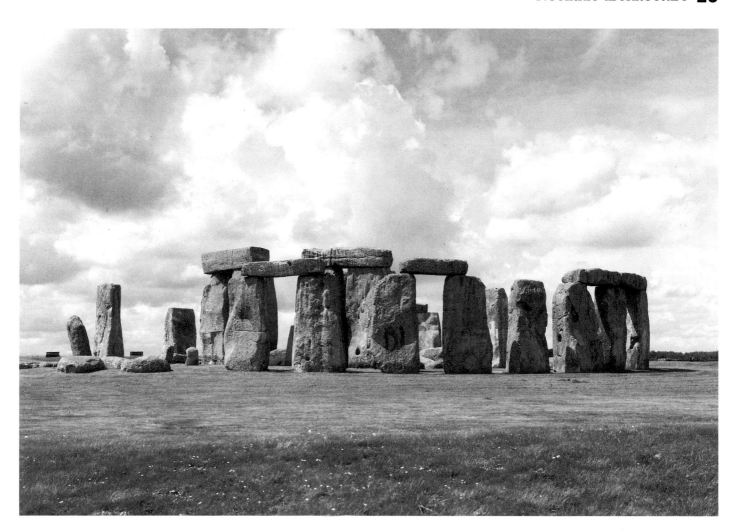

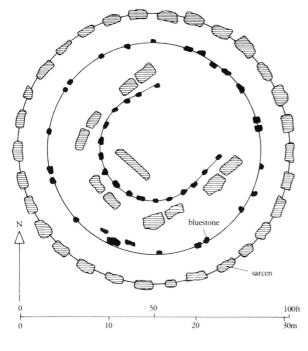

bluestone

sarcen

N

| 0 | | 50 | | 100ft |
| 0 | 10 | 20 | | 30m |

1.9 (*above*) Stonehenge, Salisbury Plain, England, *c.* 2100–2000 B.C. (*below*) Plan of Stonehenge.

support stone lintels made of the same material. These lintels used to form a continuous circle. They are held in position by a form of mortise-and-tenon joint unknown in other megalithic buildings, and perhaps suggested by similar joints used in woodwork, in which the projecting part of one block fits into a corresponding hole in the other. Within this outer circle is an inner one of smaller uprights, without lintels. These are made of a wholly different variety of stone, called bluestone. Within this again there is a horseshoe-shaped group of five pairs of uprights, each originally provided with a lintel. These are made of the same sarsen as the outer circle, and are known as the "trilithons," a word coined by an eighteenth-century antiquary from the Greek for "three stones." The innermost group is a second horseshoe, made of bluestone uprights, without lintels. Almost at the center of this, near the apex of the horseshoe, is a single slab of a different kind of sarsen, now called the Altar Stone but probably once upright like the rest. There are some isolated stones outside the bank and ditch, named in modern times Heel Stone, Slaughter Stone, and Station Stones.

The monument was not created as the result of a single sustained effort. Instead, it grew over hundreds of years, and suffered radical alterations in the process. The first

Stonehenge seems to have consisted simply of the existing bank and ditch, with two unshaped sarsens outside in the entrance way, and dated to about 2100 B.C. There followed at least four complete remodelings. The bluestones appeared on the site about 2150 B.C., but were not then set in their present configuration. This version of Stonehenge was followed, perhaps 100 years later, by the linteled sarsen structure which comprises the bulk of the monument now seen. There were then yet more changes, in which the bluestones were moved to make the current pattern of an inner circle and an inner horseshoe.

In the earliest remodeling, the alignment of the entrance avenue was shifted, so that it pointed toward the position where the sun rose at the summer solstice. This suggests, but does not prove, that Stonehenge has something to do with sun worship. In the eighteenth century, thanks to the writings of the learned antiquary Dr. William Stukeley, most people were convinced that Stonehenge had been a temple of the ancient Druids, and this belief still persists, in the face of archeological evidence to the contrary. More recently, elaborate theories have been put forward concerning the possible use of Stonehenge as a lunar and solar observatory. The difficulty is, as Christopher Chippindale points out in his study *Stonehenge Complete* (London: Thames and Hudson, 1983), that there are now "not one but several Stonehenge astronomies, each using some elements in not always the same ways and leaving others astronomically unexplained."

Mesolithic and Neolithic painting

The direct successors to the cave paintings of the Paleolithic period are rock paintings found at Altamira in northern Spain—an area in which Paleolithic art in the true sense does not occur. These Spanish paintings range in date from the Mesolithic period (*c.* 6000 B.C.) to the Later Bronze Age (*c.* 1500 B.C.). The subject matter is at first sight quite close to that of Paleolithic art, but further inspection reveals important differences of attitude, as well as differences of style. There are lively hunting scenes, in which the animals are shown in headlong flight from human pursuers. Both hunters and hunted adopt a characteristic "flying-gallop" pose, expressive of rapid motion, and this also appears in a scene where the hunters, led by their chief, are shown doing a ritual dance (Fig. **1.10**). There are also occasional agricultural scenes, which show figures with digging-sticks, and battlepieces. In all of these the narrative content is unmistakable, and it is easy to speak of scenes containing many figures as true compositions, where the various parts are vividly related to the whole, so as to convey a coherent story to the spectator.

Neolithic painting continued to make a firm stylistic distinction between animals and human beings—the former were always more naturalistic in treatment, though they tended to be reduced to sensitively drawn silhouettes, without the feeling for volume that occurred earlier. The human figure was drastically stylized, and the artists employed several different conventions. Often the figures were either ribbonlike or threadlike, recognizable chiefly by their lively features, but also by their clothing, weapons and hair-styles, which were often shown in some detail.

Vigorous and amusing as they are, the Spanish rock paintings have never attracted as much attention as their Paleolithic predecessors. The reason is not only that they are newer, and thus less mysterious and romantic, but also that they do not have the same impact as works of art. The Paleolithic paintings are more complex, and aesthetically much subtler. The main interest of this Neolithic style lies in the fact that it is a universal language, and examples occur, apparently independently, in areas thousands of miles apart.

1.10 Ritual dance of four hunters led by their chief. Painting from a
cave at Remisia, Castellón, Spain.

Chapter 2

Ancient Egypt and Mesopotamia

2.1 Upper part of stele inscribed with the law code of Hammurabi, *c.* 1760 B.C. Basalt, 88 ins (223.5 cm) high. Louvre, Paris.

The sources of Western civilization

The civilization of Europe was not a thing of autonomous growth. The earliest historic civilizations arose on what are now the fringes of the European sphere, but made a great contribution to what was to happen later. Perhaps the most significant development of all was writing, which appeared in two different forms: as hieroglyphs in ancient Egypt, and as cuneiform in ancient Mesopotamia. These two civilizations had much in common, but also had marked differences.

First, the basic similarities. Both civilizations depended on rivers: ancient Egypt on the Nile and its fertile valley; ancient Mesopotamia on the Tigris and the Euphrates, and the fertile crescent between them. Both were dependent on agriculture. Thanks largely to the invention of writing, both had elaborate administrative systems. These, in turn, made sure that government in both was highly centralized. In each case there was a hierarchy which reached its culmination in the person of the king, who was regarded either as a god in mortal form, or as the only person qualified to serve as an intermediary between the gods and the people.

The differences between Mesopotamia and Egypt are based on geography and climate. Egypt was a narrow, fertile strip, broadening at last into the more ample agricultural lands of the Delta, where the Nile reached the Mediterranean. The climate was equable, and deserts on either side of the river valley provided a natural barrier against invaders. For most of the time the one great catastrophe the Egyptians had to fear was that the Nile would fail to rise, since their prosperity depended entirely on the annual inundation.

The people of Mesopotamia lived in a far more threatening, dangerous, and uncertain world. The climate was more extreme, and also more unpredictable. The region had no strongly marked natural frontiers, such as those which protected Egypt. The cities which grew up in the plains were constantly under threat, both from warlike tribes in the hills above them, and from nomadic invaders. Within the region,

▌ 2.2 Ancient Egypt and Mesopotamia.

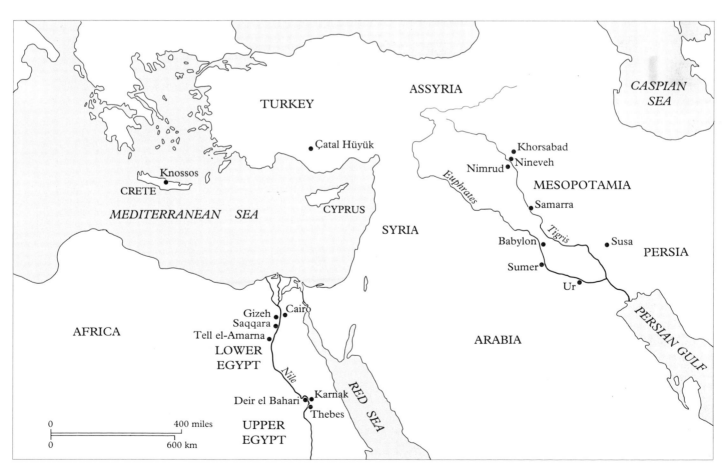

power shifted rapidly from one city-state to another. The most powerful cities were initially in the south, where Mesopotamian civilization began. Power then moved north, and fell into the hands of the Assyrians, who took their name from the city Assur but also ruled from Nineveh and Nimrud. With the fall of Nineveh in 612 B.C., it shifted south again, to Babylon, which was in any case regarded as the traditional spiritual capital, even if it was not always the political one.

There is a marked difference in temperament between the two civilizations which reflects the difference in material conditions. The Egyptians tended to be equable and optimistic. The elaborate Egyptian cult of the dead, to which we owe so many relics of the Egyptian achievement, was intended to insure that the afterlife was as much as possible like the life people already knew, which they found for the most part eminently satisfactory. Mesopotamian civilization, on the other hand, was filled with terror and foreboding. The gods must constantly be propitiated, to fend off disaster. The afterlife was nothing to look forward to. The great Mesopotamian epic *The Epic of Gilgamesh*, for example, describes the realm of the dead as a place of universal sadness (see page 44).

No ancient Egyptian would ever have thought in such terms. But, if ancient Egyptian civilization was the more stable, it was also less dynamic. While the relics of ancient Egypt which survive today are more numerous, more impressive, and usually more emotionally accessible to us, it seems likely that civilization as we know it owes more to Mesopotamia, from where it inherited that element of discontent which has constantly prodded it and made it continue to develop.

Religion and morality

Both ancient Egypt and ancient Mesopotamia have complicated pantheons. The number of the Egyptian gods is so large, and their relationships are so entangled, that they have baffled both ancient and modern observers. The ancient Greek historian Herodotus described the Egyptians wonderingly as "the most religious people on earth." The gods in both regions can, however, be divided into broad categories: they are either embodiments of the forces of nature (more rarely, of abstract qualities), or else they personify the spirit of place. The same power or essence tends to go by different names, and a successful local god will often usurp the powers of his or her rivals, and sometimes even add their names and attributes to his or her own.

These ancient religious systems are important to the student of Western civilization for two reasons. The more superficial is that even a brief glance helps us to understand what the artists of the time were trying to express. The more profound is that they foreshadow the beliefs which have helped to shape the world we know today. For example, both religions had creation myths which parallel the Old Testament version in Genesis. The Mesopotamians, in addition, had the story of a great flood which nearly destroyed humankind, as vividly recounted in *The Epic of Gilgamesh*.

Both civilizations also had a myth concerning a savior god who dies and is resurrected. The Egyptian legend is central to the idea of Egyptian kingship. It concerns the god Osiris, who was originally a god of vegetation—which dies and comes back to life. In the fully developed version, he was killed by his treacherous brother Set, thrown into the Nile, and carried by its waters, and those of the sea into which the river flows, as far as Byblos in Lebanon. Osiris's wife, Isis, rescued the corpse, but Set found it again, cut it into many pieces and scattered it. Isis painstakingly reconstituted the body and gave it life once more. She then became pregnant by the revived Osiris. The child of this union was Horus, of whom the pharaoh, the king of Egypt, was the living personification. Osiris, usually represented as a mummy, or an embalmed corpse, retired to rule over the realm of the dead.

The Mesopotamian version of the myth is less well documented, and we know it only from commentaries and allusions, not from direct narration. It too concerns a god of vegetation. In many cities the events of the story seem to have been acted out annually as a sacred play, and the god took different names depending on which city was involved.

First, at the appropriate season, the god made a triumphal entry into the city. He was then put on trial in front of the temple mount, the ziggurat (see page 34). His followers rioted and the god disappeared. Lamenting, his wife went in search of him, eventually finding his tomb. Two criminals had been tried with him—one had been pardoned and freed, the other was executed. Represented by a pig's head, the corpse of this other criminal was found tied to the lintel of the tomb doorway. The god's robe was carried through the town by the priests, and finally given up to the weeping goddess. Her husband, meanwhile, was in exile in the underworld. The queen of the underworld took the weapon out of his wound, and staunched the flow of blood. The other gods were asked to help in rescuing him. Some agreed, while others rejoiced at his misfortune. A battle followed in which evil was conquered. The god's chariot, shaped like a boat, arrived at the foot of the ziggurat, and at

	3000	2500	2000	1500	1000 · 500 B.C.
EGYPTIAN PERIODS	**ARCHAIC DYNASTIES I–III**	**OLD KINGDOM DYNASTIES IV–VI**	**MIDDLE KINGDOM DYNASTIES XI–XIII**	**NEW KINGDOM DYNASTIES XVIII–XX**	**LATE PERIOD DYNASTIES XXV–XXXI**
MESOPOTAMIAN PERIODS	**SUMERIAN**		**AKKA-DIAN** · **BABYLONIAN**		**ASSYRIAN/ NEO-BABYLONIAN/ PERSIAN EMPIRE**
HISTORICAL BACKGROUND **EGYPT**	Unification of Lower and Upper Egypt under Narmer *c.* 3200	Collapse of Old Kingdom 2258	Re-unification of Egypt under Mentuhotep *c.* 2134	"Heresy" of Akhenaten 1379–1362 Tutankhamun *c.* 1361–1352 Ramases III–XIII Decline of Egyptian power	Egypt conquered by Alexander 302
MESOPOTAMIA	Rise of Sumerian civilization *c.* 4000	Akkadian invasion 2350 Flourishing of city of Lagash Revival of Sumerian State 2125	Rise of Babylon Legal Code of Hammurabi 1792–1750	Rise of Assyrian Empire	Becomes part of Persian Empire under Cyrus the Great 539
ARCHITECTURE	Djoser Mausoleum at Saqqara (**2.3**) Gizeh pyramids (**2.4**)	Ziggurat at Ur (**2.6**)		Hypostyle Hall, Karnak (**2.5**)	Ishtar Gate, Babylon (**2.7**)
VISUAL ARTS		Lion-headed monster figure (**2.11**) Statue of Cephren (**2.8**) Statue of Gudea (**2.12**)	Statue of King Hor (**2.9**)	Colossal statue of Akhenaten (**2.10**) Paintings from tomb of Ounsou at Thebes (**2.17**)	Winged bull from Khorsabad (**2.13**)
WRITING	Cuneiform script developed in Mesopotamia *c.* 3000	Composition of Epic of Gilgamesh		*The Book of the Dead* *c.* 1300	

the same moment the god rose from the dead and appeared in glory at the top of the mount.

Striking as these religious parallels are, they do not mean that either Egypt or Mesopotamia had as yet developed a very refined and subtle system of ethical philosophy. For the ancient Mesopotamians, men and women had been created to serve the gods as servants, but the material they were made of was the flesh of a demon defeated by their great god, Marduk, and condemned to death by him and his assembled fellow deities. The Mesopotamians did, however, recognize a system of law. The most authoritative version of this known to us was codified by Hammurabi, sixth king of the old Babylonian dynasty, who reigned *c.* 1728–1686 B.C. It is inscribed on a stele (Fig. **2.1**) which is now in the Louvre in Paris. The laws are particularly concerned with the relationship between the word and the fact—for example, the question of true or false witness. Law 3 reads: "If a man shall have come forward with false testimony in a case, and shall not have proved the word which he spoke, then if the case was one involving life, the man shall be put to death."

The ancient Egyptians had the concept of *maat* or truth, personified as the daughter of Ra, the sun god. Maat was represented by the feather against which a dead person's heart was weighed when he or she came before Osiris to be judged for his or her deeds. *The Book of the Dead*, a varying collection of spells often included as part of the funerary equipment, instructed the deceased on what to say. The best-known version of this "negative confession" reads in part:

I have not inflicted pain.
I have not made anyone hungry.
I have not made anyone weep.
I have not committed murder.
I have not commanded to murder.
I have not caused anyone to suffer.

Virtue consists of the things people do *not* do, rather than of the things they actually do.

Architecture

Stone is plentiful in Egypt, so it was used widely as a building material, to supplement the more transitory mud brick. As a result a varied and impressive range of ancient Egyptian architecture survives. We know a surprising amount about the people who commissioned the greatest Egyptian buildings, which were all for sacred, not secular, use. Sometimes we also know the names of the individuals who designed them.

The history of Egypt is conventionally divided by historians into four major epochs, preceded by the so-called Archaic Period (3200–2680 B.C.). These epochs are the Old Kingdom (2680–2258 B.C.), the Middle Kingdom (2134–1786 B.C.), the New Kingdom (1570–1085 B.C.), and the Late Period (1085–332 B.C.). The Old Kingdom is divided from the Middle Kingdom, and the latter from the New Kingdom, by periods of anarchy.

The most important building complex ever erected in Egypt, the forerunner of everything that followed, is the mausoleum built at Saqqara in the Archaic Period for King Djoser of Dynasty III (Fig. 2.3) by his architect Imhotep, who was subsequently worshipped as a god of wisdom. The complex consists of a step pyramid dominating a bastioned enclosure which contains a number of chapels and other buildings. The buildings are for the most part imitations in stone of light, impermanent structures originally put up for the king's coronation and jubilee ceremonies. There are walls which are copies in stone of a rough stake fence, and there are even some interior panels decorated with blue-glazed tiles that imitate reed matting. Even when the stone carving is not a direct copy of a different building technique, it makes use of vegetable forms, such as papyrus stalks and palm branches.

The step pyramid, which is the king's tomb, seems to have evolved from an even earlier form of tomb, the *mastaba* (from the Arabic word for bench), which continued to be used for non-royal burials. Djoser's monument is one *mastaba* piled on top of another, and has therefore been compared to a staircase reaching into the sky. However, unlike a Mesopotamian ziggurat (see page 34), which is always crowned with a small temple, it reaches no conclusion.

During the next dynasty, the first of the Old Kingdom proper, the form evolved, and was enlarged, to become the familiar pyramids of Gizeh (Fig. 2.4), some of the most impressive structures ever built. At Saqqara there was a certain tentativeness in handling stone. Here the builders were able to work with massive blocks, finely jointed. The pyramids in their fully evolved form refer to an Egyptian creation myth in which the sun god, Ra, a self-created being, emerges from the waters of chaos to find he has no place to stand. He therefore calls into being a hill to support him. This hill, called the *benben*, is symbolized by the pyramids of Gizeh, and also by the miniature pyramids which form the caps of Egyptian obelisks.

In Egypt the power and success of pharaohs was always expressed by the immensity of their building works. When Egyptian prosperity reached a second climax, at the time of the New Kingdom, this expressed itself not through pyramid-building but through the creation of vast and impressive temples. Dedicated to the god Amun, an aspect of the sun god, who was also the personal god of the ruler, the great temple at Karnak was nevertheless not, as the pyramids were, a personal monument. It grew by a slow process of accretion, proceeding westwards by gradual stages. Perhaps the most impressive section is the great Hypostyle Hall (Fig. 2.5), originally erected by Seti I of the 19th Dynasty (ruled 1318–1304 B.C.) and added to by his son, Rameses II (1304–1237 B.C.). This covers an area of some 6,000 square feet (557.4 sq m), with 134 immense columns filling this space, on either side of a processional way—like other Egyptian temples, the building is bilaterally symmetrical, and offers a long-drawn-out processional route through successive colonnaded courts and halls.

Unlike the layout of a medieval cathedral, which it in some ways resembles, the great temple at Karnak somehow never reaches a satisfactory climax, of the kind provided by the Christian high altar. It terminates in a series of small, dark chapels, the domain of the priests alone. The most impressive architectural effect is due to the way the close-set columns seem to imitate a segment of marshland, blown up to a gigantic scale and transformed into stone. The columns are papyrus bundles and the capitals are vast lotus buds—the heritage of Saqqara is thus still evident.

In Mesopotamia the main, indeed almost the only, building material was mud brick, and so, because of its fragility and tendency to erode, few architectural remains survive. The most conspicuous are crumbling traces of temple mounts or ziggurats, which originally carried small shrines on their summits—places where people could confront the gods. The ziggurat (Fig. 2.6) could take slightly different forms. One of the few left in a reasonable condition is also one of the oldest—the example at Ur, which dates from the Neo-Sumerian period (2125–2025 B.C.). This is not a perfect square, as later examples tend to be, and only two of a possible three stages survive. The first is approached by a triple staircase, while a single stair continues to the second. There is no trace of the temple on top. This ziggurat was surrounded by a sacred enclosure containing other buildings, but of these, too, there is little trace.

A slightly different form of temple tower, dating from

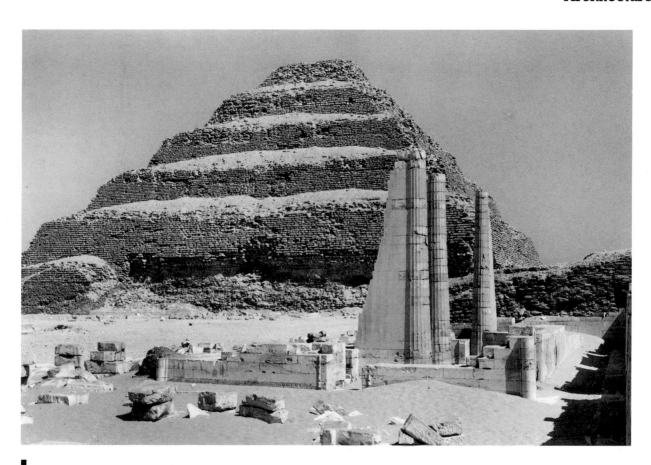

2.3 Step pyramid of King Djoser, Saqqara, Egypt, *c.* 2700 B.C.

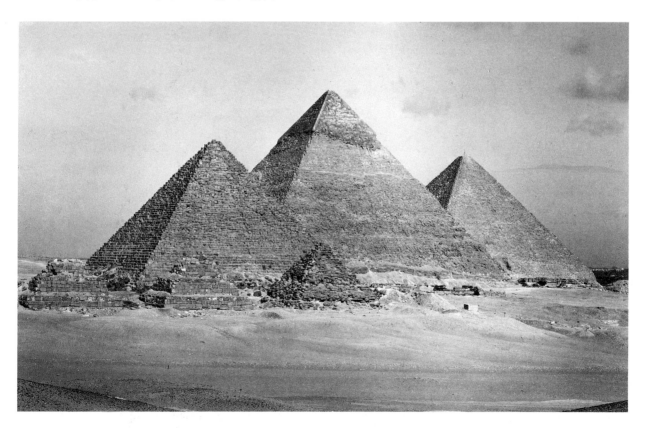

2.4 The Great Pyramids at Gizeh, Egypt.
Mycerinus *c.* 2575 B.C., Chefren *c.* 2600 B.C., Cheops *c.* 2650 B.C.

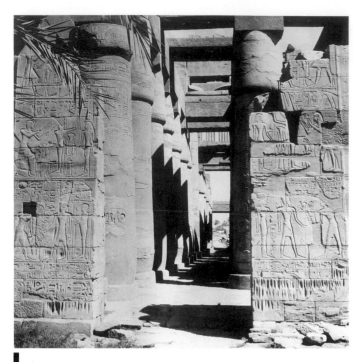

2.5 Hypostyle Hall, Temple of Amun, Karnak, Egypt, c. 1300 B.C.

the Assyrian period, was excavated at Khorsabad just over 100 years ago. The connection between the stages was by means of a continuous ramp, not a staircase, and three stages were preserved, with traces of a fourth. The lowest was painted white, the next black, the third red, and the fourth was white but may once have been blue, which is a fugitive color—one whose pigments fade easily. This arrangement conforms to descriptions of the great ziggurat in Babylon, which had seven stages, each painted a different hue, given by the fifth-century B.C. Greek historian, Herodotus.

The monument Herodotus saw belonged to the Neo-Babylonian period (c. 612–539 B.C.), and was the legendary Tower of Babel. Only the ground plan now survives—enough to show that it had three staircases leading up to it. From this late phase in the life of the greatest of all Mesopotamian cities we do have one hugely impressive architectural fragment, although it is no longer *in situ*. This is the ceremonial Ishtar Gate (Fig. **2.7**), which is now in the Pergamon Museum in Berlin. It is decorated with bulls and dragons in colored relief, made of glazed tiles. It gives at least a faint idea of why the city so much over-awed its visitors.

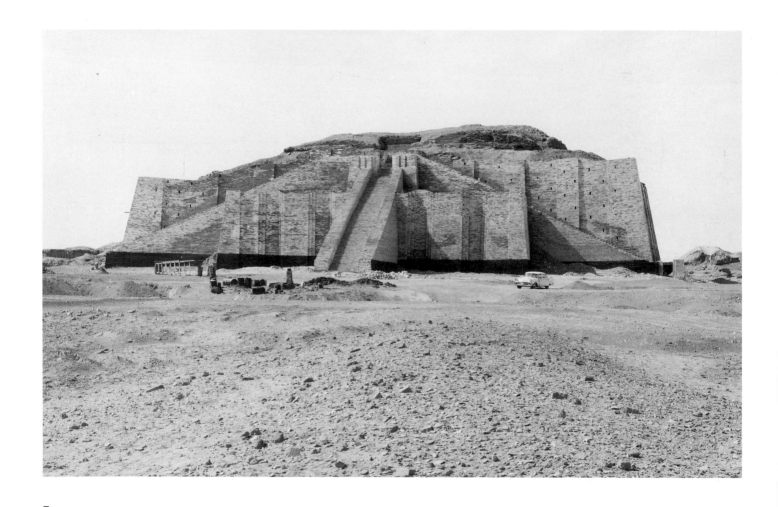

2.6 Ziggurat at Ur, Iraq, 2125–2025 B.C.

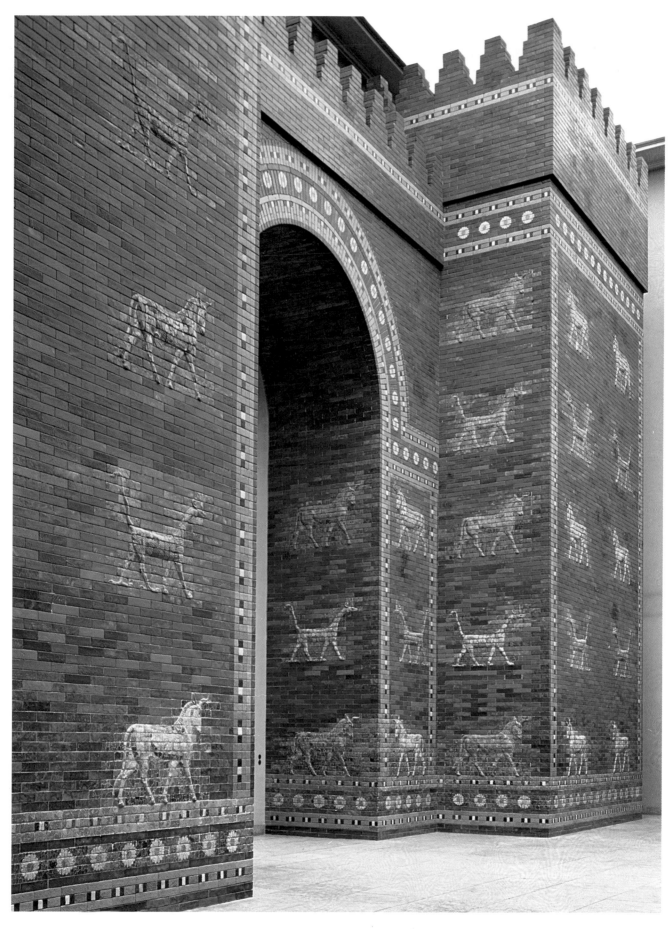

2.7 Ishtar Gate, from Babylon (restored), Iraq, *c.* 575 B.C. Glazed
brick. Staatliche Museen, Berlin.

Sculpture

Ancient Egypt

Sculpture in ancient Egypt developed according to the same stylistic pattern as architecture, with the finest work being produced at the height of the Old, Middle, and New Kingdoms. Much Egyptian sculpture is portraiture, but these are portraits of a very particular sort. They are idealized likenesses of the pharaohs, and also of royal officials, which were originally thought of as substitutes for the actual physical bodies of their subjects. Statues made for use in Old Kingdom tombs underwent a magical ritual on completion which imbued them with the spirit of the dead person represented. They were often provided with a special tomb-chamber, the *serdab*, with a spy-hole through which they could keep watch on the affairs of the living.

The likenesses of the great Old Kingdom pharaohs achieved overwhelming majesty. The pose chosen for the statue of Cephren (Fig. **2.8**), with the king seated on his throne, his left hand flat on his thigh, and his right formed into a fist as though to clasp a scepter, was copied in Egypt for many generations. The mixture of formality and naturalism now seems peculiarly Egyptian.

Some sculpture of the Middle Kingdom consciously returned to Old Kingdom models, perhaps as an affirmation of recovery on the part of the central power. This is the case with a wooden statue of King Hor (Fig. **2.9**), a personification of the king's spirit, as indicated by the upraised pair of hands attached to the figure's head (these are the Egyptian hieroglyph for "vital force"). This sculpture is also interesting because the subject is represented nude, which is rare in Egyptian art. However, though naturalistic in many ways, the work does not seem to be primarily concerned with the fact of nakedness.

In the early New Kingdom Egyptian sculpture, otherwise so conservative, underwent an extraordinary phase of experiment. This was connected with the personality of the so-called "heretic pharaoh," Akhenaten (1379–1362 B.C.). His heresy was an attempt to impose a new monotheistic religion on the confusion of Egyptian beliefs, with Ra, the sun god, symbolized by the Aten or solar disc, as the source of all life. Akhenaten was eventually to move his capital to a new, purpose-built city at El Armarna, but before he did so, he built an important temple at Karnak. There survive from it fragments of colossal standing portrait statues of the king, which were placed against the pillars surrounding a court. These depart radically from long-established Egyptian stylistic conventions. Normally, the statues of a king placed in such a position would have shown him as Osiris (see page 30), swathed in mummy wrappings. Akhenaten is shown in full royal regalia (Fig. **2.10**). His face is elongated, with slanted eyes and mysteriously smiling lips. The impression

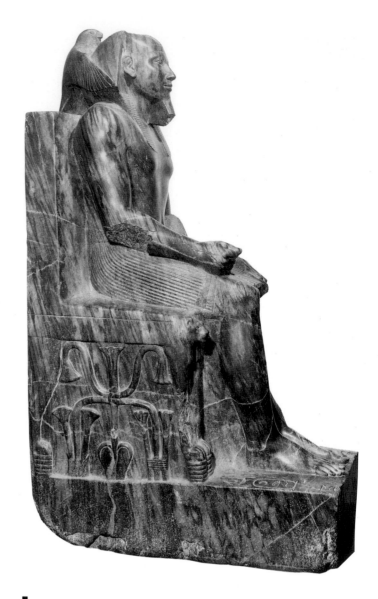

2.8 Statue of King Cephren, 4th Dynasty. Egyptian Museum, Cairo.

of effeminacy made by this visage is powerfully reinforced by the slack, plump-bellied, large-hipped body.

After Akhenaten's death, his heresy was obliterated and Egyptian sculpture returned to its old conservatism. Forms invented during the Old Kingdom were revived in the Late Dynastic period—for example, under the 16th Dynasty (664–525 B.C.), just before Egypt was conquered by the Persians.

Ancient Mesopotamia

Ancient Mesopotamian sculpture reflects the constantly changing circumstances of the region, and there is little of the stylistic continuity which prevails in Egypt. Some pieces, though extraordinarily impressive in themselves, are mysterious and isolated in the sense that there is no material which can be compared to them or used to give them a context. A case in point is the tiny figure of a monster

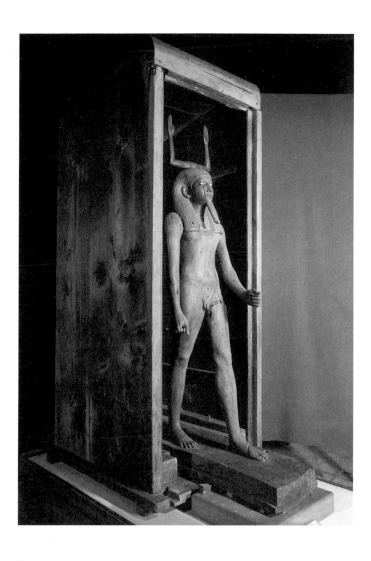

2.9 (*above left*) Wooden statue of the Ka figure of King Hor in its wooden shrine, 13th Dynasty. Egyptian Museum, Cairo.

2.10 (*above right*) Akhenaten, *c.* 1375 B.C.
Colossal statue from Karnak, *c.* 1375 B.C. Sandstone, approx. 13 ft (3.96 m) high. Egyptian Museum, Cairo.

2.11 Lion-headed monster figure holding a bird, Mesopotamia, *c.* 2100–2000 B.C. Louvre, Paris.

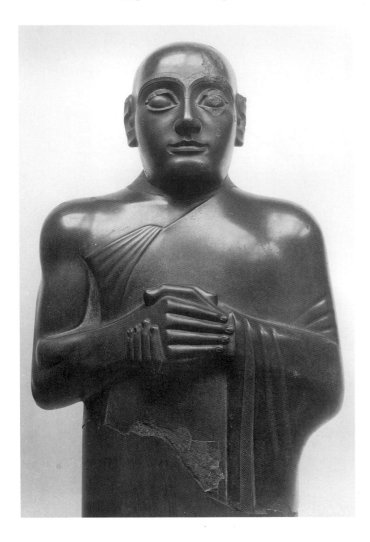

2.12 Statue of Gudea *c.* 2100 B.C. Lagash, Iraq. Hard mottled stone, probably quartz clolerite, 29 ins (73.6 cm) high. British Museum, London.

2.13 Winged bull from Khorsabad, *c.* 720 B.C. Limestone, approx. 13 ft 10 ins (4.21 m) high. Louvre, Paris.

(Fig. **2.11**), which seems to date from before 2000 B.C. and vividly illustrates the terrors which haunted the Mesopotamian imagination. It has little connection with slightly later ruler portraits, such as those of Gudea of Lagash (Fig. **2.12**), who reigned in the Neo-Sumerian epoch (2125–2025 B.C.). It has aptly been said of Gudea's portraits that they are "pervaded by the confidence and gaiety of the truly devout." The mastery these sculptures demonstrate in the handling of very hard stones rivals that shown by the sculptors of ancient Egypt. However, there is one significant difference. Egyptian sculpture always seems to presuppose a rectangular block. Early Mesopotamian carving seems to be confined not within a block but within an imaginary cylinder or cone.

The most extensive series of Mesopotamian sculptures which has come down to us dates from a much later period, that of the conquering Assyrian monarchs who reigned be-

tween *c.* 1000 B.C. and 612 B.C. A peculiarity of Assyrian sculpture is that it is essentially an art of relief, with its constituent parts projecting from a flat surface. Even the great human-headed winged bulls which protected Sargon's palace at Khorsabad (Fig. **2.13**) are not freed from the slabs on which they are carved. The front and side views of these creatures were clearly regarded by the artist as being quite separate and distinct. The oblique view, which seems not to have been considered, reveals a figure with five legs.

One feature that the human-headed bulls share with the narrative reliefs (Fig. **2.14**) which are even more characteristic of Assyrian art is a kind of linearism. Garments are intricately patterned; beards and hair are curled and braided; the musculature of arms and legs is expressed by sharp divisions. The subject matter of these reliefs is almost invariably violent. They show wars of conquest, in which the Assyrian king is always successful, and the sadistic

The Tomb of Tutankhamun

Our most vivid picture of the material and cultural wealth of the Ancient Egyptians comes from a discovery made in 1922. In that year an excavation directed by the British archeologist Howard Carter discovered the tomb of the late 18th Dynasty pharaoh Tutankhamun (*c*. 1361–1352 B.C.). Tutankhamun, who died aged about eighteen, was one of the immediate successors of the "heretic pharaoh" Akhenaten (see page 37). It was during his reign that the old religion of Egypt was restored.

Hidden beneath the much larger tomb of Rameses VI (1151–1143 B.C.), Tutankhamun's resting place suffered two minor robberies soon after the king was buried but thereafter remained undisturbed until discovered by Howard Carter. The tomb contained the king's mummy (his embalmed body), and almost all his funerary equipment.

The mass of objects buried with Tutankhamun is indicative of the Ancient Egyptian belief in an afterlife very much like life here on earth. These objects included things the king would have used in his life—thrones, beds, stools, chariots, games and game-boxes, caskets for clothes, writing materials, walking sticks, lamps, and musical instruments—and also magical objects and amulets connected with Egyptian religious belief. There was an array of beautifully made model boats for his journeys in the afterlife, and a mass of *shabtis* (small figures which would serve as the king's deputies if he were called upon to perform menial tasks in the netherworld). Whereas a private burial of Tutankhamun's time might have contained two of these substitutes, Tutankhamun had 413 of them: 365 ordinary workmen, one for each day of the year) and 30 overseers (one for each ten-day Egyptian "week" and 12 monthly overseers).

The king's body was many times enclosed. First came a series of four gilded shrines. Within these in turn was a massive yellow quartzite sarcophagus, exquisitely carved with tutelary goddesses in relief. This sarcophagus contained three coffins, nested one within another. The two outer coffins were of gilded wood; the innermost, 6 ft 2 ins (1.88 m) long, is made of solid gold and weighs 296 lb (134.3 kg). It is richly inlaid with hardstones and colored glass. The king's mummy wore a gold portrait mask covering its whole head and shoulders. This, too, is richly inlaid.

It shows the young king as the Egyptian god Osiris, who died and was resurrected from the dead (see page 30). On the brow are royal emblems—the vulture and the cobra. To the chin is strapped the artificial beard which was one of the attributes of divinity. The king's eyes, inlaid with obsidian and crystal, are outlined with kohl, a dark pigment originally used as a protection against the sun, but later for purely cosmetic purposes.

The effect is startlingly lifelike. At the same time, however, the precious materials of which the mask is made give an almost overwhelming impression of the wealth and power of Ancient Egyptian royalty.

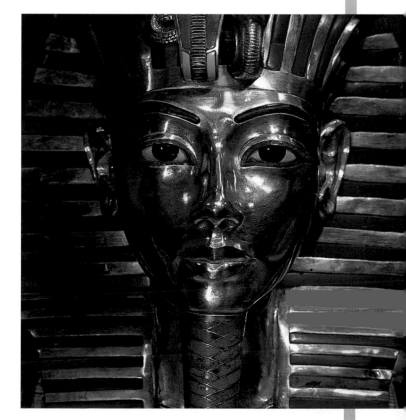

Funerary mask of King Tutankhamun, *c.* 1340 B.C. Gold inlaid with enamel and semi-precious stones, 21¼ ins (54 cm) high. Egyptian Museum, Cairo.

2.14 Mural relief from the palace of Sargon II at Khorsabad. Basalt, 5 ft 10 ins (1.78 m) long. British Museum, London.

punishments inflicted on his defeated enemies. These are varied with hunt scenes in which lions and other beasts are slaughtered *en masse*. Some of the most memorable elements in these latter compositions are representations of dead and dying animals. We must not suppose, however, that the audience for which they were carved found in them the pathos we are apt to see today. For the Assyrians, such hunts were simply yet another demonstration of the invincible strength and bravery of the king.

Assyrian narrative reliefs are generally arranged in superimposed bands—in this sense they are the predecessors of the modern comic strip. Sometimes, the space widens to allow room for an ambitious set piece, but even here the band-like arrangement is still subliminally suggested by the way the people and objects are arranged.

Egyptian paintings and reliefs, though frequently narrative in intent, never offer stories quite as detailed and specific as these sculptures from Mesopotamia. It has been suggested that Assyrian reliefs are in some mysterious way the true predecessors of the narrative historical reliefs to be found on Roman monuments such as Trajan's Column (see page 77), which also deal with war and conquest.

Painting

Ancient Egypt

The aesthetic pleasure we get from ancient Egyptian paintings today is an accidental by-product. They formed part of the elaborate Egyptian cult of the dead which has already been briefly described, and their makers knew that their work was going to be walled up forever almost as soon as it was completed. Indeed, many tombs were left with their decorations unfinished, no doubt because death overtook their owners before all the work could be done.

Egyptian tomb painting was in any case not an independent art form. It began as a substitute for more expensive and laborious shallow reliefs in carved stone, which were themselves originally tinted. Artists would have been torn between the need for haste and economy, and the desire to avoid ambiguity. Any "spontaneity" we now praise is not necessarily a quality the painters themselves would have valued, but something forced on them by circumstances. They were not interested in what was transient, but rather wanted to show things in their eternal aspect, giving all the data needed for complete recognition of what was being shown.

This desire accounts for the system of conventions which governs Egyptian painting and relief carving. Heads are shown in profile (but the eye is shown frontally); torsos are seen frontally; legs, once again in profile, are depicted in a striding position if the figure is standing, so that both can be seen (Fig. **2.16**). This coding makes sure that nothing is ambiguous. Paintings and reliefs are often accompanied by elaborate inscriptions, which help to elucidate the intended meaning. Since Egyptian art was made up of ideograms, or hieroglyphs, there was in any case no essential difference between painting and writing.

Egyptian painting was based on drawing—color was always secondary—and it is the first school of art which offers a wealth of preliminary sketches. These sketches, called *ostraca*, were usually made on stray chips of limestone, but also occasionally, as the name (Greek for potsherds) suggests, on pieces of pottery.

Once the outline had been drawn, color was used to fill it in—flat colors, without shading, though occasionally there is a skillful imitation of textures as, for example, when painting a mottled stone vase. Because of the limited range of colors available (all derived from natural earths and oxides), not much trouble was taken to make the works naturalistic but they are often richly decorative.

Egyptian tomb painting is attractive today because of the vivid insight it gives into the daily life of the time. Some subjects, such as the funerary processions with their ritual mourners, or the banqueting scenes, are fairly standard and

2.15 Banquet from the tomb of Netamun, Thebes, Egypt, *c.* 1400 B.C. Painted stucco, 25 ins (63 cm). British Museum, London.

recur from tomb to tomb, while others are more unusual. But even the representations which occur again and again have much to offer. This is particularly true of the banqueting scenes, which show ancient Egypt at its most elegant (Fig. **2.15**). The hair-styles and jewelry of the female guests are subtly varied, just as their moods and characters are differentiated by nuances of pose and gesture. There is also much dignity, as well as pathos, in the representations of blind harpists who intently finger their instruments. Unfortunately we know nothing specific about the kind of music they played.

The non-standard scenes have much to tell us about the owners of particular tombs, as they were designed to reflect the variety of their interests and occupations when alive. There is a rich range of illustration covering agriculture and the crafts. Tomb-owners may not have practiced these occupations themselves, but would have supervised them closely, for they contributed to their wealth. There are also beautiful hunting and fowling scenes. In the strict sense, ancient Egyptian artists were not interested in the representation of landscape. However, these hunting scenes are very rich in depictions of plants, as well as of birds and animals. One striking example from among hundreds of others is the little gazelle which forms part of the procession of offering-bearers in the early 18th Dynasty (*c.* 1500 B.C.) tomb of Ounsou at Thebes (Fig. **2.17**). The sensitive outline used by the artist catches the extreme delicacy of the creature.

Writing

The knowledge of writing, which marks the real divide between prehistoric and historic societies, seems to have arisen in ancient Mesopotamia and been passed to Egypt. In each civilization it followed a similar pattern of evolution.

Both civilizations began with scripts which were purely pictographic—the sign was an image of the thing designated. Then came the idea that the pictograph could also be a kind of pun, and be used to indicate words which simply *sounded* the same as the word for the object shown by the pictograph. This was the basis for the Egyptian script we now call hieroglyphic (from the Greek *hiero*, sacred, and *glyphein*, to carve). This consists of about 700 different signs, which are divided into categories. There are pure

ideograms, which show the intended meaning pictorially, and there are also phonograms, which give the sound (in this case, the consonants only). These phonograms can be still further divided. Some indicate just one consonant, some two consonants together, and still others three together. Egyptian writing generally combined both consonantal signs and ideograms in order to convey meaning. The ideogram is written after a group of consonant signs, and indicates the category to which the word belongs. For example, the sun sign ⊙ indicates that the word is something to do with light or shining.

Though writing probably traveled from Mesopotamia to Egypt soon after it was invented, there is no indication of

2.16 The ceremonial purification of Sennufer and his wife Meretjj, from their tomb at Thebes, Egypt, 18th Dynasty (second phase 1450–1372 B.C.). British Museum, London.

2.17 Painting from the tomb of Ounsou, Thebes, Egypt, 18th Dynasty, *c.* 1500 B.C., showing offerings of corn, animals, birds, and fruit.

reciprocal influence after that date. Mesopotamian script evolved in a different way from Egyptian hieroglyphs chiefly because the writing materials used were so different. The commonest writing surface was a small tablet made of soft clay. Signs were scratched using a pointed stick, and if the scribe wanted to preserve what had been written, the tablet could be baked. The earliest tablets known, which date from *c.* 3100–2900 B.C., carry pictographic signs, and there is no grammar. The signs are grouped within drawn "cases" or rectangles, but the correct ordering of them within each case is left to the reader.

Later, this pictographic writing was replaced by true cuneiform, so called because the signs are characteristically wedge-shaped, punched rather than scratched into the clay. Cuneiform works on similar principles to Egyptian hieroglyphs, using a sign to designate the actual object, but also other words or parts of words which have the same sound. And, as with hieroglyphs, the category is indicated by

means of a "sense" sign which makes clear what kind of thing is being talked about.

However, despite these similarities, cuneiform also differs from hieroglyphic writing in significant ways. First, the syllable signs indicate not only consonants but also vowels. Secondly, the actual form of writing is more abstract. The pictogram is further removed from any desire to make a detailed representation of the object it designates—an understandable development in view of the writing materials used. Both of these characteristics facilitated the evolution toward an alphabetic script.

Literature

A wide variety of literary texts have been recovered from ancient Egypt, both in the form of papyri and as inscriptions on the walls of tombs. As well as religious texts, there is a range of secular works: some, for example, deal with the rules of ordinary good behavior, while, at the opposite emotional extreme, there are passionate love-poems.

Apart from the instructions and spells of *The Book of the Dead*, the most typical Egyptian texts are probably prose narratives. Most of these are tales of wonder, full of descriptions of magic. Paradoxically, however, they are also full of the rather earthy commonsense which seems to have been part of the Egyptian character.

A different, more exalted atmosphere prevails in Mesopotamian literature. Its greatest product, *The Epic of Gilgamesh*, has been pieced together in modern times from a number of different texts, varying widely in date. The bulk of the poem was discovered in the Assyrian royal library in Nineveh in 1853, and then lay neglected in the British Museum for a further twenty years. When the tablets containing it first excited interest, it was because one of them supplied a close parallel to the biblical story of the flood. The Nineveh tablets are still our prime source, but it has come to be realized that *The Epic of Gilgamesh* goes back much further than the Assyrian period. The oldest fragments of text known are of Old Babylonian date (*c.* 2000–1600 B.C.).

Gilgamesh is the son of a goddess, from whom he inherits beauty, strength, and restlessness. From his human father he inherits mortality. The story tells of his quest to overcome mortality, or escape from it, and how in the end he is forced to accept it. *The Epic of Gilgamesh* has much greater resonance than any ancient Egyptian text that has survived. In it we hear for the first time the authentic tragic note—a lament for struggle, loss, and sorrow, then final acceptance of what life and death have to bring—that sounds throughout much of the greatest European literature.

LITERATURE

The Epic of Gilgamesh

These extracts from *The Epic of Gilgamesh* enumerate some of the characteristics of the traditional epic hero. He is "two-thirds divine . . . one-third human." He may be admirable, but he is never perfect. He usually has a companion-in-arms, in this case Enkidu, who is closer to him emotionally than anyone else, and shares his adventures.

TABLET I
Column i

The one who saw the abyss I will make the land know;
of him who knew all, let me tell the whole story
. . . in the same way . . .
[as] the lord of wisdom, he who knew everything,
 Gilgamesh,
who saw things secret, opened the place hidden,
and carried back word of the time before the Flood—
he travelled the road, exhausted, in pain,
and cut his words into a stone tablet.

He ordered built the walls of Uruk of the Sheepfold
the walls of holy Eanna, stainless sanctuary.
Observe its walls, whose upper hem is like bronze;
behold its inner wall, which no work can equal.
Touch the stone threshold, which is ancient;
draw near the Eanna, dwelling-place of the goddess Ishtar,
a work no king among later kings can match.
Ascend the walls of Uruk, walk around the top,
inspect the base, view the brickwork.
Is not the very core made of oven-fired brick?
As for its foundation, was it not laid down by the seven
 sages?
One part is city, one part orchard, and one part claypits.
Three parts including the claypits make up Uruk.

Find the copper tablet-box,
slip loose the ring-bolt made of bronze,

Draw out the tablet of lapis lazuli and read it aloud:
How Gilgamesh endured everything harsh.

overpowering kings, famous, powerfully built—
hero, child of the city Uruk, a butting bull.
He takes the forefront, as a leader should.
Still he marches in the rear as one the brothers trust,
a mighty trap to protect his men.
He is a battering floodwave, who knocks the stone walls
 flat.

Son of Lugalbanda—Gilgamesh is the pattern of strength,
child of that great wild cow, Ninsun.
. . . Gilgamesh, dazzling, sublime.

Opener of the mountain passes,
digger of wells on the hills' side,
he crossed the ocean, the wide sea, to where Shamash rises,
scouted the world regions: the one who seeks life,
forcing his way to Utnapishtim the remote one,
the man who restored life where the Flood had destroyed
 it,
. . . peopling the earth.

Is there a king like him anywhere?
Who like Gilgamesh can boast, "I am the king!"?

From the day of his birth Gilgamesh was called by name.

Column ii

Two-thirds of him is divine, one-third human.
The image of his body the Great Goddess designed.
She added to him . . .

On the sheepfold of Uruk he himself lifts his gaze,
like a wild bull rising up supreme, his head high.
The raising of his weapon has no equal;
with the drum his citizens are raised.
He runs wild with the young lords of Uruk through the
 holy places.

Gilgamesh does not allow the son to go with his father;
day and night he oppresses the weak—
Gilgamesh, who is shepherd of Uruk of the Sheepfold.
Is this our shepherd, strong, shining, full of thought?
Gilgamesh does not let the young woman go to her mother,
the girl to the warrior, the bride to the young groom.

The gods heard their lamentation;
the gods of the above [addressed] the keeper of Uruk:

"Did you not make this mightly wild bull?
The raising of his weapon has no equal:
with the drum his citizens are raised.
He, Gilgamesh, keeps the son from his father day and
 night.
Is this the shepherd of Uruk of the Sheepfold?
Is this their shepherd and . . .
strong, shining, full of thought?
Gilgamesh does not let the young woman go to her mother,
the girl to the warrior, the bride to the young groom."

When [Anu the sky god] heard their lamentation
he called to Aruru the Mother, Great Lady: "You, Aruru,
 who created humanity,
create now a second image of Gilgamesh: may the image be
 equal to the time of his heart.
Let them square off one against the other, that Uruk may
 have peace."

When Aruru heard this, she formed an image of Anu in her
 heart.
Aruru washed her hands, pinched off clay and threw it into
 the wilderness:
In the wilderness she made Enkidu the fighter; she gave
 birth in darkness and silence to one like the war god
 Ninurta.
His whole body was covered thickly with hair, his head
 covered with hair like a woman's;
the locks of his hair grew abundantly, like those of the
 grain god Nisaba.
He knew neither people nor homeland; he was clothed in
 the clothing of Sumuqan the cattle god.
He fed with the gazelles on grass;
with the wild animals he drank at waterholes;
with hurrying animals his heart grew light in the waters.

The Stalker, man-and-hunter,
met him at the watering place
one day—a second, a third—at the watering place.
Seeing him, the Stalker's face went still.
He, Enkidu, and his beasts had intruded on the Stalker's
 place.
Worried, troubled, quiet,
the Stalker's heart rushed; his face grew dark.
Woe entered his heart.
His face was like that of one who travels a long road.

(*Gilgamesh Epic, Tablet 1*, translated by John Gardner and
 John Maier. Copyright © 1984 by the Estate of John
 Gardner and John Maier. Reprinted by permission of
 Georges Borchardt Inc., on behalf of the Estate of John
 Gardner and John Maier.)

Part 2

Ancient Greece, Ancient Rome, & Byzantium

Chapter 3

Ancient Greece

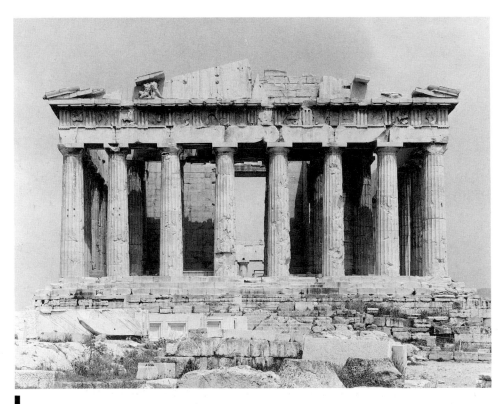

3.1 Parthenon, Athens, 447–438 B.C.

Greek mythology

Like the Egyptians, the Greeks were polytheists, and their gods and cults took a bewildering variety of forms. Beneath this variety, however, it is possible to sense an underlying order, even though the Greek pantheon, in its generally accepted guise, seems to represent the collision, and attempted reconciliation, of two cultures and ways of life.

The Minoans worshipped a Great Goddess who had been known since Paleolithic times. A little later in the development of Minoan civilization she was provided with a consort —a youthful male god, shown as a hunter rather than as a warrior. This was the vulnerable deity, the one who died and was resurrected every year.

When Greece was penetrated from the north by invaders of Indo-European origin, they brought with them a sky god, a Great Father, who displaced the Mother and became the chief figure in the Greek pantheon of Classical times. This pantheon consisted of twelve deities, with Zeus, the sky god, as ruler. Apart from Zeus himself, there were his consort, Hera; Poseidon, lord of the sea; Pallas Athene, goddess of wisdom, born motherless from Zeus's head; Phoebus Apollo, god of the sun and of music; his sister Artemis, virgin goddess of the hunt; Hermes, messenger of the gods; Ares, god of war; Aphrodite, goddess of love; Hephaistos, smith god; Demeter, corn goddess; and finally Hestia, goddess of the hearth. Hestia's position as one of the major gods was challenged by Dionysius, god of wine, ecstatic madness, and untamed nature, who is often represented in Greek myth as not fully Greek but as an unpredictable newcomer from the East.

To complicate matters further, Greek mythology made room for lesser gods, for tutelary spirits of place, and for demi-gods or deified heroes, such as Heracles. The gods themselves were manifest in many different forms, each equipped with his or her particular epithet. A "god" therefore was not an individual personality, raised to a higher power, endowed with immortality, but a force within the world whose various aspects might be manifested in different ways at different times and places.

What these deities—even the mighty Zeus—could do was never completely without limits. The Greek gods were themselves the creation of primordial powers which continued to form the framework of the universe. Though often willful and passionate, and sometimes in human terms unjust, they too were subject to the Greek concept of measure. There were certain boundaries they could not cross.

As Greek literature and art show us, the Greeks often regarded their gods with irony as well as with respect, and sometimes even laughed at them. Nevertheless, it was agreed that someone who had offended the gods was accursed—that meant he or she had to be cast out of society. Offense might be given knowingly, but sometimes also unknowingly. For example, Oedipus killed his father without being aware of the fact, and married his mother, also without being aware of it. The gods nevertheless condemned him for what he had done. The fact that the Greek gods did not operate according to simplistic moral rules was one of the problems Greek philosophy had to attempt to solve.

Greek civilization

The birth of Classical Greek civilization also marks the birth of the rational and analytical elements which are characteristic of Western civilization in general. However, it is impossible to see ancient Greece itself completely in these terms. The archeological discoveries made at the end of the last century by Heinrich Schliemann at Mycenae, and at the beginning of this century by Arthur Evans at Knossos in Crete, revealed a remote past which was indubitably Greek, even to the use of the Greek language, but which seemed to have little intellectually or aesthetically in common with what Greek civilization later became.

The prehistoric cultures which flourished in Crete and at Mycenae supplied the dimension of a heroic past. The myths and heroic stories which were their main legacy to Classical Greece supplied constant reminders that reason and moderation did not come of themselves, but were hardwon and still constantly threatened by the dark forces of irrationality and disorder.

Ancient Greek civilization has thus to be seen not just in its simplest aspect, as the embodiment of rationality, but as the emblem of resistance to both irrational fears and unreasonable or excessive actions. Dangerous impulses can be

mastered only if their existence is acknowledged. Yet even the often quoted Greek motto "Nothing too much" must also be thought of as a rebuke to rationality itself, if that is allowed to become too rigid. A completely and compulsorily rational world would also, in the Greek view, have been one seized with its own kind of madness—intolerable and therefore self-destructive.

For the purposes of this survey, the conventional historical and stylistic divisions have been used as a framework within which to study developments within Greek culture:

Minoan and Mycenaean c. 3000–c. 1100 B.C.
Geometric and Orientalizing period c. 850–c. 660 B.C.
Archaic period c. 660–c. 480 B.C.
Classical period c. 480–c. 330 B.C.
Hellenistic period c. 330–c. 100 B.C.

Greek society

Though Greek civilization has just been described in the previous section as the embodiment of rationality (and indeed was so, in its own terms) it contained elements which seem strange and repugnant today. One was the inferior position assigned to women. In democratic Athens women, even when free-born, did not enjoy the full privileges of citizenship given to their male counterparts. They were not entitled to vote. Their function was to be homemakers and mothers.

Another element was that romantic love existed, not between members of the opposite sex, but as a bond which linked an older and a younger man. While the Greek epics (see page 65) and Greek drama (see page 68) offered tender and affecting pictures of the relationships between men and women, in fifth-century B.C. Athens these had come to be thought of as things which belonged to an earlier and quite different time.

A further disturbing element of Greek civilization was the institution of slavery. It was slave-labor which offered free men the leisure time to debate the problems inherent in trying to live a good life, in both the physical and the ethical sense, in a well-balanced society. Greek attitudes to slavery were linked to Greek attitudes toward foreigners in general. Anyone who was not Greek, and most especially anyone who did not speak the Greek language, was classified as a barbarian—the Greek word for "barbarian," *barbaroi*, quite literally means someone who babbles in an incomprehensible and foolish way. The conquests of Alexander the Great (356–323 B.C.) spread Greek civilization throughout the then-known world, and many people who were not Greek in origin became Hellenized. Even so, there always remained a clear distinction between those who spoke Greek properly and were familiar with the work of the Greek poets, dramatists and philosophers, and those who did not. Those who were fully assimilated to Greek culture became the dominant class, and tended to despise and live as aliens amongst those who maintained indigenous traditions. In some of the areas Alexander conquered, but not everywhere, Hellenism became a durable force. In Greece itself (naturally enough) but also in much of Asia Minor and in Syria, and even to some extent in Egypt, Greek culture persisted until Roman times, when the imposition of Roman political dominance caused a break in cultural continuity.

Minoans and Mycenaeans

The terms "Minoan" and "Mycenaean" would not have been recognized by the people to whom they refer. The adjective Minoan is derived from the name of the legendary King Minos, who ruled in Knossos before becoming judge of the dead. Mycenaean is an adjective derived from the city of Mycenae. These two civilizations left a deep impression on Greek literature, but had much less impact on Greek art and architecture. The stories told in the two epics attributed to Homer, the *Iliad* and the *Odyssey*, which are the foundations of all Greek literature, are placed in Mycenaean times. So, too, are the events in many of the great Greek tragic dramas.

The most impressive relics the Minoans and Mycenaeans have left us are architectural. They were capable of constructing large and ambitious buildings, more complex than any others erected before the Hellenistic age. Yet they had few aspirations toward monumentality—they seem to have built no major temples, and their palaces were sprawling

	1350	1100	850	600	350	100 B.C.
	MINOAN/ MYCENEAN		**GEOMETRIC**	**ARCHAIC**	**CLASSICAL**	**HELLENISTIC**
HISTORICAL BACKGROUND	Fall of Knossos *c.* 1370 The Trojan War Fall of Myceneans		The "Dark Age" Colonization of Southern Italy *c.* 750	The Persian War 490–479 Pericles in power in Athens *c.* 460 Peloponnesian War 431–404		Campaigns of Alexander the Great Spread of Hellenistic culture
PHILOSOPHY				Thales Pythagoras Heraclitus Socrates		Plato *Symposium, The Republic* Aristotle
ARCHITECTURE	Cretan Palaces *c.* 1950 The Lion Gate at Mycenae			Temple of Zeus at Olympia The Parthenon (**3.1**) Temple of Athena Nike (**3.6**)		Theater at Epidaurus (**3.24**)
VISUAL ARTS	Bull-leaping fresco, Knossos (**3.3**)		Dipylon vase (**3.20**)	Kouros (**3.7**) Warrior from Riace (**3.9**) Olympia pediments (**3.10**) Cnidian Aphrodite (**3.12**) Red and black figure vases		Vergina wall paintings (**3.19**) Victory of Samothrace (**3.16**) Altar of Zeus, Pergamon (**3.15**)
LITERATURE/ DRAMA	Linear A tablets Linear B tablets	Homer	Development of lyric poetry Sappho	Aeschylus *The Oresteia* Sophocles *Oedipus Rex* Euripides Aristophanes		

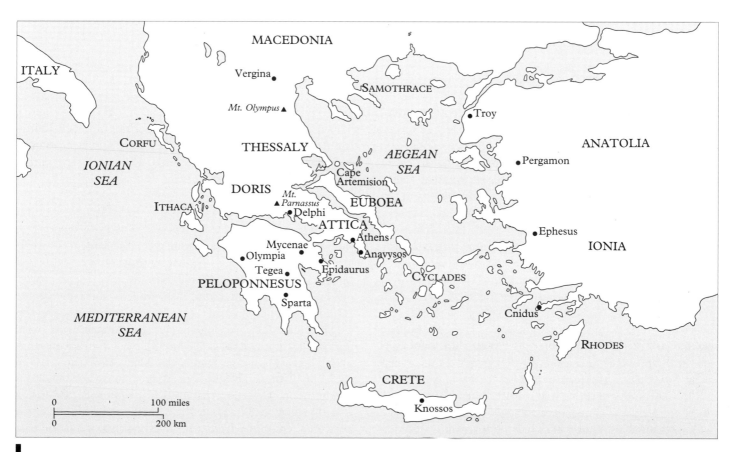

3.2 Ancient Greece.

conglomerates which paid little attention to ideas of rational proportion and order. The great Cretan palaces were built around 1950 B.C. They served a number of different purposes, being religious and administrative centers as well as seats of royal power. While the actual religious sanctuaries contained within them were quite small, they encompassed big courtyards which may have been used for the ceremonial and religious practice of bull-leaping, in which young men and women vaulted over the horns of a charging bull, grasping them and turning somersaults as they did so (Fig. **3.3**). A folk-memory of this game may lie behind the legend of Theseus, who penetrates the labyrinth (the palace of Knossos itself) and kills the bull-man or Minotaur who lives at the center of it.

Mycenaean civilization, which arose independently from that in Crete, knew a period of supremacy after the final fall of Knossos, which took place around 1370 B.C. It was at this period that some version of the Trojan War described in Homer took place.

Mycenaean political structures were hierarchical, and this fact was reflected in the architecture. Cities were heavily fortified, and the palaces enclosed within massive defensive walls of a sort missing at Knossos and other Minoan sites. It is only at Mycenae itself that one finds any trace of monumental sculpture—the chief example being the relief which adorns the Lion Gate. This is also one of the rare examples of symmetry in either Minoan or Mycenaean

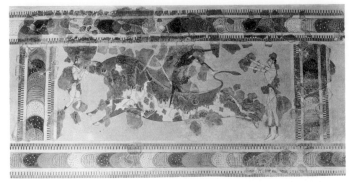

3.3 Bull-leaping fresco from Knossos, Crete. Minoan, 2nd millennium B.C.

art. The Minoans painted ambitious frescos, which often show a keen delight in nature and an equally keen eye for feminine foibles—there are some witty portraits of richly dressed court ladies. Both they and the Mycenaeans exceled in pottery and metalwork, and here the theme is usually the beauty of the natural world—a pot will be adorned with plants, or fish, or a swirling octopus, rather than the narrative scenes with figures which appear on Greek vases. Though human figures do appear, people are not the center of the universe, as they are in Greek art. The style of spirit of Minoan vase-painting in particular remains close to the miraculous freshness of Paleolithic art.

Philosophy

The Pre-Socratics

The ancient Greeks were the first people who tried to take an objective look at the world which surrounded them. They tried to understand the place of human beings in the world, and the rules which should govern their actions, through the exercise of reason. They were thus driven toward the discovery of ideas which have remained the basis of all philosophical thinking, right up to the present day.

Early Greek philosophy covered a much wider field than philosophical studies do today. It concerned itself with questions such as the origin of the physical world, the nature of physical change, the motions of heavenly bodies, and the origins of the human race, which are now considered the province of science, as well as with others, such as the relationship between perceived reality and thought, and the existence or otherwise of absolute moral truths, which philosophers continue to struggle with today.

Since the earliest attempts at true philosophical thinking were a rebellion against the irrationality and inconsistency of traditional mythology, they tended to be materialistic.

This revolt against unreason took place not in Athens but in Ionia, now the Aegean shore of Turkey, and is associated with the rich trading city of Miletus. Thales, a native of that city who lived around 585 B.C., is said to have been the first to look for a rational explanation which would bind together all the different phenomena which go to make up the physical universe. He and his followers evolved the theory that the world was composed of four primary elements—earth, air, fire, and water—and that everything could be explained in terms of their various combinations and reactions with one another. This influential theory was to survive until the Middle Ages, and beyond.

The materialist approach of the Ionians was soon opposed by Pythagoras (c. 570–490 B.C.). Pythagoras emigrated from his native Samos (an island near the coast of Ionia) to Crotona in southern Italy. There he founded a brotherhood devoted to the study of *philosophia* (a word he is said to have invented). In Pythagoras's thinking there was a shift in emphasis from the investigation of matter as a thing in itself to an investigation of the forms taken by matter. He made an analogy with music, and saw the world

as being primarily a harmonious mathematical structure. In his hands, philosophy became an attempt to define and interpret this harmony.

Pythagoras was opposed by his contemporary Heraclitus (active *c*. 500 B.C.), who contended that the ruling principle of the universe was not harmony but conflict. For him, the world consisted of an unceasing flux, but one which operated within a fixed and permanent framework.

These conflicting views provided the background for the work of Socrates, then of his successors, Plato and Aristotle, all three of whom continue to influence the way we think today.

The personality of Socrates

So far as we know, Socrates (*c*. 469–399 B.C.) wrote nothing. However, this does not prevent him from occupying an important symbolic place in the history of Greek thought, and therefore of human thought in general. His death at the hands of an Athenian tribunal certainly played an important role in enforcing the claim of Greek philosophy to stand side by side with Christian teaching.

When Socrates was condemned to death in 399 B.C. it was for "not recognizing the gods that the state recognizes," and for "corrupting the young." It seems probable that he could have escaped his fate, but his teaching had always put great stress on submission to the law, and he chose to accept his punishment. He thus established himself as the original thinker who prefers adherence to what is sincerely believed over and above any consideration of personal safety. At the same time, he established the moral superiority of the new way of thinking.

Through Socrates's death, philosophy made a claim both to superior knowledge and superior virtue. The demonstration was all the more conclusive because Socrates claimed that the two were equivalents. To this he added another proposition: "No one does wrong willingly"—that is, in his view wrong-doing was inconsistent with happiness. To some extent this statement depends on an ambiguity in the Greek language; it can also be read as: "No one goes wrong/makes a mistake voluntarily"—something much more obvious to the philosophic layperson. In addition, for Socrates—as was later true for Plato—the state of happiness was not something primarily to do with the emotions. To him it meant something more like "a successful and balanced way of living."

Socrates tried to enforce the truth of these and other propositions to do with the nature of such concepts as "justice" and "piety" through his employment of what is now called "the Socratic method"—a technique of constant questioning. A famous example of the application of this method occurs in the *Symposium*, one of the richest and most elaborate of the Platonic dialogues built around the personality of Socrates. At an Athenian drinking party, suc-

cessive speakers offer definitions of the nature of love. The host, Agathon, a rather pretentious tragic dramatist, asserts that love "is in the first place supreme in beauty and goodness himself, and in the second the cause of like qualities in others." Socrates dismantles these propositions, establishing step by step that love cannot exist without an object, and since this object must indeed be beauty, then love itself cannot be beautiful; nor, since beauty and goodness in these terms are the same, can it be good.

It is easy to understand from this exchange why many of the citizens of Athens came to regard Socrates as a socially disruptive force. With relentless irony, he applied methods originally devised in order to gain a more perfect understanding of the physical world to moral questions which most people assumed had been solved already. Instead of giving fresh answers, he tended to leave behind him a situation in which definite and authoritative answers seemed to be impossible.

Plato and Aristotle

Plato (429–347 B.C.) plays a dual role in the history of Greek thought. On the one hand he is, through the written *Dialogues* which report his master Socrates's attitudes and indeed feature Socrates as the central actor, an advocate of rigorous skepticism, for Socrates often simply identifies problems rather than offering solutions. On the other hand, Plato offers a series of arguments which make him the representative of an identifiable set of attitudes.

Plato seems to think that ideas have a separate existence of their own, independent of the world of phenomena. For him they are eternal, unchanging, and absolute. One thing which interested Plato was the apparent absoluteness of numbers and the processes numbers could be put through. For him ideas, in the true sense, were equivalents of mathematical formulae.

This, in turn, led him to elaborate a theory of Forms, which owed much to his predecessors the Pythagoreans, who put the emphasis on form rather than on matter. For Plato, things in the visible world, though "real" to ordinary people, were in fact only reflections or approximations of genuine reality, which consists of Forms which are stable and unchanging. These Forms can be known only through the mind, not the senses, because the senses are part of the process of change and decay which affects everything in the world we try to know through the body. To the changelessness of ideal Forms is opposed a mundane world—and here Plato aligns himself with Heraclitus rather than with the Pythagoreans—where everything is in ceaseless flux.

If it was important to discover the Forms of familiar objects and phenomena, it was still more imperative to discover the Forms—the true and unchanging essences—of certain concepts. This, for Plato, was the point of Socrates's incessant questioning. One concept which preoccupied

Plato, especially after Socrates's death, was that of justice. He considered that justice cannot be an isolated act, or even a series of such acts; it must be a particular condition. This condition could be only a state of mind; what we would now call a condition of perfect psychic adjustment.

Because ideal justice is so self-evidently desirable, to know it is to wish to propagate it, not merely for one's own but for everyone's benefit (if one did not wish for everyone's benefit, *ipso facto* one could not be just). The main argument of Plato's important late work *The Republic* is that justice exists only in a properly ordered state, and that such a state cannot exist unless philosophers have charge of it. Having experienced the vagaries of both democracy and oligarchy in Athens, and the caprices of tyranny (what would now be termed dictatorship) during a visit to Syracuse in Sicily, Plato was sure that all these systems were unsatisfactory. He therefore envisaged a race of morally incorruptible rulers, filled with a love of the Forms and a desire to see them embodied in the state. He thought that such an élite could be created by the careful education of the most intelligent, and that the rest would be content to be governed by these.

Though Plato's Utopia is intensely élitist, it had one feature which was surprising for its time. Plato thought that the natural abilities necessary for a philosopher could be found in women just as easily as they could be in men, so his élite is therefore totally non-sexist.

Aristotle (384–322 B.C.) was formed by his experiences just as much as Plato was. It is not surprising to find that the most powerful Greek advocate of empiricism and careful scientific inquiry was the son of a physician. Born in north-ern Greece, he came to Athens and studied under Plato until the latter's death. Some time after that he was tutor to the young Alexander the Great.

Aristotle rejected Plato's theory of Forms because he thought that Plato had failed to distinguish what was particular from what was universal. In his view the Forms reduplicated particulars rather than explaining them. For Aristotle what came first was not Form but matter. Form appears only when pre-existing matter is shaped. In this, as in his other theories, Aristotle was always careful to stick closely to a commonsense view of things: his views are, as far as possible, what "everyone" believes to be the case. In the ethical sphere this led him to stress not the idea of being a good person (a person somehow in the possession of virtue) but a person who behaved or performed in a good way. By temperament hostile to Plato's reliance on abstractions, he tried always to base his conclusions on close observation of the facts and thought it prudent to collect as many facts as possible. He also believed in comparing various opinions about a particular subject, in order to pick out both the strengths and weaknesses of a particular position. He was thus the first to formulate a systematic theory of logic and he was also the founder of modern scientific method.

Plato leads us to formulations which seem new; Aristotle gives us the underpinnings to support opinions we believed to be obvious all the time, but up till then did not know how to defend. Both, however, display the powers of deductive thought which were the distinguishing mark of Greek civilization as a whole. Almost the whole of later Western philosophy is based on their work.

The Classical ideal

It is generally said that Greek architecture, art and literature moved toward, and then successfully embodied, the Classical ideal. This concept is notoriously difficult to put into words. The term can have at least three different meanings, all of which embody some aspect of our reactions to ancient Greek culture.

In the first instance, when applied to all the arts, the Classical ideal means a sense of balance and measure. It also means a degree of idealization, so that not only objects, but also characters and events, are presented in their noblest and most elevated aspects. They are also presented in ways that suggest they sum up what is presented without unduly exaggerating mannerisms or characteristics which might distract the spectator from the essential qualities of what is being shown.

In the second place, in the visual arts primarily, the term suggests a way of working which makes human beings the essential measure of the work. Although, in the seventeenth century, the idea of classicism was to be extended to embrace the idea of the so-called "classical landscape," Greek architecture and art are focussed on human beings. They derive their whole system of proportions from the human body. This system of proportions, in turn, becomes a structure of mathematical relationships which enable the architect in particular to achieve visual harmony, not through intuition, but through applying a known and universally accepted set of rules.

The most authoritative explanation of these rules to have come down to us was written by the Roman architect and architectural theorist Vitruvius (active between 40 and 30 B.C.). Vitruvius based his analysis chiefly on the type of column used in a building. This in turn determined the

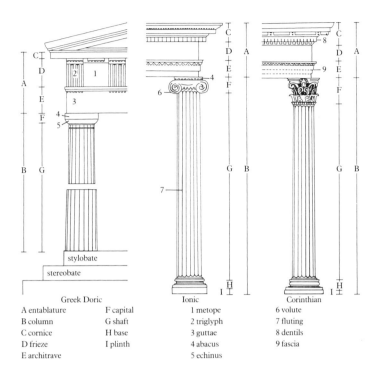

Greek Doric

A entablature
B column
C cornice
D frieze
E architrave

F capital
G shaft
H base
I plinth

Ionic

1 metope
2 triglyph
3 guttae
4 abacus
5 echinus

Corinthian

6 volute
7 fluting
8 dentils
9 fascia

"order" of architecture it belonged to, which was responsible for the relationships between all the other parts of the construction.

In the Classical epoch (*c*. 480–*c*. 330 B.C.), two main types of column were used, called the Doric and the Ionic, from their supposed origins—one among the tribes who came into Greece from the north, the other in Asia Minor. A third variety, the Corinthian, was just coming into use, and was to become increasingly popular in Hellenistic and Roman times (Fig. **3.4**). In the Doric order, the column is fluted but has no base. There is a plain circular capital resting on an echinus (convex) moulding. In the Ionic order, the column is of slenderer proportions, but is still fluted. It rises from a circular base standing on a square plinth, while the capital has two symmetrical volutes (spiral scrolls). The Corinthian order has most of the features of the Ionic, and a much richer capital—a stylized representation of an acanthus plant growing out of a basket.

3.4 Ionic, Doric, and Corinthian columns.

Greek architecture

The most typical ancient Greek building is not a dwelling—private houses were very simple and Greek democracies had no need for palaces—but a temple. In its most usual form a Greek temple was a rectangular structure with a peristyle, a continuous colonnade, surrounding a cella, which was the central structure in which the image of the god to whom the temple was dedicated was placed (Fig. **3.5**). The earliest Greek temples were made of wood, and this influenced the "post and lintel" construction of later ones, which were built of stone.

The best example of a Doric temple, and also of the precise and refined calculation of Classical architecture, is the Parthenon in Athens (built 447–438 B.C.), the shrine of the city goddess, Athena (Fig. **3.6**). Despite its apparent perfection, the design involved a compromise with an earlier construction. A first version of the building was started

before the Persians sacked Athens in 480 B.C. When work began again, more than thirty years after the sack, the original plan was altered, so as to make a wider structure with more room in the cella for an impressive cult image. Nevertheless, for economy's sake, it was decided to use material already on site. This included some of the column drums. The architect, Ictinus, had to find a set of proportions which would fit all these circumstances. What he did was to devise a fixed ratio of 4:9, which governed both the interaxial spacing of the columns (the measurement from column-center to column-center), and the plan and elevations.

Ictinus also made use of optical tricks—notably of entasis (a slight swelling of the shaft) for the columns, so as to correct the illusion of concavity which would result if the profile was absolutely straight. He also made the whole design fractionally pyramidal, so that all the columns inclined imperceptibly toward the diagonals. The result was a building which was at once grand, simple and subtle.

In general, because of its slenderness of proportion and refinement of decorative detail, the Ionic order was used either for smaller structures, such as the temple of Athena Nike (Athena, Bringer of Victory), also on the Acropolis (Fig. **3.6**); or for columns and pilasters inside buildings where the Doric order was employed on the outside. This mixed use occurs in the Parthenon itself.

Greek city life was lived in public. Great religious ceremonies took place outside the temples, not inside them, so

3.5 Representative Greek temple plans.

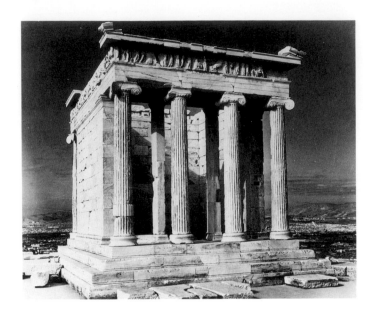

3.6 The Temple of Athena Nike, Acropolis, Athens, 427–424 B.C.

naded structures open to the elements on at least one side which provided city dwellers with a universally accessible space in which to walk and talk. They had many uses. Near a shrine, they were a gathering place for worshippers. Near a market, they were an extension of commercial facilities. At their most magnificent, they were public art galleries, with paintings and sculptures by major artists. The flexibility, simplicity, and practicality of the concept, as well as the compulsive gregariousness it implies, have much to tell us about Greek society.

Another kind of public gathering place was the theater. Greek theaters were immense open-air constructions, usually built into hillsides, with semicircular tiers of stone seats—a form which provided perfect acoustics. These theaters were the places where the plays of Aeschylus, Sophocles and Euripides were performed. Two peculiarities about them are worth noting. One was that the point of focus was a low altar, around which the chorus gathered. Greek theaters retained a connection with the religious life, and plays, Greek tragedies in particular, were something more than mere entertainment, as the structure itself made clear. The other peculiarity was that site and structure emphasized the unity between man and nature—audiences were not shut away from the surrounding world as they watched the drama unfold. Unity between man, the gods and nature was in fact the basic theme of Greek architecture, taken as a whole.

Greek architecture was exterior architecture, often specifically adapted for a communal way of life. Less spectacular than the religious structures, but very important for the understanding of Greek culture, are the *stoas* long colon-

Sculpture

Archaic

The impulse for making monumental sculpture seems to have come to Greece from Egypt, where, during the seventh century B.C., many Greeks were employed as mercenaries, and where they also set up a trading colony at Naucratis on the Nile Delta. An important step forward was the use of a finer, more recalcitrant material, marble, which is plentiful in Greece. The rapid progress of Greek sculpture can be traced in a series of *kouroi* (statues of naked youths) dedicated to the gods at sacred sites and also used as funerary monuments (Fig. **3.7**). Though derived from Egyptian standing male figures, they differed from these in a number of ways. For example, the Greek carvers were much bolder in cutting away surplus material. There was no supporting back-pillar; there was a space between the legs, placed one in front of the other, and one between the arms and the torso. The Greeks seem to have regarded these statues as naturalistic—they certainly painted them to resemble life—

but to our eyes they are more stylized, yet also, paradoxically, much more vital, than the Egyptian carvings which inspired them. The faces of these *kouroi* were given a calm, characteristically smiling expression—the "Archaic smile"—which seems to reflect pleasure in their own physical being. Their bodies are proudly naked. Male nudity had a ritual significance in Greek culture—for example, the competitors in the Olympic Games were always naked.

In addition to making sculptures in the round, Greek artists of this period made relief carvings. Some were on independent slabs intended as grave-markers. The most ambitious, however, come from various schemes of architectural decoration—among the most beautiful are those from the Siphnian Treasury at Delphi (Fig. **3.8**). Treasuries were miniature temples dedicated by various Greek states at national shrines, and used to contain precious offerings. The Siphnians of the sixth century B.C. could afford to be ostentatious because their island had rich mines of gold and silver. Part of the decoration consists of a long frieze show-

ing gods fighting with giants (the powers of civilization in combat with those of primeval disorder); the Greek gift for pictorial narrative is already apparent.

Classical period

The development of the Greek Classical style in sculpture, in the fifth century B.C., paralleled the full flowering of Classical architecture. It was extremely rapid, and we know a good deal from literary sources about leading artistic personalities. Unfortunately, it is often difficult to fit together the literary evidence and the original examples of Classical sculpture now left to us.

Surviving originals fall into two categories—rare bronzes, made as independent art objects, and fragments from the decoration of major buildings. Some of the most impressive surviving bronzes are very recent discoveries—for example, the two warriors found in the sea near Riace in southern Italy in 1972 (Fig. **3.9**). The finer and more complete of these sculptures dates, according to most authorities, from the mid-fifth century B.C. Both warriors may come from a group by Phidias, the most famous sculptor of the time, commemorating the battle of Marathon (490 B.C.).

One striking thing about this warrior is the mood conveyed by the head. It portrays a man who is already mature —the small muscles of the features are beginning to slacken a little. There is a trace of exhaustion, as if the man portrayed has just emerged from some major ordeal, and also a just visible unease, mingled with wary ferocity. These qualities are emphasized by the copper which coats and colors the parted lips, and the silver used for the teeth. The mood is far more complex than that conveyed by Archaic *kouroi*. We are plunged into the atmosphere of the great tragedies of the period, in which the participants are often similarly fierce and restlessly uneasy.

The grand tranquility we now associate with the idea of Classicism is expressed more clearly in surviving fragments of sculptures from two great architectural complexes: the Temple of Zeus at Olympia and the Parthenon.

The figures from the Olympia pediments are the masterpieces of what is now sometimes called the Severe Style, to distinguish this phase from the more supple style that followed it. Their authorship is uncertain. The most impressive of the surviving fragments is the god Apollo from the center of the west pediment (Fig. **3.10**). He is shown raising his arm to put a stop to a battle between

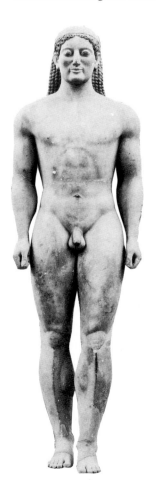

3.7 Kouros, *c.* 540–515 B.C. Marble, approx. 6 ft 4 ins (1.92 m) high. National Archeological Museum, Athens.

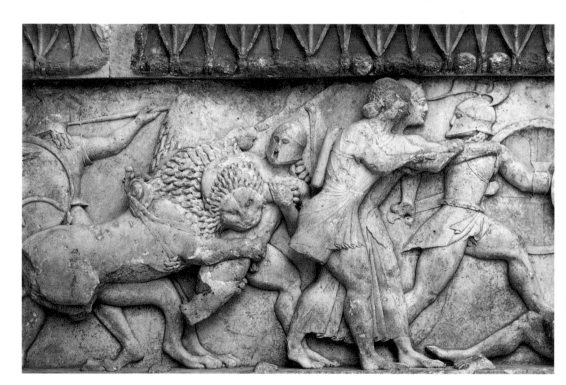

3.8 Warrior gods march into combat against enemy giants. Relief from the Siphnian Treasury at Delphi, 525 B.C.

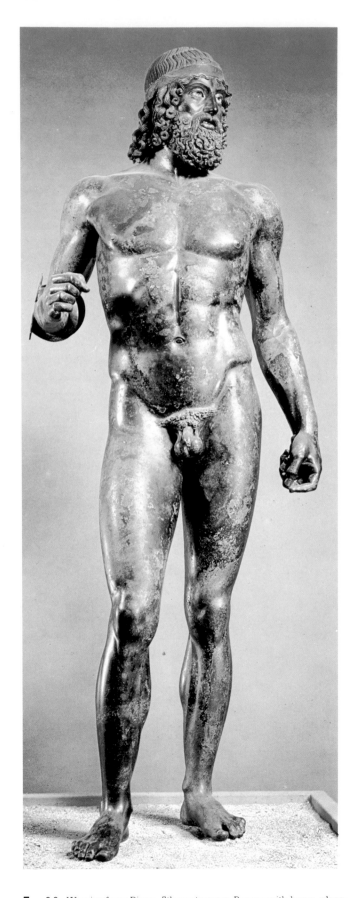

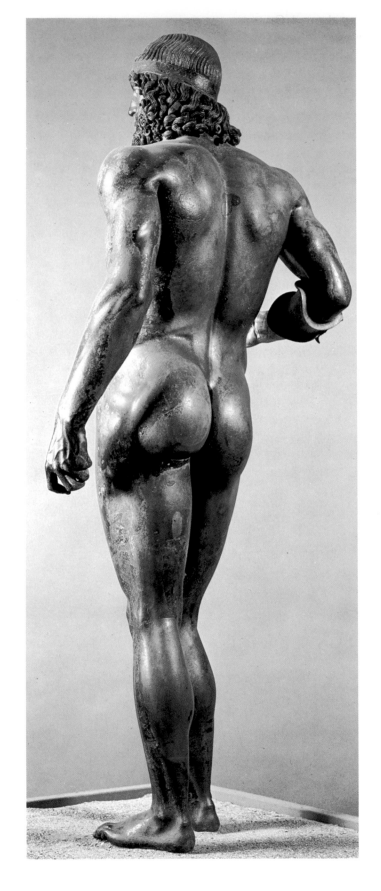

3.9 Warrior from Riace, 5th century B.C. Bronze with bone, glass-paste, silver, and copper inlay, 79 ins (200 cm) high. Museo Nazionale, Reggio Calabria.

Lapiths and Centaurs—the latter, part man, part horse, being standard Greek emblems of barbarian force, and of barbaric behavior in general.

The Olympia carvings, with thick eyelids, heavy features, and a remaining trace of stiffness in their bodies, have a definable stylistic "manner." This is missing from the sculptures of the Parthenon, which propose a different relationship with the viewer from that offered by most works of art—their aim is not to impress with some kind of stylistic signature which proclaims the artist's own view of the world (in this case, the view of Phidias, who was in charge of all the sculpture connected with the building, including the now lost gold and ivory cult statue of Athena), but to be a mechanism for heightening everyday perception, without coloring it in any way.

The pedimental sculptures are more heavily damaged than those from Olympia, and the Parthenon style is perhaps best judged from the relief carvings which adorned the building. The Parthenon frieze, in particular, is the greatest sustained narrative composition produced in the Classical period (Fig. **3.11**). Though it is traditionally ascribed to Phidias, it is not all the work of the same hand, and some parts are more skillfully carved than others. Nevertheless, it shows throughout a most sensitive control of rhythm, with the forward movement of the composition speeding up impatiently, then slowing to a more dignified pace. Particularly striking are the sections devoted to

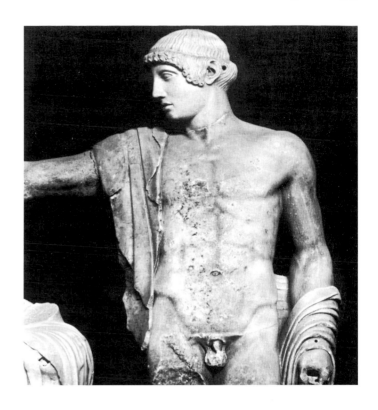

3.10 Apollo from the center of the west pediment of the Temple of Zeus, Olympia, 468–460 B.C. Marble, life-size. Archeological Museum, Olympia.

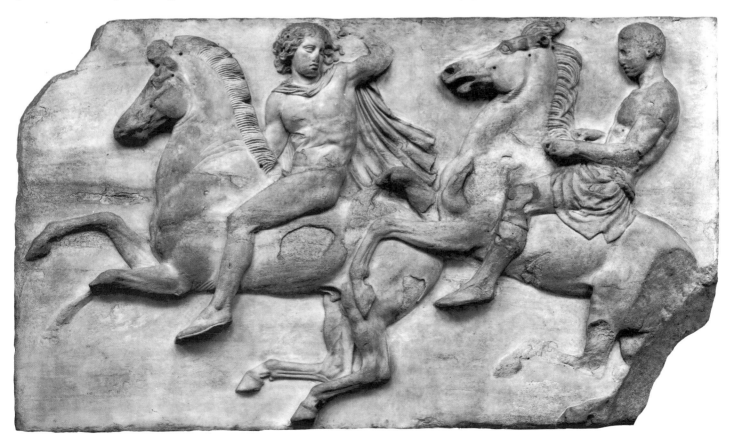

3.11 Horsemen from the west frieze of the Parthenon, Athens, c. 440 B.C. Marble, 43 ins (107 cm) high. British Museum, London.

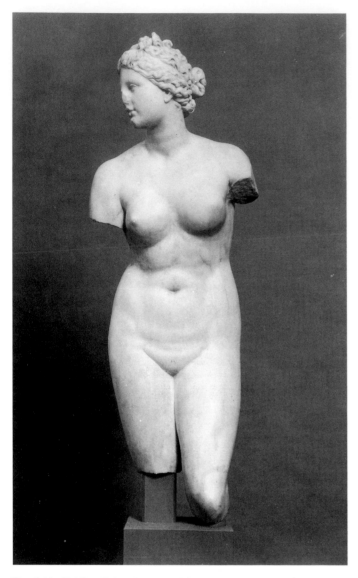

3.12 Cnidian Aphrodite. Probably Hellenistic copy of 4th-century B.C. bronze original by Praxiteles. Marble, 5 ft (1.52 m) high. The Metropolitan Museum of Art, New York (Fletcher Fund, 1952).

3.13 (*right*) *Hermes and Dionysius c.* 340 B.C. Marble, about 7 ft (2.13 m) high. Archeological Museum, Olympia.

groups of horsemen, rendered six abreast in very shallow relief, with a most skillful overlapping of planes.

In its original position, the frieze would have been seen only intermittently, between the great columns that surrounded the cella, and these interruptions, together with the changing pattern of light and shade produced by the pillars, must have added to the feeling of movement which is already so vividly present. The Parthenon frieze refutes the frequent contention that Classical art at its purest must necessarily be static.

Late Classical and Hellenistic period

According to later Greek and Roman commentators, the fourth century B.C. produced some of the greatest names in sculpture. Perhaps the most famous was Praxiteles, author of the nude *Cnidian Aphrodite*, now known only from Roman copies (Fig. **3.12**). Part of the importance of this was that it shifted the emphasis from male to female nudes.

A more reliable indicator of Praxiteles's style is the nude *Hermes* found at Olympia (Fig. **3.13**). Though its presence there in Roman times was noted by the traveler Pausanias, many twentieth-century art historians believe this to be no more than a clever copy. Nevertheless, it seems to give the best idea of Praxiteles's genius. The statue is notable both for its tall, slender proportions and for the self-conscious languor of the pose—though it is a male nude, it seems feminized. It also has wonderful technical finesse. The head shows a sfumato treatment—a delicate softening of detail—which was to be widely influential on Hellenistic art.

3.14 **Scopas**, helmeted head, 4th century B.C. Temple of Athena Alea, Tegea.

The other major influence on Hellenistic art was Scopas. The nearest we can get to original sculptures by him are a few battered heads from the temple of Athena Alea in Tegea, which Scopas designed (Fig. **3.14**). These have broad brows, deep-set eyes, and the generally passionate air which seems to have been typical of his style.

Though both Praxiteles and Scopas were influential on later sculptors, it is Scopas, despite the greater fame of his rival, who seems to have had the more profound effect. It is clear that he had a major impact on the artists responsible for the Great Altar of Pergamon, erected around 180 B.C. and the most impressive surviving relic of Hellenistic art (Fig. **3.15**). It celebrates the victories won by King Eumenes II of Pergamon over the rival kingdoms of Bithunia and Pontus. The colossal frieze shows a battle between gods and giants. In the minds of the Greeks, the giants (even more than the centaurs shown at Olympia) were associated with everything that was pre-Hellenic and therefore by definition barbarous, so the implication is that the defeated foes of Pergamon were not wholly civilized. The centaurs were half-man, half-beast, and at Pergamon the giants are even more monstrous. In the frieze, many are shown as having legs which end in snakes.

The snaky coils add powerfully to the impression made by the composition as a whole. Battle scenes had long been a favorite subject with Greek artists, but this one has an energy, a drama, and, most of all, an emotionalism which make it new. Due to this expressive theatricality, the Pergamene style has been described as "Baroque"—a term typically used to denote the art of seventeenth-century Italy (see page 245).

The Hellenistic Baroque style was also used for freestanding figures—for example, the celebrated *Victory of Samothrace* (Fig. **3.16**). Part of a monument celebrating a

3.15 Snaky-legged giants. Detail from Altar of Zeus, Pergamon, *c.* 180 B.C. Marble, height of frieze 7 ft 7 ins (2.31 m). Staatliche Museen, Berlin.

3.16 Victory of Samothrace *c.* 190 B.C. Marble, 8 ft (2.44 m) high. Louvre, Paris.

naval battle, this shows the goddess Nike, or Victory, alighting on the prow of a ship. The billowing folds of her garments create the essential form—from the late fifth century B.C. onward, the Greeks had become more and more daring in their depiction of drapery, which here seems filled with the wind of the goddess's flight, while the outspread wings deny the weight of the marble of which the sculpture is made.

The *Victory of Samothrace* is a poetic conceit. In contrast to this, one very important and original development in Hellenistic art was a tendency toward realism. A good example is the statue of a horse and rider found in the sea off Cape Artemision in Greece (Fig. **3.17**). If the jockey is seen on his own, as the figure was for many years before his mount was restored, then he seems almost like a caricature. The boy's face is distorted with emotion and effort; his hair is tousled. One is here very far from the noble calm of the Parthenon style, though the Parthenon also features horses and riders. The Cape Artemision horse is, however, more idealized than his jockey; and the two, rejoined, make a

3.17 Horse and rider, Cape Artemision, 2nd century B.C.

surging Baroque composition. The psychological complexity shown in the portrait of the boy is, nevertheless, something which belongs specifically to the Hellenistic epoch; it was inaccessible to earlier Greek artists.

Painting

Mural painting

In contrast to the wealth of material which remains on vases, Greek mural painting is largely lost, and we have to conjecture what it was like from a variety of sources—among them Roman copies and literary accounts written much later. The evidence suggests that mural painting did not become a major means of artistic expression until the fifth century B.C. Even much later, many murals and mosaics (Fig. **3.18**) retained a simple, decorative character.

The nearest archeologists have yet come to recovering a major masterpiece of Greek painting is a recent discovery from a tomb at Vergina in Macedonia, now believed to be

3.18 Lion hunt from the Pella Mosaic, Macedonia, 4th–3rd century B.C.

3.19 Wall painting from tomb at Vergina, *c.* 340 B.C.

that of Philip II of Macedon, father of Alexander the Great (assassinated 356 B.C.). It shows Pluto, god of the underworld, carrying off Persephone, daughter of Demeter. The painting is much faded, but enough remains to show the power and freedom of both composition and brushwork (Fig. **3.19**). Pluto grasps Persephone round the waist with one arm, and urges his horses forward with the reins which he clasps in his other hand, while she screams and struggles. Her body twists in a frantic diagonal across that of her abductor.

The color range is extremely restricted, and this corresponds with ancient literary descriptions of the painting of the Classical period. Sophisticated as their drawing was, painters seem to have been confined to earth colors: four hues only—white, yellow, red, and black.

Vase painting

The history of Greek painting can be traced as a continuous narrative only in vase-painting. The first major style is the fully developed Geometric (Fig. **3.20**), which made its appearance in the ninth century B.C. Here the whole surface of the pot is covered with closely knit patterns. Figures at first are absent, and when they do appear, they are stylized so as to fit in with the abstract designs which cover the surrounding areas. Vases are often of large size—made to be used as grave-monuments—and common subjects are the procession to the grave, and ritual lamentation over a body placed on a bier.

The next major step forward took place not in Athens, where the most ambitious Geometric vases had been made, but in Corinth, where the invention of the technique we now call "black figure" took place. Here everything is shown in black silhouette, with finely engraved details and touches of extra color.

The supremacy of Corinth in this field was not to last. At the beginning of the sixth century B.C. Athens had a strong political and economic resurgence. One result was an influx of craftspeople, which certainly included a number of Corinthian potters, and by the middle of the century Athenian pottery had driven the Corinthian product out of all its richest export markets.

The fascination of Athenian black-figure pottery, and of the red-figure ware that succeeded it, is threefold. First, there is the intrinsic quality of the work, which seems to carry it a long way beyond anything known as craft; secondly, the rapid stylistic evolution which takes place; and thirdly, the existence not merely of a style or school, but of many individually distinguishable artists. Some are known by their own signatures; some because they decorated vases for potters who signed them; and some have conventional designations given by modern scholars. The signatures are important—they prove that the painters were themselves conscious of their status as creative individuals.

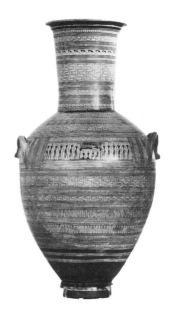

3.20 Dipylon vase. Attic Geometric amphora, 8th century B.C. 59 ins (149.8 cm) high. National Archeological Museum, Athens.

Supreme among the mature black-figure painters was Exekias. He had the power to give gods and heroes all the dignity which was their due, and he was at the same time always ready to try compositional experiments. One of his famous cups (Fig. **3.21**) shows on its bowl a ship which is carrying the god Dionysius. The hull floats freely, surrounded by dolphins, which symbolize the water, and a vine stem twists round the mast. The way the composition is arranged, and its reliance on symbolic presentation rather

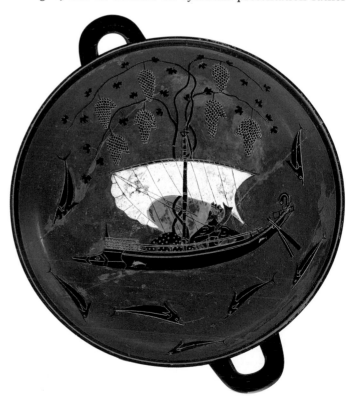

3.21 **Exekias**, black figure vase showing on the bowl a ship carrying the god Dionysius. Staatliche Antikensammlungen und Glyptothek, Munich.

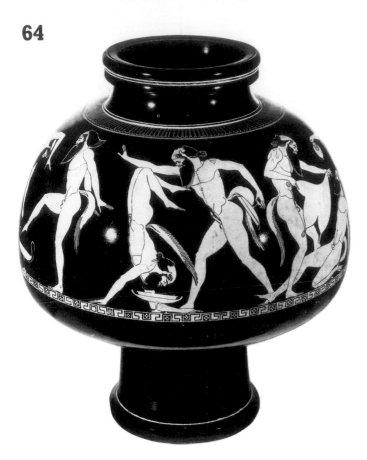

3.22 **Douris**, psykter showing dancing satyrs, *c.* 500–480 B.C. 11⅜ ins (28.7 cm) high. British Museum, London.

than literal truth, give an excellent clue to the way in which we ought to approach all black-figure compositions. This one has its own grammar, but is emphatically not illusionist art.

The red-figure technique was invented around 530 B.C. Essentially, it involved a reversal of the conventions of black-figure ware. The design now appears in the red clay of the ground, while the background is filled in with black. Anatomical details are brushed in with fine lines, which are sometimes diluted to a rusty brown. The effect is to give greater freedom. Red-figure artists were able to tackle problems of foreshortening—the technique of depicting an object lying at an angle to the viewer—which were beyond the grasp of those working in black-figure ware (Fig. **3.22**). The effect, as has sometimes been pointed out, is more like the delicate shallow reliefs being produced by Greek sculptors at this period (see page 57) than like painting with a fully developed sense of perspective and depth. In fact direct comparisons can often be made with Late Archaic reliefs, in which the background was customarily painted a strong color.

Toward the middle of the fifth century B.C. the vase-painters evidently began to fall under the influence of the Greek muralists, whose work is now lost to us. To start with, the echo is very distant and does not really affect the quality of their work. Indeed, they may have been inspired and spurred forward by what the muralists were doing. One of the most moving of all vase-compositions fills the bowl of

the huge cup which is the name-vase of the Amazon painter (Fig.**3.23**). It shows Penthesilea, Queen of the Amazons, being slain in battle by Achilles, who falls in love with his victim as she dies. This may well be related to the work of the painter Nikon, who painted a famous *Battle of Greek and Amazons* which was in the Stoa at Athens.

By the end of the fourth century the art of vase-painting was more or less extinct in Athens, just as the city itself was in decline politically and economically.

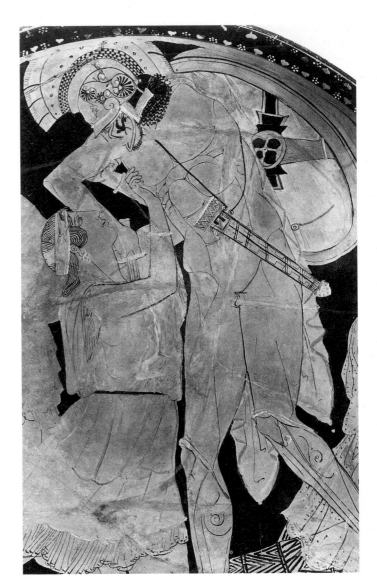

3.23 Detail from a cup showing Penthesilea, Queen of the Amazons, being slain in battle by Achilles, 5th century B.C.

Literature

The Homeric epic

Almost everything about Homer is debatable, except the centrality to ancient Greek culture of the two epics connected with his name, the *Iliad* and the *Odyssey*, and thus their importance for Western civilization as a whole. The epics belong to an established tradition of heroic tales in verse which existed, as we have already seen, in ancient Mesopotamia, and were characteristic of the Indo-European peoples as a whole, from whom the Greeks were descended.

The characteristic voice of the Homeric poems depends on the meter in which they are written. The basic unit is the hexameter, or line of six feet, which can contain between twelve and seventeen syllables. These syllables are classified as "long" or "short," not as stressed or unstressed—in this respect Greek (and also Latin) verse differs widely from English language equivalents. The meter is unusually elaborate for a "primitive" poetic form like the epic, but it is also weighty, flexible, and fast-moving.

Another important characteristic of Greek epic is the use of similes, which are often so much elaborated that they become short poems in themselves.

The sophistication and polish of the writing gave the Homeric narratives universal appeal. They remained part of the Greek consciousness throughout Greek history, and have retained their appeal today. One reason for this is that the focus of interest is always human. The Olympian gods, when they appear, are treated as beings with distinctly human frailties—they are often less admirable than the men and women whose fates they govern. Human beings, by contrast, are enlarged rather than diminished, even when they are shown behaving badly.

One of the chief ways in which the epics give dignity to their heroes is by setting the stories they tell at a time already remote from that of the writer or writers. The magnificent civilization of Mycenae was already only a memory, and because it was not a living presence, its characteristics could be altered as the poet pleased.

How were the two epics composed? The general agreement now seems to be that they arose from an existing tradition of oral poetry, and that strong traces of this remain —for instance, in the use of recurrent verbal formulae. Each hero has his own phrase or adjective: Achilles is "swift-footed," Menelaus is "lord of men," Odysseus is "Odysseus of the many schemes." Similarly the sea is "wine-dark" or "loud-roaring." Yet poems as long, elaborate, and consistent as these must surely have had a controlling intelligence behind them—or perhaps it is more convincing to say *two* controlling intelligences, since the *Iliad* and the *Odyssey* seem to be the work of different poets, working a generation apart. The now commonly accepted date for the *Iliad*, which has always been considered the earlier of the two, is

about 725 B.C. This would make it coincide very closely with the reintroduction of writing in Greece—its use had lapsed after the fall first of Knossos, then of Mycenae.

Though they have common themes—the *Odyssey* completes stories which are begun in the *Iliad*—the two poems are very different. The *Iliad* uses a restricted range of materials. It is concerned with the "Wrath of Achilles," his quarrel with the other Greek leaders, and the fateful consequences of this for both the Greeks and the Trojans, within the confined setting supplied by the siege of the city of Troy. The poem restricts itself in other ways as well—its imaginative world is a narrowly heroic one. The stress is on the universality of suffering and the shared consciousness of mortality.

The *Odyssey* deals with the aftermath of the Trojan War. It tells the story of the hero Odysseus and his long journey back home to Ithaca, where he slays the suitors who have for so long been besieging his faithful wife, Penelope. The whole poem is different in tone from its predecessor. It often stresses its hero's cleverness and "cunning;" unlike the *Iliad*. It is full of marvels and the supernatural.

With its descriptive brilliance, narrative thrust and variety of tone the *Odyssey* has been described as the "first novel" (though others give priority to certain ancient Egyptian texts). Certainly it is the direct ancestor of all the picaresque novels written since. It covers topics, and areas of psychology, which the *Iliad* does not attempt to tackle.

The two great Homeric epics had a major effect on the development of Greek culture. They provided a basic source for Greek tragedy, which tends to inhabit the same reinvented Mycenaean world, with its kings and queens unfamiliar to Greek democrats but very suitable to the purposes of drama in their passion and willfulness. Greek artists also made the poems a basic source, and it is largely thanks to the *Iliad* and the *Odyssey* that the visual arts of ancient Greece were so strongly narrative and literary.

Sappho and the Greek lyric

Only one major woman writer is known to us from antiquity: Sappho. She lived in the early sixth century B.C., and came from the island of Lesbos. She spent part of her life in exile, thanks to the political changes of her time—she belonged to an aristocratic group which was ousted from the island for a while by a complicated faction-fight within the governing class. Other scraps of biographical information, such as the story that the poet committed suicide by leaping from a cliff into the sea, seem to have no foundation in fact.

Sappho's poems are monodies—that is, they were meant to be sung by a single voice to an accompaniment played on a lyre. They are as intimate and personal as Homeric epic is public and impersonal, and this very intimacy has not helped their survival. While the Homeric epics have come down to us apparently intact, Sappho's poems are known only in fragments—from citations by other ancient writers,

Iliad: Book XXIV

Achilles has killed the Trojan hero Hector in battle, in revenge for Hector's slaughter of his own beloved companion Patroclus. Now, in the most touching scene in the *Iliad*, Hector's father, King Priam, comes to beg for his son's body.

Big though Priam was, he came in unobserved, went up to Achilles, grasped his knees and kissed his hands, the terrible, man-killing hands that had slaughtered many of his sons. Achilles was astounded when he saw King Priam, and so were all his men. They looked at each other in amazement, as people do in a rich noble's hall when a foreigner who has murdered a man in his own country and is seeking refuge abroad bursts in on them like one possessed.

But Priam was already praying to Achilles. "Most worshipful Achilles," he said, "think of your own father, who is the same age as I, and so has nothing but miserable old age ahead of him. No doubt his neighbours are oppressing him and there is nobody to save him from their depredations. Yet he at least has one consolation. While he knows that you are still alive, he can look forward day by day to seeing his beloved son come back from Troy; whereas my fortunes are completely broken. I had the best sons in the whole of this broad realm, and now not one, not one I say, is left. There were fifty when the Achaean expedition came. Nineteen of them were borne by one mother and the rest by other ladies in my palace. Most of them have fallen in action, and Hector, the only one I still could count on, the bulwark of Troy and the Trojans, has now been killed by you, fighting for his native land. It is to get him back from you that I have come to the Achaean ships, bringing this princely ransom with me. Achilles, fear the gods, and be merciful to me, remembering your own father, though I am even more entitled to compassion, since I have brought myself to do a thing that no one else on earth has done—I have raised to my lips the hand of the man who killed my son."

Priam had set Achilles thinking of his own father and brought him to the verge of tears. Taking the old man's hand he gently put him from him; and overcome by their memories they both broke down. Priam, crouching at Achilles' feet, wept bitterly for man-slaying Hector, and Achilles wept for his father, and then again for Patroclus. The house was filled with the sounds of their lamentation. But presently, when he had had enough of tears and recovered his composure, the excellent Achilles leapt from his chair, and in compassion for the old man's grey head and grey beard, took him by the arm and raised him. Then he spoke to him from his heart: "You are indeed a man of sorrows and have suffered much. How could you dare to come by yourself to the Achaean ships into the presence of a man who has killed so many of your gallant sons? You have a heart of iron. But pray be seated now, here on this chair, and let us leave our sorrows, bitter though they are, locked up in our own hearts, for weeping is cold comfort and does little good. Women are wretched things, and the gods, who have no cares themselves, have woven sorrows into the very pattern of our lives. You know that Zeus the Thunderer has two jars standing on the floor of his Palace, in which he keeps his gifts, the evils in one and the blessings in the other. People who receive from him a mixture of the two have varying fortunes, sometimes good and sometimes bad, though when Zeus serves a man from the jar of evil only, he makes him an outcast, who is chased by the gadfly of despair over the face of the earth and goes his way damned by gods and men alike. Look at my father, Peleus. From the moment he was born, Heaven showered its brightest gifts upon him, fortune and wealth unparalleled on earth, the kingship of the Myrmidons, and though he was a man, a goddess for his wife. Yet like the rest of us he knew misfortune too—no children in his palace to carry on the royal line, only a single son doomed to untimely death. And what is more, though he is growing old, he gets no care from me, because I am sitting here in your country, far from my own, making life miserable for you and your children. And you, my lord—I understand there was a time when fortune smiled upon you also. They say that there was no one to compare with you for wealth and splendid sons in all the lands that are contained by Lesbos in the sea, where Macar reigned, and Upper Phrygia and the boundless Hellespont. But ever since the Heavenly Ones brought me here to be a thorn in your side, there has been nothing but battle and slaughter round your city. You must endure and not be broken-hearted. Lamenting for your son will do no good at all. You will be dead yourself before you bring him back to life."

"Do not ask me to sit down, your highness," said the venerable Priam, "while Hector lies neglected in your huts, but give him back to me without delay and let me set my eyes on him. Accept the splendid ransom that I bring. I hope you will enjoy it and get safely home, because you spared me when I first appeared."

"Old man, do not drive me too hard," said the swift Achilles, frowning at Priam. "I have made up my mind without your help to give Hector back to you. My own Mother, the Daughter of the Old Man of the Sea, has brought me word from Zeus. Moreover, I have seen through *you*, Priam. You cannot hide the fact that some god brought you to the Achaean ships. Nobody, not even a young man at his best, would venture by himself into our camp. For one thing he would never pass the sentries unchallenged; and if he did, he would find it hard to shift the bar we keep across our gate. So do not exasperate me now, sir, when I have enough already on my mind, or I may break the laws of Zeus and, suppliant though you are, show you as little consideration as I showed Hector in my huts."

This frightened the old man, who took the reprimand to heart. Then, like a lion, the son of Peleus dashed out of doors, taking with him two of his squires, the lord Autome-

don and Alcimus, who were his favourites next to the dead Patroclus. They unyoked the horses and the mules, brought in the herald, old King Priam's crier, and gave him a stool to sit on. Then they took out of the polished waggon the princely ransom that had won back Hector's corpse. But they left a couple of white mantles and a fine tunic, in which Achilles could wrap up the body when he let Priam take it home. The prince then called some women-servants out and told them to wash and anoint the body, but in another part of the house, so that Priam should not see his son. (Achilles was afraid that Priam, if he saw him, might in the bitterness of grief be unable to restrain his wrath, and that he himself might fly into a rage and kill the old man, thereby sinning against Zeus.) When the maid-servants had washed and anointed the body with olive-oil, and had wrapped it in a fine mantle and tunic, Achilles lifted it with his own hands onto a bier, and his comrades helped him to put it in the polished waggon. Then he gave a groan and called to his beloved friend by name: "Patroclus, do not be vexed with me if you learn, down in the Halls of Hades, that I let his father have Prince Hector back. The ransom he paid me was a worthy one, and I will see that you receive your proper share even of that."

The excellent Achilles went back into the hut, sat down on the inlaid chair he had left—it was on the far side of the room—and said to Priam: "Your wishes are fulfilled, my venerable lord: your son has been released. He is lying on a bier and at daybreak you will see him for yourself as you take him away. But meanwhile let us turn our thoughts to supper. Even the lady Niobe was not forgetful of her food, though she had seen a dozen children done to death in her own house, six daughters and six sons in their prime."

Homer

(HOMER, *The Iliad*, Book XXIV, translated by E. V. Rieu. Penguin Classics, 1950. Translation © E. V. Rieu. Reprinted by permission of Richard Rieu.)

and from damaged texts found in Egypt, written on scraps of papyrus. One important fragment survived as part of a mummy wrapping; another was copied out on a large potsherd. Only one complete poem remains, and substantial parts of about five others. Apart from these, there is a scattering of remnants—single stanzas, or even single lines. These tiny scraps carry the echo of a unique poetic voice.

The chances of survival for Sappho's poems were reduced not merely by their intimacy but by their actual subject matter, which some readers find difficult even today. They are concerned almost exclusively with love and the worship of Aphrodite, goddess of love. Furthermore, the love described is an emotional bond between women. One striking feature of Greek society was its tolerance and even approval of erotic relationships between members of the same sex. For a young man to be beloved by an older one was considered a beneficial rite of passage throughout the Archaic and Classical periods. We hear less about similar relationships between older and younger women, but these seem to have flourished in the Lesbos of Sappho's time. The poet was the central figure in a circle which served as a kind of informal finishing-school for well-born young women. Its fame was widespread, and we learn from some of Sappho's poems that the women she associated with were not always from her own island. Within this circle there was a delicate play of emotional relationships, linked to the cult of Aphrodite. It seems to have been accepted by all parties that these relationships were transitory—the young women who joined Sappho's circle for a time would eventually leave in order to marry. While it is clear from Greek literature, and also from erotic vase-paintings, that homosexual love between men found full physical expression, it is not clear that this was the case when the bond was between women. Sappho does, however, give striking descriptions of the effect of desire:

To me he seems to match the gods,
that man who sits before your face,
and listens to the close
 sweet murmur of your voice

and your warm laugh, things, I swear,
that shake my heart with fear.
One glimpse of you and speech
 is far beyond my power.

(*Three Archaic Poets*, translated by Anne Pippin Burnett. Gerald Duckworth and Co. Ltd, 1983.)

This extract from one of the best preserved of Sappho's lyrics gives a good idea of her style and characteristic poetic method. The language is always simple and direct, and the poem seems to grow inevitably toward its conclusion. However, it is naïve to think of this as a purely personal outburst. The lyric creates and dramatizes a situation: the subject is not merely Sappho's love for one girl in particular, but the difference between, and the contrasting emotional lives of, men and women.

Drama

Greek drama is the earliest kind of theatrical performance where texts have come down to us. Together with medieval morality plays, Greek tragedies and comedies are the forerunners of all theatrical representations as we know them.

In the case of the Greeks, the division into two genres existed from the beginning. The nature of each was governed by what preceded them; also by the conditions under which they were performed. Both evolved from improvised songs and dances in honor of Dionysius, the god of wine. Tragedy originated in the dithyramb, a kind of choral performance in which the members of the chorus were dressed as satyrs. These performances were probably always competitive. Originally the prize was a goat, afterwards sacrificed to the god—hence the word "tragedy," which means goat-song in Greek. The origin of comedy was the comus, a ribald comic chorus with performers wearing extravagant disguises. This went round from house to house. The obscenity and scurrility associated with the comus contained a ritual element—they were thought to ward off evil.

Greek plays were performed in a special form of open-air theater (Fig. **3.24**). It consisted of several elements, the most essential being the orchestra, a circular dancing area perhaps derived from rustic threshing floors. This had an altar at its center. In Classical times it was always the main acting area, where actors and members of the chorus mingled. Facing the orchestra were semicircular tiers of seats, generally placed against a hillside and at first built in wood, but later in stone. In Athens, the entire citizen population attended—in its finished form the theater held 17,000 people. Performances took place in daylight, starting early in the morning. There was of course no stage lighting. Because of all this, and because it had from the very start been part of the tradition, all the actors wore masks. All the roles, both male and female, were taken by men.

A few Greek tragedies seem to have dealt with contemporary events, but the majority were concerned with legend—many dramatized material linked to Homer. In one instance, we can see how each of the three great Greek tragic dramatists, Aeschylus (525–456 B.C.), Sophocles (497–

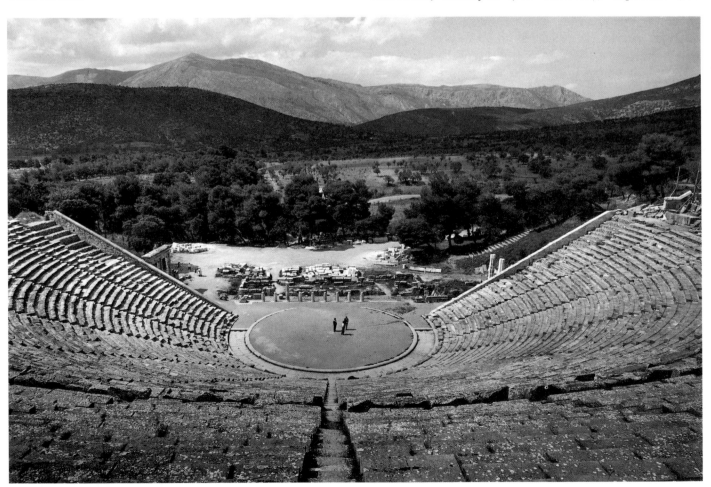

3.24 Theater at Epidaurus, Greece, c. 350 B.C. Diameter 375 ft (114.3 m), orchestra 66 ft (20.1 m) across.

406/5 B.C.), and Euripides (485–406 B.C.), dealt with the same plot—Orestes's return from exile to avenge the murder of his father Agamemnon, after the conclusion of the Trojan War.

A story very familiar to the audience is treated in three very different ways. Aeschylus, in the middle play of *The Oresteia* (458 B.C.), the only tragic trilogy which survives complete, stresses the ritual elements and the inevitability of fate. Sophocles, in his *Electra* (*c.* 420–414 B.C.), explores the psychology of Agamemnon's elder daughter, longing for revenge on her adulterous mother Clytemnestra and her lover Aegisthus. Euripides's play of the same title (*c.* 413 B.C.) reads like a direct reply to Sophocles. Electra is self-pitying and hysterical; her mother is a sad, uncertain, and unhappy woman.

Greek tragedies have some striking peculiarities—for example, all violent events, such as the killings of Clytemnestra and Aegisthus, take place off-stage, and are described for the audience; the drama thus lives in language at least as much as it does in action. In addition, the plays generally deal with events whose outcome is already known to the audience; everything that happens is preordained. In many cases the dramatists seem to have used this to give their work a special overtone. The background to both *Electra*s, for instance, is the unending fratricidal struggle of the Peloponnesian War between Athens and Sparta (431–404 B.C.). Euripides's text, in particular, is shot through with an oblique commentary on what was happening, and the brutalizing effect which it had on his fellow Athenians.

Comic plays seem to have developed later than tragedies. The first official performances of comedy in Athens—that is, the first for which state prizes were given—did not take place until 486 B.C. In the fifth century we have surviving work from only one comic playwright, Aristophanes (*c.* 448–*c.* 380 B.C.). He wrote forty plays, of which eleven survive. In the fourth century a new and very different form of comic writing developed, the chief exponent of which was Menander (341–290 B.C.). Menander wrote more than 100 plays, but only one now survives intact. It comes from a papyrus found in Egypt.

A play by Aristophanes is something like a modern revue —a loosely connected series of sketches and comic turns.

He lampoons the leading politicians of his time, satirizes personalities such as Socrates, and parodies the great tragic playwrights, especially Euripides. Many things in Aristophanes's plays seem also to be based on what had become another form of popular entertainment—the proceedings of the Athenian lawcourts. The actual story is usually episodic, and often relies on some kind of a quest, in which the central figure embodies the reactions of the ordinary citizen. Paradoxically, in one of Aristophanes's best plays, *The Frogs*, the ordinary citizen is also a god. The play describes how Dionysius, worried by the lack of tragic playwrights, sets out to rescue Euripides, then only recently dead, from Hades. In the end, however, he convicts Euripides of sophistry, quoting well-known lines from his plays, and decides to rescue Aeschylus instead, as an emblem of the good old days.

The background to Aristophanes's plays is, once again, the bitterness of the Peloponnesian War. *The Frogs* was written just before the final collapse of Athens. Menander's work belongs to a different world—one which had been altered irrevocably by the conquests of Alexander the Great. In Athens, the public was now weary of politics, and less socially diversified than formerly, because the poor had been denied the vote, and were now separated from the prosperous middle class, to the point where they no longer attended theatrical performances. Menander aimed to produce not comic fantasies but a convincing picture of ordinary life. This picture is, nevertheless, severely stylized. The playwright relied on combinations of various stock situations: love affairs going wrong; a child stolen or abandoned but later restored to family and status; a soldier returning from the wars to upset the family circle; or an eccentric whose antics cause social chaos.

Though so much of Menander's work has been lost, he is still recognizable as the ancestor of most modern comedy. His stock characters prefigure the traditional roles in Italian *commedia dell'arte* (see page 320); his five-act structure is that of standard eighteenth-century comedies. Most people think Aristophanes a greater playwright, and certainly a greater poet (his choruses are often exquisite), but Menander had the greater influence on the development of Western drama.

Chapter 4

Ancient Rome

4.1 Mosaic from the villa at Piazza Armerina in Sicily, early 4th century A.D.

Republic and Empire

The emergence of the Roman Republic as the dominant power in the Mediterranean world was an event as significant though slower moving than the conquests of Alexander the Great, which had carried Greek civilization eastwards until it reached northern India. In some respects, it was even more significant, since Roman rule was permanent, not ephemeral as Alexander's had been, and created institutions which would remain influential for thousands of years.

Rome was situated in Central Italy—a small, warlike republic with few pretensions to artistic or literary prowess. Immediately to the north lay the territories of the Etruscans, a people of mysterious origin (even their language is still undeciphered), whose paintings, sculptures, and artefacts show that they had from the beginning been heavily influenced by Greek civilization. To the south were parts of Italy which had long been in the possession of Greek settlers.

Roman military prowess was tested, first by wars within Italy itself, in the course of which Roman armies subjugated most of the peninsula, and then by a series of bitterly fought conflicts with Carthage, on the other side of the Mediterranean, with whom Rome was in competition for the rich granaries of Sicily. The First Punic War began in 264 B.C.; the Third, which ended with the destruction of Carthage itself, ended in 147 B.C. At the same moment Greece came

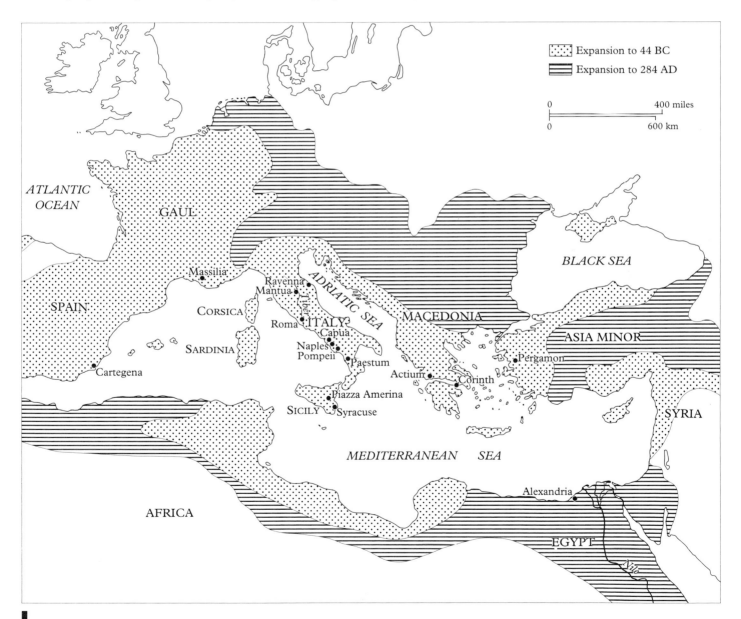

4.2 The Roman Empire between 44 B.C. and 284 A.D.

under Roman control. Rome was already in possession of much of Spain, which had become a battleground between Romans and Carthaginians, and less than two decades after the fall of Carthage Asia Minor became a Roman province.

After a series of savage civil wars, which occupied most of the first century B.C., Julius Caesar's nephew and heir, Gaius Octavius, later known as Augustus (27 B.C.– A.D. 14), defeated the combined forces of Mark Antony and Cleopatra VII, last Queen of Egypt, in 31 B.C. at the naval battle of Actium. Augustus transformed the Roman Republic into the Roman Empire, ruled by his own descendants until the death of Nero in A.D. 68.

The Empire reached its greatest geographical extent, and probably its greatest prosperity, under Trajan (98–116). After this there began an inexorable process of political and economic decline. Roman territory suffered a series of devastating barbarian invasions during the third century, and for much of this period of crisis was ruled by military emperors whose brief reigns usually ended in assassination.

At the end of the century order was finally restored by Diocletian (284–305), who divided the Empire into an eastern portion ruled by himself, and a western one ruled by his colleague Maximian (286–305). The idea of dividing the Empire to make it more manageable was revived several times during the period which followed, and the division became final at the death of Emperor Theodosius I (379– 95). An even more significant event during the course of the fourth century was the conversion of Emperor Constantine (306–37) to Christianity, making this once-persecuted faith the official religion of the state.

Once the Empire was finally divided, the two halves gradually grew apart. A continuous line of emperors ruled in the eastern capital, Constantinople, founded by Constantine on the site of the old Greek city of Byzantium. This line did not come to an end until the fall of Constantinople to the Turks in 1453. The last western emperor, the puppet ruler Romulus Augustulus (b. 461?), disappeared much earlier, deposed in 476. The territories of the western Empire were by this time already split into numerous kingdoms of barbarian origin, and it is from these that the complex Western civilization we now know descends.

Two points in particular need to be made about the phase of Western civilization represented by the Roman Empire. The first is that the cultural center was much further to the south and east than it was to be in the Middle Ages, or in fact later. Asia Minor and Syria were among the wealthiest Roman provinces, and there was a flood of cultural and especially religious influences both from these lands and from further east still, as well as from Palestine, Egypt, and North Africa.

The second is that, though we speak of Roman culture as "classical"—that is, as the direct heir of Greece, and still Greek in many of its most important manifestations—it was also necessarily in contact with other cultures of many different kinds. The kind of Roman art which is now described as "provincial" is usually a combination of elements peculiar to the region in which it was made and others which were part of the standard classical repertoire. Until recently, scholars tended to consider artworks of this kind debased. It is now increasingly realized that they have special qualities of their own, and that, furthermore, the art of the early Middle Ages, and even of the Romanesque period itself—so called because of its use of classical Roman forms—is directly traceable to sources of this kind.

	500	250	B.C. 0 A.D.	250	500
	ROMAN REPUBLIC			**ROMAN EMPIRE**	
HISTORICAL BACKGROUND	Traditional foundation of Republic 509 First Punic War against Carthage 264	Civil Wars 100–42 Destruction of Carthage 147 Augustus—founding of Empire	Nero (36–68) Destruction of Pompeii 79 Trajan (98–117) Hadrian (117–138)	Constantine (307–337) Final division of Empire 395 Collapse of Western Empire 476	
RELIGION/ PHILOSOPHY	Epicurus opens school in Athens 306		Seneca Marcus Aurelius *Meditations*	Plotinus in Rome 244– 70 Christianity becomes state religion	
ARCHITECTURE		Vitruvius *De architectura* First stone theaters in Rome	The Pantheon (**4.4**) Baths at Caracalla (**4.5**)		
VISUAL ARTS		Villa of Livia wall painting (**4.6**)	Trajan's column (**4.8**) Bust of Septimus Severus (**4.9**) *Laocoön*	Bust of Caracalla (**4.10**) Bust of Gallienus (**4.11**)	
LITERATURE/ DRAMA		Lucilius Julius Caesar *Gallic Wars, Commentaries* Cicero Virgil *The Aeneid*	Tacitus *Histories, Annals* Juvenal		

Religion and philosophy

Greek philosophy was often concerned with the philosophy and nature of the state. Under the Roman Empire such political speculations ceased, as they were no longer relevant to the situation of people living under an autocracy. Instead, thinkers turned increasingly to transcendental ideas, and philosophy, politics, and religion became inextricably intertwined.

The religious, and therefore the philosophical, situation under the Roman Empire became increasingly complex. Various solutions were proposed to the problems which confronted society, and none were found adequate. It is this sense of seeking, often combined with profound melancholy, which is half concealed by the prosperous façade of the Empire, even when in its most stable and successful phase.

During the centuries when Rome achieved world domination, religion was always an important factor in the life of the state. In the early Empire, religious belief was indistinguishable from patriotism. Traditional religion, based on a pantheon of gods similar to those worshipped by the Greeks, was extended to include the worship of the emperor and members of the Imperial family. A willingness to worship the emperor, or at any rate his genius or tutelary spirit, became the test of loyalty (it was the Christians' refusal to do this which particularly infuriated their persecutors). At the same time there was increasing private disbelief, and a growing cynicism about the validity of traditional religion. Seneca (4 B.C.–A.D. 65), the playwright-philosopher who was one of Emperor Nero's chief advisers, remarked that someone in his position had to maintain religious observances "because they are imposed by law, not because they please the gods."

On the other hand, a belief that individuals were utterly at the mercy of fate grew ever stronger as the Empire became more unstable and the political and economic situations worsened. Belief in Fate and Chance led to an equally widespread belief in astrology, which in turn produced a fear-ridden world, infested with magicians and charlatans of all kinds. All of this provided fruitful soil for the growth of various unofficial mystery religions. These characteristically offered an initiation, or even a series of initiations, which lifted participants out of the mundane sphere and freed them from the terror of "evil powers," such as magicians and sorcerers might wield. They offered unity with the divine and a secure future in the hereafter. The central feature in many of these cults was once again a savior god, who was believed to have died and then risen again.

During the late Republican and early Imperial periods the two main philosophical schools were Stoicism and Epicureanism. Both were of Greek origin, and had their roots in the Hellenistic period, just at the time when the collapse of the traditional Greek city-states began to focus attention on human beings as individuals, rather than simply as components in a social organism.

Epicurus (342–270 B.C.) regarded the senses as the only sure test of knowledge. The gods existed, he thought, simply because "Nature had impressed the idea of them on the thoughts of all men," but they moved in some kind of imaginary realm and did not concern themselves directly with the world. Though Epicureanism gained a hearing in Rome, it was always hampered by its rejection of any kind of moral imperative. This did not suit Roman traditions or the Roman temperament.

More successful was the rival Stoic school. This embraced the idea of a divine, controling providence, but did so in a curiously negative way. Its watchwords were "Endure and Renounce, Bear and Forbear." In the early Imperial period one of the chief propagandists for Stoicism was Epictetus, the freedman (freed slave) of one of Nero's ministers. Epictetus's doctrines were those followed by the philosopher-emperor Marcus Aurelius (161–80). Marcus Aurelius's *Meditations*, written in Greek and probably not intended for publication, sum up the grim endurance of Stoic attitudes: "Up and down, to and fro, round and round: this is the monotonous and meaningless rhythm of the universe. Whatever befalls you was prepared for you from beforehand for eternity, and the thread of causes was spinning from everlasting both your existence and that which befalls you."

An unlikely philosophical revival took place just as the Empire reached its worst moment of crisis, under the leadership of Plotinus (205–70). The revival of Platonic thought, in which Plotinus rooted himself, started around 100, but he now carried Plato's system of ideas much further than any other thinker of the classical period. Plato's often conflicting insights had been converted into a system with, as its keystone, something that Plato himself mentions only in passing—the presence of a supreme principle (in the vaguest terms, a "god") at the head of a hierarchy of being. Plotinus took the new Platonic system and made it both profounder and more logically knit than it had ever been previously, to the point where it crossed the frontier of what is generally called philosophy and entered the territory of religion.

For Plotinus the goal of the individual—closer unity and community with the One—could be achieved only through rigorous self-control of a more positive sort than that recommended by the Stoics. He advocated deliberate abstinence and discipline as a means of achieving the peace of mind and tranquility of body which promote contemplation.

His system contains many elements which would make it both a rival and, later, for certain thinkers, a completion of

Christian doctrine. Its most conspicuous difference from Judaism and Christianity is that it makes no distinction between, on the one hand, the "created" and, on the other, the Creator. This also means that it has no doctrine of sin, followed by redemption. The mystery religions contemporary with Plotinus, though cruder in their symbolisms, had in this respect progressed further than he was able to do by offering to transform the condition of the worshipper.

Architecture

Roman architecture is at least as important for the history of Western architecture in general as the Greek architecture which preceded it. Greek architects created a range of forms; the Romans applied these forms to buildings which have a much closer relationship to those we know today than anything built by the Greeks. The word "applied" is used here in two senses. In Roman architecture we often find a division between the actual structure and the appearance of a building. In addition to this, Roman architecture introduced forms which the Greeks used only very sparingly or tentatively, such as the arch (Fig. **4.3**), or did not use at all, such as the dome. Finally—and this is perhaps the most important development—Roman architecture was often as much concerned with the manipulation of internal space as it was with the treatment of the façades.

These differences all depended on the introduction of new methods of building. The Greeks built in cut and dressed stone; using a technique derived from primitive buildings in wood, the Romans built in brick and concrete, as well as in stone; it was concrete, in particular, which made many innovations possible.

First developed in the second century B.C., Roman concrete consisted of cement made with lime, clay, and grit, mixed with water and a rubble fill. It hardened into a dense mass the shape of which could be determined by using a wooden mold or frame into which the mixture was poured. It was just as easy to use three-dimensional curves as rectilinear forms. Concrete did, however, have one disadvantage: it needed protection from moisture—which implied some kind of surface treatment. This could be stone veneer, mixtures of brick and tufa (volcanic rock), or simply a layer of plaster.

The quintessential Roman building to have come down to us more or less intact is the Pantheon in Rome (Fig. **4.4**), begun in 118–19. Here a vast dome covers a rotunda (circular interior space) 143 feet (43.6 m) in diameter. The Pantheon was built as a single monumental structure, though

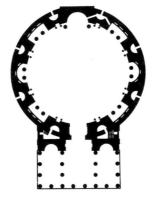
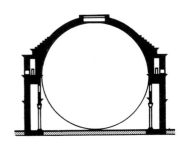

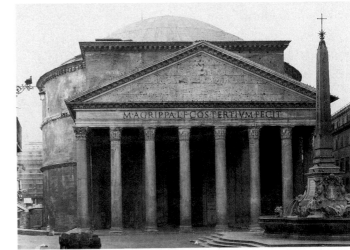

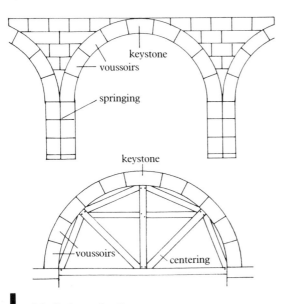

4.3 Arch construction.

4.4 Pantheon, Rome, *c.* 118–28 A.D.
(*above*) Plan and cross section of the Pantheon.

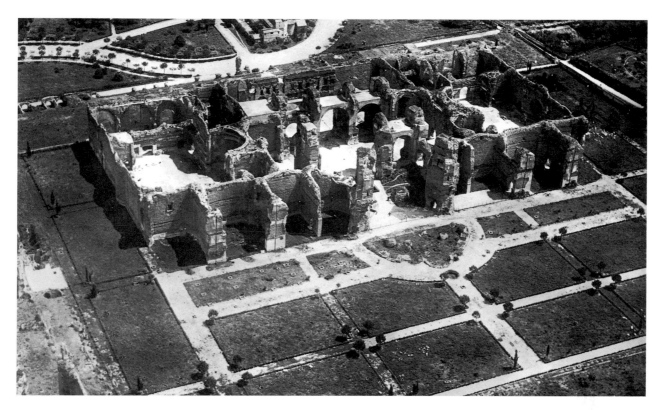

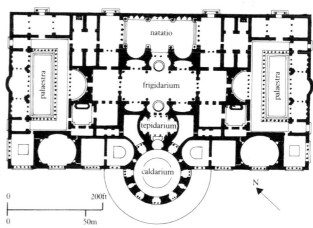

4.5 Aerial view and plan of the Baths at Caracalla, Rome, *c.* 211–17 A.D. Marble and concrete.

originally it would have been largely hidden from the outside by now-demolished surrounding buildings. This would have made the vast, unobstructed interior space even more of a surprise.

Similar domed spaces often formed part of more complex structures—for example, the great Imperial baths, which show us Roman architecture at its most elaborate. The daily visit to a public bath-house was part of the ritual of urban life; at one time there were 800 baths in Rome alone. The Baths at Caracalla (Fig. **4.5**), which were completed in 217, represent the culmination of this kind of building. Within this vast structure set on a terrace, bathers followed a prescribed route—from the dressing rooms, where they stripped, to a series of hot rooms of gradually increasing temperature, then to the *caldarium* (a room with hot-water

basins and tubs), the *tepidarium* (where the temperature was slightly lower), and finally to the *frigidarium* (with cold-water tubs in each of the four corners).

These rooms varied in size and shape: the *caldarium* was a vast rotunda; the *frigidarium* was a rectangle. These offered a constantly varying spatial experience as the bather progressed. The building is, however, axially symmetrical, with identical facilities on either side of the main rooms—two sets of changing rooms; two *palaestrae* (gymnasia) for taking exercise. This formula of variation within overall symmetry became a model for public buildings of all types, both at the time and in the future. Many features of the baths—the use of simple vaults and cross-vaults (in which two vaults intersect at right angles), for example—were carried over into Christian church architecture.

Paintings and mosaics

Many people continue to think of Roman painting almost exclusively in terms of the wall paintings discovered in and around Pompeii, which were preserved for posterity by the volcanic eruption of 79. This means that it is seen largely as a continuation and reflection of Hellenistic Greek art, and indeed as being the best evidence for Greek painting of the fourth century B.C. and later that now remains to us. The truth is that Pompeiian painting, abundant in itself, and still more abundant if we add to it the works of the same period which have been found in Rome, is only the beginning of a story which continues unbroken until the epoch of Constantine (fourth century A.D.). There is no difficulty in tracing this continuity if one expands the field of reference, for the story of Roman pictorial art is largely carried forward, after the destruction of Pompeii, by a vast wealth of mosaics, designs made by cementing small pieces of stone, glass, ceramics and so forth to a base. Figurative mosaics have been discovered in all parts of the Roman Empire. The abundant surviving material is very diverse in style and quality. After the first century A.D. it is almost impossible to treat Roman picture-making in a strictly chronological way. One has to think in terms of regions as well as styles; and one also has to think in terms of opposed styles which coexist within the same chronological framework.

The range of subject matter in Pompeiian painting is extremely wide. It ranges from mythological scenes to genre painting and burlesque. There are also landscapes, still lifes and a few portraits.

Perhaps the most fascinating thing about Pompeiian art is not its treatment of figures, which remains dependent on Greek precedent, but its depiction of landscape. On the one hand, there are magical garden scenes, like the famous one found not in Pompeii itself but in the so-called Villa of Livia in Rome (Fig. **4.6**). This very skillfully tries to persuade the spectator that he or she is in the presence of a real garden. Plants, flowers, and birds are portrayed with unrivaled directness, and the artist leads one's eye into the distance, amid the leaves and stems, so that eventually all sense of the solidity of the wall on which the decoration is painted is lost.

The mosaics made in the centuries after the destruction of Pompeii show, as has already been said, widespread regional variations. The most impressive come from Africa, or are clearly the work of artists trained in African workshops, and are quite late in date. They show what has been called a 'proto-expressionist' tendency—that is, a tendency to override naturalistic concerns in favor of a more expressive, even distorted style—in that the figures become squatter, the draperies are often shown with rigid striations to mark folds, and there is an opposition of clashing colours rather than a subtle blending of tones. These developments used to be seen as a disastrous coarsening of what Hellenis-

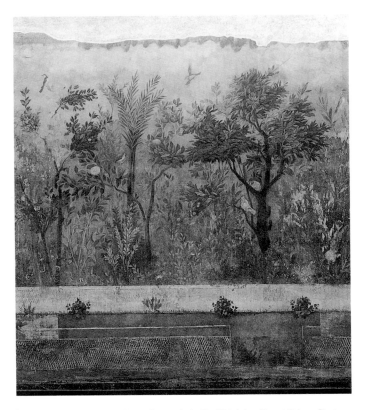

4.6 Wall painting from the main hall of Livia's villa at Prima Porta, outside Rome, late 1st century B.C. Museo Nazionale Romano.

tic artists had achieved, an inexorable decline into barbarism. It is now realized that the conventions adopted by these later Roman mosaicists have an expressiveness of their own.

The culmination of the African style is to be found not in Africa but in the great villa at Piazza Armerina in Sicily, which perhaps belonged to the Emperor Maximian. The bulk of its mosaic decorations (Fig. **4.1**) date from the first half of the fourth century. The designs cover an area of nearly 11,500 square feet (1068.4 sq m). Among the most impressive is the mosaic which shows *Giants struck by lightning*. The master who created this scene subjects his forms to extraordinary distortion, of a kind hitherto unknown in classical art, though clearly what we find here is an attempt to replicate in two dimensions the strong emotionalism achieved by the Pergamene sculptors of the second century B.C. The giants, trying frantically to tear the fatal lightning bolts from their bodies, make expressive shapes which have only a tenuous relationship to conventional anatomy. Their limbs are flattened and twisted so as to press the whole form against the surface—the effect is almost like that of Cézanne's late paintings of bathers (see page 414). The willfully inventive shapes which the artist has found serve as reminders of the strongly anti-classical element in much late Roman art.

Sculpture

Roman sculpture is best understood when divided into categories. Each of these fulfills a different function, though sometimes the categories overlap.

First, there were the ubiquitous copies and adaptations of Greek masterworks, used lavishly for decorative purposes. The great villa at Tivoli built by Emperor Hadrian (117–36) in some instances had multiple copies of the same Greek piece. Some of these copies are of such high quality that experts today find difficulty in distinguishing them from Greek originals. Secondly, there was the official art which commemorated the achievements of various emperors. Thirdly, there were numerous portrait statues and busts, of the emperors and also of private individuals.

Probably the most celebrated surviving example of commemorative sculpture is the bronze equestrian statue of the Emperor Marcus Aurelius (161–180) (Fig. **4.7**), which was to influence the great artists of the Renaissance. Nevertheless, the majority consists of narrative reliefs. These have certain characteristics which remain constant, and which distinguish them clearly from Greek equivalents, such as the Parthenon frieze (see page 59). Roman reliefs often mingle real personages with divine or allegorical ones, in a way which would have seemed incongruous to the Greeks. At the same time, they frequently aim to show actual historical events, though these are depicted in suitably idealized form.

The most elaborate of all Roman narrative reliefs is the one which adorns Trajan's Column (Fig. **4.8**) in Rome, built between 107 and 117. This winds continuously around the column and is more than 650 feet (198 m) long. Its subject matter is Emperor Trajan's two wars against the Dacians, who lived in what is now the central region of Romania. The relief is a subtle mixture of fact and propaganda. Many incidents are shown in minute and specific detail, and it is clear that these scenes derive from sketches made on the spot, perhaps originally with the idea of preparing paintings to be carried in the triumphal procession which would conclude the campaign. There is much concrete information about military equipment, camp life and siege techniques, and various ethnic groups are carefully differentiated. On the Roman side are German auxiliaries, North African horsemen, and archers from Palmyra. Yet there is also a strongly ideological element, with scenes constructed to emphasize Roman power—for example, the barbarians are often shown pleading for mercy, thus bringing out both the Imperial quality of clemency and the way the enemy is then placed under eternal obligation.

The most typical products of the Roman sculptor, in addition to narrative reliefs, are portrait heads and busts. These portraits had complex origins, and played many different roles in Roman society. In the period of the

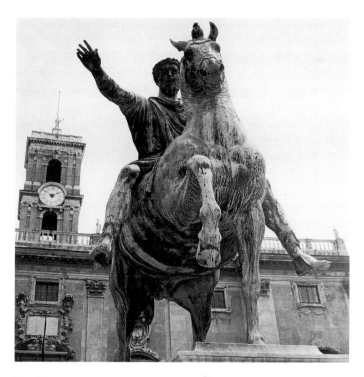

4.7 Marcus Aurelius on horseback, Rome, 164–66 A.D. Gilded bronze, 11 ft 6 ins (3.5 m) high.

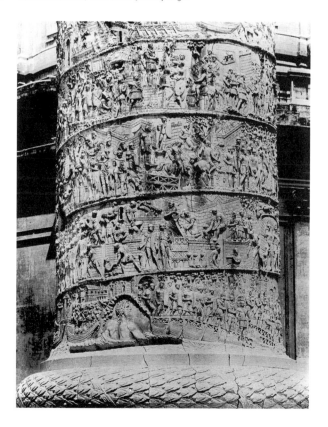

4.8 Detail of spiral relief from the Column of Trajan, Rome, dedicated 113 A.D. Marble, height of column 125 ft (38 m) including base. Height of reliefs approx. 3 ft (91 cm).

The Laocoon

Attitudes to the art of the past are not static. For example, the shift in our attitudes towards Greek and Roman art is something not always taken into account by art-historians. Most of the Greek originals we know are fairly recent discoveries. They were not available to Renaissance artists and scholars, nor to the promoters of Neo-Classicism in the eighteenth century. The ancient sculptures these artists and scholars admired are by contrast a little out of favor today.

A case in point is the Laocoon. This group of figures represents a Trojan priest who tried to warn his fellow Trojans not to bring the wooden horse of the Greeks within the walls of Troy. His warning displeased the gods, and he and his sons were strangled by sea-serpents—an incident Virgil (see page 80) describes in the *Aeneid*.

The Laocoon was excavated in January 1506 in what had once been part of the palace of the Emperor Titus (79–81 A.D.). It had been seen and described there by the Roman writer Pliny the Younger, who praised it as something "preferable to all other works of art, either of painting or sculpture." Pliny also recorded the names of the three artists responsible: Hagesandrus, Polydorus, and Athenodorus of Rhodes. When the work was found, the subject was immediately recognized, and scholars soon realized that it was identical to the sculpture praised by Pliny. This naturally prejudiced everyone in its favor, as did the perfection of the craftsmanship. Michelangelo described the Laocoon as "a singular miracle of art," and he and many other celebrated artists, such as Andrea del Sarto, made drawings of it. The Laocoon thus entered the mainstream of European art history.

In the eighteenth century, the promoters of Neo-Classicism continued to have a very high opinion of the sculpture. Winckelmann (see page 341), for example, described the sculpture as follows:

As the depths of the sea always remain at rest, let the surface rage as it will, even so does expression in the Greek figures show through all suffering a great and calm soul. This soul is portrayed in the countenance of Laocoon, and not in the countenance alone, notwithstanding the intense severity of his suffering ... The representation of so great a soul goes far beyond a representation of natural beauty. The Artist must have felt in himself the strength of the soul which he has impressed on his marble.

(GOTTHOLD EPHRAIN LESSING, *Laocoon*, translated by
Sir Robert Phillimore. Macmillan & Co., 1874.)

Today, thanks to a discovery made in 1957 at Sperlonga, south of Rome, it is recognized that the Laocoon is probably a work of the Roman Imperial period, dating from the reign of the Emperor Tiberius (14–37 A.D.). A cave was found containing sculptures in very similar style, accompanied by an inscription indicating that they are the work of the same artists. The celebrated group is thus part of the history of Roman rather than Greek art, though it is obviously influenced by the frieze of the Great Altar of Pergamon (see page 61). It is this influence which makes it difficult for a modern spectator to find any trace of the "restraint" praised by Winckelmann and his colleagues. The Laocoon is certainly not a Classical masterpiece of the best period, which is what they mistook it for. It cannot, for example, rank with the sculptures of the Parthenon or those of the Temple of Zeus at Olympia. However, its direct influence on the development of European sculpture since 1500 is much greater than that of any work we would now recognize as being genuinely and indubitably Greek.

Hagesandrus, Polydorus, and Athenodorus, *Laocoön and his Two Sons*, 1st century A.D. Marble, 8 ft (2.44 m) high. Vatican Museums, Rome.

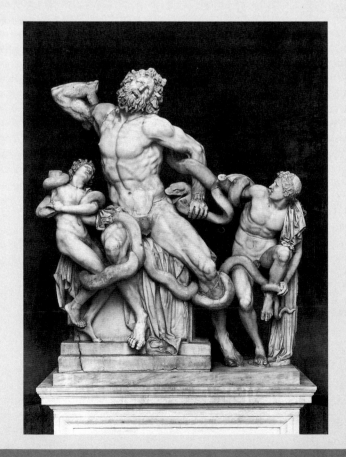

4.9 (*left*) Bust of Septimius Severus, c. 201–10 A.D.
Marble, 30¼ ins (77 cm) high.
Indiana University Art Museum. Gift of Thomas T. Solley.

4.10 Portrait head of the Emperor Caracalla, 3rd century A.D.
Marble, 14½ ins (36.2 cm) high. The Metropolitan Museum of Art,
New York. Samuel D. Lee Fund, 1940 (40.11.1a).

4.11 (*right*) Portrait head of Gallienus, 253–68 A.D.
Marble, 14½ ins (36.8 cm) high.
Antikensammlung, Staatliche Museen, Berlin.

Roman Republic, leading families had the right to display portrait heads of their distinguished ancestors. These were carried in funeral processions, and were also kept in the home. They were originally death masks. When similar likenesses began to be made in stone or terracotta, the sculptors stressed the element of extreme realism, which in any case was already a feature of later Augustan art.

The advent of Augustus (sole ruler 31 B.C.–A.D. 14) brought an attempt to fuse Greek and Roman values, and portraits became more idealized. At the same time, likenesses of members of the Imperial house became the standard means of familiarizing subjects with their rulers. Portraits of the current emperor conveyed information not only about his personal appearance but about his aims and policy. Thus portraits of Septimius Severus (193–211) combined his appearance with that of the Egyptian savior god Serapis (Fig. **4.9**), familiar to his subjects from a famous statue by the Hellenistic sculptor Bryaxis, and numerous copies.

The portraiture of the third century shows increasing tension and anxiety, and also increasing introversion and spiritualization. This tension is already visible in the likeness of Caracalla (211–17), Septimius Severus's son and successor, with its knitted brows and suspicious sidelong glance (Fig. **4.10**). The portraits of Gallienus (253–68), the emperor who survived the longest in a period of chaos marked by frequent military revolts, show the continuing shift away from naturalism which marked all the art of the period (Fig. **4.11**). Gallienus was the patron of the Neo-Platonic school of philosophers led by Plotinus, and the most striking image of him is a larger than life-size head which tries to convey not only the determination necessary to a ruler whose authority was constantly under threat but also the workings of an intense inner life behind a suitably aloof façade.

Literature

Virgil and the *Aeneid*

The great Latin epic the *Aeneid* has probably exercised a profounder influence over Western literature than its two predecessors in Greek, the *Iliad* and the *Odyssey*. To modern minds, this is at first surprising, since the *Aeneid* is an artificial construct, a poem written in an already archaic form as a work of political propaganda. The *Aeneid* did, however, enjoy one major advantage: the Latin language, though it became a learned tongue, never fell entirely out of use. In what had been the western half of the Roman Empire, Greek was almost forgotten, and had to be patiently relearned by scholars at the time of the Renaissance (see page 173).

The *Aeneid* is the work of Virgil (70–19 B.C.). Born in Mantua, of a good but not rich family, and being both too frail in health and too shy for public office, Virgil decided to devote himself to poetry. He found his models in Greek literature, not in earlier Latin works, but his poem is, nevertheless, an elaborate celebration of the spirit of Rome. He reverts to the time of the Trojan War, the epoch of the *Iliad*, and tells the story of Aeneas, son of the King of Troy, and one of the few Trojans who escaped after the fall of the city. According to long-established legend, Aeneas sailed westwards and, after many adventures, came to Italy and founded the city of Alba Longa, from which Rome itself was to spring.

Aeneas was a relevant choice of hero in more than one respect. Emperor Augustus, Virgil's patron, was the adopted son of Julius Caesar, and thus the heir to the clan of the Julii. This clan claimed descent from Ascanius, Aeneas's son. When Aeneas descends into the Underworld, in Book 6 of the poem, he not only meets the spirits of the dead, as Odysseus did before him in a similar passage in the *Odyssey*, but be also saves the whole future of Rome. The Sibyl of Cumae instructs him:

> Turn your two eyes
> This way and see this people, your own Romans.
> Here is Caesar, and all the line of Iulus,
> All who one day shall pass under the dome
> Of the great sky: this is the man, this one
> Of whom so often you have heard the promise,
> Caesar Augustus, son of the deified,
> Who shall bring once again the Age of Gold
> To Latium, to the land where Saturn reigned
> In early times . . .

(VIRGIL, *The Aeneid*, translated by Robert Fitzgerald. Harvard Press, 1984.)

When the *Iliad* describes the death of heroes, it strikes a directly tragic note. This note is echoed with great sureness at appropriate moments in the *Aeneid*. More common, however, in Virgil's poem is a tone of slightly indulgent melancholy, a concern with "the tears of things"–*lacrimae rerum*, as the poet characteristically calls them. To this melancholy is linked a very different sense of fate from the one the Greeks knew. Virgil perceives Aeneas's mission, and that of Rome after him, as a heavy duty. The Roman task is to create conditions under which people can live orderly and decent lives, but this task has no foreseeable end:

> Others will cast more tenderly in bronze
> Their breathing figures, I can well believe,
> And bring more lifelike portraits of marble;
> Argue more eloquently, use the pointer
> To trace the paths of heaven accurately
> And accurately foretell the rising stars.

> Roman, remember by your strength to rule
> Earth's peoples—for your arts are to be these:
> To pacify, to impose the rule of law,
> To spare the conquered, battle down the proud.

(VIRGIL, *The Aeneid*, translated by Robert Fitzgerald. Harvard Press, 1984.)

The paradox of the poem, and the element which gives it its special character, is that it celebrates a triumphant new regime in terms which often sound more pessimistic than optimistic.

Latin poets

The great Latin poets differed from their Greek predecessors in being the product of a complex, corrupt, disturbed, and violent urban society. They had two very different reactions to this environment. One was a cult of rural calm and peace, to be found in some of Virgil's earlier poems, the *Eclogues* and the *Georgics*, both written before he started on the great enterprise of the *Aeneid*. The other was to embrace it, as the great satirist Juvenal does.

Somewhere between these two attitudes lies the work of the man who now seems the greatest writer of lyrics in the Latin language, Catullus (*c.* 87–54 B.C.). Catullus was a generation older than Virgil, and came from the same sort of background. He was a member of the provincial gentry, hailing from Verona rather than Mantua. He came to the capital and got mixed up in the turbulent events which led to the eventual triumph of Augustus, but he was never a major player on the political scene. He writes about high life and low, love and the lack of it. His love poems, to his unfaithful mistress Lesbia, move from exaltation to anguish:

> Give me a thousand kisses, and then a hundred,
> Then give me a second thousand, a second hundred,
> And when we have made up many, many thousands
> Let us forget to count. Better not to know—
> It will bring someone's jealous eye upon us
> If people know we give so many kisses.

(CATULLUS, translated by C.H. Sisson. Macgibbon and Kee, 1966.)

Among the Greek lyric poets perhaps only Sappho is as direct; Catullus is her Latin equivalent.

Though Latin poetry owed so much to the Greeks, it did develop one genre which was particularly its own: the satire. The Latin word *satura* literally meant "a medley," and had nothing to do with Greek satyr plays. Though the first Latin satires were written as early as the second century B.C.— they were the work of Lucilius, who wrote between 133 and 102 B.C. and now survive only as scattered lines and frag-

ments—the genre did not reach its peak until quite late. It achieved maturity with the appearance of Juvenal (*c.* 55–128). By this time the imperial regime was a fully established autocracy, and Juvenal's character was formed by his experiences under the last of the Flavian emperors, the tyrant Domitian (81–96).

The following passage is typical of many, and is particularly significant because it reflects the simultaneous admiration and resentment which the Romans of the Empire felt for Greek culture. They knew it had to a large extent formed their own culture, and they envied the Greeks, yet they despised their now fallen political state and chafed under their continuing cultural hegemony.

Juvenal, nevertheless, has something of his own, which is peculiar to the genius of Latin, and this is an incomparable vividness and concreteness. He condemns the horrors and discomforts of life in Rome, yet remains always quintessentially urban. He is the first writer who makes city life the very texture and substance of his work.

The wily Greek assails his patron's heart;
Finds in each dull harangue an air, a grace,
And all Adonis in a Gorgon face;
Admires the voice that grates upon the ear
Like the shrill scream of amorous chanticleer;
Compares the scraggy neck and weedy girth
To Hercules's brawn, when from the earth
He raised Antaeus, and his every vein
Swelled with the toil of more than mortal pain.
We too can cringe as low and praise as warm,
But flattery from Greek alone can charm.

(JUVENAL, *Satires*, translated by William Gifford, revised and annotated by John Warrington. J.M. Dent and Sons, 1954.)

Latin prose

Much of Latin literature, like Greek literature before it, is in prose. Greek prose may be admired for its own virtues—Plato, for example, was perhaps one of the most elegant prose stylists who ever lived. Yet, once again, Greek prose does not have the central importance to Western culture of its Latin equivalent. The reason for this is that Latin was, for many years, the medium of learned communication, overstepping all national and linguistic boundaries. The great prose writers of the later years of the Roman Republic and of the Empire provided scholars with a variety of models—they showed the different ways in which the Latin

language could be used. And then, by the time Latin stopped being used generally, it had already influenced prose-style in the new vernaculars. In English, for example, the richness and variety of the language stems from this mixing of two parallel vocabularies, one originally Anglo-Saxon, the other consisting of loan words, the vast majority from Latin.

The three most influential writers of Latin prose were Julius Caesar (102–44 B.C.), Cicero (106–43 B.C.), and Tacitus (*c.* 56–*c.* 116). Caesar's *Gallic Wars*, an account of his conquest of Gaul, and his *Commentaries* on the Civil Wars are written throughout in the third person. Part autobiography, part propaganda, they are nevertheless carefully distanced from the author as a means of giving them authority. The main characteristics of Caesar's style are purity and simplicity: everything is clear; everything is matter-of-fact. In these texts he revealed the immense possibilities of the Latin language as an instrument of communication.

Cicero was the greatest orator of his day. In politics he opposed Caesar, and some of his most celebrated speeches were denunciations of Mark Antony, Caesar's lieutenant, when the latter tried to seize power after Caesar's murder. What Cicero did was to demonstrate the possibilities of Latin prose as an expressive instrument, and "Ciceronian" was the adjective to which all later writers of Latin aspired. His work became the accepted text for the courses in rhetoric (the ordering of language as a means of persuasion) which for a long time formed the backbone of the Western system of education.

Tacitus, one of the major Roman historians, was the contemporary of Juvenal. Like Juvenal, he was greatly influenced by what he had experienced under Domitian—he conformed more successfully than Juvenal did, but was forced to see and take part in things which haunted him for the rest of his life. His *Histories* (which deal with the period 69–96), and to a lesser extent the *Annals* (dealing with the period from Tiberius to Nero), were a personal catharsis.

In his writings, Tacitus exploits the compact, lapidary character of Latin to great effect. One of his most memorable phrases concerns the ephemeral Emperor Galba, murdered for his old-fashioned severity—Tacitus describes him as *capax imperii nisi imperasset*, which translates much less neatly and effectively as "capable of governing, had he never been emperor." The combined study of Caesar, Cicero, and Tacitus taught writers of the new vernacular languages to be less wordy. Tidiness and economy of style also necessarily brought with them a corresponding clarity of thought, and this was one of the most important legacies left by Rome to Western civilization in general.

Chapter 5

Judaism and Christianity

5.1 Mother and child. Wall painting from the Cemetery of Priscilla, Rome, mid-3rd century A.D.

Judaism and the Greco-Roman world

Whatever the contribution of the Greeks, and after them the Romans, Western civilization would be unimaginably different had it not been for the contribution of Judaism. Many of the encounters between the Jews and the pagan classical world were painful for both sides. For the Jews, the contact meant repeated catastrophes, and finally what seemed to be their extinction as a nation, if not as a race. The world which oppressed them was nevertheless transformed by ideas which were in origin Judaic.

The history of the Jewish nation had been a stormy one for hundreds of years before the Romans became rulers of Judea. After the Babylonian captivity of the sixth century B.C., the Jews were permitted by the Persians, who had conquered Babylon, to return to Jerusalem, to rebuild the Temple (516 B.C.), and, after much opposition, to refortify the city (450 B.C.). When Alexander the Great overthrew the Persian Empire, the Jews became subject to one of the successor states carved out by Greek generals from the mass of Alexander's conquests. Their new masters were the Seleucids of Syria. They were left in relative tranquility, despite their uneasy position as a buffer between Syria and its chief rival, Egypt, until the time of Antiochus IV (175–164 B.C.). Losing patience with Jewish separateness, Antiochus tried to Hellenize his Jewish subjects by force, and had an altar of Zeus set up in the Temple itself, in defiance of Jewish monotheistic beliefs and the Old Testament prohibition against "graven images." The result was

the first and most successful of Jewish nationalist revolts, led by Judas Maccabaeus. Judea enjoyed a precarious independence until 65 B.C., when Pompey entered Jerusalem, and the surrounding territory became subject to Rome, though it was provided with a series of puppet rulers whom the Jews regarded with varying degrees of antipathy. Finally, in A.D. 6, Judea passed under direct Roman rule and from then on was governed by a Roman procurator.

What happened in Jerusalem and Judea was at this stage less important than what was happening to the Jews in the rest of the Roman world. Jewish communities were now widespread throughout the eastern Mediterranean and its hinterland—there was an especially large and prosperous group in Alexandria, for example. Despite the resistance offered to Antiochus IV, these communities had inevitably absorbed much from the Greek culture that surrounded them, to the point where many Jews spoke only Greek.

Typical of the Hellenization of Jewish culture at this period was the career of the philosopher Philo Judaeus (c. 20 B.C.–A.D. 40), a practicing Jew who saw Greek philosophic teachings, and especially Platonism (see page 53), as an inferior version of the Jewish faith. For Philo, the separation of the human race into Jews on the one hand and Gentiles on the other (the word Gentile comes from the Roman *gens* or clan) was something temporary which would be ended by the coming of the promised Messiah, after which the barriers separating them would disappear.

	200	B.C. 0 A.D.	200	400	600
HISTORICAL BACKGROUND	Revolt of Judas Maccabaeus 65 B.C.	Judea becomes part of Roman Empire 6 A.D. Crucifixion of Jesus c. 27–33 A.D. Journeys of St. Paul 46–57 A.D.	Christianity legalized under Edict of Milan 313	St. Benedict founds monastic order 529 Pope Gregory unifies Western church 590–604	
PHILOSOPHY/ RELIGION	Translation of the Old Testament into Greek	Philo Judaeus Books of the New Testament St. Paul's *Letters to the Romans*	St. Augustine *Confessions, City of God*		
ARCHITECTURE		Basilica of Porta Maggiore, Rome (5.3)	Santa Constanza, Rome (5.5)	Santa Sabina, Rome (5.4)	
VISUAL ARTS			Wall painting from Cemetery of Priscilla, Rome (5.1)	The Great Fishing Mosaic (5.7) Santa Maria Maggiore mosaics (5.9)	

The traffic between Hellenism and Judaism was two-way. Many Gentiles found the stringent puritanism of Jewish monotheism attractive amid the welter of competing religions. Judaism was at this stage (unlike later) a proselytizing faith. It not only made numerous converts but also gathered to itself a large band of sympathizers who, without going so far as full conversion, which meant submitting to circumcision, were attuned to Jewish ideas and adopted Jewish ritual practices.

One important product of this cultural intermingling was the Septuagint: the translation of the Old Testament into Greek, which made Jewish sacred texts available not only to Jews who had lost their Hebrew but also to a much wider spectrum of readers.

The coming of the Messiah

The expectation that a Messiah would appear to save the world was deeply implanted in Jewish myth. It was also in accordance with the longing for the savior god who died and then triumphantly rose again, expressed in the numerous mystery religions which flourished throughout the Roman Empire (see page 73).

Despite these facts, the career of Jesus of Nazareth at first caused a stir only within Palestine itself. The political situation there had become increasingly tense. The procura-

tors appointed by the Romans repeatedly outraged Jewish religious feeling, and the Jews were deeply divided among themselves. Among the various, conflicting Jewish sects were the Sadducees, a conservative, aristocratic group who largely controled the Temple and its services; the Pharisees, who were rigorous supporters of Jewish religious law; the Zealots, a break-away Pharisee group who favored open rebellion against the Romans; and the Essenes, who, despairing of the current situation, had withdrawn from ordi-

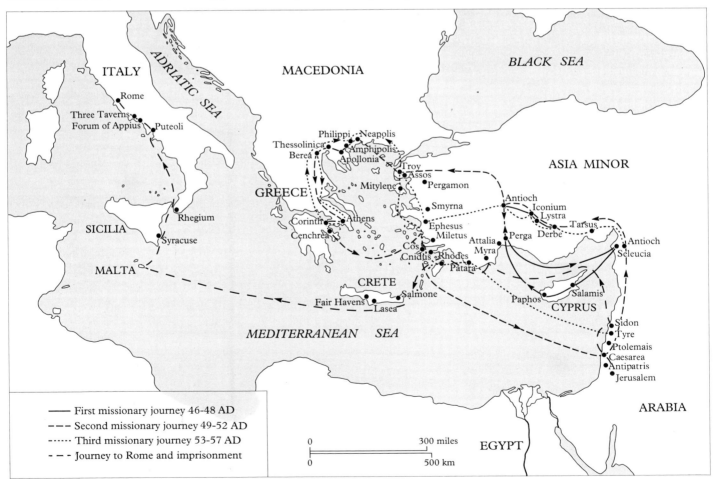

Legend:
—— First missionary journey 46-48 AD
--- Second missionary journey 49-52 AD
······ Third missionary journey 53-57 AD
-·-·- Journey to Rome and imprisonment

5.2 St. Paul's Journeys.

nary society and set up isolated communities which held all property in common.

Jesus and his disciples thought of themselves as orthodox and believing Jews. However, they aroused the opposition of the Pharisees because they seemed to disregard the letter of the religious law, particularly by mingling with those considered ritually impure. Jesus preached the inter-relatedness of all men. Most important of all, his followers claimed that the promised Messiah had indeed appeared, in the person of Jesus himself. "The time is fulfilled, and the kingdom of God is at hand; repent and believe in the gospel." (Mark 1:15)

Jesus's mission was halted by the events leading up to the Crucifixion, and most of all by the Crucifixion itself, the most shameful punishment for any convicted criminal. Both Romans and Jews were involved in his death. The movement he had started, at that point known only locally, should in all logic have collapsed immediately, and never been heard of again. Jesus had been publicly executed. He had been discredited among his own people and his closest followers were scattered—deeply shaken by the catastrophe which had overtaken them and afraid to show themselves. What changed the situation was the rumor, soon replaced by the conviction, that this failed prophet and condemned criminal had risen from the dead, fulfilling the pattern of the long-established myth of a savior god who dies and is resurrected.

Even after Jesus's disappearance, the earliest Christianity was still a heresy within Judaism. Those members of the new sect who lived in Jerusalem—the majority—worshipped at the temple and participated in its rituals. They seem to have taken over certain customs from the Essenes, eating their meals together and sharing their possessions. Unlike the Essenes, however, they continued to mingle with the world around them, and spread propaganda vigorously for the new faith.

At first, there seems to have been some difference of opinion among them as to whether this was to be confined to Jews alone. Even Jesus had been unwilling to mix too freely with the Gentiles (Mark 7: 24–30), despite the fact that he consorted on occasion with those who were considered ritually unclean. To begin with, the issue was blurred by the fact that Judaism itself was willing to accept converts. The rite of baptism, which became part of Christian practice, had originally been devised as a means of ridding converts of ritual impurity, before the further rite of circumcision. The decisive step was taken not by any of the group who had known Jesus but by a Jewish outsider, Paul. From Tarsus, he had begun his career as an active persecutor of the new cult. It was Paul who set Christianity on the road to becoming a world religion. In the history of Western thought, he was at least as influential as Plato and Aristotle. It was by being intermingled with the doctrines he preached that Greek philosophy was able to survive.

Philosophy

St. Paul

Paul did not come from Judea but from a region in Asia Minor where Judaism already had many competitors. He did not in fact arrive in Jerusalem until three years after his conversion. During his visit there, he received no encouragement to stay. His spectacular missionary career was spent in regions where many of those whom he met were Gentiles, attracted to the new faith but with only a sketchy knowledge of the Jewish heritage as it was understood in Palestine. In the course of his journeyings (Fig. 5.2) he created a Church which was decisively influenced by external circumstances but most of all by his own temperament.

Among the circumstances which influenced his work was the already powerful inclination toward monotheism, free of the tawdry trappings of the competing pagan religions, which had been noted earlier by Philo Judaeus. In addition, there was the fact that the Christian myth, provided by the record of Jesus's life, required little or no tailoring to fit the

pattern already offered by the leading mystery cults, which laid heavy stress on rites of passage which led the initiate to new knowledge and spiritual rebirth, and which often centered on a sacrificial death followed by a triumphal return to life.

The foundation Paul built on was nevertheless fundamentally Jewish. For him, God had a direct and personal relationship with each individual, and wrong or improper actions must always be construed either as a rebellion against God or as a submission to some power opposed to God. Upon this belief Paul based the central Christian doctrine of the Redemption. In his view, all people had a share in the original sin of disobedience to God committed by Adam, but correspondingly all people could be redeemed by the sacrifice made on their behalf by Jesus. Until individuals brought themselves to accept that this was the case, they remained morally impotent. Good actions in particular counted for little.

The doctrine of the Redemption applied to Gentiles just

as much as it did to Jews, and the Church therefore could make no distinction between Jews (born or converted) and others. Through baptism, believers expressed their identification with Christ and became part of his "new creation." "As in Adam all die, so also in Christ shall all be made alive." (I Corinthians 12: 22)

What remained was the problem of the relationship between the Old Covenant—that of God with the Jews—and the New Covenant—that of God with everyone. In his Epistle to the Romans (9–11), Paul made his position clear: God had temporarily bypassed Israel, whose people had made the mistake of trying to achieve a special position simply through obedience to ritual law. Their rejection of the Messiah and his message had led to its being proclaimed to the Gentiles (Romans 10: 18–11: 22). Later, the Church Fathers were to be harsher still. St. Jerome theorized that God had designed the law so as to deceive the Jews and deny them salvation.

Early Christianity

The Jewish Revolt of 66–70 had far-reaching consequences for both Christianity and Judaism. Jewish nationhood was destroyed, and the attempt to revive it in Hadrian's time, under the leadership of Simon Bar-Kochba, failed miserably. The Sadducees, the Zealots, and even the Essenes disappeared. Jewish teaching, following the lead set by the Pharisees, now emphasized strict adherence to Jewish law and ritual as the only remaining element of unity. Any links with Gentile Christianity were cut.

The revolt also reduced the community of Jewish Christians in Palestine to insignificance. The focus of Christian activity, and Christian struggle, now lay elsewhere—in Rome, for example, the capital of the Empire. Though the relationship between the Jews and their Roman overlords had always been an abrasive one, Judaism did, except at moments of extreme crisis, enjoy a certain degree of protection as one of the recognized religions of the Empire. As Christianity separated itself more definitively from Judaism, so it became more exposed. Because they refused to sacrifice to the state gods, and in particular to make offerings to the emperor's image, Christians were constantly suspected of subversion.

The contrast between the state and this eccentric minority must have seemed very unequal to the Roman authorities, but the willingness of the Christians to suffer martyrdom—the word "martyr" in Greek implies that they were literally "witnesses" to their faith—proved to be the rock upon which the secular power eventually broke. The solution was for the emperor to become Christian, and the whole Imperial hierarchy with him. From the first, the Christian emperors made an implicit claim to a closer relationship with God than the great mass of the people, and in this sense their adherence to Christianity immediately

began to subvert some of the basic ideas which Paul had stressed when he began to construct a doctrine and a Church.

One feature of early Christianity was an expectation of the imminent end of the world. The notion of a suddenly mutable universe was totally alien to Greek philosophical thinking, which tried to arrive at a reasoned view of an essentially changeless world. For the Greek "progress" in the modern sense was impossible, since either things remained the same, behind the easily penetrable screen of current events, or else, if there was real change, history always returned to the same point.

What Christianity took from Judaism was the idea of a world created out of nothing. What it added was the idea that individuals could make their own future, by their acceptance or rejection of the ransom offered by Jesus. The ransom itself implied that God was not unchangeable, since the initiative in offering it came from him. This was something which shocked those trained in Greek philosophy.

Yet sooner or later Christianity was going to have to complete the process begun by Philo Judaeus, and come to terms with all-pervasive Hellenism. The story of the earliest Christian centuries, quite apart from being one of savage but intermittent persecution, was one of how this was accomplished. Early Christian apologists, seeking sympathy for their cause among those as yet unconverted, found it prudent to stress similarities rather than differences between Christianity and the already established doctrines of Greek philosophy.

In general, the philosopher these apologists found most amenable to their purpose was Plato. The Logos—the Word "that was in the beginning with God" of the Gospel of St. John—was seen as the emanation of Plato's the One.

A problem to which Christian apologists found no answer in Plato was that of the presence of evil in the world. Here Christianity faced competition from doctrines of eastern origin—Gnosticism and Manicheism. According to the Gnostics humans were made not by God but by evil beings, but had a seed of goodness added by a supreme being who was good. The history of the world was thus a struggle between two almost equally balanced sets of forces. Gnosticism assimilated itself into Christianity by dividing the God of the Old Testament from the God revealed by Christ in the New. The former created the visible world, but was cruel and vindictive; the latter was the creator of a new and better invisible world, and was personified in Christ.

Manicheism stemmed from the teachings of the Persian prophet Mani (205–74), and proposed a universe in which the power of good and the power of evil were absolutely equal, and engaged in an eternal struggle which would end only with the destruction of the universe.

These explanations of the problem of evil were, though slightly different from one another, simpler than anything which orthodox Christians could offer. Their assimilation, or attempted assimilation, into Christianity marked an im-

The Letters of Paul

This extract from St. Paul's *Epistle to the Romans* contains two of his most important statements: first that there is "no distinction between Jew and Greek," the new faith is open to all; and second that salvation is by God's grace, and not on the basis of good works, "otherwise grace would no longer be grace."

11 The scripture says, "No one who believes in him will be put to shame." 12For there is no distinction between Jew and Greek; the same Lord is Lord of all and bestows his riches upon all who call upon him. 13For, "every one who calls upon the name of the Lord will be saved."

14 But how are men to call upon him in whom they have not believed? And how are they to believe in him of whom they have never heard? And how are they to hear without a preacher? 15And how can men preach unless they are sent? As it is written, "How beautiful are the feet of those who preach good news!" 16But they have not all obeyed the gospel; for Isaiah says, "Lord, who has believed what he has heard from us?" 17So faith comes from what is heard, and what is heard comes by the preaching of Christ.

18 But I ask, have they not heard? Indeed they have; for
"Their voice has gone out to all the earth,
and their words to the ends of the world."

19 Again I ask, did Israel not understand? First Moses says,
"I will make you jealous of those who are not a nation;
with a foolish nation I will make you angry."

20 Then Isaiah is so bold as to say,
"I have been found by those who did not seek me;
I have shown myself to those who did not ask for me."

21 But of Israel he says, "All day long I have held out my hands to a disobedient and contrary people."

11 I ask, then, has God rejected his people? By no means! I myself am an Israelite, a descendant of Abraham, a member of the tribe of Benjamin. 2God has not rejected his people whom he foreknew. Do you not know what the scripture says of Elijah, how he pleads with God against Israel? 3"Lord, they have killed thy prophets, they have demolished thy altars, and I alone am left, and they seek my life." 4But what is God's reply to him? "I have kept for myself seven thousand men who have not bowed the knee to Ba'al." 5So too at the present time there is a remnant, chosen by grace. 6But if it is by grace, it is no longer on the basis of works; otherwise grace would no longer be grace.

7 What then? Israel failed to obtain what it sought. The elect obtained it, but the rest were hardened, 8as it is written,
"God gave them a spirit of stupor, eyes that should not see and ears that should not hear,
down to this very day."

9 And David says,
"Let their table become a snare and a trap,
a pitfall and a retribution for them;
10 let their eyes be darkened so that they cannot see,
and bend their backs for ever."

11 So I ask, have they stumbled so as to fall? By no means! But through their trespass salvation has come to the Gentiles, so as to make Israel jealous. 12Now if their trespass means riches for the world, and if their failure means riches for the Gentiles, how much more will their full inclusion mean!

13 Now I am speaking to you Gentiles. Inasmuch then as I am an apostle to the Gentiles, I magnify my ministry 14in order to make my fellow Jews jealous, and thus save some of them. 15For if their rejection means the reconciliation of the world, what will their acceptance mean but life from the dead? 16If the dough offered as first fruits is holy, so is the whole lump; and if the root is holy, so are the branches.

17 But if some of the branches were broken off, and you, a wild olive shoot, were grafted in their place to share the richness of the olive tree, 18do not boast over the branches. If you do boast, remember it is not you that support the root, but the root that supports you. 19You will say, "Branches were broken off so that I might be grafted in." 20That is true. They were broken off because of their unbelief, but you stand fast only through faith. So do not become proud, but stand in awe. 21For if God did not spare the natural branches, neither will he spare you. 22Note then the kindness and the severity of God: severity toward those who have fallen, but God's kindness to you, provided you continue in his kindness; otherwise you too will be cut off.

portant transitional step. Christians passed from combating creeds totally different from their own to combating perversions of Christian doctrine. In fact, to a struggle against heresy.

St. Augustine

The most touching—and most telling—book left to posterity by the earlier Christian centuries is the *Confessions* of St. Augustine (354–430). It is the only text of its time which describes the experience of conversion to Christianity from the inside. It shows how an intelligent and highly educated man struggled against the seductions of classical culture, which for a long time seemed more attractive to him than the faith of his parents, who were already Christians.

As a young man, Augustine, precociously gifted, discovered his own personal identity through his love of classical authors, preferring Latin writers (whom he admired for their force and conciseness) to Greek ones. He was especially influenced by the great orator Cicero, and became a successful teacher of rhetoric, first in his native North Africa, next in Rome, and then in Milan, which had now become the seat of the Imperial court. He was never a pagan but did for a while become a rather shamefaced adherent of Manicheism, by that time a proscribed sect, just as Christianity itself had once been. The simple Manicheist doctrine of the struggle between good and evil found an echo in his own divided nature.

He finally accepted Christianity in 386, after a severe psychological crisis, graphically described in the *Confessions*. It is significant, both in relation to his own nature and gifts, and within the context of the whole development of the early Church, that his route back to Christianity was via Neo-Platonism (see page 53). That is, he was able to accept Christian beliefs only when he at last encountered them in a form which he found intellectually satisfying.

Augustine became Bishop of Hippo, in North Africa, in 396, and spent the rest of his life there, elaborating the doctrines which were to form the foundations of medieval theology. Just as the study of rhetoric (which meant more than mere eloquence—it was also the process of putting one's thoughts in order and connecting one idea with another) formed the basis of classical higher education, so the new discipline of theology, in addition to confirming the faith, became an exercise which strengthened mental muscles.

Augustine's works raised theological issues of great importance, without always solving them. One idea which concerned him greatly was predestination—did humans possess free will or was everything preordained by an omniscient deity? In later centuries Augustine's teachings were to form the basis of those of Wyclif and Calvin, two of the pillars of the Protestant Reformation, both of whom saw man's fate as being largely preordained (see pages 156 and 209). Despite this, Augustine continues to be regarded by the Catholic Church as the touchstone of orthodoxy, the most important of the early Fathers of the Church.

The shift in attitudes which he represented is summed up in one of many telling declarations. It derived its form from Cicero but the attitudes it represented were new, and were to dominate European thought for many centuries: "God is hidden everywhere; He is manifest everywhere. No one can know Him as He is, but no one is permitted not to know Him."

Early Christian architecture

Like the other arts of early Christianity, early Christian architecture was an adaptation of existing models to new uses. During the time their religion was persecuted, Christians came together to worship wherever they could. When they were able to choose what sort of buildings they would have (and the patronage of the newly converted Emperor Constantine led to a great burst of church-building), they were influenced by what they knew. Two models in particular were important—the buildings already used by other mystery cults, where people came together for congregational worship, and the large public meeting halls, called basilicas, already familiar in many cities of the Empire.

The cult chapels tended to be small, but already had a more or less standard plan—a nave and aisles, with an apse at the end. A surviving example dating from the first century A.D. is the Basilica of Porta Maggiore in Rome (Fig. 5.3), a subterranean building about 40 feet (12.2 m) long. It looks just like a primitive Christian church, but was in fact built for a mystery cult.

Secular basilicas were often very large. They generally consisted of a hall surrounded on all sides by a colonnade, so as to make an ambulatory or walkway around the main space. A single, or even a double, apse at one end might be provided, but it was generally cut off from the hall itself by a screen of columns.

After the conversion of Constantine, when large places of worship were needed, the secular basilica was the obvious model. The colonnades at the sides were retained, but the

apse at the end furthest from the door was now left without a screen, so as to focus attention on the altar. An elegant example of a church built according to this formula is Santa Sabina in Rome (Fig. **5.4**), constructed around 450.

Another pattern for sacred buildings was a rotunda or octagon, once again with an ambulatory surrounding a central space. Buildings of this type were not designed for secular use, but functioned as baptisteries or, alternatively, as mausolea, or burial places. A good example is Santa Constanza in Rome (Fig. **5.5**), built *c*. 320 as a mausoleum for Constantine's daughter Constantina. Here the break with pagan architecture is scarcely perceptible, as very similar buildings had been erected in pre-Christian times to serve an identical purpose.

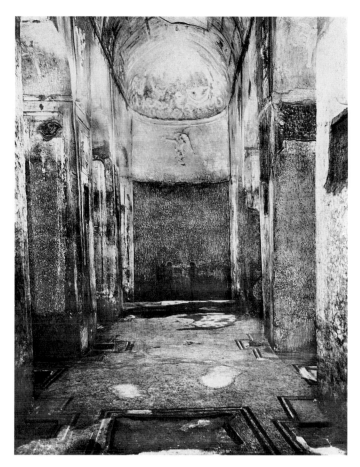

5.3 Basilica of Porta Maggiore, Rome, 1st century A.D.

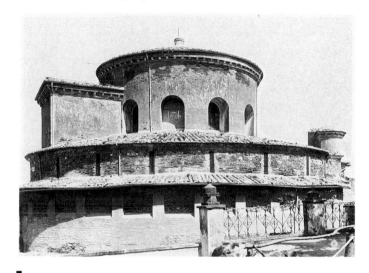

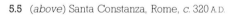

5.5 (*above*) Santa Constanza, Rome, *c*. 320 A.D.

5.4 (*below*) Santa Sabina, Rome, *c*. 450 A.D.

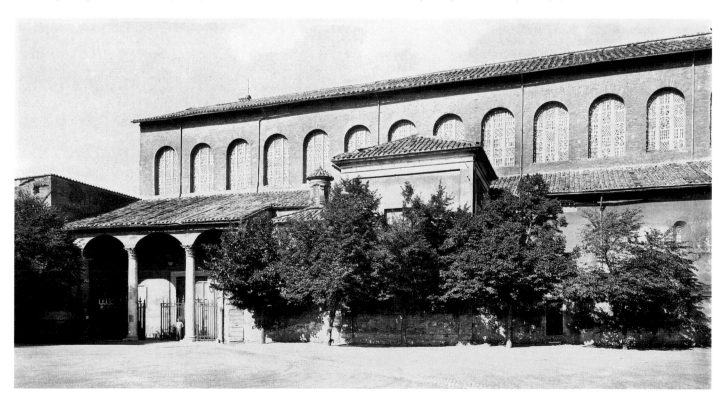

Early Christian painting

The Jewish law forbade figurative representations, though this prohibition was sometimes ignored during the Roman period—there is an impressive series of figurative scenes from a synagogue in the remote eastern frontier city of Dura Europos (see page 98), which fell to the Persians in 256. Christianity, in so far as it remained linked to Judaism, was at first uneasy about creating images of any kind, whether painted or sculpted.

On the other hand, the Gentile converts made by Paul and his successors brought certain cultural expectations with them from their former lives. The result was an artistic compromise which was also strongly affected by the prudence necessary to a savagely persecuted faith.

The most familiar types of early Christian art are the paintings found in the catacombs where Christians were buried. Most of these are in Rome, but there are also painted catacombs in Naples and Syracuse. The paintings date from the third century and are seldom of high quality. Elements familiar from the existing repertoire are put to new use, with hidden symbolic meanings attached to them.

Figure subjects in particular tend to be safely ambiguous. A *Mother and Child* of the mid-third century (Fig. **5.1**) in the Cemetery of Priscilla (lunette of cubicle 5) is thought to be the earliest-known representation of the Virgin and Child, but might be any mother and her baby. The true meaning emerges only if one looks at the image with already informed eyes.

The Old Testament was less controversial and dangerous than the New. The episodes chosen for illustration are often those with special meanings for persecuted Christians—for example, *Daniel in the Lions' Den* (Fig. **5.6**), from the Cemetery of the Jordani (right-hand pilaster of the fourth *sacellum*). This particular image is painted in the vigorous loose style common to much late Roman wall painting—in fact, there is little to distinguish it from pagan work apart from the actual subject matter. It is only very occasionally that early Christian paintings from the catacombs show flashes of transcendental feeling.

5.6 Daniel in the Lions' Den, *c.* 300 A.D. Wall painting from the Cemetery of the Jordani, Rome.

5.7 Great fishing mosaic, *c.* 310–20 A.D.
Mosaic from Bishop Theodore's basilica at Aquileia.

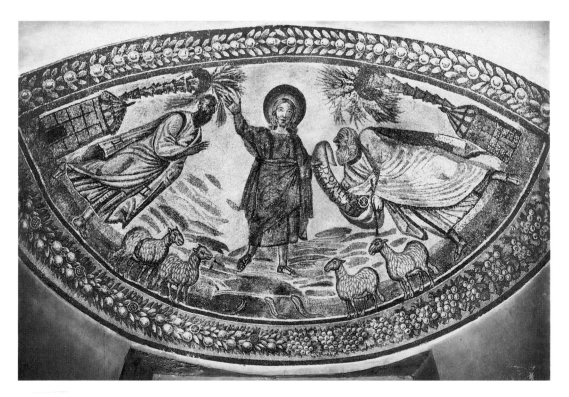

5.8 "Traditio Legis" (Christ between St. Peter and St. Paul),
c. 320 A.D. Santa Constanza, Rome.

When Christianity at last emerged into the light of Imperial favor, styles of pictorial decoration remained conservative. Clearly the Church did not immediately find a new idiom to suit its changed circumstances. What survive are mostly mosaics rather than paintings—the earliest of these "overt" decorations are the mosaic floors of Bishop Theodore's basilica in Aquileia, Italy. They are contemporary with, and not stylistically different from, the mosaics at Piazza Armerina (see page 70). The mosaic of the *Great Fishing* (Fig. **5.7**), which here takes on an allegorical significance, is in fact closely related to a scene showing Cupids fishing at Piazza Armerina. Inserted into the scene, however, is an inscription commemorating the bishop, and there are also episodes from the story of Jonah, who was, like Daniel, and for similar reasons, an Old Testament hero particularly favored by the Christians.

Santa Constanza in Rome, the fourth-century mausoleum of Constantine's daughter Constantina, has mosaics which mark the transition from a secular to a specifically sacred art. The earliest mosaics, on the vaults, show standard Roman decorative subjects, such as Cupids among vine tendrils. Those in the lunettes, which are a generation later, have specifically Christian subjects. In one scene, the *Traditio Legis* (Fig. **5.8**), Christ stands between Saints Peter and Paul, giving the former a scroll inscribed with the words *Dominus pacem dat* (the Lord gives peace), and additionally with the sacred Chi–Rho monogram (the initial letters in Greek of the word "Christos"). In contrast to earlier work, the composition has an otherworldly feeling, and a strong, confident emotionalism. Christian art was at last moving into a world which was peculiarly its own.

The narrative mosaics in Santa Maria Maggiore (Fig. **5.9**), also in Rome, are today almost overwhelmed by the glittering later decoration that surrounds them. They were set up fifty years later than the lunettes in Santa Constanza, during the pontificate of Sixtus III (432–40). They show scenes from the lives of the patriarchs—Abraham, Isaac, Jacob, Moses, and Joshua—and also from the life of Mary. Crowded and often chaotic in narrative, they cross the frontier into a new stylistic region where the old classical ideals were becoming so attenuated as to be almost invisible.

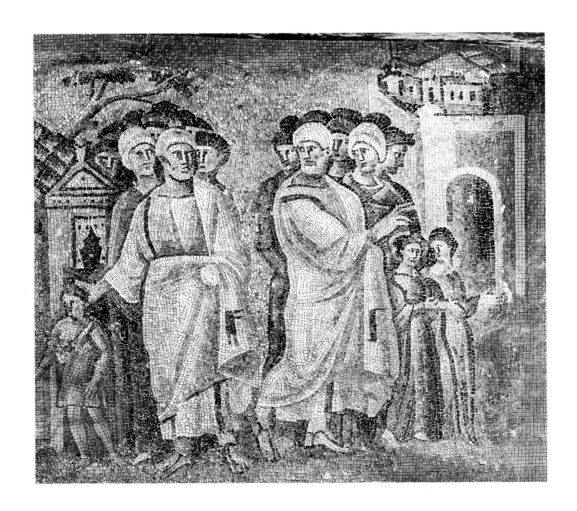

5.9 *Parting of Lot and Abraham* c. 430 A.D. Mosaic from Santa Maria Maggiore, Rome.

Chapter 6

Byzantium

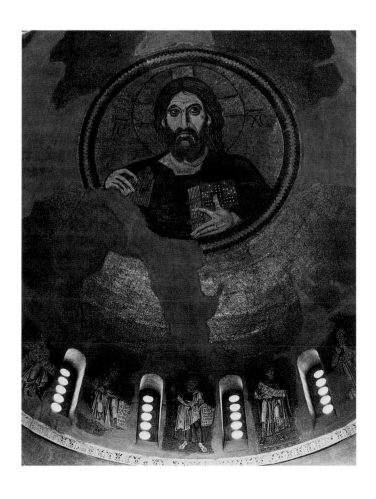

6.1 Christ Pantocrator c. 1020, Daphni, near Athens.

The Byzantine Empire

The Byzantine Empire played an essential role in the civilization of the West, both as a repository of knowledge inherited from Greece and Rome, which might otherwise have been lost, and as a source of new inventions and ideas. Yet for Westerners Byzantium always stood a little apart, and Western greed and envy played as large a part in its eventual destruction as did the expansion of militant Islam.

To the very end of the Byzantine Empire's existence, its rulers considered themselves the only legitimate heirs of Imperial Rome. Nevertheless, as it developed the Empire shifted ever further from the Western orbit. Its capital was Constantinople, which stood at the traditional point of division between Europe and Asia. The lands it inherited had indeed been Roman once, but their inhabitants were not Latins—their common tongue was Greek.

Byzantine territory fluctuated widely from century to century. Justinian I (527–65) ruled parts of Italy and most of North Africa, as well as Greece, Anatolia, Syria, and Egypt. Heraclius (610–41) lost much of the Balkans to the Slavs and Avars, and much of the Near East to the Persians. He made a miraculous reconquest of most of the lost territories, but then lost Syria, Palestine, and Egypt to the Arabs. Later emperors never recovered them. Henceforth the main Byzantine powerbase was Anatolia, the modern Turkey, and the Byzantines also generally ruled Greece and parts of the territories to the north of it.

In both geographical and cultural terms the Byzantine emperors were more truly the successors of the Hellenistic kings whom Alexander left behind him than the Roman rulers whose heirs they claimed to be. As in the Hellenistic successor states, Hellenic influences mingled with Eastern ones.

When we compare the Byzantine achievement to that of Greece and Rome, and also to what eventually took place in the West, the picture culturally seems lopsided. The Byzantines were, at least during the early centuries of the Empire, great architects. Byzantine painting constantly renewed itself—strikingly so after the ravages of Iconoclasm (711–843), a religious and political movement hostile to all sacred images. The Byzantines also made a major contribution to the development of Western music, which stems from them and not from Greece and Rome. However, they did not produce a great and original literature, and there is almost no major Byzantine sculpture.

	300	500	700	900	1100	1400
HISTORICAL BACKGROUND	Constantinople founded by Constantine 330 Fall of Rome	Justinian I (527–65) Heraclius (610–41)	Charlemagne unifies Western Empire End of Iconoclast struggle	Byzantium breaks with Papacy 1054		Constantinople sacked by Frankish crusaders Fall of Constantinople to Ottoman Turks 1453
PHILOSOPHY		Justinian closes schools of pagan philosophy in Athens 529 History developed as High Art			Recurrence of Platonic thought	Gregory Palamas and Hesychasm
ARCHITECTURE		San Vitale, Ravenna Hagia Sophia, Istanbul (**6.3**)				
VISUAL ARTS	Narrative Christian Art begins	Mosaic floors Emperor Justinian mosaic, San Vitale (**6.6**) Christ in Majesty mosaic, SS Cosmas and Damian, Rome (**6.7**)		Christ Pantocrator, Daphni, near Athens (**6.1**)		Mosaics and murals in Kariye Camii, Istanbul (**6.8, 6.9**)
MUSIC	Christian Hymnody well established	Romanus comes to Rome 491 Invention of "Kontakion"	Organs sent as presents to West			

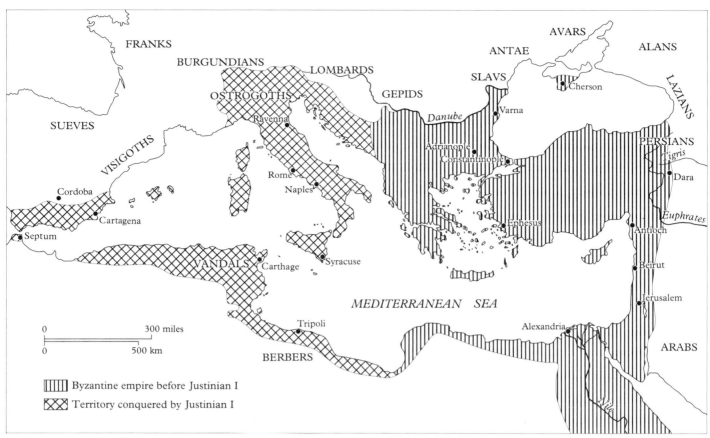

FRANKS

BURGUNDIANS

LOMBARDS

AVARS

ANTAE

SLAVS

GEPIDS

OSTROGOTHS

SUEVES

VISIGOTHS

Ravenna

Cherson

Danube

Varna

Adrianople

Constantinople

ALANS

LAZIANS

PERSIANS

Tigris

Dara

Cordoba

Cartagena

Septum

Rome

Naples

Ephesus

Euphrates

Antioch

Beirut

VANDALS Carthage

Syracuse

Jerusalem

MEDITERRANEAN SEA

Tripoli

Alexandria

Nile

BERBERS

ARABS

						Byzantine empire before Justinian I
XXXX	Territory conquered by Justinian I					

0 300 miles

0 500 km

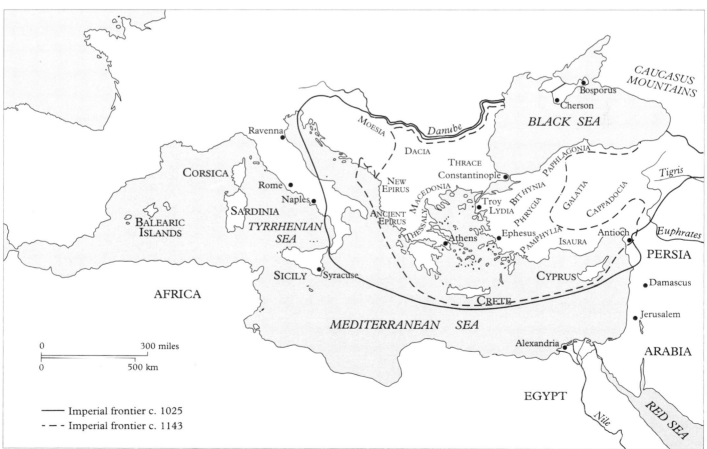

CAUCASUS
MOUNTAINS

Bosporus

Cherson

BLACK SEA

Ravenna

MOESIA

Danube

DACIA

THRACE

PAPHLAGONIA

Tigris

CORSICA

Rome

Naples

SARDINIA

*TYRRHENIAN
SEA*

BALEARIC
ISLANDS

NEW
EPIRUS

Constantinople

BITHYNIA

GALATIA

CAPPADOCIA

MACEDONIA

ANCIENT
EPIRUS

THESSALY

Troy
LYDIA

PHRYGIA

Athens

Ephesus

PAMPHYLIA

ISAURA

Antioch

Euphrates

PERSIA

SICILY Syracuse

CYPRUS

Damascus

AFRICA

CRETE

Jerusalem

MEDITERRANEAN SEA

Alexandria

ARABIA

EGYPT

Nile

RED SEA

0 300 miles

0 500 km

—— Imperial frontier c. 1025

- - - Imperial frontier c. 1143

6.2 (*above*) The Byzantine Empire before Justinian I and the territories conquered by him.
(*below*) The extent of the Byzantine Empire *c.* 1025 and *c.* 1143.

These gaps suggest that Byzantine civilization did indeed have a significantly different orientation from its Western counterpart. Iconoclasm itself is one confirmation of this. It was rooted in age-old Near Eastern prejudices against figurative representations, especially of sacred beings, reinforced by contact with Islam.

Though the Renaissance was deeply indebted to Byzantium for what it had preserved from ancient Greece and Rome, its revival and reinterpretation of a lost classical world was in many ways a rejection of the Byzantine love of what was abstract, or nearly so, and otherworldly. The thousand-year love–hate relationship between Byzantium and the West, fueled by bitter theological differences, reached a final point of rupture just as Constantinople fell to the Ottoman Turks, who were already masters of Anatolia, in 1453. Once Constantinople was in Turkish—that is to say, Islamic—hands, Byzantine culture became in retrospect even more alien to Westerners than it had in fact been. Meanwhile, the Ottomans inherited important things from Byzantium, notably its architectural tradition, which the West had been unable to absorb.

Theology and philosophy

In the East, Platonism shaded very early into Christian mysticism—the idea that the knowledge of God was attainable only by direct revelation, bypassing both the physical senses and human reason. The writer known as the Pseudo-Dionysius provides us with a good example of this approach. Much of his success was based on the fact that he was confused, by the readers of his own time and later, with Dionysius the Areopagite, one of the companions of St. Paul. In fact, he seems to have lived in the late fifth or early sixth century—sometime just before 528. The Pseudo-Dionysius speaks rapturously of angels or intelligences who are "heralds of the divine Silence" bearing torches "which light up the presence of him who dwells in inaccessible places." His doctrine is that "the knowledge of God is the knowledge that he is unknowable."

Very soon after this a great change came over the intellectual life of the East when, in 529, Justinian closed the schools of pagan philosophy in Athens. This had the effect of making Constantinople the center of intellectual life, as well as the seat of government. It also reinforced a tendency which was already present for theological debate to absorb all other forms of discussion, and intellectual and even straightforwardly political disagreements henceforth tended to be expressed in theological terms. For example, Emperor Heraclius lost large parts of the Empire mainly because his subjects in Syria and Egypt preferred to be ruled by followers of a Muhammad rather than by fellow Christians not of their own theological persuasion. The Emperor and the Patriarch of Constantinople took the "orthodox" position, as laid down by the Council of Chalcedon in 451—that is, they believed the Savior united two natures in one person, the human and the divine. The inhabitants of Syria and Egypt, on the other hand, were passionate monophysites (as their name implies, the monophysites believed that Christ possessed the divine nature only).

In 1054 Byzantium broke with the papacy. The quarrel was once again officially due to a theological controversy, but in fact the great age of religious debate was over and the diplomatic breach had more to do with an ever-widening cultural gap. The Empire now used Greek, not Latin, as its official language, and the eleventh century saw a tremendous revival of interest in the Greek classics, which were cherished as the direct precursors of Greek Christian civilization. It was fashionable to discover Christian allegories in Homer, and to think of the Greek philosophers as men who had been Christians without knowing it.

Under the Palaeologan dynasty (1259–1453), the Byzantine tendency to mysticism produced one final extreme manifestation. It was called Hesychasm, and the chief figure in the movement was Gregory Palamas (1296?–1359/60). Most of his followers were monks in the various communities on Mount Athos. The hesychasts believed that it was possible to achieve direct and immediate union with God through a special method of prayer. Prayer was treated as a meditative discipline, after the manner of certain Buddhist sects. Chin resting on chest, breathing as slowly as possible, the initiates hoped to achieve perception of a great light, which would fill them with ineffable joy. This "uncreated" light was compared to the light which the disciples saw surrounding Christ at the Transfiguration. Hesychasm was a rebellion against rationalism, stressing the superiority of emotion to reason. Paradoxically, it was the final product, in terms of original thought, of one of the most consistently intellectual of all cultures.

▮ 6.3 **Anthemius of Tralles** and **Isidorus of Miletus**, Hagia Sophia, Istanbul, 532–37 A.D.

Architecture

The supreme achievement of Byzantine architecture, and probably the supreme achievement of Byzantine aesthetics in general, came early in the history of the Empire, with the construction of Hagia Sophia (Fig. **6.3**). Justinian ordered it to be built to replace an earlier church destroyed in the Nika Riots of 532, which had nearly cost him his throne. It was dedicated in 537, but the dome collapsed in an earthquake in 558 and had to be rebuilt with a slightly steeper curve.

The direct ancestor of Hagia Sophia is the Pantheon in Rome (see page 74)—that is, it essentially consists of a great dome used to shelter a vast unobstructed space. But whereas the internal space of the Pantheon reveals itself at the first glance, its successor is spatially very complex (Fig. **6.4**). It can be thought of as an attempt to marry a dome, suspended over a square not a rotunda, to a version of the standard basilica. This is effected by means of pendentives, curving triangular surfaces which are themselves segments of a sphere. The square is extended to east and west by

lower half-domes. On either side of each half-dome is a pair of curved niches, backed not by solid walls but by two tiers of columns, making a curved screen. Further screens close off the central space to north and south. The main area, which is comparatively light, is thus surrounded on nearly all sides by lower spaces which are much darker. Its boundaries remain mysteriously undefined.

The whole building is entered by two narrow vestibules—an exo-narthex and a narthex—which run laterally across the west front. They help to make the vastness of the interior a dramatic surprise for the visitor.

The building, almost from the beginning, had an overwhelming effect on anyone who saw it. Quite apart from any other considerations, it was for many hundreds of years the largest covered space in the world. Even so, its impact on Western architecture was not great, for it remained largely inaccessible to Westerners, and its spatial manipulations were on the whole too subtle for Western medieval taste.

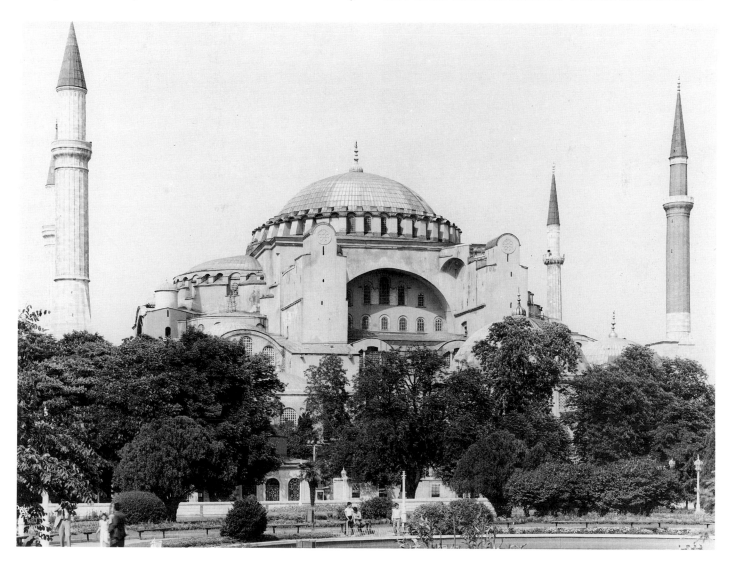

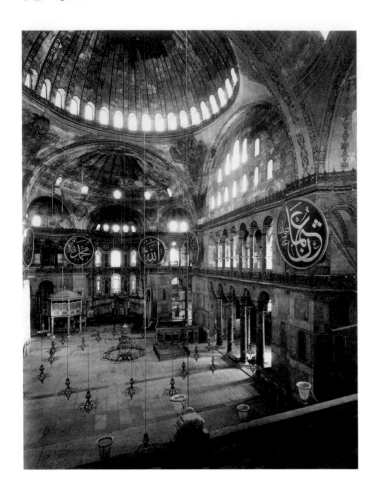

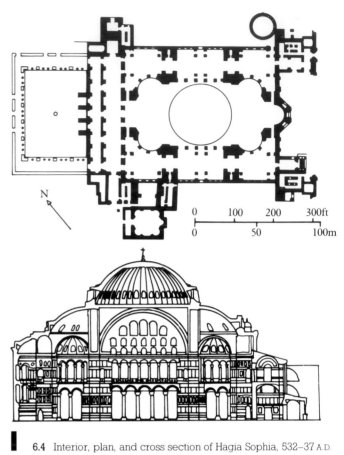

6.4 Interior, plan, and cross section of Hagia Sophia, 532–37 A.D.

Mosaics and painting

Byzantine art was foreshadowed by developments in the art of the eastern Roman Empire long before Christianity became the official religion of the Empire. The remote frontier city of Dura Europos was home to many cults. The most impressive paintings to be discovered there are in a Temple of the Palmyrene gods. These date from the end of the first century A.D. One scene, *Conon Sacrificing* (Fig. **6.5**), has much of the otherworldly grandeur later associated with Byzantine art. The eastern part of the Empire was already well prepared to respond to the mystical and transcendental side of the Christian cult. It also remained rich. Byzantine mosaics and paintings combined mysticism with a luxurious refinement that Christian art in the West could not rival for several centuries.

It is a historical accident that Ravenna and Rome, the two cities where the emergence of the new eastern style can best be studied, are both in the territory of the western Empire. Ravenna was for a while the seat of Byzantine power in Italy. Rome was in constant communication with Constantinople because it was the city of the pope.

The chief Byzantine church in Ravenna is San Vitale. The building itself was probably begun shortly before the Byzantines established themselves in the city but the decorations belong to the decade immediately following—they were done *c.*550. The most famous of the mosaics, which differ from their Roman predecessors because of their shimmering reflective backgrounds made of glass squares or tesserae bonded with gold leaf, have secular rather than sacred subject matter. They show the Emperor and Empress, Justinian and Theodora, moving toward the altar with offerings in their hands (Fig. **6.6**). Since Byzantine art is generally thought to be antirealistic, it is interesting to reflect that these representations stand at the head of a long series of portraits of rulers which continues almost until the fall of Constantinople in 1453. They always take the same form: the ruler is shown in full regalia, with all the remote grandeur of his or her office, though the face is often strikingly alive. He or she plays a special role, as the chosen intermediary between God and subject. One striking thing about the Ravenna panels is their sense of contained energy. Justinian

forms part of a tightly packed group, a wedge expressed as a frieze. He is stepping through the picture-frame to make his presentation, and, as he does so, Bishop Maximian beside him seems almost ready to jostle him. Maximian had his own rights to assert—he was the man responsible for carrying the church and its decorations to completion.

The impact of this developing style was also felt in Rome. The most impressive mosaic of the period in the city is very Byzantine. It was commissioned by Pope Felix III, who died in 530, and adorns the apse of the Church of San Cosmas and San Damian (Fig. **6.7**). Christ is the central figure. He is both a surrogate Jehovah and a successor to the pagan Zeus—bearded and long-haired, robed splendidly in white and gold. On either side of him are St. Peter and St. Paul, who introduce the titular saints of the church. Both the actual type chosen for the Christ figure and the whole composition make this mosaic seem like a forerunner of the impressive Pantocrator (a conventional representation of Christ as ruler of all) (*c.* 1020) of the high Byzantine period at Daphni near Athens, which looks down from the dome of the church (the accepted place for such an image) with the sternness of an all-seeing judge (Fig. **6.1**).

Byzantine culture once again suffered a major setback with the sack of Constantinople by the crusaders in 1204, though a line of legitimate rulers continued at Nicea in Asia Minor, and still saw themselves as the true heirs for the Roman Empire. The feeble Latin emperors then installed were expelled in 1261 and replaced by the cultivated Palaeologan dynasty, which ruled until the fall of the city to the Turks almost two centuries later. During this period Constantinople, though permanently impoverished, became the scene of a surprising artistic revival. Its most striking monument is the little church of the Monastery of the Chora, now better known by its Turkish name, Kariye Camii.

The building was constructed in its first form between 1077 and 1081, and was twice remodeled, the second time in the fourteenth century. The great series of mosaics and frescos which adorns the interior was put up between 1315 and 1341. The elaborate mosaics are in the main body of the church, while the frescos are in the side chapel, which was intended as a place of burial. Though mosaics and frescos both seem to be the work of the same hand, they are different in mood, and show the full emotional range of Palaeologan art. The mosaics have a new tenderness and intimacy, a delicacy and charm not previously characteristic of Byzantine pictorial expression. *The Birth of the Virgin* (Fig. **6.9**) has a charming domesticity, unexpected in the rather formal medium of mosaic.

The paintings in the side chapel strike a stormier note, especially the great *Anastasis* (Fig. **6.8**) which decorates the apse. There is a visionary quality here, but now it has become a vision which appeals to the emotions through the senses—which speaks very directly of the terror of death and the hope of a new life. The old restraint and intellectualism which characterize so much Byzantine art have gone. On the eve of the city's fall, a Byzantine artist portrayed the mysteries of the faith with vivid freedom.

Byzantine music

No Byzantine secular music or music for instruments survives intact, though recent attempts have been made to reconstruct compositions of this type. Secular music was in general disliked by the Church, which inherited its distaste for it from the early Christians, who had associated it with the most debauched aspects of paganism. What does survive, however, is a fairly substantial body of church music. This has recently become accessible again because the problems of reading Byzantine musical notation have been solved by twentieth-century scholars. It is now clear that Byzantine music influenced the Gregorian chant (see page 131) which was used for church services in the West.

Byzantine sacred music is written for unaccompanied voices, and its own sources seem to be almost entirely Eastern. It can be traced back to Syriac chants used by the early Christians in the eastern part of the Roman Empire, through these to traditional Jewish music, and perhaps even beyond that to the religious music of Ancient Near Eastern civilizations.

The most influential figure in the history of Byzantine church music was Romanus. A Jew by birth, Romanus was born at Emesa on the Orontes. He came to Constantinople in the reign of Anastasius I (491–518) and seems to have died soon after the year 555. Romanus was the inventor of the "Kontakion," an elaborate new kind of hymn consisting of eighteen, or even more, stanzas. Each stanza, called a "Troparion," could be between three and thirteen lines long; and each exactly repeated the rhythmic pattern set by the first in the series. Each stanza ended with a refrain, and they were linked together by the fact that the first letter of each verse either followed the order of the letters in the Greek alphabet, or formed an acrostic—a short sentence giving the name of the writer or the title of the hymn.

An intermediary territory between sacred and secular music was occupied by "acclamations"—sung panegyrics or formal songs of praise addressed to the emperor, members of the Imperial family, or to high ecclesiastical personages such as the Patriarch of Constantinople. These

6.5 Fresco of "Conon Sacrificing," Dura Europos, Syria, 1st century
A.D. National Museum, Damascus.

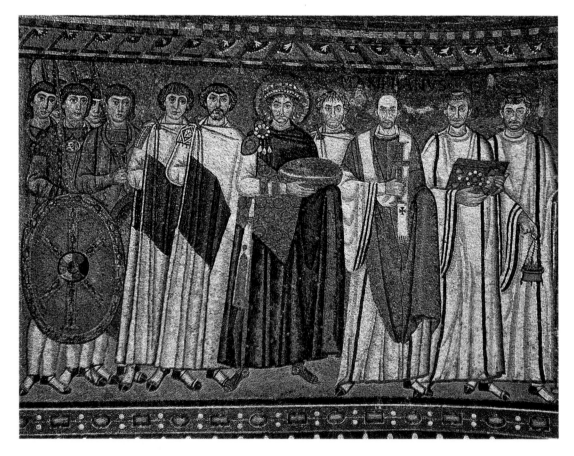

6.6 Emperor Justinian and his court *c.* 547 A.D.
Wall mosaic from San Vitale, Ravenna.

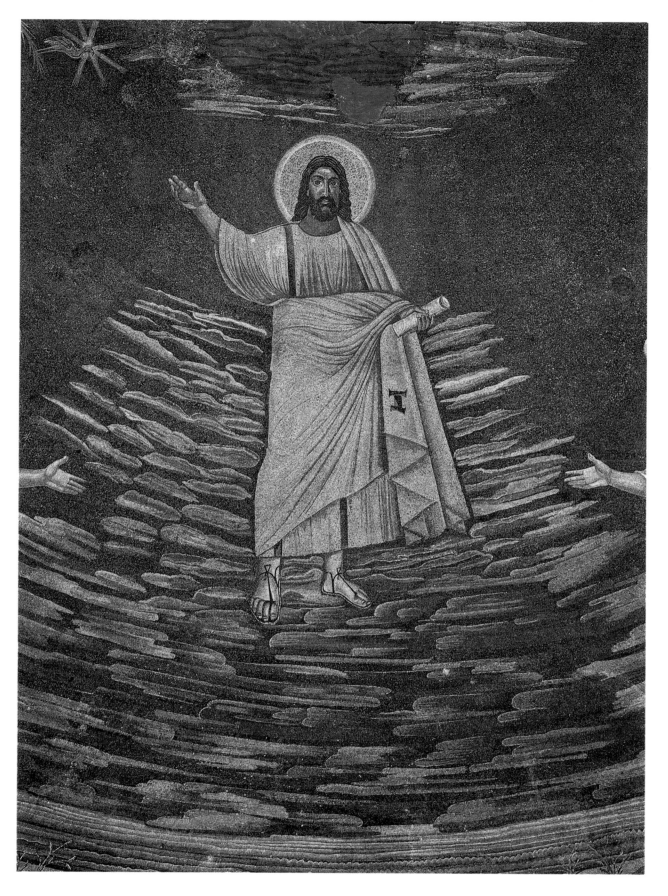

6.7 Christ in Majesty 526 A.D.
Mosaic from SS Cosmas and Damian, Rome.

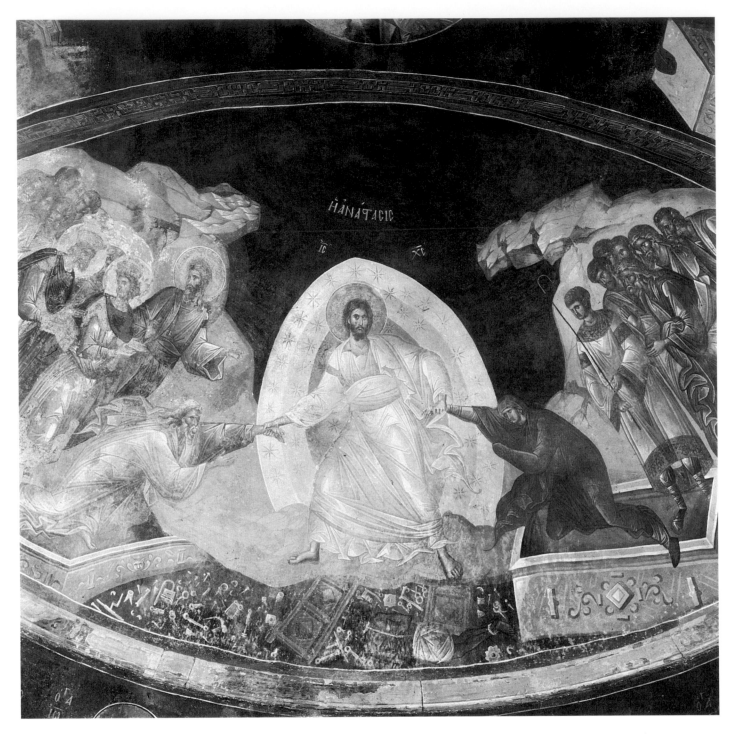

6.8 The *Anastasis c.* 14th century. Mural in the apse of the
Parecclesion, Kariye Camii, Istanbul.

were a development of the rehearsed cheering already customary in Imperial Rome.

Acclamations upon purely secular occasions—for example when the emperor appeared in his box at the Circus—were accompanied by an organ. The Byzantines favored portable organs worked with the help of a pair of bellows. In the eastern Empire, these organs were strictly forbidden in church, but when an acclamation took place in an ecclesiastical building—for instance when the emperor appeared in Hagia Sophia—then the ban on instrumental music was somewhat relaxed for the occasion. The Imperial band consisted of trumpeters, horn-players, cymbal-players and pipers. These accompanied the choral part of the acclamation, and also played interludes when the choir was silent.

Organs reappeared in the West (large hydraulic organs had been known to the Romans), when the Byzantine emperors sent them as presents to their western counterparts. The Emperor Michael I sent one to Charlemagne in 812. Soon after this they began to be adopted for church use by the Franks, who cared nothing for Byzantine prohibitions on their use.

6.9 *The Birth of the Virgin* 1315–41. Mosaic in East Lunette, second bay, Kariye Camii, Istanbul.

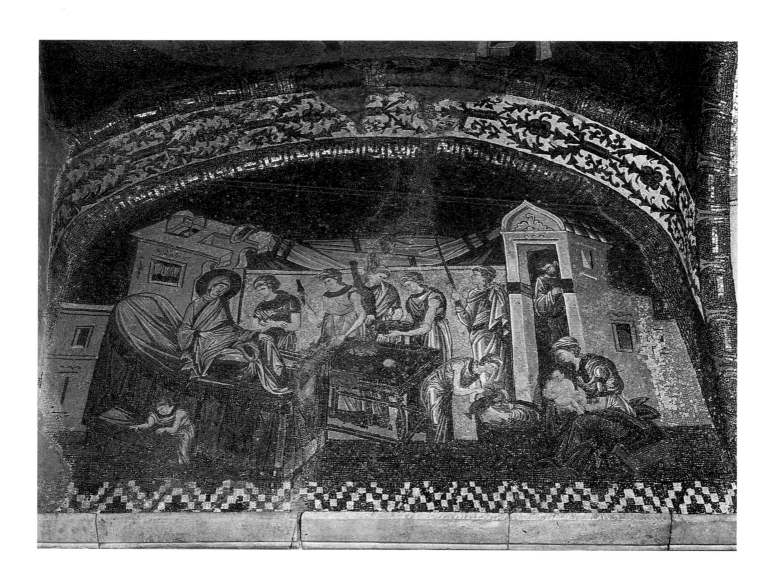

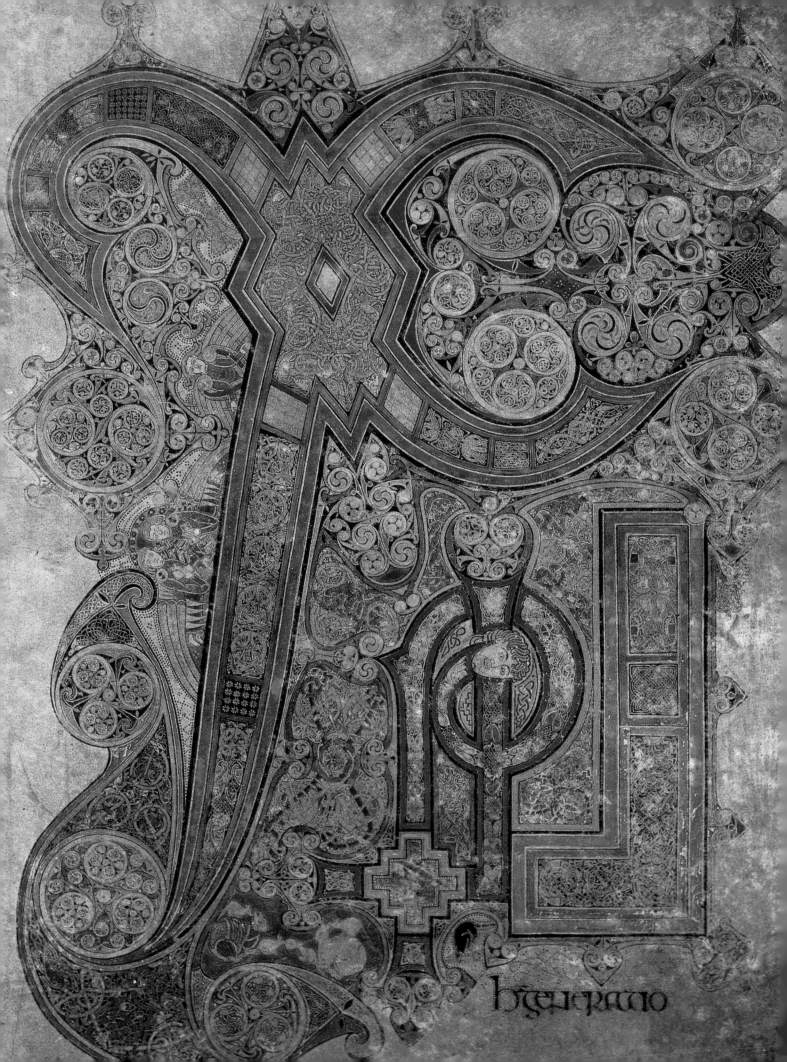

hgenerario

Part

3

The Middle Ages

Chapter 7
The Early Middle Ages

7.1 Charlemagne's Palatine Chapel, Aachen, Germany, 792–805 A.D.

The Early Middle Ages

The traditional view of European history, which stressed the break with the Classical past, has been replaced in the present century by an approach which puts more emphasis on the essential continuity of Western civilization, even in those lands—nearly all of Europe—where the Roman Empire fragmented into a multitude of barbarian kingdoms.

Since the word "barbarian" will recur in this chapter, it is worth trying to define the way in which its meaning shifted gradually from the sense in which it was employed by the Greeks. The Roman Empire, centered on the Mediterranean basin, was almost always under pressure from nomadic tribes, mostly Germanic, hungry for land and plunder, who pressed against its northern frontiers. The collapse of the Empire was at first a gradual process, one feature of which was the employment of these tribes as mercenary troops, and the settlement on them of what used to be Roman territory.

The social organization of these tribes was very different from that of the Empire itself. An emperor had only subordinates; a barbarian chief was surrounded by his *comitatus*, a band of companions who considered themselves almost his equal, often bound to him by blood relationships, but also by the comradeship of war. If the Romans considered the tribesmen barbarous (not least because they were illiterate), the latter thought of the Romans as effete and servile. After the official conversion of the Empire to Christianity, another division opened between the two sides. Since the tribespeople mostly remained pagan, the Church, which suffered severely from their depredations, tended to teach that they were something less than human.

The collapse of the Empire as a viable political structure brought adjustments on both sides. The tribes destroyed the existing secular authority, but not the religious one. They converted to the religion of the territories they had invaded, and began to absorb elements of the old Classical literary culture, of which the Church had become the guardian. At the same time they retained, and even elaborated, the traditional tribal social relationships they had brought with them.

While admitting that the new dispensation inherited much from the old, both imperial and tribal, important changes must be pointed out. One of the most striking was the temporary disintegration of urban life. Towns began to

	800	1000	1100	1200	1300	1400
	EARLY MEDIEVAL	**ROMANESQUE**		**GOTHIC**		
HISTORICAL BACKGROUND	Growth of Monasticism Charlemagne (742–814) "The Carolingian Renaissance"	Period of Norman expansion *c.* 1000 First Crusade 1095–99	Growth of town life First universities	Fourth Crusade takes Constantinople 1204		Hundred Years War begins 1337 Black Death ravages Europe Great Schism 1378–1429
PHILOSOPHY/ RELIGION			Hildegard of Bingen Abelard *For and Against*	St. Thomas Aquinas *Summae Theologiae*		William of Ockham John Wyclif
ARCHITECTURE	Palatine Chapel, Aachen (**7.1**)	Abbey Church at Cluny Jumièges Abbey (**7.4**) Speyer Cathedral (**7.6**) Pisa Cathedral (**7.8**)	Durham Cathedral (**7.5**) Saint-Denis (**7.9**) Laon Cathedral (**7.11**)	Chartres Cathedral (**8.2**) Sainte-Chapelle (**8.4**) Salisbury Cathedral (**8.5**)		
VISUAL ARTS Stained glass/ illumination	Vatican Virgil (**7.13**) Book of Kells (**7.14**) Godescale Gospel (**7.15**)	Illuminated books flourish		Chartres (**8.9**) Psalter of St. Louis (**8.11**)		Hours of Jeanne d'Evreux (**8.12**)
Painting		San Clemente fresco cycle (**7.18**)	Berzé fresco cycle (**7.17**)	Cimabue (**8.15**)		Giotto (**8.16–18**) Duccio (**8.19**) Simone Martini (**8.21**)
Sculpture		Moissac Apostles (**7.22**)	Prophet Isaiah, Souillac (**7.24**) Chartres statues, west portal (**8.24**)	Nicola Pisano (**8.27**)		Giovanni Pisano (**8.28**) Sluter (**9.11**)
LITERATURE	Revival of Epic Composition of *Beowulf*	*Song of Roland*	Development of Romance and Troubadour lyric			Dante *The Divine Comedy* Chaucer *The Canterbury Tales*

An Anglo-Saxon Chieftain's Regalia

We can get a picture of the life-style of the barbarian chiefs who imposed their authority in place of that of Rome from a rich ship burial found in 1939 at Sutton Hoo near Woodbridge in Suffolk (England). This contained the grave-goods of an Anglo-Saxon king of the seventh century. The finds correspond closely to descriptions given in the Anglo-Saxon epic poem *Beowulf* (see page 127). Christianity had existed in Britain in Roman times, but had disappeared in the south of the British Isles after the Roman withdrawal. It was reintroduced into England in 597, by a mission sent by Pope Gregory I the Great (590–604), and led by St. Augustine of Canterbury (d. *c.* 607). Nevertheless the king commemorated at Sutton Hoo seems to have been still a pagan.

Weapons of high quality were prominent amongst the objects found. There was a sword with a pattern-welded blade and gold bosses on the scabbard, a shield, and a richly decorated helmet. The decoration of the helmet includes two warriors performing a ritual sword dance. There were also emblems of royalty, such as a ceremonial whetstone—the latter perhaps connected with the cult of the smith god Thor. There were also reminders of the kind of feasting described in *Beowulf*—a number of drinking horns including two from an aurochs or wild ox which would have held about a gallon and a half (5.45 liters) of liquor each. Since the aurochs was already extinct in Britain in Roman times these horns probably came from Germany or Scandinavia, where it did not die out until 1627.

Other items—silver spoons, dishes, and bowls—appear

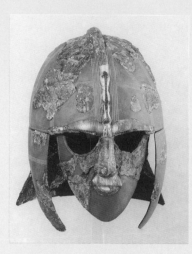

to have been loot. One large dish carries control stamps dating it to the reign of the Byzantine Emperor Anastasius I (499–518).

The most impressive objects in the burial were superb pieces of gold jewelry which, unlike the silver, are almost certainly of Anglo-Saxon workmanship. They include a massive gold buckle, more than five inches (12.7 cm) across, and a pair of gold, garnet, and glass mosaic shoulder clasps. The jewelry shows the mixture of influences in barbarian culture. The buckle has an intricate interlacing pattern. The intertwined straps are ornamented with biting animal heads—an idea which came from Scandinavia and which was to enjoy a long life. It appears in Romanesque illumination (see page 120). The clasps also have animal heads interlaced along their edges, and a carpet pattern in the middle. They were made to be fitted to the shoulders of a leather harness, copied from the parade dress of a Roman *imperator* (commander-in-chief).

The Sutton Hoo burial shows that the Anglo-Saxons, even at this early period in their recorded history, had a wide range of cultural contacts, stretching throughout the whole of Europe. It also speaks of a nomadic, tribal existence—a society without fixed roots and not as yet possessing a written literature. The only inscriptions—the names Paul and Saul on a pair of silver spoons—are written in Greek. Works of art were expressions of royal authority, in terms of material wealth. Inevitably they were portable, and the most characteristic took the form of personal adornments.

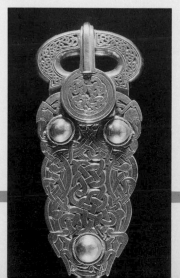

Artefacts from Sutton Hoo. (*far left*) Sword with pattern-welded blade, (*above*) helmet, (*left*) gold buckle, early 7th century. British Museum, London.

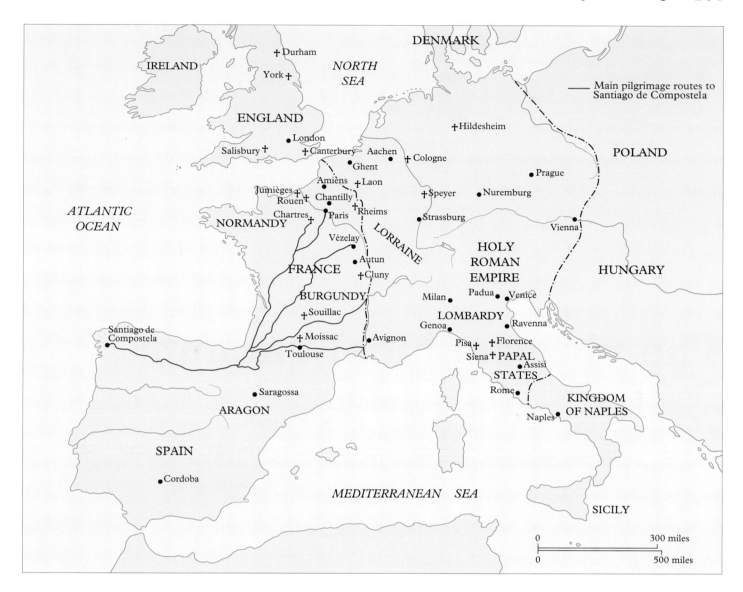

I 7.2 Europe in the Middle Ages.

play an important part again only in the tenth or eleventh century. Meanwhile culture took refuge in the monasteries, which were the successors of the great country villas of the later Empire. For a while these enjoyed a near monopoly in the production of literature and art, and were certainly the only place where it was possible to receive an education.

The new kingdoms created by tribal leaders themselves came under threat from a new power, Islam, which had already seized much of what was formerly Byzantine territory. The Mediterranean, once the center of Classical civilization was now largely in hostile hands, and the Christian powers withdrew northwards and inland. Europe resumed its grip on at least one sector of the great Mediterranean sea-routes only after a great Pisan naval victory in 1063.

By this time Europe possessed a new set of political and social relationships, summed up in the word "feudalism"— a system of government in which land was held by a subject

as a gift from a chieftain in return for services, military or otherwise. These stemmed from the bonds which joined the barbarian chieftain to his companions. Feudalism formalized and reinforced such bonds, giving them Christian sanction by means of sacred oaths. The relationship between the ruler and the ruled became for the first time a fully reciprocal one. The moral universe within which political actions took place was thus entirely altered.

The recovery of energy and confidence in Europe was symbolized by the proclamation of the First Crusade by Pope Urban II in 1095, followed by the capture of Jerusalem in 1099. The crusades brought Europeans into contact with a Muslim civilization. This civilization was in many respects superior to their own—in material luxuries, in technology, and in the ability to handle abstract thought. The legacy of Aristotle, for example, was largely preserved by Arab scholars. The conviction of European superiority was maintained by the belief that Christians, being in possession of religious truth, must necessarily be preferred to their opponents. The Arabs, another conquering and

proselytizing group, felt the same thing about their own position, and perhaps with more reason, since the crusaders were unable to maintain themselves permanently in the Near East. Nevertheless, the adventurers brought back to Europe new products, new visual forms and new philosophical ideas, gained as much from closer contact with the Byzantine Empire as from the Arab world itself.

The crusades can be seen as a revival of the nomadic restlessness which had brought the Germanic tribes flooding into the Roman Empire in the first place. A powerful motivation, quite apart from the religious one, was the strain put on feudal relationships by an increase in population, and especially by the need to provide for younger sons of the nobility. A similar pattern—a mixture of religious and purely materialistic urges—can be seen in the Spanish conquest of the Americas in the sixteenth century, and in the European colonizing ventures of the seventeenth, eighteenth and nineteenth centuries—so much so, that the pattern can be seen as typical of European history as a whole.

In the Middle Ages this restlessness also expressed itself in a more personal form in the desire to go on pilgrimages—if not to Jerusalem, then to the great shrine of St. James at Compostela in northwest Spain. This impulse was of direct importance to architecture. It brought with it the need for large churches which would serve the throngs who made these journeys. Sumptuous shrines were built and beautified with the help of offerings brought by the pilgrims themselves. Meanwhile, every pilgrim broadened his or her knowledge of the world.

The philosophical vacuum

The political and economic collapse of the western half of the Roman Empire brought with it a break in intellectual continuity. This is symbolized by the absence of anything resembling true philosophical thinking for the best part of 600 years. Charlemagne (c. 742–81) and his able adviser Alcuin (735–804) had to rebuild the educational system from the ground up. After Charlemagne's death, this revival stagnated, and much ground was lost again. Learning once more retreated into the monasteries, and in Greek and Roman terms it remained a very limited kind of learning, in general confined to purely literary subjects—grammar and rhetoric.

The return of abstract thinking, the product of a more settled society in which people no longer lived from day to day, was marked by a renewal of interest in what had been the third element (the *trivium*) in the basic course of education—dialectic, the sustained application of logic to a given theme or subject. If this was taught between 600 and 1000, it tended to be just as a piece of memory work, something to be learned by rote. When it became a living thing again, rather than a fossil, those who employed it had to come to terms with Christian absolutism. Was it or was it not legitimate to use dialectical methods in matters which concerned the Faith? Methods borrowed from the old classical Greek culture were reshaped, and endowed with recognizably Christian forms.

Peter Abelard

The conflict between faith and reason was stirred to fever pitch in the twelfth century because of the extraordinary personality of one individual. The Frenchman Peter Abelard (1079–1142) enjoys legendary fame because of his tragic love affair with Heloise. The boldest and most original thinker of his day, he is in fact better known than any of his contemporaries because of his candid autobiography, *Historia calamitatum meum* (*The Story of My Calamity*).

Abelard did not establish a new basis for thought in absolute rationalism, but he did go a long way toward rationalizing theological debate by insisting that here, as elsewhere, the only way forward was by means of arguments formally arranged pro and con, leading to a unified conclusion and thus to a judgment. Faith became a matter of discussion and explanation, not simple assertion.

Behind this, however, there lurked something heterodox: the idea that faith was in some way the product of a reasoning process which was pre-existent, and already rooted in nature. Abelard's intellectual convictions and his own passionate nature also united in defence of a doctrine of free will which he pressed so far as to stress the idea that this freedom was reciprocal—that if an individual's will was free, then so was that of God, to the point where a different moral order from the accepted one became imaginable.

OCUS

The Emperor Charlemagne

Following the collapse of the Roman Empire in the West, the first significant effort to revive the culture of classical antiquity was made by the Emperor Charlemagne (*c.* 742–81), who succeeded his father Pippin the Short as ruler of part of the Frankish dominions in 768 and became sole ruler upon the death of his half-brother Carloman in 771. The Franks were the Germanic tribe which occupied most of the territories of modern France and modern Germany. By Charlemagne's day they were already Christianized, though many of his wars were fought against opponents who were not Christian. These included the Saxons, in what is now northern Germany, who still held to the old Germanic pagan religion; the Avars, in what is now Hungary; and the Islamic conquerors of Spain. One of Charlemagne's rare defeats, the annihilation of his rearguard as it recrossed the Pyrenees after a campaign against these Islamic rulers, was the inspiration for the Old French epic, *The Song of Roland* (see page 128).

Historically, some of Charlemagne's most important campaigns were fought in northern Italy, where the Franks allied themselves with the pope to destroy another tribe of Germanic origin, the Lombards. It was Charlemagne's father who first led the Franks into Italy, in 754, in response to an appeal from Pope Stephen II. In return for Frankish help, Stephen offered Pippin the title of Patrician of the Romans, that is, titular head of the Roman secular nobility, and this honor was extended to his two sons, Charles and Carloman. Pippin's campaign across the Alps and those led by Charlemagne were the precursors of successive French invasions of Italy in more recent times—in the fifteenth and sixteenth centuries under Charles VIII, Louis XII, and Francis I; and later still under Napoleon.

Charlemagne himself paid three visits to Rome. On the third of these, in December 800, Pope Leo III crowned him Emperor. The Frankish realm was thus recognized by the Church as the true successor to the imperium of antiquity, and the emperors who still ruled in Constantinople were by implication disinherited. The title of Holy Roman Emperor was to be reclaimed by another Germanic ruler, Otto of Saxony, in 962, and was to remain in use until 1806, when Napoleon forced its then holder, Francis II of Austria, to renounce it.

Charlemagne's biographer Einhard, author of a brief but vivid Latin *Life* drawn from personal observation, puts special emphasis on the emperor's love of learning, but also seems to tell us he was illiterate:

He tried also to learn to write, and for this purpose used to carry with him and keep under the pillows of his couch tablets and writing sheets that he might in his spare moments acustom himself to the formation of letters. But he made little advance in this strange task which was begun too late in life.

(*Early Lives of Charlemagne*, edited by Prof. A. Grant. Alexander Moring Limited, The de la More Press, 1907.)

Some of Charlemagne's admirers assert, however, that this means simply that he was unable to learn the new script, Carolingian minuscule, introduced during his reign. This notably clear and simple script was revived by Renaissance scholars in Italy and provided the model for most of the typefaces still in use today.

Portrait of Charlemagne from a legal manuscript written between 817 and 823, preserved in the library of the monastery of St. Paul in Carinthia.

Architecture

Early medieval

Surviving buildings from the early medieval period are rare, and those that do survive do not follow any stylistic pattern. Some structures, like Charlemagne's Palatine Chapel at Aachen (Fig. **7.1**), have links to early Christian and Byzantine architecture which were afterwards severed. Others, though constructed of stone, seem to show the influence of building techniques in wood—these would, of course, have been familiar to the northern barbarian tribes before they came in contact with the Roman Empire.

The Chapel Palatine is the most sophisticated building of its period, and can have had few competitors even when it was first built. It is in the form of a rotunda, and the architect seems to have taken his inspiration from the rather similar church of San Vitale in Ravenna, though he has simplified the plan. A central octagon of open arches surmounted by arcades is surrounded by an ambulatory—but the space lacks the subtle harmonies typical of the Byzantine churches of Justinian's time. At Aachen, the upper gallery emphasizes the link with Roman antiquity because the columns are antique ones, transported all the way from Italy and reused. By employing them, Charlemagne gave emphasis to his own Imperial claims.

An example of a much more primitive approach is given by one of the few substantial remains of Anglo-Saxon church-building to have survived—the tower of the church of All Saints at Earls Barton in Northamptonshire (Fig. **7.3**), dating from the second half of the tenth century. This has no Roman echoes. Instead, the elaborate surface decoration seems to imitate timber-framed building techniques. As with the early Doric temples of the Greeks, an established vernacular idiom is here translated into something more substantial and permanent. The tower, which clearly formed the major part of the original church, is, however, innovative in a way which it is now quite easy to miss. The whole notion of a tall feature of this type as a near-essential part of a church building was a novel feature invented in the West, not deriving from anything in Roman or Byzantine architecture.

Romanesque

The Romanesque style is the characteristic expression of the first great age of church-building throughout western Europe. Like all styles which are the product of practice rather than theory, it is difficult to define. Among its more conspicuous hallmarks are round arches, massive construction in masonry, heavy moldings, and deliberately plain architectural forms, sometimes contrasted with rich carving and

7.3 All Saints Church, Earls Barton, England, 2nd half 10th century.

areas of repetitive pattern. Romanesque churches are far more numerous and in general more ambitious than the church buildings created previously outside the two Imperial cities, Rome and Constantinople. They reflect both universal needs and local tastes. For example, it was now expected that each priest would say Mass every day. Large churches served by many priests therefore needed numerous altars, and this led to the addition of transepts—extensions at right angles to the nave—and ambulatories to the main congregational space in order to house them.

The Romanesque, however, also offers diversity within unity. Isolation led to the birth of different regional styles, and these were further encouraged by the fact that primitive transportation systems made it almost impossible to haul heavy building materials over any but the shortest distances. In church-building, the character of the local stone influenced what could be done, and played a decisive role in determining whether churches in a given region were highly ornamented or very plain. Even so, ornament, or the lack of it, was still also an expression of local taste, as were considerable variations in ground plan.

Among the most significant contributors to the develop-

ment of Romanesque style were the Normans, Viking marauders who had settled in the north of France. Expensive building operations were begun in Normandy itself even before the invasion of 1066 which made the Norman duke William ruler of England. The early version of Norman Romanesque style can be seen, for example, in the ruined abbey church at Jumièges, begun *c.* 1040 (Fig. **7.4**). Plain, strong, and virtually unornamented, this typifies the new style which was carried across the Channel at the time of the Norman Conquest.

After the Norman triumph at Hastings, the English Church, like all other English institutions, was subjected to a drastic reorganization. One result of this was the great cathedral at Durham (1093–*c.* 1130), an undisputed masterpiece of Romanesque architecture (Fig. **7.5**). An innovatory feature is the use of cross-rib vaults—that is, vaults with ribs that intersect diagonally, forming square or rectangular compartments. The massive pillars at Durham, rather than being left plain, are ornamented with simple but emphatic patterns—zigzags and lozenges—as well as the more conventional fluting.

In terms of size and massiveness, Durham finds a continental equivalent in the cathedral at Speyer (Fig. **7.6**) on the Upper Rhine in Germany (consecrated 1061). This has a cross-vaulted nave, the earliest of its type in Germany. The west end, with its paired towers, and a larger, lower tower between and behind them, is a development of a Carolingian feature called a westwork, and shows the continuity between this and much earlier types of medieval architecture.

In southern France, the major Romanesque churches are often to be found along the pilgrim route to Santiago de Compostela. One of the best known is the church at Vézelay

7.4 Ruined Abbey Church of Jumièges, France, *c.* 1040.

7.5 Durham Cathedral (from the north), England, 1093–*c.* 1130.

0 100ft
0 30m

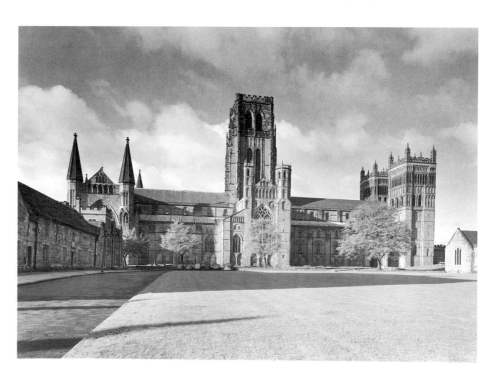

OCUS

Monastic Life: Life at Cluny

The great abbey of Cluny in Burgundy, France, was founded in 910. The monks followed the rule laid down by St. Benedict of Nursia (*c.* 480–*c.* 547), the founder of Western monasticism (a form of monasticism already existed in what had been the eastern part of the Roman Empire). The idea was that men with a religious vocation would live as a community under the rule of an abbot, who would exercise patriarchial authority over them, rather as a feudal king did over his subjects. Because monasteries could accumulate property, especially lands, the rule had a tendency to become lax and corrupt. The foundation of Cluny was one of a series of attempts made during the Middle Ages to correct this situation. Eventually, in the early thirteenth century, a new formula was tried. The mendicant orders, the Franciscans (founded 1210) and the Dominicans (founded 1215), were not allowed to own land or property, or to possess any fixed source of income.

Cluny prospered under the leadership of a succession of able abbots, chief among them St. Odo (926–44), St. Odilo (994–1049), and Peter the Venerable (1122–57). Numerous other monasteries were founded which were ruled directly from Cluny, so that this part of the Benedictine Order became almost an independent European power. At one time these dependent monasteries and convents (eventually there were some houses for women) numbered nearly a thousand—836 in France and Switzerland, 26 in Spain, 36 in Italy, and 39 in Britain. There was even one in Palestine, founded in 1100 by Tancred, Prince of Galilee.

The abbey church at Cluny itself was vast: 415 feet (126.4 m) in length, with a nave 92 feet (28 m) high. A further addition in 1220 made it, at 525 feet (160 m) long, the largest church in Christendom.

Cluny was a cross between a boarding school and a factory for prayer. Every aspect of life was regulated—what the monks wore, what they ate, when they were shaved (once a

Elevation and plan of the third Abbey Church at Cluny, France, *c.* 1095–1100 (from an 18th century engraving).

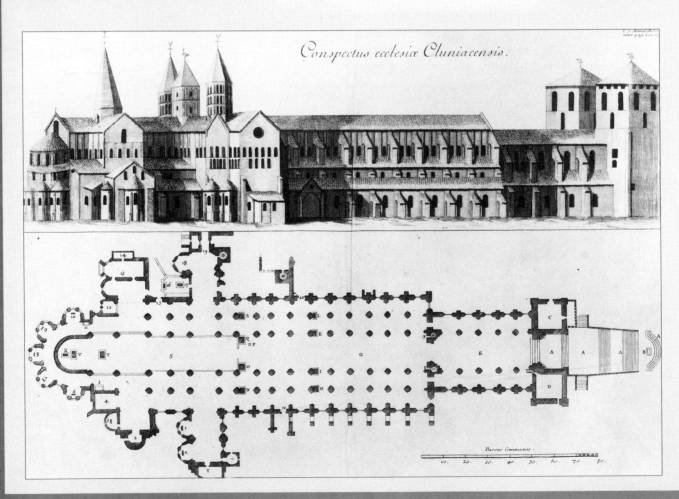

week), and when they bathed (twice a year). The day was regulated by the Canonical or Regular Hours—the church services held throughout the day, starting at dawn with Matins, followed by Prime, Tierce, Sext, Nones, Vespers at sunset, Compline at nightfall, and Nocturns and Vigils in the course of the night. Sleep was interrupted for the night-time offices. In winter, from November to Easter, the monks were woken for Nocturns at about two in the morning. These services, with two daily Masses and additional hymns, canticles, responses, and anthems, took up a great part of the day. In addition, there was a meeting in the chapter house every morning, after morning Mass, where the business of the monastery was transacted and breaches of discipline were dealt with.

The original Benedictine rule had prescribed that the monks do manual labor for seven hours a day. At Cluny, the amount of time spent in prayer did not allow for this. Instead there were occasional days of ritual work, when the monks sallied forth en masse to weed the monastery bean-field. The task of cultivating the monastery's extensive lands fell to lay brethren, serfs, and servants. In this sense, the monastery fitted into the general pattern of feudal life, and acted as a collective overlord to these employees and dependants. The monks did, however, wash and mend their own clothes, bake bread, and cook food.

Where the medieval diet was often largely based on meat, especially that of the nobility, the monks were forbidden to eat it. There were normally two meals a day, dinner and supper, at which they ate dried beans (hence the importance of the bean-field), eggs, cheese or fish (fish came from the monastery ponds), and vegetables. The vegetables were cooked in fat, unless it was a fast day. The monks ate a great deal of bread—the allowance was up to a pound-and-a-half per person per day—and they were given onions and little cakes instead of beans on feast-days. They drank wine in moderation—a cup a day. All meals were served in the refectory, and there were readings at mealtimes.

The monks were allowed to talk freely for only half an hour a day; otherwise they kept silent. As a result they developed an elaborate language of signs. Joining the thumbs and first fingers of both hands to make a circle signified bread; moving one's hand like a fish's tail was the sign for fish.

In addition to hearing sacred and theological works read aloud, the monks also did much silent reading. The monastery library was unusually rich and included lives of the saints, works by the Fathers of the Church, books on Civil and Canon Law, and books on mathematics, music, and medicine. There were books on Roman history and on the history of more recent times (Cluny had a copy of Einhard's *Life of Charlemagne*. There were also books by Roman orators and poets—Cicero, Virgil, and even Juvenal. Among the monks were a number of historians and poets, all of whom wrote in Latin, the "learned" tongue.

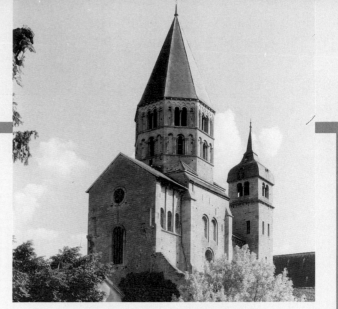

■ Ruins of the Abbey Church at Cluny, France.

One major occupation of the monks was the copying of manuscripts. Since printing had not yet been invented, this was the only way of multiplying the number of books. Peter the Venerable, abbot in the mid-twelfth century (when Cluny was at its most powerful), considered this task to be of paramount importance:

It is more noble [he wrote] to set one's hand to the pen than to the plough, to trace divine letters upon the page than furrows on the fields. Sow on the page the seed of the word of God, and when the harvest is ripe, when your books are finished, the hungry readers shall be satisfied with an abundant harvest.

(JOAN EVANS, *Monastic Life at Cluny*. Oxford University Press, 1931.)

The manuscripts the monks copied were also richly decorated, first with ornamental initials, and later with miniatures as well. It is known that Cluny was richly adorned with frescos (the monastic buildings were pulled down in the eighteenth century, and the great church after the French Revolution) and it seems likely that these were painted by the monks. It also seems likely that there were stained glass and goldsmiths' workshops, but these were probably staffed by laymen.

Though the monks remained in their cloister (apart from the ruling abbot, and one or two high monastic officials, who were often forced to travel widely), the world came to Cluny. Guests who came on horseback (the gentry) were allowed to spend three days in the monastery guesthouse, which had separate lodgings for 40 men and 30 women. A bishop or other great personage would be escorted in procession to the church. Visitors who came on foot were lodged in the adjacent town, and provided with food. There were also poor pilgrims who were received at the almonry and the monastery put aside a fixed proportion of its revenues in order to look after them.

In the turbulent world of the eleventh and twelfth centuries Cluny was thus both an oasis of order and tranquility, and a political and economic focus, whose network of information spread almost throughout the known world. It preserved learning, increased it, and also disseminated it.

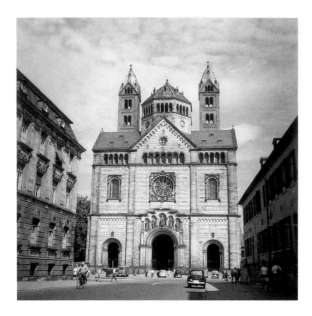

7.6 Speyer Cathedral (west front), Upper Rhine, Germany, *c.* 11th century.

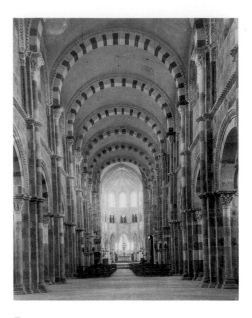

7.7 Pilgrim Church of Vézelay (interior view), France, *c.* 12th century.

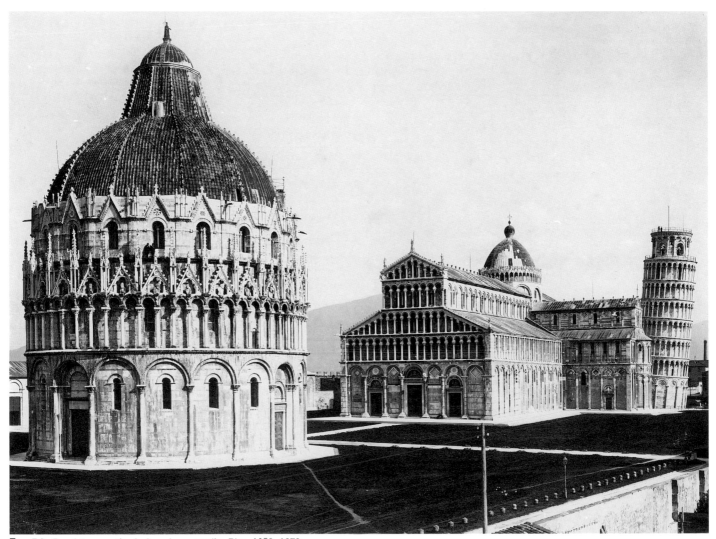

7.8 Baptistery, cathedral, and campanile, Pisa, 1053–1272. (*right*) Plan of Pisa site.

(Fig. **7.7**). This is now chiefly famous for its wealth of sculpture, but the large interior, with its tranquil forms, deserves to be equally celebrated. These forms counter-balance the elaboration of the carving.

A very different kind of Romanesque, so different indeed that one is inclined to look for a completely different label, appears in Italy. One of the finest examples is the great Duomo at Pisa (Fig. **7.8**). This was begun soon after the Pisans defeated the Saracens in a great sea-battle off Palermo in 1063. The victory made them masters of the western Mediterranean for the best part of a century. The building has five aisles, transepts of three aisles, a small dome over the crossing, and three apses to east, north, and south. The basic cross-shape is concealed by the fact that the transepts are not treated as part of the main space, but as what are almost ancillary churches. The exterior is extremely rich, with blind arches below, then galleries on the upper stories. The capitals and the edges of the arches are finely decorated.

The beginnings of Gothic

Gothic architecture takes its name from a contemptuous eighteenth-century jest—that such buildings were the work of "Goths" or barbarians. What offended eighteenth-century architectural pundits was the fact that it ignored the Classical rules handed down by Vitruvius (see page 54). In fact, such architecture follows a recognizable program of its own—the approach to building is organic and gradualist, rather than conceptual. Few Gothic buildings offer the kind of absolute unity offered by a Greek temple.

The style developed surprisingly soon after the maturation of the Romanesque, at first in one or two quite specific localities. It only afterwards spread to the rest of Christian Europe. It is characterized by the use of the pointed arch, by windows which take up an ever larger proportion of the available wall space, and above all by elaborate patterns of vaulting and an emphasis on height and apparent lightness of construction. Its sources were various. Some ideas came from close at hand—for example,

the cross-rib vaulting already seen at Durham and a number of other Romanesque churches. Others were imported—Arabic architecture had been making use of pointed arches for some centuries, and elaborate vaulting systems had already been developed in distant Armenia.

The inspiration behind Gothic buildings seems to have been both spiritual and practical. There was the impulse, especially powerful in the perpetually clouded regions of northern Europe, to create buildings which would be flooded with God's light, as an emblem of spiritual power. And then there was a desire to find safer systems of construction, which were also more economical in their use of materials. The cross vaults employed in Romanesque churches only made sense in engineering terms if each vaulted compartment was square. Otherwise the diagonal arches became more and more flattened, even if the side arches remained semicircles or nearly so. This made them structurally dangerous. Pointed arches, with their greater resistance to thrust, supplied a solution, and made the system of compartmentalization more flexible.

The Gothic system of vaulting first appeared complete at Saint-Denis (Fig. **7.9**), just outside Paris (the church was built in two stages, the first *c.* 1130–40, the second 1140–44), and in the cathedral at Sens (Fig. **7.10**) (*c.* 1130–64). Sens, the more conservative of the two buildings, shows clear signs of Anglo-Norman influence—for instance, the way in which it is divided into three stories. Saint-Denis was more radically innovative, to the point where it took other

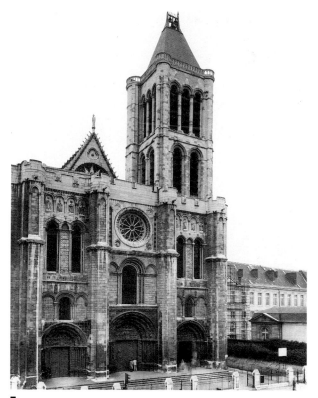

7.9 Saint-Denis, Paris, *c.* 1130–44.

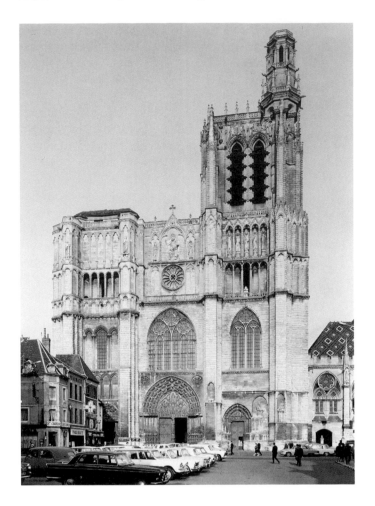

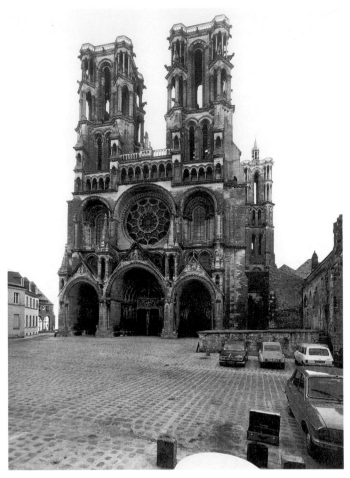

7.10 (*left*) Sens Cathedral, France, *c.* 1130–64.

7.11 Laon Cathedral, France, late 11th–early 13th century.

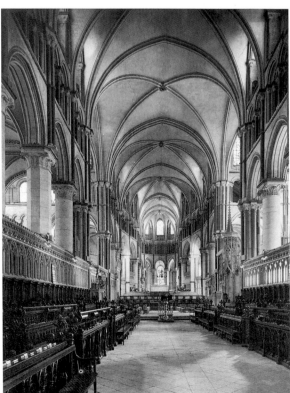

7.12 Choir of Canterbury Cathedral, England, begun 1174.

church-builders some time to absorb the ideas incorporated into it. Its originality is now best experienced at the extreme east end of the building, in the ambulatory, which has an extraordinary undulating lightness when compared to all previous constructions.

In France, Gothic reaches its first maturity with the construction of Laon Cathedral (Fig. **7.11**), which was begun in the last quarter of the eleventh century and completed after 1205. Laon is one of the most unified of the great French cathedrals. It combines simplicity and elegance with radically new features. One major innovation was the use of large rose windows to light the east end and the ends of the transepts. These were perhaps introduced into France from Italy. They were to become an essential component of the mature Gothic style in England as well as in France. Also original to Laon, but not as much copied, were the com-

pletely hollowed-out top stories which crown the towers—a design which is the essence of Gothic transparency and lightness.

In England the beginning of the Gothic is represented by the choir of Canterbury Cathedral (Fig. **7.12**), begun in 1174, after the old choir had been destroyed by a disastrous fire. The architect was William of Sens. William's place of origin is significant, and so is the survival of his name and of some account of his personality. For the first time, a medieval architect emerges as an individual. When he was crippled after falling from the scaffolding, his work was continued by his namesake, William the Englishman, whose work shows clear signs of familiarity with what had already been achieved at Laon. Nevertheless, in some ways his contribution was even more original than that of his predecessor. The chapel to the east of the choir, known as

the Corona, or Becket's Crown, was built to house the shrine of the martyred archbishop, St. Thomas à Becket, which had very quickly become an important place of pilgrimage. Though it occupies the position usually given in other cathedral buildings to the Lady Chapel, there are in fact not many constructions with which it can be compared. The ground plan is completely unconventional, consisting of an irregular oval within a horseshoe-shaped apse.

The Early English style, as one sees it at Canterbury, impresses with its purity of line, and also its essential independence and willingness to look for new solutions. There is, however, a certain timidity in the actual handling of details which serves as a reminder that the two Williams, men of genius though they were, were still very much in the process of familiarizing themselves with the repertoire of Gothic forms.

Illumination

Early medieval

Whereas Byzantine art seems to have developed from the art of the eastern Roman Empire with a continuity which makes it difficult to know where one epoch ends and the next begins, this is not the case with pictorial art in western and northern Europe. There was a perceptible hiatus—a moment when painting as a means of expression seemed to have sunk temporarily from view. The barbarian cultures which overwhelmed the western Empire put all their aesthetic energy into portable objects, such as weapons, jewelry and horse-trappings.

When the thread was picked up again, it was at a point very distant from the Mediterranean basin. Painting began to be used in a new way. Only scanty remains of large-scale mural painting survive from the early Middle Ages. The one art form which allows us to experience early medieval painting as a continuity is illumination in books.

Some illuminated books survive from the Late Antique period. The Vatican Virgil (Fig. **7.13**), a manuscript of the *Aeneid* dating from the start of the fifth century A.D., shows strong links with the narrative mosaics in Santa Maria Maggiore in Rome (see page 92). At the same time the book looks forward to the Renaissance, and even anticipates the illustrated books of our own century. The simple layout marries half-page story-telling illustrations to text, with a few full-page pictures to vary the mix. The result could hardly be more different from the group of magnificent Gospel books produced in northern Britain (and perhaps also in Ireland), from the seventh century onwards. The decorations in these books seem to have their roots in a different medium—the fine metalwork produced by both

Celtic and Germanic peoples at this date and earlier.

The most magnificent of all these Hiberno-Norse manuscripts is the Book of Kells, which combines delicate naturalistic details with a profusion of scrolling ornament. The

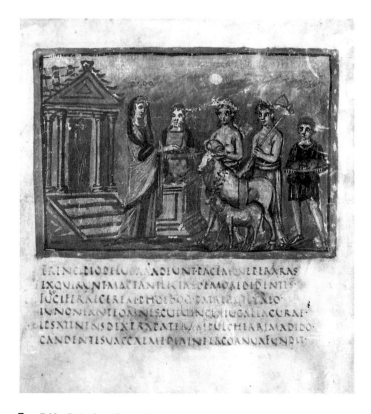

7.13 *Dido Sacrificing.* Illustration to Virgil's *Aeneid*, early 5th century A.D.

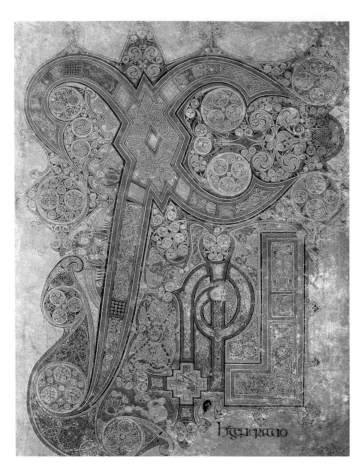

7.14 Illustration from the Book of Kells, ms 58, folio 34r, early 9th century A.D. The Board of Trinity College, Dublin, Ireland.

more closely one examines the page filled with a huge XPI (the sacred monogram), the more these naturalistic details tend to spring to the eye—there are cats with mice, and an otter with a fish (Fig. **7.14**).

Relatively large numbers of early medieval manuscripts produced on the mainland of Europe survive. The best of them demonstrate the nature of the cultural reforms which Charlemagne imposed from his capital at Aachen. These reforms involved a deliberate return to classicism. The influence of Charlemagne's taste, and that of the scholars and artists who surrounded him, was felt in varying degrees across a vast empire which stretched from eastern Germany to the Pyrenees. Centers for the production of manuscripts were Aachen itself, and the large monasteries which Charlemagne founded.

An early example of the Carolingian style is the Godescale Gospel (Fig. **7.15**). It has a close connection with Charlemagne himself, who commissioned it to mark the baptism of his son Pippin by the pope, in Rome, at Easter 781. It was one of the first manuscripts to use the new and more legible script sponsored by Charlemagne's advisers— the Carolingian minuscule—which has continued to influence both writing and print until the present day. The Godescale Gospel also shows a strong influence from English workshops in Northumbria. This is not surprising,

since Charlemagne's reforms were spearheaded by the English scholar Alcuin, once of York. The contrast with Hiberno-Norse manuscripts is nevertheless striking in the sense that there is much greater stress on the idea that a book is primarily a means of communication, rather than a purely magical and beautiful object.

Romanesque

The Romanesque period saw a big increase in the production of books, thanks to the growth of monasticism and a steep rise in literacy. Books were no longer kept strictly for use in the ceremonies of the Church, with the status, almost, of sacred relics. However splendid, they had now become objects of everyday use—for private study, and also for public readings in a monastic refectory. This did not mean that they became workaday. The major monasteries took a particular pride in the splendor, as well as the number, of the books they possessed, whether these were created in their own scriptoria (rooms set aside for the copying of manuscripts), or acquired through gift or purchase. There was a fashion for huge, lavishly illustrated Bibles, which were produced in great numbers throughout Europe, and which tended to replace the psalters and Gospel books of earlier epochs. There was also a fashion for books which told, in word and picture, the life-story of a particular patron saint.

The pictorial decorations in Romanesque books were of two kinds: actual illustrations, and elaborately decorated initial letters. Between these there was not only a distinction of function, but also a distinction of taste. The illuminations were grand and serious. In general, as the Romanesque style established itself, the figures became increasingly static. The artists modeled the surface with minimal shading and adroit use of color, paying special attention to draperies. Compositions were arranged in a hierarchical way—that is, the important figures are much larger than the rest. Full-page illustrations were often divided into compartments, and were commonly provided with rich ornamental borders.

Romanesque initials, which themselves often occupied most of a page, showed a very different spirit. Ornamental forms proliferated to the point where they almost smothered the body of the letter and concealed its identity. Floral tendrils were lavishly used; there were entwining quadrupeds (often monstrous ones), birds, and human figures. Particularly popular were fierce dragon-like creatures (Fig. **7.16**) which twist and turn to follow the shape of the letter, and which are transformed as they do so. A dragon possessed, not a head and a tail, but a head at either end, one attacking the other; or was transmuted halfway through its length from something animal into something vegetable.

These initials still have a relationship to the scrolling decorations of the Book of Kells, and they too sometimes

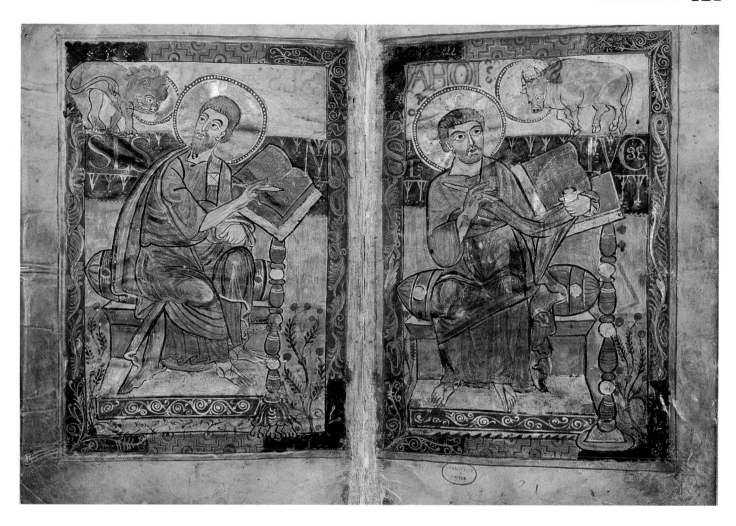

7.15 *St. Mark and St. Luke*. Illuminations from the Gospel Book of Godescale, 781–83 A.D.. Vellum, 12¼ × 8¼ ins (31.3 × 21 cm). Bibliothèque Nationale, Paris.

seem to have derived from metalwork. They offer, on the one hand, an important insight into the nature of the early medieval imagination, and are reflections of minds which found many things in the world alienating or threatening because of the lack of the necessary intellectual tools with which to deal with them. On the other hand, they also demonstrate the power and fecundity of imaginations still permeated by the myths and legends of northern Europe, which had not as yet been entirely subdued by the influence of Christianity. They became important models for other forms of artistic expression, especially the carved decoration in churches.

7.16 *St. George and Dragon "R."* Illumination from St. Gregory's *Moralia*. Dijon Bibliothèque Municipale.

Romanesque murals

Romanesque painting on a major scale is the child of architecture, and reflects the characteristics of the church buildings which are its setting (see page 112). It consists of schemes of decoration planned in a clear, easily comprehensible way. The heaviness of Romanesque construction provided the painters with large areas of wall and vault, and the solidity of the surrounding architectural forms often prompted an equal solidity of composition. This was offset by the brilliant colors needed to light up buildings which still had relatively small windows. In addition, though the compositions are well knit, the figures they contain seem to contradict this by their weightlessness and stylized flatness—qualities which in turn reflect the preference for what was transcendental in an age when faith, not reason, was the center of people's lives. The sacred stories are told with an urgency which reflects their overwhelming importance, and also with maximum directness and economy. The personages, though often clad in richly patterned clothes, are shown in settings which omit everything which is not necessary to the narrative itself.

In French Romanesque painting, as in architecture, there is always a distinction to be made between the regions north and south of the Loire. This can be seen by looking at two great fresco-cycles, one on either side of the river. The first is in Burgundy, in the church of Berzé-la-Ville, a priory which was once affiliated to the great reforming monastery at Cluny. The date generally assigned to these paintings is the first decade of the twelfth century. The most notable fresco at Berzé is the one in the apse. It shows Christ Enthroned amid the Twelve Apostles—a subject unique in France (Fig. **7.17**). The choice seems to carry a political meaning. Christ is delivering the New Covenant to Sts. Peter and Paul, with the other apostles as witnesses. The theme is specifically Roman and was chosen for this Cluniac chapel in order to signify Cluny's own unswerving loyalty to the Holy See. The rest of the decoration also indicates strong links with Rome. For example, the saints on the lowest part of the apse were all especially venerated in the Holy City.

Technically the pictures at Berzé are very skillful. They are striking for their use of color—the palette is much richer than in churches further south. Equally striking is the way in which the artist handles space. He is good at complicated minor details, like foreshortening heads, and also skilled at suggesting recession. Everything is kept close to the picture-plane in the usual Romanesque way, but space is indicated by the use of diagonals, and of figures placed slantwise.

The major set of Romanesque frescos south of the Loire —the most complete and important in France—is in the church of Saint-Savin-sur-Gartempe, near Poitiers. Four major groups of paintings survive in good condition; it is surprising that so much is left since they are not carried out in true fresco, but in a kind of distemper painted directly on the wall. (Whereas with "true fresco" the pigments, having been applied onto the wet plaster, become embedded in the wall surface, distemper, a water-based paint, remains on the surface and is therefore more easily washed off or abraded.) The color range is typical of the "southern Romanesque" school, and is restricted to red and yellow ocher, green, white, and black. The touch is much broader than at Berzé. This, and the lightness of the tones, helps to make the paintings more legible in those parts of the building which are not well lit.

The most striking of the surviving paintings, a long sequence of Old Testament scenes (Fig. **7.19**), fill the barrel vault of the nave. After the first three bays, they are treated as a continuous strip. The main scenes are interspersed with episodes taken from traditional beast fables—the Fox and the Crow, the Cat hanged by Rats. In all cases the compositions are usually kept parallel to the picture-plane, with the occasional use of rudimentary architecture to provide a setting.

There was little dialogue between Italian painters and their counterparts across the Alps. In Italian art, a strong Byzantine influence persisted. Not surprisingly, the most interesting group of Romanesque murals is to be found in Rome, or within easy reach of it. Rome had the papacy— though in the thirteenth century on an increasingly nominal basis, until Clement V, newly elected, decided to take up residence in France at Avignon in 1305. And Rome drew to

▎ **7.17** Christ Enthroned c. 12th century. Apse fresco from Berzé.

itself distinguished visitors from all over the world—some to pay homage to the pope's authority, and a few to challenge it. This is not to say that all works of art were commissioned by the pope, or by resident or visiting grandees. The earliest murals in the city which can plausibly be described as Romanesque are in the buried Lower Church at San Clemente (Fig. **7.18**). There is some controversy about whether they belong to the period just before or just after Robert Guiscard's sack of Rome in 1084. It is certain, however, that they were commissioned by a butcher's daughter, who appears in them with her family. The tall thin figures who act out the various narratives are extremely elegant, and they appear in front of equally elegant simplified architecture—the buildings sometimes cut away so as to show what is going on inside. All of this links these paintings to the Byzantine tradition. They depart from their Byzantine forerunners, however, in their absence of mysticism or otherworldliness. They are quite matter-of-fact in the way they handle the stories the artist wanted to tell.

7.18 Butcher and family. Mural from the Lower Church at San Clemente, Rome, c. 1084.

Romanesque sculpture

The sculpture of the Romanesque combines two opposed currents of influence. One set, as in illumination, comes from Celtic and Germanic cultures. The model is generally metalwork or woodcarving, and reaches back into the pre-Romanesque period. The relationship between Celtic metalwork and some of the stone crosses found in Ireland is obvious, and the lack of competing influences is not surprising, since these are found in a region which was never occupied by the Romans. A good example is the mid-eighth-century north cross at Ahenny, Co. Tipperary (Fig. **7.20**). The east side of this is covered with abstract interlace which is derived from metalwork processional crosses. The technique was to cover a metal core with embossed metal sheets, and the effect is faithfully reproduced in stone. Even the ornamental rivet heads which fastened the plates to their support are reproduced as part of the ornament.

The Viking style of ornament, featuring ornamental interlace made of intertwined biting beasts, was more generally disseminated, and examples can be found scattered throughout northern Europe, and in some southern locations as well. At Kilpeck in Herefordshire there is a small but especially richly decorated twelfth-century church. The south doorway shows how barbarian tradition was pressed into the service of Christianity. The door jambs are carved with dragons biting their own tails, plus an assortment of other monsters (Fig. **7.21**). Here they symbolize the demons which Christians must brush aside before they enter the house of God.

The other influences on Romanesque sculpture are Late Roman art (despite the long gap in continuity) and contemporary illumination. The cloister at Moissac, completed in 1100, has a series of pier reliefs showing full-length figures of the apostles (Fig. **7.22**). These are in essence flattened versions of Late Antique statues (so-called *togatus* figures) used to represent magistrates and high dignitaries. The mixture of stylistic conventions is interesting. The most conspicuous of these is the use of a frontal eye in heads which are almost in profile—something which occurs in Greek Archaic reliefs (though the resemblance is probably accidental)—combined with other stylistic features which seem much more developed, such as the rich drapery, which comes from Roman Imperial art. One very unclassical feature of the reliefs is their denial of weight. The feet of the figures are not planted firmly on the ground. This emphasizes the fact that they are representations of spiritual beings.

7.19 Old Testament scene from the barrel vault of the nave in
Saint-Savin-sur-Gartempe, near Poitiers, France, c. 1100.

7.20 North cross at Ahenny, Co. Tipperary, Ireland, mid-8th century. Commissioners of Public Works, Ireland.

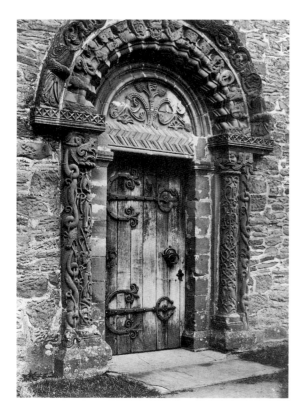

7.21 Detail of doorway of the Church of St. Mary and St. David, Kilpeck, England, 12th century.

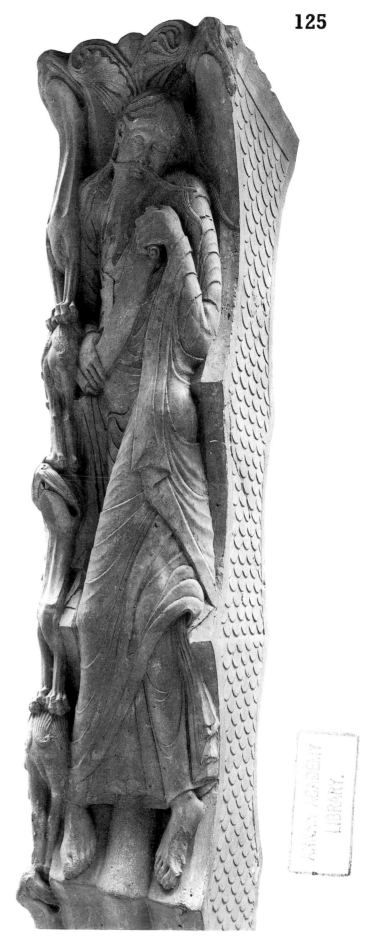

7.22 Door jamb of St. Pierre, Moissac, France, c. 11th century.

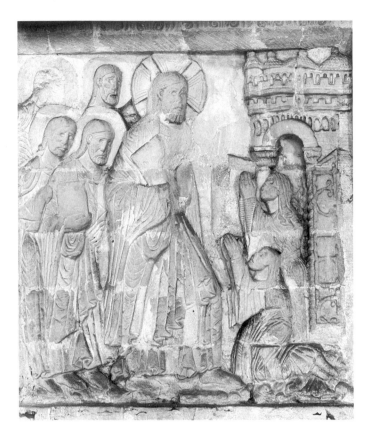

7.23 Relief showing Mary and Martha after the Resurrection from the choir of Chichester Cathedral, England, *c.* 1130.

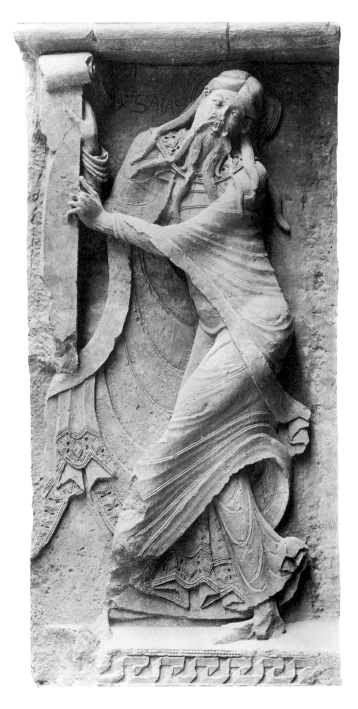

Narrative relief carvings closely parallel the illuminations found in Romanesque Bibles (see page 120). This is the case with two fine reliefs in Chichester Cathedral—their original position in the building is unknown, as they were rediscovered in fragments after having been dismantled and hidden, probably at the time of the Reformation. The better preserved shows Mary and Martha after the Resurrection (Fig. **7.23**). Two things are noticeable—the extreme severity, even grimness, of the expressions, and the hierarchical arrangement of the figures, with Christ much taller than the rest.

The Romanesque was eventually to break out of its bondage to classical art. The marvelous relief of the prophet Isaiah dancing in ecstasy, at Souillac in Périgord (Fig. **7.24**), which dates from *c.* 1130, perhaps contains a distant reminiscence of the dancing maenads of classical times. But the flame-like forms of the carving (including even the locks of the prophet's beard) belong to a completely different spiritual universe.

7.24 Relief of Prophet Isaiah at Souillac in Périgord, France, *c.* 1130.

Literature

Early medieval epic

During the Early Middle Ages there was a revival of the verse epic. Social conditions—a warrior society with great emphasis on personal honor and heroic deeds—in some ways paralleled those which had led to the creation of the *Iliad* and the *Odyssey* in early Greece. These epics, springing as they did from the barbarian rather than the classical tradition, were in vernacular languages—all the chief examples seem to have existed as part of a purely oral tradition before they were written down. None are pre-Christian, though in some, such as the Old English *Beowulf*, the Christian content is minimal—the name of Christ is not mentioned, and scriptural references are to the Old Testament rather than the New.

Estimates as to when *Beowulf* was created vary between *c.* 620 and *c.* 800; the only surviving manuscript dates from *c.* 1000. The hero, strangely enough, is not an Englishman but a Geat, a member of a tribe living in what is now southern Sweden and allied to the Danes. The poem is written in a meter characteristic of Old English, which was to persist into the Later Middle Ages before it was abandoned. It consists of heavily stressed alliterative lines, with a caesura, or pause, between the two halves of the line, which the alliteration helps to bridge. It is a medium ideally suited to recitation.

The poem tells the story of a tragic hero, who defeats two monsters—first Grendel, who is taking and devouring warriors at night from the Danish royal hall at Hereot, then Grendel's vengeful mother. After these triumphs Beowulf reigns successfully over his own people for fifty years, but has to meet his fate at last when he dies doing battle with a dragon. It has been said that, despite Beowulf's successes, the poem is essentially an extended prelude to the account of the hero's funeral, and certainly it is very Nordic in its insistence that everyone must finally submit to fate.

The poem makes a striking contrast with *The Song of Roland*, which was written down about a century later. *Roland* lacks the vivid sense of the uncanny we find in *Beowulf*, and its theme is male bonding, not solitary adventure. There is the loyalty of comrades, such as Roland and his friend Oliver, and the loyalty of a man to his lord. The assumptions are not only courtly but directly feudal. The story concerns an expedition made by Charlemagne (as much a legendary figure to the author as the Mycenaean kings were to them) against the Saracens in Spain. The campaign is successful, but the emperor and his armies are forced to turn back because of trouble elsewhere. As they recross the Pyrenees, the rearguard of Charlemagne's army, led by Roland, is ambushed and annihilated.

Roland, if not perfect as a human being, perfectly fits the mold of the hero: brave to the point of rashness, headstrong, and arrogant, but always impeccably loyal and noble. His death, still moving today, is that of a Christian knight:

Now Roland feels his time is at an end;
On the steep hillside, toward Spain he's turned his head;
And with one hand he beats upon his breast;
Saith: "*Mea culpa*; Thy mercy, Lord, I beg
For all the sins, both the great and the less,
That e'er I did since first I drew my breath
Until this day when I'm struck down by death."
His right-hand glove he unto God extends;
Angels from God now to his side descend.

(*The Song of Roland*, translated by Glyn Burgess.
Penguin Classics, 1990.)

What is missing is the sense of inevitable doom which pervades *Beowulf*. European literature is moving into a new and different world.

Arthurian romance

Connected with, but in the end quite distinct from, the epic poems which have just been described are a cycle of poems and prose tales about the legendary King Arthur and his knights of the Round Table, and about the search for the Holy Grail. Though King Arthur is said to have been a British monarch, these tales were popular throughout Europe, and the finest early versions are in French and in German. They differ from the epics in many ways—they are not tragic in tone; they devote much attention to love relationships between men and women; and they are generally built upon a bedrock of Christian allegory.

Though so heavily Christianized in the form in which it has come down to us, the Arthurian romance was nevertheless pagan rather than Christian in origin. Descriptions of the magic castle in which the Grail is housed make it fairly obvious that this was originally the castle, appearing and disappearing at will, of the pagan Celtic god Brân the Blessed, famous for his hospitality. Brân was variously a god and a legendary wounded king whose head was buried in London to protect the island of Britain from invaders.

The Celtic myths which form the basis of the stories about King Arthur were disseminated throughout Europe by Breton minstrels, descendants of exiles driven out of Britain by the Anglo-Saxons.

The major poets of the Arthurian cycle were Chrétien de Troyes (*fl.* 1160–90) in France and Wolfram von Eschenbach (*c.* 1170–*c.* 1220) in the Germanic lands. Chrétien's major patron was a woman—Countess Marie of Cham-

The Song of Roland

In this extract Roland knows that he is mortally wounded, and tries to break his sword Durendal, so that it will not fall into the hands of the enemy. Failing, he lies down to die alone. The repetitions are typical of a poem meant to be recited and heard by a crowd of listeners, rather than read in solitude.

171

Roland feels that he has lost his sight;
He rises to his feet, exerting all his strength.
All the colour has drained from his face.
Before him lies a dark-hued stone;
On it he strikes ten blows in sorrow and bitterness.
The steel grates, but does not break or become notched;
"O, Holy Mary," said the count, "help me!
O, my good sword Durendal, what a fate you have
 suffered!
Now that I am dying, I have no more need of you;
With you I have won so many battles in the field
And conquered so many vast lands,
Which Charles with the hoary-white beard now holds.
May you never be owned by a man who flees in battle!
A very fine vassal has held you for so long;
There will never be such a man in blessed France."

.

173

Roland struck upon the dark-hued stone;
He hacks away more of it than I can tell.
The sword grates, but neither breaks nor shatters;
It rebounds towards heaven.
When the count sees that he cannot break it,
He lamented over it to himself very softly:
"O, Durendal, how fair and sacred you are!
In the golden hilt there are many relics:
Saint Peter's tooth and some of Saint Basil's blood;
Some hair from the head of my lord Saint Denis
And part of the raiment of the Blessed Virgin.
It is not right for pagans to possess you;
You must be wielded by Christians.
May no coward ever have you!
With you I have conquered vast lands.
Charles with the hoary-white beard now holds them;
They have made the emperor mighty and rich."

176

Count Roland lay down beneath a pine tree;
He has turned his face towards Spain.
Many things began to pass through his mind:
All the lands which he conquered as a warrior,
The fair land of France, the men of his lineage,
Charlemagne, his lord, who raised him.
He cannot help weeping and heaving great sighs;
But he does not wish to be unmindful of himself.
He confesses his sins and prays for the grace of God:
"True Father, who has never lied,
You who brought back Lazarus from the dead
And rescued Daniel from the lions,
Protect my soul from every peril
And from the sins which I have committed in my life."
He proffered his right glove to God;
Saint Gabriel took it from his hand.
Roland laid his head down over his arm;
With his hands joined he went to his end.
God sent down his angel Cherubin
And with him Saint Michael of the Peril.
With them both came Saint Gabriel.
They bear the count's soul to paradise.

174

Roland feels that death is upon him;
It is moving down from his head to his heart.
He ran over to a pine and beneath it
And lay face down on the green grass.
He places his sword and the oliphant beneath him;
Towards the pagan host he turned his head,
Because it was his earnest wish that
Charles and all his men should say
That he, the noble count, had died victoriously.
He confesses his sins over and over again;
For his sins he proffered his glove to God.

175

Roland feels that his time has come;
He is on a steep hill facing Spain.
With one hand he beat his breast:
"O God, the Almighty, I confess
My sins, both great and small,
Which I have committed since the time I was born,
Until this day on which I have been overtaken."
He held out his right glove to God;
Angels come down to him from Heaven.

(*The Song of Roland*, translated by Glyn Burgess, 1990.
Penguin Classics, 1990. Copyright © Glyn Burgess,
1990. Reprinted by permission of Penguin Books Ltd.)

pagne, daughter of Eleanor of Aquitaine by her first husband, Louis VII of France. This points to the fact that the Arthurian writers were addressing a new audience, in which women were as important as men.

Onc of Chrétien's best narratives, in many ways typical of the whole genre, is *Yvain, or the Knight with the Lion.* This is written in rapid, musical octosyllabic lines, which carry the story forward with great speed, and allow place for vivid, colloquial language, especially in direct speech. The poem combines Breton legend with things learned from Ovid—Chrétien translated Ovid's *Ars Amatoria* into French, before embarking on original work of his own.

The Celtic elements in *Yvain* are nevertheless obvious to experts in mythology. The knight the hero kills in the first episode, Esclados the Red, is identified by his red hair as the Celtic god Curoi, master of sun and storms. The town which Yvain enters, in pursuit of his mortally wounded opponent, and where he shelters, kept safe by a magic ring which confers invisibility, is the Celtic Otherworld. Yvain's wife, Laudine, and her attendant damsel, Lunete, are Celtic fairies—this is one of the reasons why Yvain's failure to keep his promise to Laudine, who is a vengeful magical being, results in madness. But these Celtic elements are skillfully re-ordered, so as to suit the new courtly society which was growing up in Chrétien's time. Two elements are particularly interesting. The first is that the whole plot turns on the conflict between duty to a wife and duty to a warrior's own innermost nature, which demands that he continue his search for honor and glory. The second is that Laudine and Lunete debate together like two medieval scholars, using the newly revived dialectical techniques.

In terms of their epoch, the first Arthurian romances were simultaneously traditional and novel. They reached back into the remote past for themes, using stories from peoples who had been overwhelmed, first by the Romans, then by the Germanic tribes, but who had somehow succeeded in preserving their own culture on the margins of Europe. Yet they also took a self-consciously admiring look at feudal society, and especially at the new code of chivalric behavior.

Chivalry was an idealization of social, political and personal relationships. It put particular emphasis on three things. First, knighthood—which formalized the old status of "chieftain's companion"—which was seen as a form of dedication to God (some knights, like the Templars, were members of religious orders). Second, there was the sacred character given to the relationship between the knight and his sovereign lord. Third, and this was an especially novel feature, there was the relationship between the knight and the chosen lady who inspired him. He was bound, in all circumstances, to put her interests above his own.

Courtly love, which finds its first embodiment in the Arthurian romances, is linked to a shift in religious orientation—the cult of the Virgin Mary, which increasingly tended to put the Mother of God on the same footing as the Savior himself as an intercessor for humankind.

Anyone wishing to love must needs know fear,
otherwise he is incapable of loving.
But he should only fear the woman he loves
and be totally fearless on other occasions.

(CHRÉTIEN DE TROYES, *Cligés*, quoted by Z. F. Zaddy,
"The Courtly Ethic in Chrétien de Troyes," *The Ideals and
Practice of Medieval Knighthood III*—papers from the
fourth Strawberry Hill conference 1988. The Boydell
Press, 1990.)

Troubadour poetry

The popularity of the Arthurian cycle, with its tales of knight errantry and damsels in distress, was linked to another new phenomenon in European literature—the appearance of the troubadour poets. In their lyrics, the drama of courtly love was not simply narrated at second hand, but directly acted out. The chief rule in their poetry (though sometimes broken for satirical effect) was that the man was always the petitioner, while the woman gave or withheld favors as she considered best.

The first troubadour poet now recognized as such by literary historians was the great nobleman Guilhem Count of Toulouse and Duke of Aquitaine (1071–1127). Troubadours did not, however, have to be of noble birth. They could be ennobled by poetic skill. One of the most typical members of the movement, which centered chiefly in southern France, with poetry written in the southern French dialect, the *langue d'oc*, was Bernart de Ventadour, the son of a baker. His poems, many addressed to the Viscountess of Ventadour, who was the wife of his lord, use all the accepted formulae. For instance the poet feels an inner certainty of the power of love, but at the same time is condemned to separation and suffering:

I thought in love's ways I was wise,
yet little do I know aright.
I praised a woman as love's prize
and she gives nothing to requite.
My heart, my life she took in theft,
she took the world away from me,
and now my plundered self is left
only desire and misery.

(JACK LINDSAY, *The Troubadours and Their World.*
Frederick Muller Limited, 1976, p. 101.)

While the main role of women in the game of courtly love was to be objects of worship, capricious goddesses, women were also allowed to join in as participants, producing poems in reply to those addressed to them. Inevitably they sacrificed some of their dignity in doing so, often complain-

ing of the faithlessness of those who were supposed to be in love with them. In the facing extract the Countess Beatrice de Die, the best known female troubadour, is reproaching a fickle lover.

Troubadour verse was important for two reasons. Firstly, because it created a new pattern for lyric verse, quite different from the models handed down from antiquity. Secondly, it proposed a new pattern for relationships between the sexes in which women were accorded much greater importance and respect—at least if they belonged to the nobility.

O great is my unhappiness
through love of an untruthful knight.
For times to come I tell the plight
I've earned through loving in excess
For he indignantly has fled
and says I'm niggard of my grace.
That fault of mine I do not trace,
whether I'm dressed or stretched abed.

(JACK LINDSAY, *The Troubadours and Their World*. Frederick Muller Limited, 1976.)

Early medieval drama

The early Christian Fathers were violently hostile to the theater, which not only competed with the church as a place of public resort, but which they associated with everything in paganism which was corrupt and degraded—with cruelty, violence, and especially with lewd sexual displays. Nevertheless, despite this hostility, the theater survived as a public institution, even in the western part of the Empire, till as late as the sixth century, when *spectacula* ("spectacles") were still being presented in Rome, which was now under the rule of the barbarian Ostrogoths.

The theater as the Greek and Roman world had known it was finally killed off not by Christian hostility but by economic decline, the collapse of urban life, and—most of all—by barbarian ignorance and indifference. What remained were small groups of entertainers who scraped a living as best they could, performing at feasts, in public places such as markets, or simply by the roadside, wherever an audience could be found. These were the ancestors of the minstrels and buffoons so often portrayed in later medieval art.

Nevertheless, the dramatic instinct would not be denied. Through a strange turn of events, the theater was gradually revived under the auspices of the religion which was officially so hostile to it, and took the church for its setting. The first step came with a gradual elaboration of the liturgy, from the ninth century onwards. The standard antiphons—a sung response in the liturgy—were enriched, first with the insertion of new melodies without words, sung to vowel sounds alone, then with intelligible phrases, which made the tunes easier to remember. These words, in turn, responded to the antiphonal character of church singing, by turning themselves into little dialogues. The earliest, called *Quem quaeris* (Whom seek ye?) was the interview between the three Marys and the angel at Christ's empty sepulcher. This, suitable for Easter, was soon followed by other dialogues appropriate to Christmas and the Ascension. It was

only a short step to dramatic presentation of what was being said, with appropriate gestures and a few symbolic props. By gradual stages, the drama thus acquired the protection of the Church.

Liturgical dramas grew longer and more elaborate. Their authors began to attempt a wider range of subject matter—themes taken from the New Testament, such as the raising of Lazarus and the conversion of St. Paul; and also from the Old Testament—the story of Daniel was particularly popular. There were also plays dramatizing the lives of favorite saints. By the end of the twelfth century the writers of liturgical plays had become consciously "literary." They borrowed from classical sources—there are echoes of Virgil's *Eclogues* and the *Aeneid*. On rare occasions, they broke away from biblical sources entirely. One example is an impressive play devoted to the theme of the Antichrist—his appearance on earth, initial successes, and final defeat—which comes from the Bavarian abbey of Tegensee, and was written *c.* 1160.

It has been doubted if this unconventional *Antichrist* was actually performed in church at all. Churches did, however, remain the setting for the more conventional liturgical plays, and those responsible for writing and producing them developed an elaborate technique for changing scenes, which made these dramas very different in structure from Greek tragedies, which demanded unity of time and place. Developing as it did from the liturgy, the drama remained processional. Each new scene had its proper "station" or location within the building, whose associations were known to everyone, and the playwrights were able to rely on this as a simple means of setting the scene.

A final and decisive step was for the revived drama to leave the hands of the clergy and pass into those of the laity. It left the church building and moved into the open air, becoming once again a fully public and collective spectacle.

Early medieval music

The music of the early Middle Ages, as it is now known to us, is essentially church music. We can, however, assume that there was a musical accompaniment to almost every aspect of life—every feast, every court ceremony, every seasonal celebration of peasant life. The reason why church music has survived more successfully than the rest is that (till very late in the period under review) only clerks were musically (or verbally) literate, and only religious material was considered worth the trouble of writing down.

At this stage in its development, church music was monophonic—that is, it was sung in unison, unaccompanied, and not divided into parts. There were two standard means of varying the music. One was to divide the choir into two parts, and have them sing antiphonally, with one half answering the other. The other, only slightly different from the first, was to set the text as a versicle followed by a response.

The kind of music sung in what had been the western part of the Roman Empire derived from the church chants which had been used in the East from at least the fourth century onwards. The music began to move away from its early Christian and Byzantine models through what were intended as a series of reforms, meant to standardize church liturgy and remove excesses and aberrations. In particular, Charlemagne made an effort to impose a correct Roman or Gregorian (so called after St. Gregory the Great, Pope from 590–604) rite on the chaos of Frankish practices. But plainchant, as unaccompanied monophonic singing is called, did not remain static after this reform, as no doubt Charlemagne and his ecclesiastical mentors had intended. Elaborations soon began to be introduced, in order to enable church music to keep pace with the increasing complexity and grandeur of religious ritual. The most important of these were sequences and tropes. Sequences were hymns written in couplets, with the music repeating itself in each pair of lines. The tunes, to judge from inserted titles, often seem to have been taken from secular sources. Tropes were supplementary phrases of various kinds. The main text could be "farced" or stuffed, with added words and music,

which provided a commentary on it. Or else melismas could be introduced, in which a single syllable was made the basis for a number of notes, instead of being firmly related to a single one. These melismas, in turn, developed texts of their own, as this made them easier to remember—in medieval parlance, they were "prosed." This practice eventually, as it was pushed still further, provided a basis for the new liturgical drama.

Despite the limited means available, and the comparatively narrow boundaries imposed on music by the preconceptions of the time, some beautiful compositions have come down to us from the early Middle Ages. Some of the finest and most personal are the work of a woman, Abbess Hildegard of Bingen (1098–1179). Hildegard, whose parents were German nobles, entered the religious life at the age of eight. She was a religious visionary, an able administrator, the confidante and adviser of popes, kings and emperors. She was also a poet—she wrote in Latin—and a musician. None of these activities were separated in her own mind—she spoke of "writing, seeing, hearing and knowing, all in one manner." Her songs, many of which fall into the category of "sequences" as previously described, have an ecstatic, visionary beauty which seems to mirror an extremely individual and attractive psyche. Some are hymns in praise of the saints; others sing the praises of the Virgin Mary:

O virdissima virgo ave
que in ventosa flabro scisitatonis
sanctorum prodisti.
.
Hail, o greenest branch,
sprung forth in the airy breezes
of the prayers of the saints.

(Translated by Christopher Page, quoted from the sleeve notes to *A feath in the breath of God: sequences and hymns by Abbess Hildegard of Bingen*, Hyperion CDA66039, n.d.)

Chapter 8
The Late Middle Ages

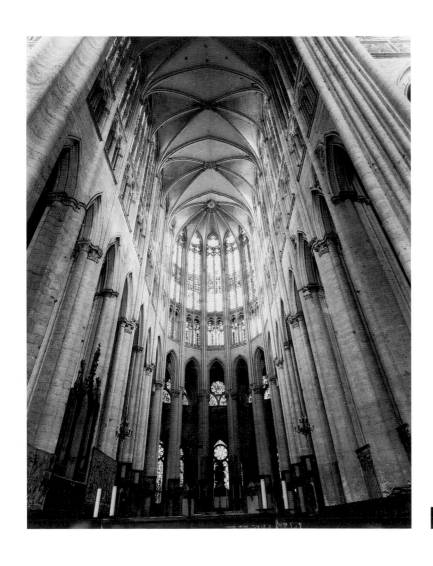

8.1 Beauvais Cathedral, France, 1225–84. Interior
view showing choir vaults and side aisles.

Achievement and decline

The two centuries from 1200 to 1400 cover both the high point of medieval civilization and its rapid decline. In material terms, the thirteenth century was the most prosperous Europe had known since the fall of the Roman Empire. There was a great increase of wealth and trade, and in particular a rapid growth of towns. Paris became by far the largest city in Europe. There was a new urban middle class of merchants and tradesmen. Craft-skills became more sophisticated, and this sophistication was recognized in the increasing elaboration of the guild system, which regulated the training of craftsmen, conditions of labor and methods of manufacture.

Theological debate refined its methods, but worldly considerations impinged more and more brutally on supposedly religious enterprises. From the beginning, the crusades had possessed a materialistic element. By the time of the Fourth Crusade, which captured and sacked Constantinople in 1204, the original idealism had almost completely vanished. In 1229 there was a tellingly ironic event. Jerusalem, lost to Saladin in 1197, was briefly retaken by the Holy Roman Emperor Frederick II, who had been excommunicated because of his political quarrel with Pope Gregory IX. The futile expedition made to the Near East in 1249 by St. Louis (Louis IX of France) marked a last return to the old crusading fervor.

The fourteenth century was marked by a series of catastrophes, chief among them the Black Death which ravaged Europe from 1347 onwards, in some places reducing the population by more than half and causing economic and social chaos. The disease became endemic, and constantly checked attempts at recovery. In 1379 religious unity was shattered by the Great Schism, which left Europe with rival popes for nearly forty years. In 1392 the feeble Charles VI of France lost his reason, and the most powerful kingdom in Europe, already badly damaged by the Hundred Years War between France and England (which started in 1337 and did not end till 1453) seemed likely to disintegrate completely.

Philosophy

St. Thomas Aquinas

The most important thinker of the later medieval period was St. Thomas Aquinas (1224/5–74). Aquinas came from a family of the minor nobility, and was born near Monte Cassino in Italy. He entered the great abbey at that place very young, at his parents' wish, and later studied at the University of Naples, before proceeding to Paris and Cologne for further studies. He taught at Paris from 1252 onwards, and was head of the Dominican house there from 1256 to 1259. He then spent ten years in Italy, following the papal court. Returning to Paris for a second time, he found his ideas being increasingly disputed by the conservative theologians entrenched at the Sorbonne. Perhaps because of this, he left for Naples in 1272. When he died two years later, he was still in Italy but was on his way to the great Church Council being held in Lyons. His greatest work is the *Summae theologicae*, produced at the very end of his life. The first two parts were written between 1266 and 1272; the third was left unfinished at his death.

Aquinas is the most typical, and also the finest, product of the philosophical revolution which took place during the thirteenth century, and his thinking, Thomism, became the basis of medieval intellectual development until the advent of humanism. This revolution was sparked off by a revival of interest in Aristotle, many of whose ideas were now being reimported from the Arab world. Like Aristotle, Aquinas believed that the mind is essentially a blank sheet, upon which external things impinge through the agency of the senses. It is the function of the mind to separate what is incidental and individual about these sense impressions and grasp what is essential.

Aquinas's conviction was that reason and the orderliness it brings with it reflect the unchanging mind and law of God. The crucial distinction in Aquinas's philosophy is between the idea of "essence" and that of "existence." God is the only being in which there is no division between the two—this is because God is entirely perfect. The only way in which humans can achieve any knowledge of God through the exercise of their natural powers, which are necessarily imperfect, is through the use of analogy, which helps us to distinguish what is essential from what is not. That is, when we say "God is good," we recognize that our concept of goodness must fall far short of the goodness actually possessed by God, while at the same time arriving at some idea of what it is.

There is a conflict in Aquinas's thought between imported Aristotelian elements, which ultimately seem to demand that God can be reduced to abstract good or

The Black Death

The Black Death (this name is comparatively modern) is the appellation now usually given to the great epidemic of bubonic and pneumonic plague which swept through Europe in the mid-fourteenth century, killing, at a conservative estimate, between 25 and 45 per cent of the total population. Among the characteristic symptoms of bubonic plague were the black buboes or swellings which appeared in the armpits or groins of the victims. Pneumonic plague, a variant of the same disease, attacked the lungs, and killed more quickly. Infection was spread by fleas, and, in the case of pneumonic plague, through direct contact with an infected person.

The disease seems to have spread to Europe from Central Asia, where it was endemic. It reached Italy in 1347, affecting port cities first, then spreading rapidly through the rest of the Italian peninsula. It reached Paris by the spring of 1348, and London in September. By 1351 the first epidemic had run its course, but the disease reappeared in 1361–2, and there were further epidemics in the fifteenth and sixteenth centuries, with an especially severe outbreak in 1478–80.

Both the social and the artistic consequences of the Black Death were immense. The whole social hierarchy was dislocated. Serfdom was effectively brought to an end; because the demand for labor outstripped supply, peasants were able to move to towns, and the freeing of social structures meant that a new group of manufacturers and tradesmen—the germ of an entrepreneurial middle class—were able to challenge the absolute dominance of the aristocracy. Another consequence of the labor shortage was the development of a new technology based on wind and water power, which in some ways anticipated the Industrial Revolution of the late eighteenth and early nineteenth centuries. This development might have gone still further if the techniques needed to mine and shape metals, particularly iron, had kept pace with other innovations.

Another consequence of the Black Death was that art and literature lost their unity. On the one hand there was an increased emphasis on the transcendental, one important aspect of which was an increase in devotional mysticism centering on the figure of the Virgin Mary, and a horrified contemplation of death and corruption. The miniature showing *Man before His Judge*, in the Rohan Hours (c. 1415), is an example. On the other hand there was a new secularism, the development of a matter-of-fact bourgeois taste interested in the surfaces of things, not their hidden or allegorical meanings. The *Arnolfini Wedding* by Jan Van Eyck (see page 163) is a case in point.

There was a high mortality rate in the universities and among the learned professions. As a result the vernacular tended to replace Latin. In England, it also replaced French, widely used until then as an official language. It was not until 1362, for example, that English became the language of all high courts of law in England. The shift to English in prestigious official contexts necessarily had a profound effect on literature. It was the Black Death which helped to make Chaucer's *Canterbury Tales* (see page 153) possible.

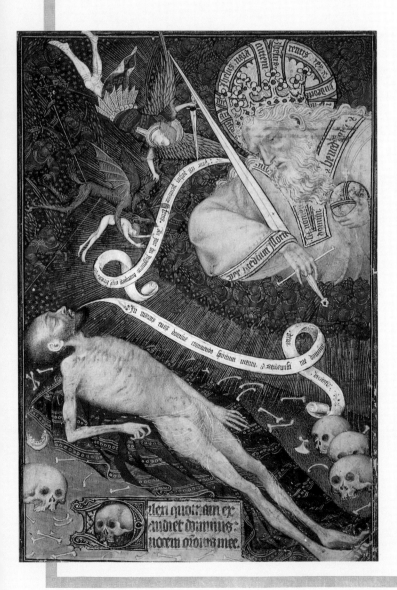

Dead Man before his Judge, from the Rohan Hours, c. 1418–25. Bibliothèque Nationale, Paris.

abstract reason, and therefore that God is limited to acting in accordance with reason, and the more traditional way of thinking inherited from St. Augustine (and ultimately from Moses) which insists that God is beyond human reason and understanding.

In many respects, Aquinas comes close to a kind of deter-

minism. The possibility of any action depends on the form from which it issues; this form in turn is an expression of energy which itself is finally and fundamentally an expression of God's will. We cannot will—that is, decide on a particular course of action—if we do not know what we are willing; completeness of knowledge remains with God.

Architecture

The developed Gothic

The most celebrated, typical, and fully developed buildings in the Gothic style which evolved after 1200 are to be found in France and in England. These buildings, almost invariably ecclesiastical, were often built over long periods, as and when community resources allowed. Sometimes there

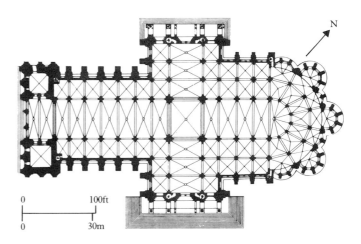

8.2 (*below*) Chartres Cathedral (view of west front), France, 1194–1230. (*right*) Plan of Chartres Cathedral.

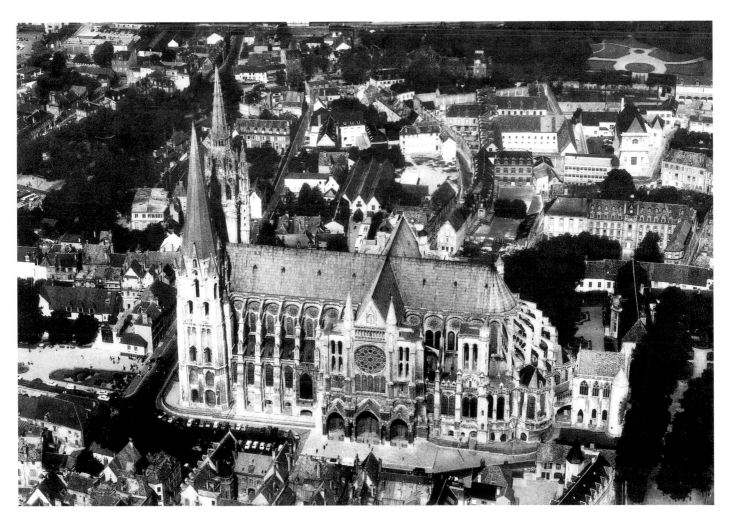

were long breaks between building campaigns; very often the structure was left unfinished in some way, when money or enthusiasm ran out. Many, though not all, Gothic churches show considerable variations in style from one part to another—these reflect the complex history of the enterprise, which could stretch over many generations.

One great cathedral which was built over a comparatively short space of time—though several architects were involved—was Chartres (Fig. **8.2**). The eleventh-century Romanesque church which preceded the present building was destroyed by fire in 1194. A new building was started immediately. The nave was finished by *c.* 1210, the choir by *c.* 1220, and the transepts were completed shortly after 1230. Chartres drew on the experience of previous cathedral-builders, especially those of Notre-Dame in Paris and Laon. It nevertheless represented a new approach to Gothic structure. Basically this involved the immense enlargement of the main windows, so as to let more light into the building. The outside of the building became more intricate—this was partly thanks to the seven towers clustering around the main structure, and partly to the use of elaborate flying buttresses—arched props to support walls by resisting the lateral thrust of vaulted buildings. Within, by contrast, the spaces are larger and simpler than they were in previous buildings of the same type.

Chartres showed the direction French Gothic architecture would take, especially in northern France. The two main characteristics were an exaggerated emphasis on height, and the blurring of the outer boundaries of the structure.

Emphasis on height was carried to its furthest extreme in the cathedral at Beauvais (Fig. **8.1**), where the choir and the western part of the transept were built between 1225 and 1272, and altered after a structural collapse in 1284. After this construction stopped, and was not resumed until the sixteenth century. Since the building never reached the size originally planned, the height of the interior seems even more astonishing. The principal vaults of the choir rise to 144 feet, and even the choir side aisles are 65 feet high. Even after the reconstruction of 1284, which involved dividing the original huge bays into two, the structure seems extraordinarily airy and transparent, a cage for the inpouring light which symbolized Divine Wisdom.

The cathedral at Le Mans, built in several stages between *c.* 1217 and *c.* 1254, makes its effect not as much through sheer height, but through the interpenetration of interior and exterior spaces. It is here that the flying buttresses envelop the apse, the semicircular eastern end of the building, and form a cage within which the main mass is contained. The interior of the church, especially at its upper levels, seems intricately hollowed out, with numerous narrow windows, and the whole structure thus becomes a metaphor for organic, natural growth (Fig. **8.3**).

The Sainte-Chapelle in Paris, built between 1243 and 1248, has the same organic feeling, with much use of plant forms, delicately stylized so as not to break the boundaries of the architectural language which is being used. The building is, however, on a different, much smaller scale from that of the great cathedrals, and was intended for a different purpose. This was not a gathering place for crowds of worshippers, of every social condition. It was the chapel of a royal palace, and also a giant reliquary for a most precious relic—the Crown of Thorns—brought to Paris from Syria and Constantinople in 1239.

One of the ways in which the dual function of the building was emphasized was through the lavish use of stained glass—a feature seen at Chartres, but whose impact is intensified here by the reduced scale of the interior space. The architecture as such is only a framework—the actual substance of the walls is not stone but glass, all the vast windows are filled with glorious sheets of translucent color (Fig. **8.4**).

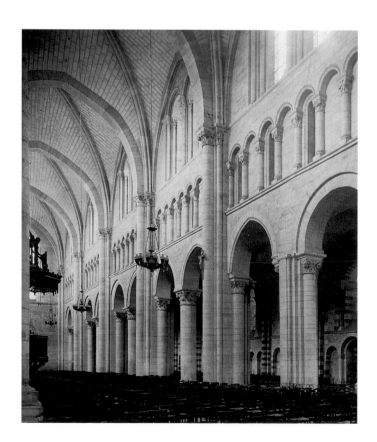

8.3 Le Mans Cathedral (interior), France, *c.* 1217–54.

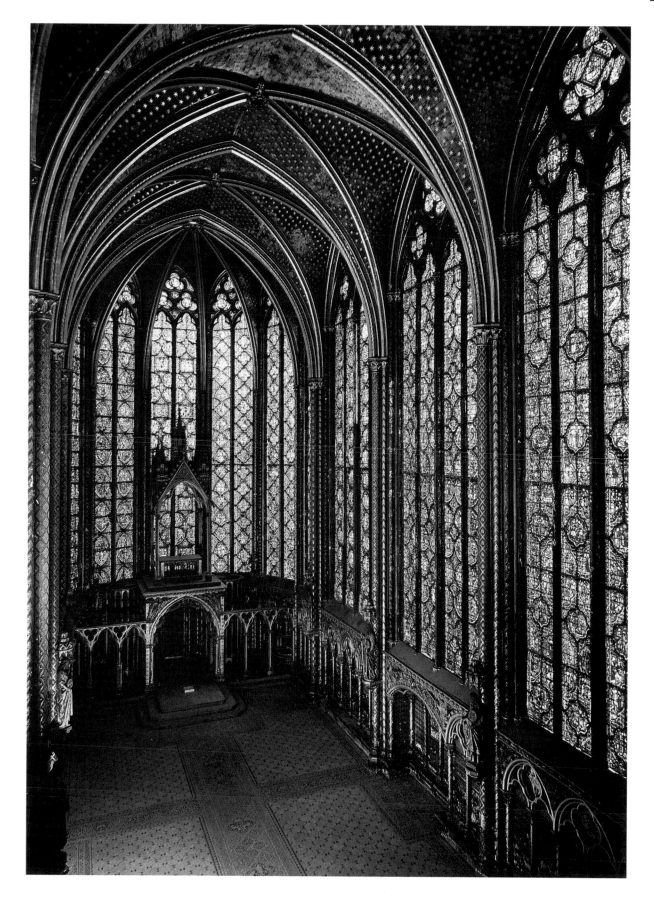

8.4 Sainte-Chapelle, Paris, 1243–48. Interior showing stained-glass windows.

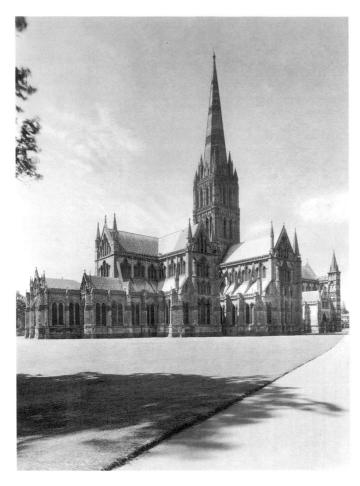

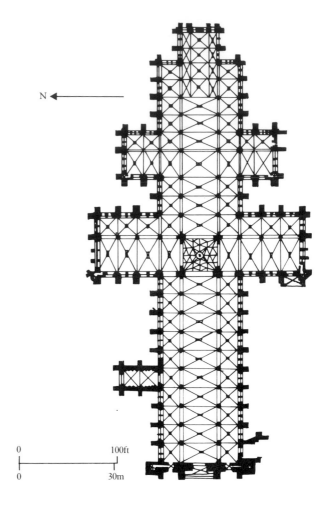

N ←

0 100ft

0 30m

8.5 Salisbury Cathedral (view from the northeast), England, begun 1220. (*right*) Plan of Salisbury Cathedral.

Major English churches differed from their northern French counterparts in being elongated and comparatively low. English Gothic architecture shows a continuous stylistic debate, governed by certain deep-rooted national preferences, which led to marked reversals of taste. From Anglo-Saxon times onwards, for example, English artists had had a taste for the linear. When compared with its French contemporaries or near-contemporaries, the cathedral at Salisbury, for example—one of the most typically English of all Gothic buildings—seems very restrained in most of its details (Fig. **8.5**). The exception is the soaring spire. One marked difference from French cathedrals is the absence of radiating chapels—the east end, like the ends of the transepts, is firmly rectangular. The flat façade, with its repetitive arcades, puts almost as much emphasis on breadth as on height, while the calm, luminous interior space lacks the activity of French equivalents.

The cool simplicity and elegance of Salisbury were replaced, *c.* 1290, by a new style—the Decorated. This makes much use of rich naturalistic carving, and develops the tra-

cery of windows into fantastic, flame-like forms. Characteristic examples can be found in York Minster (Fig. **8.6**).

Around 1330 there was another change, this time to the style known as the Perpendicular, which persisted up to, and well beyond, 1400. A superb early example is the choir of Gloucester Cathedral (Fig. **8.7**), which was radically transformed in the mid-fourteenth century. The funds for this transformation were probably provided by offerings made by pilgrims at the tomb of King Edward II, who was murdered in 1327 and turned into a kind of saint in the popular imagination. Though the walls of the old choir were retained, they were now decorated with rectangular panels with lancet tips. Similar shapes were used for open screens in front of the apertures of the arcades, and the east end was filled with a gigantic tripartite window, again using the same forms. The roof is a network of close-set ribs which spring uninterrupted from soaring pilasters, which emphasize the verticality of the whole. The choir at Gloucester has been compared to a "rigid net through which light and air are allowed to filter."

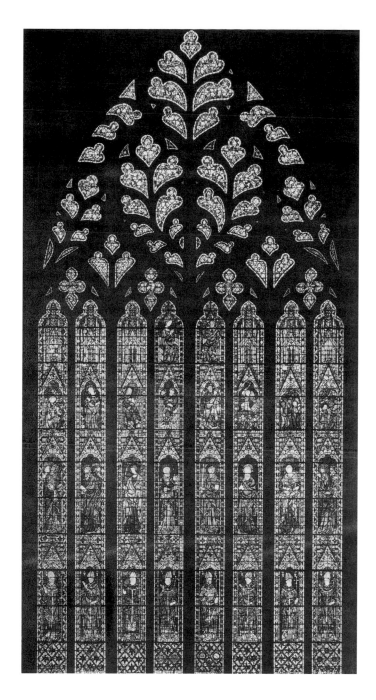

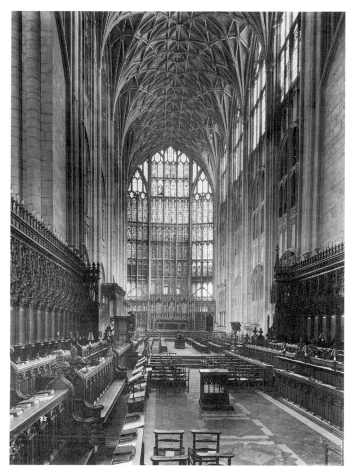

8.7 Gloucester Cathedral, England, mid-14th century. Interior view showing choir and east window.

8.6 (*left*) The great west window of York Minster, England, *c*. 1290.

Stained glass

Stained glass is a way of painting on a monumental scale with colored light. It is particularly suited to the cage-like forms of Gothic architecture, but was introduced into churches long before the development of the Gothic style. The earliest stained-glass windows now surviving go back to the eleventh century, and the technique appears in its full glory a little later, in twelfth-century windows at Chartres and Canterbury. At Canterbury, the earliest surviving glass

is a series of windows depicting the ancestors of Christ (Fig. 8.8). These tremendously grand figures resemble Romanesque portraits of the evangelists in English manuscripts. Indeed, everywhere they appear, stained-glass windows are closely linked to contemporary illumination. The difference is that they are on a monumental scale. The impact of these windows, with their overwhelming color, must have been profound. They were perhaps the most effective means of

fixing the stories found in the Bible and the legends of the saints in the minds of an audience most of which remained illiterate. It is not surprising that, in all the lands where Gothic architecture burgeoned most vigorously, the technique rapidly became the successful rival of mural painting.

In the first half of the thirteenth century, it was Chartres Cathedral which drew to itself all the most accomplished makers of stained glass. The effort they undertook was enormous. Between 1200 and 1235 they created 107 windows—over 1,000 square yards of stained glass. The donors of these windows included princes and members of the high nobility, and also collective patrons of much humbler status—trade guilds such as the furriers, cloth merchants, shoemakers, haberdashers, masons, and carpenters. The windows paid for by the guilds feature the story of an appropriate patron saint, but in their lower borders they also have lively scenes showing the activities of those who paid. If these scenes can seem surprisingly matter-of-fact, the element of romance is not absent from the stained glass at Chartres. One celebrated window tells the story of Charlemagne, and is based on *The Song of Roland* (Fig. **8.9**).

8.8 Canterbury Cathedral, England, 12th century. Interior view showing Ancestors of Christ stained-glass window from the southeast transept.

8.10 Robert of Rochester drowned while throwing stones at the frogs. Panel 47 from the North Ambulatory, Trinity Chapel, Canterbury Cathedral, England, 13th century.

This window is interesting in other respects as well. It offers a typical example of the way narrative scenes are treated both at Chartres and in other stained glass of the same date. The various episodes fill shaped panels, in this case circles and segments of circles, placed against a richly checkered background. These narrative episodes in separate frames are one of the things stained-glass windows have in common with Gothic manuscripts.

English stained glass shows the same arrangement of narrative scenes in medallions that one meets in France, together with the same gradual evolution toward a softer style of drapery that can be seen in French glass of the same date.

8.9 (*left*) The Charlemagne Window, donated by the furriers in the 13th century, Chartres Cathedral, France.

The major cycle of stained-glass windows is at Canterbury. Many are devoted to the story of St. Thomas à Becket and his posthumous miracles (Fig. **8.10**). Several illustrations to the latter have a homely touch: for example, there is one that tells the story of a little boy who fell into the River Medway while throwing stones at frogs.

Much English stained glass also survives from the fourteenth century, especially at York. The donors of the York Minster windows were the usual mixture of aristocrats and commoners, each intent on signaling their own interests. For example, the west windows were the gift of Archbishop Melton in 1338 (Fig. **8.6**), while other windows were the gift of the bell-founders, who naturally had a professional interest in the great church. It was now becoming customary to commission stained glass not merely out of piety but also to commemorate events held to be of general significance. The great east window at Gloucester, for example, put up between 1347 and 1349, is a memorial to the Battle of Crécy, one of the turning points of the Hundred Years War, and was paid for by the commander of the English divisions.

Gothic illumination

The dominance of stained glass as a means of pictorial expression led to close links being forged between this and the art of illumination. Some French manuscripts often have the air of being sets of stained-glass windows transposed into book form. This is the case with the Psalter of St. Louis, which dates from *c.* 1256 (Fig. **8.11**). It begins with a series of seventy-eight full-page paintings showing Old Testament scenes, and the stylization of the architectural settings conforms even more closely than the figures to the graceful attenuated line of the Gothic. The architecture reproduced is that of Sainte-Chapelle in Paris, also commissioned by St. Louis, and there was perhaps direct intervention from the architect of the building, Pierre de Montreuil.

The full blossoming of the Gothic style in northern Europe can be traced most readily in France—and particularly in illumination. Thanks to the portability of books, as opposed to buildings, these French creations had a widespread influence, to the point where the developed Gothic became a completely international stylistic language. The leading French illuminator of the mid-fourteenth century was Jean Pucelle, and the most famous manuscript ascribed to him is the Hours of Joan of Evreux, wife of Charles IV of France (Fig. **8.12**). One feature of Pucelle's work, very visible in this manuscript, is its rhythmic elegance, which

8.11 *Gideon's Army Surprises the Midianites.*
Illustration from the Psalter of St. Louis, *c.* 1256. 4¾ × 3⅝ ins
(12.1 × 9.2 cm). Bibliothèque Nationale, Paris.

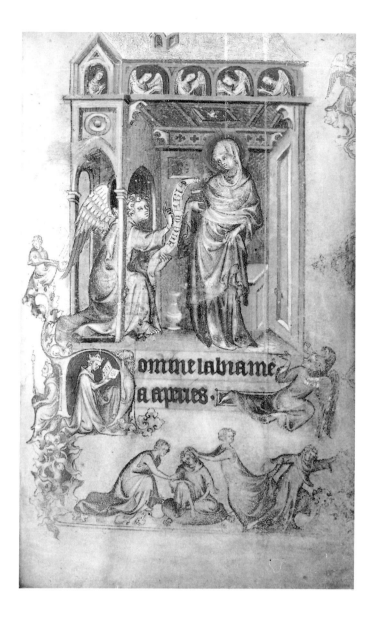

8.12 Jean Pucelle, *The Annunciation*. Illustration from the *Hours of Jeanne d'Evreux*, 1325–28. Grisaille and color on vellum. 3½ × 2⁷⁄₁₆ ins (8.9 × 6.2 cm). The Metropolitan Museum of Art, New York (The Cloisters Collection, 1954).

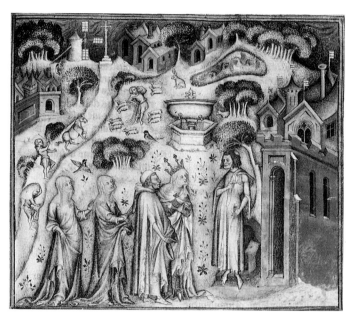

8.13 *Nature Presenting Her Children, Sense, Rhetoric, and Music to Guillaume de Machaut*. Illustration from the "Works" of the musician Machaut, *c.* 1370. Bibliothèque Nationale, Paris.

does not exclude subtle modeling, obtained almost entirely through the use of color. This color is not necessarily very strong—in fact, the manuscripts associated most strongly with Pucelle himself show a subdued range of clear tones.

After Pucelle a current of realism is identifiable in French illumination. This style is well represented in a series of tinted drawings of *c.* 1370 which illustrate a copy of the *Works* of the poet and musician Guillaume de Machaut (see page 154). The illustration showing "Nature Presenting Her Children, Sense, Rhetoric, and Music, to Guillaume de Machaut" (Fig. **8.13**), shows the earliest attempt made in France to integrate figures and landscape. This style looks forward to what was to happen in the first decades of the fifteenth century.

Painting

Italian *dugento* and *trecento* painting

The scarcity of both frescos and panel paintings in France, and indeed throughout the whole of northern Europe, due both to the competition offered by stained glass and to hostile climatic conditions, which meant a poor rate of survival, does not extend to Italy. The development of Italian painting from the end of the thirteenth century onwards is to be traced through frescos and altarpieces, not through stained glass and illuminated manuscripts. Two figures of seminal importance are Cimabue and Giotto.

Cimabue (*c.* 1240–1302) is the first major Italian painter on panel. The context he emerges from is obscure and confusing. The earliest Italian panel paintings seem to cut across all theories about the development of western European art. Some are sculptures almost as much as they are paintings—they are painted crucifixes, made to be fixed to a beam running across the chancel, from which they dominated the whole church. The earliest-known example is dated 1138, and is in the cathedral at Sarzana, near Spezia. Christ is shown living, upright, and calm. This symbolism, implying that Christ remained triumphant over death, con-

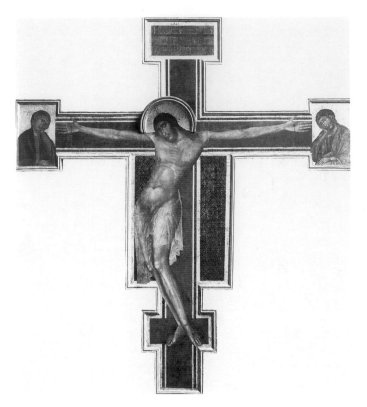

8.14 Cimabue, *Crucifix*.
Tempera on panel, 15 ft × 13 ft (4.57 × 3.95 m).
Museo dell'Opera, Santa Croce, Florence.

8.15 Cimabue *Madonna Enthroned c.* 1280–90.
Tempera on wood, approx. 12 ft 7½ ins × 7 ft 4 ins (3.84 × 2.24 m).
Uffizi Gallery, Florence.

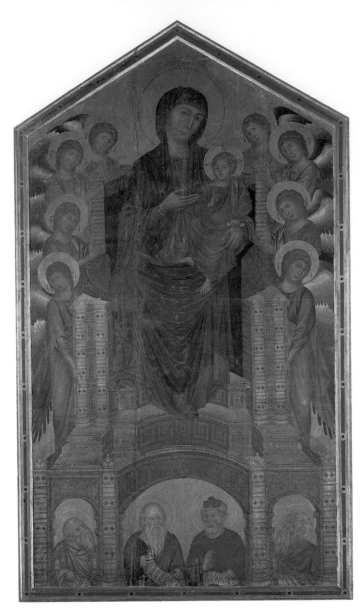

tinued to be used in the early thirteenth century, but gradually the conception of the Christ figure became more dramatic. By about 1240, it had become the rule to show the Savior already dead on the Cross, his body twisted and agonized by his sufferings. The crucifixes attributed to Cimabue are the culmination of this development, deeply moving, tragic images (Fig. **8.14**). The type Cimabue chooses for his Christ figure, and most of all the face, reveals his stylistic roots—there is a close connection with contemporary Byzantine art. Cimabue's paintings of the Madonna and Child (Fig. **8.15**)—the most securely attributed is the great panel now in the Uffizi in Florence—confirm this Byzantine connection. There are, however, significant deviations from Byzantine prototypes. The Madonna looks sweeter and more approachable than she does in Greek Orthodox paintings—she seems to invite a more popular kind of devotion. She is also, at the same time, more solid and monumental. Both these characteristics point the way forward for Italian art, and, in particular, they seem to set the stage for the work of Giotto (*c.* 1267–1337), acknowledged as a turning point in the history of Western art.

Giotto, Duccio, and Simone Martini

Giotto's importance was widely acknowledged in his own time—for example, by Dante (see page 152), who was his contemporary. It was reaffirmed in the sixteenth century by Giorgio Vasari, whose *Lives of the Artists* created a long-accepted pattern for the interpretation of Italian art. Vasari's life of Giotto begins with a resounding claim:

> In my opinion painters owe to Giotto, the Florentine painter, exactly the same debt they owe to nature, which constantly serves them as a model and whose finest and most beautiful objects they are always striving to imitate and reproduce.

(GIORGIO VASARI, *Lives of the Artists*, Vol. I, translated by George Bull. Penguin Books Ltd., 1987.)

For historians of Italian Renaissance art, Giotto is the great precursor, standing at the beginning of something. For historians of the Gothic he is an embarrassment, since

he seems like a rock round which the current of the Gothic eddies as it flows. He becomes explicable only if one compares him not to contemporary painters but to contemporary sculptors, and in particular to Nicola and Giovanni Pisano (see page 151) and to Arnolfo di Cambio. Giotto's style has shed the Byzantine elements in Cimabue, and has become a translation of the sculptors' work from three dimensions into two, with the addition of a keen interest in the movement of his figures, and their psychological interplay.

Perhaps Giotto's greatest works are those in the Arena Chapel at Padua. The patron, significantly, was neither a king nor a prince; he was Enrico Scrovegni, a rich merchant whose father had been a notorious usurer. The chapel, built

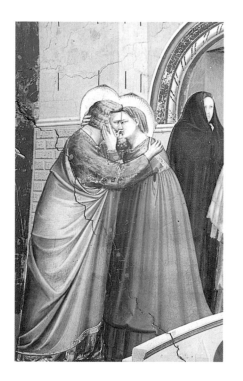

8.16 Giotto, *The Meeting of St. Joachim and St. Anna at the Golden Gate c.* 1304–13.
Fresco in the Arena Chapel, Padua.

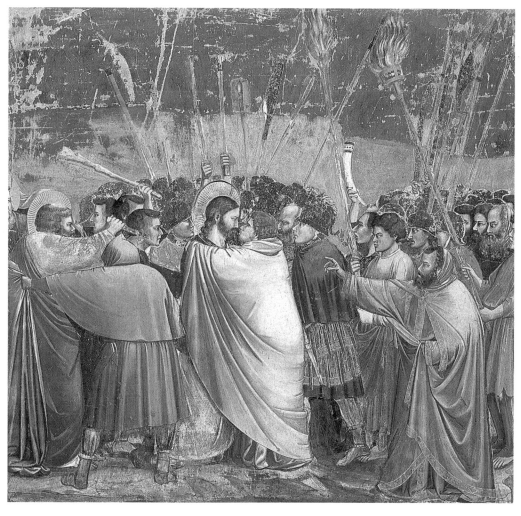

8.17 Giotto, *The Kiss of Judas c.* 1305–6.
Detail of fresco in the Arena Chapel, Padua.

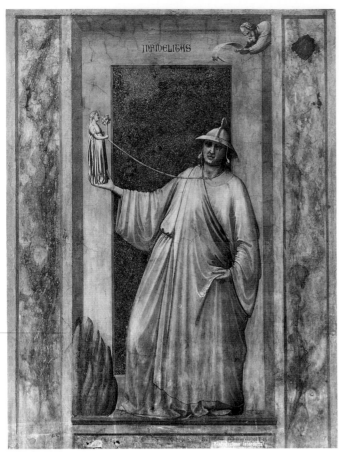

8.18 Giotto, *Infidelity* from the *Seven Virtues and Vices* 1304–13. Fresco in the Arena Chapel, Padua.

8.19 Duccio, central panel from the *Maestà: Madonna Enthroned c.* 1311.
Panel, approx. 196 ins (497.8 cm) wide.
Museo dell'Opera del Duomo, Siena.

and consecrated between 1303 and 1305, seems to have been partly an expression of social and political ambition, and partly an expiation for the transgressions of Enrico's father. The frescos themselves were painted between 1304 and 1313, probably toward the beginning of that period. The interest in weight and volume is everywhere apparent and makes Giotto's work quite different from the Gothic style then flourishing north of the Alps. Some of the compositions are extremely calm and hushed—for instance, the scene showing the meeting of *St. Joachim and St. Anna* (Fig. **8.16**), where the heavy folds of the garments help to establish the equilibrium of the figures. Others are filled with energy. One feels this in *The Kiss of Judas* (Fig. **8.17**), which features a similar embrace, though with a very different meaning. Here the waving torches help to establish the agitated pictorial rhythm.

The chapel is full of innovatory ideas with much significance for the future. For example, there are small monochrome frescos of the Seven Virtues and the Seven Vices punctuating the dado. These *trompe l'oeil* representations (Fig. **8.18**) stress Giotto's commitment to the idea of realism in art, and are the precursors of the fictive statues, also in monochrome, which appear on the backs of the side-panels of some Flemish fifteenth century altarpieces. The idea, in these cases, was to make the altarpieces look like pieces of sculpture when the wings were closed.

Apart from Giotto, the most important painter working in Italy during the early years of the fourteenth century was his slightly older contemporary from Siena, Duccio (active *c.* 1278–1318). Siena was smaller than Florence, politically more conservative, and more under the domination of the Church. As far as is known, Duccio painted no frescos. The work which made him celebrated was his now partly dis-

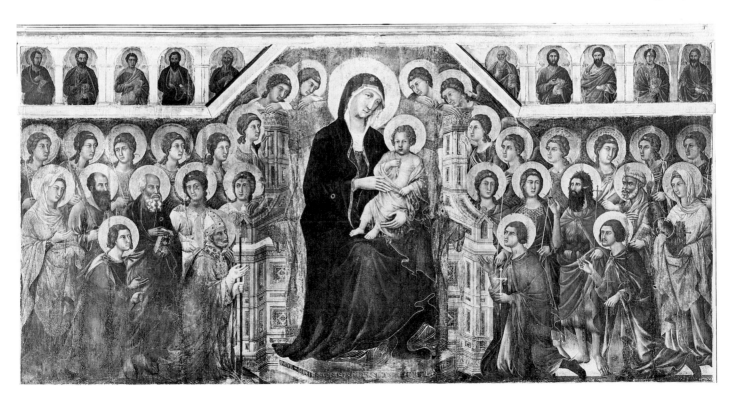

membered *Maestà* (Fig. **8.19**), painted for Siena Cathedral, and carried there in a triumphal procession on June 9, 1311. In addition to the main panel, showing the Virgin and Child surrounded by saints and angels, this offers a wealth of subsidiary scenes. Not all of these are now attributed to Duccio himself, but the one which shows the *Twelve-Year-Old Christ Child Discoursing in the Temple* (Fig. **8.20**) demonstrates that Duccio's feeling for spatial organization was very different from that of Giotto. The irrational yet nevertheless convincing perspective construction, with its uptilted, violently patterned floor, seems to enfold the figures and place them in a special sphere.

Among the painters who helped Duccio with the *Maestà* were other leading Sienese artists of the early fourteenth century, chief among them Simone Martini (*c.* 1284–1344). His work shows that the Italian art of the time was by no means impervious to influences from across the Alps, but this was combined with an equally obvious debt to Giotto. Giotto's influence is visible, for example, in the huge canopy which shelters the Virgin and her attendant saints in Simone's own *Maestà* of *c.* 1315 (Fig. **8.21**), now in the Palazzo Publico, Siena. Yet the throne on which the Virgin sits is pure French Gothic.

Orcagna, Florentine painting, and the Black Death

The painting of Simone Martini influenced all Europe, not least because of his prestigious connection with the papal court at Avignon. Meanwhile, art in Italy, and specifically in Tuscany, began to develop in a different direction. The Tuscan painting of the second half of the fourteenth century has been seen as an inexplicable deviation from the progressive course already mapped out for art by Giotto.

The artist most closely associated with this new tendency was Andrea Orcagna (*c.* 1308–68), now chiefly known from

8.20 **Duccio**, panel from the *Maestà: The Twelve-Year-Old Christ Child Discoursing in the Temple c.* 1311.
Panel, approx. 18¾ × 18⅘ ins (47.6 × 47.8 cm).
Museo dell'Opera del Duomo, Siena.

8.22 **Andrea Orcagna**, *The Glory of Paradise*.
From the Strozzi Altarpiece, 1354–57, in the Strozzi Chapel, Sta. Maria Novella, Florence.

8.21 **Simone Martini**, *Maestà c.* 1315. 300⅖ × 382 ins (763 × 970 cm). Palazzo Pubblico, Siena.

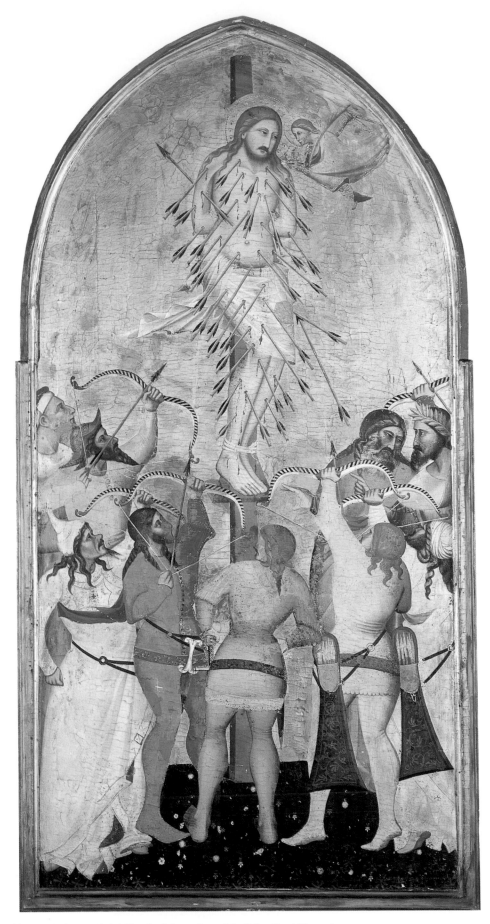

8.23 **Giovanni del Biondo**, *Martyrdom of St. Sebastian* 14th century.
Museo dell'Opera del Duomo, Florence.

his altarpiece (Fig. **8.22**) in the Strozzi chapel in Santa Maria Novella in Florence, painted between 1354 and 1357. Orcagna, in addition to being a painter, was the chief director of an important sculptural enterprise—the richly carved tabernacle for Orsanmichele, also in Florence. Yet the Strozzi altarpiece is not a work one would immediately associate with a sculptor. It shows a powerful reaction against Giotto's solidity, and a rebellion against the demand for a logically ordered pictorial space. Giotto's experiments with perspective have been abandoned and the composition is bound together with a purely linear rhythm. Christ is the central figure, seated but apparently floating in the air, staring straight out at the spectator. To his left is the Virgin, and the kneeling St. Thomas Aquinas, to whom Christ hands a book. To the left again are the paired figures of St. Catherine and St. Michael. These are locked together in a spatially ambiguous way—St. Catherine stands behind St. Michael, but is taller and so at first appears to be in front of him.

Orcagna's altarpiece makes no direct allusion to the Black Death, which appeared in Florence in 1348, killing about half the population of the city, just a few years before the Strozzi altarpiece was painted. Yet the new spirit it exemplifies—remote, hierarchic, slightly threatening—can be seen as part of a climate of feeling generated by the calamity, and also by the various economic and social ills which preceded and followed it. In the years immediately before the Black Death the Florentine banking system was shaken by a series of bankruptcies. After the first visitation of the plague there was inevitable social disruption, spiraling inflation, and a movement of population from the countryside to the towns. Further visitations of plague kept people's minds on the idea of divine wrath and consequent damnation.

There are works from Orcagna's immediate circle which do seem to allude directly to these catastrophic events. One is a particularly cruel painting showing *The Martyrdom of St. Sebastian* (Fig. **8.23**) by Giovanni del Biondo (*fl.* 1356–92). This shows the saint's tortured body running with blood and riddled with more than thirty arrows. The cult of St. Sebastian had become newly popular, as he was considered to be an intercessor against epidemic disease. The plague was thought of as a kind of divine thunderbolt, and was symbolized by a shower of arrows.

Gothic sculpture

There is a marked division between the Gothic sculpture produced in northern Europe, especially in France, and the sculpture produced at the same period in Italy, though in both there is a dialogue with the Classical past. In France, this dialogue, already visible in Romanesque stone-carving, developed smoothly. It continued in a subtler and more sophisticated form in the work produced between 1200 and 1400, and there is no sense of a violent break.

The transition from Romanesque to Gothic occurs first at Chartres Cathedral, and is embodied in the figures of the ancestors of Christ which adorn the west portal of the cathedral (Fig. **8.24**). These date from *c.* 1145–70.

Each figure is placed on a pedestal, and is carved more or less fully in the round. It forms part of an architectural whole, and is elongated so as to conform with the column to which it is attached, but there is no pretence that it has any structural function. The carving of the drapery is of rather mannered delicacy, and every head is individually characterized. Those of the women often wear an equivalent of the "Archaic smile" to be found in early Greek art. The treatment of the hair and of the men's beards also has the exquisiteness associated with sixth-century B.C. Greek statues and reliefs.

The mood of the figures, however, is one of solemn inwardness. Their rigid poses are in part dictated by the

8.24 Jamb statues, west portal. Chartres Cathedral, France, *c.* 1145–70.

8.25 Sculptures over the central door at Rheims Cathedral, France, c. 1225–45.

8.26 Portrait tomb statues of Charles V of France and his Queen, 1364. Basilica of Saint Denis, near Paris.

architectural setting, but also by the revelation which has been made to them, and which now entrances them and holds them fast. Greek art never had this transcendental quality, and Gothic art was soon to lose it.

The next phase of French Gothic is represented by the sculptures over the central door at Rheims Cathedral (Fig. 8.25). What the figures have in common is a greater solidity, yet also a greater fluidity, than their predecessors at Chartres. One leg is firmly placed, the other is slightly bent. The drapery is much rounder, fuller, and weightier, and has often been compared to drapery in Roman statuary. Few classical statues, however, sway in quite this self-conscious fashion. What one sees here is the beginning of the exaggerated S-curve which was to appear in the fourteenth century.

In the fourteenth century French sculpture started to move in two different directions. On the one hand, there was a tendency toward ever-greater refinement and other-worldliness, exemplified in many statues and statuettes of the Virgin and Child, the statuettes often made in precious material such as ivory. The swaying hip-shot pose of the

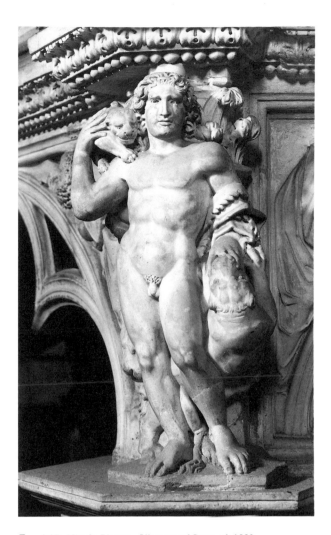

8.27 Nicola Pisano, *Allegory of Strength* 1260. Marble, 22 ins (56 cm) high. Baptistery pulpit, Pisa.

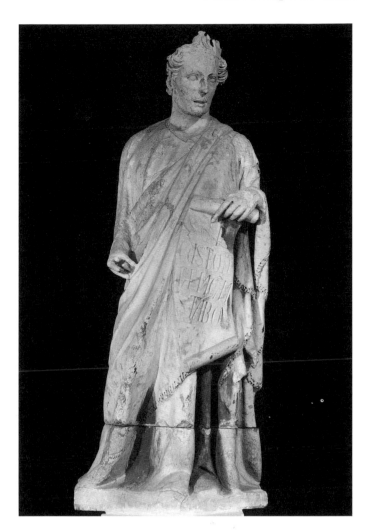

8.28 Giovanni Pisano, *The Prophet Habbakuk* c. 1314–19. Museo dell'Opera del Duomo, Siena.

Virgin is increasingly exaggerated; her smile is always aloof and enigmatic. On the other hand, there was an increasing interest in realism, exemplified in portrait statues, such as those of Charles V of France (1364–80) (Fig. **8.26**) and his queen, Jeanne de Bourbon. These are work of unsparing, indeed rather brutal, veracity. The royal dignity of the figures is maintained chiefly by the heavy folds of their costumes.

In spite of the greater poise and coherence of French Late Gothic sculpture, it was the Italian sculpture of the period which provided a starting point for later artists. Nicola Pisano (*fl.* 1258–78) appears to have been born and trained in the south of Italy, but executed his chief works in Pisa and Siena. Though the pulpit he carved for the baptistery in Pisa is undoubtedly Gothic as far as its actual architecture is concerned, many details show his fascination with Roman sculpture. An example is the statuette of Strength (Fig. **8.27**), one of six which stand at the corners of the hexagonal structure. This is a sturdy but rather naïve classical nude, which follows a Classical model with much greater liberalism than anything seen in France. It is derived from a

Roman sarcophagus, and foreshadows all the would-be classical nudes which were to be created by the sculptors of the Italian Renaissance.

Pisano's son and successor, Giovanni (*c.* 1250–after 1315), anticipates Renaissance sculpture in a different way. He signals that it was also to contain a powerful anti-classical element. Among his major achievements is a series of figures designed for the façade of Siena Cathedral. The best known of these is the prophet Habbakuk (Fig. **8.28**). Formally, this is innovative. It leans forward, as if ready to abandon the building against which it is placed, and opening up the possibility that sculpture could embrace multiple viewpoints. Sculpture is here loosening the bonds with architecture which had governed possibilities and forms ever since the Romanesque period.

At the same time there is an intensity of mood which marks the birth of a new kind of inner life. This intensity was something which would reappear in Renaissance art—in the work of Donatello (see page 184) and then Michelangelo (see page 203). The otherworldly mood of so much Gothic sculpture is here definitively abandoned.

Literature

Dante's *Divine Comedy*

Dante's position as one of the greatest medieval poets has always been recognized. The importance of his work is enhanced by his decision to write "in the vulgar tongue"—that is, in the vernacular Italian spoken in his own day and not in Latin. His work, therefore, marks a major step forward in the creation of the various literatures which give the civilization of western Europe so much of its distinctive coloring.

Dante was a Florentine, born in 1265. His involvement in the complicated politics of the city led to his exile in 1302. His chief work, the *Divine Comedy*, was begun about 1308, and completed just before his death, which took place in Ravenna in 1321.

The *Divine Comedy* is an intricately planned, rigorously symmetrical narrative poem which owes much, both in its actual shaping and its philosophical attitudes, to the work of St. Thomas Aquinas. It tells of the poet's descent into Hell (the *Inferno*), and how he then passes through the center of the world, and ascends the two terraces and seven cornices of Mount Purgatory (the *Purgatorio*). From Mount Purgatory he proceeds to Heaven itself (the *Paradiso*), and is brought into the presence of God—"the love that moves the sun and other stars." The whole poem is thus an elaborate allegory which describes the final union of the individual human will with the Universal Will which presides over the whole of creation.

One of the striking things about the *Divine Comedy* is the contrast between its intricate, crystalline intellectual structure and the concrete, specific detail with which Dante fills almost every line of the poem, especially in the first two parts. Many of the personages described are contemporaries, whom Dante would have known when they were alive. Among the damned, for example, he finds Bruno Latini, an old scholar who once taught him, condemned to run eternally over the burning sand. The moment of meeting is extraordinarily affecting:

"Keep handy my *Thesaurus*, where I yet
Live on; I ask no more." Then he turned round,

And seemed like one of those who over the flat
And open course in the fields beside Verona
Run for the green cloth; and he seemed, at that,

Not like a loser, but the winning runner.

(DANTE, *Inferno*, translated by Dorothy L. Sayers.
Penguin Books Ltd., 1949.)

These contemporary personages are mixed with legendary ones—for example, Ulysses, condemned for his deception of the Trojans by means of the wooden horse which got the Greeks into Troy. Virgil compels Ulysses, imprisoned within a flame which he shares with his confederate Diomedes, to tell the story of his last voyage, after the triumphant return to Ithaca. Here the poetry is as resonant and grand as anything could be:

"When at long last hove up a mountain, grey
With distance, and so lofty and so steep,
I never had seen the like in any day.

Then we rejoiced, but soon we wished to weep,
For out of the unknown land there blew foul weather,
And a whirlwind struck the forepart of the ship;

And three times round she went in a roaring smother
With all the waters; at the fourth, the poop
Rose, and the prow went down, as pleased Another,

And over our heads the hollow seas closed up."

(DANTE, *Inferno*, translated by Dorothy L. Sayers.
Penguin Books Ltd., 1949.)

These two extracts show, within a small compass, Dante's directness, combined with a great flexibility of tone. The whole narrative, meanwhile, is carried forward by the interlocking rhymes of the *terza rima*—the first and third line of every three-line stanza rhymes with the second line of the one preceding.

Chaucer's *Canterbury Tales*

Geoffrey Chaucer (*c.* 1349–1400) was a universal writer of a very different stamp from Dante. Instead of trying to provide a comprehensive account of the three realms which humans might, according to their conduct upon earth, expect to see after death, he attempted to provide a panoramic picture of earthly society as he himself knew and experienced it. His experience was wide—he was of middle-class origin, served in the English armies in France and then as a royal administrator, and married the sister of the third wife of John of Gaunt, Duke of Lancaster, uncle of Richard II.

The Canterbury Tales, Chaucer's most important work, was begun *c.* 1386–7, and never fully completed. The original intention was that there should be around 120 tales, told by thirty pilgrims. Each was to tell two on the way to Canterbury and two on the way back. It is not surprising that this gigantic scheme was never finished. Nevertheless, as it stands the work gives a strikingly vivid portrait of English society in the fourteenth century. The popular pilgrimage to the shrine of St. Thomas à Becket provides a framework which allows Chaucer to introduce a wide variety of human types. The great medieval pilgrimages, more than any other social event, brought apparently ill-assorted people together for a common purpose.

The Cook's Tale

The Cook's Prologue followed by *The Cook's Tale* demonstrate Chaucer's basic method throughout *The Canterbury Tales*. One of the pilgrims is described, then tells a story to entertain the others. The characterization of the scapegrace prentice shows Chaucer's eye for lifelike details.

The Cook's Prologue

The Cook, in joy to hear the Miller pickled,
Laughed like a man whose back is being tickled;
"Haha!" he roared. "Haha! Christ's blessed passion!
That miller was paid out in proper fashion
For trying to argue that his house was small!
'Be careful who you bring into the hall,'
Says Solomon in Ecclesiasticus,
For guests who stay the night are dangerous.
A man can't be too careful when he brings
A stranger in among his private things.
May the Lord send me misery and care
If ever, since they called me Hodge of Ware,
I heard a miller scored off so completely!
That jest of malice in the dark came neatly.

 "But God forbid that we should stop at that,
So if you'll condescend to hear my chat,
I'll tell a tale, though only a poor man;
But I will do the very best I can,
A little joke that happened in our city."

 "Well," said our Host, "let it be good and witty;
Now tell on, Roger, for the word's with you.
You've stolen gravy out of many a stew,
Many's the Jack of Dover you have sold
That has been twice warmed up and twice left cold;
Many a pilgrim's cursed you more than sparsely
When suffering the effects of your stale parsley
Which they had eaten with your stubble-fed goose;
Your shop is one where many a fly is loose.
Tell on, my gentle Roger, and I beg
You won't be angry if I pull your leg,
Many a true word has been said in jest."

 "That's sure enough," said Roger, "for the rest,
'True jest, bad jest' is what the Flemings say,
And therefore, Harry Bailey, don't give way
To temper either if I have a plan
To tell a tale about a publican
Before we part. Still, I won't tell it yet,
I'll wait until we part to pay my debt."
And then he laughed and brightened up a bit
And he began his story. This was it.

The Cook's Tale

There was a prentice living in our town
Worked in the victualling trade, and he was brown,
Brown as a berry; spruce and short he stood,
As gallant as a goldfinch in the wood.
Black were his locks and combed with fetching skill;
He danced so merrily, with such a will,
That he was known as Revelling Peterkin.
He was as full of love, as full of sin
As hives are full of honey, and as sweet.
Lucky the wench that Peter chanced to meet.
At every wedding he would sing and hop,
And he preferred the tavern to the shop.

 Whenever any pageant or procession
Came down Cheapside, goodbye to his profession!
He'd leap out of the shop to see the sight
And join the dance and not come back that night.
He gathered round him many of his sort
And made a gang for dancing, song and sport.
They used to make appointments where to meet
For playing dice in such and such a street,
And no apprentice had a touch so nice
As Peter when it came to casting dice.
Yet he was generous and freely spent
In certain secret places where he went.
Of this his master soon became aware;
Many a time he found the till was bare,
For an apprentice that's a reveller,
With music, riot, dice or paramour,
Will surely cost his shop and master dear;
Though little music will his master hear.
Riot and theft can interchange and are
Convertible by fiddle and guitar.
Revels and honesty among the poor
Are pretty soon at strife, you may be sure.

 This jolly prentice—so the matter stood
Till nearly out of his apprenticehood—
Stayed in his job, was scolded without fail,
And sometimes led with minstrelsy to jail.

 But in the end his master, taking thought
While casting up what he had sold and bought,
Hit on a proverb, as he sat and pored:
"Throw out a rotten apple from the hoard
Or it will rot the others": thus it ran.
So with a riotous servant; sack the man,
Or he'll corrupt all others in the place;
Far wiser to dismiss him in disgrace.

 His master, then, gave Peterkin the sack
With curses, and forbade him to come back;
And so this jolly apprentice left his shop.
Now let him revel all the night, or stop.

 As there's no thief but has a pal or plucker
To help him to lay waste, or milk the sucker
From whom he borrows cash, or steals instead,
Peter sent round his bundle and his bed
To a young fellow of the self-same sort
Equally fond of revelling, dice and sport,
Whose wife kept shop—to save her good repute;
But earned her living as a prostitute . . .
(Of the Cook's Tale Chaucer made no more)

Chaucer

(CHAUCER, *The Canterbury Tales*, translated by Nevill Coghill.
Penguin Classics, 1951. Copyright Nevill Coghill,
1951. Reprinted by permission of Penguin Books Ltd.)

Chaucer illuminates the characters of his pilgrims in two ways—through the tales they tell, and through the descriptions he gives in the "Prologue," which is perhaps the most-celebrated part of the whole work. His characterizations are as economical as they are brilliant:

There also was a *Nun*, a Prioress,
Her way of smiling very simple and coy,
Her greatest oath was only "By St. Loy!"
And she was known as Madam Eglantyne.
And well she sang a service, with a fine
Intoning through her nose, as was most seemly,
And she spoke daintily in French, extremely,
After the style of Stratford-atte-Bowe;
French in the Paris style she did not know.

(GEOFFREY CHAUCER, *The Canterbury Tales*, translated by Nevill Coghill. Penguin Books Ltd., 1951.)

One significant aspect of the work is the way in which it satirizes not religion itself but the failings and follies of the Church. The portrait of the Prioress offers a mild example

of this. A much sharper one is the characterization of the Pardoner—a pardoner was a man who had papal authority to sell pardons and indulgences (the latter were remissions of the time to be spent in Purgatory):

He aimed at riding in the latest mode;
But for a little cap his head was bare
And he had bulging eyeballs, like a hare.
He'd sewed a holy relic in his cap;
His wallet lay before him on his lap,
Brimful of pardons come from Rome all hot.
He had the same small voice a goat has got.

(GEOFFREY CHAUCER, *The Canterbury Tales*, translated by Nevill Coghill. Penguin Books Ltd., 1951.)

Good-humored though this is, one catches a note which heralds the great religious upheaval of the Reformation (see page 208).

Another very significant thing about Chaucer is his actual language. Though not as close to modern English as the language of Dante is to modern Italian, it is recognizably the beginnings of the tongue we now speak and write.

Music

Guillaume de Machaut

The period from 1200 to 1400 was marked by a much increased use of polyphony, and by the emergence of composers who were distinct and rounded personalities. Both of these developments depended to a large extent on the increased accuracy and sophistication of musical notation.

Guillaume de Machaut (*c.*1300–77) was the most important composer of the fourteenth century. The fact that he was French is an indication of the primacy of French musical culture at this period. Machaut is known through a considerable body of work—altogether 141 different compositions remain. Twenty-three of these are motets—the motet being one of the most important musical forms of the period, and a route to further innovation.

The motet was a quintessentially polyphonic piece of vocal music. This new form evolved in the thirteenth century when upper parts began to be added to the original melodic line or *cantus firmus*. These upper parts were often given words (French = *mots*) to help the singers remember them and keep them separate from the rest, hence the name motet. These added words were often quite unrelated to what was being sung to the supporting melody—for example, secular texts were sometimes oddly combined with purely religious ones. The effect, in aural terms, resembles the sinuous, tendril-like elegance of Gothic window tracery.

Though Machaut is the author of the earliest known complete setting of the Mass by a single composer, and though, too, he was a cleric (he was a canon of Saint Quentin and also of Rheims) the bulk of his work was secular—settings of his own texts (he was also a gifted poet). His songs are longer and more elaborate than those written by his predecessors and often employ virtuoso technical tricks.

An example is his best-known song, *Ma fin est mon commencement* (My end is my beginning). The words are in *rondeau* form. That is there are eight lines, divided into four couplets. The first line of the opening couplet is also line four, while the whole of the opening couplet reappears at the end, as lines seven and eight. The poem is thus circular. Machaut mirrors this—and the actual meaning—by making the second voice used sing exactly the same notes as the first, only backwards.

Machaut's work is representative of the musical style known as the Ars Nova. In this a fluid, free-floating top part with syllables stretched by distributing them over more than one note (a device technically described as a melisma) is often contrasted with a syncopated tenor. At this time the word "tenor" meant not a particular type of singing voice but the fundamental voice-part of any composition containing more than a single line. The jagged, mismatched effect produced by the use of melismas on top of syncopation was not yet softened by the use of imitation, with one voice echoing the melodic phrase originally given to another.

Chapter 9

Transition to the Modern World: Northern Europe

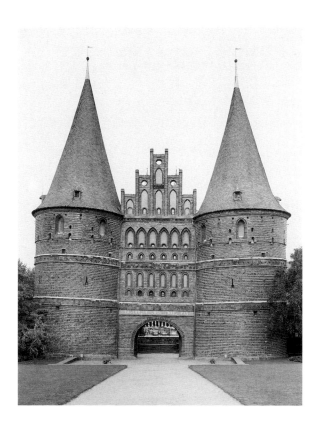

The end of medieval feudalism

Northern Europe in the fifteenth century resembled our own epoch far more closely than did the Early Renaissance in Italy. Like our own time, it was internationalist, yet Europe at that time was also racked by wars and uprisings. It had, especially in Flanders, a bustling commercial life, but also a chronically unstable economy, with frequent financial crises. Both the intellectual and the material stresses which were to create the Reformation (see page 208) had begun to make themselves felt.

One of the major religious and political events of the time was the Hussite revolution in Bohemia (the Czech part of modern Czechoslovakia). Religion was linked to a kind of nationalism which was new in Europe. The Bohemian religious leader John Huss (1369–1415) was condemned and burned by the Council of Constance for teachings based on those of the Englishman John Wyclif. His followers rebelled against both religious and secular authorities. Bohemian quasi-independence was ratified by a compact signed in 1438, which endured until 1620.

In 1493 there was another political event full of significance for the future—the first peasants' revolt broke out in Alsace and southwest Germany.

The center of economic and creative activity in the north was not, however, located in Bohemia or in Germany, but in Flanders. The cities of Ghent and Ypres were immensely wealthy thanks to their dominant position in the cloth industry, whose organization foreshadowed that of modern industrialism. Bruges, with its port at Sluis, controled a trade route which ran from Italy to Scandinavia and the Baltic.

Though these cities were communes, and looked after their own affairs, they had an overlord—the Duke of Burgundy, who was also Count of Flanders. In the fifteenth century there were three dukes—John the Fearless (1405–19), Philip the Good (1419–67), and Charles the Bold (1467–77)—all of whom were members of the French royal house. The Burgundian court was the wealthiest and most magnificent in Europe. It ignored the mercantile sources of this wealth, and spent its revenues on political adventures in France and Germany, and on tournaments, feasts and other chivalric entertainments. Not surprisingly, the communes which ruled the Flemish towns were in frequent conflict with their masters. Bruges rebelled against Philip the Good in 1436–7, and Ghent in 1452–3.

The downfall of the Burgundian realm did not, however, come from this, but from the quarrel between Charles the Bold and the Swiss, whose peasant levies humiliatingly defeated the duke's chivalric forces at Granson and at Morat in 1476. The defeat became final when Charles was killed in battle near Nancy in 1477, by René, Duke of Lorraine, aided by forces from Switzerland and Alsace. His catastrophic fall signaled the end of the whole feudal epoch.

Philosophy

William of Ockham and John Wyclif

The origins of the new intellectual climate can be seen in the thoughts of two men, both English, neither of whom lived to see the century begin. Both were churchmen who became opponents of the medieval establishment, and were regarded as particular foes by the whole hierarchy of the Church. To complete the picture, the younger man detested the doctrines of the elder. The two represent not a single current of thought but the extremes between which fifteenth-century thinkers oscillated.

William of Ockham (1285–1346/9), a Franciscan friar, was the founder of the philosophical school which came to be called Nominalism. What he did was to abandon every approach to abstraction in his account of the way human beings think and arrive at knowledge. For him knowledge was solely the product of experience (an approach known as empiricism), and could be arrived at only as the result of direct acquaintanceship, made through the senses, with objects which themselves remained singular—things-in-themselves, rather than items in a category. According to Ockham, abstract ideas had no existence outside the boundaries of the mind.

In theological terms, since we cannot see or touch or taste God, this meant that what we know of the deity cannot be knowledge in the ordinary sense—it has everything to do with faith and nothing to do with reason. This means a radical separation between the material world and the spiritual one.

John Wyclif (c. 1339–84), one-time Master of Balliol College at the University of Oxford, moved from condemnation of the abuses of the Church to outright condemnation of the papacy. His attitudes were confirmed by the Great Schism of 1378, after which Christendom found itself with two popes instead of one—Urban VI at Rome and Clement VII at Avignon.

In trying to assess Wyclif's impact on his own and later times, one must take into account his practical deeds as well as his thoughts. His beliefs were radical enough. Rather than thinking that knowledge was empirical, as Ockham did, Wyclif took an extreme Platonist position and declared that all human knowledge pre-existed humanity, since it depended on what was already in the mind of God, which was the governing fact in the universe. It followed from this that the individual's fate was already settled: he or she was predestined to be either damned or saved, according to God's grace. However, no one could be sure that they were one of the elect: "If the pope asked me whether I were ordained to be saved or predestinate," Wyclif said, "I would say that I hope so, but I would not swear it."

Moving from this position, Wyclif came to a number of conclusions which were profoundly disturbing to the society he lived in. He thought that everyone had a direct relationship with God, with no intermediaries. He had a special reverence for the Bible, which he called a "Charter written by God" and "the mirror of eternal truth." Everything necessary to the Christian was already to be found there. The translations of the Bible into English made under Wyclif's auspices (though not directly by him) were the precursors of profound social as well as religious change. Their efficacy was reinforced by increasing literacy among lay people. One of his contemporary opponents lamented, in so many words, that Holy Writ was being "laid open to the laity, and even to women." It was the vernacular Bible which, more than any other single thing, made possible the direct relationship with God that Wyclif demanded.

Wyclif laid great stress on preaching, fiercely condemning the failure of many churchmen to fulfill their duty as preachers. Under his inspiration there grew up a network of men, not necessarily priests, who were prepared to undertake this duty. Because they spoke simply, and in the common tongue, they were known as Lollards—the word originally meant people who stumbled in their speech. These unofficial preachers and their sympathizers were fiercely persecuted by the English ecclesiastic authorities during the fifteenth century—Henry V responded in an especially savage way to them.

The Lollards can be regarded as the forerunners of the Reformation (see page 208), not only in England but throughout northern Europe.

Architecture

Fifteenth-century Gothic

In nearly all of Europe, the architectural idiom of the fifteenth and even of the early sixteenth centuries continued to be Gothic. The experiments of Renaissance architectural theorists were exceptions made the more conspicuous by their comparative rarity. In Gothic architecture, however, there is a subtle shift of tone. Though some of the most ambitious of all buildings in the Gothic style belong to this era, it is also obvious that the style itself was losing coherence, and that some fundamental creative element was going out of it.

Though Gothic architecture had originated in France, its most original manifestations were now to be found elsewhere. In north Germany it appeared in a stripped-down, exaggeratedly simplified form, partly dictated by the needs of construction in brick rather than stone. This *Backsteingotik* (brick Gothic) had already reached its peak toward the end of the fourteenth century, but persisted into the fifteenth. Though partly dictated by the characteristics imposed by a different material, it also shows a kind of disillusionment with the possibilities offered by the Gothic idiom. A good example, secular rather than ecclesiastical in this case, is the Hodstemtor in Lübeck (Fig. **9.1**), a gateway erected in 1477 as a symbol of civic pride.

In England building was checked by the final and most

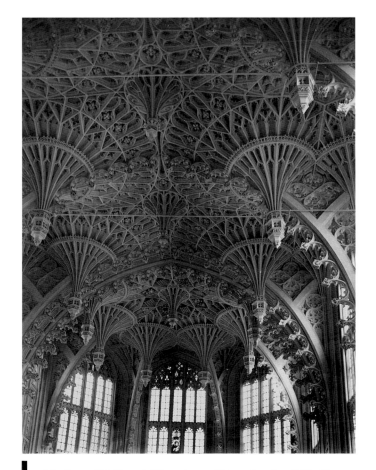

9.2 Henry VII Chapel, Westminster Abbey, London, 1503–19.

9.3 Ornamental motif at the Abbey of the Hieronymites, Belem, Lisbon, Portugal, 1502.

acute phase of the Hundred Years War (1338–1453), then by the civil strife of the Wars of the Roses (1455–85). Prosperity returned with the final defeat of the Lancastrian cause in 1483. From that date until the Reformation there was a spate of Gothic building in England. New forms of architectural ornamentation were introduced, among them pendant vaulting, which was a further refinement of the fan vaults associated with an earlier phase of the Perpendicular.

Pendant vaulting is a conspicuous feature of Henry VII's sumptuous chapel at Westminster (Fig. **9.2**), constructed between 1503 and 1519. The chapel, like other English architectural projects of the time, was the product of identifiable creative personalities—in this case, Robert and William Vertue, who were also responsible for designing Bath Abbey. That is, though Gothic did not, even at the very last, develop a theoretical basis to match that upon which Renaissance architecture was founded, it did in its final days become a vehicle of personal artistic expression.

Another country which developed its own rich, fanciful variation of Late Gothic style was Portugal. This local variant, called Manueline, is associated with King Manuel I, the Fortunate (1469–1521), who succeeded to the throne in 1495. Manuel was the promoter of the maritime explorations undertaken by Portuguese seamen; it was during his reign that Vasco de Gama discovered the sea-route to India, reaching the Malabar Coast in 1498. The chief Manueline monument is the Abbey of the Hieronymites (Fig. **9.3**) at Belem, on the outskirts of Lisbon, begun in 1502. This shows an astonishing variety of exotic ornamental motifs—among them shellfish, vines, and fantastic fauna—in tribute to the discoveries then being made. These ornaments seem to reflect the taste not only of a single patron, Manuel himself, but of a single architect, one Boytac or Boitac, whose name suggests that he may have been of French rather than Portuguese origin. Like the Henry VII Chapel, the monastery at Belem is the product of a luxuriant, but by now uneasy, creative imagination unrestrained by theory.

Painting

International Gothic

The prevailing style throughout Europe during the years of crisis at the end of the fourteenth and the beginning of the fifteenth centuries was the gracious International Gothic, an expression *par excellence* of princely and aristocratic taste, and of a determination to ignore both political catastrophe and rumblings of social discontent. The style is sweetly charming, consciously aristocratic, rhythmic, and without serious commitment to emotion. A supreme example is the Wilton Diptych (Fig. **9.4**), which shows Richard II of England being presented to the Virgin by his patron saints St. John the Baptist, St. Edward the Confessor, and St. Edmund. The artist has transformed this into an elegant courtly ceremony—the angels wear Richard's heraldic badge of a white hart, and this emblem is repeated on the back of one of the panels. The date of the painting is disputed—scholars have suggested anytime from Richard's accession in 1377 to 1415, when his body was moved from King's Langley, where it was originally buried, to Westminster Abbey. The artist's nationality is also disputed—he could have been English, French, or Bohemian (Richard's first queen, Anne, was Bohemian-born).

As its name suggests, International Gothic was extremely widespread geographically. Painters who worked in the style can be found, not only in England, France and Bohemia, as the controversy about the origin of the Wilton Diptych suggests, but in Germany and Austria, and even in Italy. One of the best representatives of the style is in fact Italian—Gentile da Fabriano (*c.* 1370–1427), who represents a reaction toward the Gothic in the very heartland of the Renaissance. Gentile's *Adoration of the Magi* (Fig. **9.5**) is entirely International Gothic in style. It is a telling fact that Gentile appears to be without geographical allegiance. He was working in Venice in 1408, painting frescos in the Doge's Palace (these are now lost). Later he worked in

9.4 Richard II of England presented to the Virgin. Detail from the Wilton Diptych, c. 1377–1415. National Gallery, London.

Siena, Orvieto, and finally in Rome, where he painted frescos (also lost) for the Lateran Basilica.

The main centers for International Gothic were, however, France and Flanders—territories which were governed by the King of France and his over-powerful vassal the Duke of Burgundy. The greatest art patrons of the day were the rival members of the French royal house, who plundered the public treasury to support their extravagant tastes. Particularly active was the greatest manuscript collector of the age, Jean, Duke of Berry, the youngest uncle of the mad King Charles VI.

The Duke of Berry's most important artists came to him late in his career. They were the three brothers Limbourg: Pol, Jean, and Herman (or Armand). They came from Gelderland in the Low Countries and obtained their first commission from the duke c. 1410. Their joint masterpiece is the *Très Riches Heures* (Fig. **9.6**), left unfinished at their patron's death in 1416. Especially famous are the twelve pictures in the calendar, one for each month of the year. These show scenes from everyday life—in so far as life could be "everyday" in the milieu of a French royal duke. A number of the miniatures have representations of the Duke of Berry's castles in the background, so that they make a kind of inventory of his territorial possessions. The settings

are treated in an extremely realistic way, and some of the figures are recognizable portraits, notably the snub-nosed duke himself. In this sense, they are a major innovation—it was the first time art had come close to holding a mirror up to real life. On the other hand, one senses that this exquisitely precise, rather dandified realism remained firmly linked to the sensibility of the International Gothic style, which was always élitist. Realism was a new dish for ultra-refined palates, and this was why the Limbourgs offered it to the best-informed, most progressive royal patron of their time.

The Van Eycks and Van der Weyden

It has long been recognized that the fifteenth century saw not one but two separate revolutions in art, at opposite ends of Europe. In each of these, painting rather than architecture or sculpture played the predominant part. It has also, however, long been customary to stress the theoretical revolution, which took place in Italy, at the expense of the pragmatic one, which took place in Flanders. In many respects they are of absolutely equal importance, though the Flemish revolution flows more naturally from what preceded it. The brothers Van Eyck, for example, are clearly related to the Limbourgs, yet seem to belong to a different emotional world.

9.5 Gentile de Fabriano, *Adoration of the Magi c.* 1423.
Wood, 118⅛ × 111 ins (300 × 282 cm).
Uffizi Gallery, Florence.

9.6 The Limbourg Brothers, *May*, from *Les Très Riches Heures du Duc de Berry*. Illumination, 8½ × 5½ ins (21.6 × 14 cm). Musée Condé, Chantilly, France.

To understand fifteenth-century Flemish art, one has to understand fifteenth-century Flemish society. Though Flanders was ruled by the Valois dukes of Burgundy from the center of a glitteringly chivalric court, its true importance was not military but commercial. Most of the ingredients of a recognizably modern system were already present. Yet there was also a strong strain of mystical religious feeling in Flanders, and religious confraternities were a feature of urban Flemish life.

The masterpiece of Hubert (1366–1426) and Jan Van Eyck (1385–1440) is their Ghent altarpiece, *The Adoration of the Mystic Lamb* (Fig. 9.7), at the church of St. Bavo. The Van Eycks seem to have begun their careers as book-illuminators, like the Limbourgs, but the altarpiece makes use of the new technique of painting in oils. (At one time the Van Eycks were thought to have invented this, but the theory is now discredited.)

Oil painting, as its name suggests, uses vegetable oils, such as linseed, walnut or poppy, as a medium to bind the pigment. On exposure to air, these oils slowly dry so as to give a solid transparent substance. Painting carried out in oil has a much denser, more glowing look than painting done in tempera, where the medium is an emulsion (a mixture of oily and watery elements) usually made with egg yolks.

Superb manuscripts were commissioned by princes; the Ghent altarpiece, on the other hand, was commissioned by a member of the bourgeoisie. As the authorship inscription tells us, it was completed in 1432. The idea was taken not directly from the Scriptures, but from the writings of the mystic poet and composer Hildegard of Bingen (see page 131). It corresponds to her thirteenth and last vision, described in her book *Scivias*. Thus, for all its brilliant realism in terms of detail, the altarpiece is securely linked to the transcendental, mystical current in late medieval thought.

When the altar is open, the bottom row of panels shows the whole of humankind, as typified by its noblest representatives—princes, prophets, saints, martyrs, and pilgrims—moving forward to worship the Lamb, who stands on an altar at the center. In the center of the figures on the top row is the Glorious Christ, a figure who combines the attributes of God the Father and God the Son in a single image. In the same row of panels are an amazingly fleshly Adam and Eve—a later generation banned them from St. Bavo as indecent.

The altarpiece is not fully unified—the figures in the top row are huge in comparison with the scene below, and seem to belong to a different world. What is impressive is the brilliantly solid realization of the separate parts. In the main scene so many of the figures have a lifelike, portraitlike quality that repeated attempts have been made to identify them with contemporary historical personages. What really counts is not the question of whether in fact they existed but the conviction with which the artists realized what they had imagined.

Hubert Van Eyck died before the Ghent altarpiece was completed. Jan Van Eyck survived to paint a number of signed works, plus others which are unsigned but universally accepted as his. Among the signed paintings are a series of portraits. The most startling and innovative, as well as the most elaborate, is the double portrait of Giovanni Arnolfini and his wife, known as the *Arnolfini Wedding* (Fig. 9.9), which shows the sitters full-length in a meticulously depicted room. The realism of every detail is much more intimate, less detached and distant, than the realism in the *Très Riches Heures*.

The artist himself may have been conscious of the extreme originality of the work, as his signature above the circular mirror in the center of the composition reads *"Johannes de eyck fuit hic"*—"Jan Van Eyck was here," rather than "Jan Van Eyck painted this." He seems to offer himself less as the author of the picture and more as a witness to the betrothal of Arnolfini and his future wife. Indeed, if one looks closely in the mirror, one can see the painter entering the room with a companion. The *Arnolfini Wedding* has never been surpassed in any period for its hushed, crystalline actuality. It seems to hold a moment of time suspended, and when we look at it the fifteenth century is still present and with us. The interplay of different realities is more complex than anything to be found in the work of the Limbourg Brothers.

Imagination and a sense of the real mingle in a different way in the work of Rogier Van der Weyden (c. 1399–1464). Where the Van Eycks' work has an air of calm objectivity, Van der Weyden's religious paintings combine intense but intermittent realism with equally intense emotion.

The work which best sums up his artistic personality is the large *Descent from the Cross* (Fig. 9.8). This is extremely sophisticated in technique, but also conspicuously irrational in composition. The close-packed group of mourners appears against a plain ground of gold flecked with brown. At first sight they look like sculptures painted to resemble life, contained within a shallow wooden box. This idea is promptly contradicted by the fact that they have real vegetation under their feet. In addition, the figure furthest toward the back (the servant with a ladder) seems to have caught his sleeve in one of the crossbow-shaped architectural ornaments that fill the corners, and this detail seems to make nonsense of the idea that the figures in any way fit into the shallow space provided.

In fact everything conspires to make it impossible for spectators to tell if what they are looking at is meant to be taken as a real event or a *trompe-l'œil* representation of a sculpture. All the devices used seem intended (as in Italian Mannerist painting a century later—see page 222) to create a feeling of unease which will make the spectator more vulnerable to the violent emotions which are being generated. Van der Weyden quite literally aims to put anyone who looks at the painting off balance, and the accumulation of minutely realized details only adds to this effect.

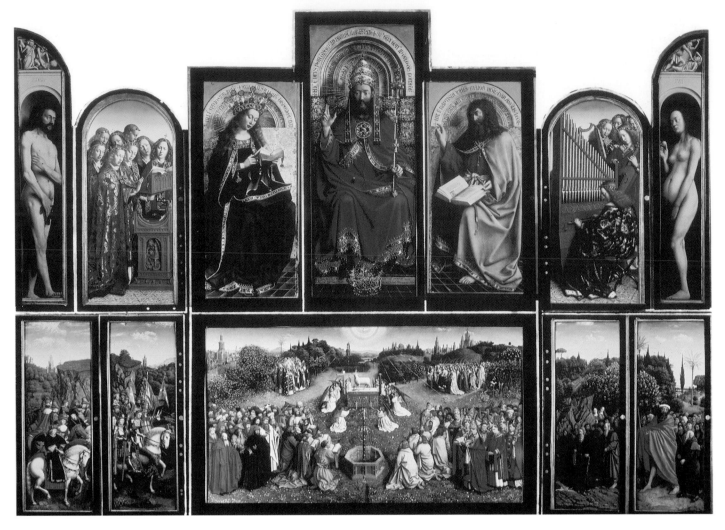

9.7 Hubert and Jan Van Eyck, *Adoration of the Mystic Lamb* 1432,
the Ghent Altarpiece. Tempera and oil on panel, approx. 11 × 15 ft
(3.3 × 4.6 m). St. Bavo, Ghent.

9.8 Rogier Van der Weyden, *Descent from the Cross c.* 1435.
Oil on panel, 7 ft 2⅝ ins × 8 ft ⅞ ins (2.2 × 2.46 m). The Prado,
Madrid.

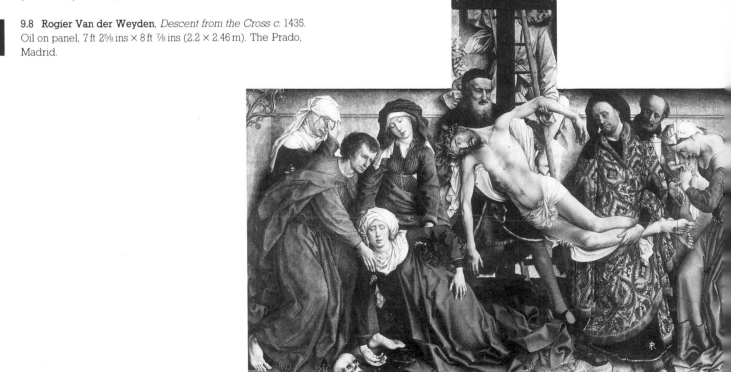

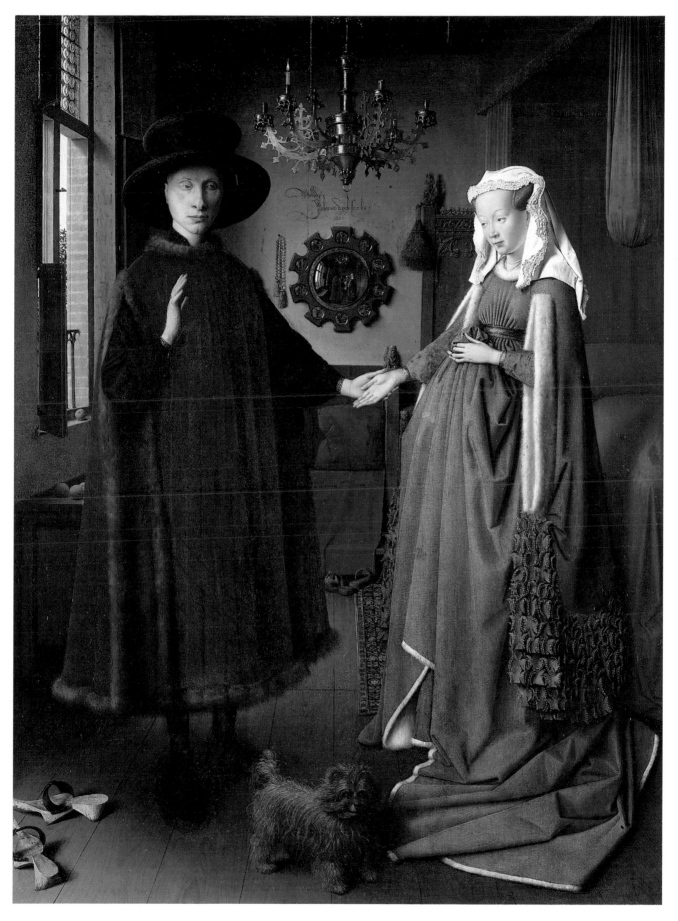

9.9 Jan Van Eyck, *The Arnolfini Wedding* (*Giovanni Arnolfini and His Bride*) 1434. Oil on panel, 33 × 22½ ins (83.8 × 57.1 cm). The National Gallery, London.

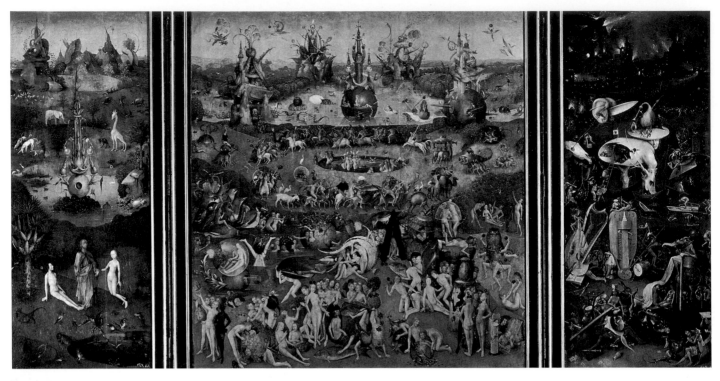

9.10 Hieronymus Bosch, *The Garden of Earthly Delights* 1505–10. Oil on panel, wings 86⅜ × 38⅛ ins (219.4 × 96.8 cm) each, central panel 86⅝ × 76¾ ins (220 × 195 cm). The Prado, Madrid.

Hieronymus Bosch

The intimations of unease already latent in the work of Rogier van der Weyden reveal themselves fully in the extraordinary art of Hieronymus Bosch (*fl.* 1474–1516). Despite this, he is in many ways isolated within the Netherlandish art of the period, though this is not so true of the general cultural context of northern Europe.

Bosch took his name from the city where he lived and worked—s'Hertogenbosch, on the northern edge of the Duchy of Brabant. Its character was middle-class and commercial—there was no court life, no university, and it was not the seat of a bishopric. However, it had a very active religious life, with an unusually large number of religious foundations. While this may testify to the fervor of the population, there was also conflict between religious and lay inhabitants for economic reasons, and Bosch's paintings often display a certain hostility toward the clergy.

His paintings can be divided into two kinds—devotional subjects and those with some moral or didactic purpose which are not specifically devotional. The latter are the works for which he is most famous. A typical example is *The Garden of Earthly Delights* (Fig. **9.10**), which, as with other works of the same type, is presented in triptych form. It is as if these were intended to be altarpieces only a little more unorthodox in their imagery than the *Adoration of the Mystic Lamb*.

The Garden of Earthly Delights shows a panoramic view with many small figures—humankind plunged into sin (the sin of lust) and unmindful of divine law. Many details show the power of the artist's vivid and pessimistic imagination, and also his ability to transform everyday appearances and combine familiar objects so as to produce new forms. Nowhere is this more apparent than in the right-hand panel, which represents Hell. The focal point of the swarming composition is a man whose trunk is a hollow tree. He stands supported on two rotten tree stumps, and his egg-shaped torso is left open at the rear so as to show a tavern scene. On his head there is a circular table-top with a set of bagpipes in the center, and devils parading round it.

Many of Bosch's transformations and combinations can be traced back to Netherlandish proverbs, which he translates into visual terms with ironic literalness: in this case he is a more truly "popular" painter than the Van Eycks. Yet he is also more complex than they are: the tree man fuses many meanings into a single emblem which cannot be interpreted literally.

Sculpture in northern Europe

Sculpture was produced in great quantity in northern Europe during the late fourteenth and throughout the fifteenth centuries, but has not had the long-lasting cultural impact that work produced in Italy at the same time had, for several reasons. However sought-after and prosperous certain master sculptors became, they continued to be thought of as artisans, and did not have either the mobility within the social structure or the developing intellectual freedom that their Italian Renaissance counterparts enjoyed. Sculpture remained a subordinate art form, and was usually seen as part of a larger architectural ensemble. When this was not the case, it was used for large altarpieces, where sculpture was often mingled with painting, or in which, at least, it was used in a thoroughly pictorial fashion. The huge losses caused first by the destruction of images in the Reformation (see page 208), and then the French Revolution (see page 363), mean that many great works of sculpture have vanished altogether. Others have been left as mere shadows of their former selves, mutilated and incomplete.

It was characteristic of the leading sculptors of the period that their careers ranged widely in a physical sense—they are often found working in locations very far from where they were born. Claus Sluter (*fl.* 1379–1405/6) came from Haarlem, and worked in Brussels before moving to Dijon. His chief patron was Philip the Bold, Duke of Burgundy, ruler of the Low Countries as well as Burgundy.

One of Sluter's chief surviving works (though only in mutilated form) is the *Well of Moses* (Fig. **9.11**) at Chartreuse de Champmol near Dijon, the ducal capital. The base, composed of figures of Moses and five prophets, remains *in situ*. It was originally surmounted by a Crucifixion, with figures of the Magdalen, the Virgin, and St. John. The idea was that Christ was "the Fountain of Living Waters." The six figures are powerfully characterized, the draperies have a fullness and energy which express the movements of a living body.

At the beginning of the fifteenth century the stylistic leadership was with artists from the Low Countries—Sluter and his immediate successors. By the end of it, it had passed to German sculptors such as Veit Stoss (*fl.* 1477–1533) and Tilman Riemenschneider (*fl.* 1478/9–1531). Both worked as much in wood as they did in stone—a material which could be carved both with greater freedom and with greater intricacy.

Stoss left Nuremberg in 1477 to go and work in Cracow, where his chief surviving work is the immense high altar in the church of St. Mary, which dates from 1477–89. The main subject is *The Death of the Virgin* (Fig. **9.12**). The scene is shown as if it takes place on stage—the figures occupy a shallow box which can be hidden from view with wings which carry smaller scenes in three tiers. The dying

Virgin is shown kneeling, while surrounding her are towering figures of apostles—one stands at the back, violently wringing his hands, which make a kind of arch over her figure. Above is represented the Virgin's ascent to heaven. The figures are less realistic than Sluter's, but their gestures and facial expressions are more dramatic. The fact that they are painted stresses the pictorial nature of the whole composition.

The equivalent of Stoss's Cracow altar in Riemenschneider's output is the *Altarpiece of the Holy Blood* (Fig. **9.13**) in St. Jacob's church, Rothenburg, which dates from 1501–5. The main subject is the Last Supper. In contrast with Stoss's work, the figures are unpainted—the wood is covered with a glaze, and details such as lips and eyes are lightly touched in. The lack of paint reveals the full virtuosity of the carving, with its exquisite refinement of detail.

In a slightly paradoxical way, the Rothenburg Altar is nevertheless even more pictorial than *The Death of the Virgin*

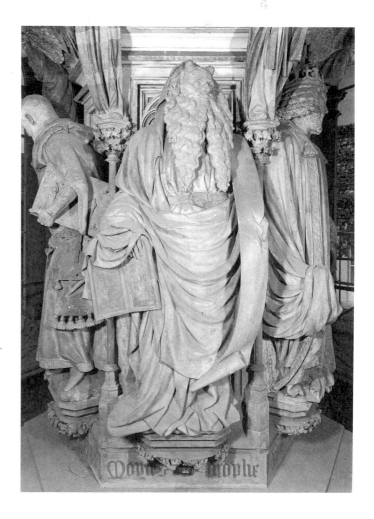

9.11 **Claus Sluter**, *Well of Moses*, Mausoleum of Philip, Duke of Burgundy, 1395–1406. Height of figures, approx. 6 ft (1.82 m).

in Cracow. All accents suggesting real recession in space are omitted, and the complex group of figures is flattened, and brought as close as possible to the frontal plane. What is striking about the work as a whole, quite apart from the artist's supreme technical skill, is Riemenschneider's empathy with what is presented. He wants the spectator to empathize with the scene as he does himself.

There is another element as well—an air of psychological unease about his figures and their relationships within the scene which makes the spectator at least subliminally aware of the looming religious and social crisis within Germany. Riemenschneider was in fact to side with the insurgents in the German Peasants' War of 1524–5, and was lucky to escape with his life.

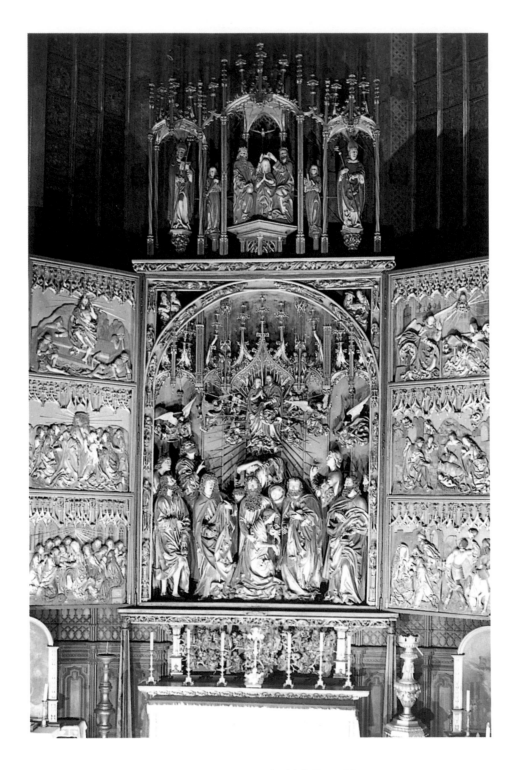

9.12 **Veit Stoss**, *The Death of the Virgin*, from the High Altar of the Church of St. Mary, Cracow, 1477–89.

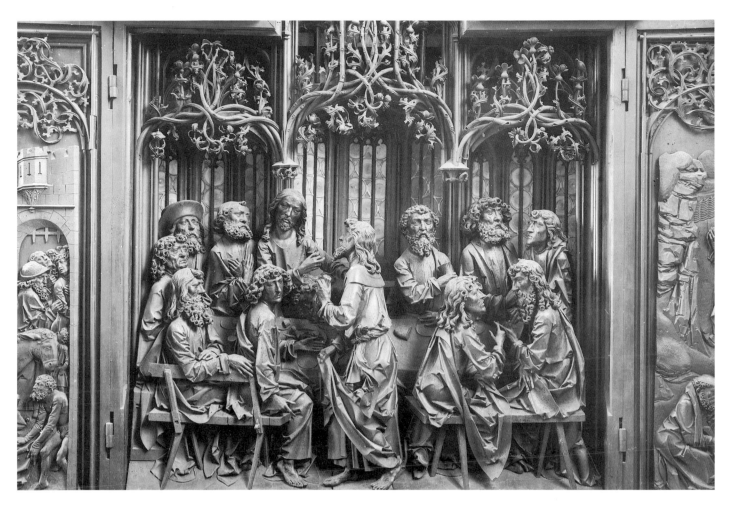

9.13 **Tilman Riemenschneider,** *Altarpiece of the Holy Blood* 1501–5. St. Jacob's Church, Rothenburg.

Literature

François Villon

The extraordinary personality and life-story of François Villon (1431–after 1463) make him seem as representative of the disturbed epoch he lived in as Dante is of the confident High Middle Ages. Villon is regarded as the poet of medieval low life, but he did not come from the lower classes. He is the representative of a new type—the socially displaced intellectual.

His poetry is autobiographical, and ranges through every style and type of language available. He writes in the purest and most courtly French, but also in a deliberately archaic version of the language, and in thieves' cant. His sense of what constituted the "vernacular" was thus much more complex and sophisticated than Dante's. His poetry is frequently an intricate fabric of puns, personal allusions, and bawdy jests, using verse forms which require the utmost virtuosity. There is an ironic tension between "low" subject matter and sophisticated literary forms.

The two chief strands in Villon's work are his insistence of the importance of the "I"—the individual—and his keenly melancholic sense of human fragility and passing time. His most ambitious work is, appropriately enough, entitled *The Testament*. It consists of a miscellany of poems, in the form of a will—one made by a man with nothing to leave behind him except the memory of his genius:

Here is poor Villon's final word;
The ink upon his will is dried.
Come see him properly interred
When by the bell you're notified.
And come in scarlet, since he died

Love's martyr, through his gentle heart;
This on one ball he testified
As he made ready to depart.

("A Ballade of the End," translated by Richard Wilbur in
New and Collected Poems. Faber and Faber, 1989.)

Margery Kempe

There is a kind of parallel between Villon and his near
contemporary in England, Margery Kempe (*c.* 1373–after
1439), in the sense that both wrote very directly and
nakedly about their lives, and both describe existences very
much on the margin of history. Margery Kempe has left us
the earliest prose autobiography in English—*The Book of
Margery Kempe.* Because she was illiterate, her narrative had
to be written down by somebody else, but the vivid phrase-
ology is clearly very much her own.

Kempe was one of the female visionaries who abounded
in the Middle Ages. One of the very few ways in which a
woman could assert herself as an independent personality
was to claim some sort of divine revelation. In the fifteenth
century, such claims were encouraged by the apocalyptic
atmosphere of the time, and by the teachings of William of
Ockham, John Wyclif and their peers. Perhaps the best
known example is Joan of Arc, whose visions altered the
course of European history.

Kempe was the daughter of a prosperous burgess of the
East Anglian town of King's Lynn, then called Bishop's
Lynn. Her visions started when she was about twenty years
of age after a nervous breakdown following the birth of her
first child. In addition to seeing visions, she was seized with
a desire to go on pilgrimage, and made herself conspicuous,
both at home and on her travels, by clothing herself all in
white and indulging in noisy fits of sobbing and weeping.
While her behavior irritated some of her contemporaries,
and aroused the suspicion of others (she was frequently
accused of being a Lollard), she deeply impressed others.

The account of her life is written in the third person—
Kempe calls herself "the creature" throughout the narra-
tive. This gives a vivid picture of her travels as she went on
pilgrimage to Rome, and then to the Holy Land. Later she
made pilgrimages to the shrine of St. James at Compostela
in Spain, then to Norway, Danzig and finally to Aachen in
Germany. In between times she traveled widely within
England.

In addition to demonstrating what it was possible for a
woman to do at that time, the book gives an extremely fresh
and lively self-portrait. One of Kempe's most conspicuous
public successes was an encounter with the authoritarian
Archbishop of York, Henry Bowet (archbishop 1407–23),
the second most important prelate in England. She was
brought before him in 1417, under suspicion of being a
heretic, but rebuked him roundly when he dared to
question her conduct. Bowet asked: "Why do you weep so,
woman?", and Margery replied: "Sir, you shall wish one
day that you had wept as sorely as I." The boldness of this
response is comparable to some of the answers given by
Joan of Arc at her trial, and sprang from the same source:
utter self-assurance based on unswerving belief.

Unlike Villon, whose work is shot through with ironic
reflections on his own situation, Kempe had no pretensions
to conscious literary art, and certainly no sense of irony.

Drama

Medieval mystery plays

In the Late Middle Ages sacred drama passed from the
control of the Church into the hands of the laity. The chief
incidents in the Old and New Testaments, from the Cre-
ation to the Resurrection, were now represented in great
cycles of plays, acted in the vernacular. Such cycles became
a typical part of the bustling civic life of large towns. They
were acted on one of the great annual holidays, typically on
the Feast of Corpus Christi, created by papal decree as late
as 1311, or else at Whitsuntide. These feasts were chosen
because they fell at times of the year when the weather was
likely to be good, and the plays were acted out of doors.

In England, where the mystery plays were richly devel-
oped, the general system was to use pageant wagons—plat-
forms with rudimentary scenery, mounted on wheels. The
action took place partly on the wagon, but also partly in the
area surrounding it. The system was to wheel the wagon
round in procession to several "stations"—in the city of
York there were as many as ten or twelve of these—and the
plays were successively repeated at each stopping point.
The complete representation of a mystery cycle lasted at
least one full day—in York the first play began at
4.30 a.m.—and was sometimes prolonged for three days or
even more.

The custom was for each of the tradesmen's and crafts-
men's guilds to be responsible for a particular play, chosen
either for the appropriateness of the subject matter or
because the guild in question was in a position to provide
appropriate props. Thus the shipwrights, or else the fisher-
men, were usually responsible for the story of Noah's Ark,
while the goldsmiths enacted the story of the Magi, who
came to find the Christ Child bearing their rich gifts.

Since the mystery plays were first and foremost popular
entertainment, the language used by the anonymous play-
wrights was simple and direct. This did not mean that it

could not cope with complex ideas. At the beginning of the York cycle, for example, God opens the proceedings by identifying himself thus:

I am gracious and great, God withouten beginning,
I am maker unmade, all might is in me,
I am life and way, unto wealth winning,
I am foremost and first, as I bid it shall be.

(ALFRED W. POLLARD, *English Miracle Plays, Moralities and Interludes*. The Clarendon Press, 1904.)

The mystery play texts are also characterized by much use of irony and humor, descending to burlesque even at the most solemn moments. In one English play portraying the Crucifixion Christ's executioners jestingly compare him to a knight-errant, with the Cross as his battle-charger. They say they will help him to mount, and then make sure he does not fall off by nailing him to his steed.

The satirical and contemporary note is almost invariably struck when the writers have to deal with persons set in authority—Herod, for example, or the Jewish high priests who condemned Jesus. The latter were customarily shown in the dress of contemporary bishops.

With their splendid costumes and general air of pageantry, many of the scenes represented in the mystery plays must have seemed like living equivalents of the great painted and carved altarpieces made at the same epoch, and there can be no doubt that there was a strong reciprocal influence between these theatrical representations and the visual arts in northern Europe.

Music

The Franco-Flemish school

Throughout the fifteenth century, the leading European composers were men from the north—the Italian Renaissance had at first little or no creative impact on music. The majority of these composers were Flemings or Franco-Flemings, though there was also one important English musician, John Dunstable (c. 1390–1453). These composers can be divided into two generations, those born around 1400, which includes Guillaume Dufay (c. 1400–74), Gilles Binchois (c. 1400–60), and Johannes Ockeghem (c. 1410–97), in addition to Dunstable; and those born half a century later, led by Josquin des Prez (c. 1440–1521) and Heinrich Isaak (c. 1450–1517).

These musicians were celebrated and sought after, and seem to have enjoyed a superior social position to other kinds of artist. A favorite way of rewarding them was through prebendaries (an honorary but paid position within the Church) and other ecclesiastical offices, and they were sometimes asked to serve as diplomatic emissaries for the royal and aristocratic patrons who competed fiercely for their services. Among the most enthusiastic of these were the kings of France, the dukes of Burgundy, the Medici in Florence, the Malatesta family in Pesaro and Rimini, and members of the Sforza clan in Milan and in Rome. A number of the leading Franco-Flemish composers—Dufay, des Prez, and Isaak—spent important parts of their careers in Italy, in the service of Italian patrons, but none ever rooted themselves there for good. When the composers did not travel, their music did. Much of Dunstable's output is known through Italian manuscripts.

The music produced by members of the Franco-Flemish school followed patterns already set in the previous century. Much was settings for the Mass; much of the rest consisted of elaborate motets. It developed in three ways—these appear to be in intellectual conflict with one another but are reconciled within the fabric of the music itself. Firstly, music became increasingly rich and elaborate, often making use of conceptual elements. Canons (polyphony where each part imitates and overlaps the part that precedes it as in the modern songs "Frère Jacques" or "Row, row, row your boat") were much employed—Ockeghem wrote one Mass, the *Missa Prolationum*, entirely constructed of them. This intellectual elaboration and impulse toward formal intricacy and completeness was, in the composers' minds, a way of reflecting and expressing the divine order which sacred music was supposed to make manifest.

Interest in canons was combined with an interest in motto themes which often had a hidden personal meaning. One of des Prez's masses, written for the Duke of Ferrara, uses the words "Hercules, dux Ferrariae" with the letters of the alphabet given their musical equivalents, as a basis for the entire composition. There was also a fascination with the esoteric: some new compositions were deliberate parodies of older ones—a characteristic which only the musically informed would notice.

By contrast, there was also a concern with making music smoother, richer and easier on the ear. The angularities of the Ars Nova fell out of fashion. Even sacred music now borrowed popular melodies from court and theater, and there was a new fashion for setting lightweight, racy, erotic texts to music. Dunstable, in particular, showed a new concern for "singability" in vocal music, with easily identifiable melodies (for example in his song "O rosa bella"), and settings which followed the natural line of declamatory speech patterns (as in the motet *Quam pulctra es*).

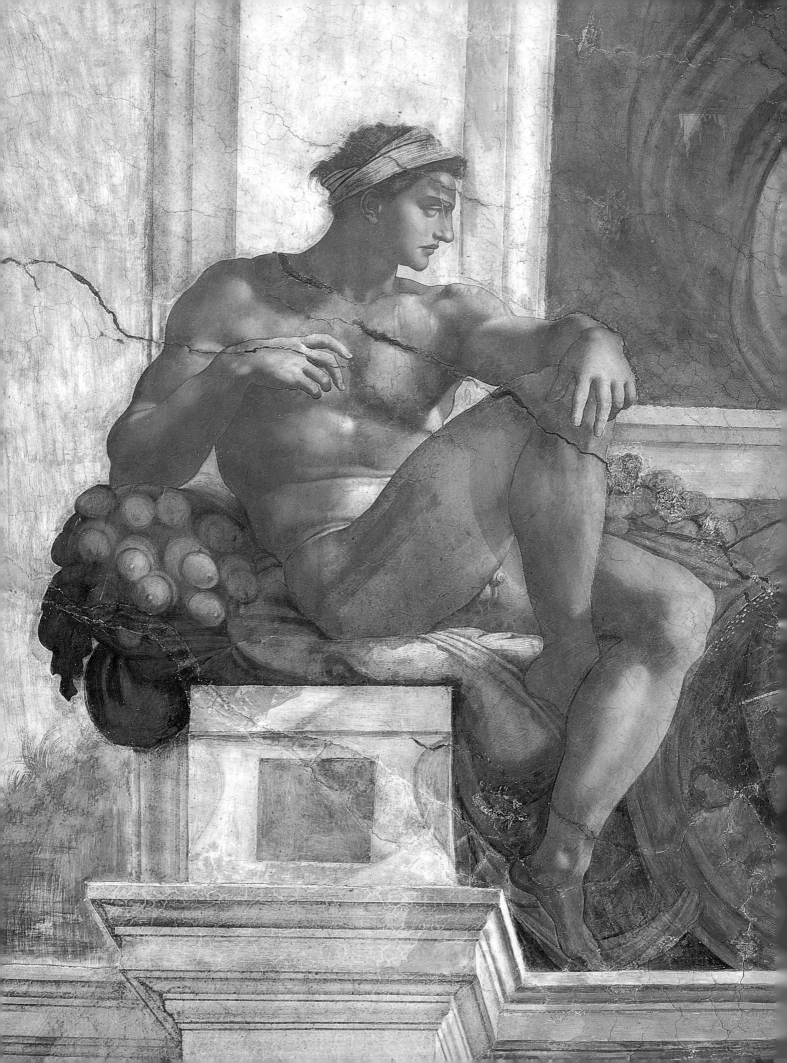

Part

4

The Renaissance

Chapter 10

Humanism in Italy

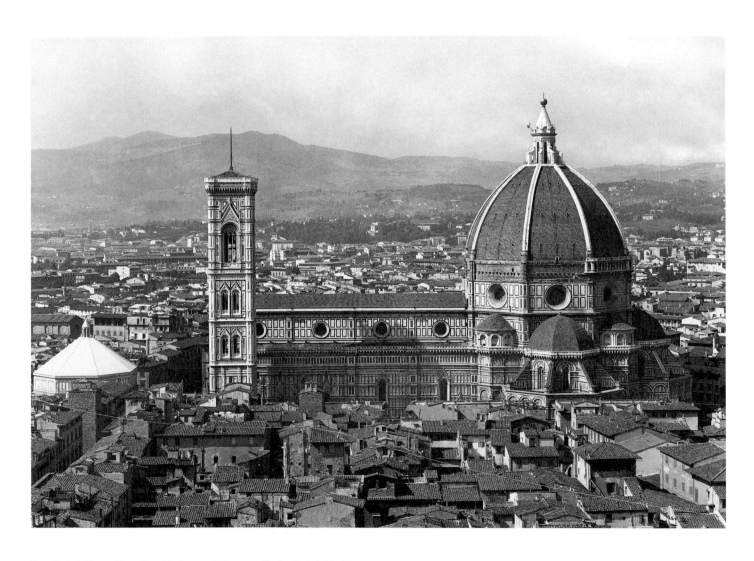

■ 10.1 **Filippo Brunelleschi**, dome of Florence Cathedral, 1420–36.

The Renaissance

The modern conception of the Renaissance is largely the invention of a nineteenth-century Swiss historian, Jacob Burckhardt, whose pioneering book, *The Civilization of the Renaissance in Italy*, was published in 1860. Burckhardt saw the Renaissance as almost purely cultural, the work of a small Italian élite who pioneered a new attitude toward human beings, seeing them as people who had suddenly acquired a new consciousness of their own uniqueness and individuality.

In fact the Renaissance has three dimensions—historic, economic and cultural. In historical terms, there was a growing interest in the remote past, that of Greek and Roman antiquity, and a tendency to reject the more recent past that we now call the Middle Ages. In Italy, this was fed by the presence of numerous survivals—Roman buildings in more or less ruined state and the occasional piece of sculpture which had never been buried, such as the equestrian statue of the Emperor Marcus Aurelius (see page 77). In 1453 the fall of Constantinople to the Turks brought a flood of scholarly refugees to Italy, and with this a new access to Greek language and literature.

Economically and politically, the Renaissance was largely the product of the Italian city-states, chief among them Florence. These were proud, independent entities whose trading and banking systems were the most sophisticated in Europe. It also owed much to the lavish patronage offered by an increasingly secularized papacy.

Though Burckhardt has been sharply criticized by more recent writers, he was nevertheless right to put the intellectual and cultural aspect of the Renaissance in first place. The elaborate theological systems of the Middle Ages, typi-

10.2 Renaissance Italy.

fied by the work of Aquinas (see page 133), were challenged by a new breed of secular scholar, the humanists. The visual arts were reinvented. This reinvention took place from the mid thirteenth century onwards but the effort was at its most intense from *c.* 1400 until the Sack of Rome by the troops of the Emperor Charles V in 1527. The influence of Italian art and architecture soon made itself felt all over Europe.

Philosophy

The Renaissance humanists

Much has been made of the intellectual revolution brought about by the Italian humanists of the fifteenth century. Writing in 1860, Jacob Burckhardt called the humanists "the first-born among the sons of modern Europe." In fact, it is important to draw a distinction between what the humanists were and what they achieved intellectually.

As to the former, they were thinkers of a new kind. Throughout the Middle Ages learning had been almost the exclusive property of the men of the Church, and intellectual debate had run largely on theological lines. New tech-

niques in logic had been devised, but only to serve the purposes of a dialectic which remained rooted in theology. In fifteenth-century Italy this changed. It changed due to the rise of a new class of secular administrators, the product of the governmental and financial mechanisms of the Italian city-states, with Florence at their head. These men had literary and antiquarian interests, in addition to theological ones, which now focussed on the attempt to fuse the Classical with the Christian. If they took service with autocratic rulers, these rulers often shared the intellectual preoccupations of those who advised them. Cultivated courts grew up in cities such as Mantua, Urbino, and Ferrara. The

Medici family played a decisive role in encouraging the new learning in Florence.

This is not to say, however, that the new learning produced immediate and spectacular results. The abstract thought of Early Renaissance Italy does not seem comparable, in boldness and originality, to that of medieval scholastic philosophers such as St. Thomas Aquinas (see page 133) or William of Ockham (see page 156). The humanists often tended to shy away from the rigorous forms of dialectic developed by these men, in part because they disliked the ugliness (as it seemed to them) of the linguistic forms in which the arguments were expressed. There was a revival of interest in correct Latin style, and there was a parallel and even more powerful renewal of interest in Greek language and literature, which was further quickened in 1453, when the fall of Constantinople to the Turks brought many Greek scholars to Italy. But these studies tended to remain self-enclosed—good Latin was written for its own sake, not for any original thought which it might communicate.

Though the humanists often prided themselves on their "realism"—that is, on their recognition of facts established on the basis of direct observation—they had as yet little notion of the way in which a spirit of scientific inquiry should ideally operate. No distinction had as yet been made between science and pseudo-science—astronomy, for example, was simply the servant of astrology—and among the humanists there was a rather snobbish obsession with whatever was esoteric—occult symbolisms, magic, the Kabbalah. It was these esoteric interests which attracted them to Plato, and more particularly to his later followers such as Plotinus (see page 73). Their Neo-Platonism, however, was also a reaction against the Aristotelianism of Aquinas.

One of the most sympathetic of the Italian scholars and writers of the period is Giovanni Pico della Mirandola (1463–94). He was the younger son of a family of minor nobility who had the good fortune to spend most of his career under the powerful protection of the Medici family. His best-known text, not published until two years after his death, is an *Oratio* composed as a preface for a public disputation which he planned to hold in Rome. This was aborted when some of the theses Pico put forward for discussion were condemned by the Church.

In the first part of the *Oratio* Pico tells a fable about the creation of man. Man, he says, was not given a fixed nature, like the other creatures in the world, but instead was given the power to choose his own nature for himself. All other forms of life are present in man: he can become a plant, an animal, a heavenly being, an angel, and a son of God, or he can even surpass all other creatures through his union with God.

Enthusiasts for Renaissance thought have seen in this fable a turning point in history—the first outright assertion of an individual's freedom to choose his or her own nature through the activities he or she undertakes, and thus an assertion of human liberty and dignity in relation to the cosmos. More recently, however, has come a realization that, in Pico's own mind, the fable was of strictly limited application. It was intended simply as a metaphor for the moral order which exists within every human being. Pico does not see man as engaged in transforming the whole universe—the possibility had never occurred to him—but as someone who rises or sinks according to the way he acts. All of this is, of course, in complete agreement with the doctrines of the Church Fathers, handed down by medieval theologians.

	1400	1440	1480	1520	1560	1600
		EARLY RENAISSANCE		HIGH RENAISSANCE		MANNERISM
HISTORICAL BACKGROUND		First printing press End of Byzantine Empire 1453	Columbus reaches America 1492 Italian wars begin 1494	Luther excommunicated 1520 Beginning of Reformation		
PHILOSOPHY/ LITERATURE		Guttenberg's Bible printed 1453–5	Machiavelli *The Prince* Ariosto *Orlando Furioso* Luther *95 Theses*	Castiglione *The Courtier* Loyola *Spiritual Exercises*	Montaigne *Essays* Shakespeare *Hamlet* Cervantes *Don Quixote*	
ARCHITECTURE	Brunelleschi, Dome of Florence Cathedral (**10.1**)	Alberti, Tempio Malatestiano (**10.5**)	Bramante, Tempietto (**11.1**)	Michelangelo, Laurentian Library (**13.2**)	Palladio, S. Giorgio Maggiore (**13.4**)	
VISUAL ARTS	Van Eyck (**9.9**) Masaccio (**10.7**) Fra Angelico (**10.13**)	Donatello (**10.17**) Botticelli (**10.14**) Mantegna	Leonardo da Vinci (**11.4**) Michelangelo (**11.6**) Raphael (**11.11**) Titian (**11.16**) Dürer (**12.2**) Grünewald (**12.5**) Cranach (**12.7**)	Holbein (**12.9**) Pontormo (**13.6**) Cellini (**13.22**)	Veronese (**13.15**) Bruegel (**13.13**) Bologna (**13.23**) Tintoretto (**13.16**)	
MUSIC	Josquin des Prez Dufay Ockeghem		Madrigal Rise of instrumental music	Tallis *Puernatus est* Palestrina *Missa Papae Marcelli*	Byrd *Cantones Savae*	

Early Renaissance architecture

The fifteenth century in Italy saw the emergence of architects as independent personalities—they became intellectuals, working according to rational rules, rather than artisans, dependent on instinct and the established customs of their trade. The new rationality in architecture was linked to a return to Greek and Roman models. This took place under the influence of the new enthusiasm for antiquity, promoted by the humanists. Architects began to study and measure the Roman remains which still surrounded them in Italy, so as to discover what general rules for architecture could be deduced. They were also greatly influenced by their study of the Roman architectural theorist Vitruvius (Vitruvius Pollio, *fl.* 46–30 B.C.) (see page 54). Vitruvius's *De architectura*, the only complete treatise on the subject to survive from antiquity, circulated widely in Italy during the fifteenth century, and the first printed text was published in Rome *c.* 1486.

The two leaders of the revolution in architecture, Filippo Brunelleschi (1377–1446) and Leone Battista Alberti (1404–72), were both of Florentine origin, but were very different from one another in personality and background.

Brunelleschi began his career as a goldsmith and sculptor— in 1401–2 he took part in the competition for the second bronze door of the Florentine Baptistery, tying with Ghiberti. He was friendly with Donatello, with whom he visited Rome in 1402. His interest did not shift decisively to architecture till *c.* 1418.

The achievement which firmly established Brunelleschi's reputation with his contemporaries was his dome for Florence Cathedral (Figs. **10.1** and **10.3**). To engineers at the time this presented an intractable problem, since they thought in terms of wooden centering, and the octagonal space to be covered was too wide for any timbers which might be available. Brunelleschi's solution came from his study of the Pantheon in Rome, which he realized must also have been built without centering. He combined Gothic and Roman elements. The dome was designed with twenty-four ribs, rising to a point, thus making use of the load-bearing capacities of the Gothic arch. But it was constructed out of self-supporting stone courses.

This was a feat of engineering rather more than an example of true innovation in architecture. Brunelleschi's

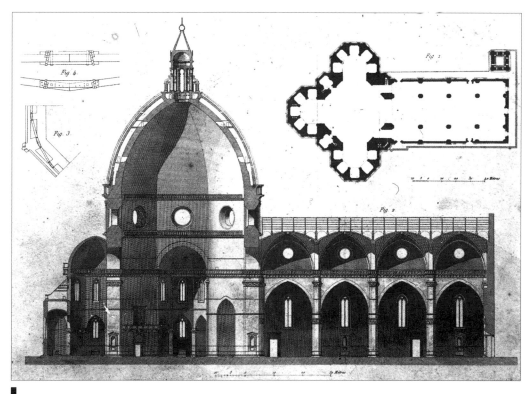

10.3 Plan and section of Florence Cathedral, 1420–36.

Focus

The Early Medici

The history of the Italian Renaissance is inextricably bound up with that of the Medici family in Florence. The Medici were plutocrats, not aristocrats. Their wealth came from banking; the family fortune was founded by Giovanni, born *c*. 1360, who became banker to the popes, newly restored to Rome after the Great Schism (see page 133).

Giovanni's heir, to whom he left a fortune of 180,000 florins (a vast sum of money at that time), was his son Cosimo. Cosimo, educated by the leading Florentine humanists of the day, always insisted that he was no more than a private citizen, but in fact he controled the government of the supposedly republican city of Florence.

Cosimo became the first important Medici art patron. Among the celebrated architects and artists he employed were Brunelleschi, who built the church of San Lorenzo for him, and Donatello, from whom he commissioned, among many other works, the celebrated statue of *Judith* (see page 186). His attitudes toward the due acknowledgment of this patronage were complex. Contemporaries regarded the buildings he commissioned as being as much his "work" as that of the architects who designed them. When he decided to rebuild the church of San Lorenzo in Florence at his own cost, the agreement he made with the chapter made it clear that this was done "provided the choir and nave of the church, as far as the original main altar was assigned to him and his sons ... it being understood that no other coats of arms or devices should be placed in the aforesaid choir and nave, except those of Cosimo and of members of the Chapter" (E. H. Gombrich, *Norm and Form*. London: Phaidon Press, 1966).

On the other hand Cosimo was careful not to seem too ostentatious in secular things. He rejected Brunelleschi's designs for a new Medici palace with the words: "Envy is a plant one should never water."

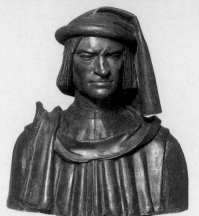

Andrea del Verrochio, *Bust of Lorenzo de'Medici c.* 1481. Terra cotta, 25⅞ × 23¼ × 12⅞ ins (65.8 × 59.1 × 32.7 cm). National Gallery of Art, Washington. Samuel H. Kress Collection.

When Cosimo died in 1464, he was succeeded, after a brief interval, by his grandson Lorenzo, a very different figure, even though he still maintained the pretence of being merely a private citizen. Athletic, attractive to women, a fine horseman and an equally good poet, Lorenzo delighted in the company of scholars, writers and artists. His personal commissions were nevertheless less important than Cosimo's, though one of the artists he patronized was Botticelli (see page 185). Instead, Lorenzo became a much respected artistic *éminence grise*, or adviser. "How greatly he excels in architecture!" wrote an enthusiastic contemporary. "In both private and public buildings we all make use of his inventions and harmonies." Perhaps the greatest proof of his taste and prescience in artistic matters was the encouragement he gave to the young Michelangelo.

One of Lorenzo's greatest political triumphs was to obtain a cardinalate for his son Giovanni, then aged only fourteen. Soon after the formal proclamation of this, in 1492, Lorenzo died of gout, a complaint which was hereditary in the Medici family. Medici fortunes immediately declined, and the family were exiled from Florence by a restored republican government. Lorenzo's son Piero, his direct heir, was killed in battle in 1503, fighting for the French invaders of Italy. However, because of the papal connection, Medici power was about to ressurect itself. In 1512 the Medici, now led by Cardinal Giovanni, recovered control of their native city; and in the following year Giovanni was elected to the papacy, as Pope Leo X. Medici patronage had the opportunity to blossom yet again. However, the circumstances were now very different. As sovereign pontiff, Leo had no need to conceal his personal involvement. Nor did he confine his patronage to Florentine artists alone, unlike his predecessors, to whom the patriotic Florentine element had always been very important. The artist whom Leo most favored, Raphael (see page 197), was by birth an Umbrian, though he had learned part of his trade in Florence.

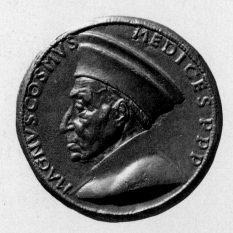

Medal of Cosimo Medici 15th century. Cast bronze, 3 ins (7.7 cm) diameter. Victoria & Albert Museum, London.

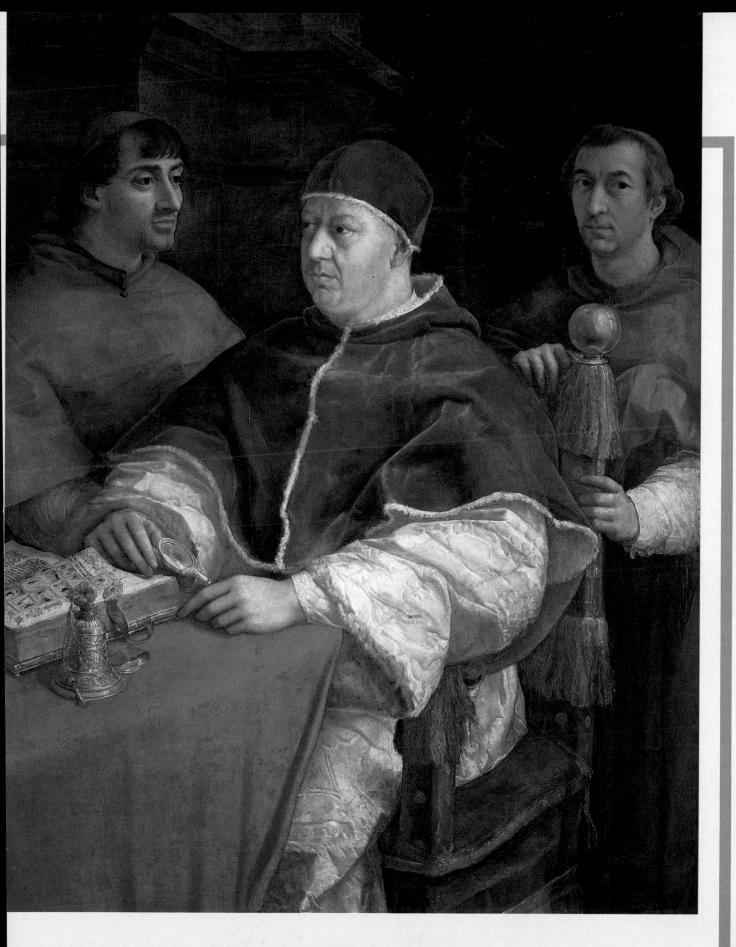

Raphael, *Portrait of Leo X* 1518–19. Oil on board,
60¾ × 46¾ ins (154 × 119 cm). Uffizi Gallery, Florence.

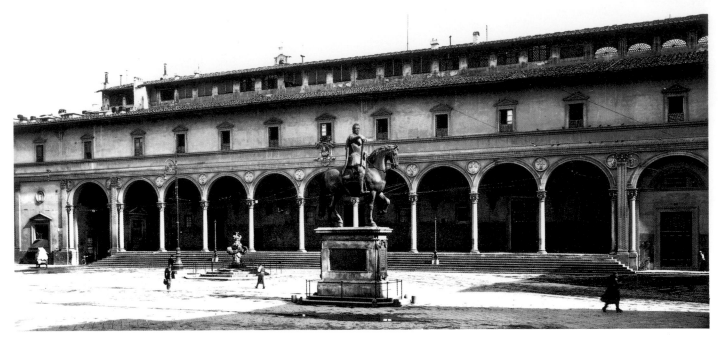

10.4 **Filippo Brunelleschi**, Ospedale degli Innocenti, Florence, 1419–24.

qualities as an architect can be better judged from other projects which are less ambitious but show his classical affiliations more clearly. The best known is the Ospedale degli Innocenti (Fig. **10.4**) in Florence, often called the first Renaissance building, which was designed in 1419 and built between 1421 and 1444. Compared with what came later, the design is cautious—a compromise between the Tuscan Romanesque of the eleventh and twelfth centuries, and what Brunelleschi had learned from looking at Roman buildings. The façade consists of an arcade carried by wide-set Tuscan columns, rather thin and fragile for the function they are called upon to perform, with, above them, small,

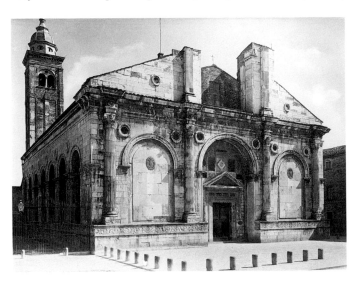

10.5 **Leone Battista Alberti**, Façade of the Tempio Malatestiano, (S. Francesco), Rimini, 1446.

wide-set windows placed above the center of each arch, and crowned in turn with simple pediments. The chief ornament of the façade is very unclassical—a series of blue-and-white glazed terracotta roundels set in the spandrels, the triangular areas of stone between successive arches.

Leone Battista Alberti's background was very different from Brunelleschi's. The illegitimate son of a Florentine exile from a once extremely wealthy family, he was educated at Padua and Bologna (where he studied law), and did not set foot in Florence until 1428. In 1431 he joined the papal civil service in Rome, and gradually came to undertake missions where he combined the functions of diplomat and of cultural adviser.

Architecture was only one of Alberti's many interests, which also included music, mathematics, the natural sciences, and drama. He was as much an architectural theoretician (a new breed) as he was a practicing architect; his approach was rooted in the study of the antique—both actual Roman remains and the writings of Vitruvius. Unlike Brunelleschi, constructional problems interested him very little. For him architecture was an intellectual discipline, and also something with close analogies to painting. "Can anyone doubt," he wrote, "that painting is the mistress of the arts, or at least something more than the mere ornament of everything else? If I am not mistaken . . . the art of the painter guides all artisans, sculptors, and workshops." It is interesting to note the link between the architectural backgrounds in Masaccio's and Piero della Francesca's paintings, and what Alberti built in reality.

Alberti was always careful to retain his amateur status. He was content to supply designs, and to leave the super-

visory work, as well as the work of construction, to others. His best-known project is his transformation of the existing Gothic church of San Francesco in Rimini (Fig. **10.5**) to serve as a memorial to the local ruler, Sigismondo Malatesta. This building, now known as the Tempio Malatestiano, remained unfinished, since Sigismondo lost control of the city before the work was completed. One of its most significant features is the entrance façade, adopted from a Roman triumphal arch. This is an early instance of the way in which the new classical architecture used forms invented by the Romans to serve a given, quite specific purpose for other, rather different ones.

Painting

Masaccio and Early Renaissance painting

Early Renaissance painting in Italy inevitably demands that one approach it in a different way from the painting which was being produced in the rest of Europe. The reason for this is not that Italian painting was so much more "advanced" than painting in the north—in many respects the art of the van Eycks was just as revolutionary as that of Masaccio. But their approach was pragmatic rather than theoretical. What Italian fifteenth-century painting does is invite us to look at art in a different and much more intellectual way. The style of the Italian Early Renaissance masters is the embodiment of new concepts about the nature of pictorial representation.

If Giotto foreshadowed the Renaissance, his discoveries were nevertheless for a period neglected and forgotten. The man who changed the course of Italian painting is Masaccio (1401–29). Masaccio's active career as a painter covers much less than a decade—he enroled in the Florentine painters' guild in 1422, and his earliest surviving work dates from that year. Though he is an astonishing phenomenon, it is important to realize that he did not spring from wholly barren soil. However, those who prepared the way for him were not painters but sculptors. This, of course, was also true of Giotto. If Giotto's exemplars were the Pisani, Masaccio's were Donatello and Lorenzo Ghiberti.

Donatello led Masaccio, and through him Masaccio's successors, to consider the importance of two things: the human figure as a solid form in a given volume of space, and the shaping of the space itself. For the latter, Donatello's reliefs were as important as his three-dimensional sculptures, since they demonstrate that Donatello already had a thorough knowledge of mathematical or linear perspective. Masaccio does not surpass Donatello in these skills, but he made what the latter did in low relief available to painters, and this had far more impact on the history of painting than the reliefs themselves had on that of sculpture.

Masaccio's most important works historically are his frescos in the Brancacci Chapel in Santa Maria del Carmine in Florence. These belong to the very end of the artist's brief life, and were painted in 1427/8. The two most famous scenes in the chapel are *The Tribute Money* (Fig. **10.7**) and *The Expulsion from Eden* (Fig. **10.6**). *The Tribute Money* is particularly reminiscent of Giotto in its command of clearly expressed dramatic action, but the way in which the figures stand freely in space marks a great step forward. The massive dignity of Christ and his followers—unsurpassed by any High Renaissance artist—is in striking contrast to the frantic emotion of the *Expulsion*, where Eve lifts her head and howls inconsolably as she and Adam are driven out of Eden. But these figures, too, have a new solidity and strength of articulation—something which was recognized by the artist's contemporaries and successors. Michelangelo studied Masaccio carefully, and did not think it beneath his dignity to borrow from him when he came to paint his own version of the *Expulsion* on the Sistine Chapel ceiling (see page 195).

Piero and Mantegna

Though the classical revival of the fifteenth century is so closely associated with Florence, in art as well as in architecture, it is arguable that the most interesting painters who showed strong classical influences were not in fact Florentines—that is, apart from Masaccio himself. Masaccio's truest direct successor is Piero della Francesca (*c.* 1416–92). Although he had close contacts with the Florentine artistic milieu, he had been born in Borgo San Sepolcro and most of his career was spent outside Florence, though within the Florentine orbit.

The frescos showing *The Story of the True Cross* in the choir of the church of San Francesco at Arezzo demonstrate his commitment to the new monumental ideals, but also show the way in which he differed from Masaccio and Masaccio's immediate followers. The two-part composition, *The Adoration of the Wood by the Queen of Sheba* and *The Meeting of the Queen of Sheba and Solomon* (Fig. **10.8**), demonstrates some of the differences. The figures are grand and solemn, but deliberately inexpressive. They are not taking part in a drama but in a ritual. The impassivity of the faces is especially notable. Though Piero was deeply interested in the new science of perspective, and even wrote a treatise on the subject, he was careful to use perspective

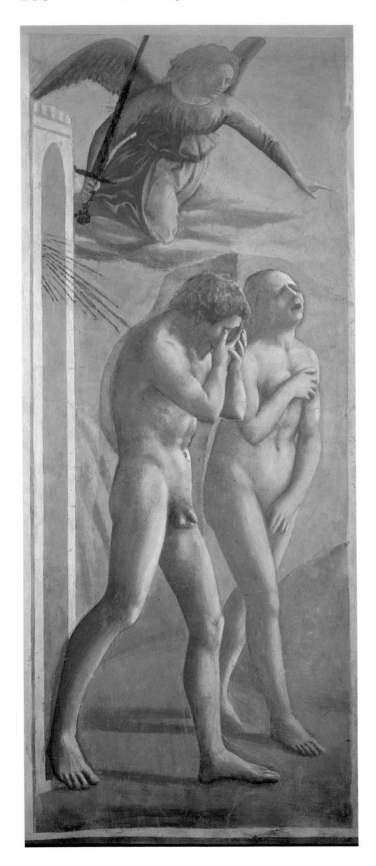

10.6 **Masaccio**, *The Expulsion from Eden c.* 1427.
Fresco in the Brancacci Chapel, Santa Maria del Carmine,
Florence.

effects with great restraint. He does not seek to convince the spectator that he is looking through an opening, but rather at a unified wall surface. The painted column which divides the two scenes plays an important role in preserving this unity, as does the close-packed mass of bodies in the scene to the right and the frequent appearance of figures in true profile.

The unselfconscious nature of Piero's classicism makes a striking contrast with the attitudes expressed in the work of his near-contemporary, Andrea Mantegna (1421–1506). Mantegna came from Padua, which was one of the places in which Donatello worked, and this no doubt helped to re-inforce an already powerful classicizing bias.

His best-known achievement is the set of frescos for the Camera degli Sposi in the Ducal Palace at Mantua, painted between 1465 and 1474. The subject of the main scene is Duke Lodovico III Gonzaga, accompanied by his wife, his children, and his court. The figures occupy a narrow area of space—it is not too much to call it a kind of shelf—in front of a fictive architectural setting, the latter distantly derived from Roman art. The striking thing is that they are sculptural yet living—the human relationships are as clear as the relationships between the forms.

In the Camera degli Sposi Mantegna uses some of the illusionist tricks which were to become such an important feature of High Renaissance and Baroque art. Particularly delightful, not only for its charming subject matter but also because it is better preserved than the rest, is the ceiling painting (Fig. **10.9**)—a circular opening, with a balustrade, reveals winged putti and also human spectators looking down at whoever is in the room. There is a sophisticated interplay of different levels of reality here which shows how programmatic classicism was already beginning to be leavened with both playfulness and irony.

Early Renaissance painting in Venice

Mantegna's classicism was to make its mark in Venice, but this was not the natural direction of Venetian art, which was processional and narrative.

One of the first to break away from the Gothic style in Venice was Jacopo Bellini (*c.* 1400–70/1). It was his elder son, Gentile (*c.* 1429–1507), who established the vogue for enormous narrative paintings full of figures—in Venice these took the place of frescos painted on walls. (The reason for the substitution was the damp climate of the city.) Gentile, in turn, was followed in doing this kind of work by Vittore Carpaccio (*c.* 1460–1526), whose fame has now eclipsed that of the senior artist—not unjustly, since his narrative scenes surpass Gentile's because they are suffused with unifying light. Carpaccio's *Dismissal of the English Ambassadors* (Fig. **10.10**), from his series devoted to the life of St. Ursula, uses ideas picked up from Mantegna and Piero without real conviction—among them the architectural set-

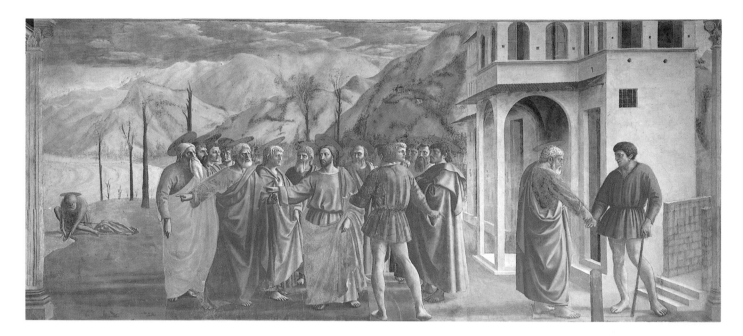

10.7 **Masaccio**, *The Tribute Money* c. 1427.
Fresco, 8 ft 4 ins × 19 ft 8 ins (2.54 × 5.9 m). Brancacci Chapel, Santa
Maria del Carmine, Florence.

10.8 **Piero della Francesca**, *The Adoration of the Wood by the
Queen of Sheba, The Meeting of the Queen of Sheba and Solomon*
from *The Story of The True Cross* c. 1452–64. Approx. 11 × 24 ft
(3.35 × 7.3 m). Fresco in the Church of S. Francesco, Arezzo.

ting, and the way the figures are composed in carefully
linked groups. But Mantegna's forceful plasticity is miss-
ing. The emphasis is on the story being told, and details of
formal organization are never obtrusive enough to disturb
its flow.

The true innovator in late-fifteenth-century Venice was
Giovanni Bellini (*c.* 1432–1516), who happened to be Man-
tegna's brother-in-law. Bellini's work is closer to that of
Mantegna than it is to that of the other members of his own
family. There are, however, important differences between
Bellini and Mantegna. The former's work is softer, less

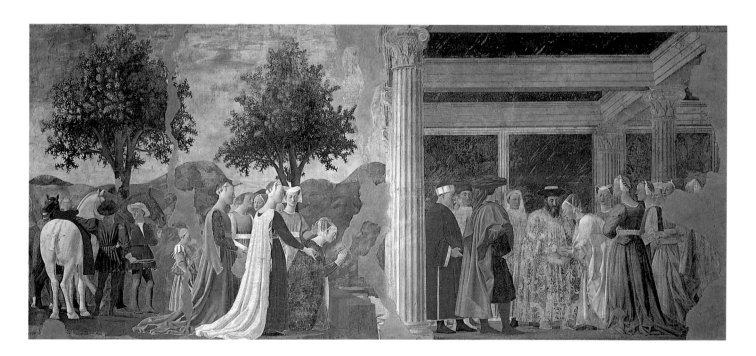

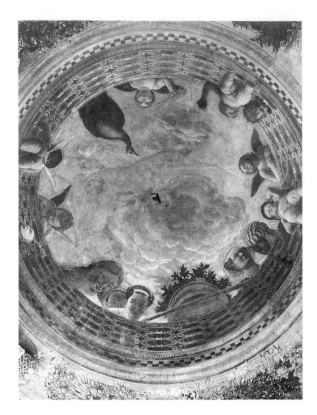

10.9 **Andrea Mantegna**, ceiling painting from the Camera degli Sposi, Ducal Palace, Mantua, 1465–74.

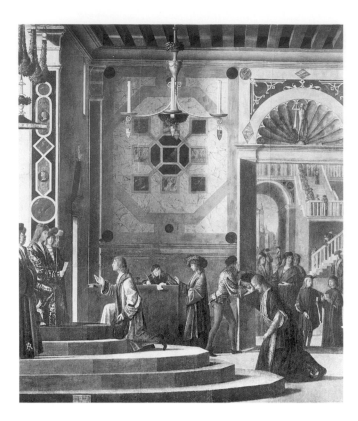

10.10 **Vittore Carpaccio**, *The Dismissal of the English Ambassadors* 1495. 110¼ × 99¾ ins (280 × 253 cm). Accademia, Venice.

glacially insistent on the power of drawing. He is able to find effects of color which are beyond Mantegna's reach, linked to a more moving and human approach to basic subject matter. Yet the two artists share an underlying classicism of compositional structure.

There are a number of striking paintings from Giovanni Bellini's hand which feature the dead Christ, supported by the Virgin and St. John, or by two or more lamenting angels. Perhaps the greatest is now in Berlin. Christ is shown as a sleeping hero, tenderly nursed by his angelic attendants (Fig. **10.11**). There is an overt allusion to classical sculpture—Christ's torso is like an antique marble—but the source is flexibly used. Bellini is well aware that this is a painting—colors and tones on a surface—and not a fictive version of something first imagined in three dimensions.

In mid-career Bellini began to use oil paints rather than tempera. According to tradition, he was introduced to oils by Antonello da Messina (1431?–79), a Sicilian artist who had already produced a great deal of work in Sicily and the south of Italy, where he is first recorded in 1475. Antonello is the only important Italian artist of the fifteenth century to come from the south, and it is therefore strange that he is also the one most closely linked to Flemish painting.

Documentation concerning him is scanty. His work is startlingly various and seems to pull in contrary directions. The San Cassiano altarpiece (Fig. **10.12**) in Vienna, though mutilated, is obviously the ancestor of similar pictures by

Bellini and Giorgione (see page 200), in which a monumental figure is enthroned on high. Yet, though monumental in form, the central figure of the Madonna has a particularity which is new—she is the forerunner of the Madonnas which would be produced by Dürer, after his Venetian visit. What one sees in Antonello is a constant dialogue of styles. He performs the apparently impossible feat of building a bridge between the van Eycks on the one hand and Piero della Francesca on the other.

Fra Angelico and Botticelli

It would be convenient for the cultural historian if all major Italian painting of the fifteenth century could be firmly yoked to the idea of classicism. But even in Florence itself this was not the case. During the first half of the century, for example, we immediately encounter Fra Angelico (1399?–1455), who had close personal connections with the "reformers" of Florentine art. He was the apprentice of Masolino, who collaborated with Masaccio himself.

Fra Angelico nevertheless represents a conservative current in Florentine painting. As a member of the Dominican Observants—the reformed wing of the Dominican order—his main aim was to subordinate art to the service of religion. But his artistic conservatism is not entirely consistent. Since the representation of spirituality through the

visual image was his aim, Fra Angelico could make radical departures from traditional practice if these seemed to be justified by the overriding purpose of his art. One thus finds in his work elements from the new approach which was being pioneered in the first half of the fifteenth century side by side with others that look back to the *trecento*. Fra Angelico's altarpiece of the *Annunciation* in Cortona (Fig. **10.13**), painted *c*.1438, shows just such a fusion—the weightless, otherworldly figures refer back to the world of Gothic art, while the setting they are placed in already belongs to the new dispensation. The combination was so successful that the work became an important archetype for later Florentine painting.

The classical strain in Italian fifteenth-century painting was later to be contradicted, in a more complex and interesting way, by Sandro Botticelli (1445–1516), one of the most famous artists of the time. Like Masaccio, Botticelli owed much to contemporary sculpture—in his case not to Donatello but to Verocchio, in whose studio he worked between 1465 and 1470. Botticelli was, of course, keenly aware of the new fascination with classical antiquity. He even became involved with it, but in a literary way. Some of his best-loved paintings, such as the *Birth of Venus* (Fig. **10.14**), use classical subjects of a kind still unthinkable in northern Europe. They signal the radical and experimental nature of Botticelli's intellectual milieu. The *Birth of Venus* is imbued not only with literary ideas borrowed from the Greek and Roman classics but with others, more hermetic, which come from Renaissance Neo-Platonism. Yet the capricious forms and irrational organization of space have few similarities to anything attempted by Masaccio. Botticelli's charm comes from his command of line, not from his ability to construct solid volumes in imagined space. He proposes an esoteric ideal of beauty which can exist only in the imagination, not in reality. This ideal was very much to the taste of the Neo-Platonist circle which surrounded him in Florence.

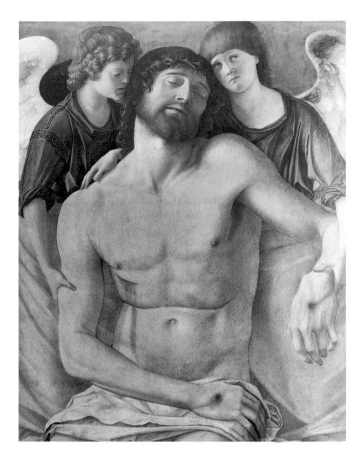

10.11 **Giovanni Bellini**, *Christ supported by Angels*, 1468. Oil on canvas, 82 × 66 ins (208 × 167.5 cm). Staatliche Museen, Berlin.

10.12 **Antonello da Messina**, The San Cassiano Altarpiece, Vienna, mid-15th century. Kunsthistorisches Museum, Vienna.

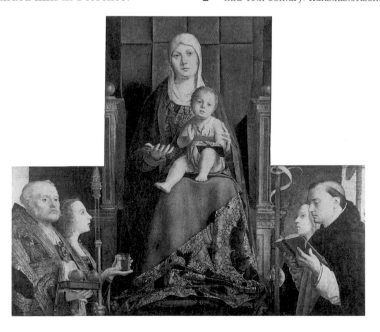

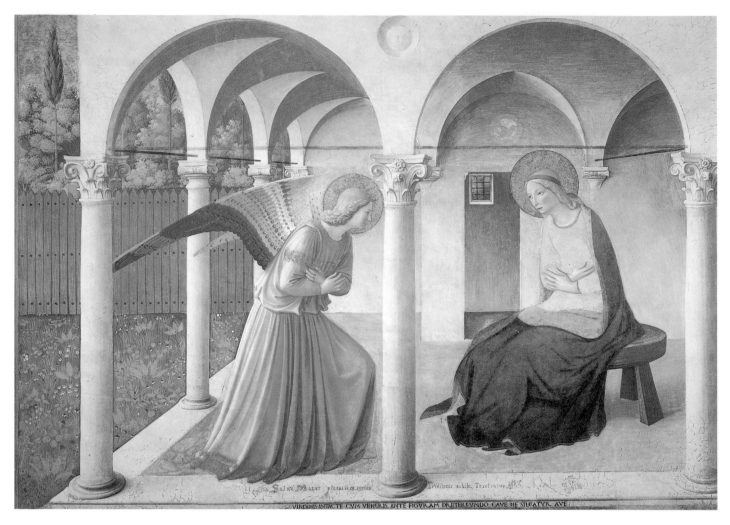

10.13 Fra Angelico, *Annunciation c.* 1440–5.
Fresco, 73½ × 61½ ins (187 × 157 cm). The Convent of S. Marco,
Florence.

Early Renaissance sculpture

Donatello and Verrocchio

The most remarkable artist of the Early Renaissance, one who, unlike Masaccio, was fortunate enough to live a long, creative life, was the sculptor Donatello (*c.* 1386–1466). Like Donatello himself, the Renaissance style in sculpture was born in Florence, and we are even able to give it a precise beginning. It originated in 1401, the year in which a competition was held to select an artist for the second pair of bronze doors for the baptistery in Florence. The victor was Lorenzo Ghiberti (1378–1455), but the contest was an extremely close one. At one stage it was suggested that Ghiberti should divide the task with Filippo Brunelleschi, who had also submitted a trial relief on the chosen theme of the *Sacrifice of Isaac* (Fig. **10.15**).

Brunelleschi's relief survives. While less fluent than that of the more experienced Ghiberti, it has a forceful realism which was quite new in sculpture: Abraham is horror-struck, but still resolute about what he has to do; Isaac is terrified; the angel messenger intervenes physically, grabbing Abraham's arm in order to halt the blow. Henceforth Renaissance sculpture was to make this sense of being true to life an important criterion of merit. In his treatise *De Statua* (*On Sculpture*), Leone Battista Alberti says bluntly that sculptures "should appear to those who look at them like real forms."

Renaissance sculptors first studied the antique not so much for its own sake, but as a means of getting back to nature, and it is important to remember this when looking

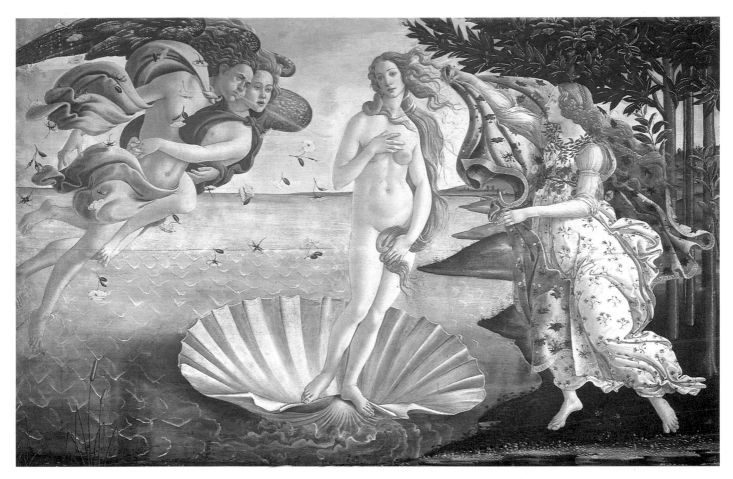

10.14 **Sandro Botticelli**, *The Birth of Venus c.* 1480.
Tempera on canvas, 68 × 109 ins (173 × 277 cm). Uffizi Gallery, Florence.

at their earliest products. Nowhere is this more obviously the case than in the work of Donatello.

Donatello was Brunelleschi's close friend and associate and he pursued the path the latter might have taken, had he stuck to sculpture instead of turning to architecture. His career, uniformly successful, embraced thirty-seven years of work in Florence, another ten in Padua (1443–53), and a final period spent back in his native Tuscany. The work he produced was always innovatory. Single-handed he re-invented the idea of the freestanding statue, making it something which was meant to be viewed in isolation, as an independent work of art. He was also responsible for the creation of an entirely new kind of relief sculpture. His reliefs, rather than Masaccio's frescos, first put the new science of perspective to practical use.

The freestanding statue evolved through several stages of development, all of which are exemplified in Donatello's work. The gap between the first stage and the last is very wide. The first can be seen in Donatello's early *St. George* (Fig. **10.16**), made for the guildhall of Orsanmichele in Florence. This, like the other full-length, life-size statues which adorned the structure, was displayed in a niche. But the niche is shallow, and projects the figure toward the

10.15 **Filippo Brunelleschi**, *The Sacrifice of Isaac* 1401. Gilt, bronze, 21 × 17½ ins (53.3 × 44.4 cm). Museo Nazionale del Bargello, Florence.

10.16 **Donatello**, *St. George* c. 1415–17. Marble, approx. 82 ins (208 cm) high. Orsanmichele, Florence.

10.17 **Donatello**, *Judith and Holofernes* 1455. Bronze, height 7 ft 9 ins (2.35 m). Piazza della Signoria, Florence.

onlooker; views from the side are therefore nearly as important as the directly frontal one. Though the figure has a lanky Gothic elegance, one can see that Donatello was very much preoccupied with producing a strong silhouette which could be read clearly from all possible viewpoints, and that the architectural setting concerned him very little—which would not have been the case with a genuinely Gothic sculptor.

His bronze *Judith* (Fig. **10.17**) dates from 1455, after his return from Padua, and thus belongs to the last phase of his career. Even at the mid-century, bronze statues on a large scale were still relatively new, and were regarded chiefly as being deliberate, rather self-conscious attempts to rival the antique. Donatello ignored this. He was determined to exploit the qualities of the material in a new way, and to get rid of references to antiquity altogether. His *Judith* is not in fact a single figure, but a group. The figures make a single, unitary form, yet it is also clear that they are in violent motion. Judith stands over Holofernes as Brunelleschi's Abraham stands over Isaac. She pulls him forcefully upwards by the hair, while still pinning him to the ground by standing on one of his wrists; she is preparing to sever his head with a single blow. Ancient Greek and Roman sculpture offers nothing quite so vivid and immediate.

The revival of the equestrian monument was prompted by a spirit not of contradiction but of direct emulation of the ancients—the famous statue of Emperor Marcus Aurelius in Rome was an important stimulus to the sculptors of the Early Renaissance. The vogue began with figures made of impermanent materials, such as stucco or wood, but these were unlikely to satisfy Renaissance ambitions for long. In the early 1450s two equestrian monuments in bronze were under way. One, a statue of Niccolo III d'Este, was set up by his son Lionello in Ferrara in 1451 (it was demolished in 1796). Donatello's portrait of the celebrated *condottiere* Gattamelata (Fig. **10.18**), designed for Padua, was by that time almost ready—the chasing of the bronze was complete in 1450, but the statue was not put in place until 1453.

The figure is innovatory, but in less obvious ways than the *Judith* which followed it. Donatello keeps to the formula suggested by the statue of Marcus Aurelius—a general commanding his troops. But the relationship with the spectator is much more direct than that suggested by the Roman figure, where the rider is remote and godlike. Gattamelata glares in front of him, filled with determination to be obeyed. The head is both a true portrait and an icon of command, with compressed lips and enlarged, slightly bulging eyes.

In contrast with the Gattamelata, which is so obviously dependent on an antique prototype, Donatello's most characteristic reliefs reject previous examples even more decisively than his *Judith*. The technique he used is called *rilievo stiacciato*—flattened relief. The forms seem lightly engraved into the surface, with the very minimum of either projection or recession. The advantages were twofold: first,

Donatello avoided the difficulty of making a convincing transition from fully modeled figures to a detailed background which would not be in scale with them; secondly, the technique wrapped all the figures in a shimmering, atmospheric envelope. This atmosphere, in turn, made it much easier to suggest that they were actually in motion. In Donatello's hands *rilievo stiacciato* has the precise perspective construction associated with Masaccio.

Some of the most remarkable examples of Donatello's virtuosity occur in the reliefs he made for the high altar of San Antonio in Padua. These show miracles from the life of the saint to whom the church is dedicated. St. Anthony of Padua was—and still is—the subject of a local cult of uncommon fervor, and it is the atmosphere of this which Donatello successfully renders. In *The Miracle of the Mule* (Fig. **10.19**), the animal genuflects to the saint, who is holding out the Host, while ignoring the oats held out to it by two men behind. The foreground on either side is crowded with intently watching figures, and there are more, on a smaller scale, further back. The setting consists of three deep, Albertian barrel vaults. There is a rear wall which is pierced with three semicircular windows, each blocked with a grill, and through these yet another grill is visible. The precision of the almost willfully elaborate perspective construction serves to emphasize the spontaneous charm of the foreground narrative. Greek and Roman art offer no parallels for a relief of this kind. On the other hand, it is instantly recognizable as one of the best products of a particular time and place—Renaissance Italy of the fifteenth century.

None of the other Italian sculptors of this time was Donatello's equal, but there were a number of men of great talent

10.18 **Donatello**, *Equestrian Monument to Gattamelata* 1445–50. Bronze, approx. 11 × 13 ft (3.4 × 4 m). Piazza del Santo, Padua.

in whose hands Renaissance sculpture took on an identity which made it something completely separate and different from the Gothic art which still prevailed throughout the rest of Europe.

One very powerful preoccupation of the time was with the idea of lasting fame. It was this which inspired Donatello's equestrian statue of Gattamelata, and the Gattamelata found a worthy successor in another equestrian monument

10.19 **Donatello**, *Miracle of the Mule* 1446–53. Relief from the high altar of S. Antonio, Padua. Bronze, each 22½ × 48½ ins (57.15 × 123.2 cm).

10.20 **Andrea Verrocchio**, Equestrian monument of Bartolommeo Colleoni c. 1481–96.
Bronze, height approx. 13 ft (3.96 m).
Campo SS. Giovanni and Paolo, Venice.

to a successful *condottiere*—Andrea Verrocchio's Bartolommeo Colleoni (Fig. **10.20**). Verrocchio (1435–88) was not purely a sculptor, any more than Brunelleschi or Alberti were purely architects, and his workshop turned out goldsmiths' work and paintings as well as sculptures. One of his junior collaborators was Leonardo da Vinci. However, the Colleoni is now his most celebrated surviving work. It has a dynamism, a suggestion that horse and rider are on the brink of violent movement, which is something new. If the group as a whole is a little inferior to the Gattamelata, that is largely because Verrocchio died before the statue was cast and it lacks some finishing touches.

A growing interest in the quirks of human personality, plus a desire to emulate classical prototypes, led to an increasing production of portrait busts. The fifteenth-century preoccupation with achieving a true likeness to nature meant that these were often based on life-masks. An example is the bust by Antonio Rossellino (1427–79) of Antonio Cellini (Fig. **10.21**). A tell-tale detail is the way in which the subject's ears are flattened against his head. But Rossellino was not content to use the cast as it stood; he was at pains to make a "speaking likeness." We feel, looking at his work, the presence of a fully recognizable personality, with a well-developed inner life.

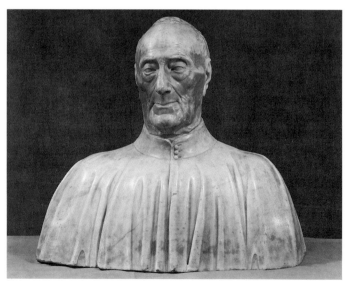

10.21 **Antonio Rossellino**, *Bust of Cellini*, 1456.
Marble, 20 ins (51 cm).
Victoria and Albert Museum, London. Courtesy of the Trustees.

Chapter 11

The Italian High Renaissance

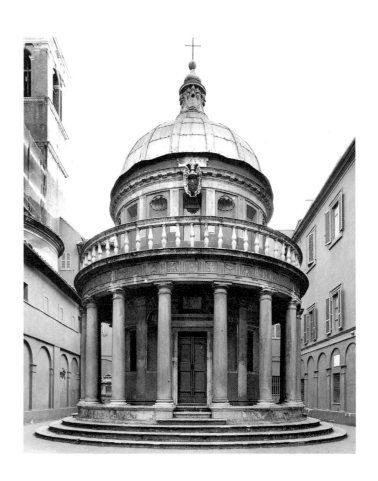

11.1 Bramante, The Tempietto, S. Pietro in Montorio, Rome, 1502.

Philosophy

Machiavelli and Castiglione

The two most characteristic texts of the High Renaissance are not philosophical treatises but books of practical instruction in which philosophical ideas play an underlying but important part. One is *The Prince*, by Niccolò Machiavelli (1469–1527); the other is *The Courtier*, by Baldassare Castiglione (1478–1529). *The Prince* was written in 1513; *The Courtier*, though not published until 1527, was largely composed between 1516 and 1518. The backgrounds to both are the foreign invasions of Italy, which began with the French incursion of 1494 and reached a horrific climax in 1527, when Rome was sacked by the largely German troops of the Emperor Charles V. These invasions reduced the formerly independent states of the peninsula to vassalage.

Both books owe much to the direct, practical experience of their respective authors. Machiavelli served the Florentine republic as civil servant and diplomatic agent till forced into retirement by the return of the Medici family in 1512; Castiglione was himself a courtier, first in his native Mantua, then in Urbino. He undertook diplomatic missions for the dukes of Urbino, and later for Pope Clement VII, and was serving as Papal Nuncio in Spain at the time of his

death. The approach adopted by both authors is essentially pragmatic, and makes a striking contrast with the Neo-Platonic philosophizing of their fifteenth-century predecessors. This loss of idealism reflects the political climate of the times.

Machiavelli's attitudes—the tone of aggressive practicality which he adopted, and his apparently contemptuous disregard for conventional standards of morality—shocked his contemporaries, and have continued to shock posterity. In the later sixteenth century his name became a synonym for the devil. The basic proposition he puts forward is that successful rulers can afford to consult only their own interests.

The role model he proposed had nothing to do with the republican institutions of his native Florence. It was inspired by the ruthless Cesare Borgia (1475–1507), illegitimate son of Pope Alexander VI, who, with his father's help, carved out an ephemeral principality for himself in central Italy.

The Prince has been described as the earliest treatise on political science, and it is worth putting some emphasis on the word "science." Unlike the humanists, who were his predecessors, Machiavelli makes a point of confining him-

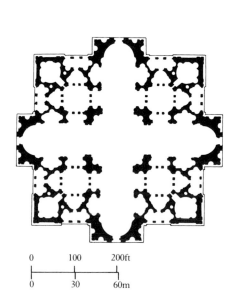

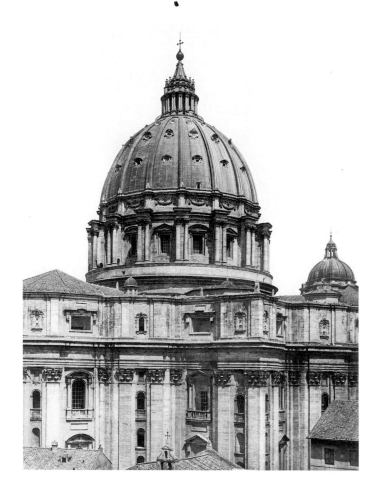

0 100 200ft

0 30 60m

11.2 (*above*) Bramante's original plan for St. Peter's, Rome, 1506. (*right*) Dome of St. Peter's.

self to what is already firmly established. Indeed, his book derives its memorable and characteristic tone from a gleeful insistence on unorthodox conclusions built upon universally agreed data. Machiavelli never claims to know more than the reader; he simply arranges familiar facts to make a new and disturbing intellectual pattern. In this respect, he bears an unexpected resemblance to Socrates, whose incessant questioning was aimed at breaking the grip of received ideas.

Castiglione's book is longer than Machiavelli's, and deals with a wider variety of subject matter. *The Courtier* is cast in the form of a series of discussions between regular members of the court at Urbino and distinguished visitors from outside. The theme is the formation of the perfect courtier—that is to say, in modern terms, what goes to make a "gentleman." Almost every conceivable aspect is covered: the courtier's physical attributes and skills, what he should wear, and how he should behave in the presence of others. When dealing with matters of behavior, Castiglione introduces the important concept of *sprezzatura*: the apparent casualness which disguises artifice and forethought. There is considerable discussion of relationships between men and women. While Castiglione defends the position and dignity of women, he is far from being a feminist in any modern sense. His ideas spring from the old chivalric code, mingled with still-fashionable Neo-Platonism.

The real core of the debate is not reached until near the end. It is to be found in the question: What is the purpose of the courtier, once formed in the mold Castiglione describes? The answer is that his job is to please the ruler, since only through pleasing him can he exert influence—he has no independent power of his own. The ruler, thus subtly conditioned, will reward the courtier by providing the kind of secure environment within which true leisure and tranquility can be enjoyed. For Castiglione, the function of the court is largely negative. It is the only plausible shelter against the dangerous storms of the world.

The ideal prince, Castiglione implies, without actually daring to say so outright, is a figment of the imagination; the perfect courtier, just because of his perfection, might easily become an object of resentment. While the tone adopted in *The Courtier* is very different from that chosen by Machiavelli, Castiglione's underlying conclusions, obliquely stated, seem to be very close to those arrived at in *The Prince*.

Architecture

Donato Bramante

Donato Bramante (1444–1514), more even than artists such as Leonardo, Michelangelo, and Raphael, has been considered the real progenitor of High Renaissance classicism. It is true that he welded together ideas found in the work of predecessors such as Brunelleschi and Alberti, and also in Vitruvius and surviving examples of Roman architecture, to create an architectural style which makes inventive use of the rediscovered classical vocabulary of forms. But there is also very little which is orthodox about his buildings.

Bramante came from Urbino, and was of humble origin—his parents were peasants. Nothing is known of his activities as an architect until 1477, by which time he was in Lombardy. He left Milan in 1499, driven out like many other artists by the fall of Ludovico II Moro, the Sforza ruler, and the French occupation, and arrived in Rome in early 1500. His Roman buildings and projects, created in the last fourteen years of his life, established his claim to be a new kind of architect.

The most important of his uncompleted projects was his design for rebuilding St. Peter's. A vast new classical church with a dome was to be erected on the site of the old Constantinian basilica. The plan was to be a Greek cross, and the purely classical forms were to represent the antiquity of the Church in Rome (Fig. **11.2**). Bramante seems never to have fully thought out his scheme, and for both financial and political reasons it did not get very far. Our completest representation of what he envisaged appears on a medal by Caradosso, cast in 1506 and buried in the new foundations. However, this scheme was several times modified before the architect's death in 1514. Despite all this, Bramante's ideas for the new church remained influential for a full century, and St. Peter's as we see it now still owes something to him.

The only building he fully completed during this Roman period is as small as St. Peter's was meant to be vast. It is the Tempietto at the church of San Pietro in Montorio, intended to mark the place of St. Peter's crucifixion on the Janiculum Hill. The Tempietto—"little temple"—(Fig. **11.1**) is a circular, classical building, crowned with a dome. This is not the one Bramante designed, but the rest remains unaltered.

The building is often cited as an example of the way in which Renaissance architects made direct imitations of Greek and Roman models. Yet closer examination shows unorthodox features. For example, the pillars of the colonnade correspond to the pilasters which articulate the wall of the cella. Yet, because the building is a miniature, these pilasters leave little room for windows, or indeed for a door. Bramante solves these problems adroitly, but with little reference to classical rules. The window frames are inserted

into the thickness of the wall, rather than projecting from it. The doorframe, by contrast, extends over the two pilasters on either side. It is out of scale with all the other architectural elements, and negates the supposed bearing function of the pilasters. This sort of contradiction would afterwards come to be called Mannerist (see page 219). In this form it demonstrates the essential inventiveness of Renaissance architecture, even when its classicism seems at first glance most orthodox, and its constant readiness to adopt *ad hoc* solutions.

High Renaissance painting

General attitudes

There are three different ways of looking at the brief period in Italian art at the beginning of the sixteenth century which saw the transition to a new style, and which at the same time produced a small group of painters of genius. The first is to see it in purely stylistic terms, as a return to, and deepening of, the classical style pioneered by Masaccio toward the beginning of the fifteenth century. Another way of looking at what happened is to see things in social terms. There was, thanks to the evident genius of a small group of artists, a marked rise in the social status of all painters and sculptors. This change has been attributed to the demands made by leading artists, and in particular to the stress put by Leonardo da Vinci on the "noble" qualities of art. Another reason, however, was the enthusiastic patronage offered by the papacy, and especially by Julius II, who saw artists such as Michelangelo and Raphael as men who could contribute to the glory of his office and treated them accordingly.

Finally, and this was perhaps the most important factor, there was the growth of the cult of genius, based on Michelangelo's personality in particular. Thanks to Michelangelo, artists were allowed a greater and greater say in the design, content, and actual execution of their work. Their right to make it a purely personal expression of subjective ideas and feelings was increasingly recognized, and this set artists free to experiment and innovate: they ceased to be artisans and became artists in the full sense of the word as we now use it. Though Michelangelo was responsible for bringing this process to fruition, he did not initiate it. That honor belongs to an artist of a slightly earlier generation, the mysterious Leonardo da Vinci (1452–1519).

Leonardo da Vinci

Leonardo's *œuvre* is extremely small, and many of his paintings remained unfinished, due to his own reckless impatience, his perfectionism, and also his tendency to abandon painting altogether for long periods, in favor of projects which had little direct connection with art, though Leonardo's thoughts about them were nevertheless recorded in magnificent drawings.

The *Adoration of the Magi* (Fig. **11.3**), left unfinished when Leonardo went to Milan in 1483, is his first fully independent work. One of the striking things about its design is the subtlety of the geometrical relationships. Basically the composition consists of a triangle, made up of the Madonna and the two old men nearest to the spectator; plus a semicircle made up of the other personages. The pyramidal structure, so typical of High Renaissance painting and of Raphael's Madonnas in particular, here makes its début. In order to get these geometrical relationships as he wanted them, Leonardo disregarded the perspective construction which had established itself as the norm in fifteenth-century Italian painting.

From the *Adoration* Leonardo progressed to the now-ruined *Last Supper* (Fig. **11.4**) of *c.* 1495–7 in Santa Maria delle Grazie, Milan. This is a direct restatement of the classical ideal, and shows Leonardo consciously returning to the lessons offered by Masaccio—though here, too, he felt free to depart from conventional perspective construction, so as to make a space which throws the figures and their gestures into greater dramatic prominence than would have been the case if the accepted rules had been scrupulously obeyed. The most striking thing about the *Last Supper*, however, even in its present condition, is the concern for decorum—for grandeur and nobility which never overstep the bounds of well-mannered constraint. Leonardo here states the fundamental concerns of High Renaissance art. He then proceeds to reject these in the works that follow—among them the *Mona Lisa* (Fig. **11.5**) of *c.* 1503.

The eternal fascination of the *Mona Lisa* resides not only in the almost superhuman finesse of its technique, nor even in Leonardo's control of chiaroscuro—a technique where minute gradations of light and dark are used to create the sensation of form—here used with a subtlety never previously achieved and never to be surpassed, but in the sense of transience, and therefore ambiguity, which the image conveys. Leonardo's sense of the primacy of nature made portraiture a perfectly possible genre for him, but he cannot help trying to reach a realm attained by no other portraitist. He seems to want to convey the fact that human personality is fluid rather than fixed. The *Mona Lisa* passes from one state of being to another before one's very eyes.

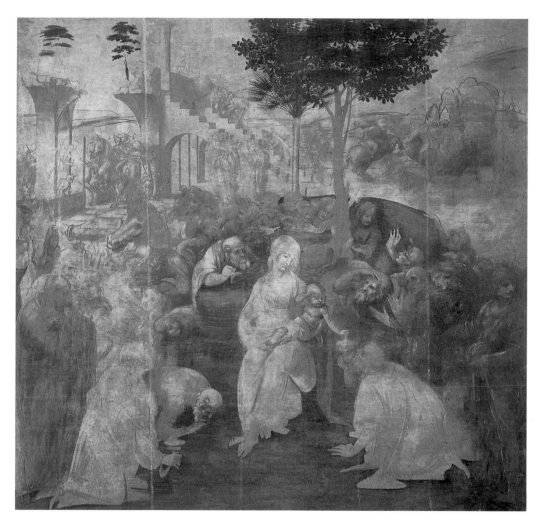

11.3 **Leonardo da Vinci**, *Adoration of the Magi* begun 1481.
Underpainting on panel, 96 × 97 ins (244 × 246 cm) Uffizi Gallery,
Florence.

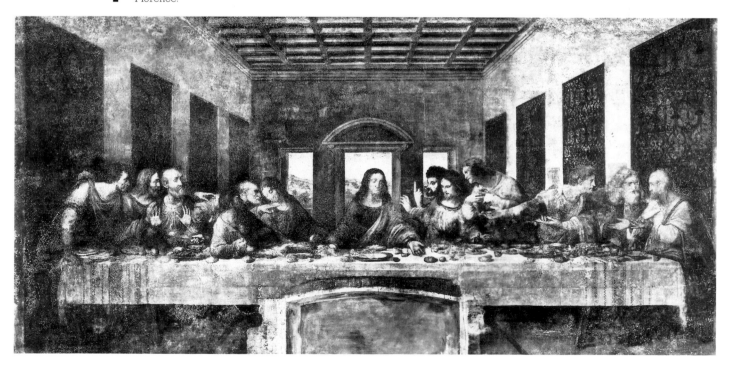

11.4 **Leonardo da Vinci**, *The Last Supper* c. 1495–97. Fresco, 15 ft × 28 ft 10½ ins (4.6 × 8.8 m). Sta. Maria delle Grazie, Milan.

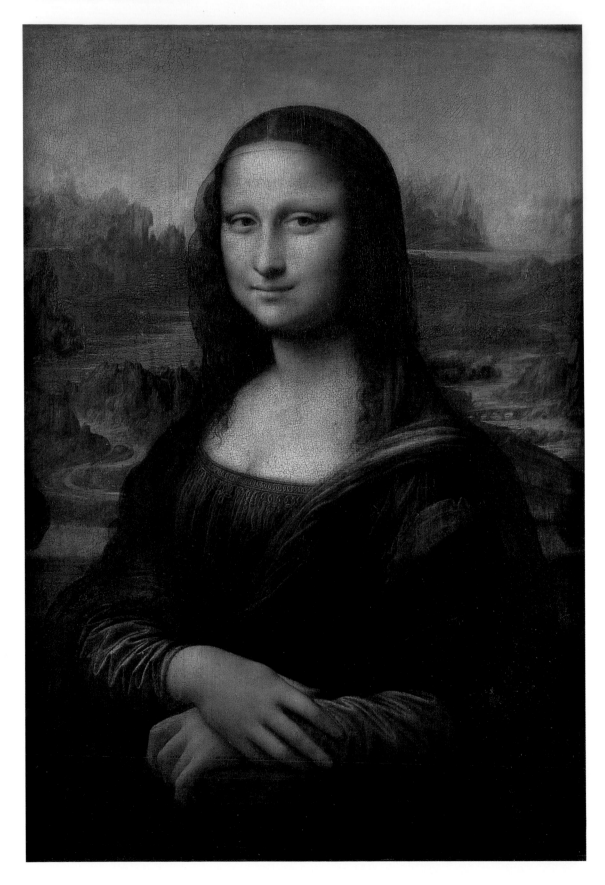

11.5 Leonardo da Vinci, *Mona Lisa c.* 1503–5.
Oil on panel, 30¼ × 21 ins (76.8 × 53.3 cm). Louvre, Paris.

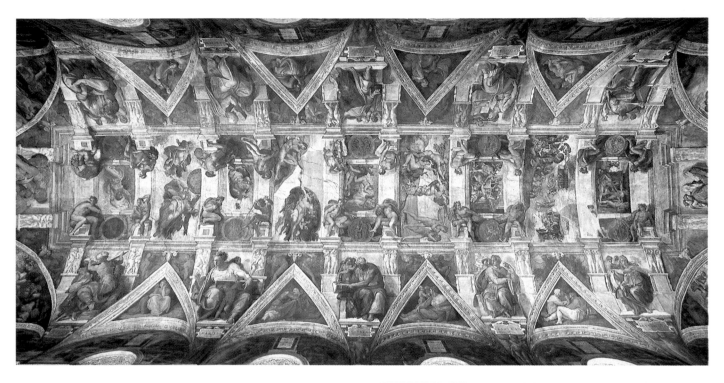

11.6 **Michelangelo**, ceiling of the Sistine Chapel, The Vatican, Rome, 1508–12.

11.7 **Michelangelo**, *The Creation of Adam*. Detail from the ceiling of the Sistine Chapel, The Vatican, Rome, 1508–12.

Michelangelo and the Sistine ceiling

Michelangelo Buonarroti (1475–1564), a Florentine like Leonardo, began his career in the workshop of Domenico Ghirlandaio (1449–94) when he was thirteen. He clearly received a sound training as a painter—early drawings document his interest in frescos by Masaccio and Giotto—yet he always regarded himself as primarily a sculptor. Throughout his adult career he undertook painting only unwillingly, and for long periods did no painting at all.

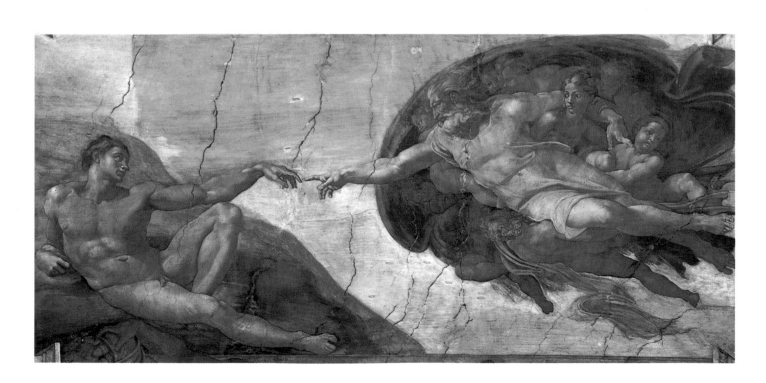

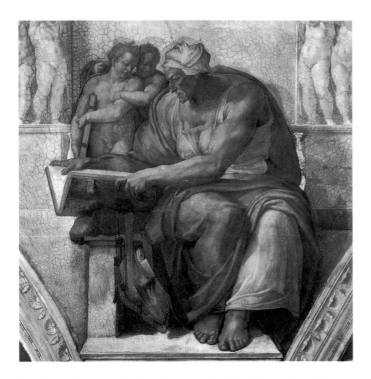

11.8 **Michelangelo**, *The Cumaean Sibyl*. Detail from the ceiling of the Sistine Chapel, The Vatican, Rome, 1508–12.

Michelangelo did not become fully involved in painting until he left Florence and entered the service of Pope Julius II in Rome in March 1505, having been commissioned to make an elaborate tomb for this new patron. The project stagnated, and there was a period of extreme strain between the artist and the strongwilled pope. In 1508 Michelangelo was summoned to Rome for a second time, and given a fresh task, much less to his liking. He was now to decorate the ceiling of the chapel within the Vatican complex which had been built and partly decorated by Julius's uncle and predecessor, Sixtus IV.

The decorative program for the ceiling (Fig. **11.6**) is extremely complex. It consists of a series of scenes from the Old Testament, from the Creation to the Flood, accompanied by figures of prophets and sibyls (the latter serve as representatives of ancient, non-Jewish prophecy), and by the famous *Ignudi*—seated male figures arranged in pairs, whose precise significance has long been disputed. Lunettes above the windows of the chapel contain the ancestors of Christ, and four spandrels at the corners of the ceiling are painted with salvation subjects, among them *David and Goliath* and *Judith and Holofernes*.

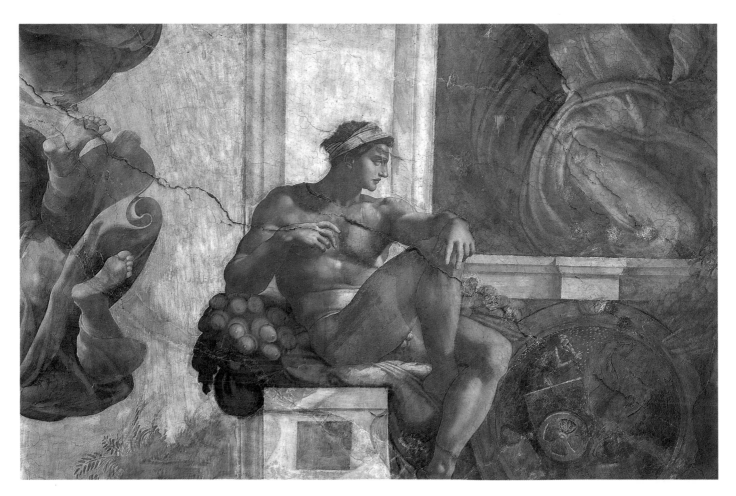

11.9 **Michelangelo**, *Ignudi*. Detail from the ceiling of the Sistine Chapel, The Vatican, Rome, 1508–12.

Michelangelo's ideas about the ceiling developed as the work progressed. The figures grew larger and grander, often seeming to burst the boundaries of the spaces provided for them, while the compositions became correspondingly simpler and more emblematic. The panels concerned with the major acts of the Creation are imaginative feats of immense power. In the *Creation of Adam* (Fig. **11.7**) the way in which the first man stirs languidly to life at the touch of the Creator's extended forefinger is forever memorable. The prophets and the sibyls are similarly expressive— each carefully differentiated in character. They grew increasingly massive as the work went on, and also increasingly less conventional in their proportions, often with tiny heads perched on top of massive bodies. The ponderous *Cumaean Sibyl* (Fig. **11.8**), peering at her book, is an eccentrically personal creation which owes nothing to classical canons of proportion.

The *Ignudi* (Fig. **11.9**)—the single feature of the ceiling which had most impact on contemporary and later artists— do not stray so far from the norm, but they have a repressed energy which strains the classical framework in a different and subtler fashion. They were certainly a major factor in the disintegration of the synthesis which High Renaissance art momentarily achieved—a synthesis between solidity and grandeur on the one hand, and a feeling of balance and unobtrusive rightness of proportion on the other.

Raphael

The only indisputably major artist who seems to fit the High Renaissance pattern completely is Raphael (1483–1520). His progress was the more extraordinary because he came from a distinctly provincial environment. Born in Urbino, the son of a painter of no great distinction who worked for the ducal court there, he began his career as an assistant to Perugino (*c.* 1450–1523). His early work has the calm, impersonal blandness of Perugino's own.

In 1504 Raphael moved to Florence, and came into contact with Florentine art. He studied those works by Leonardo and Michelangelo which were available in the city, and during this period produced a series of Madonna paintings—images for private devotion—of moderate size in which one can see him working out the implications of classical form and composition for the models he had found.

A good example from this series in *La Belle Jardinière* (Fig. **11.10**), dated 1507. Raphael's model is Leonardo's *Adoration* (see page 193), but the composition is greatly simplified. There are only three figures—the Madonna, the Child and the infant St. John—and these are arranged so as to form a compact pyramid which occupies almost all the available space. The group has a slight suggestion of spiral torsion (moving leftwards from the kneeling figure of St. John) which helps to give it life. Behind the group is a calm, level landscape with none of the eerie strangeness of the

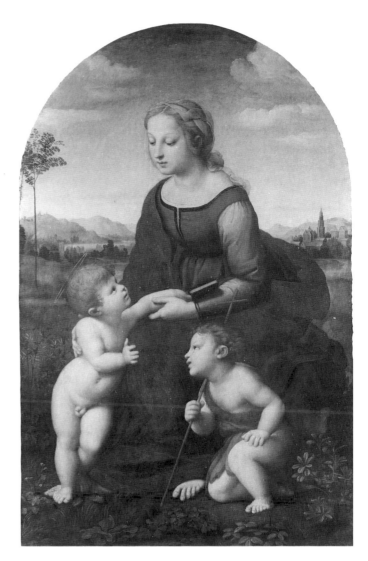

11.10 **Raphael**, *La Belle Jardinière* 1507.
Oil on panel, 48 × 31½ ins (122 × 80 cm). Louvre, Paris.

landscape background to the *Mona Lisa*, which helps to reinforce the devotional tranquility of the image.

Raphael's major works were painted not in Florence but in Rome. He went there sometime in 1508, and was almost immediately employed by Julius II, who had decided to establish and decorate a new set of papal apartments quite different from those used by his predecessors. The first room Raphael tackled for his new patron was the Stanza della Segnatura, which was intended to be Julius's private library. The main scenes reflect the use to which the room was to be put, and provide a panorama of the intellectual concerns of the time. The main themes illustrate the disciplines of Theology, Philosophy, and Poetry; and there are two smaller compositions illustrating Jurisprudence. In the three major compositions Raphael achieved the grand classical manner he had been striving for throughout his earlier career.

The calm grandeur of the style Raphael forged for himself in Rome reaches its culmination in the work illustrating Philosophy, *The School of Athens* (Fig. **11.11**), painted in

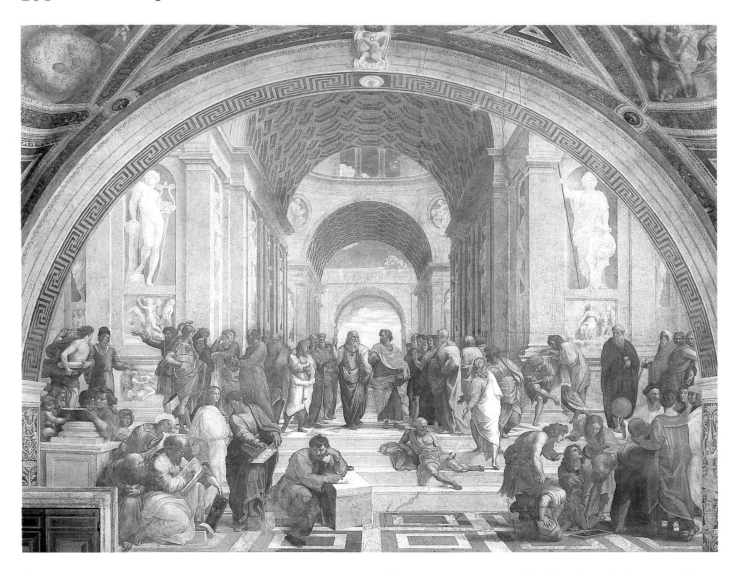

11.11 Raphael, *The School of Athens* 1510–12.
Fresco, 26 × 18 ft (7.92 × 5.49 m). Stanza della Segnatura, Vatican, Rome.

1510–12. The figures are not only fully realized in space, they are also linked in groups which in turn are joined to make a unified larger whole—a composition focussed on Plato and Aristotle, who stand together in the center, framed by a distant arch. The grandiose architecture of this setting, based on the ruined Ancient Roman Basilica of Maxentius, stresses the power the figures have to activate the space which surrounds them—there are no dead areas in the whole vast composition. The eye travels to whatever point it chooses within it, and is then smoothly returned to the two dominant personages.

The success of the decorations in the Stanza della Segnatura was immediate, and Raphael became, with Michelangelo, one of the two leading artists in Rome. Attempts were made to set them up as the heads of equal, opposed factions. Yet for two reasons Raphael's short-term effect on the visual arts was much greater than Michelangelo's. The first was that he remained essentially a painter, rather than being a sculptor who occasionally condescended to paint.

The second was that, unlike Michelangelo, he was willing to use assistants on a regular basis. Raphael employed a large workshop to help him with the huge number of commissions he was offered, and the existence of this workshop often makes it difficult to distinguish between what is genuinely Raphael's work and what is the work of others. The emphasis shifted from the originality of the actual artwork to the originality of the concept it embodied.

Nevertheless, even at this stage in his career, Raphael managed to produce a number of works which were extremely personal, and obviously entirely by his own hand. One of these is the portrait (Fig. **11.12**) of his friend Baldassare Castiglione, author of *The Courtier*. Castiglione is seen turning toward the viewer, seemingly about to speak. His clothes are painted with such freedom of brushwork—the manner suggests Venetian art—that vitality is to be found both in the figure itself and in the technical means used to create it; in fact, the portrait's most striking qualities are a combination of alertness and ease which the brushwork itself seems to echo.

The main classical currents in European art run through Raphael's wide-ranging work and not through the works of

11.12 Raphael, *Baldassare Castiglione* c. 1514.
Oil on canvas, approx. 30¼ × 26½ ins (77 × 67 cm). Louvre, Paris.

11.13 Correggio, *The Assumption of the Virgin* 1526–30.
Decoration from the interior of the dome in Parma Cathedral.

Leonardo and Michelangelo, not simply because he was the only one of the three to have a large workshop organized on a regular basis, but because he was the one who devised an artistic language which was relatively impersonal, and which could therefore be absorbed and reused in their own fashion by other artists.

Antonio Correggio

In the early sixteenth century Parma was a remote and rather provincial city of about 15,000 inhabitants. Giorgio Vasari, the chief contemporary historian of Renaissance art, seems to deny that the leading artist who worked there, Antonio Correggio (1494?–1534), ever went to Rome. The evidence that he knew Raphael's work in the Vatican at first hand is, nevertheless, plainly visible in much of what he produced in his native town.

The spirit of Correggio's art is subtly different from that of the prototypes he found in Raphael—more sensual and carefree, less antiquarian and intellectual. As he developed, he more and more came to contradict everything which has so far been said about the nature of High Renaissance art. His achievement was to be immensely important for the Italian painting of the seventeenth century. It was he who became the main protagonist of the illusionist, often deliberately irrational, art of the Italian Baroque (see page 249).

The most impressive example of his skill in creating illusionist effects is the dome of the cathedral in Parma, which shows the *Assumption of the Virgin* (Fig. **11.13**). Christ is at the center of the cupola; the Virgin rises toward him; thronging figures witness the miraculous event—first the massive draped figures of the apostles, standing on a painted cornice, then a ring of half-naked angels, then a crowd of personages from the Old and New Testaments. The dome itself, rather smaller than it appears to be in photographs, has a violent kinetic energy—spatial boundaries between the various parts of the composition are blurred or swept away altogether. In this sense, the composition has a curious resemblance to Michelangelo's fresco of the *Last Judgment* in the Sistine Chapel. Both painters set out to convince spectators that they are actually present at an apocalyptic event.

Correggio's gift for quasi-mystical religious painting was matched by another, sharply contrasting one. He was a supremely talented painter of erotic nudes. *Jupiter and Io* (Fig. **11.14**), one of four paintings depicting the loves of Jupiter, shows the god making love to Io in the guise of a cloud—an idea which is apparently impossible to paint. Correggio solves the problem triumphantly, showing the divine figure as mist in the process of becoming flesh.

The physical type Correggio chose for Io—small-boned and plump without being unduly heavy—had immense appeal for later artists, and particularly for the masters of the French Rococo, Boucher and Fragonard (see page 315).

The fact that their names are called to mind by Correggio indicates how difficult it is to fit him into the idea of a developed classical style—though he has more connection with classical style than with the intellectual Mannerism which was to dominate Italian art in the second half of the sixteenth century. Indeed, one of the points about Correggio is his lack of intellectualism—his work suggests that painting can still achieve greatness while making its appeal almost entirely to the senses and the emotions.

Giorgione and the early Titian

Correggio's lack of intellectualism is also typical of the Venetian art of the same epoch. The special position of Venetian painting, despite frequent visits to the city made by masters from elsewhere, is emphasized when one looks at the way in which the High Renaissance spirit expressed itself in Venice.

Giorgione (1477?–1510) undoubtedly represents a radical new departure, but his innovations are more difficult to assess than those of Leonardo, Michelangelo, or Raphael. Some of the difficulties are practical. Giorgione died young, his work is poorly documented and there is much controversy concerning attributions. Yet these problems are also compounded by the essential nature of his art. Beneath Florentine art we perceive a firm structure of ideas; Giorgione seems to challenge us by its absence.

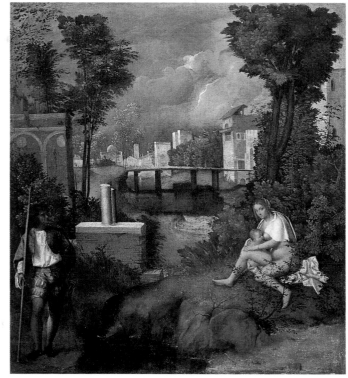

11.14 **Correggio**, *Jupiter and Io*, early 1530s.
Canvas, 64½ × 28 ins (163.8 × 71.1 cm).
Kunsthistorisches Museum, Vienna.

11.15 **Giorgione**, *The Tempest* c. 1506.
Oil on canvas, 26¾ × 23¼ ins (68 × 59 cm). Accademia, Venice.

Giorgione's most famous painting, *The Tempest* (Fig. **11.15**), of *c.* 1506, is as ambiguous as the *Mona Lisa* (see page 194), but in a different way—the ambiguity lies in the very subject. The painting shows figures in a landscape—Renaissance convention suggests that there ought to be a narrative to bind them together or explain their mutual presence, but no critic has been able to explain what the story or allegory actually is. This ambiguity is confirmed, and even deepened, by technical examination. X-rays reveal that the man to the left, leaning on a staff, is painted over a female bather. Could the landscape have been painted for its own sake? This would have contradicted the expectations of Giorgione's contemporaries. The mysterious atmosphere distilled by the composition is in fact dependent on the presence of the figures, who seem to be waiting for something momentous to happen. Even the flash of lightning splitting the cloud in the background must be related to their presence, because it suggests some menace which may threaten them.

After Giorgione's premature death, some of his paintings were finished by Titian (1477?–1576). The two artists seem to have been collaborators from about 1508, and the attribution of a number of paintings is disputed between them. Once he became independent, Titian soon revealed his consummate skills in nearly all branches of painting except fresco, which because of the dampness of the local climate was never a major Venetian mode of expression. His reputation rose so rapidly that in 1517 he was appointed the official painter of Venice, in succession to Giovanni Bellini. At about this time, or shortly before, he painted a large altarpiece showing the *Assumption* (Fig. **11.16**) for the church of the Frari in Venice. In this painting, the Apostles are placed together in a compact mass, just as they are in Correggio's dome, and do not function as individual shapes. This focusses attention on the soaring figure of the Madonna, standing on a bank of clouds supported by numerous angels and raising her arms in prayer to a daringly foreshortened God the Father. As with Correggio, what counts is not the stringency with which individual forms are constructed, but the sweep and emotional drama of the whole composition.

During these years Titian also made a reputation as a portraitist, and his fame soon spread well beyond his native city. His portraits are considerably less formal than those of Giovanni Bellini, and their air of ease and naturalness makes them directly comparable to Raphael's portrait of Castiglione (see page 199). A portrait such as the *Man with a Glove* (Fig. **11.17**) has an aristocratic informality which would continue to influence portraiture for centuries to come.

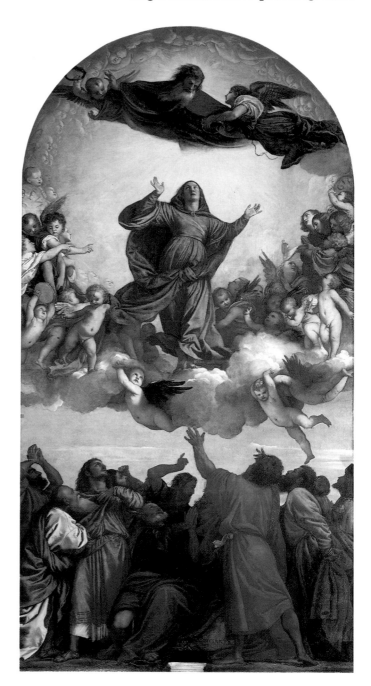

11.16 **Titian**, *Assumption of the Virgin* 1516–18.
Panel, 22 ft 6 ins × 11 ft 10 ins (6.9 × 3.6 m). Sta. Maria Gloriosa dei Frari, Venice.

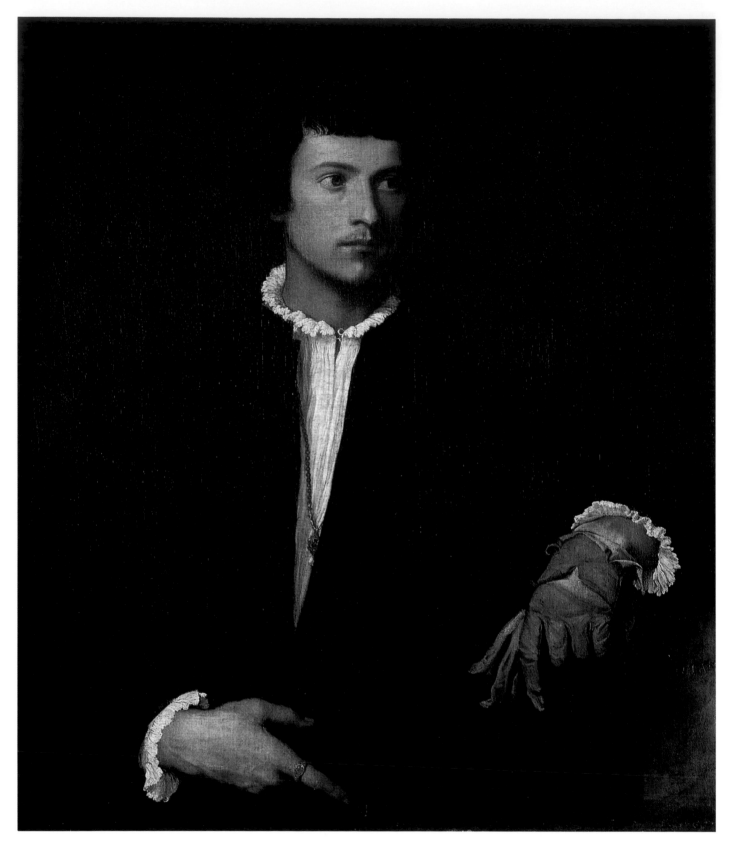

11.17 **Titian**, *Man With a Glove* 1527.
Oil on canvas, 39⅜ × 35 ins (100 × 88.9 cm).
Louvre, Paris.

Sculpture

Michelangelo

More than any other works of art, or indeed any work of literature, Michelangelo's sculptures sum up the meaning and achievement of the High Renaissance. What is embodied in them is not a particular intellectual attitude or range of subject matter, but the human spirit itself in action: the power to imagine something, and then give it convincing form. The fact that Michelangelo's sculptures are so often unfinished plays its part in governing our response to them. His failure to complete the tasks he set himself is symbolic both of the difficulty of those tasks and of his courage in undertaking them.

Unlike his Mannerist successors, who in general preferred to work in bronze, and unlike Donatello, who seems to have been at home with all materials, Michelangelo was not only instinctively a sculptor but instinctively a stone-carver. He was temperamentally unable to make much use of assistants. For him, the form waited already within the block, and he alone could liberate it.

Perhaps the most striking early example of the imaginative lengths to which this attitude could take him is the colossal *David* (Fig. **11.18**) of 1501–4, still perhaps the most celebrated of all his works. The subject chosen had particular resonance for the instinctively republican Florentines, and for Michelangelo as a native of Florence. David traditionally symbolized the victory of the underdog over tyranny. The figure—that of a youthful nude warrior—also had classical connotations. Michelangelo's originality lay not in the choice of subject but in the actual moment in David's story which he chose to depict—the hero before, not after, his combat with Goliath; not triumphant, but contemplating the danger that awaits him.

The *David* is unusual in Michelangelo's work, not only because it is finished—it is indeed a supreme demonstration of technical virtuosity—but because it makes a complete, self-referential artistic statement. Most of what Michelangelo produced subsequently was a reaching out toward a perfection which even he could not fully imagine, and perhaps it is more moving and emotionally suggestive for this reason. The fact that they were not completed is one reason for the emotional power of his figures of *Slaves*, which were originally intended to adorn the tomb of Julius II—his failure to bring this commission to a satisfactory conclusion, the "Tragedy of the Tomb," as it is called by Michelangelo's contemporary and biographer Condivi, occupied a large part of Michelangelo's career.

The *Slaves* were originally meant to symbolize the Arts, crushed by Julius's death. The *Dying Slave* (Fig. **11.19**) of 1513–16, the most nearly complete of the series, should have had a monkey behind him, emblematic of painting,

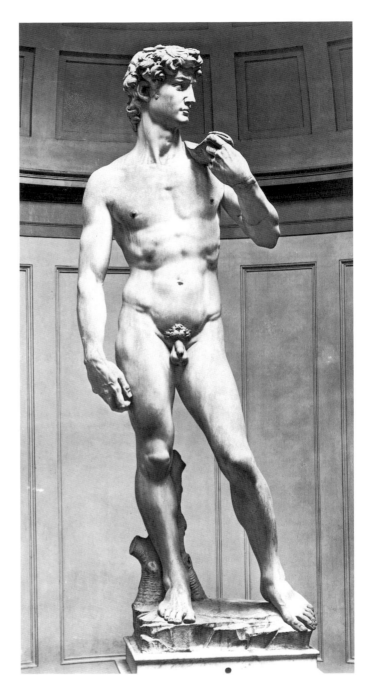

11.18 Michelangelo, *David* 1501–4.
Marble, 18 ft (5.5 m) high. Galleria dell'Accademia, Florence.

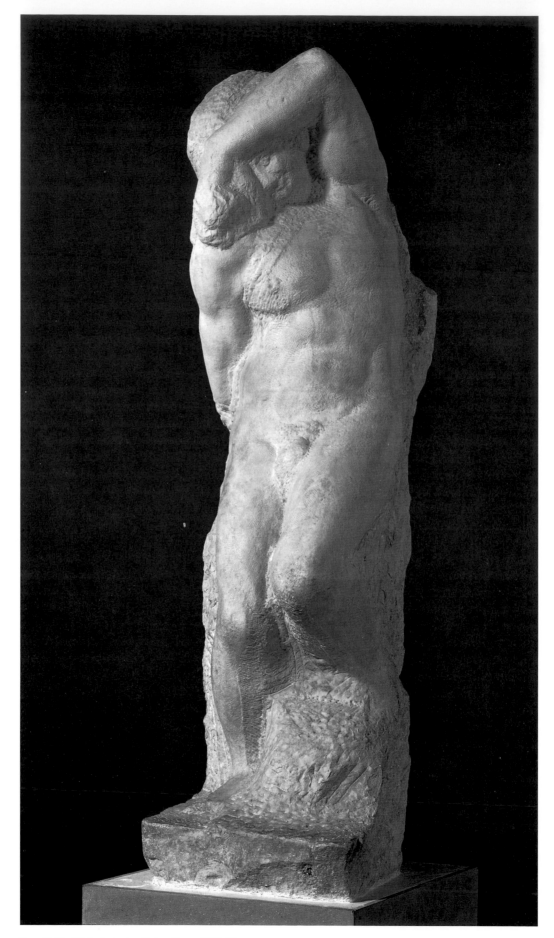

11.19 **Michelangelo**, *Dying Slave* 1513–16.
Galleria dell'Accademia, Florence.

which "apes" nature. The monkey was never carved, and the figure is the more powerful for its absence. A specific allegory would clearly have diminished its effect, and compromised its mood of suffering yet erotic languor.

The contrast between active and contemplative states of being, symbolized in the *David*, is subjected to further analysis in the Medici tombs in Florence. These, one for Lorenzo de' Medici, the other for his brother Giuliano, murdered in the Pazzi Conspiracy of 1478, are unfinished, but have been brought much nearer completion than the tomb of Julius. Each consists of a warrior seated in a niche, with below him a sarcophagus adorned by a pair of reclining nudes. The warriors, in classical armour, symbolize rather than actually portray the deceased. They are contrasted in character: the figure of Giuliano is an emblem of the active life; that of Lorenzo, of the contemplative one. The nudes

below Giuliano are allegories of Night and Day. Michelangelo noted in a jotting, "Night and Day speak, and say: we with our swift course have brought Duke Giuliano to Death."

Where the *Dying Slave* is sensual, *Night* (Fig. **11.20**)—a female not a male—is a complete contrast, even though the pose derives from an antique Leda. Yet within its context the figure has a wonderful expressiveness. "In her [*Night*]," Vasari says in his *Lives of the Artists*, "may be seen not only the stillness of one who is sleeping but also the grief and melancholy of someone who has lost something great and noble." Michelangelo set out to express grief for an individual, and succeeded in expressing the mood of loss and unease—of being somehow bereft—which characterized the situation of western Europe at one of its acknowledged peaks.

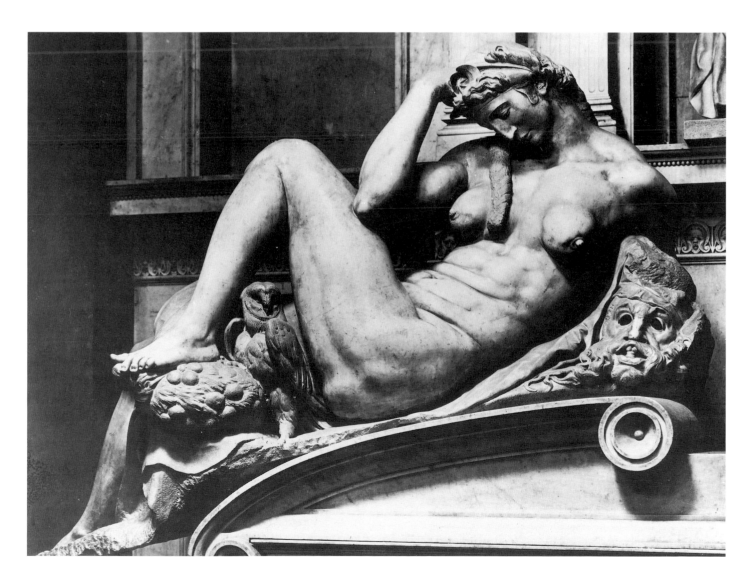

11.20 **Michelangelo**, *Night*, on the Tomb of Guiliano de' Medici, designed 1521, carved 1524–34. Marble, length 76½ ins (194.3 cm). Medici Chapel, Florence.

Literature

Ludovico Ariosto

The early sixteenth century saw the appearance of the most important long poem to have been written in Italy since the *Divine Comedy* of Dante. Ludovico Ariosto (1474–1533) came from the same social background as Baldassare Castiglione, and had a similar career. A native of Ferrara, he attached himself successively to two princes of the ruling Este family—first, Cardinal Ippolito, and then Ippolito's elder brother, Alfonso, the ruling duke from 1505. Ariosto's masterpiece, *Orlando Furioso* (*The Madness of Orlando*), was first published in 1516, and appeared in a final and heavily revised version in 1532. The first edition sold only a few hundred copies, but the poem soon achieved massive popularity and it has been calculated that about 25,000 copies were in circulation by the end of the century.

Orlando Furioso is technically a sequel to Matteo Maria Boiardo's *Orlando Inamorato*, which appeared in 1495. Orlando, the protagonist of both poems, is none other than Roland, the hero of the *The Song of Roland* (see page 128), in another guise.

Yet Orlando, who goes mad when the woman he loves prefers another, is far from being the only major character in Ariosto's complex narrative. Many other chivalric heroes and heroines appear in the story, which consists of several different plotlines woven together. One of the most important concerns the pagan knight Ruggiero, whose conversion to Christianity and marriage to his faithful (and forbearing) lover Bradamante conclude the poem. One of Ruggiero's many adventures is an amorous encounter with the sorceress Alcina, an old hag who can make herself seem beautiful by the use of enchantments. This stanza describes Ruggiero's impatience as he awaits her reappearance:

Now was Rogero couchèd in his bed,
Between a pair of cambric sheets perfumed,
And oft he hearkened with his wakeful head,
For her whole love his heart and soul consumed;
Each little noise hope of her coming bred,
Which, finding false, against himself he fumed,
 And cursed the cause that did him so much wrong,
 To cause Alcina tarry thence so long.

(ARIOSTO, *Orlando Furioso*, translated by Sir John Harington, London 1591, printed by Robert Field. Taken from Edward Lucie-Smith, *The Penguin Book of Elizabethan Verse*, 1964.)

These lines give a glimpse of just one of the many tones of voice Ariosto uses in his poem. He can be heroic and romantic, but also comic, and curtly matter-of-fact. The poem is full of magical episodes, but usually these are treated in a deliberately skeptical way. What is less deflationary is Ariosto's attitude toward the knightly ideal. For this he still preserves a nostalgic respect. *Orlando Furioso* is thus deeply ambiguous in tone. On the one hand, it often seems deliberately simple-minded and naïve, determined to preserve the old chivalric ideas, even if this means flying in the face of reason. On the other hand, Ariosto has a sharp eye for folly and self-deception, and is a master of gentle irony.

Ariosto's poem and still more so its huge popularity with the contemporary audience show a persistent nostalgia for some of the values of the Middle Ages which are also present in Castiglione's *The Courtier*. In both the theme of "courtly love," inherited from Arthurian romances (see page 127) and the world of the troubadours (see page 129), is gently questioned, but by no means entirely abandoned.

Chapter 12

The Reformation

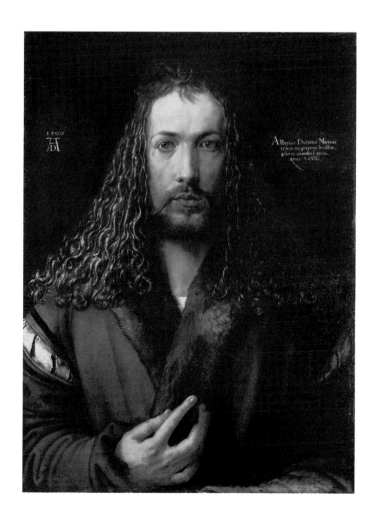

12.1 **Albrecht Dürer**, *Self-Portrait* 1500.
Panel, 26⅖ × 19³⁄₁₀ ins (67 × 49 cm). Alte Pinakothek, Munich.

The Reformation

The Reformation, like the Renaissance (the two were closely connected), was a complex phenomenon. Thanks to the misfortunes of the papacy, chief among them the Great Schism (see page 133), and the corruption of the Church, graphically described by Chaucer (see page 152) and many other writers, there was already a feeling that drastic change was needed.

This feeling was particularly widespread in northern Europe. It was here, too, that secular rulers were becoming increasingly impatient with papal claims to authority, and still more so with demands for money to finance such enterprises as the rebuilding of St. Peter's in Rome (see page 190). They formulated the wish to bring the Church under their own control, and to keep any financial benefits in their own hands.

Meanwhile the intellectual situation was being changed by two originally independent forces which soon combined with explosive effect. One was the humanist exploration of Greek. Acquisition of Greek also made it possible to acquire a much more accurate knowledge of the Gospels, since this was the tongue they were first written in. The Latin version, the Vulgate, was only a translation—but one which had the full authority of the Church behind it. Any challenge to the accuracy of the Vulgate became, inevitably, a challenge to

the Church—and such conflicts were now inevitable. The other force was the introduction of printing, a modification of a Chinese invention. Johann Gutenberg (1396–1458) printed the complete Bible at Mainz in 1453–5. Books, once rare, valuable and difficult to gain access to, because they had to be copied by hand, were on their way to being put into the hands of anyone who could read. One result was a new climate of impassioned religious debate.

Most of all, however, the Reformation was the result of a profound spiritual change—something which sprang from the rediscovery of the historical core of Christianity. This, which took place primarily in northern Europe, was akin to the rediscovery of Greek and Roman antiquity taking place in Italy.

The uniqueness of Christianity, in historical terms, was now seen, not as something mediated by the Church, but as something which could be directly experienced by reading accurate versions of the Scriptures—the actual record. This led to the conclusion that ecclesiastical authority counted for little or nothing when compared with the direct relationship between God and the individual. Such was the essential doctrine of Martin Luther (1483–1546) who, more than anyone else, was to be responsible for the religious revolution which created turmoil in Europe.

Philosophy

Desiderius Erasmus

A significant point of contact between the humanist movement and the Reformation was the career of the Dutch-born scholar and writer Desiderius Erasmus (1469–1536). The illegitimate son of a priest, Erasmus unwillingly became an Augustinian monk, but then escaped to Paris, where he attended the Sorbonne, the most celebrated university in Europe at that time. Later he traveled to England and Italy, before settling in the Swiss city of Basle.

Erasmus became a best-selling author, thanks to the new printing presses—he was surpassed in this only by Luther—and his witty satire *In Praise of Folly* (1509), composed in Latin like all his literary work, can be read with pleasure today. His most important works, however, in terms of their actual practical impact, were his *Enchridion militis christiani* (1502–4)—the title translates as *The Handbook of the Christian Soldier*—plus his edition of the New Testament, accompanied by full notes and a new Latin translation. His *Enchridion* is a guide to practical piety,

which also contains a program for moral reform. Significantly, the declaration of faith with which it begins lays especial stress on the teachings of St. Paul, who was to be the apostolic standard bearer of the Reformation taken as a whole.

The version of the New Testament was an even greater step forward. Not only did Erasmus's edition point to many errors in the Vulgate, the only Latin translation, by St. Jerome, which was endorsed by the Church as divinely inspired, but the preface to the first edition asserted, in direct opposition to official teaching, that no lay person should be denied the opportunity to study the Bible for himself or herself. The ample annotations to the new text attacked both ecclesiastical abuses and contemporary superstitions. The most significant thing about the book, however, was to be found not in any of the notes, nor in its changes of meaning and of traditionally accepted phraseology, but in the fact that the whole enterprise tended to separate the authority of the Bible from that of the Church as an institution.

It is nevertheless doubtful whether Erasmus saw himself as a "reformer," in the sense in which that word later came to be used. The criticisms he made of the Church were more forceful and better documentations of ideas which had already been expressed earlier—such ideas had been in the air for the better part of a century. The demands he made for direct access to the Scriptures were also far from novel. He never considered separating himself from the Church and its traditional leadership, and this attracted bitter attacks from Luther and his followers.

Martin Luther

The decisive breach with Rome was made by Martin Luther (1483–1546). Luther studied at the University of Erfurt, and in 1505 became an Augustinian monk in a monastery there. In 1511 he moved to Wittenberg, a new university in Saxony. At Wittenberg he received his doctorate in theology and was appointed Professor of the Bible there in 1512. Wittenberg, with one brief interruption, was to provide Luther with a public pulpit for the rest of his life.

What turned Luther into a figure of European importance was the controversy over the selling of indulgences (see Chaucer, page 152). The concept of indulgences had developed by gradual stages from the eleventh century, and now played an important part in the way the papacy financed both religious and secular activities—its wars in Italy on the one hand, and the construction of the new St. Peter's on the other. Indulgences were at first a release from temporal punishments imposed by the Church in return for money. Later, they became a remission for punishments to be suffered after death, in purgatory. Finally, there came the idea that indulgences could be bought on behalf of others—chiefly relatives—who were already dead and might be suffering the pains of purgatory at that very moment.

In 1517 the papacy began a fresh and particularly cynical campaign of indulgence-selling throughout Germany. This provoked adverse reaction almost everywhere, but the most violent and most cogently argued was that of Luther, who in October 1517 published his Ninety-five Theses, attacking both the selling of indulgences and the whole theological substructure upon which this practice was based. Thesis 62 asserts: "The true treasure of the Church is the most holy gospel of the glory and the grace of God."

Luther's rebellion had an immediate and overwhelming response. This came from many of the German princes—among them the Elector of Saxony, who was to be Luther's protector thereafter—as well as from the common people.

The core of Luther's thinking was a new conception of the individual's relationship with the godhead. Like Wyclif before him, he believed in predestination—that is, some were "elect" and destined to be saved; others were inexorably damned. But he gave this brutal doctrine a special tone. Predestination was the inevitable consequence of divine omnipotence. God's decisions cannot be altered by anything that a mere human can do, and humans are in any case born corrupt, thanks to the original sin committed by Adam. However, though humans stand totally naked and helpless before God, there is one form of action which remains open to them, which is to believe, totally and absolutely, both in God Himself and in Christ's sacrifice on the Cross. Humans must take God into themselves, to allow God to inhabit them, by means of an act of conversion which has nothing to do with conventional good works. The vehicle for this conversion is the Bible, the written word of God. Luther's own translation of the Bible into German was a major part of his life's work. The new printing presses put this translation into the hands of many people who in former times would not have had access to it for purely practical and economic, as well as linguistic, reasons.

Zwingli and Calvin

Impassioned study of the Bible did not, however, bring uniformity of opinion. The religious revolution Luther set in train produced not a unified movement which could compete on equal terms with the old Church, still led from Rome, but many competing sects. The two most important of these were based in Switzerland, and were significant because they demonstrated that the new Protestantism did after all have a strong capacity for discipline and organization. The first, under the leadership of the Swiss pastor Huldreich Zwingli (1484–1531), ended in failure; the second, under the exiled Frenchman Jean Calvin (1509–64), was a long-lasting success.

Zwingli, during the early part of his career, served as a field chaplain to the Swiss mercenaries who fought for the French in Italy. In 1518 he was appointed People's Priest at the Great Minster of Zurich, one of the most important Swiss cities, and prepared to use this position to initiate a local Reformation. Zwingli himself always claimed that Erasmus was a greater influence on his thinking than Luther. His aim was precise biblical authority, and he based his approach on the Scriptures even more rigorously than Luther did. This quickly led him and his Zurich followers to a denunciation of church images and pictures, and also of church music. The characteristic iconoclasm of Protestantism, which was to blight the visual arts throughout northern Europe, thus first showed itself in Zurich, not in Wittenberg. So too did the tendency of Protestant communities to turn themselves into independent theocratic states. The Reformation led by Zwingli in Zurich attracted the hostility of other Swiss cantons—Zug, Uri, Unterwalden, Lucerne, and Schwyz—which had remained Catholic. The friction between the two sides led to open warfare, and Zwingli was defeated and killed by his Catholic opponents at the Battle of Kappel in 1531.

Calvin was trained as a lawyer in Orleans and Bourges, and felt free to turn to theological studies only after the death of his father in 1531. His conversion to the ideas of

the Reformation seems to have taken place in 1533, and it was in this year that he had to take flight from the Sorbonne. In 1535 he reached Basle, and there published his *Institute of the Christian Religion*. This was later several times revised and enlarged, reaching its definitive version in 1559. The full title of the work sets out Calvin's intentions with admirable clarity: *The Basic Teaching of the Christian Religion comprising almost the whole sum of godliness and whatever it is necessary to know on the doctrine of salvation. A newly published work well worth reading by all who are students of godliness. A Preface to the most Christian King of France, offering to him this book as a confession of faith by the author, Jean Calvin of Noyon.*

Calvin's claim was not to be an opponent of the Church, but to be the legitimate heir of the early Christians, whose doctrines had been perverted and forgotten. For him there could be only one Church in a state, whether this state was France, from which he had fled, or the Swiss city of Geneva, over which he ultimately gained control.

Calvin shared with Luther a belief in predestination. Like Luther, he preached complete self-surrender to God. What he was able to do, however, was project these beliefs into convincing and workable social forms. By magnifying the sovereignty and providence of God, who "counsels and wills all men . . . so as to move precisely to that end directed by him," he laid the foundations for a kind of Church which could govern ordinary daily conduct. The regime he set up in Geneva was the expression of a disciplinary ideal, with close supervision of every aspect of the moral life of a city. It was Calvin's sense of the necessity of discipline, both in himself and in others, which insured the survival of the reformed religion as a true alternative faith.

Painting and printmaking

During the fifteenth century the prestige of Netherlandish art had been high in Italy. In the sixteenth century interest shifted to German artists, who learned much from Italian sources but also had something of their own to give to art beyond the Alps. At the same time, German art began to make its influence felt in the Low Countries. A major reason for this change of attitude was the rise of printmaking. The German lands witnessed the birth of printing, and it was therefore natural that they should breed the most successful and prolific makers of printed images. Prints disseminated artistic ideas far more rapidly than had previously been possible, and with much greater authenticity. They had two other results as well. They democratized art, and especially the possession of art objects, just as printed books democratized knowledge. They also tended to put the stress on the image itself, the artist's invention, rather than the way in which the image was executed. For these reasons we tend to judge sixteenth-century German art in a subtly different way from its Italian equivalent, and there is cause to think that contemporaries did so too. In Germany the paintings an artist produced were regarded as only a part, and perhaps not the most important part, of his significance as a creative personality.

Albrecht Dürer

It is impossible, for example, to consider Dürer's paintings as separate from his massive graphic output. Albrecht Dürer (1471–1528) was the leading German artist of his time, and the painter whose work had the greatest impact not on German rivals but on painters in Italy and the Low Countries. Born and trained in Nuremberg, Dürer traveled,

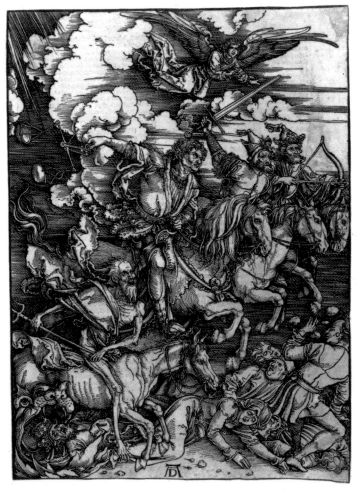

12.2 **Albrecht Dürer**, *The Four Horsemen of the Apocalypse* c. 1497–8. Woodcut, 15⅝ × 11 ins (39.2 × 27.9 cm). Museum of Fine Arts, Boston (Bequest of Francis Bullard).

at the conclusion of his apprenticeship, to Basle, where he immediately established a reputation as a book illustrator. In 1494 he went to Venice—the first of two visits to Italy; he made a second and longer one in 1505–7. After that he settled down in his native city, making one final trip, to the Low Countries, in 1520.

His first success was as a printmaker, using the woodcut technique, in which a print is made from a block of wood, parts of the surface of which have been cut away, leaving the design raised up, in a position to receive the ink. The *Apocalypse* series (Fig. **12.2**) of 1498 elicited a ready response throughout Germany. Many people were convinced that the world was going to end in 1500, or at any rate that apocalyptic events involving political and religious changes were imminent. Though still Gothic in style, the prints had a scale and boldness which were something entirely new in the woodcut medium. They staked a claim to be artworks in their own right, not mere illustrations to a text.

The paintings Dürer was producing at this period were just as original, and even more personal. Throughout his life he seems to have felt a compulsive interest in the development of his own personality, and in 1500 he painted the most famous of several self-portraits, a full-face image which echoes the representations of Christ, long traditional in Gothic art, while giving the established iconography a new twist (Fig. **12.1**). The painting suggests, first, that man is the image of God in the most literal sense possible (in Church thinking God remained officially of the male gender until 1969); and second, that the artist is himself a divine creator. One of the truly novel things about this self-portrait is its self-consciousness. For the first time the painter sees what he does not as a trade, nor even as a profession, but as a role to be played to the hilt.

After 1500 Dürer broke away from the Gothic world (hitherto the world of all German artists) in a decisive way. The first half of the decade saw his search for a system of ideal proportions in the representation of the human figure. The results of his researches are summed up in the superb engraving of *Adam and Eve* (Fig. **12.3**), dated 1504. Like the *Apocalypse* woodcuts, this has a biblical subject; it is nevertheless totally different in spirit. The figures are presented with a strict rationality which is something totally new in German art.

In his later years Dürer enjoyed immense fame, enhanced by the fact that he had now become the favorite artist of the cultivated Emperor Maximilian. At the same time, the growing religious conflict began to affect the direction taken by his art, and to rob him of the full range of opportunities that had been available to the German artists of preceding generations. He turned increasingly toward portraiture, and away from religious painting. Nevertheless, his most important late work does have a religious theme. The two panels portraying *The Four Apostles* (Fig. **12.4**) were not a commission. Dürer painted them for his own satisfaction, and presented them to the Council of his

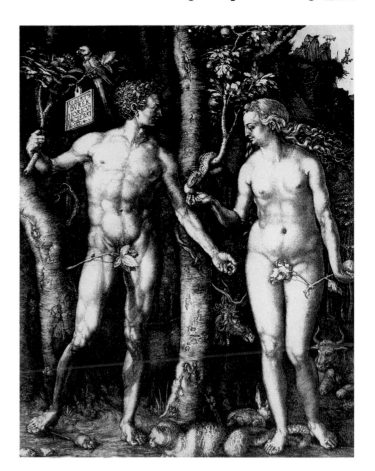

12.3 **Albrecht Dürer**, *Adam and Eve* 1504. Engraving, approx. 10 × 7½ ins (25.4 × 19 cm). Museum of Fine Arts, Boston.

native city. The panels are like the wings of a traditional altarpiece, but the central panel was never painted. The fact that it is missing reflects the new circumstances created by the Reformation.

Dürer himself was affected by the new religious doctrines. The journal he kept during his visit to the Low Countries reveals his interest in Luther, and his anxiety about the great reformer's physical safety. Yet he was also worried about the way in which the religious reform seemed to be going to extremes. These feelings are reflected in the long inscription which he added to the *Apostles*, urging the City Council not to listen to false prophets. His plea was for reasoned and moderate loyalty to the Reformation, and the words he chose are closely related to Luther's own writings. The simplicity and sense of scale conveyed by this great final work are not merely mirrors of the intrinsic monumentality of the High Renaissance—as seen, for example, in Raphael's frescos for the Stanza della Segnatura (see page 198)—but a statement made by a new and chastened religious art whose development was to be cut short by the intolerance of Protestant iconoclasts.

12.4 Albrecht Dürer, *The Four Apostles* 1523–26.
Oil on panel, each 85 × 30 ins (216 × 76 cm). Alte Pinakothek,
Munich.

Cranach and Holbein the Younger

Lucas Cranach (1472–1553) found different and in some
ways more radical solutions to the problems created for
artists by the Reformation. Born at Kronach, near Coburg,
he began his career as a painter in Vienna, around 1500.
The decisive break in his career came in 1504, or at the
beginning of 1505, when he was appointed court painter to
Frederick the Wise, Elector of Saxony, later to become the
great patron of the Reformation. Cranach continued to
serve successive Saxon electors for the rest of his life.

The environment in which he now found himself was a
provincial one, and Cranach has been criticized for falling
back on the old medieval artisan tradition. Many of his
compositions exist in multiple versions, made by his large
workshop. Yet in many respects he continued to be an

inventive and innovative artist. He continued to paint altarpieces for his Saxon patrons, but these were, in the second half of his career, specifically Protestant in subject matter. He also produced large numbers of portraits. Some of his likenesses of Saxon rulers are full-length—for example, the flaunting likeness of *Duke Henry the Devout* (Fig. **12.6**), painted *c.* 1514. These portraits put strong emphasis on the elaborate costumes worn by the sitters, and the figures are silhouetted against a black background. Paintings of this kind became the prototypes for sixteenth-century court portraits all over Europe.

In addition, Cranach made numerous paintings of female nudes—an unexpected product of an environment devoted to religious reform, until we remember that reform also meant secularization. The nudes are given respectability by being placed in biblical narratives, or in scenes from Greek and Roman mythology. They have been both condemned in modern times as being near-pornographic and described as Mannerist. In fact they are neither. They have a naïve inventiveness, displaying a total lack of any attempt to convey physical presence, which makes them unique. In a painting like his *Judgment of Paris* (Fig. **12.7**), the artist Cranach has most in common with is the Botticelli of the *Birth of Venus* (see page 185).

Hans Holbein (1497/8–1543), a generation younger than Cranach, had a more restless and also less fortunate career. He was born and trained in Augsburg, Germany, but in 1520 became a citizen of Basle in Switzerland. It was the decline of patronage, especially for religious work, there which led him to try his fortunes in England, where he finally obtained royal support. His most famous work in England, certainly with his contemporaries, was a wall

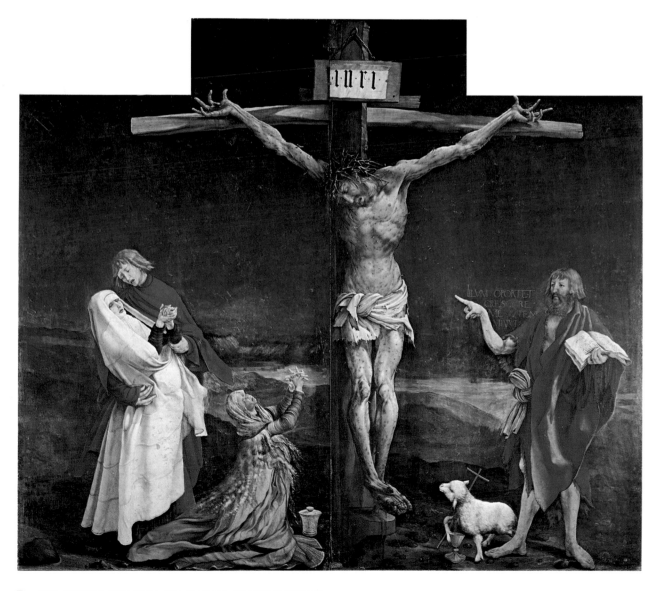

12.5 **Matthias Grünewald**, *The Isenheim Altarpiece* (closed)
c. 1510–15. Oil on panel, 8 ft × 10 ft 1 in (2.4 × 3 m). Musée Unterlinden, Colmar.

painting in Whitehall Palace (Fig. **12.8**), showing Henry VIII with his father Henry VII, but this perished in a fire in 1698, and only the cartoon, or full scale preliminary drawing, survives.

It was Holbein's misfortune that he was very seldom offered the opportunity to produce monumental compositions, or indeed compositions of any complexity. The bulk of his output consisted of portraits, the only paintings for which there was now a market, and most of these are in head and shoulders format. A few more ambitious paintings survive. One, dating from the last phase of his activity, is the full-length double portrait called *The Ambassadors* (Fig. **12.9**)—Jean de Dinteville and Georges de Selve. This includes an elaborate still life, and also, in the foreground, a large image of an anamorphic skull. (An anamorphosis is a painting or drawing which seems distorted when looked at frontally, but resumes its normal proportions when viewed obliquely, from one side.) The latter is completely out of context, a gratuitous display of virtuoso skill, and the way in which it disturbs the unity of an otherwise classical composition somehow makes it an emblem, not only of human mortality, as Holbein intended, but of the psychological unrest of the time.

Grünewald

Gothic traits persisted in northern European art long after the dawn of the Renaissance. A striking example is the work of Matthias Grünewald (d. 1528), who may even have been a pupil of Albrecht Dürer. His work has nothing classical about it—at points there are resemblances to Bosch. His principal work, the *Isenheim Altarpiece*, dates from *c.* 1513–15.

The altarpiece is an elaborate complex of folding panels which are even more ambitious in size than the Ghent altarpiece by the van Eycks (see page 162), which had long set the scale for paintings of this type. Its most memorable image, the *Crucifixion* (Fig. **12.5**, see page 213), is only the first scene. The shutters open successively, first to reveal an *Annunciation*, then a carved shrine with figures by Nicholas Hanenauer.

In the *Crucifixion* Grünewald aims at intensity rather than absolute realism—the Christ-figure is gigantic in comparison with the other people who are present at the scene, and in that sense he can be considered heroic. There is, however, much emphasis on painful realistic details. Christ is broken and degraded by maltreatment and suffering. His

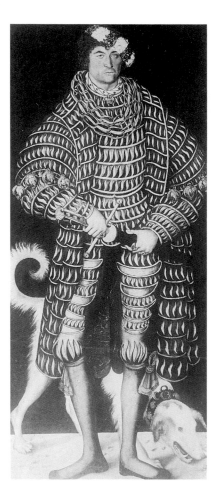

12.6 Lucas Cranach, *Duke Henry The Devout c.* 1514. Oil on canvas (transferred from wood), 72½ × 32¼ ins (184 × 82 cm). Gemäldegalerie, Dresden.

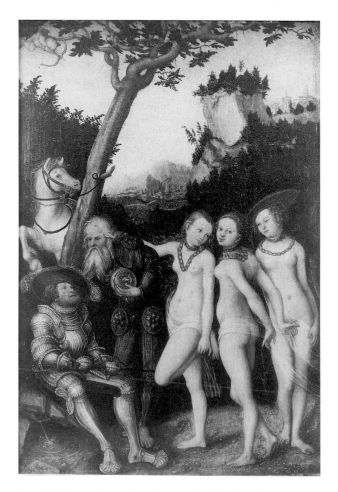

12.7 Lucas Cranach, *Judgment of Paris c.* 1530. Oil on wood, 41 × 28⅜ ins (104 × 72 cm). The Metropolitan Museum of Art, New York.

arms have been pulled out of their sockets by the weight of the body; the torso is covered with lacerations, and bristles with fine splinters of wood.

The Virgin, St. Mary Magdalene, and St. John the Evangelist appear on the left of the Cross; St. John the Baptist stands alone on the right. The group on the left is perhaps the most famous expression of grief in art. Like the image of the crucified Christ which they accompany, these show the way in which many of the intensely devoted worshippers of the period tried to identify themselves as closely as possible with Christ's sufferings—perhaps as an escape from the ever-increasing secularism which was tearing a once familiar world apart, just as surely as the religious controversies of the time.

12.8 Hans Holbein the Younger, *Henry VIII with Henry VII* 1536– 37. Charcoal on paper, 10½ × 54 ins (26.6 × 137.2 cm). National Portrait Gallery, London.

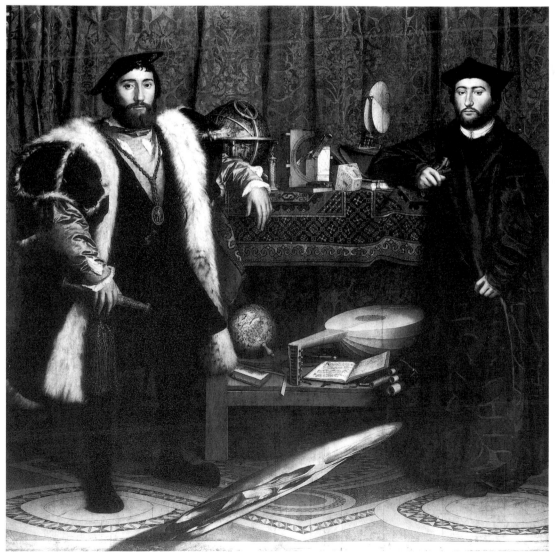

12.9 Hans Holbein the Younger, *The Ambassadors.* Oil on oak, 81½ × 82¼ ins (207 × 209 cm). National Gallery, London.

Literature

François Rabelais

The greatest creative writer of the first half of the sixteenth century in northern Europe had many links to the Reformation, but never committed himself to it. François Rabelais (1483 or 1494–1553) began his career as a Franciscan friar, perhaps as early as the age of seven. His thirst for knowledge and in particular his desire to learn Greek (which was considered suspect because Greek was the foundation of heterodox biblical studies) displeased his superiors who at one time confiscated his books and imprisoned him in his monastery. Rabelais, who by this time had influential patrons, managed to transfer himself to the more tolerant Benedictine order. In 1530, after only a few weeks of formal study, he was awarded a medical degree at the University of Montpellier, and in 1532 he was appointed physician to one of the most important hospitals in France, the Hôtel-Dieu in Lyons. At about this time, he seems to have abandoned monastic life altogether. Despite his priestly orders, he lived with a common-law wife, by whom he had at least three children. He traveled widely, visiting many parts of France, and making two journeys to Rome, in 1535–6 and 1547–9, in the company of his principal patron, Cardinal Jean du Bellay, Bishop of Paris.

Rabelais' chief works are the five books devoted to the story of the giants Gargantua and Pantagruel. The first version of *Pantagruel* was published in 1532. *Gargantua*, which is what would now be called a prequel to *Pantagruel*—in that it chronicles events which are previous to those in the first book—appeared in 1535. There were further instalments which appeared in 1546, 1552 and (posthumously) in 1564. The authenticity of the fifth book is doubtful.

Pantagruel, the name Rabelais gives to the hero of the first story, was ironically that of a comic dwarf in French folk-lore. Rabelais makes him into a giant. Gargantua is Pantagruel's father. Rabelais' chronicle of their adventures consists of an appropriately gigantic, relentless outpouring of language, which matches the literally gigantic, and also grotesque, nature of the characters involved—the conventions of the chivalric epic (still much relished by sixteenth-century readers) are turned upside down, and Rabelais mocks knights, bourgeois, monks, lawyers, and pedants with exuberant impartiality. He also directs his mockery at women, to the point where he has been described as anti-feminist. These passages are often extremely gross. For example, when a fine Parisian lady refuses her favors to Pantagruel's friend Panurge, the rejected suitor sprinkles her dress with a drug which brings the dogs running from miles around to urinate all over her (*Pantagruel*, Chapters 21 and 22).

The best glimpse of Rabelais' personal philosophy can be found in *Gargantua*, in the famous chapters devoted to the Abbey of Thelema. The abbey is an earthly paradise; also a conventional monastery stood on its head. Men and women live there together in perfect freedom:

All their life was regulated not by laws, statutes or rules, but according to their free will and pleasure. They rose from their bed when they pleased, and drank, ate, worked and slept when the fancy seized them. Nobody woke them; nobody compelled them either to eat or to drink, or to do anything else whatever. So it was that Gargantua had established it. In their rules there was only one clause:

DO WHAT YOU WILL

(FRANÇOIS RABELAIS, *Gargantua*, Chapter 57 from *The Histories of Gargantua and Pantagruel*, translated by J. M. Cohen. Penguin Books Ltd., 1955.)

Modern admirers of Rabelais have perhaps taken this admonition too much at its face value, and have made him an advocate not of liberty but of licence. What Rabelais had in mind was *libertas Christiana*—the freedom of Christian believers to cast off the crippling bondage of both Old Testament and ecclesiastical law, and to live balanced, united, gracious lives in accordance with the Gospels. This attitude aligned him with Erasmus (to whom Rabelais wrote an admiring letter in 1532), and with the party of moderate reformers in Germany headed by Philip Melancthon (1497–1560). His own patron, Cardinal du Bellay, engaged in lengthy negotiations with Melancthon, trying to bring about a reconciliation between the Reformers and the Church. Calvin, on the other hand, was no admirer or advocate of Rabelais. He got to know the latter's writing and was scandalized by it.

Chapter 13

Mannerism

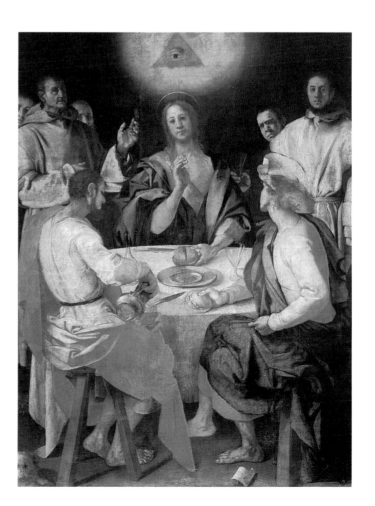

13.1 **Pontormo**, *Supper at Emmaus* 1525.
Oil on canvas, 90½ × 68 ins (230 × 173 cm).
Uffizi Gallery, Florence.

The Counter-Reformation

This chapter is headed with the term "Mannerism" which was invented by art historians for their own purposes. It is now sometimes also applied to literature. Yet what was the general spirit of the age which produced Mannerist art and attendant phenomena?

The last two-thirds of the sixteenth century were an epoch rent by religious wars. The theological controversies sparked off by Luther and other reformers soon triggered a series of political conflicts, in which supposedly religious ends were pursued by the use of military force. These politico-religious conflicts persisted into the next century. They raged in Germany, in the Netherlands (where Protestantism inspired a revolt against Hapsburg rule which led to the creation of the Dutch Republic), and in France, where the now best-remembered incident in a series of Wars of Religion was the St. Bartholomew's Day Massacre (1572) of protestant partisans.

Faced with the new religious ideas evolved by protestant theologians, the supporters of the Catholic Church could not rely on force alone. They had to create a new intellectual structure and a new sense of discipline within the Church—the phenomenon we now call the Counter-Reformation. Its terms were largely worked out at the Council of Trent (1545–64).

Underlying these religious conflicts, however, was an ever-increasing secularism. The Peace of Augsburg (1555), which ended the first round of religious wars in Germany, established a principle which was deeply injurious to papal power. It not only tolerated Lutheran princes (and Lutheran control of some of the councils which ruled the German free cities), it gave these the right to determine both their own religion and that of those over whom they ruled. The example was contagious. Even on the Catholic side—in Spain, for example—the secular power more and more came to exercise control over the Church. The popes protested, but to no avail. Either the Church existed in uneasy partnership with the lay power, or it entered into conflicts it was almost bound to lose.

The new secularism had a social aspect as well as a purely political one. There was now a deep fissure in European culture. Individuals more and more began to think for themselves, and in particular they became self-consciously aware of their own individuality. Yet there was also a tougher religious discipline, and an emphasis on self-abnegation and submission to God, and on the Church as an arbiter whose decrees should be unquestioned. The result of this fissure was either an edgy defiance, or else a profound spiritual unease.

Philosophy

Loyola and Montaigne

The deep divisions in sixteenth-century attitudes are nowhere better symbolized than in the contrasting attitudes of St. Ignatius Loyola (1491–1556) and Michel de Montaigne (1533–92).

Loyola, founder of the Jesuits (1534), began life as an aristocratic Spanish soldier, but passed the later part of his life in Rome, where the papacy was trying to regroup its forces in order to combat the Reformation. The Jesuits were intended to be the intellectual shock troops of the Church, leaders of the counter-attack against heresy. Loyola was a brilliant organizer, but not a brilliant original thinker. What he did was to make a last stand for the doctrines of medieval scholasticism, those of Aquinas in particular. He also did something else. In his *Spiritual Exercises* (begun in 1521 but not published until 1548) he formulated a new and very effective method of religious instruction. The believer was encouraged to envisage the pains of hell and the rewards of paradise in concrete detail, and was urged, at the same time, to obey the Church in all things as the best way of avoiding the one and gaining the other:

> To make sure of being right in all things, we ought always to hold by the principle that the white that I see I would believe to be black, if the hierarchical church were so to rule it.

> (ST. IGNATIUS LOYOLA, *Spiritual Exercises*, quoted by Michael Foss, *The Founding of the Jesuits*. Hamish Hamilton, 1969.)

If Loyola represents, in part at least, an attempt to put back the clock, Montaigne's writings mark the beginnings of a process of intellectual change which gathered pace in the next century. In a sense Montaigne was an improbable initiator of such a revolution. He was a French country gentleman, with a comfortable property near Bordeaux, who spent most of his life in reading, thinking and writing. In 1580 he published two volumes of *Essays*; a third volume

was added later. The essay was a form which Montaigne reinvented for modern times, using suggestions taken from Greek and Latin models. In French, the word *essai* can additionally mean a "test" or "trial," and also an "attempt." Montaigne's beginnings were tentative—the earliest of his essays were written nearly a decade before their publication. Yet the titles which feature in his collection are also enough to show that he was prepared to tackle a wide range of themes. The last four essays in Book 1, for example, are "Of Vain Subtleties," "Of Smells," "Of Prayers," and "Of Age."

Montaigne's writing shows two especially significant traits. One is pragmatic skepticism, combined with close observation of everything that surrounded him. Another, found again and again in his writing, is detached consciousness of self—whereas Loyola exhorts the devotee to lose the sense of self completely. "I would rather," wrote Montaigne, "be an authority on myself than Cicero. In the experience I have of myself I find enough to make me wise, if I were a good scholar" ("On Experience," Book III, Chapter 13). To this he adds a sense of the harmony which can exist within things and circumstances which are apparently disharmonious:

> A man must learn to endure that patiently which he cannot avoid conveniently. Our life is composed, as is the harmony of the World, of contrary things; so of divers tunes, some pleasant, some harsh, some sharp, some flat, and some high. What would that Musician say that should love but some one of them? He ought to know how to use them severally and how to intermingle them. So should we both of goods and evils which are consubstantial in our life. Our life cannot subsist without this commixture, whereto one side is no less necessary than the other.

> ("On Experience," John Florio's translation, with modernized spelling)

This represents precisely the attitude to be found in some of the profoundest Mannerist art. It also represents an attitude exemplified by the greatest creative writers of the period, chief among them Shakespeare and Cervantes, who were Montaigne's slightly younger contemporaries.

Architecture

Michelangelo and Palladio

During the sixteenth century Italian architecture developed in two directions, one exemplified by Michelangelo's Laurentian Library in Florence, the other by Palladio's work in Venice and the Veneto.

The Laurentian Library (Fig. **13.2**), attached to the church of San Lorenzo in Florence, was designed in 1524–6, and finally completed in 1558–9. The library is long and narrow, because it forms an additional upper story to an already existing cloister. Such a site was usual for books, because it offered freedom from damp. Michelangelo took the classical vocabulary developed by his Florentine predecessors, Brunelleschi and Alberti (see page 175), and combined these with certain elements which were already traditional in Florence, even before the Renaissance—for example, an emphasis on contrasts of color and on intricate low-relief surface patterning. The walls of the long room which houses the library are divided at frequent intervals by *pietra serena* (fine grained gray limestone which contrasts with the whiteness of the walls) pilasters. These look as if they are merely decorative, but in fact carry the weight of the roof. In order to put the least possible weight on the cloister below, the wall panels between the pilasters are not load-bearing. Michelangelo turned this structural necessity into the starting point of an intricate grid system, which

makes the reading room into a space where vertical and horizontal emphases continually contradict one another, to notably restless effect.

The actual library, however, is not nearly as startling as its vestibule, which was the last part to be completed. The most extraordinary feature of this vestibule is the staircase, which consists of three flights, the two outermost unprotected by a balustrade (Fig. **13.3**). These lead to an intermediate landing, and combine to reach the single door that leads into the library itself. The central stairway has treads of convex shape, with ornamental scallops at either end. The treads are thus not particularly easy to climb. Yet this perverse construction has an energy of form, and a sculptural authority, which make it forever memorable. It is the ancestor of all the triumphal stairways devised by the Baroque artists of the seventeenth century.

There is a striking contrast between the restless, depressive mood instilled by the Laurentian Library and the serene creations of Palladio. Andrea Palladio (1508–80) was born in Padua, and started his career as a stone mason. He then moved to Vicenza, where he attracted the patronage of an influential member of the local circle of humanists.

Palladio built a number of handsome city palaces, in Vicenza and elsewhere, which are refinements of those already designed by men such as Brunelleschi and Bramante. Many remained incomplete because his patrons

13.2 Michelangelo, The Laurentian Library, 1524–6 (completed 1558–9). Attached to S. Lorenzo, Florence.

13.3 Michelangelo, staircase in the Laurentian Library.

usually had ambitions beyond their financial means. Palladio also built country villas, and a small group of important churches, chief among them San Giorgio Maggiore (Fig. **13.4**) and Il Redentore in Venice. It is these structures—the villas in particular—publicized by means of a superb illustrated book, the *Quattro libri dell'architectura* (1570), which have assured his lasting influence on western European architecture.

Palladio's major churches, which belong to the end of his career, are innovatory in the treatment of the façades. Italian builders had found difficulty, ever since the Renaissance, in designing church façades which would both express the nature of the structure within and conform to the rules of classical architecture. At the Tempio Malatestiano Alberti (see page 178) had experimented on adaptations of the triumphal arch. Palladio discarded this in favor of a version of the classical temple, with columns supporting an entablature with a triangular pediment above it. In order to get this to conform to what was behind—a nave flanked by aisles—he adopted the device of temple fronts which overlapped, or seemed to do so. Thus at San Giorgio Maggiore a wider, lower temple frontage, supported on pilasters, has superimposed upon it a taller, narrower one, carried by giant columns. Palladio gets over the problem of two sets of supports of different proportions and heights by placing these columns on massive bases, which rise to half the height of the main door.

Palladio's churches were influential models for Counter-Reformation church-building in general, though the simplicity and severity he favored was soon overlaid with exuberant Baroque ornament. His villas provided models which were yet more widely imitated. The Venetian villa was a revival of the idea of the country house as a self-sufficient unit that had first flourished in Roman times. This revival depended on two things: increasing agricultural investment on the Venetian mainland, as Venice's overseas empire dwindled, and local conditions, which were now sufficiently settled, so that the country houses of the region no longer had to be fortified.

One of the most celebrated of Palladio's villas is the Villa at Maser (Fig. **13.5**), built for two Venetian aristocrats, Daniele and Marcantonio Barbaro. It was designed as the center of a working farm—the main dwelling is flanked by symmetrical arcades to shelter farm equipment and animals. The main rooms are raised above the level of the arcades. They are all elaborately frescoed by Veronese (see page 228) and his assistants. At the back they face on to an enclosed courtyard, which is closed by an elaborate structure with niches containing statues. Thus, in addition to being a farm, the Villa at Maser was designed as a permanent residence for wealthy and cultivated people.

The notion that the dwelling-place is not merely practical but also symbolic of the value of a civilized lifestyle helps to give Palladio's villa designs poetic resonance. The whole image of the villa, especially as Palladio himself projected it

13.4 Andrea Palladio, S. Giorgio Maggiore, Venice, begun 1566.

through the plates in the *Quattro libri*, proved immensely appealing to landowners throughout Europe, and most particularly to members of the oligarchy who ruled England throughout the eighteenth century. There were no religious barriers to the imitation of Palladio's villas, as there were to the imitation of his churches, and this aspect of Late Renaissance taste was one of the very few which appealed equally to both Catholics and Protestants.

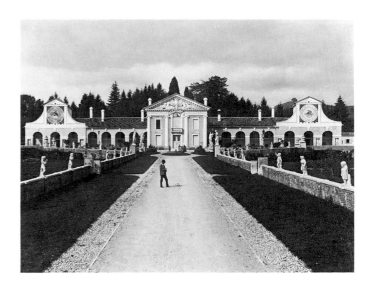

13.5 Andrea Palladio, Villa at Maser, near Asolo, Italy *c.* 1560.

Painting

Early Mannerism: Pontormo and Michelangelo

The definition of Mannerism in art has given rise to many disagreements. The term derives from the Italian word *maniera*, which was used in the sixteenth century simply to mean "style," in the absolute sense. In 1550 Vasari listed it as one of the qualities which made the art of his own period superior to that of 100 years earlier. In the seventeenth century, however, the term "Mannerist" began to be used pejoratively, to denigrate something which had by then gone out of fashion, and which was associated with artificiality, self-conscious virtuosity, and capricious elegance. In the nineteenth century German art historians revived the term Mannerism as a label for the period which intervened between the High Renaissance and the Baroque, usually with the implication that this was a decadent epoch.

Florence had always produced a number of artists who were opposed to whatever happened to be the ruling stylistic orthodoxy of the time. Botticelli, for instance, can be described in these terms. In the High Renaissance period, the chief of these resident in Florence was Jacopo Pontormo (1495–1557), who has consistently been described as a Mannerist. Pontormo is one of the first Italian artists to be influenced by Dürer. His *Supper at Emmaus* (Fig. **13.1**), dated 1525, is based on one of Dürer's *Passion* series prints. The painting is important in another way in that the powerfully realistic still life on the table demonstrates the way in which naturalistic details, which conflict stylistically with the context in which they are put, become part of the Mannerist repertoire of shock effects.

The painting which is generally held to be Pontormo's masterpiece is his *Deposition* in Santa Felicità, Florence, also begun around 1525 (Fig. **13.6**). The elements used in this composition would fit more logically into a horizontal format but instead are arranged vertically. The figures are placed on a sharply rising slope, but this is concealed by the fact that they form a densely packed mass, enlivened by the twisting, serpentine patterns of limbs and drapery. This pattern is revealed in all its complexity by the fact that the artist has renounced chiaroscuro, and relies on strong, precise drawing and clear color. There are inexplicable changes of scale, and the figures seem unstably planted on the ground which is supposed to support them. The result is a visionary evocation of a sacred event, not an attempt at realistic depiction.

In the final years of his career, after falling under the spell of Dürer, Pontormo fell increasingly, and much more completely, under the spell of Michelangelo, with unhappy results. Michelangelo's late frescos are extremely personal, and in the strict sense inimitable. The *Last Judgment* (Fig. **13.7**), on the east wall of the Sistine Chapel, was painted

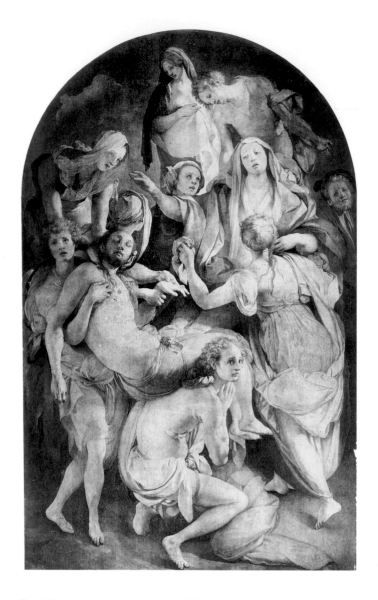

13.6 Pontormo, *Deposition* c. 1525.
Oil on wood, 123¼ × 75⅝ ins (313 × 192 cm). Capponi Chapel, Church of Sta. Felicità, Florence.

more than twenty years after the completion of the ceiling. Though its style is intimately connected with that of the ceiling itself, the mood is very different.

The *Last Judgment* has little to do with the forgiveness of sins. The saints who surround Christ do not urge him towards mercy; they want him to give their just deserts to people who have not been as steadfast in the Faith as they themselves. Partly because of the vast size of the area to be covered, and partly in response to his own inclination, Michelangelo abandoned any attempt at conventional perspective, thrusting this aside even more violently than Pontormo had done in the *Deposition*. Every figure is given its own space, and is then related to one of a series of compart-

ments. The first, in the left-hand bottom corner, contains the resurrected dead emerging from their tombs; the last, also at the bottom but on the right, shows Hell and the damned, with Charon in his boat moving toward Hell's Mouth. The cross on the altar of the chapel is placed symbolically in front of this, in the center of the bottom margin of the composition. Between the resurrection to the left and the final condemnation to the right, the design rises in a great arch, with Christ himself as the keystone.

The *Last Judgment* is such a unique and profoundly personal work of art that it is foolish to try and force it into a specific stylistic category. All one can say about it is that it did, with its disregard of the conventional rules of composition and its concentration on the nude figure, have a profound effect on the artists who followed in Michelangelo's wake. It is Mannerist because Michelangelo's followers made it so by the things they borrowed from it.

Parmigianino

The real father of Mannerism in its most usual guise, as an exquisite decorative idiom, was neither Pontormo nor Michelangelo but Parmigianino (1503–40), who, in an artistic career of only twenty-one years, created artistic models which gained currency all over Europe.

Though Parmigianino was already a fully-fledged artist by the time he came into contact with Correggio, the latter influenced him deeply. He found ways of refining Correggio's melting sensuality and at the same time etherealizing it.

Parmigianino's main achievement lies in the translation of everything he used in his art into an invented stylistic idiom, which pointedly calls attention to its own separateness. His most typical paintings, such as the *Madonna del Collo Lungo (Madonna with the Long Neck)* (Fig. **13.8**), which has become one of the best known of all Mannerist creations, shows Parmigianino's innate tendency to attenuate forms carried to an extreme—a process of distortion related to Michelangelo's Sybils, though here used to stress elegance rather than power. Also striking is the contrast between foreground and background. The latter is pushed away to some completely indeterminate distance, yet its importance is emphasized by the presence of a tall Tuscan column which echoes the elongation of the foreground figures. A colonnade was clearly intended, but the painting is unfinished. Its incomplete state signals the neurotic character of Parmigianino's temperament: in this at least he does resemble Pontormo.

The School of Fontainebleau

Italian Mannerism, with its easily imitable quirks, proved simpler to export than the subtly balanced art of Raphael's Stanza della Segnatura. The chief patrons of the new art in the north were not ecclesiastical institutions but ruling princes and the courtiers who surrounded them. In an increasingly secular society, it was they who had both the resources and the will to patronize art, and the things which artists were now asked to express can be related to the new secularism and the movement toward autocracy typical of the European society of the time. Art glorified the prince, and portrayed him and those who surrounded him as beings of a different order, privileged to occupy a fantastic world of their own creation.

The most typical example of this court art was the School of Fontainebleau in France, which was directly dependent on Italian Mannerism. It is possible to pinpoint the exact date when this came into being. In 1528 Francis I of France, newly returned from a humiliating captivity in Spain, decided to transform a hunting lodge near Paris into a sumptuous royal residence. Just at that moment Italian artists were looking for employment, thanks to the sack of Rome the year before, and the impoverished and unsettled state of Italy.

The School of Fontainebleau was Italian Mannerism seen at its most decorative, and transferred with certain important modifications to French soil. It took its special character from two things—the way in which the artists learned to combine painting and sculpture, and the emphasis placed on the female nude. Such nudes were a novelty in France, and, like Lucas Cranach's (see page 214), they were a symbol of the new secularism.

Much of the work done by Italian artists at Fontainebleau itself has been destroyed, largely by inept restoration. The artist best represented by surviving original works is Niccolo dell'Abate (*c.* 1512–71), who carved out a special role as a painter of mythological landscapes. His *Eurydice and Aristarchus* (Fig. **13.9**) has a wonderful poetic charm. It shows small, elegant, typically elongated figures in front of a panorama adorned with numerous fantastic buildings. The treatment suggests the influence of Parmigianino, but also that of Giorgione and Netherlandish landscape painters.

Pieter Bruegel the Elder

It is interesting to compare dell'Abate's work to that of Pieter Bruegel the Elder (*c.* 1527/8–69), which was addressed to a rather similar kind of aristocratic audience, not in France but in the Spanish Netherlands. There is a lively debate about whether Bruegel should be counted as a Mannerist, or as the leading anti-Mannerist painter of his time. In fact he is not so much anti-Mannerist as simply anti-Italian. His earliest reputation was made through paintings and prints which derived directly from Bosch (see page 164). Later, in a series of paintings of the *Months*, he developed imagery used by the Limbourg brothers in the *Très Riches Heures* (see page 160).

There is, nevertheless, a link between his work and dell'Abate's *Eurydice and Aristarchus*. Bruegel's *Magpie on the Gallows* (Fig. **13.10**), signed and dated 1568, offers the

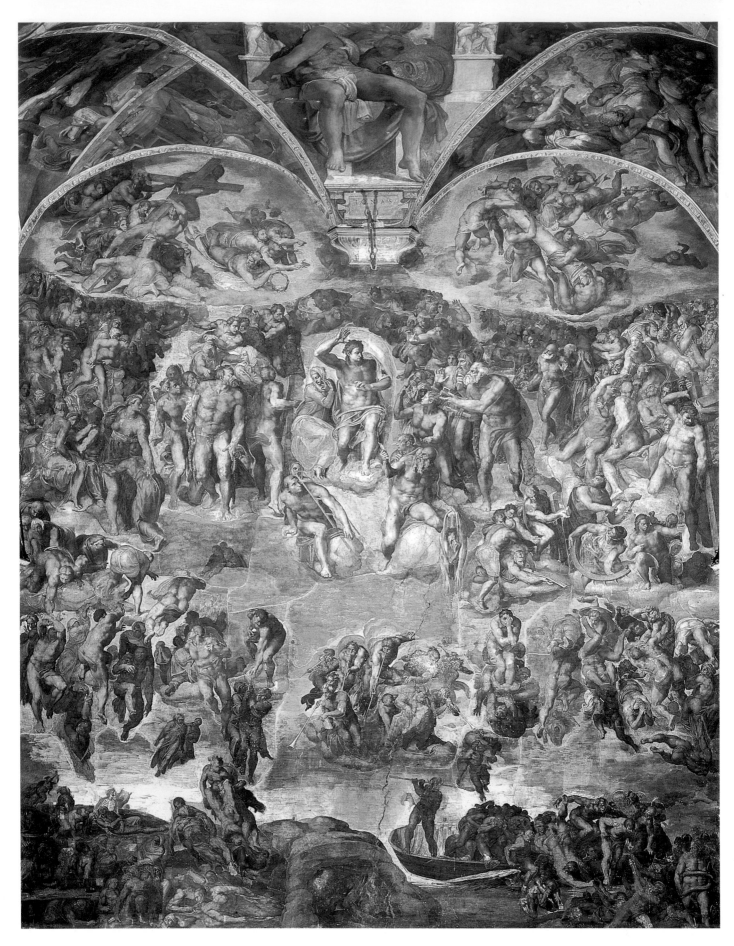

13.7 Michelangelo, *The Last Judgment* 1534–41.
Fresco on the altar wall of the Sistine Chapel, The Vatican, Rome.

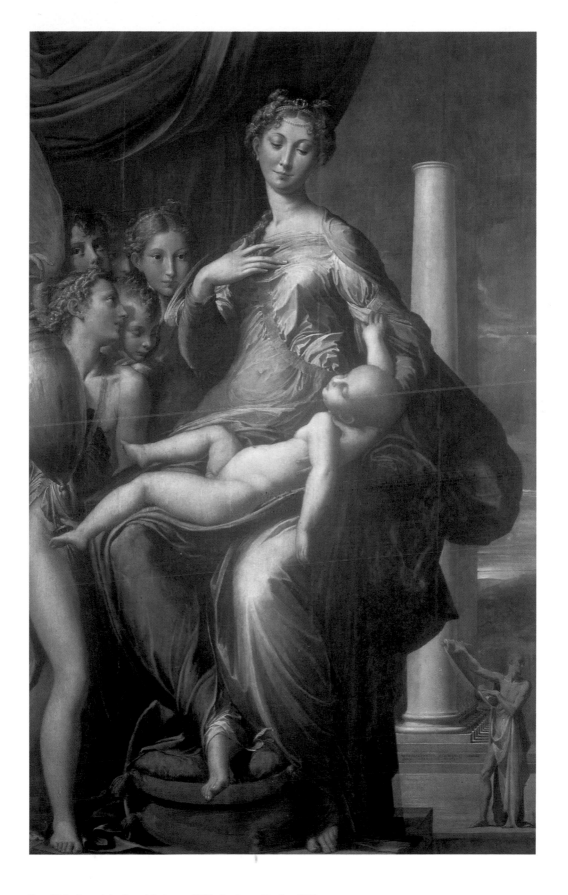

13.8 Parmigianino, *Madonna With the Long Neck* c. 1535.
Oil on panel, approx. 85 × 52 ins (216 × 132 cm).
Uffizi Gallery, Florence.

13.9 Niccolo dell'Abate, *Eurydice and Aristarchus*.
Oil on canvas, 74½ × 93½ ins (189.2 × 237.5 cm). National Gallery, London.

13.10 Peter Bruegel, *Magpie on the Gallows* 1568.
Oil on panel, 18¹⁄₁₀ × 20 ins (45.9 × 50.8 cm). Darmstadt, Germany.

same kind of panoramic landscape in which all human activity is distanced—there are numerous figures, but, even more obviously than in dell'Abate's painting, they have become incidental. The painting is punctuated and given focus by a single, sardonic comment. Bruegel apparently intended the magpie itself to symbolize all the gossips he would like to hang. Bruegel's *The Wedding Dance* (Fig. **13.13**) of *c.* 1567–8 is closer to the work of the Limbourgs. The profusion of sharply observed naturalistic detail makes it easy to ignore the actual structure of the composition, which is that of a Mannerist "Last Supper," of the type painted by Tintoretto, using the table as a long diagonal, thrusting into the background. Bruegel thus employs the Italian heritage even when seeming to reject it.

The later Titian and Veronese

In the days when Mannerism was despised and out of fashion, it used to be said that at least the Venetian art of the sixteenth century had managed to remain free of its contamination. Now the pendulum has swung the other way, and there is an increasing tendency to try and integrate the history of Venetian painting post-1530 into the history of Mannerism in general.

Two great Venetian artists, Titian (*c.* 1487/90–1576) and Veronese (*c.* 1528–88), reacted to Mannerism in a particularly personal way, taking some elements and rejecting others. Titian is generally held to have been a conservative force in Venetian art. An examination of his work from 1530 onwards, at a time when he was firmly established as one of the greatest Venetian painters of his time, does not support this idea. He remained fecund in new inventions and solutions. Many of these sprang from his dual situation—first as a Venetian, but secondly as the preferred painter of the Holy Roman Emperor Charles V and the latter's son, Philip II of Spain. The Hapsburgs were to him what Francis I of France was to the artists of the School of Fontainebleau.

In 1548 Titian painted the magnificent *Charles V on Horseback* (Fig. **13.11**). This was the first painting of its kind, the equivalent of a Roman or Early Renaissance equestrian statue. In its overwhelmingly romantic presentation of a not very charismatic monarch, it initiated a whole genre.

Philip II began to take on the role of the painter's chief patron in the 1550s, in 1554 commissioning one of the artist's loveliest mythological pictures, *Venus and Adonis* (Fig. **13.12**). The painting is a typical example of what Titian himself called a *poesia*—a paraphrase, rather than a direct illustration of a mythological subject. For Philip, a true connoisseur of painting and very much a man of his time, *Venus and Adonis* was an intriguing blend of sensuality and artifice—for example, there is the skillful but rather artificial contrast between the poses of the two figures, one seen from the front, the other from the back.

Paolo Caliari, called Veronese, was born in Verona but

13.11 Titian, *Charles V on Horseback* 1548.
Oil on canvas, 130⁷⁄₁₀ × 109⁴⁄₅ ins (332 × 279 cm).
The Prado, Madrid.

13.12 Titian, *Venus and Adonis* 1554.
Oil on canvas, 42 × 52½ ins (106.7 × 133.4 cm). The Metropolitan Museum of Art, The Jules Bache Collection 1949.

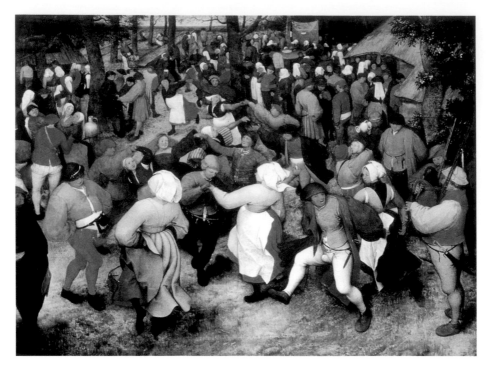

13.13 Pieter Bruegel, *The Wedding Dance c.* 1567–8.
Oil on panel, 47 × 62 ins (119.4 × 157.5 cm). The Detroit Institute of
Art.

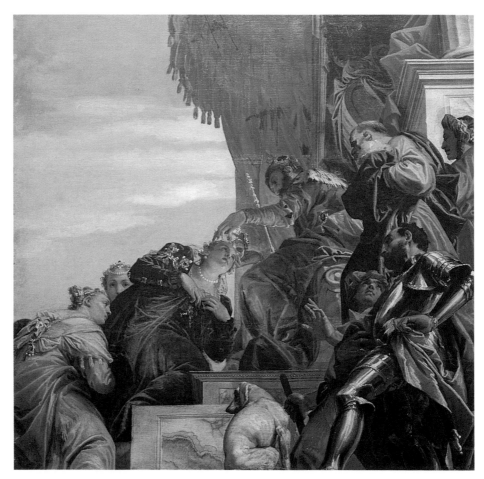

13.14 Veronese, *Triumph of Mordecai* 1553.
Ceiling painting from San Sebastiano, Venice.

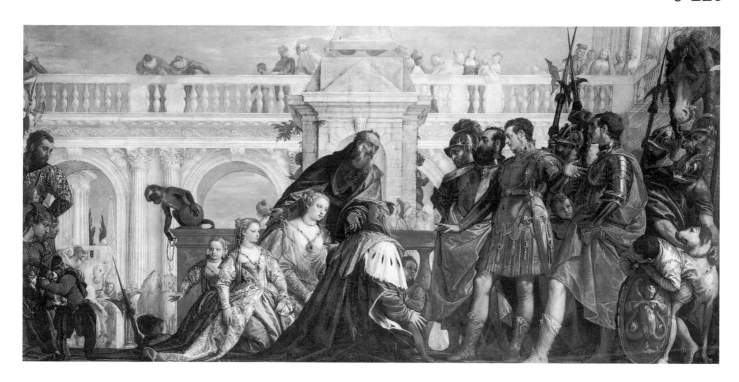

13.15 **Veronese**, *The Family of Darius Before Alexander* 1565–67.
Oil on canvas, 93 × 187 ins (236.2 × 475 cm).
National Gallery, London.

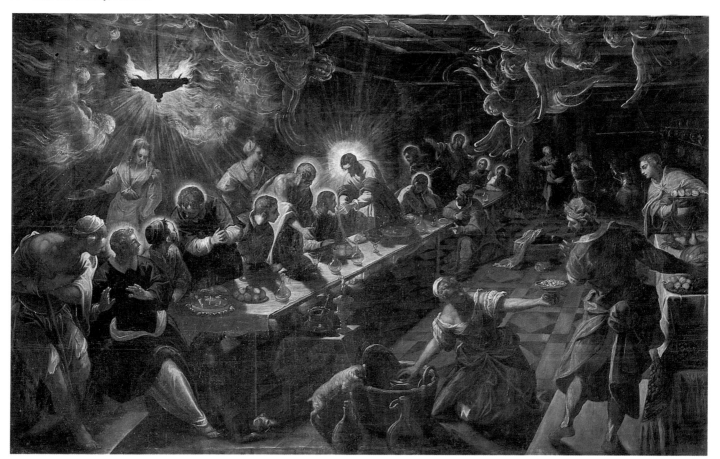

13.16 **Tintoretto**, *The Last Supper* 1592–94.
Oil on canvas, 144 × 224 ins (366 × 569 cm). S. Giorgio Maggiore,
Venice.

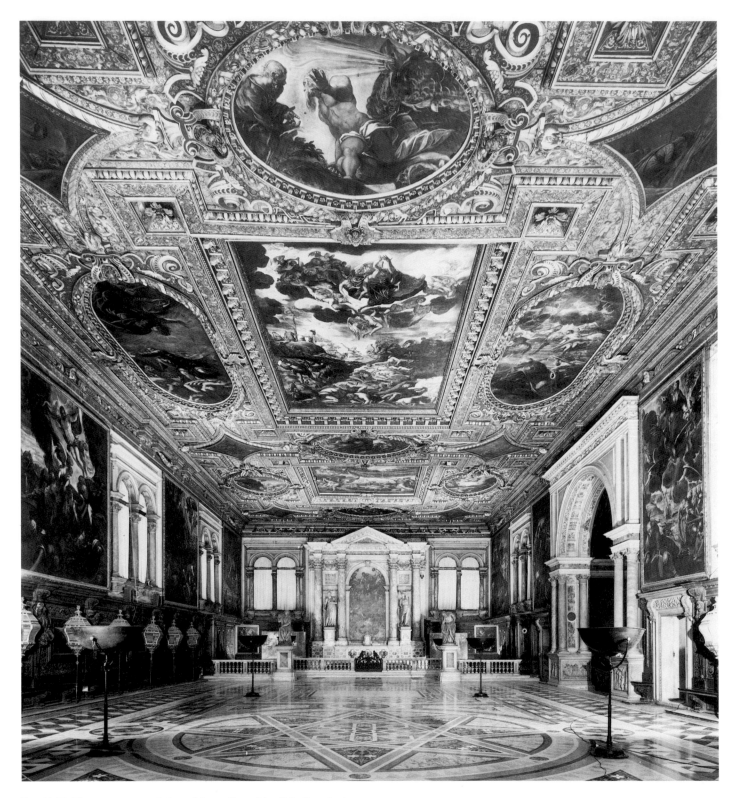

13.17 Tintoretto, general view of the ceiling of the Sala Grande, in the Scuola di S. Rocco, Venice, painted 1575–78.

spent most of his career in Venice. One of his early influences was Parmigianino, but, when he came to Venice at the beginning of the 1550s, he was inevitably impressed by Titian. Central to his stylistic development was a synthesis of Titian's ideas with the less intellectual sort of International Mannerism.

Though he was already employed in the Palazzo Ducale in 1553, the commission which established Veronese's reputation in Venice was for decorations carried out in the church of San Sebastiano. These demonstrate the subtle but nevertheless very real distinction between Veronese and Titian. While Titian produced single canvases which were gloriously decorative, Veronese was a specialist in rich decorative schemes. The sumptuousness of the interiors he devised for San Sebastiano surpass those of any other Venetian artist. The paintings and especially the ceiling paintings which tell the story of Esther (Fig. **13.14**)—regarded as the Old Testament prototype of the Virgin—provide virtuoso demonstrations of Veronese's skills, not only as a colorist but in his handling of extreme foreshortening. The curious thing is that much of Veronese's later work involves a denial of this characteristically Mannerist manipulation of space.

Typical of this denial is his large *Family of Darius before Alexander* (Fig. **13.15**), where the composition is deliberately friezelike. This belongs to a Venetian tradition of narrative tableaux which goes back to Carpaccio and Gentile Bellini (see page 182). Two things, however, are new. One is the scarcely hidden irony, which makes the scene fundamentally frivolous—a ceremonial re-enactment, not without a wink at the audience. The other, perhaps connected with this frivolity, is the casual fluency with which the whole thing is put together. The costumes, which are a mixture of contemporary dress and a fanciful version of the antique, may derive from stage-costuming. They reinforce the spectator's feeling that what is being witnessed is no more than a sumptuous charade.

Jacopo Tintoretto

Jacopo Tintoretto (1518–94) was a different sort of artist from the rest of his Venetian contemporaries, however eminent. For one thing, unlike them he seems to have been largely self-trained. Though he was later to boast of his ability to produce work in the style of any of his Venetian rivals—even Titian himself, or Veronese—his painting shows quirks of technique which may be the result of his having had to discover his own methods, rather than being able to rely on traditional recipes.

Another consequence of Tintoretto's lack of professional training may have been his love of shock effects, though these were also very much part of the Mannerist ethos. His *Last Supper* (Fig. **13.16**) in San Giorgio Maggiore, Venice, is arranged in an entirely different way from Leonardo's High Renaissance fresco of the same subject (see page 193). The

table is set at a diagonal to the spectator, and drives deep into the cavernous picture space. Christ is placed toward the center of the canvas, just as he is in Leonardo's composition, but he is also pushed into the background. It is only the aureole of light around his head which enables the spectator to pick him out.

The individuality of Tintoretto's technique matches the individuality of his attitude toward the business of making works of art. Like the other great Venetians, he created a family shop, which continued to work long after his death. However, his primary motivation for making paintings was not purely commercial, as Titian's seems to have been. He was notorious for undercutting his rivals, and elbowing them out of commissions; what he was after was the opportunity to express himself. For Tintoretto, making paintings became an end in itself. The outstanding example of his need for self-expression is the great cycle of works which he produced over a period of years for the Scuola (Confraternity) di San Rocco in Venice (Fig. **13.17**). The terms he offered the Scuola were so generous that his main motivation must have been to find an assured outlet for his creativity.

All Tintoretto's moods can be surveyed in the Scuola di San Rocco, and it is here too that one senses a limitation of possibilities imposed by the success of his predecessors and contemporaries in Venice. There is a slightly strained search for concepts not yet explored or effects not yet exploited. An example, judged at the highest level, is the vast *Crucifixion* (Fig. **13.18**), which is Tintoretto's attempt to rival the power of Michelangelo's *Last Judgment* (see page 224). One notices several faults—the monotony of the color, when compared to Titian or Veronese, and, still more so, the uncertainty of Tintoretto's grasp of spatial organization, so that the exact relationship between various figures and groups is not always clear.

El Greco

Tintoretto's most important direct successor was not Venetian, and did not spend the main part of his career in Venice. His name was Domenico Theotocopuli, commonly called El Greco (1541–1614). He was born in Crete, and seems to have received a grounding in the techniques of traditional icon-painting before he came to Venice in about 1560. Here he soon rejected his Greek heritage and fell under Tintoretto's spell. Around 1568 he abandoned Venice, going first to Rome, and then to Spain, where he at last became fully himself.

His stylistic progress can be traced from the *Holy Trinity* (Fig. **13.21**) of 1577–9—a Counter-Reformation icon centered on the twisting, serpentine shape of Christ's body, through *The Burial of the Count of Orgaz* (Fig. **13.20**) of 1586–8, with its divided composition, to his truly extraordinary late works. One of the most unconventional pro-

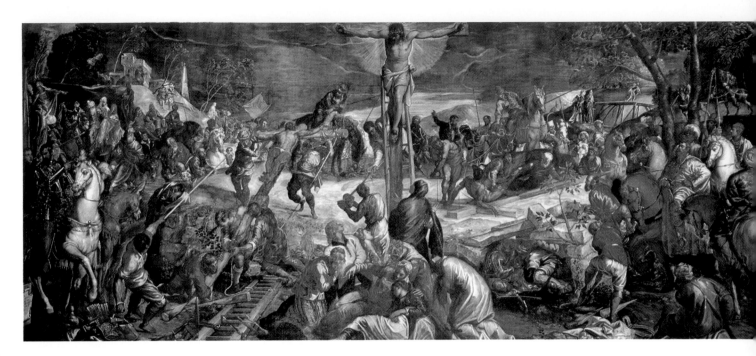

13.18 Tintoretto, *Crucifixion* 1565.
Canvas, 17 ft × 40 ft 2 ins (5.18 × 12.3 m). Scuola di S. Rocco, Venice.

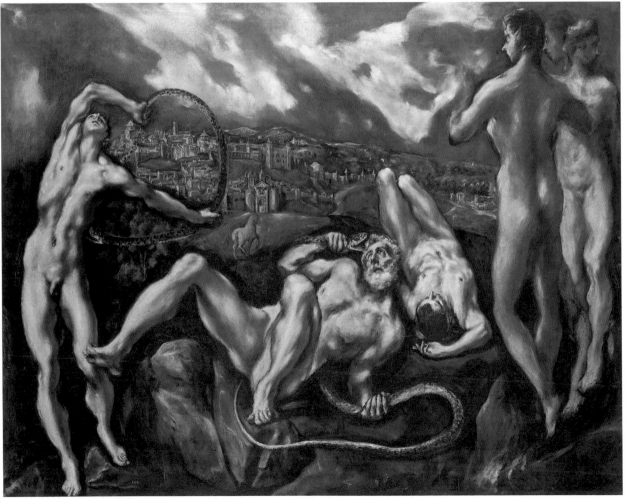

13.19 El Greco, *Laocoön* c. 1610.
Oil on canvas, 54⅛ × 67⅞ ins (137.5 × 172.5 cm). National Gallery of
Art, Washington. Samuel H. Kress Collection.

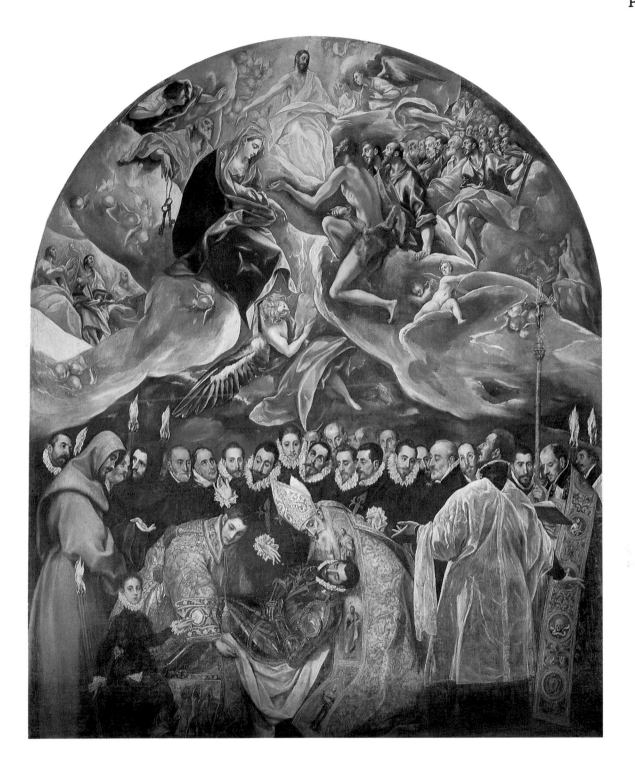

13.20 **El Greco**, *The Burial of the Count of Orgaz* 1586–88. Oil on canvas, 16 ft × 11 ft 10 ins (4.87 × 3.6 m). Church of S. Tomé, Toledo.

ducts of this late phase is the *Laocoön* (Fig. **13.19**), where the Roman group is seen tumbling in disarray, with a vast panorama of Toledo behind the figures.

Throughout his career El Greco's technique remained basically Venetian, working in color patches rather than in line; but, even when compared to Tintoretto, he becomes very detached from the reality of appearances. This detachment becomes a statement about the importance of the spiritual realm, as opposed to the purely material one.

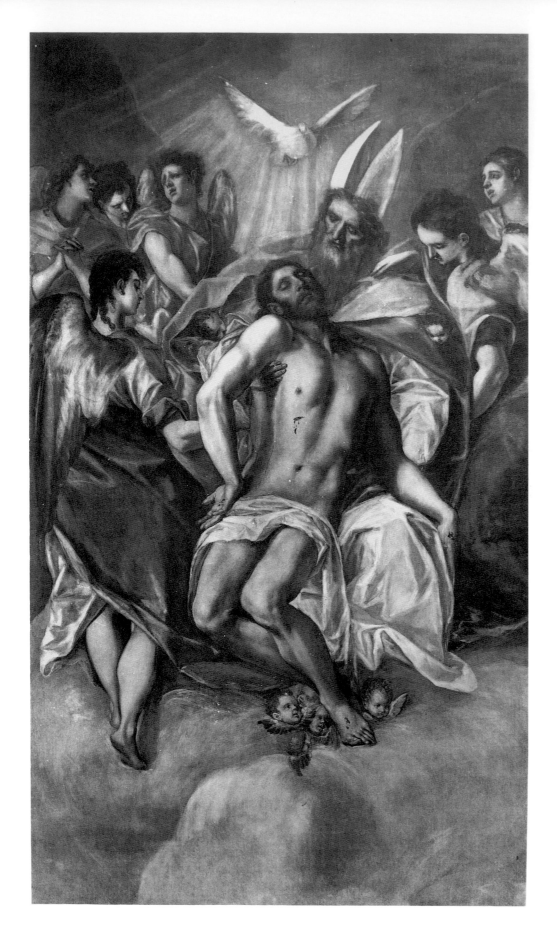

13.21 El Greco, *The Holy Trinity* 1577.
Oil on canvas, 138⅛ × 76½ ins (351 × 194.3 cm).
The Prado, Madrid.

Sculpture

Cellini and Giambologna

The two most important sculptors of the later sixteenth century share certain features. Each did his most important work in Florence; each was an exponent of *contrapposto* (the Italian word, translated literally, means "placed opposite") —a way of representing the various parts of the human body so that they are obliquely balanced round a central axis, giving a spiral, twisting form; and each was an outstanding virtuoso in handling materials. In other respects, though, they make a striking contrast.

Benvenuto Cellini (1500–70) was born in Florence and trained as a goldsmith. During the early part of his career, spent in Rome and then France, his work tended to be small scale, using precious metals. Because of the nature of the materials, a great deal of it has disappeared—melted down again when his patrons were in need of money. Our chief record of it is Cellini's lively *Autobiography*, now at least as celebrated as any of his surviving sculptures. It gives a vivid picture of the vaunting, competitive, but also resourceful nature, not only of Cellini himself but of most of the artists who were his contemporaries and rivals.

In 1545, though, he returned to Florence and succeeded in obtaining the commission for the work by which he is now best known as a sculptor, *Perseus* (Fig. **13.22**). The subject appears to have been chosen by his patron, Cosimo I, Grand Duke of Tuscany. A victorious Perseus, holding Medusa's severed head, had already appeared on a medal made for Cosimo's predecessor, Alessandro de' Medici.

For Cellini the great attraction of the commission was not only that it enabled him to fulfill his ambition to make large-scale sculpture but also that it enabled him to challenge the two men universally acknowledged as the greatest sculptors Florence had produced. Michelangelo's *David* (see page 203) stood in the Piazza della Signoria; Donatello's *Judith* (see page 186), originally made for the Palazzo Medici, had now been moved to the Loggia dei Lanzi, where Cellini's own statue was to stand.

The connection between the *Perseus* and the *Judith* is very close. Both sculptures are on the same scale; both are meant to be seen completely in the round; both show a triumphant victor standing over the prostrate body of an enemy. The differences are that Judith is clothed, whereas Perseus is naked; and that she is about to sever Holofernes's head, while Perseus has already cut off Medusa's, and now holds it aloft. Cellini successfully imitated the extreme refinement of surface to be found in the *Judith*, and borrowed, too, the instability of pose—Perseus literally tramples on the enemy he has defeated. What is most typically and fundamentally Mannerist about Cellini's statue is the way in which the artist distances himself from what is being shown, and makes a bloody deed playful and rather

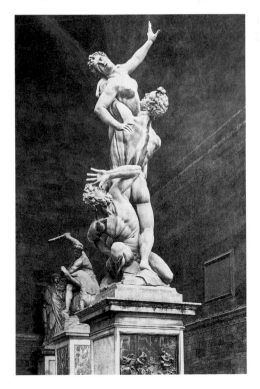

13.22 Benvenuto Cellini, *Perseus with the Head of Medusa* 1554. Bronze, 10 ft 6 ins (3.2 m) high. Loggia dei Lanzi, Florence.

13.23 Giovanni Bologna, *Rape of a Sabine* 1583. Marble, 13 ft 6 ins (4.11 m) high. Loggia dei Lanzi, Florence.

elegant. Even the blood spurting from Medusa's trunk is treated in a decorative way.

Giovanni Bologna (Jean Boulogne, 1509–1608) carried this detachment from subject matter a stage further. Bologna was a Fleming who, like so many northern artists, decided to go to Italy. He was particularly impressed by some of the elaborate Hellenistic groups showing figures in violent action which were on view in Roman collections. From these he learned the technique of deep undercutting which was to be characteristic of his stone-carving. He visited Florence in order to study the work of Michelangelo, and ended up settling there. He was soon successful—by 1561 a monthly stipend from the Medici family was paid to him. Unlike Cellini, who preferred to work alone, he built up a large workshop of skillful collaborators, who continued to produce work based on his conceptions for a long period after his death. His sculptural ideas were broadcast throughout Europe by numerous bronze statuettes of fine quality.

One of Bologna's most complex and successful sculptures is the *Rape of a Sabine* (Fig. **13.23**), which shares the Loggia dei Lanzi in Florence with Cellini's *Perseus*. Bologna knew that Michelangelo had wanted to combine three figures into a completely unified group, and had never succeeded in doing so. His own group, finished in 1583, set out to prove that Michelangelo could be surpassed, in this one respect at least. Though the figures are adroitly bound together, not only by the arrangement of their limbs but by the actual direction of their glances, the announced subject seems to have been a matter of indifference to the artist; it was the forms alone that counted.

Literature

Miguel de Cervantes

One work of the late Renaissance period shares the universality of Shakespeare's plays, having the kind of reputation which is otherwise accorded only to Homer, Virgil, Dante, and, perhaps more controversially, to Goethe's *Faust*. This is *Don Quixote* (published originally in two parts, 1605 and 1615) by Miguel de Cervantes (1547–1616).

Admirers of *Don Quixote* have approached the book in a wide variety of ways. In seventeenth-century Spain, while the book was a popular success, it tended to be despised as lightweight by the Spanish intellectual establishment. However, it was received with universal enthusiasm abroad—an English translation of Part I appeared in 1612 and a French translation in 1614. At this early period both Spanish and foreign readers saw it as something purely comic. By the eighteenth century, however, foreign critics, notably Samuel Johnson in England, were already inviting readers to empathize with the protagonist, and the process of interpretation has been further elaborated over the years.

Don Quixote had two main aspects for Cervantes himself. In part it was a parody, full of literary references, and in part it was a realistic description of human character—of two antithetical characters in particular, Don Quixote and his faithful squire, Sancho Panza.

Of all literary devices, parody is perhaps the most conspicuously Mannerist. Like much Mannerist art it is "learned," but not necessarily respectful—the parodist builds a new creation from distorted and shattered versions of previous artistic creations. It is part of the technique that the original source material remains clearly recognizable to the informed—that is, the ideal—reader. Cervantes's target is chivalric romance; *Don Quixote* is the last twisted descendant of the Arthurian tales of the Middle Ages. A more immediate ancestor is *Orlando Furioso* (see page 206), which Cervantes seems to have read when he was serving as a soldier in Italy, but Ariosto's wry, mildly ironic approach to chivalric conventions is discarded in favor of brutal satire.

The chief vehicle for this satiric approach, and its chief victim, is Don Quixote himself, an impoverished country gentleman, living in La Mancha, an open, windy, sparsely populated area of Spain (Cervantes knew it well from his own activities as a tax-collector). Quixote has been driven out of his wits by reading too many chivalric romances, and abruptly, in the first chapter, decides to go adventuring as a knight errant. His first, disastrous sally lasts for only three days. On his second, and always thereafter, he is accompanied by Sancho Panza, a local peasant who serves as his squire. Sancho is a complex mixture of the shrewd and the credulous, the loyal and the greedily self-interested, and it is his interplay with his master which gives the narrative its resonance. Because Sancho (and the description is Quixote's own, which endows it with a special irony) "doubts everything yet believes everything," he at times goes along with his master's fantasies, but at times stands outside and comments on them. It is his oscillations, as well as Quixote's lapses into something resembling sanity, which give light and shade to the main character.

For Cervantes and his contemporaries, these moments of lucidity were themselves proof that Don Quixote was indeed mad. They were regarded as part of the pattern of the mental malady. But here the modern reader encounters a gulf between himself and the author so wide that he scarcely knows how to span it. For the men of the twentieth century madmen are pathetic, and on some occasions terri-

The Royal Icon

Full-length life-size portraits did not appear until the sixteenth century. The earliest seem to have been painted by Cranach (see page 212) for his patrons the Electors of Saxony. They are thus connected with the rise of Protestantism, since the Saxon rulers were also the protectors of Luther (see page 209). Portraits of this type seem to have had many functions in addition to that of providing a likeness, especially when the subject (as so often) was a ruling prince. In this case, verisimilitude was largely subordinated to other needs.

Among the most striking examples of this subordination are the portraits of Queen Elizabeth I of England (1558–1603). These became steadily less realistic as the queen grew older. The magnificent *Ditchley Portrait*, painted *c.*1592 by the Flemish-born Marcus Gheeraerts the Younger (*c.*1561–1615) is designed to convey a wealth of meanings. When it was painted, the subject was already an old woman, who had long exercised rigorous control over the way her image was presented, for reasons of state as well as personal vanity. One of her prejudices was against the use of chiaroscuro. She insisted that her face be shown "without shadows," as a kind of mask, just as it is in this painting. Gheeraerts skillfully hinted at her true age, without breaching this convention.

The queen's magnificent clothes were a means of reinforcing her aura of power. In the *Ditchley Portrait* she is shown wearing a white dress—not a usual color for an elderly woman. The hue was, however, emblematic of sincerity and chastity. Elizabeth was a "Virgin Queen," who had deliberately remained unmarried, and who wished to remind her subjects of this fact. Her cumbersome farthingale (padded skirt) and leg-of-mutton sleeves hold her figure immobile and make her look more like a sacred image than a living being. Her double ruff is like a saint's halo. As a Protestant ruler, and Head of the Church of England, Elizabeth consciously offered her own likeness as a substitute for the traditional images of the saints which were forbidden in England at that time.

The otherworldly impression of this portrait is reinforced by the elaborate allegorical trappings Gheeraerts added to it. Elizabeth stands on a map of England—she is the ruler of the realm, and also its protector. Behind her to the right a storm is retreating, banished by her majesty. The painting is inscribed with a Latin motto, now only partly decipherable, and also with a sonnet. The first line of this sonnet describes Elizabeth as "the prince of light," thus making the allegorical content perfectly clear. These inscriptions reinforce the impression that the painting is meant to be "read" as much as simply looked at. It confirms the literary bias of Elizabethan culture taken as a whole, and stresses the marked

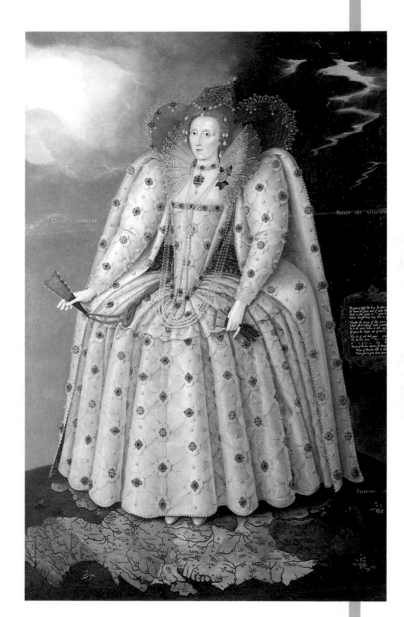

Marcus Gheeraerts the Younger, *Elizabeth I* 1592. Panel. 37⅜ × 23⅝ ins (95 × 60 cm). National Portrait Gallery, London.

cultural differences at this time between England and the rest of Europe. If Gheeraerts had been working for a patron in his native Flanders, his work would have been much more naturalistic.

fying. For the men of the sixteenth century they were often funny, just as peasant simpletons, capable of the occasional shrewd if naïve observation, were also funny. Famous episodes in the book, such as Don Quixote tilting at windmills, under the impression that they are giants (Part I, Chapter 8) carried no poetic or symbolic overtones for Cervantes's original readership, whether in Spain or elsewhere.

What happens is that the two chief characters have broken loose from the book and its author, and have taken on an independent life of their own, a life which often contradicts things which Cervantes describes in plain language—Don Quixote's humiliations, and the heartless reactions they arouse in those who are directly involved in his adventures, are conveniently forgotten.

The moment when these two different worlds—the one which Cervantes invented and the other which posterity has created on his behalf—come closest together is in the last few pages of the narrative, when Don Quixote has returned home for the last time and is on his deathbed. He begs pardon of the weeping Sancho, for making him "fall into the same sort of error as myself, the belief that there were and still are knights errant in the world." Sancho, in reply, compassionately tries to encourage him to continue to the end in this belief.

"Let us go gently, gentlemen," said Don Quixote, "for there are no birds this year in last year's nests. I was mad, but I am sane now. I was Don Quixote de la Mancha, but today, as I have said, I am Alonso Quixano the Good. May my sincere repentance restore your former esteem for me."

(CERVANTES, *Don Quixote*, translated by J. M. Cohen. Penguin Books Ltd., 1950.)

Drama

William Shakespeare

We know a certain amount concerning external events in the life of William Shakespeare (1564–1616), but almost nothing about his inner life or personal feeling apart from what his plays and non-dramatic poems tell us. The most intimate of these poems, the *Sonnets* (published 1609, but clearly written much earlier), are ambiguous, and have been very variously interpreted. What we do know for certain is that Shakespeare was born in Stratford-on-Avon, went to London and became involved with the newly fashionable theater as actor, writer, and business partner in a theatrical company; he grew to be modestly prosperous and used his money to build up real estate holdings in his native town. In due course he retired to Stratford, but seems to have remained in touch with his old theatrical associates. It is a story of bourgeois success.

The Elizabethan theater, like the Ancient Greek theater and the medieval miracle plays, was a popular form of entertainment, in the sense that it was addressed to everyone. Unlike its two predecessors, it was almost entirely secular, and carried few religious overtones. The dramas were presented in a way which still owed something to medieval custom, but they were now performed in purpose-built structures. At least, this was the case in London. The players used whatever venues they could find when they went on tour. The London theaters were reminiscent of the inn courtyards from which they seem to have evolved. Galleries for moneyed spectators surrounded an open, unroofed space which was occupied by less prosperous ones. The stage thrust forward into this area, so that the audience surrounded it on three sides. It was at least partially roofed. There were doors at the back for exits and entrances, and also an upper level. Scenery was always minimal and often purely symbolic, though there were a few mechanical aids, such as trapdoors, and a mechanism for "flying" performers—those, for example, who represented supernatural beings or gods and goddesses. One quirk was that no actresses were employed (their presence on stage was thought to be an invitation to immorality). Women's parts were always played by boys.

We can get a general idea of the way in which the plays were presented from the Chorus's opening speech in Shakespeare's *Henry V*:

But pardon, gentles all,
The flat unraised spirits that hath dar'd
On this unworthy scaffold to bring forth
So great an object: can this cockpit hold
The vasty fields of France? or may we cram
Within this wooden O the very casques
That did affright the air at Agincourt?
O, pardon! save a crooked figure may
Attest in little place a million;
And let us, ciphers to this great accompt
On your imaginary forces work.
Suppose within the girdle of these walls
Are now confin'd two mighty monarchies,
Whose high upreared and abutting fronts
The perilous narrow ocean parts asunder;
Piece out our imperfections with your thoughts;
Into a thousand parts divide one man.

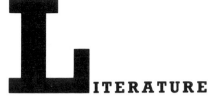

Hamlet

These two extracts from *Hamlet* show the astonishing stylistic range of the play. In a famous soliloquy Hamlet shows the self-consciousness typical of the Mannerist ethos. Then, later, in a scene which is almost entirely written in prose, he jokes gruesomely about death with two grave-diggers.

ACT 3: SCENE 1
Enter **Hamlet**

Ham. To be, or not to be—that is the question;
Whether 'tis nobler in the mind to suffer
The slings and arrows of outrageous fortune,
Or to take arms against a sea of troubles,
And by opposing end them? To die, to sleep—
No more; and by a sleep to say we end
The heart-ache and the thousand natural shocks
That flesh is heir to. 'Tis a consummation
Devoutly to be wish'd. To die, to sleep;
To sleep, perchance to dream. Ay, there's the rub;
For in that sleep of death what dreams may come,
When we have shuffled off this mortal coil,
Must give us pause. There's the respect
That makes calamity of so long life;
For who would bear the whips and scorns of time,
Th' oppressor's wrong, the proud man's contumely,
The pangs of despis'd love, the law's delay,
The insolence of office, and the spurns
That patient merit of th' unworthy takes,
When he himself might his quietus make
With a bare bodkin? Who would these fardels bear,
To grunt and sweat under a weary life,
But that the dread of something after death—
The undiscover'd country, from whose bourn
No traveller returns—puzzles the will,
And makes us rather bear those ills we have
Than fly to others that we know not of?
Thus conscience does make cowards of us all;
And thus the native hue of resolution
Is sicklied o'er with the pale cast of thought,
And enterprises of great pitch and moment,
With this regard, their currents turn awry
And lose the name of action.—Soft you now!
The fair Ophelia.—Nymph, in thy orisons
Be all my sins remem'bred.

ACT 5: SCENE 1

2 Clo. Go to.
1 Clo. What is he that builds stronger than either the mason, the shipwright, or the carpenter?
2 Clo. The gallows-maker; for that frame outlives a thousand tenants.
1 Clo. I like thy wit well; in good faith the gallows does well; but how does it well? It does well to those that do

ill. Now thou dost ill to say the gallows is built stronger than the church; argal, the gallows may do well to thee. To 't again, come.
2 Clo. Who builds stronger than a mason, a shipwright, or a carpenter?
1 Clo. Ay, tell me that, and unyoke.
2 Clo. Marry, now I can tell.
1 Clo. To 't.
2 Clo. Mass, I cannot tell.

Enter **Hamlet** *and* **Horatio**, *afar off.*

1 Clo. Cudgel thy brains no more about it, for your dull ass will not mend his pace with beating; and when you are ask'd this question next, say "a grave-maker": the houses he makes last till doomsday. Go, get thee to Yaughan; fetch me a stoup of liquor.
 [*Exit Second Clown.*
[*Digs and sings*] In youth, when I did love, did love,
 Methought it was very sweet,
 To contract-o-the time for-a my behove,
 O, methought there-a-was nothing-a meet.
Ham. Has this fellow no feeling of his business, that 'a sings in grave-making?
Hor. Custom hath made it in him a property of easiness.
Ham. 'Tis e'en so; the hand of little employment hath the daintier sense.
1 Clo. [*Sings*] But age, with his stealing steps,
 Hath clawed me in his clutch,
 And hath shipped me intil the land,
 As if I had never been such.
 [*Throws up a skull.*
Ham. That skull had a tongue in it, and could sing once. How the knave jowls it to the ground, as if 'twere Cain's jawbone, that did the first murder! This might be the pate of a politician, which this ass now o'erreaches; one that would circumvent God, might it not?
Hor. It might, my lord.
Ham. Or of a courtier; which could say "Good morrow, sweet lord! How dost thou, sweet lord?" This might be my Lord Such-a-one, that praised my Lord Such-a-one's horse, when 'a meant to beg it—might it not?
Hor. Ay, my lord.
Ham. Why, e'en so; and now my Lady Worm's, chapless, and knock'd about the mazard with a sexton's spade. Here's fine revolution, an we had the trick to see't. Did these bones cost no more the breeding but to play at loggats with them? Mine ache to think on't.
1 Clo. [*Sings*] A pick-axe and a spade, a spade,
 For and a shrouding sheet:
 O, a pit of clay for to be made
 For such a guest is meet.
 [*Throws up another skull.*
Shakespeare

(SHAKESPEARE, *The Complete Works of Shakespeare.*
Collins, 1951.)

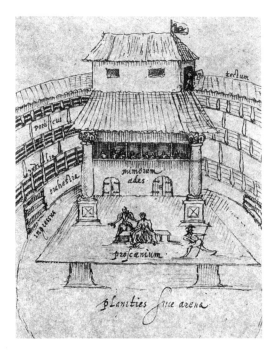

13.24 Interior of the Swan Theater, Bankside, London (opened 1598). Contemporary pen drawing.

And make imaginary puissance;
Think when we talk of horses that you see them
Printing their proud hoofs on the receiving earth;
For 'tis your thoughts that now must deck our kings . . .

(SHAKESPEARE, *Henry V*, Act I, scene 1, 8–28, from *The Complete Works of Shakespeare*. Collins, 1951.)

This speech, though not the richest in Shakespeare's plays, also gives a glimpse of his relationship with language. Shakespeare's English is both exceptionally vivid and concrete, and always in a state of evolution. He changes the language by using it, just as Rabelais changed French (see page 216). Far more than Rabelais, however, Shakespeare permanently altered the nature of the medium he used. In English he is by far the greatest coiner of proverbial phrases and sayings with the exception of the translators of the Bible. Because of this he is an inextricable part of the British national consciousness.

Here Shakespeare's genius was aided by two external factors. One was the acceptance of English as being fully the equal of learned tongues such as Latin and Greek. The way for this was prepared by Chaucer (see page 152) but perhaps even more by early translations of the Bible, such as William Tyndale's version of the New Testament (1525). The King James Version of the Bible was not published until 1611, late in Shakespeare's lifetime and too late to influence his work.

The other factor, historically linked to the first, was the way in which England was cut off from the general visual culture of Europe by its adherence to Protestantism. English art of the late sixteenth century is extremely limited and provincial. There is no sculpture of any sophistication; painters concentrated almost entirely on portraiture. The creative force which might have gone into the visual arts was poured into the English language, with explosive results. In addition to being a prolific coiner of now-proverbial phrases, Shakespeare was a great inventor of new words. His vocabulary was vast, and many of the words he uses are peculiar to himself.

When Shakespeare's plays were published in a large memorial volume shortly after his death—the First Folio of 1623—the editors arranged his work under three headings: comedies, histories, and tragedies. The histories, chronicle plays often based on Raphael Holinshed's *Chronicles of England, Scotland and Ireland* (the second edition, revised and expanded, was published in 1587), often express openly the new national self-awareness one can deduce from Shakespeare's language. As the Bastard says, in the concluding lines of *King John*:

Come the three corners of the world in arms
And we shall shock them. Nought shall make us rue,
If England to itself do rest but true.

(SHAKESPEARE, *King John*, Act V, scene 7, 116–18, from *The Complete Works of Shakespeare*. Collins, 1951.)

The comedies and tragedies pursue a greater range of objectives, and are far more varied within their categories than equivalent Ancient Greek plays. Shakespeare's resistance to compartmentalization expresses itself in several ways. For example, *Othello* is a tragedy based on a plot repeatedly used for comedy, from the Ancient Greeks onwards. Its hero is an "imaginary cuckold," who falsely believes that he has been betrayed by his wife. He is also a black man—blacks were usually seen at this period either as figures of fun or as "black-hearted" villains. Shakespeare is not afraid to press home the sexual implications, and does so in the opening scene, in lines spoken by the villian, Iago:

Even now, now, very now, an old black ram
Is tupping your white ewe.

(SHAKESPEARE, *Othello*, Act I, scene 1, 88–9, from *The Complete Works of Shakespeare*. Collins, 1951.)

Another way of upsetting the audience's expectations was to present them with a comedy so dark and sour it seemed like a tragedy. *Measure for Measure* is a good instance of this.

Even within the overall structure of a single play there is usually a variability of tone, style, and the actual literary means used which brings Shakespeare into close contact with the Mannerist ethos in the visual arts, whose effects he finds equivalents for in the theater. Printed here are two excerpts from what is perhaps the most famous of all his plays, *Hamlet*. Between them, they provide ample evidence for this contention.

Music

Palestrina, Tallis, and Byrd

Perhaps the most typical composer of the Counter-Reformation is Giovanni Pierluigi da Palestrina (1525–94). This may be because he remained close to the papal court in Rome from the 1540s onwards, and his music was a direct reflection of papal tastes and requirements during the second half of the sixteenth century.

Palestrina trained in Rome and, aged about twenty, obtained a post as an organist and singing teacher at the cathedral in nearby Palestrina. This brought him into contact with the local bishop, Cardinal Giovanni Maria del Monte, who in 1550 was elected pope, taking the title of Julius III. Julius gave Palestrina a post in the choir of the Sistine Chapel. He was turned out of this position by Paul IV, because he was married, but he soon became *maestro da cappella* at St. John Lateran, transferring in 1560 to Santa Maria Maggiore. After an interval spent working for Cardinal Ipollito II d'Este in the pleasant surroundings of the Villa d'Este at Tivoli, he returned to Rome in 1571 as choirmaster of the papal choir and retained this post for the rest of his life.

What Palestrina did was to take the complex polyphony he had inherited from the Netherlandish composers who worked in Italy during the late fifteenth and early sixteenth centuries, and adapt it to new religious needs. For example, there was now a demand that the words of sacred texts should be clearly heard, and it is this that the *Missa Papae Marcelli*, written for the austere pontiff Marcellus II (1555), undertakes to do. From 1577 onwards, at the behest of Gregory XIII (1572–85), he was concerned with a thorough-going revision of traditional plainchant, and this naturally affected his own music.

Palestrina's music is not immune to the tendencies of its time—the richness and splendor of some of his late works foreshadow what was to happen during the Baroque period to follow. But it preserves a serenity, a free flowing tranquility which established a standard for future sacred compositions. More than a century later, composers still looked to the "Palestrina style" as an idiom in its own right, useful for the more serious and devotional kinds of church music.

The vigorous musical life of Counter-Reformation Italy was paralleled in England, where William Byrd (1543–1623) enjoyed a career in some ways similar to that of Palestrina. He served first as organist and choirmaster of Lincoln Cathedral, and later as joint organist of Elizabeth I's Chapel Royal, sharing the post with Thomas Tallis (1505–85) who had been his master. Tallis was old enough to have been brought up in the old pre-Reformation tradition, and served Mary I before being employed by her younger sister Elizabeth I. An ambitious Latin Mass, *Puer natus est*, is said to have been written for Mary's wedding to Philip of Spain in 1554.

Byrd continued the tradition of setting Latin texts, which Elizabeth I, in many ways a traditionalist, sanctioned for use in her own chapel. Byrd was in any case increasingly drawn toward this language, rather than the vernacular, by his own religious convictions. These convictions are movingly expressed in two collections of *Cantones sacrae (Sacred canticles)*, published in 1589 and 1591, which use biblical themes of persecution and oppression. By 1591 Byrd had withdrawn from court service and was working instead for members of the old Catholic nobility, writing settings of the Mass for use in their private chapels. This output of traditional church music was matched by another and very different one of songs and keyboard music, addressed to the same group of patrons. Byrd's fantasies and preludes for the virginal, a plucked keyboard instrument which was the predecessor of the more powerful and sonorous harpsichord of the eighteenth century, anticipate the purely "abstract" compositions associated with much later keyboard composers such as Domenico Scarlatti (1685–1757).

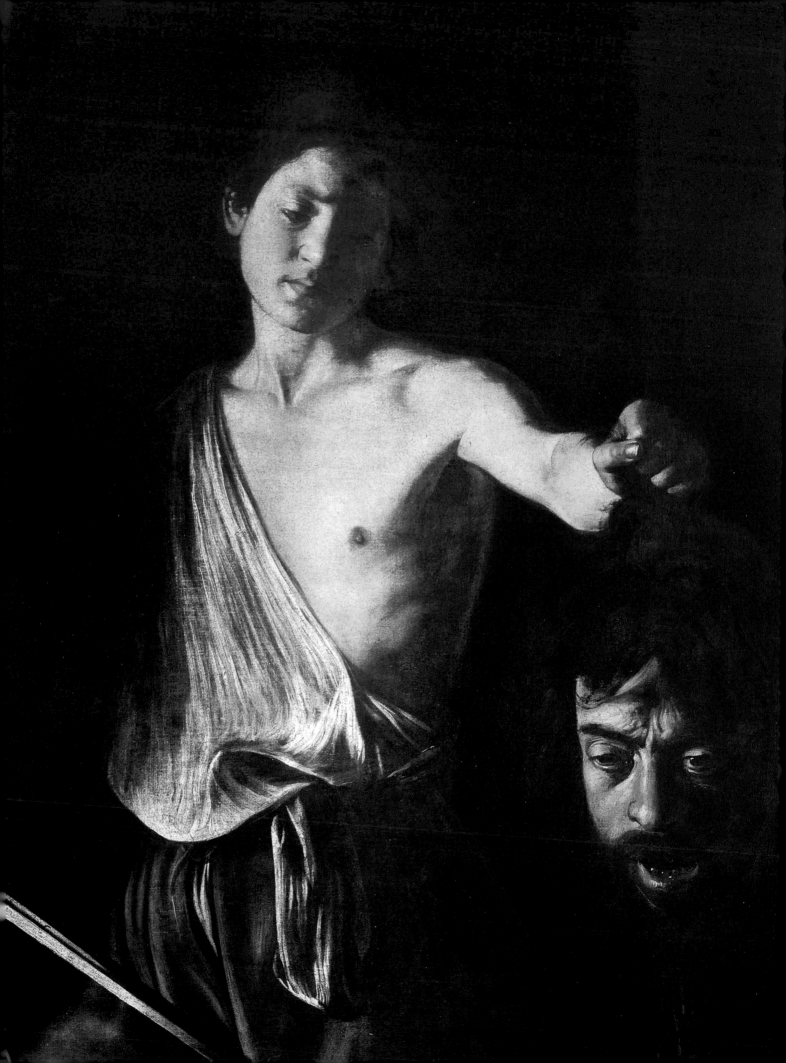

The Baroque

Chapter 14

The Baroque in Italy

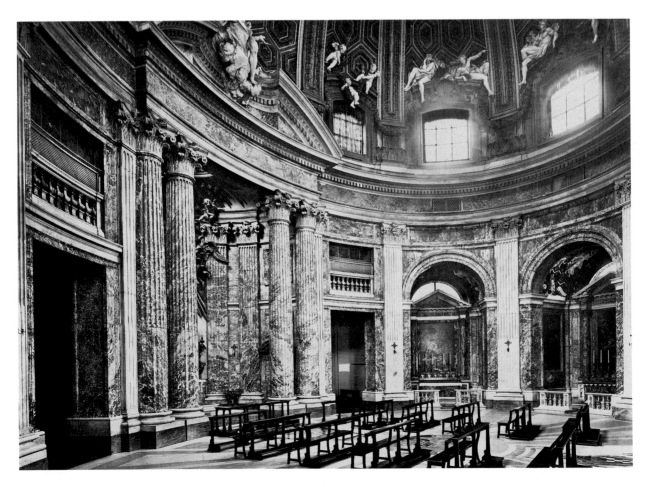

14.1 Gianlorenzo Bernini, interior of S. Andrea al Quirnale, Rome, 1658.

Seventeenth-century Italy

Italy in the seventeenth century was largely dominated by foreign powers, though the Medici dynasty survived in Florence, and Venice preserved its independence. The great focus of artistic innovation was Rome, where a series of virtuous popes, chief among them Urban VIII (1623–44), rebuilt and embellished the city, leaving it very much as it looks today. The other important center of artistic innovation was Bologna, never previously an important artistic center. It now produced a series of leading artists, beginning with the members of the Carracci family.

Philosophy

The trial of Galileo

The possibilities and limitations of intellectual life in seventeenth-century Italy, cradle of the Baroque style in art and architecture, can best be understood by looking at the career of the astronomer and scientist Galileo Galilei (1564–1642). His trial for heresy before the Inquisition in Rome has been interpreted as a summing up of the conflict between theocratic obscurantism—the repressive hand of the Church and the past—and the new scientific spirit that was abroad and about to transform the world.

The spirit of rational inquiry, proceeding from established facts, which inspired Galileo, has been seen as typifying the best features of Western civilization in its post-medieval phase. As always, the truth is not quite so simple, but there is no doubt that the arraignment and condemnation of Galileo marked a turning point; it was an initial defeat which soon, and inevitably, became a victory.

Galileo, a native of Pisa, made his reputation first as a mathematician and then, through his use of mathematics, as a physical scientist. His attention was attracted to the astronomical theories of Nicolaus Copernicus (1473–1543), who, in the year of his death, published a treatise which contradicted the then generally accepted idea that the earth was at the center of the universe, and that the heavens revolved around it once every twenty-four hours. Copernicus's notions were derided, but Galileo was able to provide evidence in their favor with the aid of a new scientific invention of his own, the telescope.

His discoveries sparked off an immediate controversy, not so much because they went against the intellectual orthodoxy of the time but because they seemed to contradict the picture of the workings of the universe that was given in the Bible. The Protestant reformers, in placing such stress on the literal truth of Holy Writ, had driven the Catholic establishment to taking up a similar position, and this had also led to strenuous efforts to define the nature of Catholic orthodoxy. One practical result was the refoundation of the Inquisition, first used in the twelfth century to combat current heresies and then set up again in fifteenth-century Spain, as a means of dealing with feigned conversions of Moors and Jews. In 1542 Pope Paul III established in Rome

	1575	1600	1625	1650	1675	1700
		NORTHERN RENAISSANCE		**MANNERISM**	**BAROQUE**	
PHILOSOPHY/ RELIGION	St. Teresa of Avila		Galileo *Dialogue on the Great World Systems* Descartes *Discourse on Method*	Hobbes *Leviathan* Spinoza *Ethics* Pascal *Pensées*	Leibniz *New Essays on the Human Understanding*	
ARCHITECTURE		Maderno, façade of St. Peters (**14.2**) Jones, Whitehall Banqueting House (**17.1**)	Bernini (**14.1**) Borromini (**14.4**)	de Vau/Hardouin-Mansart, Palace of Versailles (**16.1**)	Wren, St. Paul's Cathedral (**17.3**)	
VISUAL ARTS	Carracci (**14.9**) Caravaggio (**14.6**)	Gentileschi (**14.14**) Rubens (**15.14**)	Velásquez (**15.1**) Van Dyck (**15.16**) Poussin (**16.6**) Claude (**16.5**) Rembrandt (**17.9**)	Bernini, Altar of St. Teresa (**14.16**)		
LITERATURE/ DRAMA		Donne *Holy Sonnets*	Corneille *Le Cid* Calderon	Molière *Le Misanthrope* Milton	La Fayette *La Princesse de Clèves* Racine *Phaedre*	
MUSIC	Development of opera in Florence	Monteverdi *Orfeo*	First opera-house opens in Venice 1637		Purcell *Dido and Aeneas*	

the Holy Office of the Universal Church, whose function was to repress all opinions which ran counter to the medieval scholastic tradition inherited from St. Thomas Aquinas (see page 133).

Galileo was already under suspicion in 1632 when he published his *Dialogue on the Great World Systems*, defending Copernicus's theory. The book was written not in Latin but in vigorous Italian—Galileo was one of the great vernacular stylistics of his time. Because of this, and because of its sparkling, witty clarity, the work seemed to appeal over the heads of the "experts," theological and scientific, to the intelligent general reader. Worse still, the opinions given to a fictional character called Simplicio seemed to satirize those of the ruling pope, Urban VIII. After being hauled in front of the Inquisition, Galileo was forced to make a humiliating retraction, altogether abandoning "the false opinion that the Sun is the center of the world and immovable, and that the Earth is not the center of the world and moves." After he had done so, he is said to have murmured under his breath the defiant phrase "*Eppur si muove!*"—"But all the same, it moves!"

Efforts to suppress the *Dialogue on the Great World Systems* were in vain; the book was passed from hand to hand, even in Italy, and became well-known elsewhere. The result of the affair was to weaken the position of the theologians, and by extension that of the Church authorities who supported them, and to call attention to the progress being made in the sciences. In fact, many people soon came to think that the truths being revealed by scientific methods must inevitably be in conflict with Church dogma. The brilliant theological constructs of Aquinas and his peers were increasingly relegated to the intellectual scrapheap.

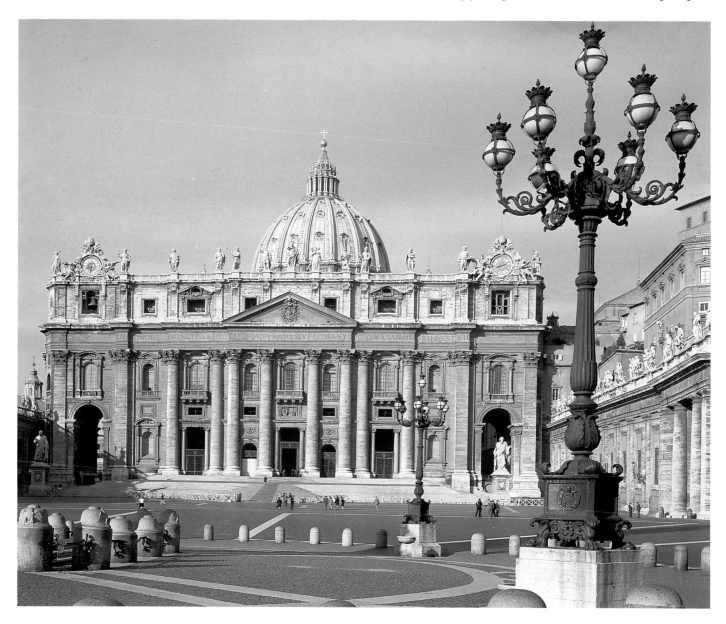

14.2 Carlo Maderno, the façade of St. Peter's, Rome, designed 1607.

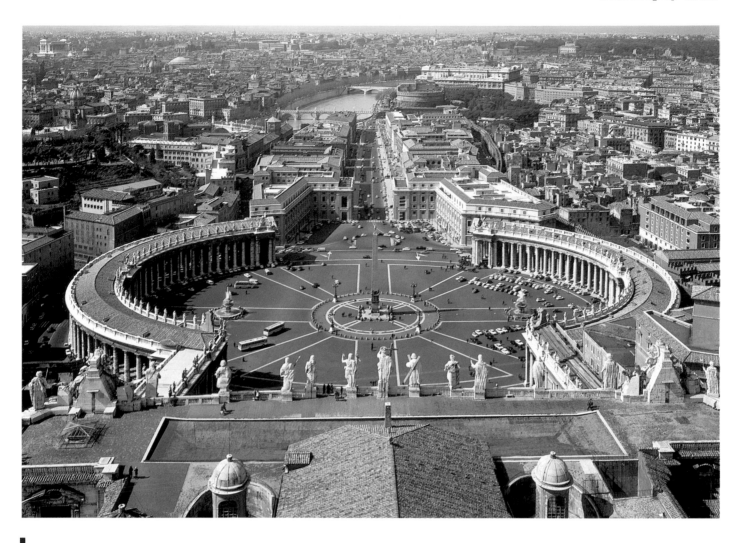

14.3 **Gianlorenzo Bernini**, the Colonnades of St. Peter's, Rome, begun 1656.

Architecture

Bernini and Borromini

The rebuilding of Rome began with the pontificate of Sixtus V (1585–90), who, despite the brevity of his reign, transformed Rome more radically than any previous pope, though unfortunately without the services of architects of genius. During and immediately after his reign, there was an increasing demand for large churches, to meet the needs of the religious revival fostered by leaders such as St. Ignatius Loyola, founder of the Jesuits, and St. Philip Neri (1515–95), founder of the Oratorians, another new Catholic order. The most important and most successful architect in Rome during the first quarter of the seventeenth century was Carlo Maderno (1566–1623), who was put in charge of

St. Peter's in 1603. He was responsible for the façade of the great church (Fig. **14.2**), thus bringing to a conclusion the enterprise Bramante had begun a century before (see page 191). This façade, majestic but not particularly original or dynamic, is Maderno's best-known design, and well represents the spirit of Early Baroque architecture.

When Italy produced an architect of genius, Gianlorenzo Bernini (1598–1680), major opportunities for architects were already becoming limited. Bernini added to Maderno's St. Peter's the curving colonnades which are the perfect solution to a problem not of his own making—that of how to unite the vast building with its surroundings. The colonnades symbolize the all-embracing nature of the Church, and provide shelter for processions when the weather is inclement (Fig. **14.3**). At the same time, they do not block

the view of St. Peter's itself. They remain Bernini's best-known work in architecture.

The churches he designed from scratch are few and small. The most important is San Andrea al Quirinale (Fig. **14.1**), which is also the most complex and sophisticated. The plan is unusual—an oval, with the transverse axis longer than the main one. The interior has giant pilasters crowned by a massive entablature, broken only where the high altar makes a niche. Through the broken pediment of this niche St. Andrew, to whom the church is dedicated, soars to heaven on a cloud. The design makes the whole interior into a single dramatic event, and it is this feeling for drama which defines the essence of Bernini's art.

There was one other architect working in Rome who rivaled Bernini—in originality, if not in success. Francesco Borromini (1599–1667) was a relative of Maderno, and briefly one of Bernini's collaborators. Whereas Bernini was intimately concerned with St. Peter's, Borromini worked on the restoration of another major Roman church, the basilica of St. John Lateran. His true genius appears only in the few small churches he was able to design from the beginning. Borromini's San Carlo alle Quattro Fontane (Fig. **14.4**), 1638–41, is an oval church, like Bernini's San Andrea, but differs from it in almost every other respect. The entrance is on the long axis, not the short one. The ground plan undulates—the walls curve in, then out again. Over this, and linked to the ground plan by pendentives—triangular sections of vaulting—is an oval dome. The arrangement manages to suggest that the church is, after all, in the shape of an equal-armed Greek cross. The impression of spatial complexity is further enhanced by the elaborate coffering of the dome itself—a maze of octagonal, hexagonal, and cross shapes.

14.4 **Francesco Borromini**, San Carlo alle Quattro Fontane, Rome, begun 1635. (*right*) Plan.

0 10 20 30ft

0 5 10m

Painting

Michelangelo Merisi da Caravaggio

The late sixteenth century saw the beginnings of a revolution in European painting. The movement was chiefly associated with Rome, though the artists responsible were Italians but not native Romans. The revolution itself took two forms—a radical reconsideration of art and its purposes, associated with the name of Caravaggio, and a more careful and sober attempt to reform the art of painting, associated with the Carracci family.

Michelangelo Merisi da Caravaggio (1571–1619) was born near Milan and received his earliest training from a mediocre local painter called Simone Peterzano. Somewhere around 1592 or 1593, having completed his apprenticeship, he came to Rome. His earliest independent works are genre studies of modest size painted to sell. They often feature rather insolent young boys, sometimes in mythological disguises. Fresh and disturbing, they are important not only for their intrinsic merits as works of art but also because they show the way painting was starting to divide into specialties or "genres." There was a hierarchy with history painting (religious works and representations of mythological and historical events) at the top, portraiture and landscape in the middle, and still lifes and genre studies, like those produced by the young Caravaggio, at the bottom.

Soon Caravaggio's genre scenes became more ambitious, and began to challenge this newly established structure. He graduated to pictures where two or three figures from everyday life are shown life-size and half-length. One of the best-known examples is the *Gypsy Fortune Teller* (Fig. **14.5**), and

it was pictures of this kind that provided him with steadier patronage.

Caravaggio was now on the brink of his first great public success. In July 1599 he was commissioned to do two paintings for the side walls of the Contarelli Chapel in San Luigi dei Francesi in Rome. The subjects were *The Calling of St. Matthew* (Fig. **14.6**) and *The Martyrdom of St. Matthew*. These pictures, finished a year later, revealed Caravaggio as a great religious artist, with a gift for making sacred events seem part of the immediate experience of the spectator. The compositions were of course more elaborate and more complex than anything he had attempted before, but retained the realism of his early genre scenes.

Throughout his career Caravaggio rejected pictorial formulae. In particular, he would have nothing to do with the idea that pictures must be built up laboriously from preliminary studies. His most notable technical innovation was a consistent use, from the time of the Contarelli Chapel paintings onwards, of violent chiaroscuro, which left some figures, or parts of figures, brilliantly illuminated, and the rest plunged into the surrounding darkness. It was this device which gave his work its turbulent drama, while at the same time often making the pictorial construction ambiguous and difficulty to construe.

On May 29, 1606 Caravaggio committed a crime which was to change the course of his life. He was playing *palla a corda*, a kind of primitive tennis, near the Villa Medici, and quarreled with one of his companions about the game. In the brawl which followed, the artist fatally stabbed his opponent. He was forced to flee to Naples. His later work,

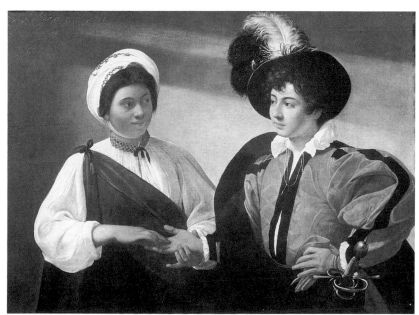

14.5 **Caravaggio**, *The Gipsy Fortune Teller (La buon aventura)*
c. 1594. Oil on canvas, 39 × 52⅜ ins (99 × 132 cm). Louvre, Paris.

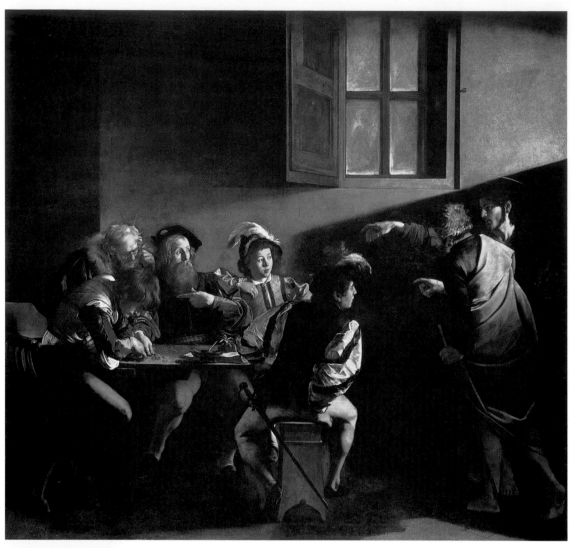

14.6 **Caravaggio**, *The Calling of St. Matthew* c. 1596–8. Oil on canvas, 11 ft 1 in × 11 ft 5 in (3.38 × 3.48 m). Contarelli Chapel, S. Luigi dei Francesi, Rome.

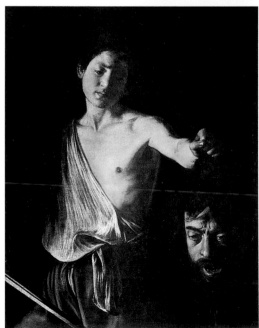

14.7 **Caravaggio**, *David with the head of Goliath* 1609–10. Oil on canvas, 49¼ × 39⅜ ins (125 × 100 cm). Borghese Gallery, Rome.

painted in Naples, Malta, and Sicily, made use of the techniques he had elaborated earlier but—not surprisingly in view of the harried nature of his existence—took on an improvised look. One of the most striking of his later pictures is a triumphant David, carrying the severed head of Goliath (Fig. **14.7**). The head is a sardonic self-portrait, something which emphasizes the autobiographical element in Caravaggio's art.

Caravaggio's influence was not confined to Italy alone. He found enthusiastic followers among the northern artists who were flocking to the city, and they propagated a version of his distinctive style when they returned home. At its worst Caravaggism was a dead-end, a bundle of tricks based on over-emphatic use of chiaroscuro. At its best, it brought a new, deeper humanity to art, a new kind of immediacy based on a more candid and immediate treatment of emotional states.

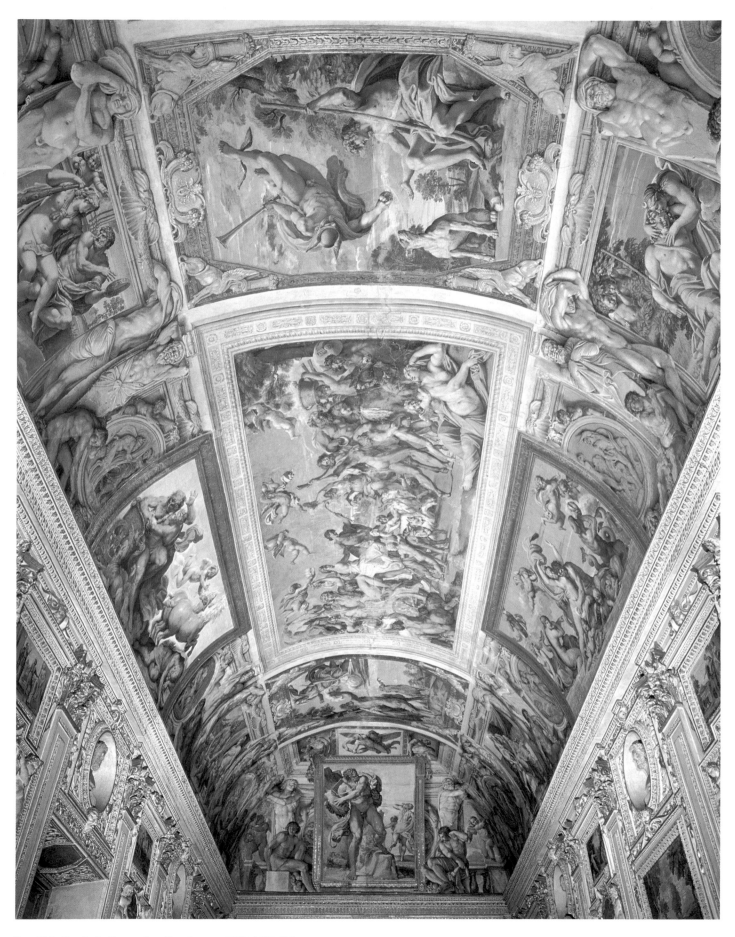

14.8 Annibale Carracci, ceiling frescos, 1597–1600. Palazzo Farnese, Rome.

The Carracci family

Annibale Carracci (1560–1609) had a very different effect on the history of painting from that of Caravaggio—one which, at first glance, was more strictly confined to the Italian peninsula—and the Italian Baroque flows much more directly and logically from him. It was Annibale who studied, combined, and systematized the work of Correggio, the Venetians, Michelangelo, and Raphael, so as to produce a new style. He also influenced the way artists were trained, stressing both the benefits of studying the nude model, and the need to build up the composition stage by stage, with the help of numerous preparatory drawings. The whole "academic" tradition in painting came to regard him as its progenitor.

Annibale is always associated with his elder brother Agostino (1557–1602) and his cousin Lodovico (1556–1619). During their early period, when they worked together in Bologna, they formed a kind of family firm, and even their contemporaries did not distinguish very clearly between them. It was only when he came to Rome that Annibale achieved an independent public identity.

Like Caravaggio, he began his career as a painter of low-life genre, and he too sometimes treats these subjects with what would then have been considered incongruous, and therefore provocative, monumentality. This is the case with his large painting of a *Butcher's Shop* (Fig. 14.9). After this he went through successive phases of discovery and imitation before being summoned to Rome by Cardinal Odoardo Farnese to undertake decorations to the monumental Palazzo Farnese, which had been completed some five years before. Annibale arrived in Rome on a preliminary visit in 1594, and began work the following year. His most important creation in the Palazzo, and his most innovative and influential, is the vault of the great gallery (Fig. **14.8**). This ceiling decoration celebrates the universal dominion of love and is essentially light-hearted in tone—the complete opposite of the dramatic religious paintings which made Caravaggio's reputation.

Annibale, always very open to influences, tried to devise a style for this major commission which would combine elements taken from the ceiling of the Sistine Chapel with others borrowed from Raphael. Also, the gallery was to be used to show the cream of the ancient marbles from the

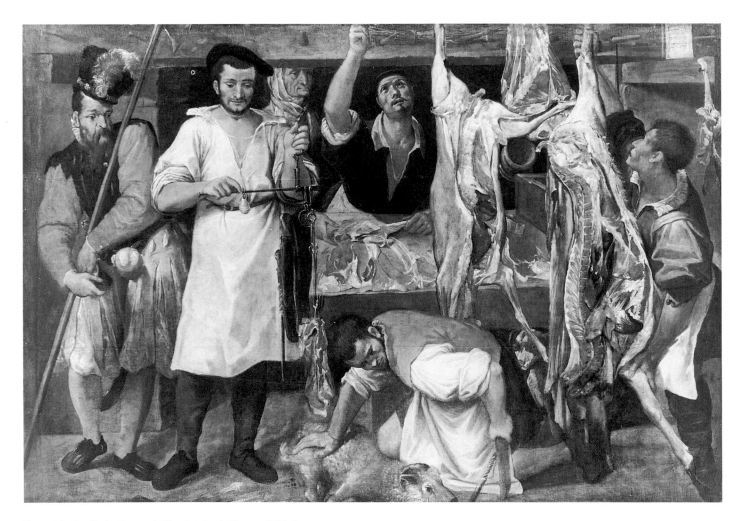

14.9 Annibale Carracci, *The Butcher's Shop* c. 1582–3.
74¾ × 106¾ ins (190 × 271 cm). Christ Church, Oxford.

Farnese collection. His formal solution was ingenious and complex. There are framed scenes presented like easel paintings, plus fictive stone architecture incorporating *trompe-l'œil* painting and statues. In addition there are fictive bronze medallions and "real" *ignudi* and putti. Annibale purged Michelangelo of his anxiety and endowed Raphael with a new dynamism. The finished result struck his contemporaries as an inspired return to the best the past had to offer, stripped of Mannerist fussiness and affectation.

Annibale was able to innovate in other ways as well. For example, though landscape played a comparatively small part in his total output, he was the real inventor of the idealizing classical landscape which played so prominent a part in seventeenth-century painting, and retained its popularity in the eighteenth century. This type of composition first reaches perfection in *The Flight into Egypt* (Fig. **14.11**).

Unlike Caravaggio, Annibale was an important teacher and his pupils continued his work. The Carracci Academy, originally founded in Bologna as early as 1580, played an important part. At first a modest organization, it gradually turned into a laboratory for new ideas, and an instrument for artistic propaganda. In 1590 it took on a new name, the Accademia dell'Incamminati—"those who are on their way." There were lectures and discussions with leading scholars about mathematics, science, history, and literature. These activities were dominated by Annibale's brother Agostino, and it was here that Agostino made his real impact: he set in motion the process whereby Annibale's intuitive discoveries could in due course be turned into artistic laws. In Italy, Caravaggio's influence died away within a quarter-century of his death; that of the Carracci continued to make itself felt well into the eighteenth century.

Outside Rome

Though the revolution in Italian painting was made by Caravaggio and the Carracci in Rome, the most interesting artists of the following period often preferred not to live and work there. The major innovators mostly lived in or near Bologna. Guido Reni (1575–1642), for example, had early success in Rome but was never happy there and from 1614 onwards based himself in his native Bologna. His deceptively simple late style reached its full development in paintings like his *Cleopatra* (Fig. **14.13**) on page 255 of *c.* 1630. Here he stressed the use of pale, sugary colors and employed a technique of exaggerated delicacy, with little contrast of tone. Works of this type won him immense admiration in his own time and for some years to come, but by the nineteenth century, his work had fallen out of favor, because of its apparent lack of structure. His reputation has only recently recovered.

Another painter who visited Rome and did not care to remain there was Francesco Barbieri (1591–1666), called Guercino because of his squint. Born at Cento, which was part of the Duchy of Ferrara, he came to Rome only for the brief pontificate of Gregory XV (1621–3), who had been his chief patron during a period in Bologna. Guercino's work is more solid and painterly than that of Reni. It gives evidence of a wide range of influences—Correggio, the great sixteenth-century Venetians, and even the etchings of Rembrandt (which circulated quite widely in Italy). His paintings have a sensuousness of surface unmatched by any of his rivals of the Bolognese School. He was especially fond of half-length compositions showing life-size figures—a formula he may have inherited directly from the Venetians, rather than via Caravaggio and his followers. An outstanding example is *The Incredulity of St. Thomas* (Fig. **14.10**).

Salvator Rosa (1616–73), Neapolitan not Bolognese by birth, did spend a considerable part of his life in Rome, but he too never seems to have felt fully at home there. He was born and trained in Naples, and it was from the countryside round Naples that he took the theme with which he became permanently associated—the wild landscape, inhabited by bandits. Identification with these scenes became something of a burden, since he wanted to be known as a serious painter of historical and mythological scenes.

He was perhaps the first artist to claim that an individual's genius amounts to something over and above what is

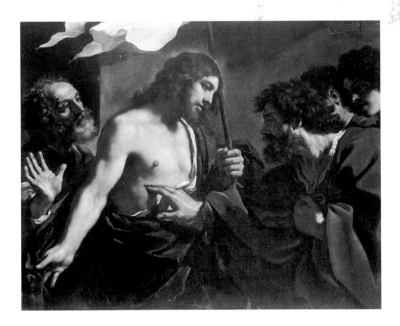

14.10 Guercino, *The Incredulity of St. Thomas.*
Oil on canvas, 45½ × 55½ ins (115 × 140 cm). National Gallery, London.

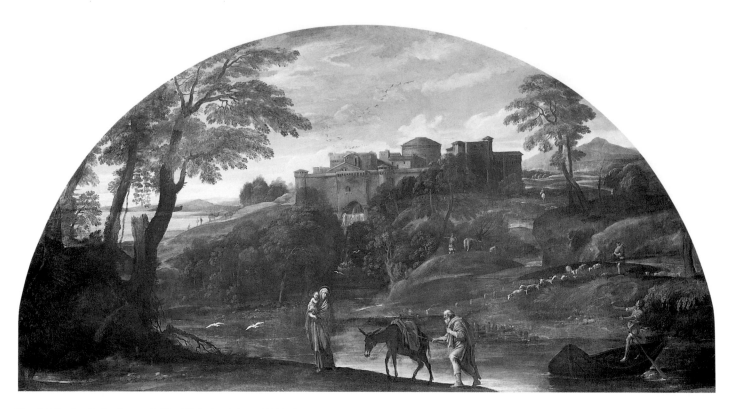

14.11 Annibale Carracci, *The Flight Into Egypt*, 1603–4.
Approx. 48 × 90 ins (122 × 228.6 cm). Borghese Gallery, Rome.

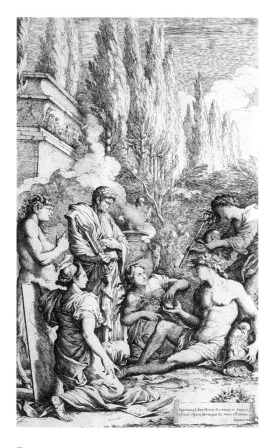

14.12 Salvator Rosa, *The Genius of Salvator Rosa* c. 1650.
Rijksmuseum, Amsterdam.

actually produced. The claim is made in allegorical form in one of Rosa's prints, *The Genius of Salvator Rosa* (Fig. **14.12**). Here genius is depicted as a handsome youth who gives away his heart while having a cap of liberty placed upon his head. There are many other symbols, all of which contribute to the basic message: genius resides not in things but in people, and is intuitive, irrational, and inspired.

Artemisia Gentileschi

The artists of the Bolognese School, such as Reni and Guercino, represent the main line of development in the generation following that of Caravaggio and the Carracci. A celebrated woman painter of the time, Artemisia Gentileschi (1593–1652), was more widely traveled than they were, but still belonged to a stylistic backwater. Her father Orazio Gentileschi (1562–1647) was a personal associate and artistic follower of Caravaggio. Artemisia, who trained in her father's studio, never completely threw off Caravaggio's influence.

Her career took her from Rome, where she was born, to Florence, Genoa, Venice, Naples, and London, where she helped her father with a major commission from Charles I—a ceiling painting for Inigo Jones's (see page 292) Queen's House in Greenwich, England. By 1642 she was back in Naples, where she spent the last decade of her life, working for important patrons such as Don Antonio Ruffo of

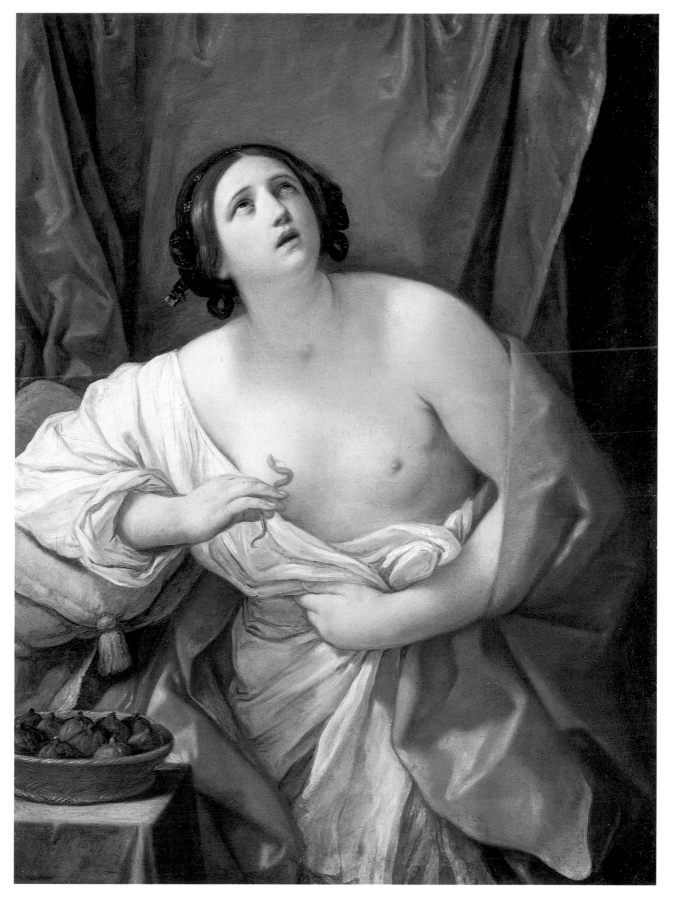

14.13 Guido Reni, *The Suicide of Cleopatra c.* 1630.
Oil on canvas, 48 × 37¾ ins (122 × 96 cm). Pitti Gallery, Florence.

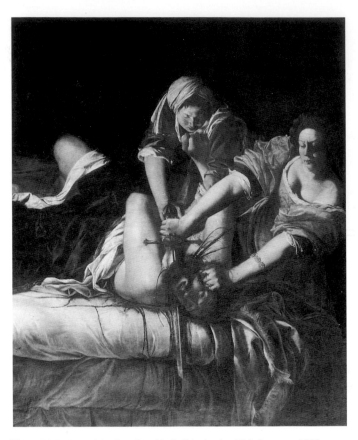

14.14 **Artemisia Gentileschi**, *Judith slaying Holofernes c.* 1620. Oil on canvas, 78½ × 64 ins (199 × 162.5 cm). Uffizi Gallery, Florence.

Messina, who also commissioned paintings from Rembrandt (see page 296) and Van Dyck (see page 271).

Today Artemisia's celebrity rests as much on her biography as on her work. Firstly, she was a very early example of a woman artist working on equal terms with men. Secondly, she was in 1612, at the age of nineteen, the central figure in a trial for rape. The man accused of raping her was another artist, the decorative painter Agostino Tassi (*c.* 1580–1644). The trial record survives and shows that Artemisia reacted to her ordeal with considerable spirit. At one point she voluntarily submitted to torture, to prove the truth of her evidence.

Not surprisingly feminist art historians have tried to find autobiographical messages in Artemisia's work, notably in a number of paintings illustrating the story of the biblical heroine Judith, who decapitated the Assyrian general Holofernes while he was drunkenly asleep (Fig. **14.14**). Artemisia's earliest and best-known painting of the subject dates from *c.* 1612–13, just after the rape case. The composition, which is extremely bloody and violent, has been thought to echo aspects of her ordeal. At one point, for example, she wounded Tassi slightly with a knife.

However, the picture is also heavily dependent on Caravaggio's painting of the same subject, dating from fifteen years earlier. Impressive as Artemisia's version is, it is therefore not wholly original—or, rather, its originality resides largely in the fact that it was painted by a woman, and this is true of her work taken as a whole.

Sculpture

Gianlorenzo Bernini

Bernini first made his reputation as a sculptor rather than an architect, and always thought that his fame would rest primarily on his sculpture. In this field he is the supreme exponent of the Baroque spirit, just as Giovanni Bologna was the supreme exponent of Mannerism (see page 236). Since some of Bernini's early work seems, at first glance, to be closely linked to what Giovanni Bologna did, it is important to understand the very real differences between them. Bernini's *Pluto and Proserpina* (Fig. **14.15**) of 1620–1 treats a subject closely analogous to Bologna's *Rape of a Sabine* (see page 235). Here, too, a nude female figure struggles violently in the arms of an equally nude male captor. The three-headed dog Cerberus takes the place of Bologna's second male figure.

However, instead of fitting within the tightly knit spiral shape which Bologna devised, the two chief figures burst violently apart from one another. Bologna's interest was in the solution of a technical problem—the composition of a three-figure group—and any emotion his figures may express is subsidiary to this, remaining generalized. Bernini is interested in telling an absolutely specific story, and expressing emotions—brutality and lust on the one hand, fear on the other—which he wants to bring home to the spectator as forcefully as possible. The group has only one principal point of view, and many of the devices used are either pictorial in themselves—for example, the marble tears on Proserpina's cheeks—or are derived from contemporary painting. An important source is Annibale Carracci's Farnese Gallery ceiling, for which Bernini is known to have had great admiration.

The emotional style which Bernini brought to this group was well suited to religious work. The culmination of his religious style is the *Altar of St. Teresa* (Fig. **14.16**) of 1645–52, which forms part of the Cornaro Chapel in Santa Maria della Vittoria in Rome. St. Teresa (see page 261) was one of the most important Counter-Reformation saints, both a religious reformer, on a footing with her compatriot St. Ignatius Loyola (see page 218), and a mystic. The group in

14.16 **Gianlorenzo Bernini**, Altar of St. Teresa, 1645–52.
Cornaro Chapel, Santa Maria della Vittoria, Rome. Marble, life-size.

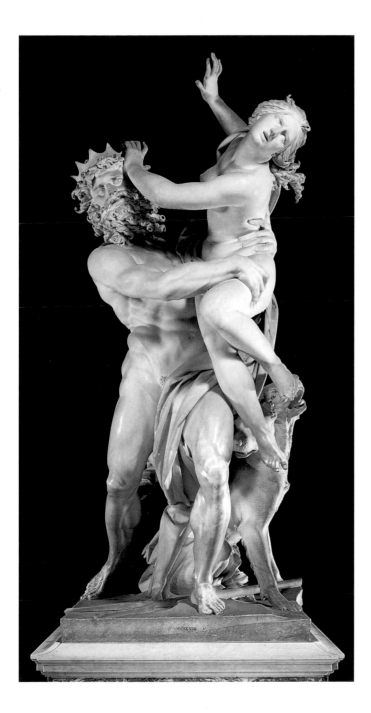

14.15 **Gianlorenzo Bernini**, *Pluto and Proserpina* 1620–21.
Marble, 8 ft 4½ ins (2.55 m) high. Borghese Gallery, Rome.

white marble which forms the centerpiece of the altar reproduces one of her visions with detailed literalism. Teresa described how an angel appeared to her and pierced her heart with a flaming golden arrow: "The pain was so great that I screamed; but simultaneously I felt such infinite sweetness that I wished the pain to last eternally."

Bernini places his two figures on a white marble cloud, and carves them from the same stone. The group is enclosed in a kind of tent of golden rays, and floats within a miniature temple of colored marbles against an iridescent alabaster background. A window of yellow glass hidden within the tabernacle sends a flood of golden light down to bathe the two figures, and helps to emphasize the otherworldliness of the miraculous event.

What is shown is thus simultaneously very real and immediate (the saint's swoon has been interpreted as something sexual), and deliberately unreal, existing in a separate realm from the one occupied by the spectator. The separation is emphasized by other features of the chapel. For instance, along the side walls, above the doors, appear eight portraits of members of the Cornaro family, each before a perspective relief which seems to extend the actual space of the chapel itself. These figures react in various ways to the miraculous event, and offer a commentary from the spectator's side of the psychological fence.

Music

The birth of opera

The major development in Italian, and indeed all European music of the Baroque period, was the birth of opera. This new form was in keeping with an aesthetic precept of the High Baroque, which laid down that the ideal work of art was by its nature a fusion of all possible artistic forms. Nevertheless opera made its appearance long before the High Baroque developed in the visual arts. It had its beginnings, not in the popular theater, but in the courtly entertainments of the late sixteenth century. It also owed a good deal to learned discussion groups of musical *savants*, many composed of interested amateurs rather than professionals, which had started to turn their attention to the possible role of music in the Ancient Greek theater. These had to re-invent what the Greeks might have done, since no historical record remained.

From such discussions came a new, experimental form of dramatic presentation which made use of continuous music, rather than the customary musical interludes. The first recorded example is *La Dafne* (1597–8), a dramatic pastoral written by the Florentine composer Jacopo Peri (1561–1633). The next step forward was taken by another Florentine, Peri's rival Giulio Caccini (1550–1618), whose *Euridice* of 1600 was the first operatic score to be published. Both of these works were entertainments for the Medici court in Florence. The style of singing favored by Peri and Caccini for these new dramatic works was a heightened form of natural speech—dramatic recitation supported by an instrumental continuo. Recitative in opera thus preceded the development of arias, though it soon became the custom to include both separate songs and instrumental interludes during which the voices were silent.

Opera reached its first maturity in the hands of Claudio Monteverdi (1567–1643), who composed operas at two widely separated moments during his long career. The first was when he was *maestro da cappella* at the court of Mantua. His *Orfeo* (1607) is the first opera which still regularly holds the stage. It was a far more ambitious version of the new genre created in Florence, with more opulent and varied recitatives, and stronger musical climaxes which allowed full scope for the virtuosity of the singers. From Mantua, which he had grown to dislike because of the stinginess of his patrons there, Monteverdi moved to Venice, where he became *maestro da capella* at St. Mark's in 1613. For a long time he wrote no operas, though he did write some elaborate madrigals in quasi-dramatic form, alternating accompanied duets and trios with ensembles. The madrigal, once an elaborated song following a regular verse pattern, had now become a form of musical declamation with little attempt to establish a set formal structure.

Monteverdi returned to the composition of operas at the very end of his life, following a new development in theatrical presentation. In 1637 the first public opera house was opened in Venice, and met with an enthusiastic response. After thirty years Monteverdi began to write for the stage again. The scores of two further operas—*Il ritorno d'Ulisse in patria*, and *L'incoronazione di Poppaea*—survive from this late period in his career. Both show a marked increase in musical flexibility. There was a mixture of recitatives, solos, duets, and ensembles.

From this time onwards opera became increasingly prominent in Italian musical life, and was in fact the chief medium for the public performance of music. Both composers and singers were freed from the tyranny of court patronage, and many were able to accumulate substantial fortunes. Among the favored opera composers of the later seventeenth century were Domenico Gabrielli (1651–90) and Giovanni Bononcini (1670–1747). The latter was a musical prodigy who, in his earliest years as a composer, enjoyed an immense success in Naples, by now the center for one of the two chief touring circuits in Italy. A work called *Il trionfo di Camilla* (1697), first produced in Naples, carried Bononcini's reputation well beyond the Italian peninsula. He traveled to Vienna, and later, after a further period in Italy, made his way to London, where he was set up by one faction of music-lovers as a serious rival to Handel.

As opera matured it grew steadily more artificial and lost the subtleties of character drawing and quickness of reaction which Monteverdi brought to his stage works. Monteverdi's operas are now frequently and successfully revived; this is not the case with operas by Gabrielli and Bononcini, though an aria by the latter, *Per la gloria d'adoravi* (from *Griselda*, 1722), has been recorded by the celebrated tenor, Luciano Pavarotti.

Chapter 15
Spain and Flanders

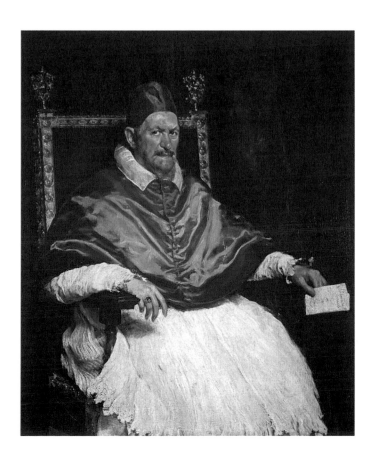

15.1 **Diego Velasquez**, *Pope Innocent X c.* 1648–51.
Oil on canvas, 55⅛ × 43¼ ins (140 × 110 cm).
Doria Pamphili Gallery, Rome.

The Spanish dominions in the sixteenth and seventeenth centuries

From the reign of Philip II (1556–98) onwards, the Spanish Hapsburg monarchy was engaged in defending the political and intellectual *status quo*—a rearguard action which inevitably ended in failure. It sought to maintain the vast European and colonial empire bequeathed to Philip II's descendants by the Emperor Charles V (Fig. **15.2**). To this, in 1580, Philip II was able to add the kingdom of Portugal, thus uniting the whole of the Iberian peninsula. The loss of Portugal (1640), when it revolted against Philip IV (1621–65), was a portent of the break up of the whole Hapsburg system.

One of the chief reasons for the political decline was

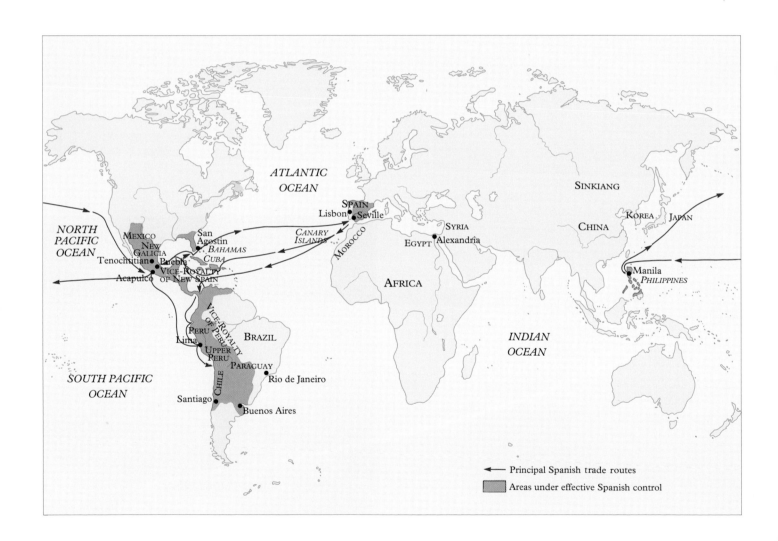

15.2 Spain and her dominions in the 17th century.

economic collapse. The vast sums of money received by the Spanish government from its possessions overseas were nevertheless insufficient to pay for the wars waged to keep the empire intact. In addition, they created massive inflation within Spain itself. Spain had already been forced to declare bankruptcy three times during the reign of Philip II.

Intellectual stagnation was more or less guaranteed by the power of the Church, and in particular by that of the Inquisition. It has been estimated that, between 1550 and 1700, the twenty-nine tribunals of the Spanish Inquisition heard about 150,000 cases. The vast majority of these were to do with heresy or suspected heresy, in what was admittedly the most devoutly Catholic nation in Europe.

Nevertheless the Hapsburg monarchs were often men of great cultivation. Both Philip II and Philip IV were connoisseurs of painting. Philip II was sometimes a generous patron of scientists. One of those whom he helped was the great Antwerp cartographer Abraham Ortelius. Philip IV, sometimes, though wrongly, described as a spineless nonentity, was, like his grandfather, an extremely conscientious bureaucratic monarch—one who used some of his leisure hours to make a translation into Spanish of the work of the Italian Renaissance historian Francesco Guiccardini (1487–1540).

Philosophy

St. Teresa of Avila

Because religion was so much the moving force in Spanish society, the figure who perhaps best represented the intellectual climate to be found in Spain was St. Teresa of Avila (1515–82). As these dates of birth and death indicate, St. Teresa was a generation or more older than Miguel de Cervantes, and only a generation younger than St. Ignatius Loyola, both of whom have already been discussed in a previous chapter (see pages 236 and 218). She appears here, rather than earlier, because her whole cast of mind was typical of Spain in the seventeenth as well as in the sixteenth century. Sor Maria de Agreda, the Carmelite abbess and mystical writer who was Philip IV's close friend and adviser during the closing years of his reign, was a woman of the same stamp.

St. Teresa is remembered for her activities as a religious reformer, but still more as a mystical writer of great gifts, and in particular as the author of the most striking religious autobiography since the *Confessions* of St. Augustine (see page 88). Her *Life*, written at the behest of her confessors, takes her story only as far as 1565, when she was approaching fifty. Her career as a reformer of the Carmelite order and founder of new religious houses had then hardly begun. What the book chiefly describes is her own spiritual development. It does so in language whose concreteness, simplicity, and lack of pretension have fascinated generations of readers, even those whose religious sympathies are not the same as her own.

In the *Life* St. Teresa often protests that she has no visual imagination, and therefore has much need of religious images. Artists have repaid this enthusiasm for their work by making her the source of some of the most vivid Baroque paintings and sculptures. An example is Bernini's depiction of the *Ecstasy of St. Teresa* (see page 257) which is based on a famous passage in her autobiography:

> But it was our Lord's will that I should see this angel in the following way. He was not tall but short, and very beautiful; and his face was so aflame that he appeared to be one of the highest rank of angels, who seem to be all on fire ... In his hands I saw a great golden spear, and at the iron tip there appeared to be a point of fire. This he plunged into my heart several times so that it penetrated my entrails. When he pulled it out, I felt that he took them with it, and left me utterly consumed by the great love of God.

(*The Life of St. Teresa of Avila, by Herself*, translated by J. M. Cohen. Penguin Classics, 1957.)

St. Teresa's writings are in fact a disconcerting mixture of things which seem immediately accessible, and others which are very much of their time. Though her whole career shows her independence, her determination, and her ability to circumvent social conventions, her *Life* is nevertheless full of expressions of deference to the male sex, who are almost invariably depicted as wiser and better informed than she is. And when she describes a diabolic manifestation rather than an angelic one, the description runs as follows: "The Lord plainly wished me to understand that this was the devil's work; for I saw there beside me a most hideous little Negro gnashing his teeth, as if in despair at losing what he had tried to win."

The Conquest of Mexico

The Spanish conquest of Mexico (1519–28), under the leadership of Hernán Cortés (1485–1547), was a significant turning point in the history of European civilization. But what sort of turning point? In recent years it has increasingly come to be seen as a discreditable episode, an outstanding proof of European greed and bad faith, and the propensity of the people of Europe to destroy other cultures with which they came in contact.

Cortés's contemporaries would have conceded the greed of the Spanish conqueror, which was much criticized at the time. Other criticisms would have seemed to them incomprehensible. The year 1492, in which Columbus made his first landfall in the Americas, was also the year in which the Spanish completed the reconquest of Spain from Islam, by taking the Moorish kingdom of Granada. That campaign had been regarded as a crusade and Cortés's campaign was, in the eyes of his contemporaries, of precisely the same nature. If one of its aims was personal enrichment for himself and his followers, the other was the winning of souls for Christ. On his banner as commander-in-chief there was a Latin motto: "Friends, let us follow the Cross; and under this sign, if we have faith, we shall conquer."

▌ Church of S. Francisco, Huejotzingo, Mexico, *c.* 16th century.

▌ Fresco from the Franciscan monastery at Huejotzingo, Mexico, *c.* 1562.

Faith was aided by technological superiority. The Spaniards had two advantages over their opponents—horses and firearms. Confronted with these, the highly centralized Aztec empire collapsed, and Cortés and his men found themselves masters of a civilization about which they knew almost nothing. Those things they did know, such as the Aztecs' ritual use of human sacrifice, repelled them.

Post-conquest Mexico saw a struggle between three different forces. One force was the conquistadors and their descendants, who wanted to take material advantage of the original success, chiefly by enslaving a vast number of the indigenous population and using them as agricultural labor. Aztec stores of gold were soon exhausted; the silver mines in northern Mexico, at Zacatecas and San Luis Potosí, did not start to be exploited until the late sixteenth century. The second force was the Church, under the leadership of the Franciscans, which wanted to convert the indigenous population and win souls for God. The third force was the Spanish royal government, which wanted to have a prosperous, and therefore profitable, new realm at its disposal. The Church and the government soon became allies, and inevitably it was they who prevailed. The aim was to rebuild the society in a new form, replacing paganism and the old Aztec system of administration with Catholicism and a version of the Spanish bureaucracy.

The Franciscan friars in particular were keen to segregate the population from the European immigrants, whom they distrusted. Their idea was to exploit what they perceived as native characteristics of docility and "innocence" in order to create an ideal Christian community, a transatlantic utopia.

More disastrous for the indigenous population than the conscious acts of the Europeans, however, were the diseases, such as measles and smallpox, which the Europeans brought with them. The first great epidemic, which took place in 1545–8, wiped out three-quarters, or perhaps even five-sixths of the native population. Central Mexico had twenty million inhabitants in 1520; by 1548 this was reduced to just over six million. There was a second plague in 1576–80, after which the indigenous population of central Mexico sank to around two-and-a-half million. By 1607, less than a hundred years after Cortés's arrival, it had been reduced to between one-and-a-half to two million—that is, to less than a tenth of its original size.

This meant that the remaining indigenous population, the Spaniards, and new arrivals—among them Blacks and also Chinese and Filipinos imported as slaves—had to come together willy-nilly to create a new society on the ruins of the old. Inevitably, since Mexico continued to be a Spanish possession, this was modeled on the European pattern. There were, however, many differences from the European model. Indigenous beliefs and customs survived, many connected with the cult of the dead. Just as had happened during the changeover from paganism to Christianity in Europe itself, old beliefs assumed new guises. A good example is the Virgin of Guadalupe, who became the

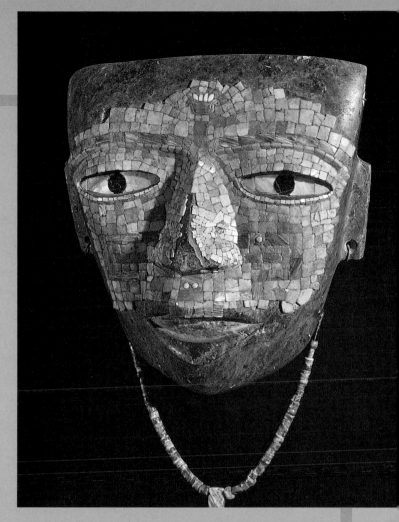

Funeral mask from Teotihuacan, Mexico, c. 6th–7th century. Musée de Mexico.

religious patron of Mexico. She miraculously appeared in 1531, at Tepeacac near Mexico City, to the humble native American Juan Diego. She seems to have been a survival and adaptation of the local mother goddess, Tonantzin, whose temple had been built on the same site.

The hybrid society which grew up in Mexico during the seventeenth century was the precursor of, and model for, other societies created in South America under both Spanish and Portuguese rule. All of these, like Mexico, showed a fusion of European and non-European elements. The non-European elements came not only from the indigenous peoples of the region, but also from Africa and the Far East. In Brazil, the African contribution has been particularly important. The process is to some extent a continuing one—during the twentieth century, São Paulo, Brazil's financial capital and largest city, has experienced a wave of immigration from Japan.

Latin America won its freedom from the European colonial powers in the early nineteenth century, in the wake of the French Revolution. Mexico, for example, declared itself to be independent in 1813. Since that time all the countries of Latin America have shown brilliant productivity in both literature and art, with some especially dazzling recent achievements, such as the novels (written in Spanish) of the Colombian author Gabriel García Marquez (see page 543).

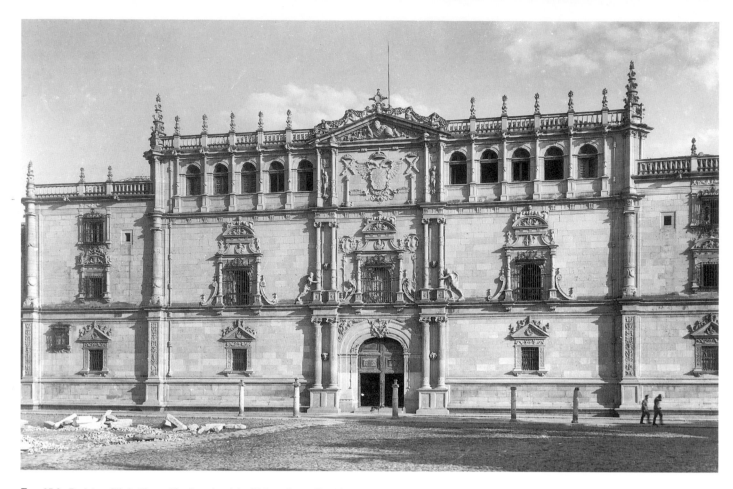

15.3 **Rodrigo Gil de Hontañón**, façade of the University at Alcalá de Henares, Madrid, 1537–53.

Architecture

Spain and Latin America

The history of Spanish architecture developed in a fashion so different from what took place in Italy. Spain offers styles which are either pre-Baroque or post-Baroque—that is, Spanish architecture reaches one climax in the sixteenth century, and another in the early years of the eighteenth.

The most characteristic expression of the Spanish sensibility during the first half of the sixteenth century is the Plateresque style. The word means "silversmith-like," and applies to a new manner of ornamentation, rather than to new principles of construction. The Plateresque is a lavish combination of ornamental motifs borrowed from a wide variety of different sources—Gothic, Renaissance, and even Moorish. These motifs are applied with very little reference to the actual structure of the building. A fairly restrained but beautiful example is the façade of the university at Alcalá de Henares (Fig. **15.3**) (of 1537–53, designed by Rodrigo Gil de Hontañón, 1500/10–77).

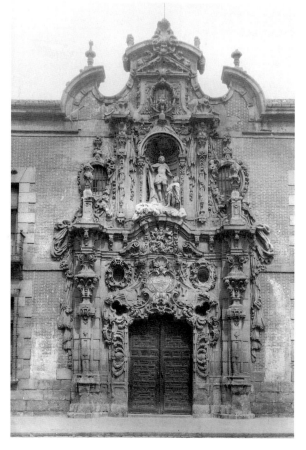

15.4 **Pedro de Ribera**, entrance portal for the Hospicio de San Fernando, Madrid, 1722.

Seventeenth-century architecture in Spain tends to be severe. Over it lies the shadow of Philip II's great monastery-palace El Escorial, built by Juan Bautista de Toledo (d. 1567) and Juan de Herrera (*c.* 1530–97). Both men had been heavily influenced by the Renaissance work they saw in Italy, but the chief factor was the king's own austere taste. Toledo's contribution has been described as being like "a military engineer's vision of ancient Roman architecture."

Toward the end of the century there began to be signs of rebellion against this severe tradition, but the reaction did not manifest itself fully until after 1700. The architects associated with it belonged to the Churriguera family, and the style has been dubbed Churrigueresque in their honor. Other leading practitioners of the style were Pedro de Ribera (*c.* 1683–1742) and Narcisco Tomé (*fl.* 1715–42). Ribera's entrance portal for the Hospicio de San Fernando in Madrid (Fig. **15.4**) of 1722 is a typical example of the new manner. The rich, lacy, crowded ornament is derived from Plateresque sources, but these are combined with ideas taken from the Late Baroque, and also from the incoming Rococo (see page 312). The surface is elaborately textured, with detailed stone draperies, putti, and floral festoons. The pilasters on either side of the door are typically Spanish *estípites*, tapering from top to bottom, and clearly without any structural function.

The Churrigueresque style reaches its richest expression not in Spain itself but in Mexico. It has in fact sometimes been suggested that its appearance in Spain was not merely a belated reaction to the Baroque, combined with a rediscovery of certain elements from early sixteenth-century architecture, but the result of ideas imported from the Spanish colonies in the Americas.

Spanish colonial architecture tends to follow the styles that appear in Spain, but with local variations. The most original colonial buildings are those which seem to betray

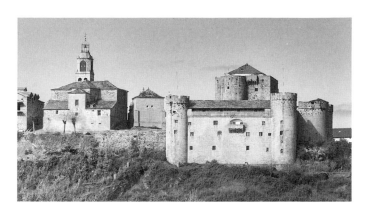

15.5 Capilla del Rosario, Church of Santo Domingo, Puebla, Mexico, 1690.

the presence of a sensibility which is not wholly European. Mexico, once the seat of major Indian civilizations, offers a number of examples, some of the most fascinating in and around the city of Puebla. One is the Capilla del Rosario (Fig. **15.5**) in the church of Santo Domingo, in the city itself. The swarming decoration, gilded and colored, is the product of popular devotion, and undoubtedly the work of artisans of Indian descent. A large part of the money raised is said to have come from the pearl divers, who regarded the Virgin of the Rosary as their protector.

In Spanish colonial buildings the emphasis is on decoration rather than, as with Italian High Baroque architects such as Bernini and Borromini, on shaping and molding space. There were practical reasons for this too—for example, the fear of earthquakes. However, the highly decorated but basically simple forms used in the Spanish Americas represent such a different approach to architecture from those adopted by the great Roman masters that one wonders if the adjective Baroque can fairly be applied to both.

Painting

Spanish: Velasquez, Zurbaran, and Murillo

The three greatest Spanish painters of the Baroque all had connections with Seville. Though not the capital, it was the wealthiest and most populous city in Spain, being the chief port for trade with the Spanish-dominated New World. Velasquez and Murillo were born there, and Zurbaran, though born in Estremadura, spent the most productive part of his career in the city.

Diego Velasquez (1599–1660) is universally ranked as one of the greatest of all European artists, yet he had an extremely circumscribed career. Most of his working life

was spent in the service of the Spanish court, and by far his most important patron was the Spanish monarch Philip IV, who tended to monopolize his production. Although the Spanish court conformed to a rigid, hierarchical etiquette, those who had access to the monarch on a daily basis saw him on intimate terms. Velasquez had the advantage of studying his chief sitters everyday, and at close hand, and he was not forced to hide the conclusions he reached.

Velasquez's earliest surviving paintings date from 1619. They are basically genre scenes, showing episodes from ordinary life. Their emotional tone, however, does not rely purely on the subject matter. Perhaps the greatest is *The*

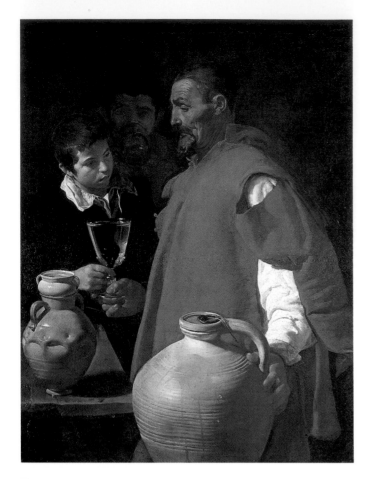

15.6 **Diego Velasquez**, *The Water Carrier of Seville c.* 1619.
Oil on canvas, 41½ × 31½ ins (105.5 × 80 cm). Wellington Museum,
London (Crown copyright reserved).

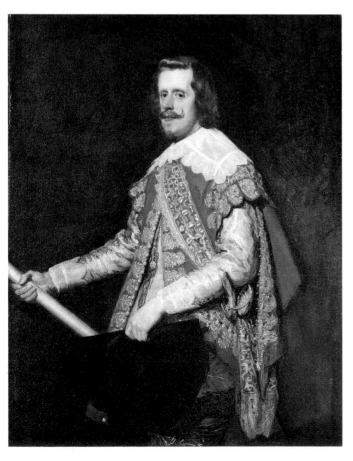

Water Carrier of Seville (Fig. **15.6**), in which Velasquez imparts a sacramental air to what was certainly an everyday sight—there is little or no difference in emotional tone from the religious scenes he was producing at the same period.

In October 1623 Velasquez was officially appointed court painter in Madrid, and remained in the royal service for the rest of his life. His chief absences from court were occasioned by two visits to Italy—in 1629–31 and 1648–51, during which he learned much from Italian art (though these lessons were also available from the Italian paintings in the Spanish royal collections). He also learned something intangible—how to rise to a great occasion. His portrait of *Pope Innocent X* (Fig. **15.1**), painted during his second Italian visit, caused a sensation in Rome. He painted the ruler of the Church with all the grandeur Raphael brought to such tasks, but added a sharpness of characterization, an unsparing truthfulness, which nevertheless kept intact the personal and artistic decorum required by the occasion.

Because his career was so closely linked to the court, the continuity of Velasquez's *œuvre* is provided by a long series of portraits of members of the Spanish royal family. In order to paint these he had to invent new formulae, as his early influences, Caravaggio and Ribera, offered no suitable precedents. His main sources were Titian and Rubens, both well represented in Spain.

Philip IV was in the habit of commissioning portraits of himself to mark special occasions. One of the best known, and the epitome of Velasquez's art, is the three-quarter-length *Philip IV at Fraga* (Fig. **15.7**), painted in the space of three days in order to celebrate the Spanish victory over the French at Lérida. The way in which the king's elaborate pink and silver costume is painted shows how Velasquez's technique was influenced by Titian. Whereas the early genre scenes are rather heavily painted, with a slightly leathery surface, this portrait carries the free, sketchy handling of details to extremes. Velasquez took Titian's late style to its logical conclusion, and invented a way of painting where the details come into focus only when spectators place themselves at a certain distance from the canvas.

A fascination with the everyday, and a sense that it possesses its own transcendent value, is a major underlying theme of Velasquez's art. It is the link between what he produced before and after his entry into the royal service. The culmination is *Las Meninas* (Fig. **15.8**), at once his most ambitious and his most triumphantly successful picture. The subject is the artist himself, and the way he functions within the context of the court. The painting is based on a visual pun: the spectator takes the place of the

15.7 **Diego Velasquez**, *Philip IV at Fraga* 1644.
Oil on canvas, 53¼ × 38½ ins (135 × 98 cm). The Frick Collection,
New York.

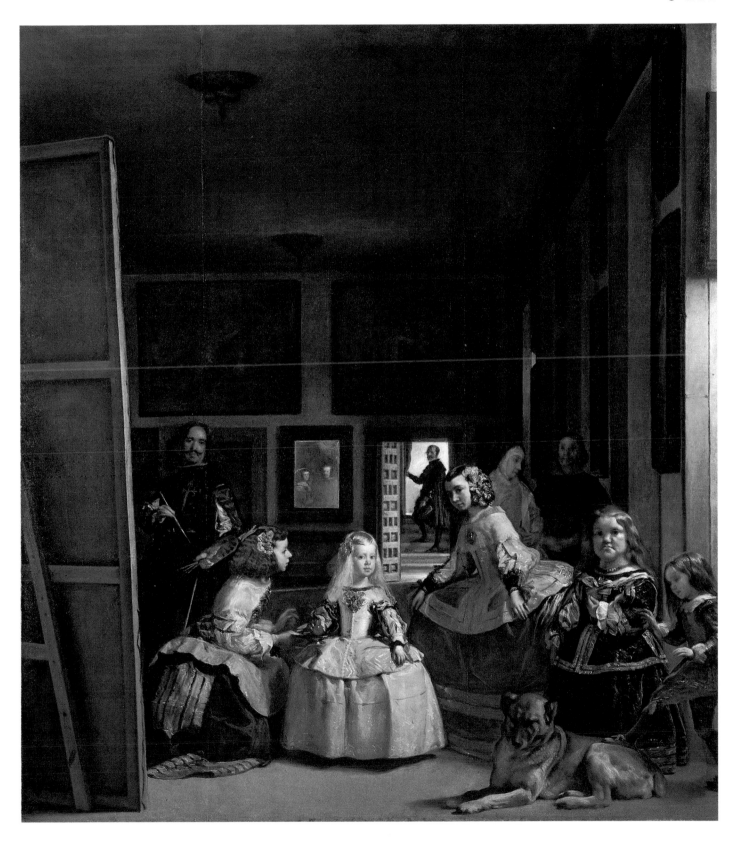

15.8 Diego Velasquez, *Las Meninas (The Maids of Honor)* 1656. Oil on canvas, 125 × 108 ins (318 × 274 cm). The Prado, Madrid.

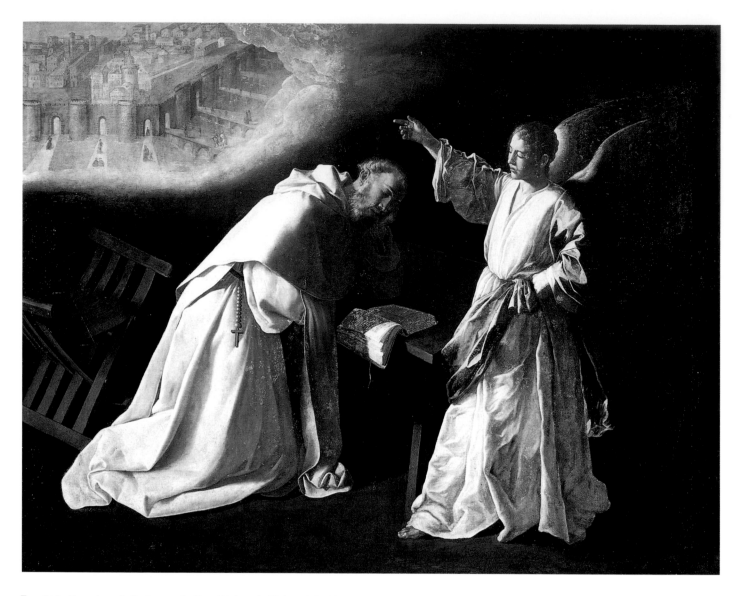

15.9 **Francisco de Zurbaran**, *St. Peter Nolasco's Vision of the Heavenly City* 1629. Oil on canvas, 70½ × 87⅘ ins (179 × 223 cm). The Prado, Madrid.

king and queen, whom Velasquez is busy painting (their joint images appear in the background, dimly reflected in a mirror).

If Velasquez is identified with the court, Francisco de Zurbaran (1598–1664) is now largely seen as the chosen artist of the Spanish religious orders, despite the fact that Philip IV described him as "painter to the king and king of painters." Like the young Velasquez, he responded to the widespread influence of Caravaggio and also had a strong feeling for the sacred existing within the framework of the everyday. Yet unlike the sophisticated Velasquez, he has an archaic quality. Zurbaran seems to have responded quite naturally to ideas which had survived from the Middle Ages. This affected not only the general atmosphere of his art but also specific technical details.

Zurbaran has a quite un-Baroque distaste for perspective lines which draw the eye away into the depths of the picture. *St. Peter Nolasco's Vision of the Heavenly City* (Fig.

15.9), a relatively early work painted in 1629, is typical in this and other respects. It shows not only a medieval disregard for coherent perspective construction but also an equally medieval directness in presenting a supernatural event. The painting of the saint's white habit shows Zurbaran's feeling for this subtlest of hues, and the slightly hard, unyielding texture is also typical.

Bartolomé Esteban Murillo (1617–82) enjoyed a conspicuously triumphant career in his own lifetime although the accusation against him now is one of excessive sweetness and sentimentality, leveled in particular against the two sorts of work which brought him fame in the first place: Madonnas and genre scenes of children.

All of Murillo's religious paintings, like Zurbaran's, are closely connected to the fervent religious climate which existed in Seville during his lifetime. His pictures are optimistic in tone, and do not reflect the disasters which struck the city while he was living and working there—the great

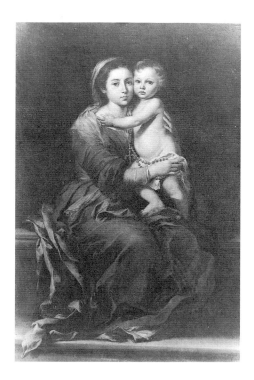

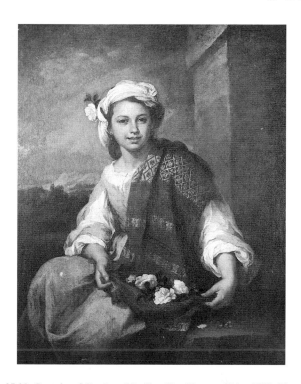

15.10 Bartolomé Esteban Murillo, *The Virgin of the Rosary* c. 1650–55. Oil on canvas, 64⅗ × 43³/₁₀ ins (164 × 110 cm). The Prado, Madrid.

15.11 Bartolomé Esteban Murillo, *The Flower Girl* c. 1665–70. Oil on canvas, 47¾ × 37⅞ ins (121.3 × 96 cm). By permission of the Governors of Dulwich Picture Gallery, London.

plague of 1649, for example, or the popular uprising of 1652. But Murillo does mirror the popular veneration for God and the saints, and the cult of the Virgin. His images of the Virgin and Child—a theme which was, until his time, not very common in Spanish painting, at least when treated as a subject in its own right—show not only the extreme delicacy of his technique but also, and more importantly, the way in which, while retaining the painterly handling of the great Venetians, he looked beyond them to Raphael for the arrangement of the composition itself. A typical example is *The Virgin of the Rosary* (Fig. **15.10**) of *c.* 1650–5, in which the influence of Raphael is very marked.

The urchins who appear in Murillo's paintings are not unlike those in Velasquez's early work, yet the general atmosphere in these paintings is very different from anything Velasquez produced—much lighter and more playful. These tendencies are summed up in *The Flower-Girl* (Fig. **15.11**), which is not merely a painting of a young flower-seller but an allegory of fleeting time and fading youth—some of the roses caught in the girl's shawl have already started to wither.

Flemish: Rubens and Van Dyck

Flemish seventeenth-century painting is associated with its Spanish counterpart here not only because the southern Netherlands continued to be a political possession of Spain but also because both are aspects of specifically Counter-Reformation art. In addition, both groups of painters were strongly influenced by their contact with the Italian

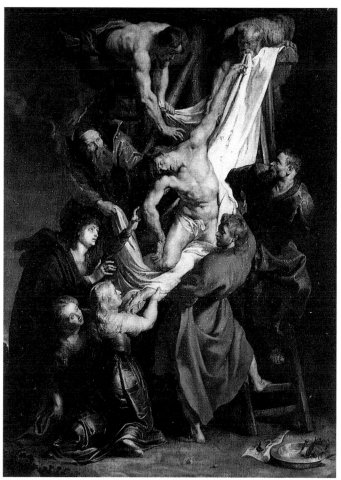

15.12 Peter Paul Rubens, *Deposition* 1611–14. Oil on panel, 172¾ × 118 ins (439 × 300 cm). Antwerp Cathedral.

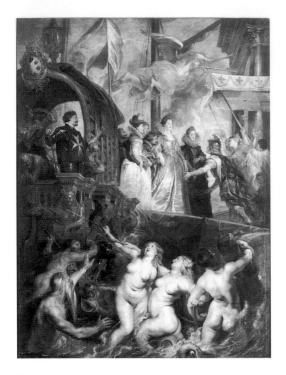

15.13 **Peter Paul Rubens**, *The Marie de Medici Cycle: The Disembarkation of Marie de Medici at Marseille in 1600* 1622–25. Oil on canvas, each 127½ × 92½ ins (324 × 235 cm). Louvre, Paris.

Baroque, while remaining distinct in style from it. Even so, Flemish art is very different from its Spanish counterpart. The exuberant energy of the two leading Flemish painters of the time—Rubens and Van Dyck—was the product of very special historical circumstances.

Antwerp was the chief city of that part of the Netherlands which had remained under Spanish domination. Its fate had not been easily decided, and the division of the Netherlands which took place as the result of the Eighty Years War (1566–1648) was ultimately fatal to what had been, at the beginning of the sixteenth century, one of the wealthiest trading cities in the world. However, the first period of its decline in fact saw an extraordinary artistic flowering.

Peter Paul Rubens (1577–1640) was one of the most dazzlingly successful artists of his age. In May 1600, already recognized as a promising painter, he left Antwerp for Italy, following a path trodden by many Netherlandish artists before him. Here he was almost immediately successful in obtaining a post as court-portraitist to Vincenzo Gonzaga, Duke of Mantua. The environment he found at Mantua was a cultivated one—the duke was interested not only in paint-

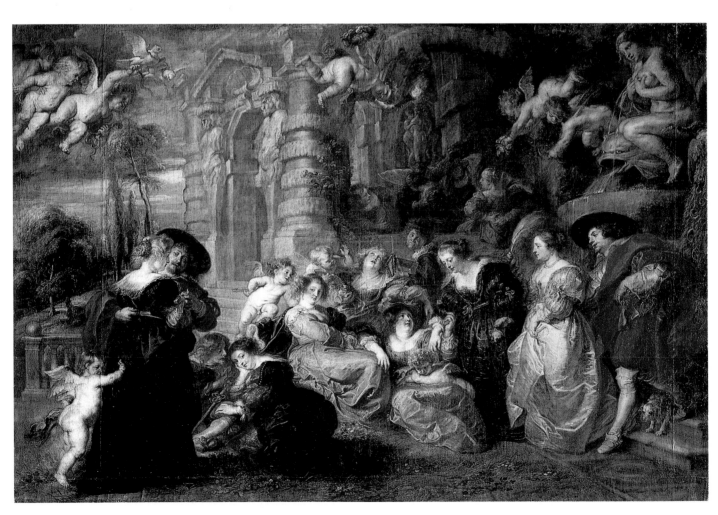

15.14 **Peter Paul Rubens**, *The Garden of Love* 1632–34. Oil on canvas, 78 × 111⅖ ins (198 × 283 cm). The Prado, Madrid.

ing but in science and music as well. He corresponded with Galileo (see page 245) and employed Monteverdi. But Rubens was not confined to the Gonzaga dominions. He traveled widely in Italy, getting to know its cities and works of art, and in 1603 the duke sent him as part of a Mantuan embassy to Spain, where he was able to study works by Titian in the Spanish royal collection. In Italy itself, the artist who made the greatest impression on him was Caravaggio, whose influence was to persist throughout Rubens's subsequent career, especially in his religious works.

In 1608 Rubens returned to his native city and the following year was appointed court-painter to the regents of the Netherlands. He was immediately in demand as a portraitist but his reputation was made by his religious pictures. A notable example is the *Deposition* (Fig. **15.12**), painted for Antwerp Cathedral. This heroic presentation of an episode from Christ's Passion has unequaled sweep and emotional force. The sacred drama is given a special immediacy by the sensuousness of texture and surface—Rubens's chief contributions to the art of his time. The heroic figure of the dead Christ has a distinctly classical feel, having the oversized grandeur of a Hellenistic torso.

Rubens soon received so many commissions that he needed to organize an extensive studio for himself, and studio intervention is noticeable in many of his mature works—for example, in what is perhaps his greatest decorative achievement, the *Marie de Medici Cycle* (Fig. **15.13**) of 1622–5, painted for the widow of Henry IV of France. Despite the inevitable weaknesses of detail which this process entailed, the formal inventiveness of the canvases was to influence generation after generation of French painters. The pictorial energy Rubens generated overcame the evident absurdity of the allegories he was commissioned to paint, as well as the fact that not everything was by his own hand.

The most successful of his late works are, however, deeply personal, painted entirely by the artist because he regarded them as documents of his own life. One of the most ambitious is *The Garden of Love* (Fig. **15.14**), which celebrates the happiness of Rubens's second marriage.

The paradox in Rubens's career is that he was, on the one hand, pre-eminently an official artist, loaded with commissions and honors throughout his life, and very much an exponent of an official style which set an example to other artists, and yet, on the other hand, he was a creator of intensely personal images. Titian was never autobiographical in this way, and even Caravaggio tended to conceal autobiographical references rather than parade them openly. The personal element is something which relates Rubens to the northern tradition, springing from Dürer (see page 210), despite his evident links with Italian art.

Anthony Van Dyck (1599–1641) set himself up independently at an extremely early age—some contemporary sources say as young as fifteen or sixteen. However, he was not yet independent stylistically. Even before he joined

15.15 Anthony Van Dyck, *Portrait of Geronima Brignole Sale and her Daughter Aurelia* c. 1621–25. Oil on canvas, 113⅖ × 79¹/₁₀ ins (288 × 201 cm). The Gallery of the Palazzo Rosso, Genoa.

15.16 Anthony Van Dyck, *James Stewart, Duke of Richmond with Lennox* 1635–36. Oil on canvas, 39 × 63 ins (99.5 × 160 cm). Iveagh Bequest, Kenwood House, London.

Rubens as an assistant in his late teens, the former was a major influence on his art, and at this early period in his career his work lacks real solidity when compared to that of his master.

In October 1621 Van Dyck left Antwerp for Italy. The six years he spent there were to be decisive in his career, and the characteristics which differentiate his artistic personality from that of Rubens now begin to appear.

Van Dyck's travels took him to Florence, Venice, Turin, and Rome, and also as far afield as Palermo in Sicily, but it was in Genoa that he evolved a new portrait style. Van Dyck's double portrait of *Geronima Brignole Sale and Her Daughter Aurelia* (Fig. **15.15**) exemplifies this. The elongated figures are cool, remote, and visibly aristocratic, yet remain charmingly human.

Late in 1627 Van Dyck returned to Antwerp with an established reputation, and found no difficulty in getting official patronage. He soon received an appointment as painter to the ruler of the Spanish Netherlands, the widowed Archduchess Isabella, and produced portraits of many members of her immediate circle. He was also given opportunities to paint religious and mythological pictures.

In 1632 Van Dyck was invited to the English court, and soon afterwards Charles I and Henrietta Maria sat for what were to be the first in a long series of portraits. Many of these portraits reflect the absolutist ambitions of the Stuart monarchy. Ultimately these portraits of the royal family were less widely and enduringly influential than those of members of the English aristocracy. Sometimes criticized for lacking character, these were extremely successful in projecting the image of a whole class. An example of this is a likeness of a sitter whom Van Dyck painted a number of times, *James Stewart, Duke of Richmond with Lennox* (Fig. **15.16**). Inscribed on this is the fundamental tenet of the aristocracy's belief in itself—so confident in the unshakability of its own values that there is no need to make a show of them.

These portraits of his English period were Van Dyck's most lasting legacy; it is not too much to say that he created the English portrait tradition almost single handed.

Spanish drama

The form of literary activity which showed the greatest degree of energy in seventeenth-century Spain was writing for the theater. In terms of the physical conditions under which it was presented, Spanish drama showed many resemblances to its Elizabethan and Jacobean counterparts in England. Plays were performed in spaces which derived from the spacious internal courtyards of Spanish town houses, just as the Elizabethan theaters found their models in the courtyards of inns. The stage projected into an uncovered auditorium, where part of the audience stood.

The most important dramatists of the so-called "Golden Age" in Spain were Lope de Vega (1562–1635) and Pedro Calderon de la Barca (1600–81). Lope de Vega has been called "the most prolific dramatist of all time." He claimed to have written 1,500 plays, over 470 of which have survived. Given the nature of Spanish despotism, his plays are often surprisingly frank about social conditions. One of the best known, *Fuenteovejuna*, deals with a village in rebellion against a brutal lord. This theme, however, is balanced by a corresponding subplot—the rebellion of the same lord against the king.

Calderon was marginally less prolific; about 200 of his plays have survived. His most active period as a dramatist was from 1625 to 1640, thus coinciding exactly with the peak period of activity for the great Spanish painters. Like Velasquez, Calderon was drawn into the life of the court, and from the 1650s onwards devoted himself to writing entertainments suited to the new conditions offered by the palace theater.

Calderon's plays cover a wide variety of themes, but there are a number of constants. One is the idea of fate, often expressed by means of a horoscope, a destiny already foreseen, which has to be fulfilled. Another is the notion of the overriding obligations imposed by the concept of honor. Some plays are almost purely symbolic—a well-known example is *La vida es sueño* (*Life is a Dream*) of 1635, which concerns a prince, brought up wholly in captivity and longing for freedom, who escapes, leads an army against his father, defeats him, and then, when he holds his father at his mercy, decides to surrender and submit to imprisonment again. It turns out that the cause of his original captivity was a horoscope which predicted the events of the play. As Calderon makes clear, however, it is in fact his unjust imprisonment which urges Sigismundo to rebel, and a final act of free will which prevents him from killing the father whom he has defeated. The symmetry of structure and the Christian moral are both typical of the classic Spanish drama.

Chapter 16

French Classicism

16.1 **Louis de Vau** and **Jules Hardouin-Mansart**, Garden façade,
Palace of Versailles, France, 1669–85.

The cultural climate in France

The seventeenth century in France is often presented as an epoch dominated, artistically as well as politically, by the personality of Louis XIV (1643–1715). Though Louis's personal patronage of the arts, especially in the first period of his personal rule (from 1661 onwards), was of great importance, the idea that all the French artistic successes of the period must be referred to his taste and his political aims is erroneous.

Before 1661, the French government had been dominated by two sagacious first ministers, Cardinal Richelieu (1585–1642), who came to power in 1624 and worked in partnership with Louis XIII (1610–43); and Cardinal Mazarin (1602–61), who worked in partnership with the Regent, Anne of Austria, during Louis XIV's long minority. Richelieu turned France from a weak and divided kingdom, exhausted by religious strife, into the powerful adversary of the Hapsburgs. Mazarin conserved the young king's inheritance, and stamped out the last remnants of aristocratic unrest. Both men were patrons of the arts—between them they had already created a new intellectual climate, in some ways subtler than Louis XIV was able to make use of.

For example, it must be noted that many of the most notable French thinkers, writers, and artists of the period had either little or no connection with the king and his court, or were in some way alienated from it. Descartes was dead by 1650. Like the painters Poussin and Claude (see page 280), he chose to spend his working life abroad. Pascal and Philippe de Champaigne (see page 282) were adherents of the persecuted Jansenists. Mme. de Sévigné and Mme. de La Fayette (see page 284) were alienated in a subtler way. Snobbishly delighted to be received and noticed at court, they still belonged to a new kind of culture, dominated by the ideas and tastes of women, which was taking root in the drawing-rooms of Paris—a milieu which aroused the king's deepest suspicions.

Yet it is also necessary to acknowledge the enormous influence exercised throughout Europe by Louis XIV's court entertainments, his building works at Versailles, and his patronage of the decorative arts. Louis turned the arts into the servants of a new concept of royal absolutism, in which the king was always supreme and everything had to contribute to the glory of the monarch. Material enrichment of literature and art, from the lavish subsidies given in the early years of his personal rule, was soon accompanied by a certain spiritual impoverishment. This became even more noticeable when the subsidies diminished, thanks to the financial strain of Louis's perpetual wars.

Philosophy

Descartes and Pascal

The intellectual climate of seventeenth-century France can be summarized by citing two names, René Descartes (1596–1650) and Blaise Pascal (1623–62). In some respects the two men are opposites—as Pascal realized, expressing his disapproval of the older thinker in memorable phrases. "I cannot forgive Descartes," he is reported to have said. "In his whole philosophy he would like to do without God; but he could not help allowing him a flick of the fingers to set the world in motion; after that he had no more use for God."

Yet in other respects the two men were alike. They were united in their determination to combat the received opinions of their time. As a result, they found themselves somewhat isolated from the main currents of French society. Descartes removed himself physically, retiring to Holland in 1629 and working there in seclusion for nearly twenty years. When he left, it was not to return to his native country but to go to Stockholm in order to teach philosophy to Queen Christina of Sweden. Pascal remained at home, but in his later years he lived in a kind of internal exile, because he was closely identified with the persecuted Jansenist sect.

Of the two, Descartes has had by far the greater influence. He was one of the main creators of the intellectual structures which are now almost automatically accepted as valid. Pascal, on the other hand, has proven to be the more alluring personality, and his work has attracted numerous modern studies.

The essentials of Descartes's thought can be found in his *Discourse on Method* (1637), a brief treatise originally designed simply as a preface to a group of other treatises on more strictly scientific subjects. The *Discourse*, like Galileo's *Dialogue on the Great World Systems* (see page 245), were filled with the new spirit of scientific inquiry, but addressed directly to the general reader.

Descartes believed that all the sciences formed a unity, and that what held them together was mathematics, which provided an idea of order through progression. His aim was to reduce the actual process of thinking to quasi-mathemati-

cal terms. He begins with the proposition, which is also an intuition, "I think, therefore I am." From this follows the rest of his "method," which may be summarized as follows:

1. The study of any problem begins with first principles—that is, with the discovery of fundamental truths which cannot be doubted. This discovery is necessarily intuitive.

2. In order to make them soluble, complex problems must first be analyzed. That is to say, they must be broken down into their component parts, and these components must, if necessary, be broken down again. What remains at the end of the process is a series of problems or questions which are now as simple as possible. To these, simple and certain answers can be provided.

3. The situation can then be reconstructed, or synthesized, by putting propositions in order, starting with the simplest. From this process of building up, the answer to the complex problem with which one began will duly emerge.

4. The synthesizing or deductive process outlined above does depend partly on memory, rather than on direct intuition. To reinforce the operations of memory, and safeguard against error, one should always try to keep clearly in mind that link between the first principles, which have been intuitively arrived at, and their perhaps distant consequences.

(adapted from BERNARD WILLIAMS, *Descartes: The Project of Pure Enquiry*. Penguin Books Ltd., 1978.)

There is a feature of Descartes's thought which particularly disturbed his contemporaries, and has continued to arouse criticism since. This is the separation he proposes between mind and body. For Descartes humans are thinking animals, always possessing the urge to dominate surrounding nature. Domination is achieved by eliminating whatever is irrational. Yet humans, defined in this way, are only uncertainly linked to nature, which seems a contradiction in terms since anything "animal" is by definition also "natural." The feebleness of this link was another reason for Pascal's rejection of Descartes.

The rejection may have been reinforced by personal disagreement. Descartes and Pascal had known one another at the start of the latter's career. Both men were briefly in Paris, where they had a long discussion on the nature of the vacuum—Pascal had just made a series of experiments which showed that vacuums could and did exist, a fact not generally accepted by scientists. Descartes had difficulty in accepting his results. It seems ironic that Pascal appeared here as the advocate of scientific rationalism, since later their positions were to be reversed. It was Pascal, after all, who said that: "it is less important to prove the existence of God than to feel his presence, which is the most useful, and taken all round, the easiest job."

Before turning to Pascal himself, it is necessary to say a little about Jansenism, the form of religious belief which dominated his thought. It was named after an early-seventeenth-century Bishop of Ypres, Cornelius Jansen, and exercised its greatest influence in France, where it rooted itself at the convent of Port-Royal, near Paris. Jansenism has been seen in two ways—representing either the Catholicism of the period in its purest and most stringent form or a kind of crypto-Protestantism. Jansenists believed, just as Calvinists (see page 209) did, that good must be chosen, not in the hope of any reward either on earth or in heaven, but gratuitously, for its own sake.

Quite apart from the Calvinist taint, such an attitude necessarily represented a direct challenge to royal absolutism, which to Jansenists seemed incompatible with the absolutism of the divine order. They found themselves involved in a long struggle with the Crown, which finished only with the final suppression of the convent of Port-Royal in 1709. Nevertheless, the triumph was theirs, for it is Jansenist thought and feeling which permeate many of the best aspects of French seventeenth-century culture.

Pascal always suffered from poor health, and his *Pensées*, the greatest book inspired by Jansenism, are scattered fragments of a great philosophical work which he did not live to complete. The proposed theme is defined in an early notebook entry:

Wretchedness of man without God . . . Happiness of man with God . . . Nature is corrupt, proved by nature itself. There is a Redeemer, proved by Scripture.

(PASCAL, *Pensées*, translated by A. J. Krailsheimer. Penguin Books Ltd., 1966.)

Where Descartes was concerned, Pascal picked on one of the great weaknesses of his basic thesis by insisting that the separation between humans and the world must itself be a fertile source of error:

The two principles of truth, reason and senses, are not only both not genuine, but are engaged in mutual deception. The senses deceive reason through false appearances, and, just as they trick the soul, they are tricked by it in their turn: it takes its revenge. The senses are disturbed by passions, which produce false impressions. They both compete in lies and deception.

(PASCAL, *Pensées*, translated by A. J. Krailsheimer. Penguin Books Ltd., 1966.)

The fascination of Pascal for modern minds is that, while Descartes offers certainties that have now come to seem inadequate, Pascal offers doubts which are very like our own. Yet one must never lose sight of the fact that, for all his eloquence, Pascal still remained a man of his time, while Descartes, for better or worse, was in the process of escaping from its intellectual frameworks, and of creating entirely new ones to replace them.

Louis XIV and Absolutism

Louis XIV of France was the first monarch since the Roman imperial period to employ all aspects of the visual arts so that they delivered the same message about the power of the ruler. The most successful single embodiment of Louis's ideas about the role of the French monarchy—"*L'Etat c'est moi*" ("I am the state")—is Gianlorenzo Bernini's portrait bust, made in 1665 during the sculptor's otherwise unsuccessful visit to Paris to provide designs for the rebuilding of the Louvre. The way in which the king holds his head is based on representations of Alexander the Great handed down from antiquity—a typically Baroque "conceit" designed to convey the idea of universal sovereignty. The king's contemporaries, and even the French artists of the time (who were very jealous of Bernini's success), agreed that the head was a good likeness.

The bust is, however, because of its characteristic Italian exuberance, not typical of Louis's official commissions. These were organized so as to reflect both the dignity and the glory of the monarch. Strict rules for art were laid down by the Royal Academy of Painting and Sculpture in Paris, which was responsible for training young artists. The ruler of the academy, as absolute in his own sphere as Louis was in France, was the painter Charles Le Brun (see page 282). Le Brun's ascendancy lasted from 1661 to 1683, and even after that date challenges to his authority were only partly successful.

In addition to either carrying out, or overseeing, the large number of decorative paintings required for Louis's great building schemes at Versailles (see facing page) and elsewhere, Le Brun was put in charge of the Royal Manufactory at the Gobelins, which supplied the royal palaces with tapestries and also with furniture. There were supplementary establishments at Savonnerie and Beauvais. Everything thus came under a rigorous central control, and this was concerned not only with the actual style of the objects, but their allegorical content, which was directed toward celebrating the glory of the Sun King. Louis was personified as a new version of the Greek sun god Apollo (see page 59), who shines upon everything and sees everything from his position in the heavens.

The same concerns informed the exterior design of Versailles, with its statues, fountains, and formal gardens. Everything pointed toward the personality of the king, as the necessary center without whom all this splendor would be meaningless. At the same time the sheer lavishness of the setting which Le Brun and the royal architects provided served as a visible expression of royal power.

Louis's contemporaries were duly impressed. Versailles became the model for royal palaces all over Europe, though these generally had to be built on a more modest scale. The sheer size of Versailles reinforced its message. As the palace was repeatedly enlarged people became more and more willing to believe that Louis was not only absolute at home, but the most powerful monarch in Europe.

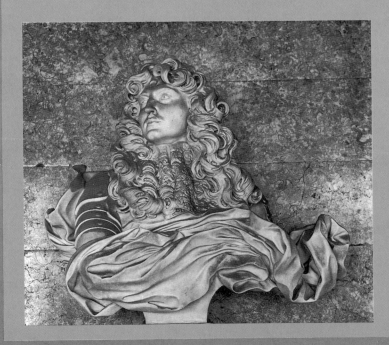

Gianlorenzo Bernini, *Bust of Louis XIV* 1665. Marble, 31½ ins (80 cm) high. Palace of Versailles, France.

Architecture

The "classical" style of architecture in France—classical in its use of the Orders (the system devised by Vitruvius, the Roman architectural historian, to categorize various types of architecture) usually in more or less orthodox fashion, and also in its use of other features, such as pediments, for ornamental purposes—developed slowly during the early decades of the seventeenth century, enjoyed a brilliant flowering just before and after 1650, and was later coarsened by the pressures put on architects by a royal patron more interested in immediate effect than in subtlety.

The style had three sources: the native French adaptation of Mannerism, already seen in the architecture of the sixteenth century; the published work of the Renaissance

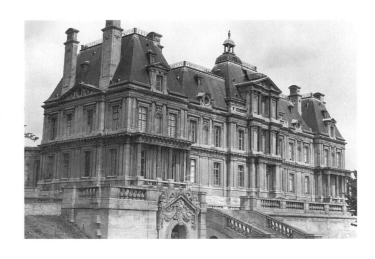

16.2 **François Mansart**, Château of Maisons, 1642.

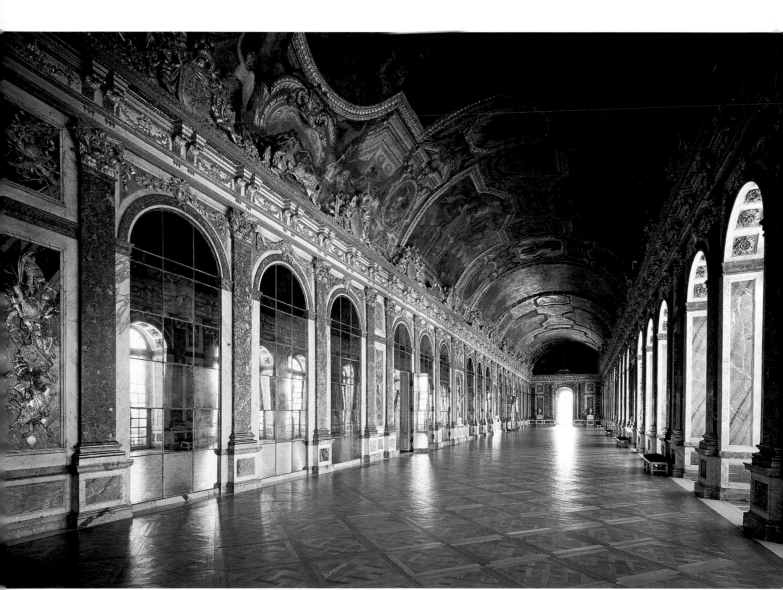

16.3 **Jules Hardouin-Mansart** and **Charles Le Brun**, The Hall of Mirrors, Palace of Versailles, France, begun 1678.

theoretician Sebastiano Serlio (1475–1544), whose treatise *L'Architettura* appeared in six parts between 1537 and 1551, and of Palladio (see page 219); and the new Roman Baroque style—the last chiefly in the chastened version of it favored by Carlo Maderno (see page 247) and his contemporaries.

The direction taken by French architecture under Louis XIV can be assessed by looking at the work of two men, François Mansart (1598–1666) and his great-nephew Jules Hardouin-Mansart (1646–98). Their careers almost completely span Louis XIV's long reign.

François Mansart was the most distinguished exponent of the new French style. His masterpiece is the Château of Maisons (Fig. **16.2**). Work on it began in 1642, the year before Louis's accession. The building is typical of the pattern inherited from the sixteenth century. The main *corps de logis* is divided into suites of rooms grouped together as apartments. The building is entered through the usual frontispiece (state entrance) at the center, and has a completely symmetrical façade. The restless rhythms of the centerpiece look back to Mannerism. Just as Palladio conceived of church façades as temple fronts which overlapped and interlocked with one another, so Mansart here was thinking of the state entrance to his building in terms of shallow layers, each advancing a little nearer to the spectator, without fully breaking away from the main façade. The three successive entablatures are all differently treated—straight and complete, breaking back, and then broken—this emphasizes the effect of plasticity.

Mansart's work is the uncompromising creation of one man. He was in fact obstinate, arrogant, and extravagant about building costs. The difficulty of dealing with him was compounded by his tendency to change his mind when a job was already in progress. These characteristics cost him his chance of winning major royal patronage. His nephew was more pliable and therefore more successful. He participated in the building and rebuilding of the vast palace of Versailles (Fig.16.1), the king's chief monument to his own splendor. The building is not a unity, like Maisons, but an accretion of different ideas. Its great glory is not the façades but some of the interiors devised as a setting for court ceremonies.

The culmination of the developed Louis XIV style is the Galerie des Glaces (Hall of Mirrors) at Versailles, which was begun in 1678, designed by Hardouin-Mansart in conjunction with the painter Charles Le Brun (see page 282). The Galerie (Fig. **16.3**) is the culmination of a suite of three reception rooms, the Salon de la Guerre and the Salon de la Paix leading into it. The vast mirrors, which catch and redouble the light from facing windows, would have been even more impressive to Louis's contemporaries than they are to us today because of the expense involved at a time when mirrors were costly luxuries. The room was originally furnished entirely in silver—tables, torchères, and hanging candelabra—and this added to the overwhelming sumptuousness of the effect.

The Galerie des Glaces marks the beginning of a new emphasis on interior rather than exterior architecture—which was to be continued and developed in France during the first half of the eighteenth century. Professional architects now began to face competition from designers of ornament, who tended to make their primary unit a room or a suite of rooms, not a whole building.

Painting

Claude and Poussin

Being in the center of Europe, French artists were exposed to a wide range of influences. They also had the opportunities to travel. Two of the most important, Claude and Poussin, chose to live and work as voluntary exiles in Rome, where they produced work which appealed to very different groups of patrons.

Claude Gellée (1600–1682) came not from France proper but from the Duchy of Lorraine. His origins and early life remain obscure; in Rome, he is said to have started off as a pastry-cook in the household of Agostino Tassi (c. 1580–1644), who specialized in illusionist architectural painting and also in decorative landscape friezes. He then graduated to being Tassi's studio assistant, and finally settled down in Rome as an independent artist.

The characteristics which we recognize as typical of his mature output begin to enter his work in the 1640s, when he began to paint heroic landscapes, illustrating both antique and biblical themes, of a kind pioneered by Annibale Carracci (see page 252). Claude often produced pictures in contrasting pairs, as is the case with *The Marriage* (Fig. **16.4**) of 1648—spreading and pastoral—and *The Embarkation* (Fig. **16.5**) of the same year, set in a superb seaport, where the distance is framed by buildings rather than trees.

Claude's work is really made up of three elements. The first is what he observed in the Campagna, a type of landscape which was then a new subject in art. The second is his understanding of light and his unequaled skill in reproducing its effects. The third element, often ignored or underrated by his admirers, is his feeling for proportion and structure. Rather than using the boxlike structure typical of Poussin even when painting landscape, Claude carries the eye freely to the horizon, discarding all obvious spatial

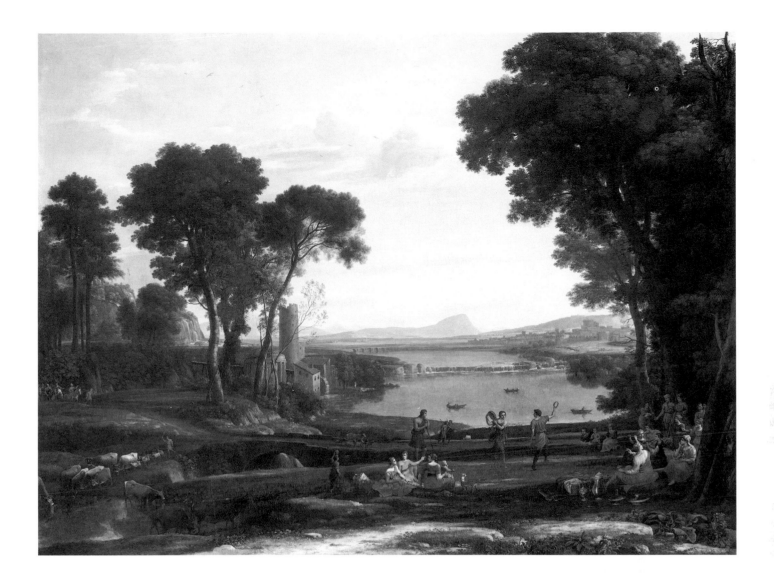

16.4 **Claude Lorraine**, *The Marriage of Isaac and Rebecca* c. 1648.
Oil on canvas, 58¾ × 77½ ins (149.2 × 196.9 cm).
National Gallery, London.

devices, such as trees at either side used as repoussoirs—devices to direct the spectator's eye into the picture. Yet this created space, apparently freely arranged, remains subject to strict laws, as can be seen from drawings with ruled divisions, showing how the subject was to be treated. The proportional geometry which Claude so meticulously worked out is what makes his landscapes so satisfying.

Nicolas Poussin (1593/4–1665) came from Normandy, and was trained in France as a late Mannerist. When he reached Rome in 1624, he found it difficult as a foreigner to get commissions for the big altarpieces and church decorations that were financial mainstays for the then dominant Italian followers of Annibale Carracci. Instead, he began to paint for a small circle of intellectuals, using themes taken from ancient mythology and from Torquato Tasso (1544–95), the successor of Ariosto (see page 206) as the poet of chivalric romance. The *Arcadian Shepherds* (Fig. **16.6**) is typical of this phase of his development, with its golden melancholy. It also shows the impact made on Poussin at this time by sixteenth-century Venetian art.

He repeated Annibale Carracci's course of development (see page 252) by becoming more classical and to a certain extent more impersonal as he matured. He also tended to be relatively indifferent to either atmosphere or surface texture. As a result, his most typical pictures make the spectator aware of the way in which the composition is built up from various combinations of regular solids.

The culmination of these tendencies came in 1644, when Poussin embarked on a series of paintings representing the *Seven Sacraments*—the second occasion on which he had represented the theme. The new series brought his art to utmost refinement. For example, *Ordination* (Fig. **16.7**) is very like Raphael's *School of Athens* (see page 198), but even more impersonally lofty. In working out his compositions, it is known that Poussin sometimes made use of a peepshow containing miniature figures and such a device clearly set the pattern here. The aim was to explore ways of creating a heightened sense of reality, by confronting the spectator with a more disciplined and perfect order than anything to be found in real life.

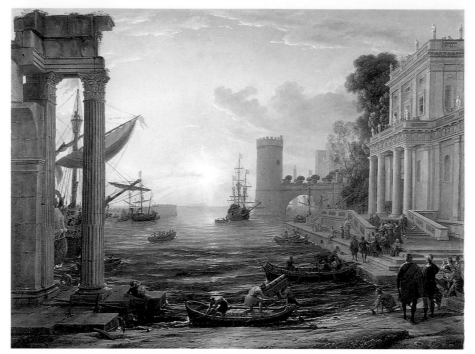

16.5 **Claude Lorraine**, *The Embarkation of the Queen of Sheba* 1648.
Oil on canvas, 58½ × 76¼ ins (148.6 × 193.7 cm).
National Gallery, London.

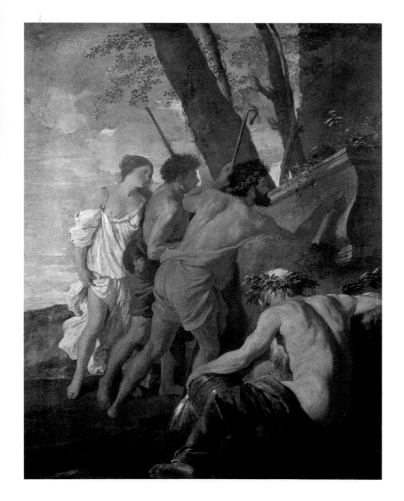

16.6 **Nicolas Poussin**, *The Arcadian Shepherds c.* 1620–30.
Oil on canvas, 39¾ × 32¼ ins (101 × 82 cm). The Trustees of the
Chatsworth Settlement, Chatsworth, Derbyshire, England.

Painting within France

In France itself, what was happening in the Netherlands—both the work of Rubens and Van Dyck (see page 269) and the work of the Dutch genre painters (see page 302)—exercised almost as strong an influence over French painters as what was happening in Italy. French art also reflected the intellectual, religious, and political conflicts of the day, from which Claude and Poussin were more or less removed. Almost none of the best French painting was directly identified with Louis XIV and his policies.

Of the artists who stayed at home, the two most important are twentieth-century rediscoveries: Georges de La Tour and Louis Le Nain. Many things remain mysterious about Georges de La Tour (1593–1652). It is not known for certain whether he went to Italy or not; there are occasional signs in his painting that he may have known early works by Annibale Carracci (a more convincing proof of an Italian sojourn than a knowledge of Caravaggio, whose style was, by the time La Tour came to maturity, widely diffused in Europe).

La Tour did not make his career in France, though he is now claimed as a French artist, but in the independent Duchy of Lorraine. He settled in Lunéville, which was then the ducal capital, in 1620. He did, however, have some contacts with France; he is known to have been in Paris in 1639 and Louis XIII of France was one of his patrons.

His mature works are all night scenes. Some are sacred subjects; some are sacred subjects treated in a way which makes them indistinguishable from genre scenes; and some are pure genre. All have marked simplicity and monumentality. Caravaggesque chiaroscuro takes on a new role. It is

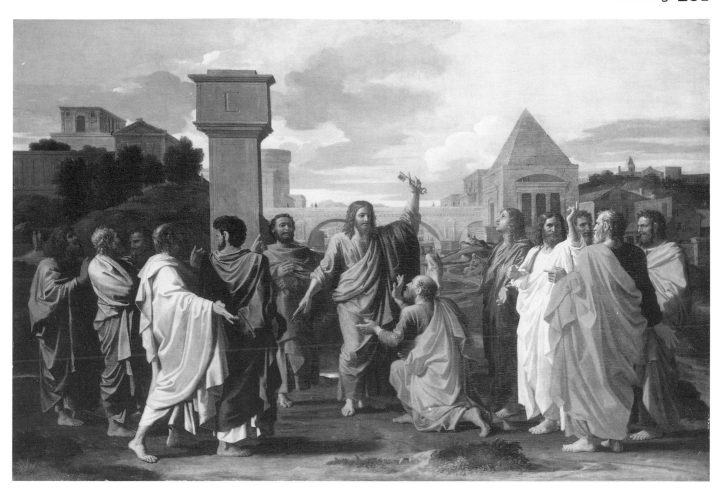

16.7 Nicolas Poussin, *Ordination* 1647.
Oil on canvas, 46¼ × 69¾ ins (117.5 × 177 cm). National Galleries of
Scotland, Edinburgh.

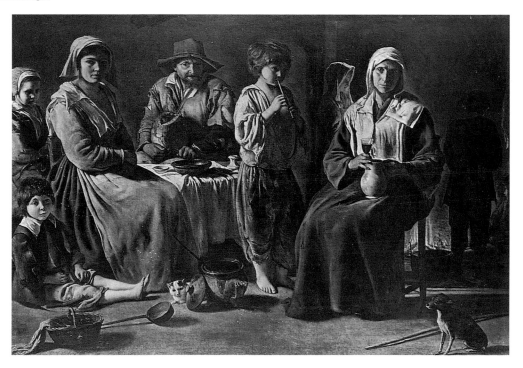

16.8 Louis Le Nain, *Peasant Family in an Interior* 1642.
Oil on canvas, 38⅛ × 48 ins (97 × 122 cm). Louvre, Paris.

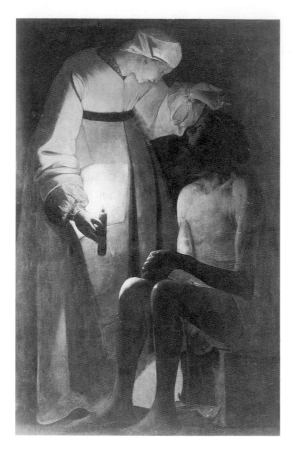

16.9 Georges de la Tour, *Job Mocked by His Wife.*
Oil on canvas, 57 × 38 ins (145 × 97 cm). Musée Départemental,
Epinal, France.

not used to dramatize an event and make it seem immediate; rather, it is used to simplify the forms and make them quasi-abstract, and in this respect La Tour resembles Poussin. Though the impulse toward monumentality is so strong, La Tour's compositions are inventive and sometimes show a certain eccentricity. *Job Mocked by His Wife* (Fig. **16.9**) demonstrates his strange formal sense more strikingly than any other picture. Job's wife is bent to fit the canvas, and her mockery becomes the more oppressive because of the way in which the space between the figures has been constricted.

La Tour is classified with the so-called Peintres de la Réalité (the title comes from a pioneering survey exhibition held in Paris in 1934), and with the brothers Le Nain in particular. The Le Nains, however, are directly linked to Dutch genre painting (see page 302), while La Tour, on the contrary, is classical and even idealizing, in the sense that he alters and edits appearances to make them suit his own purposes.

The Le Nains form a mysterious fraternal trinity: Antoine, Louis, and Mathieu. There is still much debate among art historians as to their respective dates of birth, and also as to which pictures are to be attributed to each of them. Their work, when signed at all, is signed simply "Le Nain," which suggests that they thought of themselves as a

kind of firm, producing a standard product. The best paintings from their workshop are now generally attributed to Louis, who was born between 1600 and 1619 in Laon, and died in 1648. He painted religious pictures, sometimes in collaboration with his siblings, but also a group of impressive genre scenes featuring peasants. These, for all their superficial resemblance to Dutch paintings of the same type, have a gravity and simplicity reminiscent of the early Velasquez—most of all perhaps (despite the difference in scale) Velasquez's *Water Seller of Seville* (see page 266). One painting seemingly by Louis Le Nain which sustains this tremendous comparison is the *Peasant Family in an Interior* (Fig. **16.8**). Here, while the subject matter is completely humble, the mood is as hushed and solemn as in many *Last Suppers*.

Philippe de Champaigne (1602–74) shares the severity and quietism of Georges de La Tour and Louis Le Nain, but is also clearly influenced by Rubens. He became particularly identified with the Jansenists (see page 275), and in this sense is to painting what Pascal is to philosophy. His masterpiece—and justly his most celebrated work—was directly connected to Port-Royal. It is the *Ex Voto* (Fig. **16.10**) of 1662, painted to commemorate the recovery from illness of his daughter Catherine, who became a nun at the convent in 1657. One of the most profoundly moving religious works of the seventeenth century, it discards the whole theatrical apparatus which one expects to find in Baroque religious painting. Its effect is made through directness and simplicity: the sick nun reclines on a chair; the Abbess kneels beside her. The miracle is symbolized by no more than a ray of light, falling between them.

Charles Le Brun (1619–90) makes a striking contrast with the other painters so far mentioned in this section. While they remained on the margin of official life, and had little or nothing to do with producing official art, he was the dictator of French taste for a large part of the reign of Louis XIV, playing a major role in the history of French art, without being a great painter. His strengths and weaknesses can be judged from his *Tent of Darius* (Fig. **16.11**) of 1660–1, the painting which established him in the king's favor.

The vast canvas draws an implied and—needless to say—flattering comparison between Louis XIV and Alexander the Great, magnanimously receiving the family of the defeated Persian king. The loosened Classicism which is found here was something the contemporary audience found easier to absorb than Poussin's more stringent style. It owes as much to Rubens as it does to Raphael. The situation is carefully, even pedantically, delineated, with each person given a gesture or expression suited to his or her function in the narrative. Le Brun was putting into practice the principles of the Académie Royale—the official arbiters of artistic taste—founded in 1648 and dominated by himself after it had been thoroughly reorganized in 1663. The Académie was to continue to regulate French painting right up to the outbreak of the Revolution in 1789.

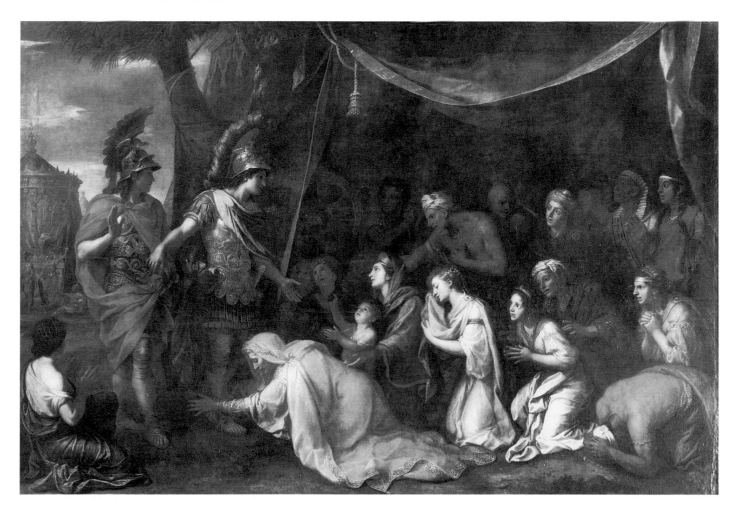

16.10 Philippe de Champaigne, *Ex Voto* 1662.
Oil on canvas, 65 × 90¼ ins (165 × 229 cm). Louvre, Paris.

16.11 Charles Le Brun, *The Tent of Darius*, 1660–61.
Oil on canvas, 117¼ × 178 ins (278 × 452 cm). Palace of Versailles, France.

Literature

Mme. de Sévigné and Mme. de La Fayette

The period of Louis XIV saw the birth of a new kind of literary situation, where women could at last hope to play a fully acknowledged role. For some time there had been groupings of literary women, ridiculed for their affectations in one of Molière's (see page 296) early comedies, *Les Précieuses ridicules* (1659). The best translation of the title is perhaps *Ridiculously Affected Women*—but their affectations, as the play demonstrates, revolve around the correct, "polite" use of language. Concerns of this sort were becoming a preoccupation, not so much at Versailles, as in the drawing rooms of Paris, where men and women met on equal terms to discuss the events of the day. The essence of these meetings was "conversation"—something a little more than ordinary social intercourse, which had become a kind of art form in itself. Men and women played the game on equal terms.

What this conversation was like is best preserved for us in the wonderful letters of Marie de Rabutin Chantal, Marquise de Sévigné (1626–96).

Most of Mme. de Sévigné's letters were written to her daughter the Comtesse de Grignan, absent in Provence where her husband was the king's Lieutenant-General (the equivalent of Governor). Mme. de Sévigné loved her daughter with a completely obsessive love, and wanted to keep her in touch with everything that was happening in Paris. The letters themselves, however, are not often obsessional in tone—in general they are sparkling, fresh, witty, and spontaneous. They have an informality, an eager curiosity about human feelings (and failings), which make them quite unlike the more formal literature of the day.

Though Mme. de Sévigné was only on the fringes of the court, she nevertheless took a keen interest in what happened there. This is the opening of a famous letter of December 1670, written not to her daughter, but to one of her cousins, Philippe-Emmanuel de Coulanges:

> What I am about to communicate to you is the most astonishing thing, the most surprising, the most marvelous, the most miraculous, most triumphant, most baffling, most unheard of, most singular, most extraordinary, most unbelievable, most unforeseen, biggest, tiniest, rarest, commonest, the most talked about, the most secret up to this day, the most brilliant, the most notable, in fact a thing of which only one example can be found in past ages, and, moreover, that example is a false one, a thing nobody can believe in Paris (how could anyone believe it in Lyons?), a thing that makes everyone cry "mercy on us" . . .

(MADAME DE SÉVIGNÉ, *Selected Letters*, translated by Leonard Tancock. Penguin Books Ltd., 1982.)

ITERATURE

Phaedra

The dramatic conventions inherited by Racine from the ancient Greeks laid it down that violent and spectacular events must always take place off stage. Here a minor character in *Phaedra* describes the death of Prince Hippolytus to his father Theseus, who has laid a curse on his own son which is now bloodily and unjustly fulfilled.

SCENE SIX
Theseus, Theramenes

Theseus: What have you done with him, Theramenes?
I put him as a boy into your hands.
But why the tears that trickle down your cheeks?
What of my son?
Theramenes: O tardy vain concern!
O unavailing love! Your son's no more.
Theseus: God!
Theramenes: I have seen the best of mortals die,
And the most innocent, I dare to add.
Theseus: Dead? When I open wide my arms to him,
The gods, impatient, hasten on his death?
What blow, what thunderbolt snatched him away?
Theramenes: Scarce were we issuing from Troezen's gates;
He drove his chariot; round about him ranged,
Copying his silence, were his cheerless guards.
Pensive, he followed the Mycenae road,
And let the reins hang loose upon his steeds.
These haughty steeds, that once upon a time,
Noble, high-spirited, obeyed his voice,
Now dull of eye and with dejected air
Seemed to conform to his despondent thoughts.
A ghastly cry from out the water's depths
That moment rent the quiet of the air.
From the earth's entrails then a fearful voice
Made answer with a groan to that dread cry.
Deep in our hearts our blood with horror froze.
The coursers' manes, on hearing, stood erect.
And now, there rose upon the liquid plain
A watery mountain seething furiously.
The surge drew near, dissolved and vomited
A raging monster from among the foam.
His forehead huge was armed with fearsome horns
And his whole body sheathed in yellow scales,
Half bull, half dragon, wild, impetuous.
His crupper curved in many a winding fold.
The shore quaked with his long-drawn bellowings.
The heavens beheld the monster, horror-struck;
It poisoned all the air; it rocked the earth.
The wave that brought it in recoiled aghast.
Everyone, throwing courage to the winds,
Took refuge in the temple near at hand.
Hippolytus alone, undaunted, stayed,

Reined in his steeds and seized his javelins,
Had at the monster and, with sure-flung dart,
Dealt him a gaping wound deep in his flank.
With rage and pain the monster, starting up,
Collapsed and, falling at the horses' feet,
Rolled over, opening wide his flaming jaws,
And covered them with smoke and blood and fire.
Carried away by terror, deaf, the steeds
No more responded to his curb or voice.
Their master spent his efforts all in vain.
They stained the bridle with their bloody foam.
In this wild tumult, it is even said,
A god appeared, goading their dusty flanks.
Over the rocks fear drove them headlong on;
The axle groaned and broke. Hippolytus
Saw his whole chariot shattered into bits.
He fell at last, entangled in the reins.
Forgive my grief. For me this picture spells
Eternal sorrow and perpetual tears.
I have beheld, my lord, your ill-starred son
Dragged by the horses that his hand had fed.
His voice that called them merely frightened them.
Onward they flew—his body one whole wound.
The plain resounded with our cries of woe.
At last they slackened their impetuous course.
They halted near the old ancestral tombs
Where all his royal forebears lie in state.
I and his guards hastened to him in tears.
The traces of his blood showed us the way.
The rocks were stained with it, the cruel thorns
Dripped with the bleeding remnants of his hair.
I saw him, called him; giving me his hand,
He opened and then straightway closed his eyes.
"Heaven takes my life, though innocent," he cried.
"When I am dead, protect Aricia.
Friend, if my father ever learns the truth,
And pities the misfortunes of his son,
And would appease me in the life to come,
Tell him to show that princess clemency,
To give her back . . .". And then he passed away,
And in my arms lay a disfigured corpse,
A tribute to the anger of the gods
That even his father would not recognize.
Theseus: My son, fond hope I have myself destroyed!
Inexorable, all too helpful gods!
What keen remorse will haunt me all my life!
Theramenes: Aricia then came upon the scene.
She came, my lord, fleeing your royal wrath,
Before the gods to pledge her faith to him.
As she drew near, she saw the reeking grass.
She saw, a grim sight for a lover's eyes,
Hippolytus, disfigured, deadly pale.
A while she tried to doubt her evil fate.
She sees the body of Hippolytus,
Yet still pursues the quest for her beloved.

But, in the end, only too sure 'tis he,
With one sad look, accusing heaven's spite,
Cold, moaning, and well nigh inanimate,
She falls, unconscious, at her sweetheart's feet.
Ismene, bending over her, in tears,
Summons her back to life, a life of pain.
And I have come, my lord, hating the world,
To tell you of Hippolytus' last wish
And to discharge the bitter embassy
Which he entrusted to me as he died.
But hither comes his deadly enemy.

Racine

(RACINE, "Phaedra" from *Phaedra and Other Plays*, translated by John Cairncross. Penguin Classics, 1963. © John Cairncross 1963. Reprinted by permission of Penguin Books Ltd.)

The flow is well-nigh irresistible as Mme. de Sévigné builds up gleefully to her surprise, which is that the Duc de Lauzun, a scapegrace Gascon soldier, is about to marry "with the King's permission, Mademoiselle, Mademoiselle de ... guess the name. He's to marry Mademoiselle, the great Mademoiselle, Mademoiselle, daughter of the late Monsieur, Mademoiselle, granddaughter of Henri IV ..." The ensuing frustration of the ill-matched love-birds' plans offers material for several more letters, each almost as delightful as the first in the sequence.

The psychological acuity which so often manifests itself in Mme. de Sévigné's letters also supplies the main material for a novel by one of her closest friends, Marie-Madeleine Pioche de la Vergne, Comtesse de La Fayette (1634–93). *The Princesse de Clèves*, published in 1678, is not the only novel she wrote, but it is considered much the best. Ostensibly historical, and set slightly more than a hundred years before the date of publication, at the end of the reign of Henri II of France (1547–59), *The Princesse de Clèves* in fact reflects the manners and attitudes of Mme. de La Fayette's own time. It is a tautly constructed love story which deals almost entirely in psychological states. About the heroine, we know only that she is beautiful and has fair hair; about the hero, the Duc de Nemours, we know even less—the reader is simply told that he is handsome, and has a reputation for being attractive to women.

Perhaps the most remarkable feature of the story is its climax. The princess, having virtuously resisted her lover is at last, because of the death of her husband, free to marry him. She refuses, and this is her reason:

> The fact is that I dare not expose myself to the misery of seeing your present love grow cold. It is sure to happen, it seems to me the most terrible of fates, and, since it is not my duty to risk it, I feel that I cannot do so. You are free, I am free, people may not have any reasons for censuring either of us if we decide to spend the rest of our days together, but in these eternal relationships does any man preserve his original passion? Can I expect a miracle in my case? And dare I put myself in a position where I shall be obliged to witness the inevitable death of a love in which lies all my joy?

> (COMTESSE DE LA FAYETTE, *The Princesse de Clèves*, translated by Nancy Mitford, revised Leonard Tancock. Penguin Books Ltd., 1978.)

In one sense this speech is unlikely, yet given everything that has gone before it is, in its mixture of idealism and hard-headed realism, completely convincing. Mme. de La Fayette has rightly been hailed as the inventor of the kind of narrative whose main interest lies, not in the characters' actions, but in the acute analysis of their minds and hearts.

Drama

Corneille, Racine, and Molière

The seventeenth century was the greatest age of French drama, which was classical in a more profound and rigorous sense than either the architecture of the period or any painting, with the sole exception of the work of Poussin. This drama—specifically tragedy—was given its particular character, first, by the insistence on the dramatic unities (the action had to take place at one spot, within the limits of a single day), and secondly, by the concern for psychological truth, combined with ease and lucidity of expression. French theorists could trace the unities back to Greek drama, but the other characteristics of French tragedy were very much an expression of the social and intellectual climate of the time—as much products of contemporary court life as of anything known to the Greeks. The emphasis on the all-transcending power of love, for example, evoked in many of the plays, was an expression of medieval rather than Greek and Roman tradition.

Unlike the tragedies of Shakespeare, French classical plays make use of a restricted, self-consciously purified vocabulary, with much greater emphasis on verbal music and subtleties of grammar than on simile or metaphor. The medium is verse, but since French versification does not recognize patterns of stress, the verses are given structure by rhyme. The standard unit is the couplet, consisting of two rhymed *alexandrines* (lines containing twelve syllables). On occasion, a single couplet can be irregularly broken up between two or more speakers.

The creator of the new tragic style was Pierre Corneille (1606–84). Corneille made his breakthrough with *Le Cid* (1636), a play which deviates in many respects from what was to become the standard formula. The plot does not respect the unity of place, and Corneille did not take his subject matter from either Greek myth or Greek and Roman history. In addition, the play does not seem to end unhappily—there is no tragic catharsis, and the resolution of the story is allowed to remain ambiguous.

Le Cid has enormous energy and panache. Its "tirades"—for example, the long speech in which the hero Rodrigue describes his victory over the Moors—have a clangorous metallic splendor. The play, because of these qualities, enjoyed great success with the French public of its time, but also aroused virulent controversy because of its

supposed breaches of dramatic decorum. This controversy took on official status when, in 1637, Cardinal Richelieu, Louis XIII's chief minister, referred the matter to the newly founded Académie Française. While praising Corneille, the Académie agreed that he had broken the rules. The dramatist, a proud man, was reluctant to accept their verdict, but his later tragedies, such as *Cinna* (1641) and *Polyeucte* (1642), adhere far more closely to the prescribed pattern.

Jean Racine (1639–99) had his first major success with *Andromaque* (1667), set amid the aftermath of the Trojan War. It was followed by a long string of triumphs, yet curiously enough, Racine's greatest play—his last classical tragedy—was a failure at the time, sabotaged by a malicious court cabal. *Phèdre* (1677) concerns Phaedra, second wife of King Theseus of Athens, who is consumed with guilty love for her stepson Hippolytus. It introduces a theme which was new to Racine's work, and to French classical drama in general—an obsession with the notion of sin. This may have been a throw-back to the playwright's Jansenist upbringing—his aunt was Abbess of Port-Royal.

In general, however, the strange thing about Racine's plays, certainly in terms of their time, is that they are tragic but neither moral nor moralistic. His characters—for example, Nero in *Britannicus*—often come straight from Machiavelli's *The Prince* (see page 190), and only occasionally get their just deserts. The plays themselves are fire within ice—as merciless in their demands on the audience as the playwright is to his own characters.

A third great playwright in seventeenth-century France was Molière (Jean-Baptiste Poquelin, 1622–73). Unlike either Corneille or Racine, Molière was a complete man of the theater, producing plays and acting in them as well as writing them. As a young man he formed a theatrical company in Paris—it failed—and then spent a number of years touring in the provinces. His troupe returned to the capital in 1658 and was able to establish itself successfully under the patronage of the king.

Molière was given permission to share a theater with an Italian *commedia dell'arte* company (see page 320), and many of his early plays borrow ideas from the traditional *commedia*, and use versions of its stock characters. But his writing soon covered a wide range. There were farces, satires on contemporary foibles, comedy-ballets designed for the court (the king himself often appeared in them, in suitably glamorous roles), and finally there were comedies of character.

These weightier plays are Molière's finest achievement. *Le misanthrope* (1666), for example, transcends the usual comic conventions. It is about a man, Alceste, who conceives himself to be the only honest individual in a hopelessly corrupt society, while being jealously in love with a pretty coquette who has no intention of rejecting worldliness and conforming to his standards. In one sense, Alceste is simply in the wrong play—he aspires to be a hero—and he is also hopelessly self-satisfied, play-acting virtue as well as being genuinely virtuous. This makes him, but only just, a comic rather than a tragic figure.

The fascination of Molière's major comedies is that, far more than in the tragedies of Corneille and Racine, the characters take charge and run away with the narrative. Corneille and Racine also wrote comedies, and it is interesting to note that in Corneille's best comic piece, *Le menteur* (*The Liar*) (1643), the plot mechanism is actually neater than anything devised by Molière, the professional in this field.

Music in seventeenth-century France

The development of music in France during the seventeenth century was dominated by Jean-Baptiste Lully (1632–87), who played a role analogous to that of Charles Le Brun in the visual arts. Like Le Brun, he was an able organizer rather than a great creative spirit. Florentine-born, Lully came to France as an adolescent. He was originally in the service of a Princess of the Blood, Mlle. de Montpensier (the heroine of Mme. de Sévigné's letters, see page 284); he successfully transferred himself to that of the king, when Mlle. de Montpensier was exiled from Paris in 1653. Louis XIV employed Lully to turn out music for the court ballets. These entertainments, in which Louis himself performed, became the vehicle for the ambitious Lully's social and professional success.

In 1664 he collaborated with Molière in the creation of a comedy-ballet for performance at court. This was essentially a feather-light comedy with elaborate musical interludes. In 1670 the two men collaborated on *Le Bourgeois Gentilhomme*, which was one of Molière's finest comic texts. The musical interludes were in supposedly Turkish style, inspired by a recent Turkish embassy to France. Lully was not satisfied with playing second fiddle to Molière's genius. In 1672, by diligent intrigue, he succeeded in taking over the recently founded Académie Royale de Musique, and

made himself thenceforth the dictator of music in France.

The Académie Royale was responsible for the production of the first French operas—*tragédies-lyriques* with music by Lully and texts by the minor poet Philippe Quinault, modeled on the classical tragedies of Corneille and Racine, but with lavish additions of dance and spectacle. These operas, the most innovative part of Lully's work, were rooted in the very early attempts at the form made by Lully's fellow Florentines Peri and Cavalli. The sung music avoided lyric expansiveness, and stuck firmly to the inflections and rhythms of spoken French. This helped to create a specifically French tradition of vocal writing.

Chapter 17

Protestant Baroque

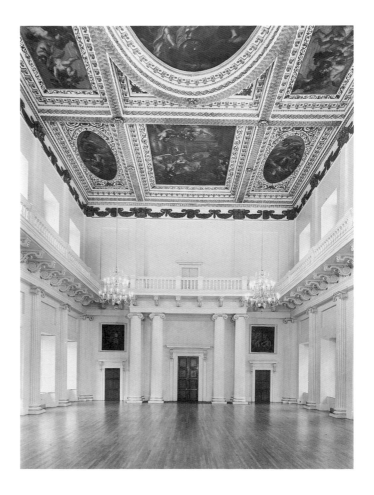

17.1 **Inigo Jones**, the interior of the Banqueting House at
Whitehall, London, completed in 1622.

Holland and England

Seventeenth-century Holland and seventeenth-century England were similar to one another in many important respects. Both were Protestant states and in the course of the century both became major maritime powers, dependent on overseas trade and with an increasing number of colonial possessions. Economic rivalry made friction inevitable between them, and this was felt from the beginning of the century, but did not reach a condition of declared and open warfare until the First Dutch War broke out in 1652. Naval conflicts continued until both countries came under the same ruler, William III (1689–1702). Already Dutch Stadtholder, William became king of England thanks to the Glorious Revolution of 1688, which displaced his father-in-law, James II (1685–8). Under William's leadership, England and Holland allied themselves in order to keep in check the ambitions of Louis XIV of France (see page 276).

Despite the resemblances, there were also marked differences between the two countries. Holland, a confederation of Netherlandish provinces which had belonged first to the French Dukes of Burgundy, then to the Hapsburg rulers of Spain, was a new nation. Its provisional independence was confirmed by a truce of twelve years signed with the Spanish government in 1609, but only fully and finally established by the Treaty of Westphalia in 1648. During this period, the United Provinces, as they were generally called, became the most important trading nation in Europe, and the city of Amsterdam developed into Europe's most important port, at the expense of Antwerp, which remained in Spanish hands.

As a nation, England was much less successful than Holland during the first half of the century, largely due to conflicts between the English monarchs and their subjects. In England, issues of civil and religious toleration, settled early in Holland, led to civil conflict and much bloodshed. The first two Stuart kings, James I (1603–25) and Charles I (1625–49), would have liked to establish an absolutist monarchy following the continental model, but were prevented from doing so by the strength of the English parliamentary tradition. Charles I's inept handling of questions of money supply and the royal prerogative, combined with growing religious conflict, led to a civil war (1642–9) which cost him his life. The Commonwealth government of 1649–60, led for most of its existence by the forceful Oliver Cromwell (1599–1658), established the future character of English society, which was henceforth to be bourgeois and mercantile, not aristocratic.

The next two Stuart reigns, those of Charles II (1660–85) and James II, were a period of transition. Despite the political turmoil of the period, certain norms of free speech and toleration were established. James, a Catholic convert, paid for interfering with these by the loss of his throne.

Philosophy

Hobbes, Spinoza, and Leibniz

Philosophical speculation flourished more vigorously in the Protestant sector of seventeenth-century Europe than it did in the Roman Catholic one. It is tempting to put this down to a more tolerant climate of opinion, and certainly Descartes seems to have spent so much of his life in Holland rather than in his native France because he felt more at liberty there. Yet the liberty accorded to speculative thinkers was not absolute. Hobbes, who divided his life between England and France, not only encountered censorship but suffered anxiety about the harm his opinions might do him. Spinoza spent his life in strict retirement, and made the decision not to publish his most important work because it was too controversial.

Hobbes, Spinoza, and Leibniz can be grouped together for positive reasons, not simply because they shared—and that only in a very loose sense—a Protestant context. All three belonged to the new intellectual world created by the sudden upsurge in the physical sciences. All were, in a philosophical sense, materialists—that is, they gave the physical world of matter a primary position, and they accepted its physicality as a fact. All were essentially determinists, that is they believed that our choices are essentially made for us by antecedent causes, not by our own decisions, though there is evidence that both Spinoza and Leibniz tried to find ways of escape from the harsher conclusions imposed by this. And, finally, all owed a good deal to Descartes, though they often resisted his conclusions.

Thomas Hobbes (1588–1679), like Descartes, was led into philosophy by Euclidean geometry, which seemed to offer the possibility of genuinely incontrovertible methods of proof. The fascination of Euclid first struck Hobbes in 1629. His philosophical interests were further developed by travels on the continent from 1629 to 1631 and from 1634 to 1637. In the 1640s he became embroiled in the politics of

the English Civil War. He wrote a tract asserting that royal authority existed by "natural right," and was forced to flee to France. Under the Commonwealth he was for a while tutor to the exiled Charles II, who later described Hobbes as "the oddest fellow I ever met with."

In 1651, just after publishing his most famous book, *Leviathan*, Hobbes returned to England. After this he was always regarded as suspect by his former friends the royalists, despite the fact that *Leviathan* seemed to contain arguments for the most absolute of absolute monarchies.

Hobbes's belief is that the individual, to insure his or her own safety, must surrender all authority to some central power—that is, the sovereign, or ruler, became "God's lieutenant, to whom in all doubtful cases we have submitted our private judgments." This belief introduces the idea of a social contract, later to be taken up in different form by Rousseau (see page 348). Hobbes is a psychological hedonist—he believes that our ultimate motive is a desire for our own happiness. He is also an ethical hedonist—he thinks that nothing can be intrinsically good but this happiness. Finally, he seems to think that the soul itself is material, and that the body is a kind of automatic machine. This credo made him a pessimist in political matters. The state was the Leviathan of his title—the only organism which, like the

monster in the Book of Job (Ch. 41), can be "without fear." Individuals are, throughout their lives, filled with fear and engaged in an almost purely negative endeavor, the struggle for self-preservation.

Put beside that of Spinoza, Hobbes's thinking tends to look crude. Spinoza was, however, much less influential in his own day, as so little of his work was published in his lifetime. The first major philosopher of Jewish origin in the modern epoch, Benedict (Baruch) Spinoza (1632–77) was born in Amsterdam, the son of Portuguese Jewish immigrants. He was soon expelled from the Jewish community because of his heterodoxy, and thus became, willy-nilly, the first of the great European thinkers to occupy a kind of religious limbo, with no strong attachment, negative or positive, to any religious faith.

Spinoza's most important book is the *Ethics*, completed soon after 1666. The book is written in Latin, and its arguments are presented in an old-fashioned form familiar from medieval scholasticism as a series of propositions, each followed by a proof, which in turn is usually followed by one or more corollaries.

Where Hobbes tackles political problems in isolation, Spinoza begins at a much more basic level, and begins with the mind–body relationship—that is with one of the funda-

17.2 Religious divisions in Europe *c.* 1600.

mental questions raised by Descartes and, in the opinion of most of his readers, not answered satisfactorily by him. Unlike Descartes, Spinoza does not feel that the two are unlike in nature. On the contrary, they are essentially one and the same. He also objects to ascribing volition and deliberate action to God, on the grounds that mind and body are both already divine manifestations. These ideas bring him close to recommending a kind of Buddhist passivity.

Spinoza escapes from this by recommending a method which has been likened to modern psychology—the deliberate heightening of self-consciousness, and the recognition of the unconscious struggle to achieve internal adjustment. He thinks that human life consists of a drive toward self-preservation, but that this drive is largely unconscious. When it is blocked or frustrated, this creates inner disturbances, whose root cause may not be immediately apparent. What other philosophers would define as vice or wickedness is for Spinoza simply a diseased state. He is thus the first to reduce human beings to the level of simply another organism, though perhaps a uniquely complex one, within the general context of nature. He is also the first to deny that humankind has been created for some specific purpose.

Toward the end of his life Spinoza was in contact with the German Gottfried Wilhelm Leibniz (1646–1716), who represents the transition from the philosophical attitudes of the seventeenth century to the more optimistic ones of the eighteenth. Like Hobbes and Spinoza before him, Leibniz regarded the world as causally determined throughout, and held that any event for which there was "no sufficient cause" was *ipso facto* nonsensical. Yet, certainly far more than Hobbes, he also stressed the infinite complexity of the created universe, which might mean that some causes would remain concealed. While accepting Descartes's view that cognition was the essential attribute of the mind, Leibniz maintained that this cognition need not be conscious, since both thoughts and the sensations on which they were based were so often confused.

Leibniz is now best remembered for the notion that the world we live in is simply one of an infinite number of possible worlds, and for his eventual corollary to this that "everything is for the best in the best of all possible worlds" —a formulation that would be cruelly ridiculed in Voltaire's novella *Candide* (see page 345).

English architecture

Jones and Wren

During the seventeenth century England produced very few native-born artists of any note. It did, however, produce a remarkable group of architects, and architecture became the summit of visual expression in England. This is all the more surprising when one considers the violence of political events, in particular the cultural hiatus imposed by the Civil War. There was one English misfortune, nevertheless, which actually promoted the progress of architecture: the Great Fire of London in 1666, which, by devastating the nation's capital, gave full scope to the genius of Christopher Wren.

The great English architects of the period were, with one exception, amateurs who turned to architecture after succeeding in some other occupation. All were heavily dependent on the royal court and aristocratic patronage. The pioneer in the creation of a new architectural style was Inigo Jones (1571–1652). He was also, as a result of the turbulent politics of the first half of the century, the one who built the least. Jones first established himself as a stage-designer, working on the elaborate masques which were fashionable at the Stuart court. A visit to Italy brought him into contact with the work of Andrea Palladio (see page 219) and in 1615, soon after his return, he was made Surveyor of the King's Works, in charge of the royal residences.

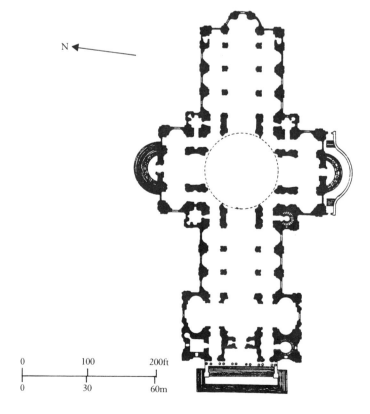

N ←

| 0 | 100 | 200ft |
| 0 | 30 | 60m |

17.3 Christopher Wren, (*right*) St. Paul's Cathedral, London, 1675–1710. (*above*) Plan of St. Paul's Cathedral.

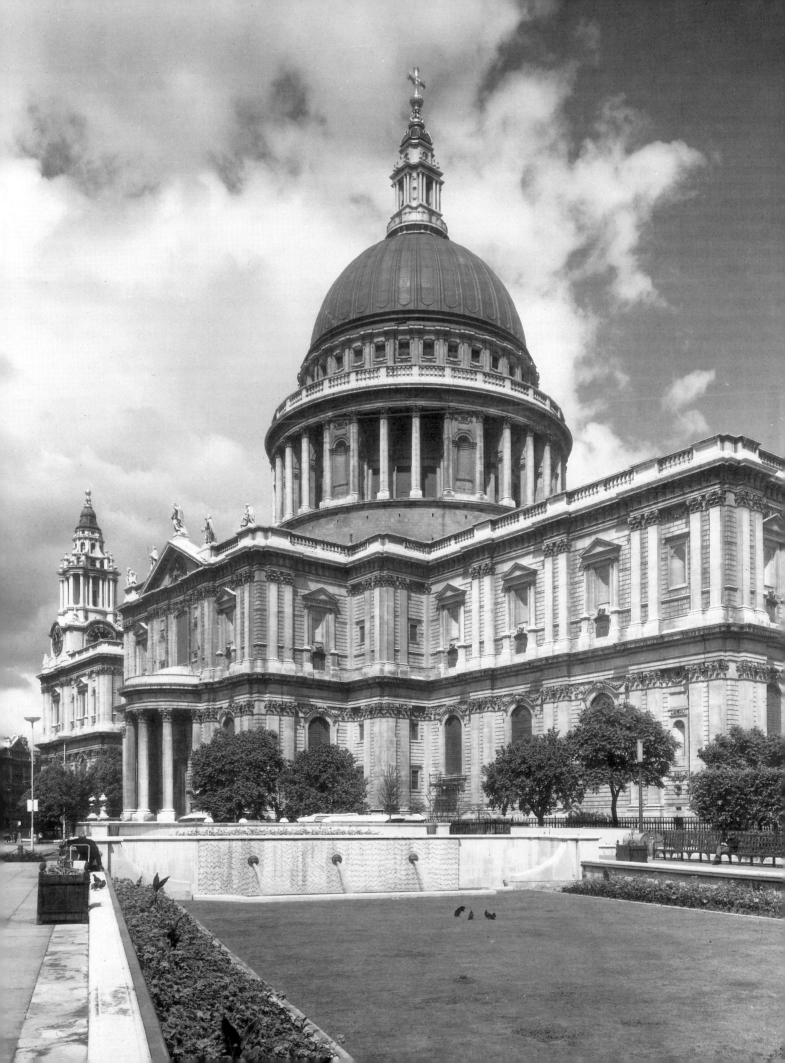

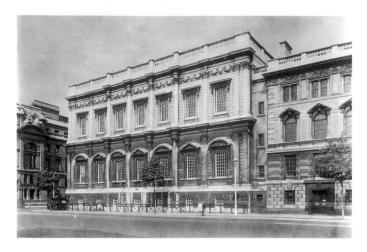

17.4 Inigo Jones, the exterior of the Banqueting House at Whitehall, London, completed in 1622.

His best-known, and least-altered, surviving work is the Banqueting House (Figs. **17.1** and **17.4**) in Whitehall, London, completed in 1622 and an absolutely revolutionary building for its time, at least in English terms. It was a splendid setting for the absolutist fantasies of the Stuart monarchs, and the intended seed from which a new Palace of Whitehall would grow. Both the interior and the exterior of the building are dependent on Palladio. The interior is a response to Palladio's ideas about the forms of ancient Roman basilicas. The exterior is more personal. It consists of seven bays of superimposed columns, with the middle bays projecting slightly. The lower columns are Ionic; the upper are Corinthian (see page 55). The entire wall surface is rusticated, and there are garlands hung from rams' heads above the upper tier of windows. The effect is more intricate and delicate than that of any façade designed by Palladio himself.

The Banqueting House itself and perhaps even more the collection of Inigo Jones's architectural designs which came into the hands of Lord Burlington in the eighteenth century were largely responsible for the rise of the Palladian movement seventy years after the architect's death. Jones's designs also had an impact on his most important immediate successor, Christopher Wren (1632–73), who was originally an astronomer and mathematician.

Wren's most famous work—his personal monument, as he himself realized—is St. Paul's Cathedral (Fig. **17.3**) in London. The chance to build a great cathedral from scratch was an opportunity offered by the Great Fire of 1666, which consumed the old and already very dilapidated one. Shortly before the fire, Wren had been called in to advise on repairing the old building, and even at that stage he had had the idea of adding a dome, rivaling that of St. Peter's.

Christopher Wren's cast of mind was empirical rather than theoretical—his design evolved in slow stages rather than being all of a piece. Like Bramante before him (see page 191), Wren was attracted by the idea of a centrally

planned domed structure, but a building of this type suited Church of England liturgy no better than it did the Roman Catholic variety. Another objection was that a centrally planned building would have to be built all at once, while the more traditional Latin cross design could be erected by stages. Wren lost the argument over central planning, but had his way over all other features of the building.

Compared with the churches built by Bernini and Borromini, St. Paul's is conventional in plan. It is also more varied in its arrangement of spaces than the large churches built by the first generation of Baroque architects in Rome, under the leadership of Carlo Maderno. Wren does not mold and manipulate space; he adds one space to another in a gently undulating rhythm, well expressed by the series of saucer domes which roof the nave. The architectural detail has a cool precision reminiscent of Mansart's buildings which Wren had studied on a visit to Paris, but the Mannerist residue is less apparent in his work than it is in Mansart's. Wren's is an architecture of order and clarity, of progressions of simple shapes. While it is certainly Baroque in a general sense, it is averse to dramatic shock effects. In this sense it prepares for the reversion to doctrinaire Palladianism which took place in England in the next century.

Hawksmoor and Vanbrugh

Before the return to Palladianism there occurred the strange and exciting episode represented by the work of Nicholas Hawksmoor (1661–1736) and Sir John Vanbrugh (1664–1726), who sometimes worked independently and sometimes in close collaboration with one another. Hawksmoor became Wren's assistant at the age of eighteen, and played an increasingly important role in his master's office. His first fully independent works date from the 1690s, and his alliance with Vanbrugh was cemented in 1699.

The buildings by Hawksmoor which now seem most exciting and individual date from late in his career. In particular, there is the group of churches which he built in East London. Following on from the numerous churches Wren designed for the City of London in the wake of the Great Fire, they were intended to cater for the religious needs of the city's ever-expanding population. His best-known London church, Christ Church, Spitalfields (Fig. **17.5**), begun in 1714, uses bold, heavily classical elements, such as the Tuscan columns on high bases which support the portico, to build up what are basically Gothic shapes. Thus the portico imitates the form of a Venetian window, with three openings, the central one arched and higher than the others, but at the same time alludes to a traditional Gothic entrance portal.

Vanbrugh's work is also backward looking. It owes much to the great country houses built by the Elizabethans. His masterpiece is a great country house, Blenheim Palace in Oxfordshire (Fig. **17.6**), begun in 1705 to commemorate

the Duke of Marlborough's victories over the French, and in particular his victory in August 1704 at Blenheim on the Danube, a turning point in the War of the Spanish Succession in which England and her allies opposed Louis XIV. Blenheim is a reversion to Elizabethan architecture at its most ostentatious and "prodigious," but it is more unified than its predecessors. Vanbrugh seems to have thought of the building as a single massive piece of habitable sculpture, and in this sense at any rate it is Baroque. Blenheim demonstrates two things in equal measure—the new self-confidence which was to make England into a world power in the eighteenth century, and the tenacious adherence to tradition which, though it manifested itself in different forms, was to be the mark of English architecture for two centuries to come.

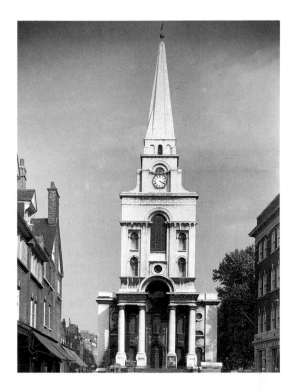

17.5 Nicholas Hawksmoor, Christ Church, Spitalfields (west front), London, begun 1714.

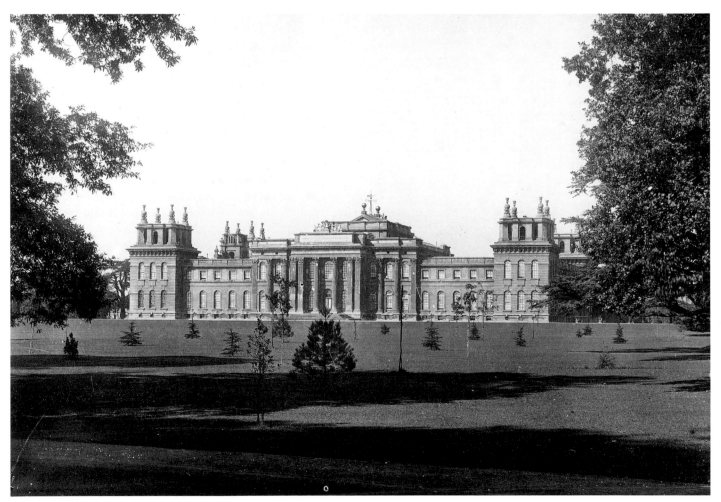

17.6 Sir John Vanbrugh, Blenheim Palace (south front), Oxfordshire, begun 1705.

Dutch painting

Hals and Rembrandt

The Dutch art of the seventeenth century often seems like a separate episode, cut off from what preceded it by the religious and political revolution against the Spanish Hapsburg monarchy which created the Dutch republic. The problem of integrating it within a general history of Western culture is complicated not only by the large number of talented artists but also by the large number of different genres which they practiced, usually specializing in just one. While "history painting" as the supreme manifestation of the painter's art continued to receive support from Dutch art theorists, on the same basis as it did elsewhere in Europe, such support was largely ineffective. This can be partly explained on religious grounds. The Calvinist faith, which of all the Protestant creeds had by far the largest number of local adherents, was hostile to religious images, though not to painted images as such. In addition, the private patrons most Dutch artists catered for did not want to surround themselves with elaborate, pompous paintings. The local passion for collecting pictures was rivaled only by that for collecting natural rarities, such as exotic seashells and new

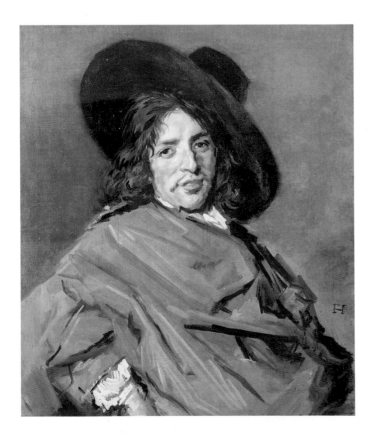

17.7 Frans Hals, *Portrait of a Man in a Broadbrimmed Hat* 1665. Oil on canvas, 31½ × 26⅜ ins (80 × 67 cm). Fitzwilliam Museum, University of Cambridge, England.

species of tulip; and art, like these "natural curiosities," became a new commodity, to be traded, admired, and accumulated, but not necessarily displayed in a princely setting.

Like their aristocratic betters, however, Dutch bourgeois patrons were very interested in commemorating themselves. They bought representations of landscapes, architecture, ships, and the sea, domestic interiors and also still lifes, but one of their ruling passions was portraiture. Many of the finest Dutch portraits are likenesses of comparative nobodies, but they have unrivaled penetration of character.

The earliest of the great Dutch portraitists is Franz Hals (1581/5–1666). His free and fluent brushwork is very different from that associated with Dutch painting in general, and seems to make him the northern equivalent of Velasquez, though the subjects he paints are usually far more extrovert than the somber personages the Spaniard depicts.

The range of Hals's art is remarkably restricted. The bulk of it consists of half-length and three-quarter-length portraits, each containing a single figure. In painting these, he obviously had to consider the wishes and preconceptions of his sitters, so the range of possibilities open to him was fairly narrow, but he seems to have deliberately narrowed it further by not experimenting much with the poses he used.

His characteristic approach is represented by the *Portrait of a Man in a Broadbrimmed Hat* (Fig. **17.7**), which comes from the very end of his career. The sitter adopts a pose Hals had used before, with one arm set akimbo as a sign of energy and extrovert vitality. In this late work, Hals's confidence in his own formula has become absolute.

Hals is sometimes accused, especially when his portraits are compared with those by Rembrandt, of superficial characterization. In fact he defines character in rather a different way from any other seventeenth-century portrait painter. His objectivity extends to an acceptance of the proposition that character, like the paints the artist uses, is essentially fluid, and may vary from moment to moment. The portrait I have just cited demonstrates why Hals is pre-eminently an artist's artist, conveying things in paint which it is impossible to communicate in any other fashion.

The greatest artist of the Dutch School, at first sight very different from any of his contemporaries, is Rembrandt Van Rijn (1606–69). During his first period of work—spent in Leyden—he was by profession a historical painter. Such portraits as he produced were of members of his family, done for his own instruction and pleasure. He also began his lifelong practice of making self-portraits.

In 1631 Rembrandt moved to Amsterdam, and there he began to look for portrait commissions. He established himself in this particular market by means of a group portrait, *The Anatomy Lesson of Dr. Tulp* (Fig. **17.8**). These group portraits were typical of the collective character of Dutch

society in the seventeenth century, but this example far surpassed anything which had been seen previously in Amsterdam. *The Anatomy Lesson* used a novel and horrific subject as a way of achieving a traditional aim. Rembrandt's work, and especially portraits of all kinds, became very much sought after, and made him financially successful. He married well—his wife, Saskia van Uylenburgh, was a girl from a rich patrician family. It was evidently a love match, and Saskia became one of her husband's favorite models.

The 1640s were years of personal misfortune for Rembrandt. Saskia died in 1642. Her widower could not remarry because of conditions in her will which meant that he would lose the income from her estate if he did so. Rembrandt's financial affairs grew ever more muddled, and he sank deep into debt. Even so, this was the period in which he painted his most ambitious pictures, including *The Night Watch* (Fig. **17.9**) of 1642. This is another group portrait, of one of the Dutch militia companies which,

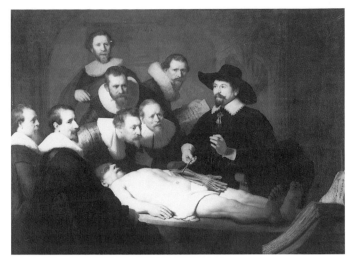

17.8 Rembrandt Van Rijn, *The Anatomy Lesson of Dr. Tulp*. Oil on canvas, 66⅝ × 85¼ ins (169.5 × 216.5 cm). Mauritshuis, The Hague.

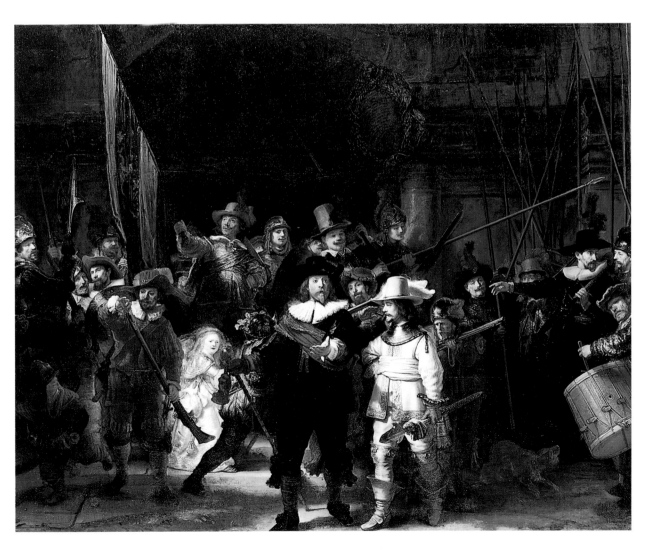

17.9 Rembrandt Van Rijn, *The Night Watch* 1642. Oil on canvas, 146 × 175 ins (370 × 444.5 m). Rijksmuseum, Amsterdam.

OCUS

Rembrandt's Self-Portraits

Though Rembrandt is celebrated for his self-portraits, he was by no means the first artist to practice self-portraiture. The Netherlandish artists of the fifteenth century, for example, had sometimes represented themselves in the guise of St. Luke, painting the Virgin. Dürer (see page 210) did not need even this allegorical excuse. What was novel in Rembrandt's case was both the sheer quantity of his self-portraits and their variety. Through their numbers alone, they added up to an emphatic assertion of the artist's place in society, and of the contribution made by his personality to the value of his art. That is, they contradicted the idea that painting pictures was primarily a craftsman's activity, like making chairs or tables—something where the patron's preferences must automatically take first place. This idea had been widely prevalent throughout the Middle Ages.

Rembrandt's self-portraits can be divided into three groups, corresponding to three different phases in his career. The first group, painted, drawn or etched when he was still living in Leyden, before his move to Amsterdam in 1631–2, are often studies in expression. Some were actually

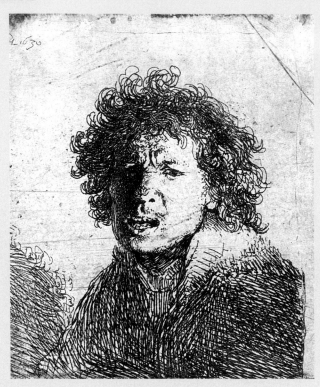

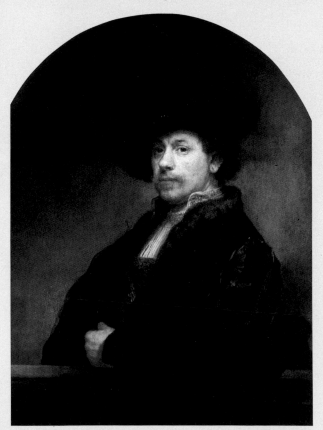

Rembrandt Van Rijn, *Self-Portrait aged 34*, 1640. Oil on canvas, 40 × 31½ ins (101.6 × 80 cm). National Gallery, London.

Rembrandt Van Rijn, *Self-Portrait open-mouthed as if shouting* 1630. Etching. Rijksmuseum, Amsterdam.

used as studies for larger and more ambitious works. Thus the tiny etching, *Self-Portrait open-mouthed, as if shouting*, was used as a source for the head of Christ in the painting *Christ on the Cross*.

After his move to Amsterdam, Rembrandt's interest in self-portraiture changed direction. Paintings showing his own image became meditations on the artist's role and status. Often they show Rembrandt wearing some version of fancy dress, and equally often they make reference to the great art of the past. An example is *Self-Portrait at the Age of Thirty-four*. The clothing Rembrandt wears belongs, not to his own day, but to the first half of the sixteenth century. Drawings of actors dating from the time when the portrait was painted suggest that one source of inspiration may have been the historical plays put on by the Amsterdam town theater. It is also clear, however, that Rembrandt looked carefully at earlier works of art—the pose used in this self-portrait derives directly from a portrait by Titian, the so-called *Ariosto*. Rembrandt was thus deliberately measuring himself against a celebrated predecessor.

In his final group of self-portraits Rembrandt's approach is simpler and more direct. A late *Self-Portrait* shows him as

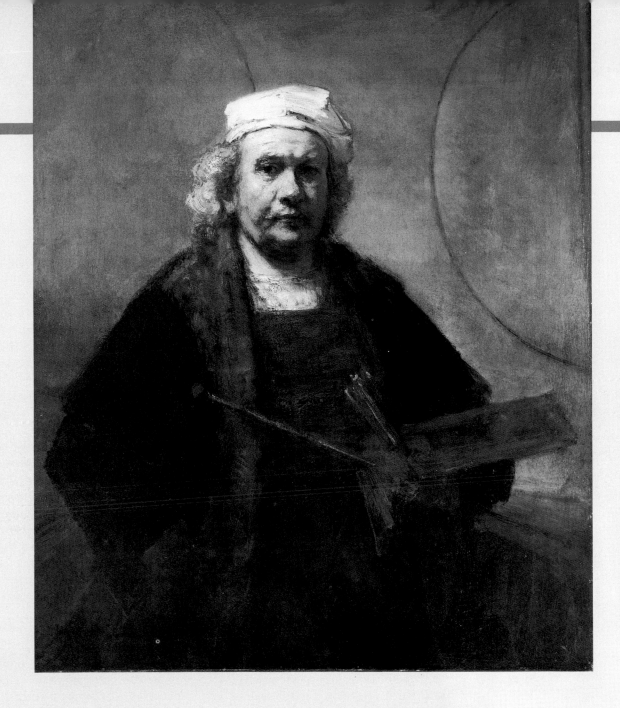

a working painter, carelessly dressed, holding a palette and brushes. At first sight, the way in which he now presents himself seems to correspond exactly with the account given by his contemporary biographer Filippo Baldinucci:

> The ugly and plebian face by which he was ill-favored was accompanied by untidy and dirty clothes, since it was his custom when working to wipe his brushes on himself, and to do other things of a similar nature. When he worked he would not have granted an audience to the first monarch in the world, who would have had to return again and again until he had found him no longer engaged upon that work.

<div align="right">(H. PERRY CHAPMAN, Rembrandt's Self-Portraits.
Princeton University Press, 1990.)</div>

Rembrandt Van Rijn, *Self-Portrait c.* 1665. Oil on canvas, 45 × 37 ins (114.3 × 94 cm). Iveagh Bequest, Kenwood, England.

Nevertheless the power and dignity of the actual portrayal contradict the denigratory tone of Baldinucci's description. There is in fact a proud assertion of the painter's powers, and his own awareness of them, in the background of the picture. The two large, partially visible circles on the wall behind Rembrandt seem to refer to a then well-known image of artistic virtuosity, the perfect circle drawn freehand. Giotto (see page 144) was traditionally supposed to have drawn just such a circle when asked to submit a demonstration of his skill to the pope. Rembrandt was thus once again, but now more subtly, aligning himself with the great artists of the past.

though not particularly effective from a military point of view, provided an important social focus for prosperous citizens. A company of Amsterdam musketeers is marching out—actually in daylight—under the command of their captain, Frans Banning Cocq. The picture was painted for the Great Hall of the Musketeers' Guild, and seventeen of the twenty-nine figures are named portraits—their names appear on a shield in the background. The true originality of the painting is that it is not static. A narrative element is fused with collective portraiture.

In the 1650s Rembrandt's financial troubles came to a head. He was forced to move out of his large house and into a much poorer quarter of Amsterdam. An increased contemplativeness typifies this period of his work. In the late self-portraits he examines himself in every mood—wounded and vulnerable, ironic or philosophically calm (see page 298). In one respect, though, these self-portraits have done Rembrandt a disservice, for they have encouraged his admirers to concentrate on his personality instead of his art.

Rembrandt is one of painting's expert technicians. His greatest gift is his control of tone. An enveloping chiaroscuro fills his paintings without concealing anything he wants to show us. Despite all this, though, his apparent individuality only half conceals the fact that, from the very beginning of his career, he had large numbers of pupils and assistants. His workshop was differently organized from that of Rubens. With Rubens, collaboration is often obvious; in Rembrandt's case it is difficult to point to works which are obviously joint efforts—in part by Rembrandt himself, and in part by other, inferior hands. Yet there are many paintings which come deceptively close to Rembrandt, and which are contemporary with him though not by him. These even include a number of apparent self-portraits. As recent art historical research has suggested, Rembrandt may have been following the commercial patterns of the Dutch society of his time, and promoting a "brand image." The financial shifts to which he resorted after his bankruptcy were part of the same way of thinking—using a stable of pupils who imitated his style, and whose products were sold under his name.

Vermeer and Dutch genre

Though Rembrandt ranks in most people's minds as the greatest Dutch painter, his art nevertheless runs contrary to the impression made on us by the seventeenth-century Dutch School taken as a whole. Essentially Dutch art is associated with genre painting, and through genre a commitment to a certain kind of realism. Though the word "genre" can mean simply a "kind" or "sort" of painting—and in this sense it is often employed in the plural—it can also be used to designate paintings which show scenes from daily life.

Much of the earliest Dutch genre painting consists of low-life scenes, such as those which feature in the work of Adriaen Brouwer (1605/6–38). Brouwer has been unfortunate on two counts—first, he fits awkwardly into histories of Dutch art because he was in fact a Fleming, and secondly, the coarseness of his subject matter offends the squeamishness of our own age. Even the exquisite refinement of his technique works to his disadvantage, as it seems to clash with the brutality of what he shows.

The relationship between Brouwer's paintings and those produced by Pieter Bruegel the Elder (see page 223) is unmistakable. Both painters show the same stubby figures, with coarse faces and abrupt, violent gestures. Yet it is also obvious that Brouwer worked in a very different spirit. While Bruegel records peasant behavior for an aristocratic audience that knows it belongs to an entirely different species, Brouwer identifies with his subjects in a far more personal way. He relishes their grossness, and stresses it as a commentary on the general nature of humankind. *Peasants Guzzling* (Fig. **17.11**) is typical of much of his work because it shows human beings without their masks, reduced to their most basic appetites.

Brouwer's emotional violence makes a strong contrast with the still, reserved art of the greatest genre painter of the next generation, the Delft artist Jan Vermeer (1632–75). There is also a striking difference in the kind of social milieu Vermeer depicted: he is not a painter of low life, but shows the prosperous Dutch bourgeoisie. Vermeer started his career as a history painter, and was a recognized expert on Italian art, so his choice of genre painting as a vehicle for personal expression is the more striking. Because of the complexity of his aims, he matured slowly, and only became truly himself around 1658.

Vermeer's mature paintings were probably painted directly from life. In order to exercise the utmost control over his material, he put strict limits both on the number of personages and the number of objects shown. His characteristic method was to place what he wanted to show in the corner of a room (often, it would seem, the same room) beside a window which offered a full but even fall of light. It is this light which is his main concern, whatever the ostensible subject of the picture. He uses it to define spatial relationships, to pick out differences of texture, and he also endows it with an independent existence of its own, sometimes making its passage more visible with sparkling specks of paint.

Vermeer reached the highest pitch of refinement in his *Woman Holding a Balance* (Fig. **17.10**). This demonstrates the contrasting yet not conflicting ways in which his art can be analyzed. On the one hand, the painting can be regarded as a triumph of abstract design—a pattern composed entirely of horizontals and verticals; on the other, it can be read as an allegory, the key to which is the *Last Judgment* hanging on the wall, Christ's weighing of souls being contrasted with the woman's weighing of earthly wealth.

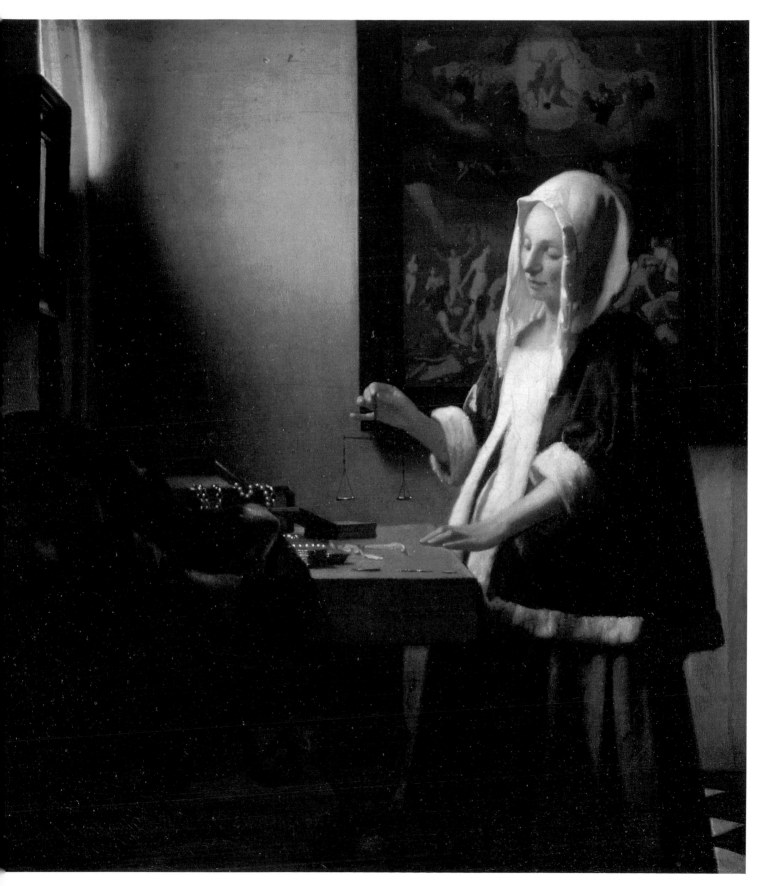

17.10 Jan Vermeer, *Woman Holding a Balance* 1664.
Oil on canvas, 16¾ × 15 ins (42.5 × 38 cm). National Gallery of Art,
Washington. Widener Collection.

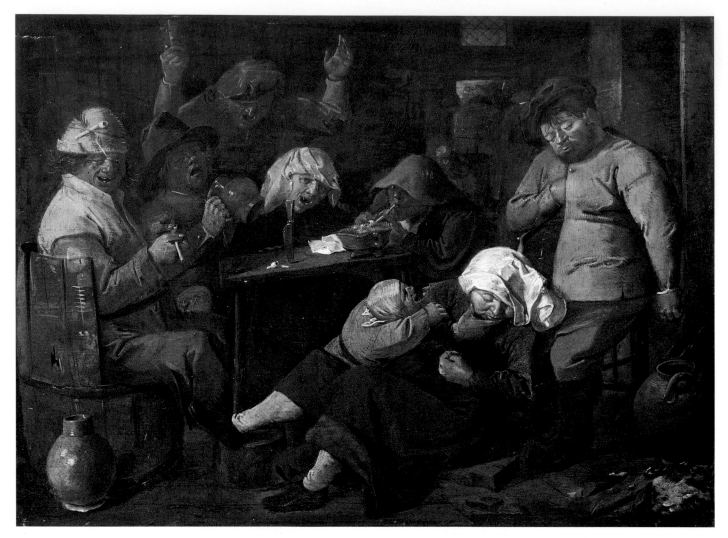

17.11 Adriaen Brouwer, *Peasants Guzzling*. Oil on panel,
19½ × 26½ ins (49.5 × 67.3 cm). Rijksmuseum, Amsterdam.

Landscape and still life

In addition to being specialists in genre painting, Dutch artists concentrated on landscape and still life, both of which were in turn subdivided.

Dutch landscape painting of the seventeenth century often bears an unexpected resemblance to today's abstract art. Abstract art is pure form; Dutch landscape painting is, on the face of it, pure description—in apparently opposite ways, both make words seem clumsy and superfluous. Yet it is also possible to trace a line of development in Dutch landscape which can be considered in isolation from what the pictures actually depict. This has something to do with the formal devices the painters use, and also with their attitude to both color and tone.

The crucial change from the landscapes which Pieter Bruegel painted in the sixteenth century is the choice of a low rather than a high horizon. The picture is therefore no longer a kind of map, cataloguing separate incidents, and separating accidents of topography, but a unified whole. If one traces the development of Dutch landscape painting through the earlier part of the century, one sees how the painters gradually learned to do without artificial props. Not only does the landscape have a low horizon but the painter has also learned to dispense with framing devices, features which funnel the spectator's eye toward the center. The landscape thus seems to extend beyond the boundaries of the canvas. It is noticeable that the artists seem to use a different system of perspective from the one sanctioned by the Italian theorists of the Renaissance. Orthodox Renaissance perspective puts the viewer firmly outside the composition. The picture is a window; the viewer looks through it and sees what is beyond. The Dutch landscapist places the spectator firmly within the canvas; we stand there and look around us. Also Dutch landscape gradually abandons firm demarcations between foreground, middle ground, and

background. There is a smooth, continuous transition from one area to another.

The culmination of the new Dutch landscape style came later in the century, with one or two paintings by Meindert Hobbema (1638–1709), and in particular with the justly famous *Avenue at Middleharnis* (Fig. **17.13**), which is dated 1689. Hobbema was an uneven artist, but this is undoubtedly his masterpiece. The sophisticated compositional scheme shows the degree to which Dutch landscape painting had been able to free itself from all artificial aids. With this avenue receding over flat, featureless countryside, Hobbema set himself an immensely difficult pictorial problem. He solved it with such virtuosity that the spectator is not even aware of the fact that it exists. Pictorial space is controled by the subtlest and most minimal of means.

Dutch still life is, as a genre or category, at first sight more neatly circumscribed than Dutch landscape. The term is essentially applied to pictures which take inanimate objects as their subject matter, presented with the greatest possible verisimilitude.

Two related categories of Dutch still-life painting are worth particular attention here, as between them they give a good idea of what the artists thought they were trying to do: one is the *Vanitas*, whose components are reminders of human mortality and warnings against the vanity of the life of the senses; the other is the flowerpiece. The *Vanitas* still lifes have deep roots in earlier Netherlandish art. Portraits painted in the early sixteenth century sometimes have simple *Vanitas* compositions on the reverse side. In the seventeenth century *Vanitas* still lifes, now much elaborated, were particularly associated with Leyden, perhaps because that town was a stronghold of Calvinism and the intellectual climate was therefore strongly moralistic; perhaps, too, because the scholars who gathered at Leyden University had a fascination with emblems and their meanings. There seems to have been a steady output of such paintings from about 1620 onwards. A typical example is the still life (Fig. **17.12**) by Willem Claesz Heda (1594–1680), dated 1621. Leyden *Vanitas* still lifes belong to the so-called "tonal" phase of Dutch art—the lack of color suits their melancholic subject matter.

The other important Dutch specialty, more popular with posterity than the gloomy *Vanitas*, was the flowerpiece—though flower painters sometimes smuggled in half-concealed references to the theme of transience, in the form of insects such as butterflies, and withered or caterpillar-fretted leaves—allusions that generally pass a modern audience by.

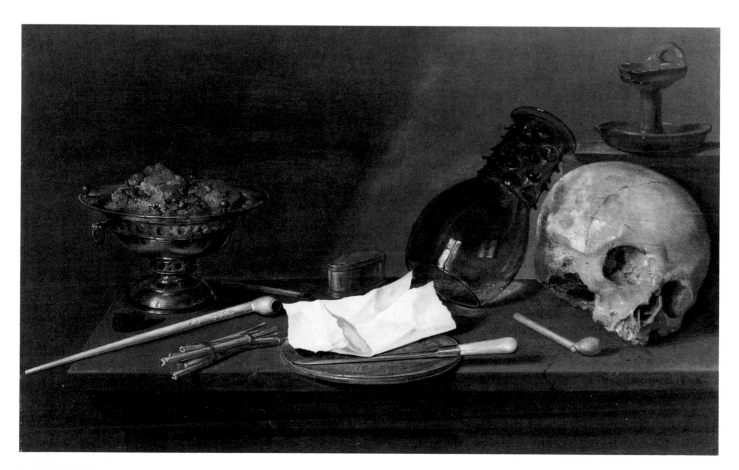

17.12 **William Claesz Heda**, *Still Life* 1621. Oil on canvas, 18 × 27¼ ins (45.5 × 69.5 cm). Museum Bredius, The Hague.

17.13 Meindert Hobbema, *Avenue at Middelharnis* 1689. Oil on canvas, 40¾ × 55½ ins (103.5 × 141 cm). National Gallery, London.

The flowers in the bouquets painted by Ambrosius Bosschaert (1573–1621), one of the earliest of the Dutch specialists in flowers, are the direct descendants of the blossoms which appear in the margins of the sumptuous late medieval breviaries produced in the illuminators' workshops at Bruges. In Bosschaert's case (see Fig. **17.14**), they also seem to be tributes to the new scientific spirit of the age, not only because the individual blooms are rendered so exactly but because each painting tends to become a catalogue of different species of plant. Bosschaert brings together flowers which do not in fact blossom at the same season—that is, his apparently "realistic" bouquets could never have existed. It is evident that his flowerpieces were not painted from life, but were compiled from large numbers of previously made watercolor studies.

English literature

Donne, Milton, and Dryden

In addition to being an age of great architecture in England, the seventeenth century was an age of great poetry. Both in tone and content this poetry was strongly affected by the religious conflict which divided English society, and which, even more than the issue of royal absolutism, motivated two great political upheavals—the Civil War of 1642–6, and the so-called "Glorious Revolution" of 1688, which replaced the Catholic James II with the Protestant William of Orange.

The three greatest poets of the century experienced these religious tensions, but each in a different way. The earliest of them, John Donne (1572–1631), came from a Catholic family, but eventually became an Anglican clergyman, and was Dean of St. Paul's when he died. His work conveys a permanent sense of guilt, and a note of anguish can be found throughout. His early poems, many certainly written before 1600, are secular, and often boldly erotic. The later ones, dating from the early years of the seventeenth century, are religious, but they too are similar in style to the early work, if ostensibly different in subject matter.

Donne is the leader of the so-called Metaphysical School. The label was borrowed by the eighteenth-century critic Samuel Johnson from John Dryden, who said of Donne: "He affects the metaphysics, not only in his satires, but in his amorous verses, where nature only should reign." What Dryden was complaining of was the importation of far-fetched metaphors and philosophical conceits into poetry, at the expense of lucidity and simplicity.

In Donne's poetry what the reader encounters is a sinewy colloquialism of language, combined with astonishing imaginative leaps and complex philosophical concepts. This is an example from one of the best known of Donne's love lyrics, "The Good-Morrow:"

My face in thine eye, thine in mine appeares,
And true plaine hearts do in the faces rest,
Where can we find two better hemispheares
Without sharpe North, without declining West?
Whatever dyes was not mixed equally;
If our two loves be one, or, thou and I
Love so alike, that none doe slacken, none can die.

(DONNE, *Complete Poems*. Penguin Books Ltd., 1971.)

Donne is saying here that only what is simple, and not mixed with anything else, or compounded of materials which are entirely compatible with one another, is free from corruption and thus immortal.

The terror of death continually haunts Donne's work, even when he is anticipating the Resurrection:

But my ever-waking part shall see that face,
Whose fear already shakes my every joynt.

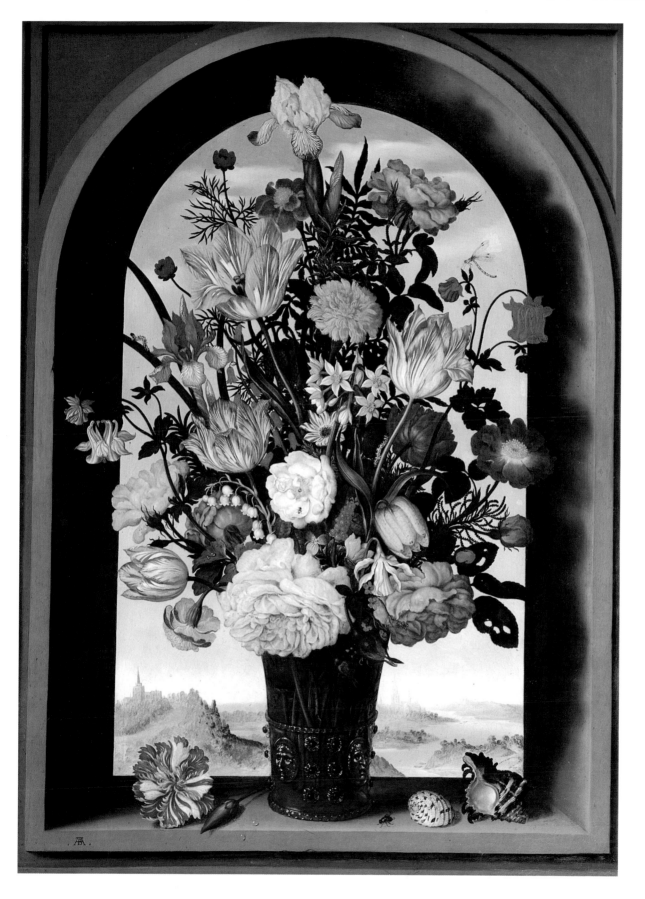

17.14 Ambrosius Bosschaert, *Flower Still Life* c. 1620.
Oil on panel, 25 × 18 ins (64 × 46 cm). Mauritshuis, The Hague.

Neither Milton nor Dryden suffered from this fear, or, if they did, they did not consider it suitable for expression in poetry.

Another difference is that Milton and Dryden gave poetry a public role, whereas Donne did not. His poems are egotistical, but also very personal. When he envisages an audience, it is one person—possibly a patron who is in a position to provide some benefit, or else a small group of like-minded friends, among whom his poetry circulated in manuscript. As we know from his correspondence, he was never quite certain whether he wanted to be publicly known as a poet. When his two "Anniversaries" were published in 1611 and 1612, at the insistence of the patrons for whom they were written, Donne was ashamed rather than pleased. "I confess I do not know how I declined to it," he said, "and do not pardon myself."

Milton and Dryden were quite different in their attitudes, but they also differ from one another in the functions they assigned to their poetic writings. John Milton (1608–74) also came from a family with Catholic connections. Unlike Donne, however, he seems to have felt no qualms about identifying himself with the Protestant cause. An excellent linguist, in 1638 Milton traveled to Italy, meeting the aged Galileo (see page 245), whose situation brought home to him the importance of liberty of conscience.

On his return to England, Milton threw himself into the controversies of the time, virtually abandoning the poetic career upon which he had embarked. His eloquent pamphleteering, combined with his linguistic abilities, eventually brought him the job of Secretary for Foreign Tongues to Oliver Cromwell's new republican government which had replaced the monarchy. It was during this period of official employment that he went blind. The Restoration of King Charles II in 1660 deprived him of his job and, briefly at least, put him in danger of being arrested. It was at this point that he seriously addressed himself to a task he had long been contemplating—the composition of an English epic. The result was *Paradise Lost*, published in 1667.

The language he evolved for his poem is not colloquial; rather it is stately and Latinate—so much so that he has sometimes been accused of writing a work that is neither quite English nor quite Latin. In fact, it owes almost as much to Italian, as it does to any classical source. Its superb euphoniousness, audible from the very first line, owes much to Milton's innate gift as a musician, and perhaps also something to his blindness, which caused him to turn the sounds and syllables over and over in his mind before finally dictating them. *Paradise Lost* is full of passages which stick in the mind because of their verbal melody:

Nor was his name unheard or unadored
In ancient Greece; and in Ausonian land
Men called him Mulciber; and how he fell
From Heaven they fabled, thrown by angry Jove
Sheer o'er the crystal battlements: from morn

To noon he fell, from noon to dewy eve,
A summer's day; and with the setting sun
Dropt from the zenith, like a falling star . . .

(MILTON, *Paradise Lost*, ed. Christopher Ricks. Penguin Books Ltd., 1968.)

A brief passage like this seems to have little to do with the colloquialisms and forced metaphors of Donne, and clearly contains within itself the seeds of much Romantic and immediately post-Romantic poetry (see page 386).

Despite the changed political and moral climate brought about by the Restoration, the merits of *Paradise Lost* were recognized as soon as it was published—by none more generously than Milton's younger contemporary John Dryden (1631–1700). Yet at first sight Dryden's own poetry seems to belong to a completely different world.

Unlike both Milton and Donne, Dryden came from a Puritan background. His first important poem, the *Heroic Stanzas Consecrated to the Memory of Oliver, Late Lord Protector of this Commonwealth*, was a celebration of Cromwell, written in 1659. Dryden gradually became more and more sympathetic to the royalist cause and finally, in the reign of James II, converted to Catholicism—something which left him stranded, from a purely careerist point of view, after the revolution which swept James away in 1688.

Before this happened, though, Dryden had embroiled himself with some vigor in the turbulent politics of the time and, in particular, had proved himself a master of verse satire. The finest of these, *Absalom and Achitophel* (1681), was written when Dryden was already moving toward Catholicism, yet it is built on a biblical parallel of a kind Dryden would have encountered in the Puritan sermons he listened to in his youth. Charles II is King David, Absalom is his illegitimate son the Duke of Monmouth, whom many people wanted to see replace Charles's stubbornly Catholic brother James as heir to the throne. Achitophel, the false counsellor who tempts Absalom to rebel, is the Earl of Shaftesbury, an entrenched opponent of Charles II and his ministers. Similar biblical equivalents were found for most of the leading political figures of the time. The vigor of Dryden's style is seen in his verse portrait of Shaftesbury himself:

Of these the false Achitophel was first,
A Name to all Succeeding Ages curst.
For close Designs and crooked Counsel's fit,
Sagacious, Bold and Turbulent of wit,
Restless, unfixt in Principles and Place,
In Pow'r unpleased, impatient of Disgrace;
A fiery Soul, which working out its way,
Fretted the Pigmy Body to decay:
And o'er informed the Tenement of Clay.

(DRYDEN, *The Poems of John Dryden*, Vol. 1, ed. James Kinsley. O.U.P., Clarendon Press, 1958.)

While this lacks Milton's stately movement and his variety of sound effects, the two poets do have certain things in common. Milton's famous "Better to reign in hell, than serve in heav'n," might just as easily have been written by Dryden, appearing in a wholly different context.

What Milton and Dryden have in common they also share with Donne—that is, a search for pithiness, for conciseness, for verbal energy. And this in turn is based on an attitude to language inspired not merely by the constant study of the Bible demanded by the Protestant tradition but by the constant scrutiny of each word, the search for the true and ultimate meaning, which is the essence of that tradition in its highest and purest form. Wherever they began from, in terms of religious belief, and wherever each of them ended, all three remained the children of the northern European Reformation, which, even in Dryden's satires, where social issues and the idea of human beings as essentially social animals play a much larger part than they do in the poetry of Donne and Milton, was only just beginning to lose its original force.

Music

Schütz and Purcell

Throughout the seventeenth century music in the Protestant north was strongly influenced by developments in Italy, and also to some extent by those in France. This reversed the situation which had prevailed during the Early and High Renaissance, when the most distinguished composers working in Italy had been northerners, chiefly from the Low Countries.

In the seventeenth century, musical life in Holland was never on a level with what was taking place in Dutch painting. The chief music publishing firm in Amsterdam, important for its pioneering use of the engraving process, thrived on editions of Italian baroque composers such as Corelli and Vivaldi.

In Germany, the most important creative musician of the period, and indeed the first really significant German composer, was Heinrich Schütz (1585–1672), who studied in Venice under Giovanni Gabrieli and who later became court composer to the Elector of Saxony, whose territories were still a stronghold of Protestantism. Schütz's music shows a gradual reconciliation of two traditions—the sumptuous, emotional Venetian style, and the Protestant chorale. He uses traditional chorale texts, but not the melodies usually associated with them. His German-language settings show an increasingly intimate understanding of the rhythms and cadences of his native tongue. Works like the *Seven Last Words from the Cross* (c. 1645) and Schütz's three Passion settings (c. 1664–6) prepare the way for comparable settings by Johann Sebastian Bach. The Passion settings are particularly austere and contemplative.

The music written by the most important English composer of the period, Henry Purcell (1659–95), is completely different in character from that of Schütz. The Civil War interrupted English musical life just as it did the development of the English theater, and a great change was inevitable when Charles II returned from exile. In reaction to Puritan austerity, the king and his courtiers favored richly elaborate music, influenced by the works which they had heard in France. Purcell wrote grandiose anthems, somewhat in the French style, for Charles II's Chapel Royal—here elaboration was a gesture of defiance to lingering Puritan sentiment. He also wrote a good deal of music for the theater, mostly for the so-called "semi-operas" which were the successors, now addressed to a paying public, of the court masques which had been popular during the early decades of the seventeenth century. Purcell only had the opportunity to write one true opera, the modestly scaled but delightful *Dido and Aeneas* (1689). Like Racine's two final plays, *Esther* and *Athalie*, this was created for a girls' school, and the piece, with a small orchestra of strings and continuo (a bass line played by a harpsichord), was laid out to suit the forms available.

Though much of Schütz's work remained in manuscript until modern times, the tradition he founded developed without a break. He is the direct ancestor of the German composers of the eighteenth century, when German music achieved a dominant position. Purcell's work, by contrast, was not followed up, and English music made a fresh beginning with the arrival of Handel, with his mixture of German and Italian influences.

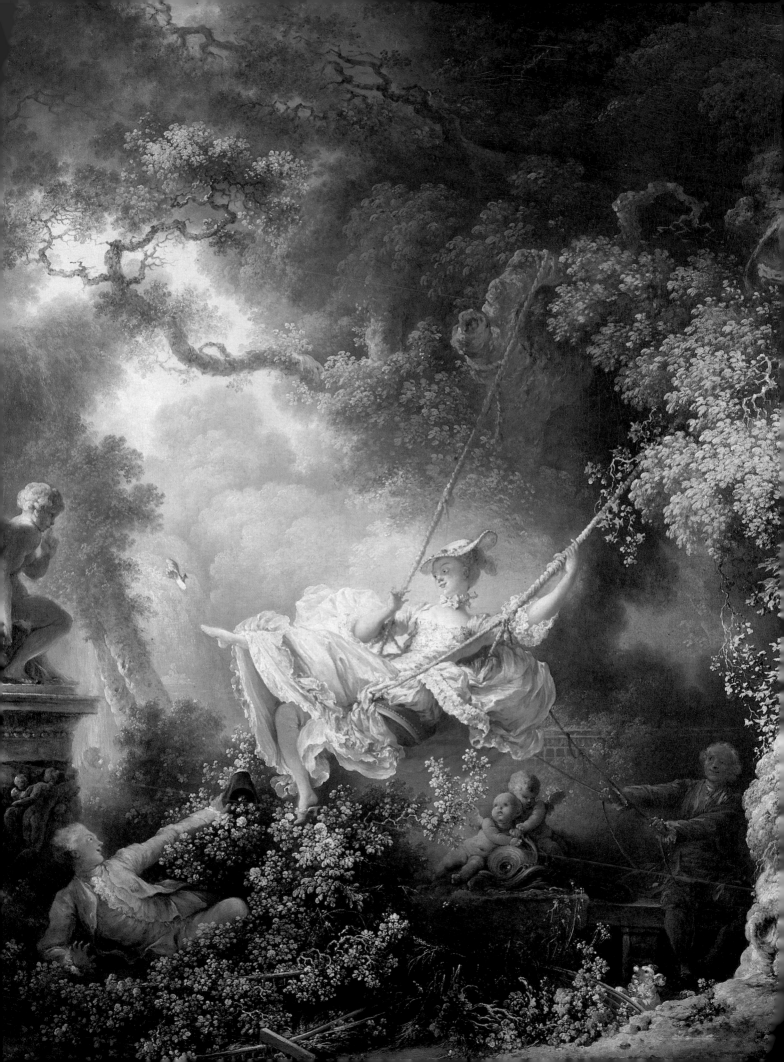

Part
6

The Eighteenth
Century

Chapter 18

The Rococo

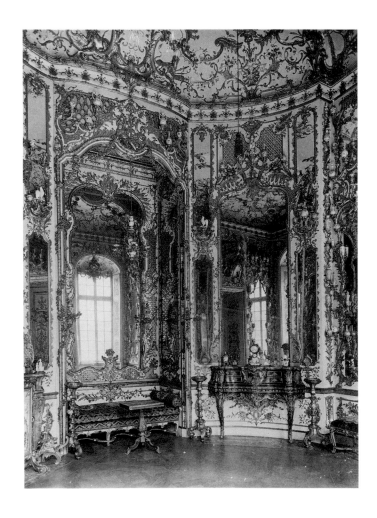

18.1 **François Cuvilliés**, Spiegelsaal (Mirror Room), Amalienburg, 1734–39.

An intellectual turning point

The eighteenth century was a more significant turning point in the history of Western civilization than the Renaissance. It saw the birth of ideas of personal freedom and responsibility which now form the foundation of our ideal of the good life. Equally, it witnessed a decisive step in the evolution of capitalism, which is still the dominant economic system in most of the countries where Western ideas hold sway. The century saw significant changes in people's awareness of the kind of world they lived in, thanks to the development of new scientific attitudes and, in a particular sphere, to the voyages of Captain Cook and other explorers. The intellectual and social energies generated during the period could not in the end be safely contained, and culminated in a great explosion—the French Revolution of 1789.

In cultural terms eighteenth-century Europe was far from being unified, though the differences were to some extent concealed by the internationalism of leading intellec-tuals. Individual regions and nation-states had specific characteristics, and produced their own kinds of art, literature, and music as a result. Britain was mercantile and expansionist, her progress scarcely checked by the loss of her American colonies. Italy was fragmented, and large parts of the peninsula continued to be dominated by foreign powers. Rome, however, was both a Mecca for foreign travelers and a center for artistic experiment—a role which increased rather than diminished as the century proceeded. Germany, though as divided as Italy, was showing the first stirrings of national consciousness, and certain artists and writers had begun to hint at the intellectual developments that would in due course become Romanticism (see page 373). It was France, however, which remained the center of European intellectual life, and it was also France which was the center of European fashion.

The paradox is that the first artistic mode launched by

	1700	1725	1750	1775	1800
	ROCOCO		NEO-CLASSICISM		ROMANTICISM
HISTORICAL BACKGROUND	Louis XIV dies 1715 Reign of George I begins 1714	First spinning machine patented in England 1735	Winckelmann *History of Art* Beginnings of Industrial Revolution Watt's steam engine	American Revolution French Revolution	
PHILOSOPHY	Locke *Essay Concerning Human Understanding*	Hume *Essays Concerning the Human Understanding*	Diderot/D'Alembert *Encyclopedie* Rousseau *Social Contract* Burke *On the Sublime and the Beautiful*	Kant *Critique of Pure Reason* Adam Smith *Wealth of Nations* Rousseau *Confessions*	
ARCHITECTURE	Cuvilliés, Spiegelsaal (**18.1**)	Kent, Holkham Hall, Norfolk (**19.2**) Royal Crescent, Bath (**19.3**)	Capability Brown, Bowood Park (**21.2**)	Iron Bridge at Coalbrookdale (**24.1**)	
VISUAL ARTS	Watteau (**18.5**)	Boucher (**18.7**) Chardin (**21.1**) Canaletto (**19.4**) Hogarth (**19.1**) Reynolds (**20.6**)	Piranesi (**21.6**) Mengs (**20.3**) Latour (**20.5**) Fragonard (**18.6**) Greuze (**21.4**)	David (**20.4**) Canova (**20.8**) Vigée Le Brun (**21.5**) Houdon (**20.9**) Fuseli (**21.7**)	
LITERATURE	Development of the novel Defoe *Robinson Crusoe*	Fielding *Tom Jones* Marivaux *Game of Love and Chance*	Voltaire *Candide* Goethe *Werther* Beaumarchais *Marriage of Figaro*	Blake *Songs of Innocence and Experience* Wordsworth *Lyrical Ballads*	
MUSIC		Bach *St. Matthew Passion* Handel *The Messiah*	Gluck *Alceste* Development of the symphony	Mozart *Don Giovanni*	

18.2 Europe in the 18th century.

French architects and painters at the beginning of the century was resolutely unintellectual. It was, indeed, one of the few major European styles to have a minimum of theoretical content. It was a continuation of the Baroque, and at the same time a rebellion against the rules which had governed seventeenth-century art, most especially the chastened or classical Baroque which had been the dominant style in France for most of the reign of Louis XIV. One of the surprising things is that this revolt was to some extent encouraged by the aging king himself.

Decoration and architecture

The term Rococo, which did not come into general use until the 1830s, is derived from the French word *rocaille*, which means ornamental rock or shellwork. It is now most exactly applied to a capricious form of interior decoration—a tracery incorporating *c*-scrolls, flowers, and shells. The first hints of the style can be seen in work commissioned by Louis XIV around 1700, for younger members of his family.

The Rococo developed rapidly in France during the second and third decades of the eighteenth century, but did not reach a climax until the years 1730–5. Its chief characteristic during the culminating phase of its development was the use of radical asymmetry of a kind not seen before in European art. For example, the two halves of a decorative panel would not form a mirror image of one another, as had always been customary before.

One of the leading innovators of the period was Juste-Aurèle Meissonier (*c*. 1693–1750), who began by supplying designs for silverwork, then moved onto designing domestic interiors. The publication of a collection of his engraved designs for architecture (Fig. **18.3**), interior decoration, silver, and bronze made him influential throughout

Europe. But significantly he never fulfilled his ambition to become a fully-fledged architect, and, despite a minor royal appointment, he did little work for the French Crown. In its country of origin, the Rococo remained a decorative style, for interiors, furniture, and domestic objects, never achieving architectural respectability.

In Germany, however, it did develop into a complete architectural style. And whereas in France Rococo was always a courtly and aristocratic taste, in Germany it democratized itself and found the means to appeal to all classes. Two different types of building are typical of the German Rococo—the pleasure palaces and garden pavilions built for the numerous ruling princes, all of whom were heavily influenced by what was fashionable in France, and the pilgrimage churches of Catholic South Germany and Austria, which appealed to a devout peasantry.

The most perfect of the German Rococo pavilions is the Amalienburg (1734–9). This was never a full-time residence but was built for picnicking and shooting pheasants in the park of Nymphenburg, near Munich. The designer was François Cuvilliés (1695–1768), who was born in the Low Countries and began his career as Court Dwarf to the Elector Max Emmanuel of Bavaria. The *Spiegelsaal* (Mirror Room) of the Amalienburg (Fig. **18.1**) is a high point, with tracery of capricious decoration covering every available surface.

In Catholic South Germany, the supposedly skeptical eighteenth century was a great age of church-building (it has been calculated that about 200 churches of some artistic merit were built in Bavaria, Swabia, and Franconia between 1700 and 1786). Pilgrimages to miracle-working shrines

18.3 Juste-Aurèle Meissonier, Elevation showing one side of the Place de Gramont. Victoria and Albert Museum, London.

remained as popular as they had been in the Late Middle Ages. The worshippers thought it entirely appropriate that the Savior, the Madonna, and popular saints should be housed just as sumptuously as local secular rulers. The main

18.4 Johann Baptist Zimmerman, Die Wies Church, 1745–54.

difference was that their residences were open to everyone. In these circumstances, the Rococo took on a mystical, otherworldly tinge, quite alien to its frivolous French beginnings.

The architecture of German Rococo churches is largely interior, with little attention paid to the outsides of buildings. Inside, Rococo forms are carried even further than they were in secular structures. What makes them appropriate is the festive atmosphere conjured up—sacred gestures and acts become the equivalent of contemporary court festivities. The devout worshipper is offered a beautiful dream, but the illusion is undercut for more sophisticated visitors by the awareness that this is all something created by a magician's wand from humdrum paint and plaster. In typical churches of this type, the effect is sumptuous but the materials are not. In more extreme examples, the precarious and unstable nature of the forms seems to have been deliberately emphasized, so that there is a hint that the vision may vanish at any moment.

The South German church-builders of the period remained almost on an artisan level. Typical were the brothers Dominikus (1685–1766) and Johann Baptist (1689–1758) Zimmermann. Their masterpiece is the pilgrimage church Die Wies (The Meadow) built between 1745 and 1754, which houses a crude but supposedly miraculous image of Christ at the Column. This is the most delicately sumptuous of all German Rococo churches, with an interior painted in white and pink, and forms which deny spectators any firm perception of what kind of space they are in (Fig. **18.4**).

Painting

Antoine Watteau

Antoine Watteau (1684–1721) is universally associated with the Rococo yet remains apart from this, or any other, stylistic tendency. He was born in Valenciennes, which had ceased to be part of the Spanish Netherlands only six years previously, and his influences were Flemish—Rubens, for example, but also genre painters descended from Brouwer (see page 302). He came to Paris in 1702, working successively with two leading decorative artists, and around 1715 he finally established his reputation by inventing a totally new genre, the *fête galante*. The term (which literally means "a feast of courtship") was applied to a type of open-air genre scene showing music-makers, actors, and flirtatious lovers enjoying themselves in an open-air setting. A major source is Rubens's *The Garden of Love* (see page 270).

It is traditional to see Watteau's paintings as essentially dreamlike and idealized. However, they do reflect the manners of the aristocratic circle the artist moved in—although he was far from being an aristocrat himself—and, in particular, the prevailing passion for amateur theatricals. But the dramas Watteau creates on canvas are always mysteriously ambiguous and fragmented. There is no obvious plot or situation; no resolution of events is in sight. Very often the paintings are clearly autobiographical. The lovely *Fêtes Venétiennes* (Fig. **18.5**) of *c.* 1718 shows the artist himself as a bagpiper, playing the tune to which the rest dance.

Watteau's method of composition was novel. Rather than first deciding what shape the picture should take, then making studies for it, he made drawings of individual figures and small groups whenever the opportunity arose, then put them aside till he found some use for them. His most characteristic paintings are jigsaws made from these pre-existing studies.

18.5 Antoine Watteau, *Fêtes Venétiennes* c. 1718. Oil on canvas, 22 × 18 ins (55.9 × 45.7 cm). National Galleries of Scotland, Edinburgh.

Thanks to this original approach, Watteau succeeded in breaking the mold of French official art, which had most typically addressed itself to the glorification of the state and the monarchy. For more than sixty years after Watteau's death artists, the new race of critics, and the royal officials entrusted with the direction of patronage struggled to create the conditions in which official art of this type—suitably weighty and serious—would once again be possible. The

situation did not resolve itself until Jacques-Louis David exhibited *The Oath of the Horatii* at the Salon of 1785.

Boucher and Fragonard

In French art the most complete representative of the Rococo was not Watteau but François Boucher (1703–70). He was, in terms of the time, a slow starter, at the age of twenty-eight still being spoken of as a promising rather than an established artist. However, he was immensely fluent and industrious, and could turn his hand to anything— charming pastorals inspired by the popular theater, domestic scenes, decorative paintings full of gamboling putti, elegant portraits, and sumptuous mythological pieces. He did designs for tapestries and book illustrations, and made drawings for porcelain statuettes. By 1737 he was a full professor at the Académie Royale, and shortly after that, thanks to the patronage of Louis XV's mistress Mme. de Pompadour, he was the most important painter in France. His appointment as Premier Peintre du Roi (King's Painter) in 1765 was belated recognition of a long-accepted pre-eminence.

At first glance Boucher is much more like his seventeenth-century Baroque predecessors than he is like Watteau. But the longer one studies his work, the more obvious the differences from the Baroque become. In the first place, Boucher's ideal is not the male body but the female one; male nudes, which appear in full vigor in his splendid drawings, in his paintings are often turned into chubby, rather feminine adolescents. In the second place, he generalizes— even his portraits lack sharp individuality. It is the vigorous rhythm of the brush which counts, and not the forms it is describing.

A typical Boucher is perhaps *Leda and the Swan* (Fig. **18.7**), in which Zeus, transformed into a swan, approaches Leda, who gazes at him with lowered lids, ripe for surrender. A companion nymph embraces Leda with one arm and raises the other in a gesture which is half-invitation, half-surprise. The two plump nudes are the real subject— no attempt is made to give the mythological episode credibility. Intellectual content is deliberately kept to a minimum.

Because of this, and because he was so successful with the court, Boucher increasingly attracted hostility from the new intellectual class which was growing up in France. In his report on the Salon of 1761, Denis Diderot attacked him bitterly; "What color! What variety! What a wealth of objects and ideas! This man has everything but the truth . . . Only persons of excellent taste, who appreciate simplicity and the antique, do not pay attention to him."

Boucher's natural successor was his one-time pupil Jean-Honoré Fragonard (1732–1806). Fragonard's technique is even more rapid and fluent than that of his master—sometimes he uses oil paint as if it were watercolor; sometimes, on the other hand, he employs a thick impasto. Despite his

18.6 Jean-Honoré Fragonard, *The Swing* c. 1768–69. Oil on canvas, 32 × 25½ ins (81 × 65 cm). Wallace Collection, London.

immense natural gifts, Fragonard never had a major reputation—he has been valued by posterity far more than he was by his contemporaries. His typical patrons belonged to a rather raffish demi-monde—actresses, their wealthy lovers, *nouveaux-riches* financiers, all people condemned to pursue fashion rather than lead it. Typical of the work he produced for them is *The Swing* (Fig. **18.6**). Here the client insisted that his mistress be shown placed on a swing "pushed by a bishop," with himself on the ground beneath, ready to look up her skirts. Fragonard turned this dubious joke into an airy masterpiece, the kind of thing we now think of as summing up the whole spirit of its period. His contemporaries would have been surprised and shocked to know this, and his work was rapidly forgotten with the advent of Neo-Classicism (see page 335) in France. The revival of his reputation was the work of mid-nineteenth-century collectors, in love with their own vision of the eighteenth century, an epoch which they admired, rather than condemned, for its unabashed hedonism.

Giovanni Battista Tiepolo

In painting the nearest equivalent to the Rococo church architecture of South Germany was the work of a much-traveled Venetian, Giovanni Battista Tiepolo (1696–1770).

18.7 François Boucher, *Leda and the Swan* 1742.
Oil on canvas, 23⅗ × 29¹⁄₁₀ (60 × 74 cm). Statens Konstmuseer,
Stockholm.

His greatest achievements—in an archepiscopal palace, not in a church—are the decorative cycles painted in 1751–3 for the Prince-Archbishop of Wurzburg, Carl Freidrich von Greiffenklau. Tiepolo decorated first the principal room of the palace, the Kaisersaal, and then the great staircase leading up to it (Fig. **18.8**).

On the staircase the theme is very simple—the Four Continents, sumptuously attended, have come to pay homage to Tiepolo's patron, the Prince-Archbishop, while the sun god, Apollo, glitters above. Much of the imagery derives directly from the work of Paolo Veronese, Tiepolo's sixteenth-century Venetian predecessor (see page 227). Tiepolo deliberately harks back to the days of great Venetian magnificence. But he transposes what he borrows into a different key, helped by a change of medium. Veronese's

work has the sumptuousness which can be created only with oils. Tiepolo's work is in fresco. The light, silvery tones of his decorations are Veronese seen by moonlight. The emotional climate is one of gentle irony.

Strangely enough, where Veronese is one of the most secular in temperament of Late Renaissance artists, and got into trouble with the Inquisition because of it, Tiepolo, in addition to being an ironist, also excelled in conveying religious emotion—for example, in the soaring ceiling composition in the Scuola of Santa Maria del Carmine in Venice (Fig. **18.9**), where the Madonna is seen handing the scapular to St. Simon Stock. The artistic conventions Tiepolo uses are the same as those which appear in his secular compositions, such as the frescos on the staircase at Wurzburg, but the mood is mysteriously different. The religious paintings offer the spectator access to an otherworldly sphere, fragile and precarious but kept in existence by the power of faith. In this sense they are directly comparable to the church interiors created by the Zimmermann brothers and their peers.

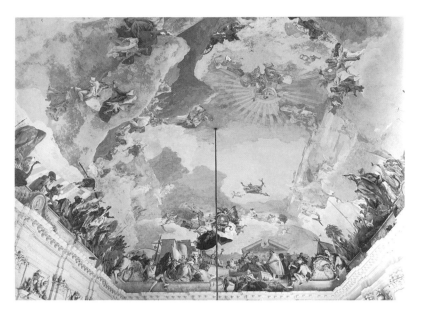

18.8 **Giovanni Battista Tiepolo**, the staircase ceiling in the
Kaisersaal, 1752, Würzburg, Germany.

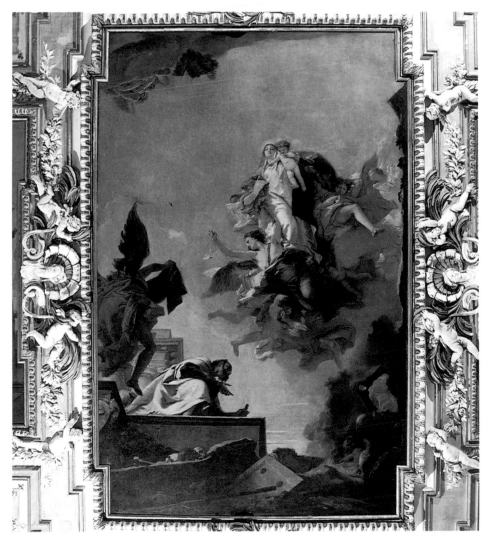

18.9 **Giovanni Battista Tiepolo**, ceiling fresco from the Scuola Sta.
Maria del Carmine, Venice, 1739–44.

Sculpture

Gunther and Falconet

The Rococo, with its emphasis on totality of decorative effect, did not produce major sculptors, and sculptors of talent were on the whole not content to remain within the framework of the style. There is a striking contrast between the fate of sculpture in Germany and in France. For a twentieth-century audience, one of the most attractive of all Rococo sculptors is the Bavarian Ignaz Gunther (1725–75). Though he received an academic training in Vienna, Gunther is in many ways a throwback to the artisanal tradition of the Middle Ages—a humble craftsman-carver, working with tremendous virtuosity in painted limewood. Among his masterpieces is the white and gilt statue of St. Kunigund (Fig. **18.10**) of 1762, which forms part of a large altarpiece in the church of Rott am Inn. This medieval empress is portrayed as ineffably superior and aristocratic, with an expression which combines in equal proportions the supercilious, the deprecating, and the compassionate. The elongated proportions of the figure and its twisting pose recall both International Gothic and Mannerist sculpture.

Etienne-Maurice Falconet (1716–91) came from an equally humble background, but contact with the stimulating milieu in France gave him intellectual pretensions which Gunther never had. He decided to learn Latin when he was thirty, and in 1772 published a translation of the first three books of Pliny's *Natural History*. Falconet's career was much more varied and turbulent than that of Gunther. He attracted the patronage of Mme. de Pompadour, for whom he created the charmingly playful *L'amour menaçant* (Fig. **18.11**). She made him Director of the Sèvres porcelain factory, but Falconet longed for higher things, and eventually won a recommendation to Catherine the Great of Russia (see page 336). He traveled to Russia, and from 1766 to 1769 worked on the great equestrian statue of Peter the Great (Fig. **18.12**), which was to become the emblem of the city.

18.10 **Ignaz Gunther**, *St. Kunigund* 1762, from the altarpiece of the Church of Rott-am-Inn. Carved and painted wood.

18.11 **Etienne Maurice Falconet**, *L'amour menaçant* 1756–57. Marble, 36 × 19¾ × 24½ ins (91.5 × 50 × 62 cm). Palace of Versailles, France.

FOCUS

Madame de Pompadour

Jeanne-Antoinette Poisson, Marquise de Pompadour (1721–62), symbolized, rather than led, the change in taste which took place in France during the first half of the eighteenth century. Installed as *maîtresse en titre* (official mistress) to Louis XV in 1745, she only acquired influence when the development of the Rococo style was already well advanced. She made little effort to alter its direction, though her brother Abel Poisson, Marquis de Marigny (1727–81), was sent to study the arts in Italy. Appointed *Intendant des Bâtiments* (the official placed in charge of all the royal palaces) upon his return, he became a pioneer of Neo-Classicism in France, especially in the realm of furniture and decoration.

Madame de Pompadour's taste in literature was more advanced than her taste in the visual arts. She helped a number of the leading *Philosophes*, among them Voltaire (see page 344), and is said to have been personally responsible for the lifting of the government ban on publication of the *Encyclopédie*. The catalogue of her library shows that she read widely. She owned over 3,500 volumes, and among the books on her shelves were *The Princesse de Clèves* (see page 286) and (in French translations) *Robinson Crusoe* and *Tom Jones* (see page 330).

The artists whom she patronized included Boucher (see page 315) and Maurice Quentin de La Tour, both of whom made portraits of her. Throughout her period of influence she kept Boucher in regular employment.

Madame de Pompadour was an unusually accomplished actress and musician, and for five years ran an amateur theater at Versailles in which she took the leading roles. The plays, generally comedies taken from the existing repertoire, were by leading playwrights of the time, while the actors and musicians included members of the highest French nobility.

These theatricals, like Madame de Pompadour's numerous but often ephemeral building works, were all part of an effort to strengthen her hold over the king, who was easily bored and always in search of distraction. They tended to accentuate the gradual withdrawal of the French monarchy from public life. The first version of her theater held an audience of only fourteen people; her new houses and pavilions, most of them small, were designed as a way of avoiding court ceremonial.

Though she patronized the leading painters and sculptors of her day, Madame de Pompadour seems to have been more interested in the decorative arts, ordering much luxurious furniture and porcelain from leading suppliers in Paris. In particular, she was a generous supporter of the royal porcelain factory founded in 1738 at Vincennes and transferred to Sèvres in 1756. A brilliant rose-pink enamel introduced in 1757 later came to be called *rose Pompadour*. In the same year the sculptor Etienne Falconet (see page 320) was

Etienne-Maurice Falconet, *Cupid on a Pedestal c.* 1761. Biscuit figure, 3 × 3¼ ins (7.5 × 8 cm). The Wallace Collection, London.

appointed chief modeler at the factory, and the delicate biscuit (unglazed porcelain) statuettes he produced between 1757 and 1766 are typical of Madame de Pompadour's taste. They feature mildly erotic themes, also chubby children engaged in various activities, and were principally intended as dining table ornaments.

François Boucher, *Madame de Pompadour* 1759. Oil on canvas, 35¾ × 26¾ ins (91 × 68 cm). The Wallace Collection, London.

> **18.12 Etienne Maurice Falconet**, *Monument to Peter The Great*
> 1766–69. Bronze on granite base. St. Petersburg, Russia.

This statue shows the limitations of the Rococo. To make something sufficiently monumental, Falconet had to go back to the previous century, and specifically to Bernini's original project for his equestrian statue of Louis XIV. Like Bernini's Louis, Falconet's Peter appears on top of a high rock—he is a second Hercules, who has reached the summit of the Mountain of Virtue. A solemn allegory of this type is alien to the frivolous, rather ambiguous spirit of Falconet's earlier work for Mme. de Pompadour. *L'amour menaçant* alludes slyly, but clearly with the patron's consent, to her position as royal mistress. Themes of this kind were better suited to Rococo taste.

Drama

The *commedia dell'arte*

An important part of the background to Rococo painting and sculpture is the Italian *commedia dell'arte*. This theatrical form was already ancient by the beginning of the eighteenth century. It was an anti-literary tradition based on improvisation within a fixed framework, with the emphasis on physical skills of all kinds—tumbling, juggling, even tightrope-walking. The central characters, whatever the storyline, were usually a rich, foolish old man and a clever but cowardly servant (Harlequin) expert in tricks and disguises. To these were added other stock figures, such as a quack doctor and a bragging soldier. The *commedia* was usually a comedy of servants against masters—among the former, in addition to Harlequin himself, were Columbine, the witty maid-servant (sometimes Harlequin's wife), and Pierrot, the embodiment of outspoken rustic simplicity. Because this form of theater was innately anti-authoritarian in tone, it was usually mistrusted by the authorities. This was particularly the case when it was exported from its native Italy—when this happened it attracted additional mistrust as something foreign as well.

In the late seventeenth century, the *commedia* became very popular in France. The competition it offered to the native, French-speaking theater was of increasing concern to the authorities and in 1697 the Italian comedians were banished. Elements of their art did survive in the entertainments given at the hugely popular Foire de Saint-Germain, held on the left bank of the Seine in Paris, and in 1716 the Italian actors were recalled by the Regent, the pleasure-loving Duc d'Orléans, who ruled France from 1713 to 1723 during the minority of Louis XV.

They now began to give non-improvised plays. Their best texts were written for them by Marivaux (Pierre Carlet de Chamblain de Marivaux, 1688–1763). His comedies have an abstract quality, with the social comment and satire to be found in Molière's comedies weeded out. What is left is a delicate self-conscious pattern of words, with a strong erotic undercurrent. Typical is this exchange from Marivaux's *A Game of Love and Chance*. Harlequin and Lisette are servants disguised as their employers.

Harlequin: Just tell me a little bit that you love me. Look, *I* love you. Be my echo, princess, repeat it.

Lisette: He is insatiable. Very well, monsieur, I love you.

Harlequin: Very well, madame, I am dying, my happiness overwhelms me. I am afraid I may run mad with it. You love me! That is amazing!

Lisette: I too would have good grounds for being amazed at the swiftness of your declaration. Perhaps you will love me less when we know one another better.

Harlequin: Ah, madame, when we reach that point, I shall lose a lot. The discount will be considerable.

Lisette: You credit me with more quality than I have.

Harlequin: And you, madame, do not know mine. I should only be talking to you on my knees.

Lisette: Remember that we do not choose our situation in life.

Harlequin: Fathers and mothers do as they think fit.

Lisette: As far as I am concerned, my heart would have chosen you whatever our social condition had been.

Harlequin: It has a wonderful chance to choose me again.

Lisette: May I flatter myself that you would be the same towards me?

Harlequin: Ah! Even if you had been only a serving-wench going down to the cellar with a candle in your hand, when I saw you, you would still have been my princess.

Lisette: May such fine sentiments prove enduring.

Harlequin: To strengthen them on both sides, let us swear to love one another always, in spite of all the spelling mistakes you may have made concerning me.

Lisette: I have more to gain than you from such a vow, and I make it with all my heart.

Harlequin: (*falls to his knees*): Your kindness dazzles me and I prostrate myself before it.

Lisette: Please stop. I cannot bear to see you in that position, and I should be ridiculous to leave you in it. Stand up. Oh! Now somebody else is coming!

Marivaux

(MARIVAUX, from *The Game of Love and Chance*, translated by John Walters. Reprinted with permission of Methuen Ltd, 1988. Translation copyright John Walters 1988, in *Marivaux Plays*.)

Music before 1750

The emphasis on entertainment, reflected in Rococo art and architecture, also finds an echo in music. The heavily ornamented harpsichord pieces of François Couperin (1668–1733), published in three books between 1713 and 1730, can be regarded as the aural equivalent of the Rococo decorative style; and there are parallels between the operas written by Jean-Philippe Rameau (1683–1764) and the world conjured up by Watteau's paintings. The best known of these is *Les Indes Galantes* (1735). But it was Germany, not France, which produced the greatest music of the period, asserting a pre-eminence which was to last throughout the eighteenth century and well into the next.

Johann Sebastian Bach (1685–1750) is commonly described as a Baroque composer, and enthusiasts for his work have sometimes tried to draw a parallel between Bach's sacred compositions and the Rococo churches of South Germany. In fact, Bach comes from a very different cultural world because he was a fervent Protestant, most of whose music was produced for his co-religionists. His career alternated between church and court appointments, and the kind of music he wrote necessarily varied with the requirements of the posts he held. His most important appointment came in 1723 when he took up the post of *Kantor* at St. Thomas's Church, Leipzig. Here he taught music, directed music at four different churches in the city, and provided music for civic occasions. Among the works most frequently required of him were cantatas for church use—they have

been aptly described as "poetic sermons," and they are as typical of the world of German Protestantism as long or short settings of the Mass by composers like Joseph Haydn (1732–1809) are of that of eighteenth-century Catholicism. They are full of deep and tranquil religious feeling, but have little concern with what is purely ornamental. More ambitious than the cantatas is the *St. Matthew Passion* (1727, revised 1736), a complex mixture of biblical narrative, poems by local poets, and chorale tunes and verses—the chorale started life as a Protestant congregational hymn, but Bach greatly elaborated this basic material.

Bach differs noticeably from the musicians who followed him because of his emphasis on structure. In a Bach fugue—where one "voice" follows or chases another, with successive voices being added until an elaborate musical structure is built up—the form, which is indistinguishable from the emotion the music produces, is self-contained, and is generated from a single musical seed or idea. There was a change in musical attitudes from about 1740 onwards, which left Bach isolated. Musical form began to stress obvious contrasts—melodic, harmonic, and dynamic changes—which Bach himself thought unnecessary. There is also the notion of a contrast, even on occasions a battle, between different musical ideas or themes. This shift marks the birth of modern sonata form, and leads music directly from the Rococo to the *Sturm und Drang* (Storm and Stress) which preceded fully developed Romanticism .

Chapter 19

The Middle Class

19.1 William Hogarth, *The Rake's Progress: The Orgy* 1735.
Oil on canvas, 24½ × 29½ ins (62.2 × 75 cm). By courtesy of the
Trustees of Sir John Soane's Museum, London.

The eighteenth-century middle class

The world of the Rococo, the sphere of an aristocracy which had outlived its functions while retaining most of its privileges, and of a conservative peasantry still ardently attached to the Catholic Church, makes a startling contrast to the world inhabited by the eighteenth-century middle class. It was largely in this world that the ideas which were to transform Europe in the course of the century arose. It was also this middle class that encouraged and financed the technological advances which created the Industrial Revolution.

Eighteenth-century thinking shows the sharp opposition of two very different approaches to reality—empiricism and idealism. The leading empirical thinkers, mostly middle class in origin, were particularly important in providing an intellectual backing for the characteristic entrepreneurial ventures of the eighteenth and nineteenth century. Yet empiricism is not in itself a theory. Rather, it implies the systematic repudiation of pre-existing theories, in favor of the evidence offered by practical experience.

Philosophy

Locke, Hume, Smith, and Kant

In the eighteenth century, all the thinkers who rooted their work in empiricism owed something to the English philosopher John Locke (1632–1704). He was influenced by the violent English politics of his own time. At one stage he was forced to flee to Holland, where he acted as one of the advisers of the future William III. He returned to England after the Glorious Revolution of 1688, which put William on the throne, and almost immediately published his two most significant works, the *Essay Concerning Human Understanding* (1689) and *Two Treatises of Government* (1690).

Locke's originality lay in the modesty of his approach. For him, human knowledge necessarily fell short of what exists in reality but remains generally sufficient for human purposes. Our ideas—he defined an idea as "whatever it is the mind can be employed about in thinking"—are not born with us, but come from experience.

For Locke, property was the foundation of society, and it was therefore one of the primary ends of government to preserve property rights, as well as to regulate the ways in which it could be used, distributed, or transferred. It was for this reason, he said, that men gave up certain individual rights and freedoms, though sovereignty remained with them. The notion of a "social contract," posited as an alternative to a state of nature where all human beings were at war with one another, was to be hugely influential among Locke's eighteenth-century successors, though they sometimes used it in ways Locke never envisioned.

David Hume (1711–76), one of a remarkable band of eighteenth-century Scottish intellectuals, pushed Locke's ideas further in *A Treatise of Human Nature* (1739) and

Philosophical Essays Concerning the Human Understanding (1748–53). He was far more consciously skeptical than Locke, and hostile to revealed religion. For Hume, all our ideas come either from sensory impressions or from inner feelings. In addition, we can never discover a matter of fact through reasoning alone; it can be discovered, or at least inferred, only from experience. He divided the reasoning process into two parts—"abstract" reasoning concerning quantity and number, and "experimental" reasoning, which concerned itself with matters of fact. As for moral decisions, these were a matter of sentiment—they depended on what people felt about them, not on some external imperative, such as religion.

Adam Smith (1723–90) was a close friend of Hume, and a member of the same Scottish intellectual circle. His main impact was in the sphere of economic theory, and his most influential publication was *The Wealth of Nations* (1776). Until this appeared, there had still been an inclination to believe that wealth consisted simply of a stockpile of possessions, land or money. Smith's definition of wealth operated on a national rather than personal level; he argued that a country's wealth and potential for economic growth depended on the amount of consumable goods which were circulated in trade, and which were continually replaced as they were used. Since, he said, "every individual is continually exerting himself to find the most advantageous employment for whatever capital he can command," the general welfare is best served by allowing each of these individuals to pursue his or her own interest, since, though intending only their own personal gain, the capitalists contribute to the general welfare by continually increasing the stock of consumable goods. Smith was thus the father of the policy

of economic *laisser faire*—the doctrine of placing minimum restrictions on capitalist enterprise and trade—which influenced governments well into the nineteenth century.

Toward the end of the eighteenth century the ideas of the British empiricists were extended, but also to some extent contradicted, by Immanuel Kant (1724–1804), who came from Königsberg in East Prussia. Kant published his *Critique of Pure Reason* in 1781 (with a second, revised version in 1788), and his *Critique of Practical Reason* and *Critique of Judgment* in 1790.

What Kant noted was that there were some aspects of sensory experience which could not be accepted as empirically given—for instance, the fundamental ideas we have concerning space and time. He also argued that to make judgment simply a matter of feeling, as Hume suggests is

the case with moral decisions, is to leave out whatever is most characteristic of the idea of judgment itself. It is typical, Kant says, of our fundamental beliefs that we accept their claim to be "true"—by which we mean that they are valid not just for ourselves, as a feeling or emotion would be, but universally. Kant also pointed out that there was a clash between the claim to freedom made by the empiricists and their acceptance of the notion that everything is decided by natural necessity. This idea is the basis of Adam Smith's economic doctrine. Kant tried to resolve the difficulty by means of a paradox: "Every being who cannot act except under the idea of freedom is by this alone—from the practical point of view—really free." At the same time, he fell back on Locke's idea of the necessary limitation of human knowledge.

Architecture

Neo-Palladianism

The Palladian style first introduced into England by Inigo Jones, then displaced in the second half of the seventeenth century by the modified Baroque of Christopher Wren, John Vanbrugh, and Nicholas Hawksmoor (see page 294), was suddenly revived *c.* 1715 by a new group of architects.

Their leader was an aristocratic amateur, Richard Boyle, 3rd Earl of Burlington (1694–1753), and Burlington's most important disciple was William Kent (1685–1748).

Some Palladian buildings were more or less direct copies of buildings by Palladio himself (see page 219) but some were adaptations of the style to suit English conditions. This is the case with William Kent's masterpiece Holkham

19.2 **William Kent**, Holkham Hall (south front), Norfolk, England, begun 1734.

Hall (Fig. **19.2**), in Norfolk, built from 1734 onwards, in which Burlington also had a hand.

Holkham was not a villa but a large country house, built for a member of the Whig oligarchy—the powerful grouping of politicians and landowners, who, after the death of Queen Anne in 1714, supported the new line of Hanoverian kings, beginning with George I (1714–27), and opposed the exiled Stuarts. This oligarchy saw itself, not implausibly, as a new senatorial class, comparable to that which had flourished in ancient Rome. They wanted their houses to be something more than the mere villas for which Palladio had provided such convincing models. The new country houses were expressions not merely of unity with the land and agricultural pursuits, as Palladio's had been, but of conscious wealth and power. Holkham, built for William Coke, celebrated for his improvement of British agriculture, is in fact a palace, but one with a rural, not an urban, setting. In this sense it differed from the town palaces built by Palladio in Vicenza, and corresponded more closely to the large and luxurious country houses favored by rich Romans of the late Republican and Imperial period. The great hall at Holkham, combines ideas taken from Palladio's churches in Venice and others taken directly from ancient Roman sources. The formula had a lasting influence not only on eighteenth-century country houses but on nineteenth- and twentieth-century country buildings generally.

The Palladian formula was also applied to English urban architecture—the town palace, often envisaged by Palladio as a multiple dwelling, was transformed into a group of town houses, bound together to make a single architectural unit. Some of the most striking examples of this formula are to be found in the resort city of Bath (Fig. **19.3**), which in the hands of a group of astute promoters became fashionable as a summer retreat. The transformation of Bath took place between 1727 and the 1790s. Most of the rebuilding was due to the elder and the younger John Wood (1704–54 and 1728–81 respectively), a father and son who were developers as well as architects.

19.3 The Royal Crescent (from the east), Bath, England, 1767–75.

Like William Kent, the Woods reached back beyond Palladio to the latter's Roman models. In 1754 work began on the Circus at Bath, one of the grandest of their architectural creations. This, in the words of a modern architectural historian, translates "the external grandeur and detailed multiplicity of a Roman amphitheatre into terms of domestic architecture." Yet the complex is still an expression of collective living. It shows prosperous equals standing shoulder to shoulder, thus using grandeur to emphasize the importance of the social bond.

Painting

William Hogarth

Eighteenth-century urban developments designed largely for upper-middle-class use, such as the Palladian terraces at Bath, give the idea that the collective life of the period was well mannered and orderly. The spectator carries away a very different impression from the paintings of William Hogarth (1695–1764). Hogarth's life story was typical of the period. He came from an artisan background, was largely self-taught, and achieved success by his own efforts. He was apprenticed at the age of fifteen to an engraver of silverplate, and then became an independent craftsman engraver. He studied painting in his spare time, and became a protégé of the successful mural painter Sir James Thornhill (1675–1734).

Hogarth's reputation was consolidated by a new kind of artistic enterprise—anecdotal paintings arranged in sequence so as to tell a moral tale, and at the same time satirize contemporary society. The most famous of these is *The Rake's Progress* (Fig. **19.1**), a set of eight paintings produced *c.* 1735. One novel aspect of these pieces is that they were painted not so much for their own sake but to be engraved. The engravings brought Hogarth a much wider audience than had been enjoyed by most of his predecessors, though a comparison can be made with the religious woodcuts of Albrecht Dürer (see page 210), which similarly widened the audience for art in Reformation Germany.

Though Hogarth was chauvinistically English in his attitudes, the paintings, with their sparkling brushwork and liking for capricious curves, show the strong influence of the French Rococo. His aesthetic attitudes are explained in some detail in his book *The Analysis of Beauty* (1753). In this he recommends a "precise serpentine line . . . twisted round the . . . figure of a cone" as the true Line of Beauty. For Hogarth, as this quotation indicates, the arabesque was never something purely linear; it helped the spectator to apprehend the solidity of three-dimensional form, and suggested the presence of real objects in an equally real and tangible setting. *The Analysis of Beauty* is also significant in that it places emphasis on practical experience. Hogarth was firmly convinced that the opinions of a practicing artist must always carry more weight than those of a mere connoisseur or theoretician. He is thus closely linked to the English empirical philosophy of his time.

Giovanni Antonio Canaletto

The realistic strain in eighteenth-century art appears in different guise in the landscapes of Giovanni Antonio Canaletto (1697–1768), but he shares with Hogarth the idea that art was made for a strictly defined market, and he treated painting as a trade, an enterprise on a par with shopkeeping. Canaletto received part of his training in Rome, where he was influenced by the tradition of topographical art already established by view-painters depicting ancient monuments for visitors to the city. When he returned to his native Venice, he began to apply the attitudes and techniques he had absorbed in Rome to the purely contemporary townscape around him. His earlier views brilliantly evoke the everyday life of Venice—a notable example is *The Stonemason's Yard* (Fig. **19.4**) of *c.* 1730, which ignores all the more famous Venetian monuments in favor of an obscure and humble corner.

Canaletto soon began to attract an enthusiastic following among the rich English tourists who came to Venice, and was soon working almost entirely for this market, painting the most "obvious" Venetian scenes, such as the Piazza San Marco and the Grand Canal, and enlivening them with the festivals and ceremonials which so enchanted foreign visitors. He was the first and most successful of the artists to turn Venetian townscapes into a stock commercial product.

Canaletto's paintings retain their fascination today, largely because they now seem to capture the life of the past with almost photographic accuracy. This impression is in one way false—Canaletto's views are often somewhat rearranged—and true in another, since one of the artist's basic tools seems to have been a *camera obscura*. A primitive precursor of a modern camera, a *camera obscura* was used to throw an image onto a piece of paper, so that the artist could trace it off, rather than being forced to draw it freehand. Some of Canaletto's drawings show the typical distortions of perspective produced by this device. The decision to use a *camera obscura* as an aid to painting landscape can be seen as another example of the empirical spirit—the basic assump-

tion is that an image taken directly from nature is superior to one which is dependent on the conventions of art.

Wright of Derby and Stubbs

One great difficulty about describing the operation of the empirical spirit in art is the fact that empiricism itself is not a style but an attitude of mind, which is free to clothe itself in different stylistic garments as occasion suits. Two of Hogarth's successors in England borrowed from the various conflicting stylistic conventions of the day, while remaining fascinated with the search for objective truth. It is significant that both were, until comparatively recently, considered second-rank painters, though they now attract more attention than many artists still officially considered "greater."

Joseph Wright of Derby (1734–97) enjoyed only moder-

ate success in his own day, working as a portrait painter mostly for a provincial clientele. Today he is revered mainly for a handful of pictures which are quite unlike anything else in eighteenth-century art. The most celebrated is *An Experiment with a Bird in an Air Pump* (Fig. **19.5**) of *c.* 1767–8. In this a philosopher-scientist demonstrates the fact that air is necessary to sustain life to an enthraled domestic audience—a pet bird flutters in a glass bowl where a vacuum is being created. The painting is lit from a concealed source, and has the smooth, hard, almost geometrical forms, plus the dramatic chiaroscuro, of a Georges de La Tour (see page 282). Into the composition Wright puts all the drama, magic, and cruelty of the new experimental science which so fascinated his contemporaries.

George Stubbs (1724–1806) trained first as an engraver and was largely self-taught as a painter. From the beginning of his career he was intensely interested in anatomy, both human and animal—he was particularly struck by the fact

19.4 Giovanni Antonio Canaletto, *The Stonemason's Yard c.* 1730. 48¾ × 64⅛ ins (123.8 × 162.9 cm). National Gallery, London.

19.5 Joseph Wright, *An Experiment with a Bird in an Air Pump*
c. 1767–8. Oil on canvas, 72 × 96 ins (182 × 243 cm). Tate Gallery,
London.

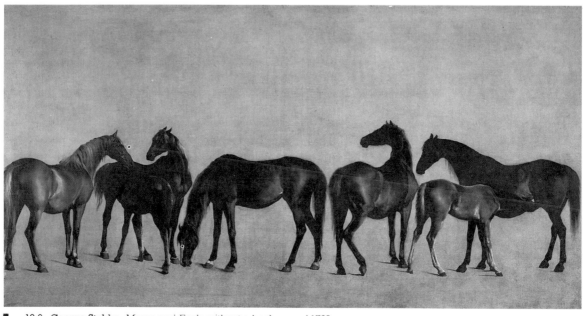

19.6 George Stubbs, *Mares and Foals without a background* 1762.
Oil on canvas, 39 × 75 ins (99 × 190 cm). Tate Gallery, London.

that little research had been done into equine anatomy. In 1756 he secluded himself in Lincolnshire and spent eighteen months dissecting horses. Ten years later he published his researches in a series of superb engravings, *The Anatomy of the Horse*.

Long before this, however, Stubbs had become celebrated as a sporting painter—a branch of art for which there was a strong demand among English patrons, though it enjoyed little prestige till Stubbs brought his sophistication

to it. Though Stubbs's range broadened to include other subjects, such as conversation pieces and portraits of exotic animals, the essence of his talent is to be found in his paintings of horses, as in *Mares and Foals* (Fig. **19.6**). Here the animals are arranged as a frieze stretching across a long, narrow canvas. There are no humans present. The painting combines extreme directness and subtlety of observation, an exquisite rhythmic sense, and an underlying objectivity which is found nowhere else in eighteenth-century art.

Literature

The birth of the novel

The creative writers whose tone best seems to catch the practical and rational aspect of the eighteenth century were, not surprisingly, English, since England was par excellence the country where empirical philosophy originated. Of them, Daniel Defoe (1660–1731) and Henry Fielding (1707–54) were responsible for the birth of the novel as we now know it, that is, as a more complex literary artifact than, for example, Mme. de La Fayette's *The Princesse de Clèves* (see page 286). The novel—an analysis of life and a parallel to life—was to become the dominant literary form of the eighteenth and nineteenth centuries, and survives, though not unchallenged, to our own day.

Defoe came from a nonconformist London family. He pursued a career first as a businessman and then as a pamphleteer and journalist. He was master of the plainest and most direct prose style wielded by any great English writer—one reason was that he lacked the classical education which was the privilege of his betters. He had an inexhuastible thirst for information, and also the knack of presenting what he knew at secondhand as if it had happened to him personally. The supreme example of this is *Robinson Crusoe* (1719). A large part of the book concerns the adventures of a man who finds himself stranded on an uninhabited desert island. The way in which he survives, the practical solutions he finds for his problems, and his reactions to solitude have fascinated generations of readers. What makes *Robinson Crusoe* a great book is not merely the way in which Defoe enforces belief by finding just the right detail for every occasion, but the way in which Crusoe himself becomes the universal representative of all humankind, simply because he is so perfectly ordinary and without special abilities. Readers can easily substitute themselves for the hero of the book.

All that *Robinson Crusoe* needs to make it a novel in the modern sense is interplay of characters. This appears in Fielding's *Tom Jones* (1749), which, despite competition from Samuel Richardson's *Pamela* (1740), is the first fully-

developed novel in the sense in which we now use that word, where both the external world (what happens) and the internal one (how the characters react) are completely represented. *The Princesse de Clèves* lacks the former quality, just as *Robinson Crusoe* lacks the latter. *Tom Jones*, unlike *Pamela*, which is epistolary—a series of letters—consists throughout of vigorous direct narrative. The basic plot is simple—boy loves girl, boy loses girl, boy goes out into the world and has a series of adventures, boy finally wins and marries girl. This is the traditional stuff of romance; what gives the book its novelty and vigor is the interplay of different personalities. Fielding's most outstanding creation is not Tom, who gives his name to the book, but the rustic, impulsive, wonderfully down-to-earth Squire Western, father of the heroine. Here he is, at the denouement of the book:

> At this instant, Western who had stood some time listening, burst into the room, and with his hunting voice and phrase, cried out, "To her boy, go to her.—That's it, little honeys, O that's it. Well, what is it all over? Hath she appointed the day, boy? What shall it be tomorrow or next day? It shan't be put off a minute longer than next day I am resolved."
>
> (HENRY FIELDING, *Tom Jones*. Penguin Books Ltd., 1985.)

Fielding seems to have owed his skill in handling characters to the fact that he was an experienced playwright. Between 1729 and 1737 he either wrote or adapted (from Molière, see page 286) no fewer than twenty-five plays. The novel, as Fielding envisaged it, was a combination of Molière's dramatic skills and the burlesque of the popular romance, already carried out to perfection by Cervantes (see page 236), whose *Don Quixote* Fielding also knew and admired. Another important influence may have been his real-life experience in the law courts—Fielding was appointed Justice of the Peace for Westminster in 1748, shortly before *Tom Jones* appeared.

L

ITERATURE

Tom Jones

Here Squire Western idiosyncratically blesses the impending union of his daughter Sophia and Tom Jones—a union he has hitherto opposed. The way in which he does so shows his earthiness, his impetuosity, his dictatorial streak, and the fundamental goodness of his character.

At this instant, Western, who had stood some time listening, burst into the room, and with his hunting voice and phrase, cried out, "To her boy, to her, go to her.—That's it, little honeys, O that's it. Well, what is it all over? Hath she appointed the day, boy? What shall it be to-morrow or next day? It shan't be put off a minute longer than next day I am resolved." "Let me beseech you, sir," says Jones, "don't let me be the occasion—" "Beseech mine a—," cries Western, "I thought thou had'st been a lad of higher mettle, than to give way to a parcel of maidenish tricks.—I tell thee 'tis all flimflam. Zoodikers! she'd have the wedding to-night with all her heart. Would'st not, Sophy? Come confess, and be an honest girl for once. What, art dumb? Why do'st not speak?" "Why should I confess, sir?" says Sophia, "since it seems you are so well acquainted with my thoughts."—"That's a good girl,"—cries he, "and do'st consent then?" "No, indeed, sir," says Sophia, "I have given no such consent."—"And wunt nut ha un then to-morrow, nor next day?" says Western.—"Indeed, sir," says she, "I have no such intention." "But I can tell thee," replied he, "why hast nut, only because thou dost love to be disobedient, and to plague and vex thy father."—"Pray, sir," said Jones interfering.—"I tell thee, thou at a puppy," cries he. "When I forbid her, then it was all nothing but sighing and whining, and languishing and writing; now I am vor thee, she is against thee. All the spirit of contrary, that's all. She is above being guided and governed by her father, that is the whole truth on't. It is only to disoblige and contradict me." "What would my papa have me do?" cries Sophia. "What would I have thee do?" says he, "why gi un thy hand this moment."—"Well, sir," said Sophia, "I will obey you.—There is my hand, Mr Jones." "Well, and will you consent to ha un to-morrow morning?" says Western.—"I will be obedient to you, sir," cries she.—"Why then to-morrow morning be the day," cries he.—"Why then to-morrow morning shall be the day, papa, since you will have it so," says Sophia. Jones then fell upon his knees, and kissed her hand in an agony of joy, while Western began to caper and dance about the room, presently crying out,—"Where the devil is Allworthy? He is without now, a talking with that d—d lawyer Dowling, when he should be minding other matters." He then sallied out, in quest of him, and very opportunely left the lovers to enjoy a few tender minutes alone.

Fielding

Robinson Crusoe

Robinson Crusoe begins to discover that his solitary existence on his desert island is not without moral and even spiritual advantages. The terms in which Defoe evokes this change of heart remind the reader that the author was a Dissenter—that is, a protestant who did not recognize the religious authority of the Church of England.

In this journey my dog surprized a young kid, and seized upon it, and I running in to take hold of it, caught it, and saved it alive from the dog. I had a great mind to bring it home if I could; for I had often been musing whether it might not be possible to get a kid or two, and so raise a breed of tame goats, which might supply me when my powder and shot should be all spent.

I made a collar to this little creature, and with a string which I made of some rope-yarn, which I always carry'd about me, I led him along, tho' with some difficulty, till I came to my bower, and there I enclosed him and left him; for I was very impatient to be at home, from whence I had been absent above a month.

I cannot express what a satisfaction it was to me, to come into my old hutch, and lye down in my hamock-bed. This little wandring journey, without settled place of abode, had been so unpleasant to me, that my own house, as I called it to my self, was a perfect settlement to me, compared to that; and it rendred every thing about me so comfortable, that I resolved I would never go a great way from it again, while it should be my lot to stay on the island.

I reposed my self here a week, to rest and regale my self after my long journey; during which, most of the time was taken up in the weighty affair of making a cage for my Poll, who began now to be a meer domestick, and to be mighty well acquainted with me. Then I began to think of the poor kid, which I had penned in within my little circle, and resolved to go and fetch it home, or give it some food; accordingly I went, and found it where I left it, for indeed it could not get out, but almost starved for want of food. I went and cut bows of trees, and branches of such shrubs as I could find, and threw it over, and having fed it, I ty'd it as I did before, to lead it away; but it was so tame with being hungry, that I had no need to have ty'd it; for it followed me like a dog; and as I continually fed it, the creature became so loving, so gentle, and so fond, that it became from that time one of my domesticks also, and would never leave me afterwards.

The rainy season of the autumnal equinox was now come, and I kept the 30th of September in the same solemn manner as before, being the anniversary of my landing on the island, having now been there two years, and no more prospect of being delivered than the first day I came there. I spent the whole day in humble and thankful acknowledg-

ments of the many wonderful mercies which my solitary condition was attended with, and without which it might have been infinitely more miserable. I gave humble and hearty thanks that God had been pleased to discover to me, even that it was possible I might be more happy in this solitary condition, than I should have been in a liberty of society, and in all the pleasures of the world; that He could fully make up to me the deficiencies of my solitary state, and the want of humane society, by His presence and the communications of His grace to my soul, supporting, comforting, and encouraging me to depend upon His providence here, and hope for His eternal presence hereafter.

It was now that I began sensibly to feel how much more happy this life I now led was, with all its miserable circumstances, than the wicked, cursed, abominable life I led all the past part of my days, and now I changed both my sorrows and my joys; my very desires altered, my affections changed their gusts, and my delights were perfectly new from what they were at my first coming, or indeed for the two years past.

Before, as I walked about, either on my hunting, or for viewing the country, the anguish of my soul at my condition would break out upon me on a sudden, and my very heart would die within me, to think of the woods, the mountains, the desarts I was in; and how I was a prisoner, locked up with the eternal bars and bolts of the ocean, in an uninhabited wilderness, without redemption. In the midst of the greatest composures of my mind, this would break out upon me like a storm, and make me wring my hands and weep like a child. Sometimes it would take me in the middle of my work, and I would immediately sit down and sigh, and look upon the ground for an hour or two together; and this was still worse to me; for if I could burst out into tears, or vent my self by words, it would go off, and the grief having exhausted it self would abate.

But now I began to exercise my self with new thoughts; I daily read the word of God, and apply'd all the comforts of it to my present state. One morning, being very sad, I opened the Bible upon these words, *I will never, never leave thee, nor forsake thee*; immediately it occurred that these words were to me; why else should they be directed in such a manner, just at the moment when I was mourning over my condition, as one forsaken of God and man? "Well then," said I, "if God does not forsake me, of what ill consequence can it be, or what matters it, though the world should all forsake me, seeing, on the other hand, if I had all the world, and should lose the favour and blessing of God, there wou'd be no comparison in the loss?"

From this moment I began to conclude in my mind that it was possible for me to be more happy in this forsaken, solitary condition than it was probable I should ever have been in any other particular state in the world; and with this thought I was going to give thanks to God for bringing me to this place.

Defoe

(FIELDING, *Tom Jones*. First published 1749. Published in the English Library 1966. Reprinted in Penguin Classics, 1985.)

(DEFOE, *Robinson Crusoe*. First published 1719. Published in Penguin English Library 1965. Reprinted in Penguin Classics, 1985.)

Drama

Beaumarchais

The theater, rather than the novel, remained the dominant literary form throughout most of the eighteenth century, in the sense that it was the theater which offered an important collective experience, which swayed people's emotions most easily, and which had an immediate impact on the other arts, especially painting. It is thus a surprise to discover that it was not an epoch of great plays. Of the meager harvest of those which are still viable, the majority are comedies.

In France drama underwent a significant shift of emphasis, which can be seen when one compares the comedies of Marivaux with those of his most important successor as a comic playwright, Pierre Augustin Caron de Beaumarchais (1732–99). The energy of Marivaux's comedies is to be found in their inventive use of language. Beaumarchais created a comedy of situation. His two major plays demonstrate both the social importance of the theater and its growing political potency.

The Barber of Seville (1775) and *The Marriage of Figaro* (1784) both had difficult births. With the *Barber*, the difficulties were largely technical. Beaumarchais was not an experienced playwright and, when first produced, his play was too long; it became a success only after drastic pruning. What particularly attracted the Parisian public was its antiauthoritarian stance, and the fact that a clever manservant (the "barber" of the title) was the true hero, rather than his master. The role of Figaro looks both forward and back—it expresses the growing spirit of egalitarianism, and yet is in

some ways a logical extension and elaboration of the part of Harlequin in the *commedia dell'arte* (see page 320).

Beaumarchais's *The Marriage of Figaro*, the sequel to the *Barber*, and the source of Mozart's opera of the same title (see page 359), uses some of the same characters, especially Figaro and his master, Count Almaviva. The plot turns on the efforts of the Count to bed a pretty maidservant, Susanne, through the crude exercise of his feudal rights, and also as a kind of fee for allowing her to marry his valet. Though it was set in Spain, the play was a scarcely veiled attack on the French social system of the time, and specifically on aristocratic privilege. In the valet hero, the author turns the character into a portrait of himself. At one point, Figaro tells his master: "Because you are a great lord, you think you are a great genius! Nobility, rank, palaces—all that makes one so proud! What have you done to have so much? You have been to the trouble to be born, nothing more."

Louis XVI made the play the subject of a personal veto, but Beaumarchais (acting just as Figaro would have done) outmaneuvered him by arranging a private performance attended by the king's youngest brother, the Comte d'Artois. The result was such an enormous clamor for a public production by the Comédie Française that the king could resist no longer. A little later, the piece was performed at Versailles, with the queen, Marie-Antoinette, in the role of the maid. Few theatrical occasions can have been more loaded with irony.

Music

Gay and Handel

Across the Channel, nearly sixty years earlier than the first performance of Beaumarchais's *The Marriage of Figaro*, another and very different theatrical entertainment caused a comparable stir. This was John Gay's unpretentiously tuneful *The Beggars' Opera*, based on already familiar popular tunes, which was first staged in 1728. Its political allusions were more specific and cutting than anything ventured by Beaumarchais—the prime minister of the day, Sir Robert Walpole, was satirized as Peachum, the buyer of stolen goods and police informer who is one of the main characters of the piece. However, England in the early eighteenth century had a more stable and flexible political system than France toward the end of it. The real importance of *The*

Beggars' Opera lay not in its political commentary but in its brilliant deflation of operatic conventions, which are constantly exposed as ridiculous and irrational. The universe of art, the piece tells us, crumbles at the touch of real life.

The person who was most likely to suffer from the success of *The Beggars' Opera* was not Walpole, but George Frederick Handel (1685–1759). Handel was a German from Halle who had learned his trade as an operatic composer in Italy, and who had revived musical life in London by introducing operatic performances on a regular basis.

Handel was resilient enough to adapt himself to the shifts in musical fashion in England, which were not due to Gay alone. He gradually discovered that the English middle class offered more solid patronage than the aristocrats upon whom he had relied at first, though his *Water Music* (1715–

17, revised 1736) and his *Music for the Royal Fireworks* (1749) show his skill in turning out pieces for ceremonial occasions. From the early 1730s, therefore, he turned out a string of brilliant works in a new form, the oratorio.

The oratorio was a compromise with British puritanism. In particular it got round the ban on representing sacred personages on stage. Handel presented familiar Bible stories in epic form, using principals and a chorus all of whom remained static. His immediate models were Racine's sacred dramas *Esther* and *Athalie*, both of which he adapted and set to music, but the true ancestor of the English oratorio was Greek tragedy, in which the chorus played a major role. The use of the chorus is very evident in those of Handel's oratorios which are most often heard in the concert hall today, *The Messiah* (1742) and *Samson* (1743).

Handel was an immensely skillful orchestrator always in search of new brilliancies of tone. The large oratorio chorus appealed to him because it added a new dimension to the sound he was able to produce. At that time, when orchestras were comparatively small, these great choral outbursts must have sounded overwhelming. Yet they were also a manifestation of the English collective spirit, as opposed to the star-system which prevailed in operatic performances and which had formed one the objects of satire in *The Beggars' Opera*.

19.7 William Hogarth, *The Beggars' Opera c.* 1729. Collection of Paul Mellon, America.

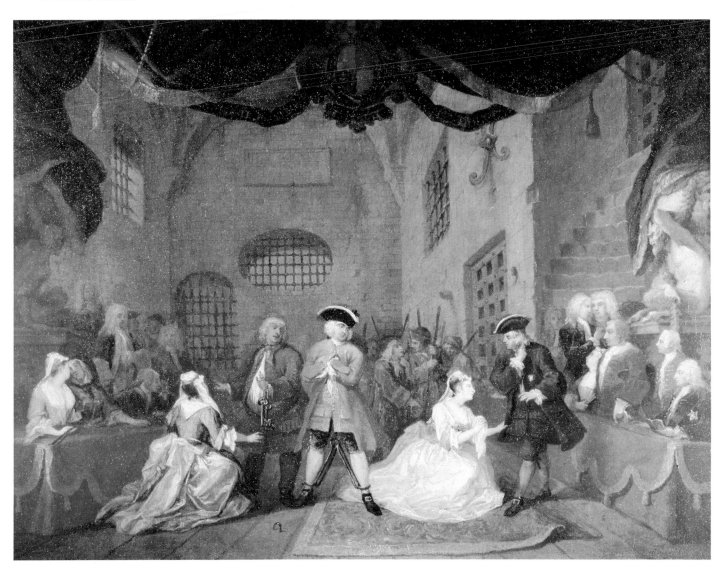

Chapter 20

The Enlightenment

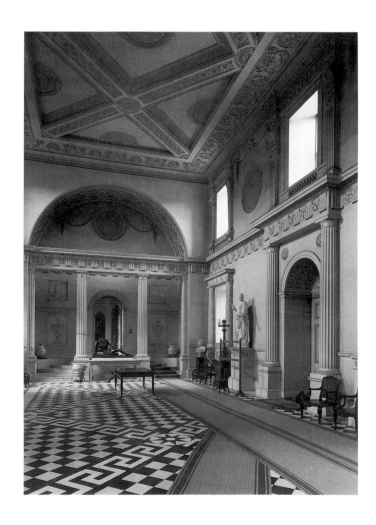

20.1 **Robert Adam**, entrance hall at Syon House, Hounslow, Middlesex, England, 1760–69.

Philosophy

The Enlightenment

The Enlightenment was, as its name suggests, a rebellion against unreason. Intellectuals throughout Europe, but especially in France, allied themselves to promote a tempered and rational approach, not only to natural phenomena but to politics and society as well. These intellectuals were known as *Philosophes*—the French word for "philosopher" was and still is used to distinguish the instigators of this new way of thinking from practitioners of philosophy more narrowly defined. Their energy and curiosity led them into a large number of different fields, and they concerned themselves with the whole range of human knowledge. The empiricism of Locke informed the approach taken by the leaders of the movement, most of whom had great admiration for English social and political institutions.

One of the most important things that leaders of the Enlightenment set out to do was to bring different branches of knowledge into a convincing and coherent relationship. They felt that reason and tempered judgment should be sovereign in all fields of research, including religious belief.

Most of all, they believed in making knowledge as widely available as possible. In France the greatest achievement of the *Philosophes* was their *Encyclopédie*, a vast compendium of knowledge presented from a rationalist point of view. This was physically as well as intellectually the greatest publishing enterprise of the eighteenth century. It began modestly with a project for a French translation of an English work of reference, Ephraim Chambers's *Cyclopaedia*. The men chiefly responsible were Denis Diderot (1713–84), who became editor-in-chief in 1747, and Jean Le Rond d'Alembert (1717–1783), who wrote the "preliminary Discourse" for the first volume, published in 1751. Because it appeared in France, where there was active censorship, the *Encyclopédie* encountered many difficulties. It was twice suppressed in the course of publication—in 1752 and 1759. Yet even a hostile and suspicious government came to realize that the complete work would provide an essential source of information, of a kind previously unobtainable anywhere in Europe. This struggle against the authorities gave the enterprise a glamor it might otherwise not have had. The Encyclopedists suddenly became heroes and were courted by progressive rulers in Europe, such as Catherine the Great of Russia and Frederick the Great of Prussia. These rulers, in turn, were responsible for a new political concept—Enlightened Despotism—which was an attempt to use new intellectual and social ideas to shore up the old political framework.

Neo-Classicism

An important by-product of the attack made by the Enlightenment on traditional ways of looking and thinking was the Neo-Classical style, a supposed revival of the ancient Greek approach to architecture, sculpture, and painting based on simplicity of form and extreme restraint in the use of ornament, with a deliberate avoidance of the dynamism and plasticity emphasized by Baroque art and its successor, the Rococo. Neo-Classicism also embodied a new moral seriousness as opposed to the frivolity and hedonism associated with the Rococo.

While it was neither the first nor the last attempt to present a radical change in art under the guise of a return to ancient ways, it did have one special characteristic. It was probably the first art style to be invented by writers and theoreticians, rather than by practicing artists. The leading propagandist for Neo-Classicism was the German scholar Johann Joachim Winckelmann (1717–68), who settled in Rome in 1755 as the librarian of Cardinal Albani, a leading collector.

Winckelmann divided the development of Greek art into periods, using a system of classification still employed today—the Archaic Style (before Phidias) being followed by the severe Classicism of Phidias and his contemporaries, then by the softer, more "beautiful" Classicism of Praxiteles. Later still came the long aftermath of Hellenistic and Roman imitation. Winckelmann was also the first to try to make a distinction between original Greek works and Roman copies.

His researches, and the writings which resulted from them, such as his *History of Ancient Art* (1764), were motivated by a powerful subjective attachment to the Greek civilization he imagined. For him Greek art provided an intellectual, physical, and moral idea that could be discovered nowhere else. However, as can be seen from his reactions to the *Laocoon* which we now know to be Roman rather than Greek, these conclusions were dependent on a still imperfect knowledge of Greek art.

This was only one aspect of Neo-Classicism—the nostalgic, even sentimental aspect which links it to the rise of Romanticism (see page 373), and makes it, indeed, the very earliest phase of the Romantic movement. There was another and very different aspect as well. With its emphasis on simplification of form, on clear, crisply defined shapes, on unambiguous forms and relationships of form, Neo-Classicism became the vehicle for rationalist, standardized architecture and design, able to respond to the demands made by the Industrial Revolution.

FOCUS

Catherine the Great

Catherine II of Russia (1762–96) was perhaps the most remarkable ruler to appear in Europe during the eighteenth century, outstripping even her rival Frederick the Great of Prussia (1740–86).

Catherine had no Russian blood. Born in 1729, she was the daughter of a petty German prince, Christian August of Anhalt-Zerbst, and was selected by the Empress Elizabeth of Russia (1741–62) as a suitable wife for her nephew and heir Peter, later Peter III. She married Peter in 1744. Much more intelligent than her husband who, as soon as he succeeded to the throne, began to threaten to divorce her, she engineered a successful *coup d'état*, with the help of one of her lovers, Grigori Orlov, together with his brother Alexis and some of their friends.

From these unpromising beginnings came a long and prosperous period of rule. Catherine completed the transformation of Russia begun by Peter I, the Great (1682–

Joshua Reynolds, *The Infant Hercules*. The Hermitage, St. Petersburg, Russia.

1725), and became perhaps the best example of an Enlightened Despot—one of a group of European rulers influenced by the French *Philosophes* (see page 335), who used their power to impose many of the ideas of the French Enlightenment on sometimes reluctant subjects. Among Catherine's regular correspondents were Voltaire (see page 344), Diderot and D'Alembert (see page 335).

Catherine was an organizer, a patron and a collector. She created a Russian Academy of Fine Arts upon the French model, and refounded the Academy of Sciences created by Peter I (its original statutes had been drawn up by Leibniz (see page 290). The Academy of Sciences interested itself in many topics. A new, comprehensive grammar of the Russian language was produced, and so was a new Russian atlas. Following a practice initiated by Peter I, Catherine sent scientific expeditions to every corner of the Russian empire. Interested in improving the state of medicine, the empress had herself publicly inoculated in 1768 against smallpox.

Catherine was also responsible for the construction of some magnificent buildings. She arranged for the completion and extension of the Winter Palace in St. Petersburg, begun by the Empress Elizabeth, and the construction of the Hermitage to house her collections. Summer palaces at Tsarkoe Selo, Peterhof, and Gatchina, all in the environs of St. Petersburg, were also built. She was an enthusiast for the newly fashionable Neo-Classical style. Among the architects she employed were the Italian Giacomo Quarenghi (1744–1817) and the Scotsman Charles Cameron (1746–1812).

Catherine was also an avid collector of both Old Masters and modern (mostly French) pictures. Her greatest triumph as a collector was the purchase, in 1779, of the distinguished collection of pictures made in the first half of the eighteenth century by Sir Robert Walpole, the English prime minister. In Paris Diderot acted as her adviser and sometimes as her agent. Among her more notable contemporary purchases were a second version of Houdon's seated statue of Voltaire (see page 343), and an allegorical painting commissioned from Sir Joshua Reynolds, showing the *Infant Hercules strangling the Serpents*. Reynolds intended this as a complimentary reference to the new strength of the Russian Empire.

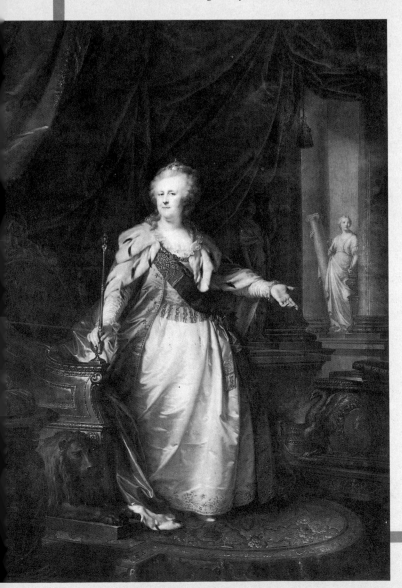

Portrait of Catherine the Great, from the Imperial Palace, St. Petersburg, Russia.

Neo-Classical architecture

The Neo-Classical spirit found natural expression in architecture, since the eighteenth-century public was already fully accustomed to the use of classical forms. But now these were reinterpreted in terms of a new and more searching examination of ancient buildings. The distinction between Greek and Roman architecture came to be better understood, thanks to the rediscovery of the early Doric temples at Paestum in southern Italy and Agrigentum in Sicily, and still more so to the publication in 1762 of Stuart and Revett's *Antiquities of Athens*. For the first time this made available good illustrations of buildings on the Greek mainland. The new generation of architects was also open to ideas taken from Roman architecture. Piranesi's prints of the *Antiquities of Rome* suggested new ways of looking at familiar buildings—he was probably responsible for the renewed popularity of massive rustication, in which masonry was treated to resemble huge square blocks, often with a deliberately rough surface finish. The excavations at Pompeii and Herculaneum provided new models for domestic decoration; more exotic influences came from late Roman buildings outside Italy, such as Diocletian's palace at Spalato in Dalmatia, and the impressive ruins at Baalbek and Palmyra.

Neo-Classical architecture rejected the plasticity of the Baroque, and its incorrect use of antique forms—curved, broken pediments, for example. It was particularly hostile to the capricious asymmetry of the Rococo. But it was not itself completely coherent, pulling architectural style in two different directions. One was an impulse toward the linear, with surfaces ornamented with a filigree of low-relief decoration. This was the direction taken, at least for interior architecture, by the Scotsman Robert Adam (1728–82). His designs for the superb entrance hall (Fig. **20.1**) at Syon House, a ducal seat just outside London, perfectly catch the new decorative spirit. They suggest that an English territorial magnate, the Duke of Northumberland, was indeed the latter-day equivalent to a Roman emperor in splendor, luxury, and power. They also suggest that Great Britain was, even at this early stage in the development of its empire, becoming a consciously imperial regime.

The other impulse was toward massive unitary forms—geometrical solids which were used to express the new sense of "the Sublime" (which is discussed in the next chapter, see page 352) and are found at their most extreme in visionary projects which could never have been carried out in practice. The best known is the proposed cenotaph designed by the French architect Etienne-Louis Boullée (1728–99) for Isaac Newton (Fig. **20.2**). It was to consist of a hollow sphere 500 feet (152 m) in diameter. "From whatever side we look at this shape," Boullée wrote, "no trick of perspective can alter the magnificence of its perfect form." The sphere was clearly chosen as the most perfect and regular of all shapes, and thus an especially suitable way to commemorate the begetter of the new Age of Reason. The project itself, however, is divorced from ideas of rationality or utility.

■ 20.2 Etienne-Louis Boullée, *Cenotaph for Isaac Newton* 1784.

Painting

Neo-Classical history painting

Paradoxically, since the ancient world offered many fewer models, and these were Roman rather than Greek, Neo-Classicism found expression in painting before it did so in sculpture. To begin with, it was a negative creed.

Anton Rafael Mengs (1728–79) was a new kind of artist, rootless and international. By birth he was German; he was also Jewish. His father, Ismael Mengs, who produced miniatures in enamel for the Saxon Elector's court in Dresden, was one of the first Jews to overcome both racial prejudice and the deep-rooted religious inhibitions felt by Orthodox Jews against making figurative art. He was determined that his son should be a greater artist than himself, and took him to Rome to study in 1741. By all accounts, he subjected the boy to an extremely harsh discipline. In 1755, on his second visit to the city, Mengs met Winckelmann and was converted to his ideas, which provided the kind of intellectual anchor he had lacked before. In Winckelmann's circle, Mengs became an insider rather than an outsider; in return his friend hailed him as "the greatest artist of his own, and perhaps of later times."

Mengs's *Parnassus* (Fig. **20.3**) of 1761 is a manifesto picture which throws out the devices of Baroque illusionism and presents Apollo and the Muses in a deliberately flattened, friezelike composition. Mengs's inspiration came partly from the decorative panels showing mythological subjects which were then being excavated at Pompeii, and partly from the work of his namesake Raphael, in particular the fresco of the same subject in the Vatican. Compared to Raphael's version, however, Mengs's work is extremely static and simplified.

Mengs was hugely successful in his own day, becoming a court painter in Madrid and the successful rival of Tiepolo. Looked at now, he seems to be one of those artists who had major impact without possessing any great talent. His most striking works are a group of self-portraits which seem to dramatize his own uneasy search for a convincing identity.

Neo-Classical painting makes its full impact only with the emergence of Jacques-Louis David (1748–1835) in France. Far from being rootless, David, more than any other French painter, became part of his country's history. Critics such as Diderot, and even the royal administrators responsible for organizing official patronage, had long been looking for a new and more serious art which would carry a message of moral regeneration. David was the perfect choice. At the Salon of 1785 he made an overwhelming impression with a classical scene entitled *The Oath of the*

20.3 Anton Rafael Mengs, *Parnassus*. Ceiling of the Villa Albani, Rome, 1756.

20.4 Jacques-Louis David, *The Oath of the Horatii* 1784–85.
Oil on canvas, approx. 14 × 11 ft (4.27 × 3.35 cm). Louvre, Paris.

Portraits

The Enlightenment, with its curiosity about the world, naturally led to a keen interest in the vagaries of human character. This made the eighteenth century a great age of portrait painting. In France significant portraiture was generally carried out in formats of moderate size which gave, so to speak, a close-up view of the sitter. Pastel—work done using sticks of pigment bound with gum which combined the qualities of drawing and painting—was often preferred to the less delicate medium of oil. The greatest pastelist of the age was Maurice Quentin de Latour (1704–88). He portrayed a wide range of sitters—Louis XV, his queen, Mme. de Pompadour, and popular actresses—but he was perhaps most at home with the leading *Philosophes*. His portrait of D'Alembert (Fig. **20.5**) is characteristic in its vivacity and directness. The sitter is shown in everyday dress, and looks as if he is just about to speak. We seem to be brought into the actual presence of the man himself.

At the beginning of his career, when he was still trying to attract clients, Latour had pretended to be English—a sign that England was recognized as the home of portraiture, at least in a commercial sense. The two leading portraitists in England were Joshua Reynolds (1723–93) and Thomas Gainsborough (1727–88). Both profited from an aristocratic

Horatii (Fig. **20.4**). The subject was taken from the early history of Rome, as recorded by Livy and Plutarch. Three brothers swear an oath to their father to defend the city against three rival champions, the Curatii, from the neighboring kingdom of Alba. In the background is a group of lamenting women. The two groups—one male and fiercely angular, the other female and full of drooping curves—take on the character of contrasting moral emblems. The composition has no space for extraneous decoration, and the simple geometrical design on which it is based is apparent from the first glance. *The Oath of the Horatii* had an immense effect on the contemporary Parisian audience—an antique subject had never before been given such tension, such immediate force. The brothers' response to the call of patriotic duty implied a strong criticism of contemporary French society. Though not directly revolutionary in sentiment (it had, after all, been commissioned on behalf of Louis XVI), the picture came to be seen as a prophecy of the French Revolution of 1789.

20.5 Maurice Quentin de Latour, *Portrait of Jean Le Rond D'Alembert* 1753 (exhibited). Pastel, 21½ × 17¾ ins (55 × 45 cm). Louvre, Paris.

fashion in England for full-length likenesses. These emphasized the social status of the sitters, and at the same time made portraiture the rival of "history painting" (the depiction of serious religious, mythological, and historical themes), which was by tradition the superior genre.

Reynolds was a knowledgable and cultivated man, anxious to raise the professional status of the artist, not yet as high in England as it was in France or Italy. Perhaps his most important contribution to the achievement of this aim was his central role in the foundation of the Royal Academy of Arts in 1768. This act was of practical significance in providing a stable institutional home for the training of artists and in mounting a prestigious annual exhibition in London. In his *Discourses* Reynolds laid down a theoretical basis for the Academy's students which encouraged the production of elaborate history paintings.

His own most characteristic work, however, is portraiture. His aim was to endow a contemporary likeness with "wit" (the term used by the critics of the time) by giving it a resonance borrowed from established masterpieces, so that the sitter became part of a great historical succession. One of Reynolds's most startling devices was to show his sitters in modern dress but posed in attitudes derived from antique sculpture. Winckelmann's adored Apollo Belvedere appears thinly disguised as a likeness of the naval officer *Viscount Keppel* (Fig. **20.6**), who thus acquires a grace and stateliness of gesture which perhaps did not naturally belong to him. In

20.7 Thomas Gainsborough, *Blue Boy (Jonathan Buttall)* 1805. Oil on canvas, 70 × 48 ins (177.8 × 121.9 cm). The Huntington Library and Gallery, San Marco, California.

1754 this portrait established Reynolds's reputation after his return from studying in Italy.

Gainsborough, a much less intellectual artist, also borrowed, but from a narrower range of sources. The landscapes he painted for his own pleasure had their roots in seventeenth-century Dutch art, although gradually he broke away from this model. The landscapes became less and less specific, and were in fact painted not from real places but from little models in twigs and cork set up on a studio table. His portraits passed through a number of phases, starting with small-scale figures almost in the manner of Hogarth, but stiffer and more doll-like. The later ones are a distillation of things learned from Watteau and Van Dyck. An example is the famous *Blue Boy* (Fig. **20.7**), in which the sitter wears a fanciful costume derived from the portraits of Van Dyck's English period. Gainsborough was thus able to work in a flattering historical allusion, and enable the subject to be both himself and a figure in an idealized dream world. In many of Gainsborough's late portraits the features have a deliberate vagueness, which enables us to project into them any mood or nuance of character we please. He was thought by contemporaries to be much Reynolds's superior in catching a likeness as a result.

20.6 Joshua Reynolds, *Viscount Keppel* 1754. Oil on canvas, 94 × 58 ins (238.8 × 147.3 cm). Trustees of the National Maritime Museum, London.

20.8 Antonio Canova, *Theseus and the Minotaur* 1781–83.
Marble, 57⅕ ins (145.4 cm) high. Victoria and Albert Museum,
London.

Sculpture

Canova and Houdon

The first fully Neo-Classical sculptor was Antonio Canova (1757–1822), who by the end of his career enjoyed a kind of universal fame which had never before been given to any artist. (This in itself tells us something about the success of the style as an artistic idiom.) The key work in establishing his reputation was *Theseus and the Minotaur* (Fig. **20.8**) of 1781–3, which can also be regarded as the starting point of Neo-Classical sculpture as a whole. The group, based to some extent on the Ludovisi Ares, a Roman copy of a work by Scopas, is a direct attempt to vie with Greek and Roman sculpture, as opposed to simply borrowing features from it. In accordance with classical principles, Canova chose not the moment of struggle, which might have attracted a Baroque sculptor such as Bernini, but the moment of repose, when the young hero, weary and a little melancholy, contemplates his victory. The composition has a complex balance of opposing forces, with one shape echoing another, but Canova was careful to keep it (but for one detail) within the confines of a basically pyramidal shape. The exception is Theseus's club, the brutal instrument of his deed.

Theseus and the Minotaur is a didactic work, preoccupied with making a particular stylistic point. In human terms it makes far less impact than another sculpture which is almost precisely contemporary with it—the seated portrait of Voltaire (Fig. **20.9**) made by Jean-Antoine Houdon (1741–1828) for the Comédie Française. When it was made Houdon was already long-established as the leading portrait sculptor in France—the equivalent of Maurice Quentin de Latour in searching directness. Houdon had the power, often remarked upon in his own time and since, of catching his sitters in apparent transition from one mood to another. His fluidity, which is like Gainsborough's, is somewhat opposed to the Neo-Classical preference for things which were fixed and static. Yet the statue does have recognizably classical elements, which are cleverly accommodated to the demands of a contemporary portrait.

Voltaire sat for Houdon at the very end of his life, in 1778, on his return to Paris after a long absence. As Houdon knew, the work had to sum up a complex personality, about whom most educated people already had some kind of opinion. The statue combines likeness and commentary in an extremely subtle way. Voltaire is shown without a wig, and is thus immediately identified as a philosopher of the ancient sort. He wears a voluminous dressing gown which suggests a toga without actually being one, and sits in a chair adapted from the antique. But the pose is far from static. The subject leans forward eagerly, gripping the arm of his seat, and his animated expression tells us that he is about to deliver one of his devastating retorts. While it suggests many parallels with ancient sculpture (the motif—a figure seated in a chair—has a long pedigree in Greek and Roman art), Houdon's image of Voltaire is nevertheless "modern" in terms of its time. Unlike the *Theseus*, it does not attempt to rival antiquity directly; it suggests, rather, that the eighteenth-century Enlightenment can justly compare its own achievements to those of classical civilization.

20.9 **Jean-Antoine Houdon**, *Seated Portrait of Voltaire* 1781. Terracotta and plaster, after a marble statue now in the Comédie Française, Paris. Fabre Museum, Montpelier, France.

Literature

Voltaire and *Candide*

The pioneer, and also the figurehead, of the Enlightenment was Voltaire (1694–1778), born François Marie Arouet. Under his adopted name, which he took in 1718 after a brief imprisonment in the Bastille, he became famous all over Europe as the personification of the new liberal, anti-clerical spirit and the embodiment of French intellectual life. The paradox was that many of the most important of his ideas came originally from England. He visited that country in 1726–9, and absorbed the doctrines of Locke and the other empiricists. *Letters Concerning the English Nation*, his first important philosophical work, was published in English translation in 1733 and in the original French the next year.

Writing philosophy was only a small part of Voltaire's activities. He made his reputation as poet, playwright, polemicist, and writer of prose fiction. He provided France with a national epic, the *Henriade*, and pioneered the revival of interest in Joan of Arc with a burlesque poem about her, *La Pucelle (The Virgin)*. His collected letters fill many volumes. Monarchs treated him as an equal, and one of the most complicated relationships in his long life was with Frederick the Great of Prussia.

Posterity has tended to find Voltaire's life and career more interesting than his literary works. The exception is *Candide* (1759), a brief comic novel inspired by the Lisbon earthquake of 1756—a cataclysm which killed 30,000 people. Voltaire was always preoccupied with the problem of evil. How could a benevolent deity be responsible for a world which had so much which was terrible in it? "Things cannot be otherwise than as they are; for as all things have been created for some end, they must necessarily be created for the best end." Voltaire puts these words into the mouth of Pangloss, a fatuous schoolmaster, but strikes through him at an eminent adversary—the German philosopher Gottfried Wilhelm Leibniz (see page 292), who tried to find a logical proof that God was always good, even on those occasions when appearances suggested the contrary.

Candide, the hero of Voltaire's story, is in fact subjected to one horrific catastrophe after another. But he always survives them unscathed, with his innocence untouched and his faith unshaken that "all is good in nature." It is significant that Voltaire chose to make his hero a German—in his day, Germans were regarded as the embodiment of bucolic simplicity. Yet there is also in the young Candide something of Voltaire himself, who shared his creation's powers of survival, remaining optimistic throughout his life that the world could, through the efforts of well-intentioned individuals, be made into a better place.

Music

The operas of Gluck

In the mid-eighteenth century opera was still dominated by the conventions of *opera seria* (literally "serious opera"). This treated heroic themes in a formal, dignified way, halting the action frequently for extended soliloquies in the form of arias—the same number for each of the chief characters, so as to prevent quarrels among the cast. The *da capo* ("from the head," or "from the beginning") form of these arias, with the first section repeated literally after an intermediary bridge passage, gave plenty of scope for virtuoso singing but little for real drama.

The composer who tried to reform this situation was Christoph Willibald von Gluck (1714–97). Gluck came from the world of German music; he studied in Prague and first made a reputation as an opera-composer in Vienna. This early phase of his career culminated with the moving *Orfeo* (1762), based on the myth of Orpheus who tries to fetch back his dead wife Eurydice from the underworld, with its concern for dramatic truth and simplicity of expression. *Orfeo* already shows Gluck's sympathy with French opera, which followed different traditions from those which prevailed in Italy and Germany. There was less emphasis on virtuoso singing, and much greater use was made of ballets and choruses. It was perhaps inevitable, therefore, that Gluck should spend the second part of his career in Paris, composing new operas and presenting revised versions of others. One of the most important, from a historical point of view, is *Alceste*, based on another Greek myth, this time about a wife who offers to die in place of her husband. The Italian version, written in Vienna, dates from 1767; the French one from 1776. In his preface to the Italian version Gluck set out his ideas for operatic reform, recommending "noble simplicity" and condemning ornament:

Candide

In the opening chapter of *Candide* Voltaire sets out the basic terms of the story. These are Dr. Pangloss's belief, following Leibniz (see page 292), that "this is the best of all possible worlds," and Candide's unshakeable naïveté of character. Throughout the book, a tone of dry humor stresses the author's omniscience and superiority to the events he describes.

CHAPTER I

How Candide was brought up in a beautiful country house, and how he was driven away

There lived in Westphalia, at the country seat of Baron Thunder-ten-tronckh, a young lad blessed by nature with the most agreeable manners. You could read his character in his face. He combined sound judgment with unaffected simplicity; and that, I suppose, was why he was called Candide. The old family servants suspected that he was the son of the Baron's sister by a worthy gentleman of that neighbourhood, whom the young lady would never agree to marry because he could only claim seventy-one-quarterings, the rest of his family tree having suffered from the ravages of time.

The Baron was one of the most influential noblemen in Westphalia, for his house had a door and several windows and his hall was actually draped with tapestry. Every dog in the courtyard was pressed into service when he went hunting, and his grooms acted as whips. The village curate was his private chaplain. They called him Your Lordship, and laughed at his jokes.

The Baroness, whose weight of about twenty-five stone made her a person of great importance, entertained with a dignity which won her still more respect. Her daughter, Cunégonde, was a buxom girl of seventeen with a fresh, rosy complexion; altogether seductive. The Baron's son was in every way worthy of his father. His tutor, Pangloss, was the recognised authority in the household on all matters of learning, and young Candide listened to his teaching with that unhesitating faith which marked his age and character.

Pangloss taught metaphysico-theologo-cosmolo-nigology. He proved incontestably that there is no effect without a cause, and that in this best of all possible worlds, his lordship's country seat was the most beautiful of mansions and her ladyship the best of all possible ladyships.

"It is proved," he used to say, "that things cannot be other than they are, for since everything was made for a purpose, it follows that everything is made for the best purpose. Observe: our noses were made to carry spectacles, so we have spectacles. Legs were clearly intended for breeches, and we wear them. Stones were meant for carving and for building houses, and that is why my lord has a most beautiful house; for the greatest baron in Westphalia ought to have the noblest residence. And since pigs were made to be eaten, we eat pork all the year round. It follows that those who maintain that all is right talk nonsense; they ought to say that all is for the best."

Candide listened attentively, and with implicit belief; for he found Lady Cunégonde extremely beautiful, though he never had the courage to tell her so. He decided that the height of good fortune was to have been born Baron Thunder-ten-tronckh and after that to be Lady Cunégonde. The next was to see her every day, and failing that to listen to his master Pangloss, the greatest philosopher in Westphalia, and consequently the greatest in all the world.

One day Cunégonde was walking near the house in a little coppice, called "the park", when she saw Dr. Pangloss behind some bushes giving a lesson in experimental physics to her mother's waiting-woman, a pretty little brunette who seemed eminently teachable. Since Lady Cunégonde took a great interest in science, she watched the experiments being repeated with breathless fascination. She saw clearly the Doctor's "sufficient reason", and took note of cause and effect. Then, in a disturbed and thoughtful state of mind, she returned home filled with a desire for learning, and fancied that she could reason equally well with young Candide and he with her.

On her way home she met Candide, and blushed. Candide blushed too. Her voice was choked with emotion as she greeted him, and Candide spoke to her without knowing what he said. The following day, as they were leaving the dinner table, Cunégonde and Candide happened to meet behind a screen. Cunégonde dropped her handkerchief, and Candide picked it up. She quite innocently took his hand, he as innocently kissed hers with singular grace and ardour. Their lips met, their eyes flashed, their knees trembled, and their hands would not keep still. Baron Thunder-ten-tronckh, happening to pass the screen at that moment, noticed both cause and effect, and drove Candide from the house with powerful kicks on the backside. Cunégonde fainted, and on recovering her senses was boxed on the ears by the Baroness. Thus consternation reigned in the most beautiful and delightful of all possible mansions.

Voltaire

(VOLTAIRE, *Candide*, translated by John Butt. Penguin Classics, 1947. Copyright John Butt 1947. Reprinted by permission of Penguin Books Ltd.)

I undertook to divest [the form] entirely of those abuses, introduced either by the mistaken vanity of singers or by the too great complaisance of composers, which have too long disfigured Italian opera and made the most splendid and most beautiful of spectacles the most ridiculous and wearisome.

What Gluck did was to return to the origins of opera, in the late sixteenth and early seventeenth century, when the music was used to heighten natural speech patterns. It was this emphasis on restraint, naturalness, and simplicity which makes him the counterpart in music of Neo-Classicism in the visual arts, and not the classical subjects he chose, since these had long been the common currency of operatic composers and librettists. From the beginning his was a form of opera which appealed to intellectuals—even in Paris a strong faction came together to oppose him. Though the best of his operas continue to hold the stage, posterity has on the whole tended to prefer such "unreformed" works as Mozart's *Idomeneo*, which, despite its late date (1781), is a full blown example of *opera seria* in which the florid passion of the music overcomes the stiffness of the convention.

Chapter 21

The Cult of Nature and the Cult of Feeling

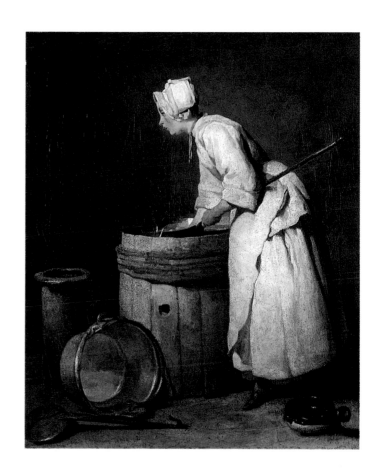

21.1 Jean-Siméon Chardin, *The Scullery Maid* 1738.
Oil on canvas, 17⅞ × 14½ ins (45.4 × 37 cm). The Hunterian Art
Gallery, the University of Glasgow, Scotland.

Philosophy

The Age of Sentiment

The eighteenth century is commonly spoken of as the Age of Reason. During its second half it became more and more the Age of Sentiment. People began to speak of nature, rather than God, as the supreme arbiter, and there grew up a cult of conscious simplicity and "naturalness" in dress, manners, and behavior. Emotions of whatever kind—but especially feelings of tenderness, pity, awe, and agreeable terror—were strenuously cultivated. Fashionable people—women and men—took positive pride in their ability, and indeed readiness, to shed tears when placed in an affecting situation, and sentiment went hand in hand with sentimentality.

Rousseau and Burke

If any one man was responsible for this change in the cultural climate it was Jean-Jacques Rousseau (1712–78).

Rousseau wrote in French, and at one period of his life was close to the circle of the Encyclopedists; till they quarreled, he was a friend of Diderot. But he was nevertheless an outsider because he was a Swiss Protestant, born in Geneva. Rousseau was a man who spent a long time finding himself. It was not until he was in his late thirties that he managed to make a name, with the prize-winning *Discourse on the Sciences and the Arts* (1750). His most influential works, the novel *Julie, or the New Heloise* (1761), his book on education, *Emile* (1762), and his political and philosophical testament, *The Social Contract* (1762), were published within a very short space of time when he was already middle-aged. They brought him a European fame which rivaled that of Voltaire. His reputation with posterity was confirmed by the posthumous publication of his autobiographical *Confessions* (1781), which are a uniquely candid record of his personal development.

What Rousseau did was to propose the existence of a radical antithesis between contemporary society and the true nature of human beings. Inverting the Christian doc-

21.2 **Capability Brown**, The Park at Bowood, 1761.

trine of Original Sin, he declared that an individual's nature was in essence good, but had been corrupted by society— "vice and error, alien to man's constitution, are introduced into it from outside." Passions were not something to be feared and repressed, but something to be educated and led toward goodness—not by reason alone, but through sensation and feeling. For Rousseau, what children brought to the educational process was as valuable as what was imparted to them: "Nature wants children to be children before being men."

Where society was concerned, Rousseau put great emphasis on the notion of liberty: "To give up freedom is to give up one's human quality; to remove freedom from one's will is to remove all morality from one's actions." Yet at the same time he insisted that this liberty must be surrendered if existence within society was to be tolerable. A human being exchanged the "physical, independent existence he received from nature" for a moral existence as a social being. This exchange was represented by the "social contract" of his book's title—an idea derived from Hobbes (see page 290) and from Locke (see page 323).

In his own day Rousseau was regarded as one of the chief prophets and instigators of the French Revolution. But because of his insistence that the ruled must totally surrender their rights to those they elect to rule over them, he has since also been regarded as an apostle of totalitarianism.

The English philosopher and politician Edmund Burke (1729–97) was one of those who attacked Rousseau's political doctrines most vehemently—for example, in his *Reflections on the Revolution in France* (1790). Earlier, Burke himself had made an important contribution to the new cultural climate with his essay *Philosophical Inquiry into the Nature of Our Ideas on the Sublime and the Beautiful* (1756). Here he put forward most of the aesthetic ideas which were to be fundamental to the Romantic movement in the arts (see page 380).

Classicists, basing themselves on principles derived from the writings of the ancient Greeks and Romans, had always argued that what was beautiful must also be clear and distinct. Turning his argument on its head, just as Rousseau had inverted the doctrine of Original Sin, Burke argued that what is greatest and noblest is the infinite, which, by definition, can be neither clear nor distinct. He added that we know from observation that our imaginations are in fact most strongly affected by what is only suggested not by what is clearly stated, and concluded that it is obscurity, at least to a certain degree, and not clarity that characterizes the most moving art.

Rousseau's insistence on the value of innocence and naturalness and Burke's assault on the value of rational and finite forms have had longer-lasting consequences for European civilization than the Enlightenment itself.

Architecture

The landscape garden

The first stirrings of the new attitude toward nature and the natural were felt in England some time before the publication of Burke's treatise, or any of Rousseau's major writings. Not surprisingly, one of the first places in which the new attitude manifested itself was in garden design. The English had always been hostile almost by instinct to the kind of garden which was imposed upon the landscape, rather than arising out of its existing character. Writing in the seventeenth century, Andrew Marvell made a plea for naturalness in his poem "The Mower."

'Tis all enforced, the fountain and the grot,
while the sweet fields do lie forgot,
Where willing nature does all to dispense
A wild and fragrant innocence . . .

(ANDREW MARVELL, *Collected Poems*, ed. Elizabeth Story Donno. Penguin Books Ltd., 1985.)

In the eighteenth century leading English garden-

designers revolutionized the concept of the garden by concealing the division between what was untouched nature and what was nature civilized and enhanced by human intervention. Straight lines—in particular, rigid avenues of trees—were abolished, and the garden and surrounding parkland united by means of the ha-ha—a sunken ditch which hid a fence meant to keep out deer and other livestock.

The first gardens of this sort were created by the Palladian architect William Kent (see page 324), but the English landscape garden was brought to its full perfection by Lancelot "Capability" Brown (1716–83), so nicknamed from his habit of saying that a place had "capabilities of improvement." Brown actually put it in his contracts that the work he did was to be carried out "with a poet's feeling and a painter's eye." His characteristic effects, however, were more like music than either painting or poetry—abstract harmonies on a huge scale, created with the help of artfully placed clumps of trees, newly dug serpentine lakes, and vast expanses of grassed areas. The park at Bowood (Fig. **21.2**), landscaped in 1761, is one of the best surviving examples of his work—an elegiac setting for a classical country house.

Later adherents of the new ideal liked their landscapes to

carry more specific messages. At Versailles Marie-Antoinette commissioned the architect Richard Mique (1728–94) to create an artificial village, accessible only to the court—the rustic Hameau (Fig. **21.3**). The buildings are very different from those to be found elsewhere in the royal park—half-timbered cottages and a watermill cluster round what seems to be a village green. Here the queen and her ladies could dabble with country occupations, under the spell of Rousseau—although in the dairy, the milk pails were made of Sèvres porcelain.

21.3 **Richard Mique**, The Hameau (Marie Antoinette's Hamlet), Palace of Versailles, France, 1775–78.

Painting

Chardin and Greuze

Today the artist who seems best to encapsulate the eighteenth-century cult of simplicity is Jean-Siméon Chardin (1699–1779). Chardin's still lifes of humble domestic objects, and his small genre scenes showing members of the bourgeoisie and their servants engaged in everyday occupations, are remarkable examples of the transforming power of art. Through paint alone, he transmutes what is humble and ordinary into something magical, catching all the nuances which are beyond the power of merely verbal description.

Chardin himself once said: "One uses colors, but one paints with feeling." This seems to make him part of the "sentimental" current which was affecting all the arts in the mid-eighteenth century. The reality of the situation, however, was rather different. Chardin owed his considerable success as a still-life painter to his links with the Dutch masters of the same genre working in the preceding century. These had become very fashionable with French aristocratic collectors. At the same time, still life occupied a lowly position intellectually. There was a strict system of genres in French art, with history painting (exemplified by works such as David's *Oath of the Horatii*—see page 339) at the top, and still life at the very bottom. What the eighteenth-century audience admired about Chardin was not the emotional content of his painting but the uncanny skill with which he represented reality.

During the middle stretch of his career, from the early 1730s onwards, Chardin tried to remedy this situation by moving into the domestic genre (it ranked slightly higher in the established hierarchy). With this kind of work, too, he was very successful. A bourgeois audience was now flocking to the Salons, the official exhibitions at which Chardin exhibited regularly. In a picture such as *The Scullery Maid* (Fig. **21.1**) of 1738, this new audience found a perfect reflection of their daily lives. Chardin made a good income, not from selling the paintings themselves but, as Hogarth did in England, from the brisk trade in reproductive engravings.

Chardin's genre scenes—characteristically undramatic, moments when time has stopped—now seem to us to be filled with what we would call "sensibility." The eighteenth-century definition of this word, though, was far more active; it required from the spectator a direct, positive identification with the emotions being displayed. This was something which the Salon audience found not in Chardin but in the paintings of his younger contemporary Jean-Baptiste Greuze (1725–1805). *The Village Wedding* (Fig. **21.4**) of 1761 shows all the essentials of Greuze's style. His art, like Chardin's, had its roots in seventeenth-century Dutch painting, but he emphasized different elements. His paintings are essentially narrative—the participants are shown at some moment when all passions are heightened. *The Village Wedding* picks the time a marriage contract is about to be signed. Everyone present—bride, groom, the bride's father and mother—responds to the event with appropriate gestures and expressions. One undercurrent, perhaps an indirect tribute to Rousseau (whose most important writings achieved publication at the very moment when Greuze's picture was first exhibited), is that the ceremony is clearly a Protestant one—the importance of morality is affirmed but not the power of the Church.

21.4 Jean-Baptiste Greuze, *The Village Wedding* 1761.
Oil on canvas, 36¼ × 46 ins (92 × 117 cm). Louvre, Paris.

These subtleties are largely lost on us today. And it is not only this that has undermined Greuze's position. We find it difficult today to understand the overwhelming enthusiasm of Diderot and other good judges of the time because his work seems to us emotionally false. The insistence on the importance of feeling is too rhetorical, and therefore becomes embarrassing.

Elizabeth-Louise Vigée Le Brun

One of the most influential propagandists for a deliberately assumed air of naturalness, a willed simplicity, during the closing years of the eighteenth century was the hugely successful portrait painter, Elizabeth-Louise Vigée Le Brun (1755–1842). If Artemisia Gentileschi (see page 254) has recently been overestimated by feminist admirers, Vigée Le Brun has still not been given her due. Her fame continues to spring largely from the fact that she was the favorite artist of Marie-Antoinette. She deserves far more than that—it is

clear that she altered the way her sitters looked at her and thought about themselves; and her female portraits, in particular, show her complex interaction with the society of her time.

The daughter of a minor portrait painter, Vigée Le Brun acquired her skills in part from her father, but was largely self-taught. By the age of nineteen she was already a fully fledged professional. In 1778 she received her first commission to paint Marie-Antoinette, and in 1783, thanks to the direct intervention of the queen, she became a full member of the Académie Royale, in the teeth of the entrenched opposition of some of its members.

Her close connection with the royal family, and in particular her loyalty to the unpopular queen, drove her into exile in 1789, soon after the outbreak of the French Revolution. She then became an itinerant portrait painter, working in Italy, Austria, Germany, Russia, and England, till her final return to France in 1809. She was everywhere able to capitalize on the success she had already enjoyed in France;

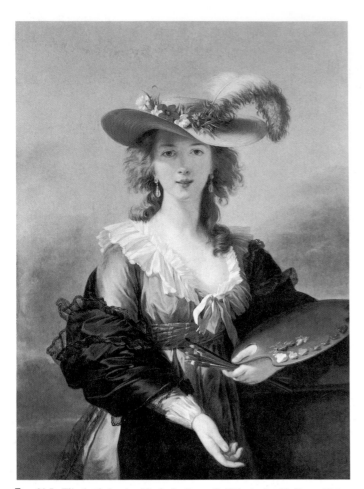

21.5 Elizabeth-Louise Vigée Le Brun, *Self-Portrait with Straw Hat.* Oil on canvas, 38½ × 27¾ ins (97.8 × 70.5 cm). National Gallery, London.

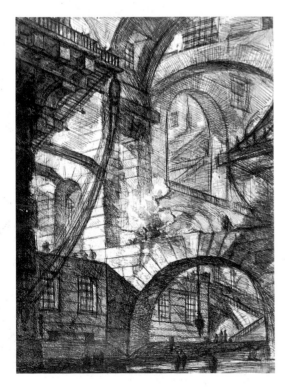

21.6 Giovanni Battista Piranesi, *Imagined Prisons* c. 1750. Etching, 21¼ × 16½ ins (54 × 41.4 cm). Cleveland Museum of Art.

her sitters came from the very highest levels of society, and she got prices which no other portraitist of the time was able to charge. In England, in 1805, it was enviously reported that she was getting three times what Reynolds (see page 341) had been able to ask in his heyday.

Vigée Le Brun was an eclectic artist, who made intelligent use of what she learned from a wide range of contemporaries, among them David (see page 338), Fragonard (see page 315), and the sculptor Houdon (see page 343). Her most important contemporary influence was Greuze (see page 350), but she owed even more to Rubens (see page 270)—she made a careful study of his work on a trip to Flanders in 1781. Everything she learned was put at the service of a highly personal vision, and it was this, far more than the royal connection, which insured her success. This success is summed up both in her memoirs and in her numerous self-portraits—a particularly brilliant example, directly inspired by Rubens, is *Self-Portrait with Straw Hat* (Fig. **21.5**).

Though she produced successful likenesses of men, the majority of her sitters were women. She had a new vision of how women ought to look, dress, and behave, and succeeded in imposing it on her sitters. This vision is well summed up in a passage from her *Memoirs*:

> As I had a horror of the current fashion [she is referring to the year 1780], I did my best to make my models a little more picturesque. I was delighted when, having gained their trust, they allowed me to dress them after my fancy. No one wore shawls then, but I liked to drape my models with large scarves, interlacing them round the body and through the arms . . . I tried as far as possible to give the women I painted the exact expression and attitude of their physiognomy; those whose features were less than imposing, I painted dreaming, or in a languid, nonchalant pose.

> (*The Memoirs of Elizabeth-Louise Vigée Le Brun*, translated by Siân Evans. Camden Press, 1989.)

By drastically and successfully remodeling the way in which her sitters dressed, and by subtly altering their customary expressions, she succeeded to some extent in changing the way in which they actually thought and behaved. They remodeled their self-images in order to conform with the flattering external image she provided.

The Sublime: Piranesi and Fuseli

The two artists who best fulfilled eighteenth-century definitions of the Sublime and the Terrible were the Italian Giovanni Battista Piranesi (1720–78) and the Swiss Johann Heinrich Füssli, generally called Fuseli (1741–1825). Piranesi occupies a pivotal position in the history of eighteenth-century taste. Born a Venetian, he became the greatest celebrator of the Roman Imperial and papal splendors of the

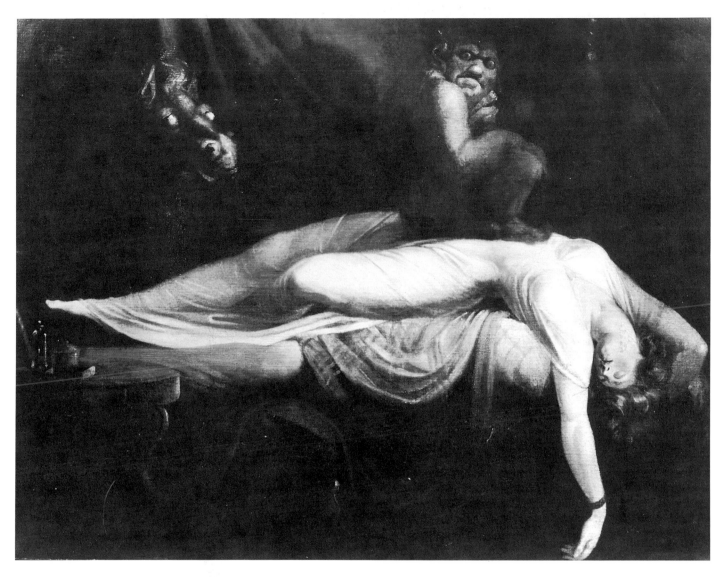

21.7 Henry Fuseli, *The Nightmare* 1781. Oil on canvas, 39¼ × 50 ins (101 × 127 cm). The Detroit Institute of Art.

city of Rome in his series of large etchings, the *Vedute di Roma*. These, even more than the actual buildings themselves, helped to form visitors' impressions of the Eternal City. His prints, and his archeological researches, made Piranesi a key figure in the development of the Neo-Classical movement. In particular, he was a passionate defender of the originality of Roman architecture, at a time when this was in danger of being devalued by the new cult of the Greeks.

The long series of *Vedute* began to be published in 1745. At about the same time Piranesi issued another group of prints, entitled *Carceri d'Invenzione* (Fig. **21.6**)—the title translates as either *Invented* or *Imagined Prisons*—and they were reissued in definitive form in 1761. It is on this series of prints that Piranesi's reputation as one of the true inventors of the eighteenth-century conception of Sublimity rests. For example, when William Beckford, an eccentric English millionaire, visited Venice in 1780 and passed

under the Bridge of Sighs in his gondola, he was immediately reminded of them: "Snatching my pencil, I drew caverns and subterraneous hollows, the domain of fear and torture, with chains, racks, wheels, and dreadful engines in the style of Piranesi."

In designing the *Carceri*, Piranesi was able to draw on earlier traditions, rather in the way that Chardin made use of the conventions of seventeenth-century Dutch still life. In the first place, there was Baroque stage design, which exploited all the resources of perspective in order to present apparently vast constructions in a limited space. Secondly, there was the Venetian tradition of the *capriccio*, a representation of a landscape or architectural scene which seamlessly combined imaginary and real features. What Piranesi did was introduce an element of deliberate irrationality. Spatial ambiguities suggest that his prisons are labyrinthine constructions stretching to infinity. To these ambiguities are added abrupt spatial discontinuities—there are vast staircases and galleries which seem to terminate only in an abyss. All these features add to the spectator's creeping sense of fear.

Fuseli specialized in the figure, not in architecture. Originally destined for the Protestant ministry, he started his professional career late, and, because of this remained a technically limited artist. He struggled with color all his life, and the figures in his striking drawings owed more to his study of Michelangelo and the sixteenth-century Italian Mannerists than they did to direct observation. But he had intellect, personality, and an extraordinary, far-reaching imagination. In Rome, where he for a time based himself, he soon became the center of an international group of artists who were interested in using classical forms but in revolt against the insipidity of *Mengs*. Fuseli's fame soon spread beyond Italy; in particular, he was admired by the new generation of German writers, Goethe among them, who saw in him the embodiment of their own ideas of *Sturm und Drang* (Storm and Stress)—the name now conventionally given to the earliest manifestations of Romanticism (see page 380).

Like his contemporary Jacques-Louis David, Fuseli wanted art to be heroic again. He tried to widen the basis of traditional "history" painting by making illustrations to Shakespeare, Milton, Dante, and the ancient Germanic sagas, the *Niebelungenlied* and the *Eddas*. His illustrations to Shakespeare, in particular, brought him much acclaim in England, where he settled in 1779.

His most personal works, however, are astonishing erotic fantasies, often featuring towering female figures with high-piled coiffures. And in one painting, *The Nightmare* (Fig. **21.7**) of 1781, he expressed these fantasies on a heroic scale. A female figure stretched out upon a bed writhes beneath the incubus seated on her stomach, the personification of her guilty conscience and resultant bad dreams. The "nightmare" itself—the horse on which the incubus rides—sticks its head through the curtains surrounding the bed. The work triumphantly challenges established eighteenth-century ideas about the sovereignty of reason, and is a suitable emblem for the great change in emotional climate which took place in the final third of the century.

Visionary art: Blake

Fuseli's younger contemporary William Blake (1757–1827), whom Fuseli described in a famous phrase as being "damned good to steal from," crossed the frontier that separates the imaginative from the genuinely visionary. Blake showed signs of both literary and artistic talent when he was very young—the poems included in his first book, *Poetical Sketches* (1783), were begun when he was only twelve years old. His artistic training was in some respects like Hogarth's, though with very different results. At the age of sixteen he was apprenticed to a leading engraver, and thus approached art almost as if it were a kind of craft.

Much of the very personal imagery in Blake's paintings, drawings, and prints seems to have presented itself to him

21.8 **William Blake**, *The Ancient of Days*. Frontispiece to "America, A Prophecy" published 1793. British Museum, London.

in the form of visions. Always impatient with the idea of studying from nature, on one occasion he wrote: "Knowledge of Ideal Beauty is Not to be Acquired. It is Born with us. Innate Ideas are in Every Man Born with him: they are truly Himself."

His art was, however, firmly rooted in his study of the Old Masters, particularly Michelangelo and other sixteenth-century Mannerists, whom he knew only through reproductive engravings, since he never went to Italy. In addition, he was influenced by his contemporaries. He took the standard Neo-Classical forms, and gave them a completely new content.

One of Blake's most significant inventions (or reinventions, since his work has affinities with medieval blockbooks) was the printed book in which the illustrations were completely integrated with the text, both being printed from a single metal plate. Blake claimed that the relief etching method he used had been revealed to him by his brother Robert in a vision soon after the latter's premature death in 1787. Some of Blake's most powerful images are illustrations to his own texts, though, like Fuseli, he also illustrated Shakespeare, Milton, and Dante, as well as the Bible.

A celebrated example of Blake's illustrations to his own work is the so-called "Ancient of Days" (Fig. **21.8**), which forms the frontispiece to his prophetic poem *America*, published in a tiny edition in 1794. In this case, too, Blake claimed to have been inspired "by a vision which he de-

clared hovered over his head at the top of a staircase." Like so many of Blake's powerful and mysterious designs, the "Ancient of Days" has been misinterpreted. The compasses are not a symbol of creative power but of limiting rationalism and materialism. Among the figures whom Blake most disliked were John Locke and Isaac Newton, the founding fathers of eighteenth-century rationalism, and the plate is a satirical transformation of the frontispiece which appears in the luxurious 1729 edition of Newton's chief work, the *Principia*.

Literature

Blake's poetry

In Blake's art the Neo-Classical basis remains evident, though he uses the borrowed forms to express ideas and feelings very different from those espoused by orthodox Neo-Classicists. His poetry is generally seen as something unique and isolated, cut off from the English literature of its time, but this is a false impression. What Blake wrote was an expression of the revolutionary changes which had been overtaking English literature since the 1760s, and this revolution involved a rejection of the tightly structured forms preferred by writers such as John Dryden (see page 304).

As so often happens, the change presented itself as a reversion to the past, and a rediscovery of earlier forms. In 1760 a Scottish schoolmaster, James Macpherson (1736–96), published some ancient fragments translated from the Gaelic. These were well received, and grew into two epics attributed to the ancient bard Ossian—*Fingal*, published in 1762, and *Temora*, published in 1763. Rather than presenting the material in verse, Macpherson chose a kind of rhythmic prose. It is now generally accepted that much of the material was forged but, nevertheless, in their evocation of a dim, heroic age the Ossian poems had a great impact throughout Europe. They were also an important model, together with the Bible, for Blake's prophetic poems, even though these often deal with contemporary politics and Blake's own libertarian philosophy.

The short lyrics in Blake's *Songs of Innocence* (1789) and *Songs of Experience* (1794) owe a debt to another book, the *Reliques of Ancient Poetry* (1765), compiled by Thomas Percy (1729–1811), an English country clergyman who later became Bishop of Dromore in Ireland. His collection of old ballads and other texts was reprinted several times. Though Percy tidied up his texts considerably when preparing them for the printer, their roughness and simplicity had a great appeal for contemporary readers.

Some of the poems in the *Songs of Innocence* are a piercing expression of the new cult of simplicity. The *Songs of Experience* are more forceful and more complex. The tone ranges from the rapt and mystical to anguished denunciations of the new industrial society—as, for example, in the lyric entitled "London:"

I wander thro' each charter'd street
Near where the charter'd Thames does flow,
And mark in every face I meet
Marks of weakness, marks of woe . . .

(WILLIAM BLAKE, *The Complete Poems*, ed. Alicia Ostriker. Penguin Books Ltd., 1977.)

Blake and Wordsworth are not very often compared to one another, but here the resemblance to *Lyrical Ballads* (see page 358), published four years later, is striking. It lies not in the subject matter, which is urban rather than rural, but in the extreme plainness and directness of the language, and its affinity to ordinary speech.

Goethe's *Werther*

The feeling of being entirely at odds with society and its demands is expressed in Blake's *Songs of Experience*, but for the most part in oblique and gnomic form. It had already been stated far more directly, and to a much wider audience, in a novel by Johann Wolfgang von Goethe (1749–1832). Goethe is a major figure in world literature, one of the creators of the Romantic movement, and Germany's greatest poet. But the book which first gave him an international reputation was a novel, *The Sorrows of Young Werther*, published in 1774.

Up to this point German literature had been regarded as hopelessly provincial, and Germans (as in Voltaire's *Candide*) were generally depicted as being a bit simpleminded—figures of fun. *Werther* changed all that at a single stroke. Based largely on the author's own personal experience and relationships, it tells the story of a young man who finds himself so much at odds with the world he lives in that he commits suicide. His unhappiness is exacerbated, and matters are brought to a crisis, by his unhappy love affair with the wife of a friend.

Following an established eighteenth-century pattern, the novel is epistolary—but there is no exchange. It consists of Werther's letters only, with a commentary added by a friend. The mechanism of the plot is unimportant, for the real subject of the book is the hero's inner experience.

LITERATURE

Tintern Abbey

Wordsworth's *Tintern Abbey*, here printed complete, is a piece of detailed landscape painting in verse, which can be compared with the topographical watercolors the young J. M. W. Turner (see page 376) was painting at the same time. Wordsworth reaches beyond mere description, however, by going on to interpret the scene as a mirror of his own subjective feelings.

Lines Composed a Few Miles
Above Tintern Abbey, on Revisiting
the Banks of the Wye
During a Tour. July 13, 1798

Five years have past; five summers, with the length
Of five long winters! and again I hear
These waters, rolling from their mountain-springs
With a soft inland murmur.—Once again
Do I behold these steep and lofty cliffs,
That on a wild secluded scene impress
Thoughts of more deep seclusion; and connect
The landscape with the quiet of the sky.
The day is come when I again repose
Here, under this dark sycamore, and view
These plots of cottage-ground, these orchard-tufts,
Which at this season, with their unripe fruits,
Are clad in one green hue, and lose themselves
'Mid groves and copses. Once again I see
These hedge-rows, hardly hedge-rows, little lines
Of sportive wood run wild: these pastoral farms,
Green to the very door; and wreaths of smoke
Sent up, in silence, from among the trees!
With some uncertain notice, as might seem
Of vagrant dwellers in the houseless woods,
Or of some Hermit's cave, where by his fire
The Hermit sits alone.

These beauteous forms,
Through a long absence, have not been to me
As is a landscape to a blind man's eye:
But oft, in lonely rooms, and 'mid the din
Of towns and cities, I have owed to them
In hours of weariness, sensations sweet,
Felt in the blood, and felt along the heart;
And passing even into my purer mind,
With tranquil restoration:—feelings too
Of unremembered pleasure: such, perhaps,
As have no slight or trivial influence
On that best portion of a good man's life,
His little, nameless, unremembered, acts
Of kindness and of love. Nor less, I trust,
To them I may have owed another gift,
Of aspect more sublime; that blessed mood,
In which the burthen of the mystery,
In which the heavy and the weary weight
Of all this unintelligble world,
Is lightened:—that serene and blessed mood,
In which the affections gently lead us on,—
Until, the breath of this corporeal frame
And even the motion of our human blood
Almost suspended, we are laid asleep
In body, and become a living soul:
While with an eye made quiet by the power
Of harmony, and the deep power of joy,
We see into the life of things.

If this
Be but a vain belief, yet, oh! how oft—
In darkness and amid the many shapes
Of joyless daylight; when the fretful stir
Unprofitable, and the fever of the world,
Have hung upon the beatings of my heart—
How oft, in spirit, have I turned to thee,
O sylvan Wye! thou wanderer thro' the woods,
How often has my spirit turned to thee!
And now, with gleams of half-extinguished thought,
With many recognitions dim and faint,
And somewhat of a sad perplexity,
The picture of the mind revives again:
While here I stand, not only with the sense
Of present pleasure, but with pleasing thoughts
That in this moment there is life and food
For future years. And so I dare to hope,
Though changed, no doubt, from what I was when first,
I came among these hills; when like a roe
I bounded o'er the mountains, by the sides
Of the deep rivers, and the lonely streams,
Wherever nature led: more like a man
Flying from something that he dreads, than one
Who sought the thing he loved. For nature then
(The coarser pleasures of my boyish days,
And their glad animal movements all gone by)
To me was all in all.—I cannot paint
What then I was. The sounding cataract
Haunted me like a passion: the tall rock,
The mountain, and the deep and gloomy wood,
Their colours and their forms, were then to me
An appetite; a feeling and a love,
That had no need of a remoter charm,
By thought supplied, nor any interest
Unborrowed from the eye.—That time is past,
And all its aching joys are now no more,
And all its dizzy raptures. Not for this
Faint I, nor mourn nor murmur; other gifts
Have followed; for such loss, I would believe,
Abundant recompense. For I have learned
To look on nature, not as in the hour
Of thoughtless youth; but hearing often-times
The still, sad music of humanity,

Nor harsh nor grating, though of ample power
To chasten and subdue. And I have felt
A presence that disturbs me with the joy
Of elevated thoughts; a sense sublime
Of something far more deeply interfused,
Whose dwelling is the light of setting suns,
And the round ocean and the living air,
And the blue sky, and in the mind of man;
A motion and a spirit, that impels
All thinking things, all objects of all thought,
And rolls through all things. Therefore am I still
A lover of the meadows and the woods,
And mountains; and of all that we behold
From this green earth; of all the mighty world
Of eye, and ear,—both what they half create,
And what perceive; well pleased to recognise
In nature and the language of the sense,
The anchor of my purest thoughts, the nurse,
The guide, the guardian of my heart, and soul
Of all my moral being.

Nor perchance,
If I were not thus taught, should I the more
Suffer my genial spirits to decay:
For thou art with me here upon the banks
Of this fair river; thou my dearest Friend,
My dear, dear Friend; and in thy voice I catch
The language of my former heart, and read
My former pleasures in the shooting lights
Of thy wild eyes. Oh! yet a little while
May I behold in thee what I was once,
My dear, dear Sister! and this prayer I make,
Knowing that Nature never did betray
The heart that loved her; 'tis her privilege,
Through all the years of this our life, to lead
From joy to joy: for she can so inform
The mind that is within us, so impress
With quietness and beauty; and so feed
With lofty thoughts, that neither evil tongues,
Rash judgments, nor the sneers of selfish men,
Nor greetings where no kindness is, nor all
The dreary intercourse of daily life,
Shall e'er prevail against us, or disturb
Our cheerful faith, that all which we behold
Is full of blessings. Therefore let the moon
Shine on thee in thy solitary walk;
And let the misty mountain-winds be free
To blow against thee; and, in after years,
When these wild ecstasies shall be matured
Into a sober pleasure; when thy mind
Shall be a mansion for all lovely forms,
Thy memory be as a dwelling-place
For all sweet sounds and harmonies; oh! then,
If solitude, or fear, or pain, or grief,
Should be thy portion, with what healing thoughts

Of tender joy wilt thou remember me,
And these my exhortations! Nor, perchance—
If I should be where I no more can hear
Thy voice, nor catch from thy wild eyes these gleams
Of past existence—wilt though then forget
That on the banks of this delightful stream
We stood together; and that I, so long
A worshipper of Nature, hither came
Unwearied in that service: rather say
With warmer love—oh! with far deeper zeal
Of holier love. Nor wilt though then forget,
That after many wanderings, many years
Of absence, these steep woods and lofty cliffs,
And this green pastoral landscape, were to me
More dear, both for themselves and for thy sake!

Wordsworth

(WORDSWORTH, *The Poetical Works of William
Wordsworth*. Houghton Mifflin Co., 1982.)

Werther constantly reflects on his own feelings. But he is far from wishing to discipline these emotions; rather, he wants to surrender to them without restraint, and in this he represents a new fictional type.

Goethe's readers responded to the passionate emotionalism of the novel—in one striking passage Werther and the heroine, Lotte, read Macpherson's Ossian poems together, and then embrace passionately; in others Werther rhapsodizes about his feelings of identification with nature.

Goethe's original readers often misunderstood—sometimes almost deliberately—what the author was trying to convey, which was in part a warning against the extravagance of his hero. They saw in the book an appeal against a rationality which had become intolerable. Some of them actually read it as a justification of suicide. Many more saw Werther as a hero, not as the failure the author meant him to be. The novel's apparent insistence that feeling must be allowed to take priority over all other demands and duties did much to change the whole cultural climate in Europe and prepare the way for a new epoch.

Wordsworth and *Lyrical Ballads*

In England the cult of nature and the cult of feeling reached a climax with the anonymous publication of the first edition of *Lyrical Ballads* in 1798. This was made up of poems by William Wordsworth (1770–1850) and Samuel Taylor Coleridge (1772–1834), with Wordsworth supplying by far the greater share. The book has commonly been described as revolutionary—a "revolt against literature or the literary elements in poetry," as the twentieth-century critic Helen Darbyshire puts it. In fact, the poems it contains can without exception be paralleled in the magazines and poetical miscellanies of the day (poetry was then enjoying a strong revival of popularity in England—something significant in itself). What made the collection outstanding was not its absolute novelty but the intensity of feeling it expressed, and in some instances the boldness with which it challenged accepted ideas about poetic language.

The two most substantial poems in the book were Coleridge's "The Rime of the Ancient Mariner"—a sustained ballad narrative, full of horrific and supernatural elements, and Wordsworth's "Lines written a few miles above Tin-

tern Abbey," both of which are among their authors' finest achievements. The two poems intensify ideas about the Sublime and the Terrible which had already long been current. "Tintern Abbey" is perhaps the most perfect statement of feelings of identification with nature to be found in the English language, and parts of it bear a striking resemblance to *Werther*.

"Tintern Abbey" is written in beautiful but still technically conventional blank verse—it is the emotional tone, not the actual language, which is new. *Lyrical Ballads* also contains a number of poems by Wordsworth which arouse controversy even today, some critics dismissing them as bare, flat-footed, and awkward, while others find them uniquely clear and stark. One case is "The Idiot Boy," for which the poet himself had a particular fondness. This balladlike piece tells the story of an idiot child put on a horse by his mother, and sent to fetch a doctor to attend a sick neighbor. When he fails to return, the anxious mother goes in search of him:

Perhaps, and no unlikely thought!
He with his pony now doth roam
The cliffs and peaks so high that are,
To lay his hands upon a star,
And in his pocket bring it home.

(WILLIAM WORDSWORTH, *The Poems, Vol. 1*, ed. John O. Hayden. Penguin Books Ltd., 1989.)

Commenting on the poem only a few years after it was written, Wordsworth said: "I have often applied to idiots, in my own mind, that sublime expression of Scripture, that 'their life is hidden with God'." Offended by the fact that the protagonist is an imbecile, later generations have missed the subtle variations of tone in the text, from the purely lyrical to the comic-ironic. Taken as a whole, the poem perfectly exemplifies the aims enunciated in the original preface to the collection: "It is the honourable characteristic of poetry that its materials are to be found in every subject which can interest the human mind." It can also be considered an example of another aim put forward in the same text: "The majority of the following poems are to be considered as experiments. They were written chiefly with a view to ascertain how far the language of conversation in the middle and lower ranks of society is adapted for the purposes of poetic pleasure."

Music

The symphonies of Haydn and Mozart

The most significant development in instrumental music during the second half of the eighteenth century was the appearance of the symphony in its modern form. The word, derived from the Greek *syn* ("together") and *phone* ("sounding") had been in use since the late sixteenth century. From 1730 onwards, concerted pieces for orchestra, first used as prefaces for operas, took on an independent existence, and were used to show off the new, better-trained, and more powerful orchestral forces which had become available. The full orchestra now consisted of a balanced string section, plus woodwind instruments in pairs (flutes, oboes, bassoons, clarinets), two horns, two trumpets, and a pair of kettle drums. A particularly fine orchestra existed at the Electoral Court of Mannheim in Germany, and this provided the stimulus for a weightier and more serious kind of orchestral music, designed to be listened to for its own sake, rather than as a background to social intercourse. Music of this sort, though originally rooted in the princely German courts, soon proved that it had a strong appeal for the cultivated bourgeois public in capital cities such as London and Paris.

The two composers who transformed the emotional scope of the symphony were both Austrians: Joseph Haydn (1732–1809) and Wolfgang Amadeus Mozart (1756–91). They combined traditional elements with others that were new, taking the close-knit counterpoint of Baroque music and uniting it to a new emotionalism, with melodies and dramatic musical effects borrowed from the world of opera.

Though the symphonies they produced, particularly Haydn's, have often since been given nicknames—"The Clock," "The Drum Roll," "The Surprise"—they are not "programme music" of the kind sometimes written by nineteenth-century symphonic composers (see page 392). Mozart's "Prague" symphony (K 504, 1786) and his "Jupiter" Symphony (K 551, 1788) stand successfully between two worlds. They are "abstract" music—the "Jupiter," for example, has an intricate fugal finale—and they are also "entertainment" music—the "Prague" is really an overture in the Italian style, and has many features which look forward to the opera *Don Giovanni*, written the following year. But at the heart of these symphonies there is deep emotion, though of an unspecific kind. The "Jupiter" gained its present nickname, which is not Mozart's invention, because of its Olympian loftiness of tone. Generations

of listeners have found it consoling and calming. The fact that works of this sort are so frequently taken to be the very archetypes of "classical" music indicates that this adjective takes on a new and elusive meaning when it is applied to forms of expression which are neither verbal nor visual, and which have in fact only the most tenuous connections with the ancient classical world.

Mozart's operas: *Don Giovanni*

Mozart's operatic output covers a wide range of different subjects and styles. *Idomeneo*, already mentioned in connection with the operas of Gluck (see page 344), is an *opera seria*, with elaborate set numbers between stretches of recitative. Mozart also wrote *opera buffa* (light comic pieces, often with an element of burlesque); and *singspiels*, in German rather than Italian, with spoken dialogue.

The operas which are generally thought to be Mozart's greatest all have something unexpected about them. A good example of this unexpectedness is *Don Giovanni* (1787). *Don Giovanni* is a retelling of the old Don Juan legend; the Don, attempting to rape the noble lady Donna Anna, is surprised by her father, the Commendatore, and kills him. Donna Anna and her lover, Don Ottavio, vow vengeance. After comic complications involving a pretty servant, Zerlina, and a half-crazed mistress whom he has discarded, Donna Elvira, Don Giovanni finds himself in a graveyard, confronted by the statue of the man he has killed. Defiantly he invites it to dinner, and a voice accepts the invitation. At the banquet, the terrible stone guest duly appears, to drag the reprobate down to hell.

Technically, the work is an *opera buffa*, and there is evidence that in early productions the farcical and burlesque elements were uppermost. But the music is so powerful that it expands the perspectives offered by the plot. Elvira's mixture of hysteria and genuine suffering is perfectly reflected in what she sings—the audience sympathizes with her without necessarily finding her whole character sympathetic. Today, the piece is usually staged in a fairly serious way, and the farcical interludes often stick out uncomfortably. Yet in any case there must always have been a whiff of sulphur about the last scene, however hard early stagings strove to ignore it. Here, in particular, the eighteenth century cult of the Sublime and the Terrible finds expression almost in spite of the conscious intentions of both composer and librettist.

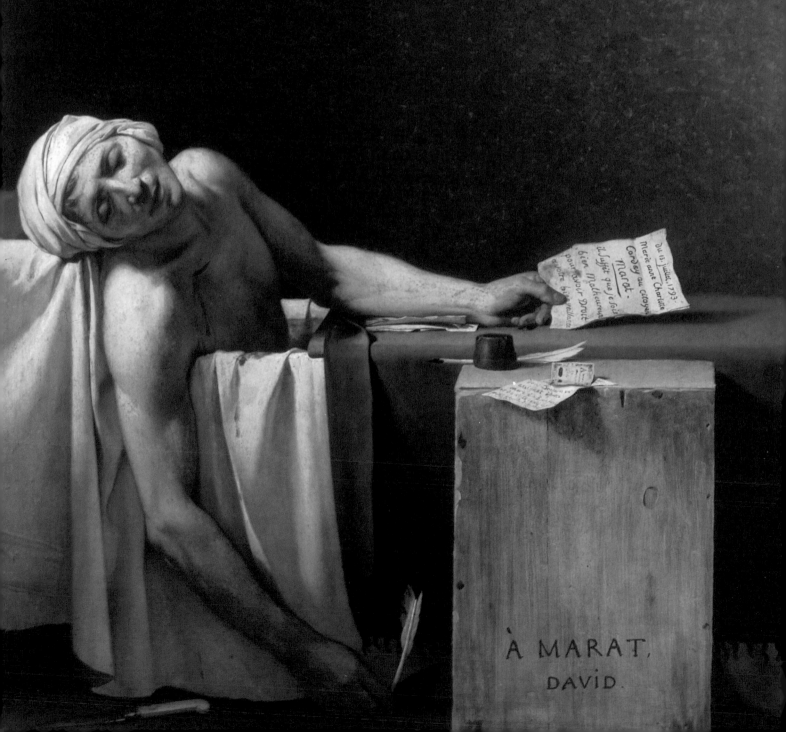

Du 13 juillet 1793.
Marie anne Charlotte
Corday au citoyen
Marat.
il suffit que je sois
bien Malheureuse
pour avoir Droit
a votre bienveillance.

À MARAT,
DAVID.

Romanticism & the Nineteenth Century

Chapter 22

The French Revolution and the Napoleonic Empire

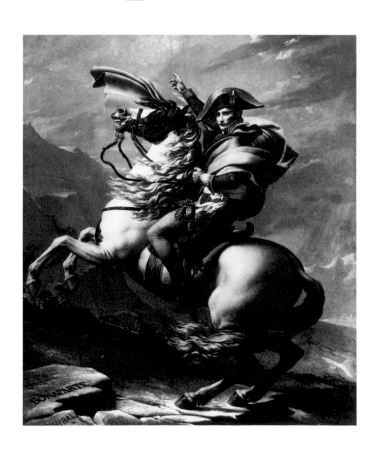

22.1 **Jacques-Louis David**, *Napoleon Crossing the Alps* 1800. Oil on canvas, 96 × 91 ins (243.8 × 231.1 cm). Musée de Versailles, France.

Revolution and Empire

Following the fall of the Bastille in 1789, the creative arts became more firmly linked to political events than they had been at any time since the end of the seventeenth century. After the fall of the Bastille, the key dates in the French Revolution are as follows:

1789 The French Third Estate transforms itself into the National Assembly.

1791 Louis XVI and his family try unsuccessfully to leave France.

1792 The French Republic is proclaimed and Louis XVI is executed.

1793 The Committee of Public Safety is established in France, headed by Danton; the Reign of Terror begins.

1794 Danton is overthrown and executed; his successor Robespierre is overthrown and executed; the Reign of Terror comes to an end.

1795 The French Directory is established.

From 1796 to 1799 the Directory had a series of military successes in Italy. Its armies were led by the young Corsican general Napoleon Bonaparte (1769–1821), who in 1799 overthrew his masters and became First Consul. He then, in 1800, consolidated his conquest of Italy by winning the Battle of Marengo. Following the brief peace of Amiens in 1802–3, Napoleon proclaimed himself Emperor in 1804. The story of the arts in France became, for a decade, the story of their relationship with Napoleon himself and the imperial authorities.

For the first half of this decade Napoleon was triumphant everywhere except at sea. His first serious mistake was the French invasion of Spain in 1808, which involved the French armies in an unwinnable guerilla war, and brought about the direct intervention of British land forces under Wellington.

In 1812, the year in which Wellington entered Madrid, Napoleon invaded Russia with 550,000 troops, of whom only 20,000 survived the campaign and the winter Retreat from Moscow which followed. Napoleon's power was broken at the so-called "Battle of the Nations" at Leipzig in 1813; and in 1814 the victorious allies entered Paris and Napoleon was forced to abdicate and retire to Elba.

An attempt to regain power in 1815 (the "Hundred Days") was defeated by the combined armies of Wellington and Blucher at Waterloo. Forced to abdicate for a second time, Napoleon was banished to the remote island of St. Helena.

At its fullest extent, Napoleon's empire brought a single culture to Europe, together with a drastic rearrangement of territorial boundaries and a reform of systems of administration and codes of law. Resistance to Napoleon, however, also brought with it a new sense of national and cultural identity among the nations whom he conquered or attempted to conquer. These feelings were to work themselves out in the fervent nationalisms of the nineteenth century.

The libertarian doctrines of the French Revolution, suppressed both by Napoleon himself and by the reactionary conservative regimes which replaced him, found a new outlet in the Europe-wide political revolutions of 1848.

Philosophy

Paine and Wollstonecraft

During the revolutionary period, the most characteristic texts were direct reactions to events. They codified what had been said before, and applied old ideas to the novel circumstances of the time. Their authors tended to stand at the margin, rather than at the very center of events. This was the case with the two "revolutionary" books which have proven to be the most durable—*The Rights of Man* (1791–92) by Tom Paine (1737–1809), and *A Vindication of the Rights of Woman* (1792) by Mary Wollstonecraft (1759–97).

The Rights of Man is traditionally regarded as a classic expression of French Revolutionary thinking. It was certainly the inspiration of republican and egalitarian movements throughout the nineteenth century. But it was written in English, was addressed to an English audience, and was largely based on the author's experience of the American Revolution, not its French counterpart.

The attraction of Paine's work is its directness, and the utter certainty of the author's convictions. He begins with the idea of "natural rights:"

Natural rights are those which appertain to man in right of his existence. Of this kind are all the intellectual rights, or rights of the mind, and also all those rights of acting as an individual for his own comfort and happiness, which are not injurious to the natural rights of others.

(THOMAS PAINE, *The Rights of Man*, introduced by Eric Foner. Penguin Books Ltd., 1969.)

	1775	1800	1825	1850	1875	1900
	ROMANTICISM				REALISM	SYMBOLISM
HISTORICAL BACKGROUND	French Revolution 1789	Napoleon becomes Emperor 1804 First steam railway in England 1825 Development of photography	Revolutionary movements in Europe 1832 and 1848	American Civil War begins 1861		Growth of Labour/ Socialist parties Automobile pioneered
PHILOSOPHY	Paine *The Rights of Man* Wollstonecraft *Vindication of the Rights of Women*	Hegel *Phenomenology of the Mind* Schopenhauer *The World of Will and Idea*	Kierkegaard *Either/ Or* Marx/Engels *Communist Manifesto*	Darwin *Origin of the Species* Nietzsche *Birth of Tragedy*		Freud *Interpretation of Dreams*
ARCHITECTURE	Soane, Bank of England (**22.4**)		Schinkel, Court Gardener's House (**23.2**) Barry/Pugin, Houses of Parliament (**23.3**)	Paxton, Crystal Palace (**24.3**)		Sullivan/Adler, Guaranty Building (**24.4**)
VISUAL ARTS	David (**22.5**)	Goya (**22.6**) Ingres (**23.11**) Géricault (**23.8**)	Delacroix (**23.10**) Turner (**23.4**) Pre-Raphaelites formed	Courbet (**24.10**) Manet (**24.12**) 1st Impressionist exhibition 1874 Renoir (**24.18**)		Seurat (**24.24**) Monet (**24.16**) Cézanne (**24.25**) Gauguin (**25.5**) Van Gogh (**25.7**) Munch (**25.9**) Rodin (**25.15**)
LITERATURE/ DRAMA	Goethe *Faust: Part I*	Jane Austen *Mansfield Park* Byron *Childe Harold*	Thackeray *Vanity Fair* Dickens Tennyson *In Memoriam*	Flaubert *Madame Bovary* Tolstoy Brontes Whitman Rimbaud		Zola Huysmans James Ibsen, Chekhov Strindberg *Miss Julia*
MUSIC		Beethoven *Eroica*	Rossini *Guillaume Tell* Berlioz *Symphonie Pastorale*	Wagner begins the Ring Cycle 1852 Verdi *Aida*		Debussy *Pelléas et Mélisande* Puccini *Tosca*

He goes on from this to argue in favor of a completely egalitarian, republican form of government. But, as the quotation above may suggest, Paine's weakness is that his conception of society is rigidly mechanistic—he sees it as an engine which must proceed along the track laid out for it by good people such as himself. He seriously underestimates the wayward variety of human nature. Yet he is always throwing up ideas which seem prophetic. For example, there is a long passage on the desirability of negotiated disarmament:

> If men will permit themselves to think, as rational beings ought to think, nothing can appear more ridiculous and absurd, exclusive of all moral reflections, than to be at the expense of building navies, filling them with men, and then hauling them into the ocean, to try which can sink each other fastest.
>
> (THOMAS PAINE, *The Rights of Man*, introduced by Eric Foner. Penguin Books Ltd., 1969.)

In some ways even more prophetic, though till recently neglected, is the work of Mary Wollstonecraft, whose texts have been fundamental to the modern feminist movement. She lived a difficult and unconventional life, struggling to achieve the financial and professional independence then almost impossible for a woman. She formed part of the radical circle in London which also included William Blake, Fuseli, and Tom Paine. Later, she lived in Paris during the most traumatic period of the Revolution.

In *A Vindication of the Rights of Woman* Wollstonecraft's argument, and it was an extremely radical one for the time, is that men and women must have equal roles in society—women could not forever be subordinated to the needs of the opposite sex. From this flowed other conclusions—for example, that the idea of "female purity" in sexual matters was largely a hypocritical pretense:

> I wish to sum up what I have said in a few words, for I have thrown down my gauntlet, and deny the existence of sexual virtues, not excepting modesty. For men and women, truth, if I understand the meaning of the word, must be the same: yet in the fanciful female character, so prettily drawn by poets and novelists, demanding the sacrifice of truth and sincerity, virtue becomes a relative idea, having no other foundation than utility, and of that utility men pretend arbitrarily to judge, shaping it to their own convenience.
>
> (MARY WOLLSTONECRAFT, *A Vindication of the Rights of Woman*, ed. Miriam Brody. Penguin Books Ltd., 1975.)

It is worth keeping this passage in mind when reading the novels of Jane Austen (see page 369), who was Wollstonecraft's contemporary, as it casts an interesting light on the narrowly conventional nature of the latter's moral judgments.

The British in India

During the second half of the eighteenth century the British built up a colonial empire in India which rivaled that of the Spanish in Mexico and South America. There were, however, important differences in both its political and social structure and its demographic effects.

Contact was not sudden and catastrophic, but gradual. This was not a case of one culture impinging on another which had hitherto been completely closed. When an East India Company was set up in England in 1600 Europeans had already long been trading with India, both indirectly and directly. During the seventeenth century this company acquired a series of "factories" or trading posts on both the eastern and western shores of the subcontinent, but no attempt was made to conquer India. The Mughal Empire, established during the sixteenth century by Muslim invaders from the north, was still a strong and stable power.

By the mid-eighteenth century this stability no longer existed. There was a power vacuum in India, and the English East India Company was engaged in a struggle with local rulers and with the French. This led to more and more ambitious military undertakings. In October 1764 East India Company troops, British led but by no means all British, defeated the Nawab of Bengal and the Nawab of Awadh at the battle of Buxar. In the following year, the Mughal emperor, still nominally the supreme ruler of the country, ceded Bengal to Company administration, and thus an important Indian territory came almost by accident to be controled by a British trading company.

The Company's dominions continued to grow by fits and starts until 1798, when a great expansion began. The reasons for this were partly local and personal—the arrival of a vigorous new Governor General (Lord Mornington, later the Marquess of Wellesley, elder brother of the Duke of Wellington), plus the desire to curb the ambitions of the able and restless ruler of Mysore, Tipu Sultan. Partly they depended on the wars in Europe. French and British rivalries on the other side of the world still found an echo in India and the British were able to take advantage of the turmoil into which European affairs had been thrown by the French Revolution.

The attitude of the British toward Indian civilization at this period was quite unlike that of the Spaniards toward the Aztecs. The primary force was the desire to trade, and to have captive markets for British manufactured goods. There was little missionary activity; and, while there was also not much understanding of Indian religions (chief among them Hinduism and Islam), there was a minimum of interference. In India there were as yet few European women, and British officials often married Indian wives, or lived with Indian mistresses. There were, however, too few Europeans of any kind to create a large population of mixed race.

When more and more Englishwomen began to appear in India, the result was an increasing separation between the

Shaykh Zain-al-Din, *An Orange-Headed Ground Thrush and a Death's Head Hawk Moth on a Branch of Bavhinia*, 1778. Watercolor and gouache on paper, 23½ × 31½ ins (59.5 × 80 cm). Courtesy Hazlitt, Gooden & Fox, London.

two communities. Contemporary racial theory tended to see the "purity" of European women as something which was constantly under threat from members of other races; the women themselves were less tolerant of Indian customs than unmarried European males had been because they wanted to preserve the monogamous structures of Christian European family life. Indians and Europeans eventually became almost completely cut off from one another socially. This divide was an important contributory factor in the Indian Mutiny of 1857, when Indians tried to shake off British rule. As a result of the mutiny, the British government assumed direct control. This situation lasted until 1947, when India then split on religious lines into two nations, India and Pakistan, one predominantly Hindu, the other Muslim.

Numerous European artists worked in India, for both European and Indian patrons. In addition, Europeans patronized Indian artists, sometimes having their portraits painted in local style. One Indian specialty was the elaborate botanical and natural history drawings made for English clients resident in India. These derived from the exquisite portrayals of flowers and animals made by court artists for the Mughal emperors, but they also reflected the new spirit of dispassionate scientific inquiry which had started to manifest itself in Europe.

The most lasting legacy of British rule in India was probably the presence of the English language. This did not displace existing indigenous tongues in the way that Spanish did in Mexico and South America, but acquired wide currency as a *lingua franca*, a bridge between Indians of different cultures, languages, and traditions. In this respect the use of English in India began to resemble the use of Latin in medieval Europe.

Architecture

The Empire style

The French Revolutionaries saw themselves as the true successors of the Romans of the Republican period. Napoleon constantly courted comparison with Augustus. It is therefore not surprising to find that a version of Neo-Classicism remained the preferred style in France, and also wherever French political influence reached. Because of the turbulence of political events, successive French regimes built much less than they projected. Napoleon's favorite architects, Charles Percier (1764–1848) and Pierre-Léonard Fontaine (1762–1853), produced ambitious schemes for the transformation of Paris into a grandiose imperial capital (Fig. **22.2**), but these remained unexecuted, as did similar schemes for Milan and for Rome itself.

Percier and Fontaine did, however, exercise great influence over the decorative arts, through their *Receuil des décorations intérieures*, published in installments from 1801 onwards, and then collected into a single volume in 1812. This did much to create the Empire style, which became

22.2 **Pierre-Léonard Fontaine** and **Charles Percier**, Sketch for the Palais de Chaillot, 1811. The façade facing the Seine and gardens. Musée de la Ville de Paris, Musée Carnavalet.

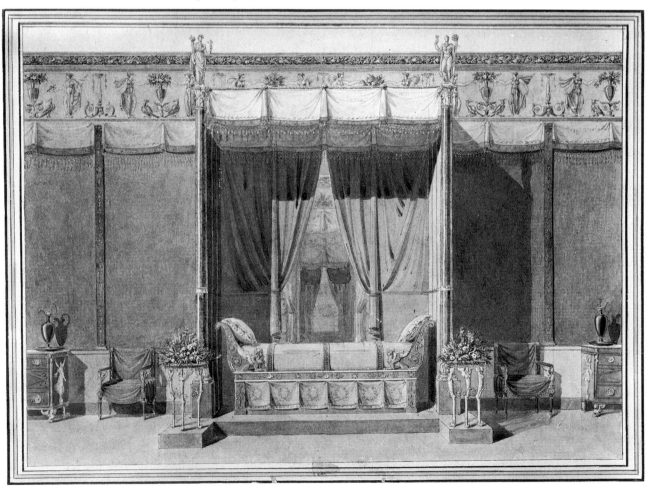

22.3 **Pierre-Léonard Fontaine** and **Charles Percier**, view of a bedroom decorated in early Empire style.

paramount throughout Europe, from Naples to St. Petersburg. It was a much heavier, more formal, and more ostentatious version of Classicism than had prevailed hitherto, with a preference for Roman forms rather than the lighter Greek ones. One of its characteristics, perhaps in reaction to the lack of opportunity for building real, freestanding structures, was the tendency to create rooms within rooms, as in the grandiose bedroom illustrated here, where the bed is isolated from the main space, and becomes a separate smaller compartment (Fig. **22.3**). In an ordinary domestic setting, the Empire style could often seem excessive, but it was ideally adapted for official use. It survived Napoleon's fall and in one guise or another continued in use long after 1815, though now in competition with other forms of decoration, such as Renaissance Revival and Gothic.

John Soane

In terms of the originality of his conceptions, and also the sheer quantity of what he built, the major architect of the Revolutionary and Napoleonic period was not a Frenchman but an Englishman, Sir John Soane (1753–1837). Soane's main influence during his earlier career was French Neo-Classicism, but he did not achieve maturity as a creative architect until the 1790s, when the Revolutionary Wars had already begun.

His greatest commission was the rebuilding of the Bank of England in London. He was appointed architect to the Bank in 1788, and it was this which put his career on a firm footing. The actual task did not begin until 1792, and the building was continually enlarged and revised as the Bank's activities expanded to meet the cost of financing England's part in the conflict—the English government often preferred to pay Napoleon's continental enemies to fight against him rather than putting armies in the field itself. The building Soane created was in itself a symbol of British financial power and resistance to French military might. By the time Soane resigned his post in 1833, the Bank had become an immense, labyrinthine construction covering three acres.

Nearly all of Soane's work at the Bank was destroyed in 1930, as a result of yet another rebuilding, but his interiors and exteriors are well documented in drawings and photographs. The interiors, in particular, show the unique characteristics of Soane's style. The standard classical forms—pilasters and the entablature they support, for example—become mere lines drawn on the masonry. The main spaces of the building, such as the Consols Office (Fig. **22.4**), were freed from classical rules of proportion, and became vast top-lit halls in which the architectural elements were no longer separated from one another, as the traditional grammar of architecture required, but melted into a mysterious unity which added to the sense of scale.

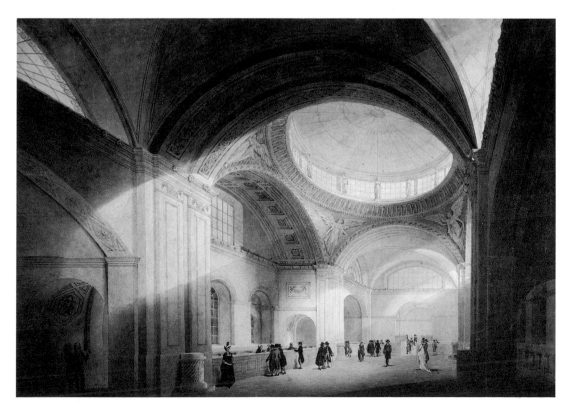

22.4 Sir John Soane, Consols Office at the Bank of England, 1796–97. Copyright the Trustees of Sir John Soane's Museum, London.

Painting

Jacques-Louis David

Painting was able to respond more flexibly to the demands made by events than the slower and more expensive discipline of architecture. In France there appeared a new kind of art which was directly political. Some of its characteristics were borrowed from earlier Baroque and Rococo paintings which glorified secular and ecclesiastical rulers— for example, Tiepolo's frescos for the Prince-Bishop of Wurzburg (see page 316). Others came directly from traditional religious art. But there was also an element of direct reportage. The amalgam itself was something entirely new.

The artist who brought this new kind of painting into sharp focus, and found a way of making it viable, was Jacques-Louis David, the creator of *The Oath of the Horatii* (see page 339). David enthusiastically cast in his lot with the Revolution, and allied himself with the most extreme faction, the Jacobins. His masterpiece of the Revolutionary period is *The Death of Marat* (Fig. 22.5), painted to commemorate the assassination of this leading journalist and agitator by Charlotte Corday in July 1793. David shows him not dead but on the point of dying, shortly after his assassin has left the room. The slumped body is starkly presented against a totally blank wall. It resembles Christ in a traditional *pietà*. At the same time, the composition is a direct report of an event which was still news when it was painted, and the "painting of real life" was to become one of the constant themes of the most important French nineteenth-century artists.

When Napoleon came to power he was more than willing to employ David's services, but he had clear ideas of how he wanted him to work. The first fruit of their alliance was an equestrian portrait showing *Napoleon Crossing the Alps* (Fig. 22.1), en route for his victory at Marengo, painted in 1800. Napoleon, the supreme propagandist, is shown, just as he requested, "calm, upon a fiery horse." The result is glamorous, but also icy and indeed rather abstract. It serves as an icon of political power, but completely lacks the immediacy of the painting of Marat. It comes as no surprise to discover that the facts have been assiduously edited—in reality Napoleon made the crossing not in a storm but in good weather, and mounted upon a mule. The painting is the equivalent of a commemorative statue—the summary of an idea rather than a direct representation of life. It seems highly appropriate that the composition is in fact based on Falconet's statue of Peter the Great (see page 320).

Francisco de Goya

A different commentary on the Napoleonic Wars came from artists who were not French. On the whole, French artists tended to find themselves working for the Napoleonic propaganda machine, but those outside France were able to offer something purely personal—a quality often emphasized by the isolation imposed upon them as a result of the conflict. The artist who gave the most intimate view of war and its meaning was a Spaniard, Francisco de Goya (1746–1828).

Spain had twice declared war on England, in 1796 and 1804, and had suffered naval defeats at Cape St. Vincent and Trafalgar, but armies did not arrive on Spanish soil until 1808, with a French invasion. This initiated a new kind of war—a bitter guerrilla conflict with many atrocities committed on both sides. By 1808 Goya was a mature artist and the leading painter in Spain, though, thanks to the traditional separateness of his country, he had missed the latest cultural influences. Neo-Classicism, for example, had completely passed him by, and his art was rooted in the

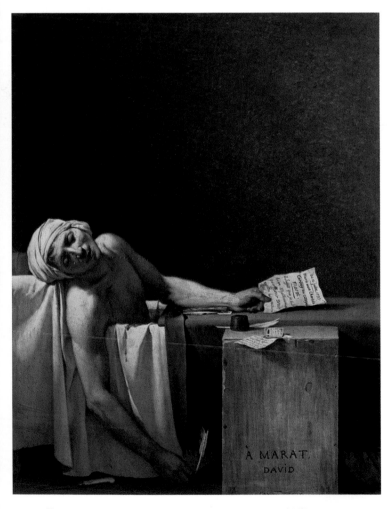

22.5 Jacques-Louis David, *The Death of Marat* 1793. Oil on canvas, approx. 63 × 49 ins (160 × 124.5 cm). Musées Royaux des Beaux-Arts de Belgique, Brussels.

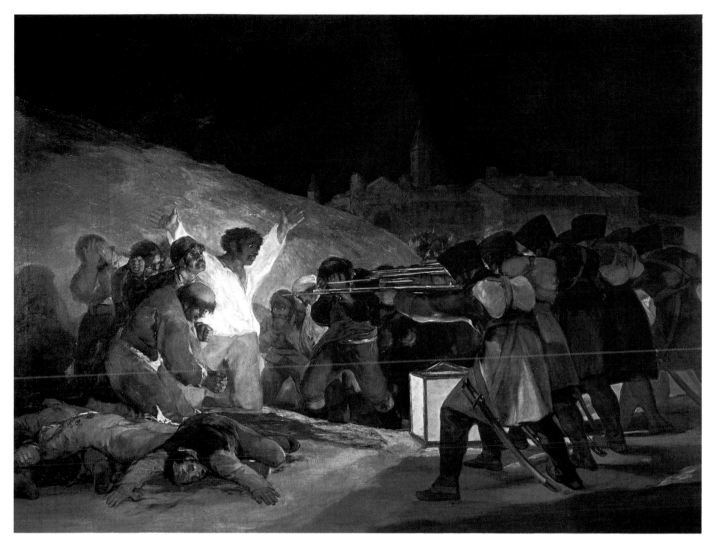

22.6 Francisco de Goya, *The Third of May 1808* 1814.
Oil on canvas, 8 ft 6 ins × 11 ft 4 ins (2.60 × 3.45 m).
The Prado, Madrid.

work of Rococo artists like Watteau and Tiepolo. He was also, but only through prints, well acquainted with the art of eighteenth-century English portraitists, especially Gainsborough.

Goya witnessed the national uprising against the French, and in particular the uprising in Madrid against Murat's troops, which took place on May 2, 1808, and the savage repression the next day. These events became the subject of a pair of large pictures not started until 1814, at the end of the war. *The Third of May* (Fig. **22.6**), which shows the execution of the Spanish insurgents, is probably the greatest work of art inspired by the whole Napoleonic conflict. Like David's *Death of Marat*, the composition carries strongly Christian overtones. The central figure, in the act of being shot, will inevitably remind twentieth-century spectators of certain all-too-familiar news photographs, but the gesture with which he flings his arms wide is also that of Christ on the Cross. There is, however, nothing ennobling about this death. The executioners are a compact, mechanical phalanx; the victim shows fear and defiance, but not ecstasy, or indeed any emotion which transcends the immediate moment.

Literature

Jane Austen

At first sight, the novels of the English writer Jane Austen (1775–1817) are conspicuous for the pains they take to exclude the Napoleonic conflict. The war is referred to very obliquely, if at all. At a deeper level, her books do reflect very clearly the social and economic changes taking place in England at the time when they were written—for example, the shift from landed wealth to new fortunes made in trade.

These changes were accelerated, if not always directly caused, by the war between England and France.

Austen's six mature novels, *Northanger Abbey* (written 1798–1803, but not published until 1818), *Sense and Sensibility* (begun 1797, published in 1811), *Pride and Prejudice* (begun 1796, published in 1813), *Mansfield Park* (1814), *Emma* (1816), and *Persuasion* (1818), are all social comedies. The only one to make a gesture toward the rising fashion for Romanticism is *Northanger Abbey*, which pokes mild fun at the spooky "Gothic novel" so popular at the time.

What gives Jane Austen's books their interest is an all-pervasive irony, and the accuracy with which they delineate both emotional and moral shades of difference. *Pride and Prejudice*, perhaps the best loved of all her novels, tells the story of the courtship of Elizabeth Bennet, who comes from a family of minor gentry, and Mr Darcy, who is not only considerably richer but also from higher up the social scale. Before they can marry, both Darcy and Elizabeth have to gain a more thorough knowledge of the world around them, and of their own natures. The marriage, which elevates Elizabeth socially, is her reward for the progress she makes, both in terms of self-knowledge and in learning to distinguish between what is true and good—that is, morally right—and events and characters (such as her flighty sister Lydia, who elopes with someone who is not only impecunious but also untrustworthy) which do not have these qualities. Comedy sparkles throughout the book, but its foundation is a rather narrow morality, married to an only half-concealed materialism.

Pride and Prejudice is a book where most of the events that carry the plot forward take place on social occasions. Austen's gift is for observing nuances, minute shades and shifts of behavior. To take an example, Darcy has succeeded in persuading Lydia's seducer, Wickham, to marry her—something he did not originally intend to do. Elizabeth, through whose eyes the reader sees what is going on, is aware of this. Elizabeth's mother, offended by Darcy's earlier behavior, is not:

> Mr. Darcy was almost as far from her, as the table could divide them. He was on one side of her mother. She knew how little such a situation could give pleasure to either, or make either appear to advantage. She was not near enough to hear any of their discourse, but she could see how seldom they spoke to each other, and how formal and cold was their manner, whenever they did. Her mother's ungraciousness, made the sense of what they owed him more painful to Elizabeth's mind; and she would, at times, have given anything to have been privileged to tell him, that his kindness was neither unknown nor unfelt by the whole of the family.

(JANE AUSTEN, *Pride and Prejudice*. Penguin Books Ltd., 1972.)

The main thrust of *Pride and Prejudice*, and indeed of all Jane Austen's novels except perhaps *Persuasion*, is that the established social order, the hierarchy of rank which runs downward from the aristocracy to the gentry, and then to those in "trade," must be upheld, even though some members of the aristocratic class, such as the domineering and snobbish Lady Catherine de Bourgh in *Pride and Prejudice*, are unworthy of the respect that is due to them because of their position. The one moderately flexible element in this scheme is the young, unmarried woman, who can go up and down in the social scale according to whom she marries.

The humor with which Jane Austen's conclusions are presented only half conceal the rigidity of the social and moral structure she presumes to be the only one possible for right-thinking people. Both her social and her moral conclusions can be read as an instinctive reaction to the threat posed, first by the French Revolution and then by the Napoleonic Wars, to people like herself.

Music

Ludwig van Beethoven

The parallelism between the careers of Ludwig van Beethoven (1770–1827) and Francisco de Goya is very striking. Both lived under regimes which were by instinct conservative, yet both had liberal sympathies, tending at first to welcome the upheaval initiated by the French Revolution and continued under Napoleon. But both in the end recoiled from the ruthlessness of the Napoleonic regime, which they experienced at first hand. Austria did not suffer from the bitter partisan war which raged in Spain, but many battles were fought on its territories—Napoleon entered Vienna as a conqueror in 1805, and then again in 1809.

Both Beethoven and Goya experienced a period in their lives when they were well-connected and fashionable. Both created works which were a direct reaction to contemporary events, with an immediacy of observation and feeling which marked a break with eighteenth-century tradition, and which made them, at least for a while, into politically significant figures (though neither was ever as closely involved with politics as David, (see page 338). Later, both men sank into isolation, after being confronted with a situation in

which tradition had begun to break down. This isolation became personal as well as professional thanks to the deafness from which both men suffered in later life—though one can argue that this malady had far more serious consequences for Beethoven, since his artistic medium was sound.

The successive phases of both men's work can be directly linked to the biographical facts—first a time when both were gradually emerging from the *galant* world of the eighteenth century; then works inspired by the Napoleonic Wars (in Beethoven's case, the "Eroica" Symphony and the opera *Fidelio*); and finally a series of late works of tortured individuality.

Beethoven was born in Bonn of Flemish stock. Like Mozart, he was brought up to be a musical prodigy. His early compositions are fluent, but do not show Mozart's originality at the same age. He was concerned chiefly to develop what Mozart and Haydn had already achieved, and to show off his own considerable virtuosity as a pianist. The technical development of the instrument enabled Beethoven to deploy a much more resonant "singing" tone. He had heard Mozart play, and in later years would criticize him to friends for his lack of a true *legato*—the seamless linking of one note to another.

He settled in Vienna in 1792, and soon made a reputation as a gifted composer, though one with a difficult temperament, not as subservient to his patrons as professional musicians were then expected to be. His future looked extremely promising, but in 1798 he began to suffer from the first symptoms of deafness, and by 1802 he knew that his affliction was likely to become complete and permanent.

This great crisis in Beethoven's life found expression in his Third Symphony, the "Eroica" (1804). But a further inspiration was the composer's admiration for Napoleon, to whom the composition was originally dedicated. However, when Napoleon declared himself Emperor, the offended Beethoven withdrew the dedication and replaced it with the words "to the memory of a great man." If one compares the "Eroica" to, for example, Mozart's "Jupiter" Symphony, one sees that it is more "literary," or at least that it has a narrative content not present in Mozart's composition. The "Eroica" is meant to evoke the idea of a hero who succeeds against the odds. The notion of the superman, glorified here, was to have great influence throughout the nineteenth century, and Beethoven stands at the beginning of a development which leads directly to the philosophy of Nietzsche.

One of the most striking things about the "Eroica" is its sheer physical scale. Writers of symphonies had never before attempted anything so large and ambitious. Directly contemporary elements, such as the references to French Revolutionary wind bands, are placed side-by-side with those which are innovatory in a quite different sense—because of their elemental force and freedom. The second movement, a solemn and pathetic funeral march (itself an innovation when used as part of a symphony), is followed by the release of the elusive, dancing scherzo, which offers a very different idea of the dance to the minuets favored by Mozart and Haydn.

Chapter 23

Romanticism

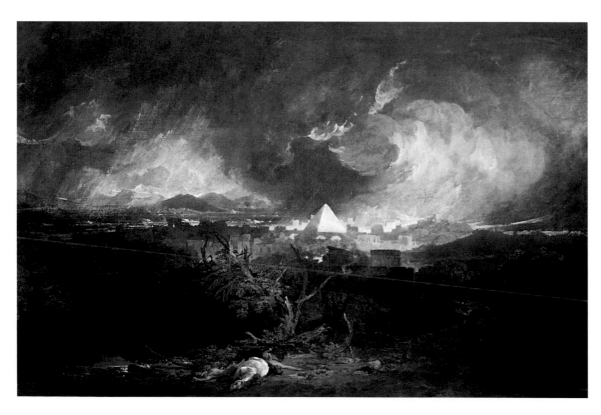

23.1 **J. M. W. Turner**, *The Fifth Plague of Egypt* 1800.
Oil on canvas, 49 × 72 ins (124.5 × 182.8 cm).
Indianapolis Museum of Art, Indiana.

The Romantic movement

The adjective "romantic," as applied to the visual arts, music, and literature, is notoriously difficult to define. It appeared in English for the first time in the mid-seventeenth century, and was then used in a somewhat pejorative way, to mean "like the old romances"—that is, like something inherently exaggerated and absurd. It was taken over by Goethe, and by his literary colleague the poet and playwright Johann Christoph Friedrich von Schiller (1759–1805), to provide an antithesis to the word "classic." Later, the poet Paul Valéry was to say: "All Classicism supposes a Romanticism which precedes it." His argument was that Classicism stood essentially for the idea of order, and that order was always built upon disorder.

Another way of interpreting the word "disorder," how-ever, was to see it as an emblem of the unfettered processes of the imagination. In historical terms, fully developed Romanticism is the successor to the cults of nature and of feeling which sprang up in the course of the eighteenth century, but now with many additional elements—for example, a fascination with the remote past, and especially the Middle Ages, and an equal fascination with alien cultures, particularly those of the Orient. Romanticism took pride in its own contradictions: it embraced free thought on the one hand, and religious mysticism on the other. Most of all, it pursued extremes, seeking out the frontiers of sensation and emotion. It was attracted to the supernatural, the morbid, the melancholy, and the cruel.

Philosophy

Hegel and Schopenhauer

In the early nineteenth century German universities were the acknowledged centers for advanced philosophical studies. The towering figure in German philosophy was Georg Wilhelm Friedrich Hegel (1770–1831). No major set of philosophical ideas is more difficult to reduce to a small compass than that professed by Hegel. In addition he has been much criticized, both by contemporaries and subsequently, for vagueness and pomposity. Nevertheless, his influence permeates most of the philosophy of the nineteenth century, and certainly everything related to the idealistic tradition originally founded by Plato.

Among Hegel's most influential works were his first important publication, *Phenomenology of Mind* (1807), and his *Lectures on Aesthetics* (1835–8), published posthumously. His belief was that only mind (the word in German is *Geist*, which has overtones of spirituality) can be thought of as real. For him this "mind" was an infinitely large and complex system of individuals, all in a state of active intellectual development. Because the system has no boundaries, it is free, but individuals can make use of this freedom only when they are aware of it. It is the responsibility of the philosopher to promote this state of awareness.

A fundamental part of Hegel's work was his use of the dialectical method. Essentially he saw this complex process as a way of exposing incompleteness and, above all, abstractness of thought by pursuing inherent contradictions. The exposure of these contradictions enabled thought to become more concrete, and therefore more accurate. One reason for Hegel's importance, particularly to the Romantics, is that he was the first to put forward the idea of the divided self—to describe a situation where individuals are conscious of a fissure within themselves which they cannot mend, and which divides them from nature. The major historical attempt to heal this split was, for Hegel, the Christian religion, in which the human and the divine—that is, the goodness which individuals can no longer attribute to themselves—are no longer separated, thanks to the presence of God in everyone, as described by the Christian revelation.

Hegel thought that one of the means through which the highest form of mind revealed itself was art, which he put on the same level as revealed religion, and also philosophy. Works of art he regarded as Absolute Mind turned into material form by artists, who have, through their gifts, become "the master of the God." That is, the artist can be thought of as something more powerful than the natural world, yet still fundamentally like it and part of it, rather than separated from it.

For Hegel there were three basic styles or levels of art. The lowest and least satisfactory was symbolic art, in which the concrete object stands for the essential content, but does not completely penetrate it and is not transformed by it. Next in the hierarchy was classical art, which makes the sacred visible and tangible in idealized form—an example would be a Greek statue of Apollo. Best of all is Romantic art, which rejects the static and overedited qualities of Classicism and instead "weaves the inner life of beauty into the contingency of the external form and allows full scope to the

emphatic features of the unbeautiful." Romantic art is superior because it is more dynamic, more complex, and more self-consciously aware of the need for complexity.

Hegel's most distinguished contemporary opponent in Germany was Arthur Schopenhauer (1788–1860), whose chief work is *The World of Will and Idea* (1818). What Schopenhauer objected to in Hegel was the latter's emphasis on the transcendent, though Schopenhauer admitted that a human being was a "metaphysical animal"—a creature who could not help speculating about the fundamental nature of the world. In order to answer these questions correctly, however, the philosopher has to acknowledge and explore the limits within which human knowledge is inevitably confined. For Schopenhauer humans see themselves in two ways—as physical objects among other objects, occupying space, enduring through time and responding to stimuli, and also as beings who express themselves through the exercise of will. The two concepts are linked because an individual's body (his or her identity as an object) becomes the "objectification" of will. Willing something and doing it are the same thing, but perceived from two different standpoints. Individuals can also be perceived as containing within themselves a little of everything which is fundamental to reality as a whole.

Having established this to his own satisfaction, Schopenhauer then took matters a step further. Instead of seeing individuals' freedom as limitless, as Hegel did, he saw those individuals as prisoners of deeply buried instinctual drives, of whose operation they usually remained unaware. "Consciousness," Schopenhauer wrote, "is the mere surface of our mind, of which, as of the earth, we do not know the inside but only the crust."

Like Hegel, Schopenhauer assigned a pre-eminent place to art. But he saw art in a very different way. For him it was not concerned with action or mastery, but with contemplation, or "will-less perception"—the means whereby we separate ourselves from everyday desires and anxieties. Aesthetic awareness is thus a higher form of consciousness—the discovery of "permanent essential form in the world and all its phenomena." Schopenhauer's contribution to the development of Romanticism was therefore the assertion that successful works of art are always things which are mysteriously set apart, an extension of normal perceptions which can be arrived at by no other route.

The one artistic activity which stood outside this theory was music. Schopenhauer believed that music could not be described as a representation, but was instead "the universal imageless language of the heart," which is the closest humans can get to the ultimate reality they sense within themselves but are incapable of describing.

Kierkegaard and Nietzsche

Two other philosophers played a significant role in the later development of Romanticism: the Dane Søren Kierkegaard (1813–55) and the German Friedrich Nietzsche (1844–1900). Kierkegaard combines elements from Hegel and Schopenhauer, stressing both the primacy of the will and the ultimacy of undetermined choice—the latter being the means whereby individuals make themselves what they are. For Kierkegaard, choosing one thing and not another is the very core of existence. And choices must not be forced by making them conform to predetermined categories. If these govern how the decision is made, then the decision itself cannot be wholly free. This demand undermines the role of logic, just as it does the operations of ethics and religion.

Nietzsche began his precocious and brilliant career, tragically cut short by incurable madness in 1889, as a restless disciple of Schopenhauer. His first book, *The Birth of Tragedy* (1872), revolutionized the vision of the ancient Greeks which had been created by Goethe and Winckelmann by stressing the presence and importance of a "Dionysian" as well as an "Apollonian" element in Greek culture. By Dionysian, Nietzsche meant a frenzied impulse to exceed all the norms, and his ideas owed something to Schopenhauer's concept of will. Yet he also thought of the Sublime as "the artistic conquest of the horrible," and would have nothing to do with Schopenhauer's "will-less contemplation" as the supreme end of art.

Nietzsche believed that the only thing men and women want for its own sake is power. He escapes from the ethical dilemma which this creates by idealizing the concept of power: he finds power in self-control, and in the creation of art. These drives are personified by the *Übermensch* or superperson, who is not a potential dictator but a member of an élite. The superperson knows how to organize the chaos of his or her own passions, and can therefore greet life affirmatively. In the world of the here-and-now he or she is the embodiment of the traditional concept of God. The Romantic cult of the genius thus reaches its climax in Nietzsche, who finds a way, even if it is a paradoxical and dangerous one, of reintegrating the individual who exceeds the human measure, and making him or her once again part of society.

23.2 Karl Friedrich Schinkel, Court Gardener's House, Potsdam, 1829–31.

Architecture

Nineteenth-century architecture was not stylistically unified. The nostalgia for the past which played such an important part in the development of Romanticism led to the use of a large number of revival styles. These ranged from an adaptation of Classicism (the Romantic spirit, and especially the taste for the sublime and mysterious, is already prominent in the work of Soane—see page 367) to versions of Gothic, Renaissance, and Baroque.

From a twentieth-century perspective, the most important early Romantic architect was the Prussian Karl Friedrich Schinkel (1781–1841). Schinkel began his career as a painter of panoramas and dioramas; many of his buildings show vestiges of this in their care for dramatic effect. More significant for the future was his modest Court Gardener's House (Fig. **23.2**), built between 1829 and 1831 at Potsdam—a new version of a fifteenth-century Italian villa which showed Schinkel's mastery of asymmetrical planning, which was to have great influence over the International Style architects associated with the Bauhaus (see page 477). The building displayed two apparently contradictory impulses: admiration for the past and a determination to serve the needs of the present. This was to be typical of the best Romantic architecture in general.

The building just cited avoided the style now most commonly associated with Romantic architecture—the continuation of the Gothic Revival. In England especially, Gothic came to be seen as a "national" style, expressive of British patriotism. Paradoxically, the same thing happened, though to a lesser extent, in Germany and France.

Thanks to the writings of John Ruskin (1819–1900), it was also perceived as something opposed to the evils of industrialism, and symbolic of the freedom allowed to medieval artisans. Additionally, it was put at the service of the religious revival which manifested itself in many forms during the first half of the century.

The most important propagandist for Gothic before the appearance of Ruskin was A. W. N. Pugin (1812–52), an ardent Catholic convert. He is now best known for his

23.3 **Sir Charles Barry** and **A. W. N. Pugin,** The Houses of Parliament, London, 1840–65.

collaboration with Sir Charles Barry (1791–1860) in the rebuilding of the Houses of Parliament in London (Fig. **23.3**), 1840–65. Barry was responsible for the plan of the new buildings and, despite the need to include certain leftovers from the old constructions, notably the medieval Westminster Hall, he succeeded in producing something extremely regular and rational in its layout, with multiple functions skillfully catered for. Pugin provided the skin of Gothic details in which the buildings were clad. Other major buildings, with functions unknown to the Middle Ages—hotels and railway stations, for example—were treated in the same way.

Landscape painting

J. M. W. Turner

In art one of the chief vehicles for the expression of the Romantic spirit was landscape painting. The reasons are easy to understand. A landscape, even peopled and with a specific subject, left the spectator more room for the exercise of personal fantasy than a narrative figure subject. The work of art became an invitation to reverie. In many, though not all, Romantic landscapes long vistas and misty perspectives seemed to invite the viewer to go beyond the actual picture space, to escape, in thought at least, from the rigors of the real world.

The quintessential Romantic landscapist was the Englishman Joseph Mallord William Turner (1775–1851), now generally recognized as one of the greatest painters England has ever produced. One of his characteristics was his immense power of assimilation. He swallowed the English watercolorists, then the Dutch masters; and he studied and imitated Claude (see page 278), who was prominently represented in the great English private collections of the late eighteenth and early nineteenth centuries. He also traveled widely, in order to study nature in all its aspects; visits to many parts of England, Scotland, and Wales were followed by extensive continental tours—he went to Switzerland in 1802, toured Holland, Belgium, and part of the Rhine valley in 1817, and in 1819 went to Italy for the first time.

But Turner was not content merely to absorb what his eyes could tell him; he was determined to invent a new kind of landscape painting which would raise landscape to the same level as the ambitious figure compositions of the Old Masters. For him, the highest kind of landscape painting was not a representation of a real scene but a poetical invention, and he was heavily influenced by the concept of the Sublime propagated by Edmund Burke. His first venture into this kind of painting was *The Fifth Plague of Egypt* (Fig. **23.1**)—the plague of hail and fire—exhibited at the Royal Academy in 1800. It has something of the wild excess of a figure painting by Fuseli and was the start of a long series of works depicting storms, cataclysms, and disasters.

Turner soon learned to be subtler than this. In addition to making intensely atmospheric depictions of particular places—such as Venice, all shifting mists and glittering reflections—he painted interpretations of literature. And toward the end of his career, he began to interpret the drama of the new industrial age. *Rain, Steam and Speed—The Great Western Railway* (Fig. **23.4**), exhibited at the Royal Academy in 1844, is a new version of the concept of the Sublime, and demonstrates Turner's awareness of the way in which new and more rapid means of travel were altering people's perceptions of their surroundings. The painting also illustrates the general characteristics of Turner's late work—the way in which everything seems to dissolve into colored vapor. The technique of his late oils was influenced by the lessons learned during his long practice as a watercolorist, and relies for its effect on the use of very dilute and transparent washes of paint, manipulated with great rapidity and virtuosity.

John Constable

The other leading British landscape painter of the Romantic epoch was an artist so different in style and approach to Turner that it has sometimes been doubted whether he

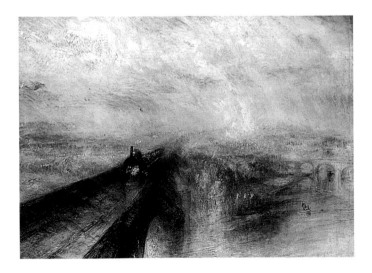

23.4 J. M. W. Turner, *Rain, Steam and Speed—The Great Western Railway* 1844. Oil on canvas, 35¾ × 48 ins (91 × 122 cm). National Gallery, London.

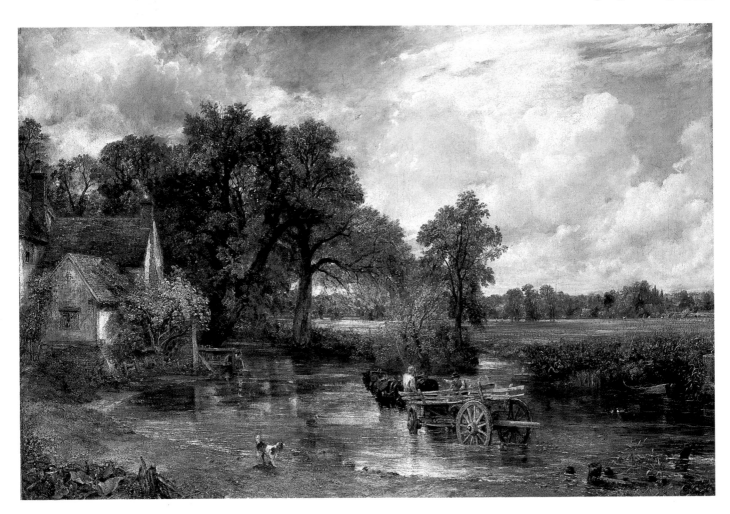

23.5 John Constable, *The Hay Wain* 1821.
Oil on canvas, 51¼ × 73 ins (130 × 185 cm).
National Gallery, London.

should be classified among the Romantics at all.

Unlike Turner, John Constable (1776–1837) preferred to paint what was completely familiar to him—chiefly the Suffolk landscape round his birthplace at East Bergholt, the London suburb of Hampstead, where he lived for a long time, and scattered places in the south of England, such as the seaside resort of Brighton. There is no symbolism, and what he paints is never used as the setting for some historical or legendary event. The subject, though, is not only what he sees but also the emotion it arouses—in Constable's own, often-quoted phrase, "Painting is but another word for feeling."

The big paintings Constable sent for exhibition at the Royal Academy were painstakingly prepared, with the help of numerous sketches. Later generations have sometimes preferred these spontaneous preparatory works to the finished product. Many of the sketches are cloud studies—Constable considered the sky to be not a backdrop but an integral and vital part of the effect made by the whole picture. "The Landscape painter," he wrote on one occasion, "who does not make his skies a very material part of his composition neglects to avail himself of one of his greatest aids." The cloud studies, while often as abstract in appearance as some of Turner's "color beginnings" (as the latter called his first ideas for paintings), are in fact scientifically accurate representations of various states of weather, as revolutionary in their keenness of observation as Stubbs's anatomical studies (see page 328). They are evidence of Constable's conviction that feeling could express itself fully only when it took all the available physical facts into account. "How strange it is," he said, "that we should prefer raising up all manner of difficulties in painting to truth and commonsense."

Though Constable never enjoyed, at least in his own lifetime, the reputation that was his due, his work did have an important impact in France. In 1822 a French dealer called Arrowsmith saw Constable's great landscape *The Hay Wain* (Fig. **23.5**) in a show at the British Institution. After much negotiation, he purchased it and sent it to Paris, showing it first at his own gallery and then in the Salon of 1824. The contemporary French painters Géricault and Delacroix (see page 381) were immediately impressed by the

23.6 **Caspar David Friedrich**, *The Cross in the Mountains* 1807–8. Oil on canvas, 45½ × 43½ ins (115 × 110.5 cm). Gemäldegalerie, Dresden.

freshness and freedom of Constable's style. "This man Constable has done me a world of good," Delacroix wrote in his journal on the evening he first saw Constable's work. Constable's French admirers also included the novelist Stendhal. In January 1825 Charles X of France awarded the artist a gold medal for his contribution to the official exhibition.

Germany and the USA

Romantic landscape flourished both on the continent of Europe and in the USA, but it took rather different forms from those it had assumed in England. The German painter Caspar David Friedrich (1774–1840), for example, was chiefly a symbolic artist who used landscape to express an inner truth. The landscapes he depicted were the flat shores of the Baltic, and the mountains of Saxony, Bohemia, and

Central Germany. But the specific "where" scarcely matters. Nature supplied him with a vocabulary of images which he combined and varied to suit his own purposes. He used to tell inquirers that his images were revealed to him in dreams. "In [my] opinion," he said, "every truthful work of art must express definite feeling, must move the spirit of the spectator either to joy or to sadness, to melancholy or to lightheartedness rather than try to unite all sensations, as though mixed together with a twirling stick."

The most extreme example of his methods is *The Cross in the Mountains* (Fig. **23.6**), commissioned in 1807 for a private chapel in a Bohemian castle. The cross appears at the top of a high rock, and the whole scene is set in a Gothic

frame carved with palm branches. Every detail has a specific meaning. The sun is setting behind the rock in order to symbolize the passing of the old pre-Christian order. The golden figure on the crucifix reflects light back toward the earth, and the rock itself symbolizes the steadfastness of faith. The green fir trees surrounding the crucifix are an allegory of the believer's hope in Christ.

On the other side of the Atlantic, landscape painting found a public, optimistic role rather different from the one it enjoyed in Europe. Yet American landscapes were still the expression of subjective feelings, still much concerned with ideas of awe and sublimity, solitude and meditation, and thus remained within the main current of the Romantic movement.

It was not surprising that American painters should turn to this branch of art. First, the American landscape, and especially the American wilderness, offered the painter something entirely new. Secondly, to depict the land was a patriotic act, a way of affirming national identity. Thirdly, artists working in America lacked a rigorous academic training of the sort available in Europe. The technical tradition of landscape painting was less fixed, and artists without an academic background felt more confident in this branch of art.

American landscape paintings of the early and mid-nineteenth century often show an obsessive concern with detail which makes them obviously unlike the work done by European contemporaries. Here, too, several factors were at work. American landscapists often saw their paintings as scientific records of new facts. From the 1850s onwards, photography supplied a new and demanding standard of verisimilitude. The public which the artists addressed was less sophisticated visually than that of Paris or London. It was, however, intensely enthusiastic and appreciative of the artists' efforts to reflect American reality.

The most successful American landscapist of the century, Frederic Edwin Church (1826–1900), reflects this situation exactly. He studied with Thomas Cole (1801–48), leader of the first generation of American landscapists and founder of the Hudson River School. By the time Cole died, Church was ready to launch himself as an independent artist. He had the means and energy to travel widely, not only within America but also in some of the remoter regions of South America. His outstanding talent was for the evocation of natural phenomena at their grandest, and many of his landscapes are on an overwhelmingly large scale. *Niagara* (Fig. **23.7**), painted in 1857, met with instant acclaim when it was first exhibited. "To write of this picture," said *The New York Times*, "is like writing of the Falls themselves."

The painting combines great force and simplicity of composition with fine detail and finish, despite its huge scale. Church's innovation was to cut out the foreground completely, so that spectators find themselves apparently over the waters of Niagara, a few feet out from the Canadian shore. By treating the composition thus, Church achieved a Romantic, visionary element despite the literal realism of the details, which makes him one of the last exponents of the Sublime as this was originally defined by Edmund Burke (see page 348).

23.7 Frederic Edwin Church, *Niagara* 1857.
Oil on canvas, 42½ × 90½ ins (108 × 229.9 cm). In the collection of The Corcoran Gallery of Art, Washington. Museum purchase, 1876.

Figure painting

France

The pioneer of Romantic figure painting in France was Théodore Géricault (1791–1824), who had already established a reputation as a precociously gifted painter of military subjects before the fall of Napoleon. Géricault's work is transitional, linking the old, large-scale propaganda paintings, glorifications of the now defunct Empire, with the new, much less exciting world of the restored Bourbon monarchy, in which adventurous and creative people felt increasingly alienated.

Géricault had great difficulty in deciding what kind of art he wanted to produce as a response to the new situation in France, and it was only after considering several other subjects that he settled on *The Raft of the "Medusa"* (Fig. **23.8**), shown in the Salon of 1819. This, like David's *Napoleon Crossing the Alps* (see page 362), deals with a contemporary event, but not one which the government of the day wanted to publicize. Géricault painted the picture for his own satisfaction, and not as an official commission. In 1816 the government frigate *La Méduse*, sailing to Senegal, was wrecked in clear weather off the West African coast. There were not enough lifeboats for all those on board, and 150 survivors found themselves crowded onto an improvised raft. After a few hours, this raft was abandoned by the ship's captain and officers, who had commandeered the boats. By the time rescue came, some days later, there were only fifteen men left alive, and five of these died shortly after reaching land.

Géricault's originality was to take this sensational contemporary episode, horrifying rather than heroic, and treat it on the scale reserved for traditional history painting. *The Raft of the "Medusa"* shows the few survivors desperately hailing a ship which seems to ignore them, from a raft encumbered with corpses and dying men. But Géricault did not wish the picture to be a literal representation of what

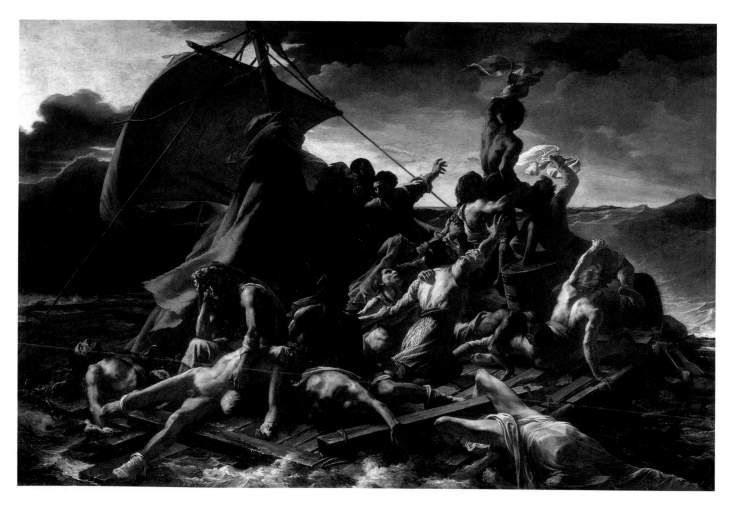

23.8 Théodore Géricault, *The Raft of the "Medusa"* 1819.
Oil on canvas, 16 ft × 23 ft 6 ins (4.91 × 7.16 m). Louvre, Paris.

had happened—an enlarged version of the popular prints showing the disaster which had already appeared. His figures are superbly vigorous and muscular, not the emaciated victims the rescuers found in reality. The painting deliberately pushes emotion to extremes, and Géricault meant this emotion to be a reflection of what he found within himself.

Eugène Delacroix (1798–1863), Géricault's disciple, who posed for one of the figures in *The Raft of the "Medusa"*, was a central figure in the whole Romantic movement. One of the most important of his early paintings, *The Massacre at Chios* (Fig. **23.9**), was shown in the Salon of 1824. The painting was inspired by the Greek struggle for independence, which had stirred the conscience of Europe. The massacre of the title had taken place two years previously, in 1822, as the Turks took revenge for reverses inflicted on them by the Greeks. Like Géricault's *Raft*, Delacroix's *Massacre* is a depiction of a sensational contemporary event. But what it adds to the horrors of the *Raft* is a strange erotic languor, a melancholy exoticism which seem at odds with the brutality of the subject.

In the Salon of 1827 Delacroix showed a picture in which this dreamlike atmosphere was greatly intensified—*The Death of Sardanapalus* (Fig. **23.10**). The subject is no longer contemporary but is placed in the legendary past. A defeated Assyrian king, besieged by insurgents in his palace and about to immolate himself, orders the destruction of his treasures, his horses, and his concubines so that nothing will fall into the hands of the victors. The theme, a mixture of pessimism, sadistic violence, and unbridled sensuality, typifies one important aspect of Romanticism—its love of emotional extremes. Delacroix reinforces the effect of his chosen imagery by creating a composition which breaks all the classical rules—a glittering cascade of figures and objects tumbles restlessly from one corner of the vast canvas to another, from the reclining figure of the doomed king at the top left to the beautiful naked concubine being brutally stabbed by a palace guard at the bottom right. The sumptuous gleam of skin and metal and silk is offset by a heavy cloud of smoke which conceals the shape of the palace hall in which all the action takes place, and threatens at any moment to obliterate the whole complex mass of writhing figures.

Throughout his professional career, Delacroix found his work contrasted with that of Jean-Auguste-Dominique Ingres (1780–1867). The two artists were seen as the heads of schools of art which were diametrically opposed to one another. Yet the fact is that Ingres was just as much a child of the Romantic movement, and was as filled with Romantic sensibility, as Delacroix himself.

The erotic sensuousness which is one of the most striking characteristics of Ingres's work can be seen in its purest form in his paintings of the female nude, which are among the supreme depictions of the subject. The *Grande Odalisque* (Fig. **23.11**) of 1814 is an image of Oriental seductive-

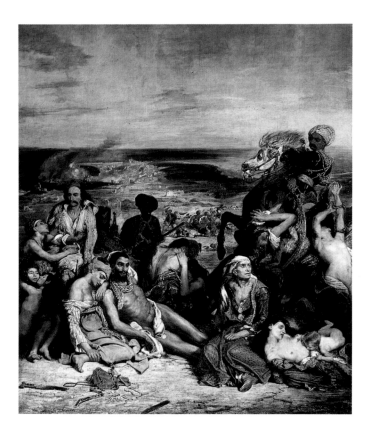

23.9 Eugène Delacroix, *The Massacre at Chios* 1824. Oil on canvas, 13 ft 6 ins × 11 ft 6 ins (4.17 × 3.4 m). Louvre, Paris.

ness even more potent than those created by Delacroix, and linked to the same world of Romantic fantasy. The anatomy is arbitrary—for example, the figure seems to have several vertebrae too many. Yet the glassy perfection of every detail—the feather fan, the silk curtain—gives the image an hallucinatory quality, like something seen in a dream.

Despite the things they had in common, Ingres violently disapproved of Delacroix's work—its loose "painterliness" most of all. Passing in front of one of Delacroix's paintings, Ingres would hold his hand in front of his eyes and declare: "I've no need to know how not to do it." He regarded himself as the heir of David (see page 339), and the upholder of the academic tradition which David had inherited from Annibale Carracci (see page 252) and Carracci from Raphael (see page 197), a painter whom Ingres idolized. His handling of paint was tight and smooth, and he built up his compositions using the old laborious methods of picture construction, making much use of life drawing.

What he drew from life was nevertheless subtly transformed when it became part of a painting. Far from stressing Ingres's classicism, contemporary critics often found something "Gothic" (in their own phraseology) about his work, even when the subject matter came from Greek legend. By this they meant that Ingres's work seemed excessively mannered; also flattened and linear, rather than fully modeled in the round.

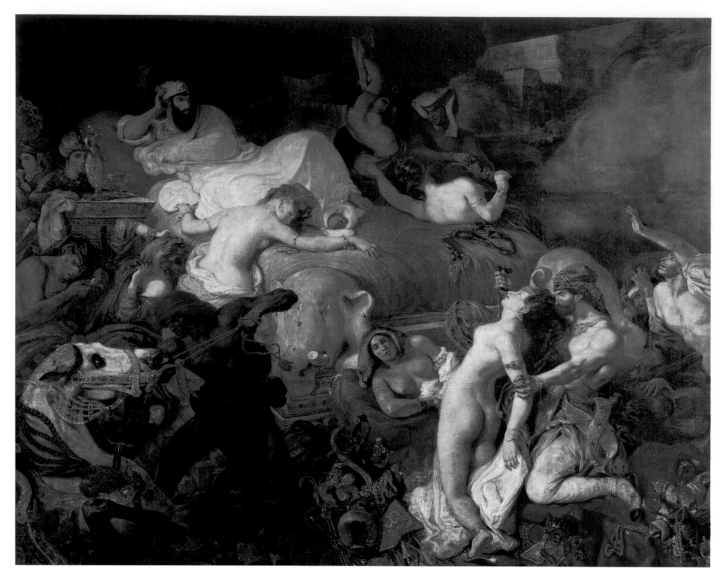

23.10 **Eugène Delacroix**, *The Death of Sardanapalus* 1828.
Oil on canvas, 12 ft 10 ins × 16 ft 3 ins (3.92 × 4.96 m). Louvre, Paris.

Nazarenes and Pre-Raphaelites

The "Gothic" element contemporaries sometimes noted in Ingres, in addition to his sensuous Orientalism, was not unique. It reappears in accentuated form in the works of the German Nazarenes and then in the British Pre-Raphaelites.

The Nazarenes were the first of all the many "secession" movements which rose up against the established academic tradition in the course of the nineteenth century, and are important for that reason alone. A group of young Austrian and German artists, led by Friedrich Overbeck (1789–1869) and Franz Pforr (1788–1812), set up an artists' colony in a disused monastery in Rome in May 1810. This community lasted only two years, but soon there was a growing colony of young German artists in the city. With their strict religious principles, wide cloaks, and long hair, they were conspicuous figures—and were derisively nicknamed

Nazarenes because they looked like so many versions of Jesus. The label stuck, and seemed less pejorative as the years went on.

While still in Vienna, Overbeck and Pforr had been influenced by the works by Dürer, Cranach, and Holbein in the Imperial Collection at the Belvedere Palace. These influences are evident in the ambitious processional picture *The Entry of Rudolf of Hapsburg into Basle in 1273* (Fig. **23.12**), which Pforr took with him to Rome and managed to finish there before he died. Overbeck was influenced by what he saw in Rome itself, but remained consciously archaizing. His *Joseph Sold by His Brethren* (Fig. **23.13**) looks like a work by a provincial follower of Raphael. It is in fact a retrospective view of Raphael, seen from a Romantic perspective.

The British Pre-Raphaelites later followed the same route of youthful rebellion, seeking remedies in the past for what

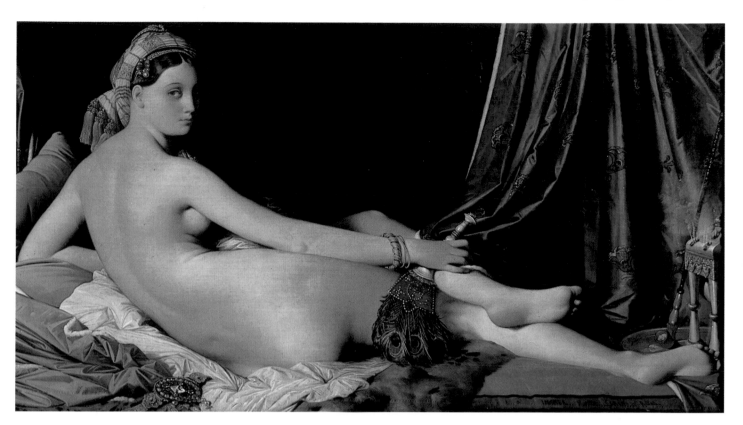

23.11 **Jean-Auguste-Dominque Ingres**, *La Grande Odalisque* 1814.
Oil on canvas, 36¼ × 63¼ ins (92 × 160.6 cm). Louvre, Paris.

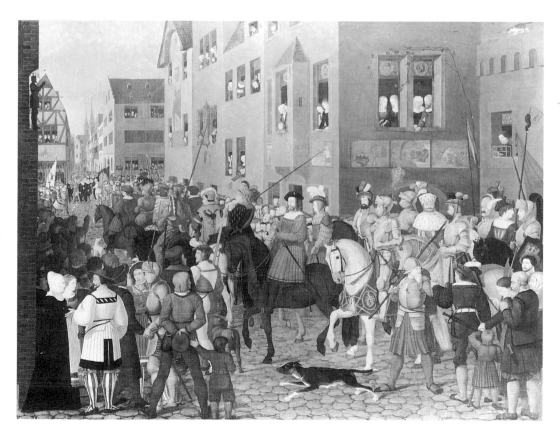

23.12 **Franz Pforr**, *The Entry of Rudolf of Hapsburg into Basle in
1273.* Oil on canvas, 35½ × 46⅞ ins (90.5 × 119 cm). Staedelinstitut,
Frankfurt.

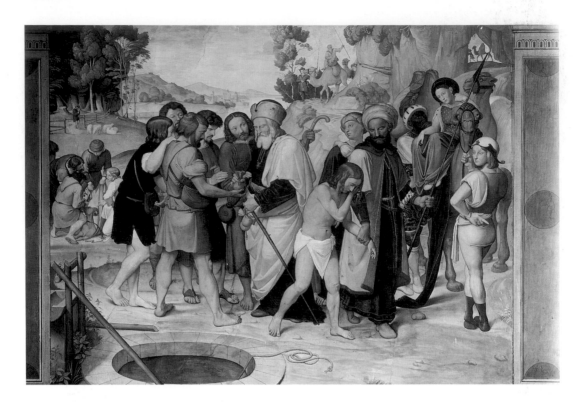

23.13 Friedrich Overbeck, *Joseph Sold by his Brethren* 1816–17.
Fresco, transposed on canvas, 95½ × 119½ ins (243 × 304 cm).
Staatliche Museen, East Berlin.

23.14 William Holman Hunt, *Eve of St. Agnes* 1848.
Oil on canvas, 30½ × 44½ ins (77.5 × 113 cm).
Guildhall Art Gallery, London.

23.15 John Everett Millais, *Lorenzo and Isabella* 1849.
Oil on canvas, 40½ × 56¼ ins (103 × 142.8 cm).
Walker Art Gallery, Liverpool.

23.16 Dante Gabriel Rossetti, *The Tune of the Seven Towers* 1857.
Watercolor, 12⅜ × 14⅜ ins (31.5 × 36.6 cm). Tate Gallery, London.

they disliked about the art of the present—the very name of the group, in this instance self-chosen, defined their attitudes. They were both more gifted and less homogeneous than their German predecessors.

The formation of the Pre-Raphaelite Brotherhood (PRB) in 1848 came about because of the sudden enthusiasm felt by Dante Gabriel Rossetti (1828–82) for a painting by William Holman Hunt (1827–1910) shown in the Royal Academy that year. Hunt's *Eve of St. Agnes* (Fig. **23.14**) was an illustration to a poem by John Keats, and, despite its medieval subject matter, it was essentially an attempt to get as close to natural appearances as possible. Though painted before the official formation of the PRB, it is already deeply Pre-Raphaelite in spirit.

Similar attitudes are visible in a work by John Everett Millais (1829–90), painted shortly after the PRB was formed. *Lorenzo and Isabella* (Fig. **23.15**) is once again based on a poem by Keats. The friezelike composition and the deliberate angularity of some of the figures demonstrate the link between Pre-Raphaelite and Nazarene ideas clearly enough.

The poetic, medievalizing aspect of Pre-Raphaelitism can be seen most consistently in the work of Rossetti himself, though he never achieved the level of technical skill possessed by his comrades Hunt and Millais. His best works are not oil paintings but watercolors, such as *The Tune of the Seven Towers* (Fig. **23.16**). This is compressed, indeed somewhat claustrophobic, in composition, meticulously detailed in finish, and jewel-like in color. Yet the high technical finish in no way suggests that this is a reconstruction of some possible past reality, which is the impression the spectator gets from Hunt's *Eve of St. Agnes*. Instead Rossetti is here creating a wholly personal dream world.

Literature

The image of the poet

In literature William Wordsworth initiated a revolution in poetic vocabulary, in versification, and in the kind of subject matter considered suitable for poetry, but he did not greatly alter the image of the poet. This task was accomplished by his younger contemporary, George Gordon Byron, 6th Baron Byron (1788–1824). Byron's poetry, combined with other factors—his high social position, his compelling physical presence his generous support for the movement for Greek freedom, and the numerous scandals which his way of life provoked—all combined to give him a European celebrity which Wordsworth was never to rival. Byron made the figure of the poet into the supreme Romantic archetype, and contributed to the rise of a new cult of

Don Juan, Canto II

In its earlier stages, the shipwreck scene of Canto II of Byron's *Don Juan* suggests a comparison with Géricault's horrific painting *The Raft of the "Medusa"* (see page 380). Later in this passage, the tone shifts and becomes lighter and more ironic, culminating (stanza 110) in a deliberately exaggerated description of Juan's physical beauty. Abrupt contrasts of this sort are typical of the poem as a whole.

100
The land appeared a high and rocky coast,
 And higher grew the mountains as they drew,
Set by a current, toward it. They were lost
 In various conjectures, for none knew
To what part of the earth they had been tost,
 So changeable had been the winds that blew.
Some thought it was Mount Etna, some the highlands
Of Candia, Cyprus, Rhodes, or other islands.

101
Meantime the current, with a rising gale,
 Still set them onwards to the welcome shore,
Like Charon's bark of spectres, dull and pale.
 Their living freight was now reduced to four,
And three dead, whom their strength could not avail
 To heave into the deep with those before,
Though the two sharks still followed them and dashed
The spray into their faces as they splashed.

102
Famine, despair, cold, thirst, and heat had done
 Their work on them by turns, and thinned them to
Such things a mother had not known her son
 Amidst the skeletons of that gaunt crew.
By night chilled, by day scorched, thus one by one
 They perished, until withered to these few,
But chiefly by a species of self-slaughter,
In washing down Pedrillo with salt water.

103
As they drew nigh the land, which now was seen
 Unequal in its aspects here and there,
They felt the freshness of its growing green,
 That waved in forest-tops and smoothed the air,
And fell upon their glazed eyes like a screen
 From glistening waves and skies so hot and bare.
Lovely seemed any object that should sweep
Away the vast, salt, dread, eternal deep.

104
The shore looked wild without a trace of man
 And girt by formidable waves; but they
Were mad for land, and thus their course they ran,

Though right ahead the roaring breakers lay.
A reef between them also now began
 To show its boiling surf and bounding spray,
But finding no place for their landing better,
They ran the boat for shore and overset her.

105
But in his native stream, the Guadalquivir,
 Juan to lave his youthful limbs was wont,
And having learnt to swim in that sweet river,
 Had often turned the art to some account.
A better swimmer you could scarce see ever,
 He could perhaps have passed the Hellespont,
As once (a feat on which ourselves we prided)
Leander, Mr Ekenhead, and I did.

106
So here, though faint, emaciated, and stark,
 He buoyed his boyish limbs and strove to ply
With the quick wave and gain, ere it was dark,
 The beach which lay before him, high and dry.
The greatest danger here was from a shark,
 That carried off his neighbour by the thigh.
As for the other two, they could not swim,
So nobody arrived on shore but him.

107
Nor yet had he arrived but for the oar,
 Which providentially for him was washed
Just as his feeble arms could strike no more,
 And the hard wave o'erwhelmed him as 'twas dashed
Within his grasp. He clung to it, and sore
 The waters beat while he thereto was lashed.
At last with swimming, wading, scrambling, he
Rolled on the beach, half senseless, from the sea.

108
There breathless, with his digging nails he clung
 Fast to the sand, lest the returning wave,
From whose reluctant roar his life he wrung,
 Should suck him back to her insatiate grave.
And there he lay full length, where he was flung,
 Before the entrance of a cliff-worn cave,
With just enough to life to feel its pain
And deem that it was saved, perhaps in vain.

109
With slow and staggering effort he arose,
 But sunk again upon his bleeding knee
And quivering hand; and then he looked for those
 Who long had been his mates upon the sea,
But none of them appeared to share his woes,
 Save one, a corpse from out the famished three,
Who died two days before and now had found
An unknown barren beach for burial ground.

110
And as he gazed, his dizzy brain spun fast
 And down he sunk, and as he sunk, the sand
Swam round and round, and all his senses passed.
 He fell upon his side, and his stretched hand
Drooped dripping on the oar (their jury mast),
 And like a withered lily, on the land
His slender frame and pallid aspect lay,
As fair a thing as e'er was formed of clay.

111
How long in his damp trance young Juan lay
 He knew not, for the earth was gone for him,
And time had nothing more of night nor day
 For his congealing blood and senses dim.
And how this heavy faintness passed away
 He knew not, till each painful pulse and limb
And tingling vein seemed throbbing back to life,
For Death, though vanquished, still retired with strife.

Byron

(BYRON, *Don Juan*. Penguin Classics, 1986, 1987.)

"many splendid errors, actual and fantastic." Eventually he is allowed to escape his bargain with Mephistopheles, and be saved.

What is the basic meaning of this extraordinarily complex work, which Goethe made into a summary of his own instinctive feelings about the nature of human existence? Toward the end of the play, Faust says:

I have only galloped through the world,
And clutched each lust and longing by the hair.

What did not please me, I let go.
What flowed away, I let it flow.

(HENRY HATFIELD, *Goethe: A Critical Introduction.* Harvard University Press, 1964.)

While these lines cannot be applied directly to Goethe himself, they indicate where his sympathies lay. What justifies Faust's reprieve is his lust for life, his eternal dynamism.

Music

Romantic opera

Romantic opera, often adapted from the Romantic dramas of the early nineteenth century, lasted longer than its spoken equivalent, and has survived more successfully. The reason is that music gives an added dimension to the extreme emotions which typified the theater of that epoch. In addition, fine music often excuses glaring faults in character-drawing and plot construction.

The composer who initiated the Romantic period in opera, Gioacchino Rossini (1792–1868), was a paradoxical figure, not least because he did not conform to the Romantic idea of the artist, either physically or in personal temperament. He treated composing opera as a form of business enterprise. His first success was an *opera buffa* (comic opera), *La Cambiale di matrimonio* (1810), and it is comic operas which preserve his reputation today, notably the delicious *Barber of Seville* (1816), based, like Mozart's *Marriage of Figaro*, on a play by Beaumarchais (see page 332). Nevertheless a large part of Rossini's output consists of "serious" operas, now only intermittently revived. Two of the most striking are *Otello* (1816), a very early attempt to adapt Shakespeare for operatic purposes, and *Guillaume Tell* (1829), based on a play by the German playwright Friedrich Schiller (1759–1805). *Guillaume Tell* has been called "the first Romantic opera." It preceded Victor Hugo's *Hernani*, often called the first fully Romantic drama, by a year. In its emphasis on political liberty, personal heroism, and rebellion against authority *Guillaume Tell* anticipated many of the themes Hugo was to make his own. The overture, now the best-known component of the piece, is a precursor of the "symphonic poems" which became popular later in the century, which illustrated literary and poetic ideas. In this case the listener is invited to imagine the sun rising over Lake Lucerne.

Rossini's successors in the Italian *bel canto* tradition were first Vincenzo Bellini (1801–35) and Gaetano Donizetti (1797–1848), and later Giuseppe Verdi (1813–1901), with whom Romantic opera entered its next phase.

Verdi transformed the whole nature of operatic writing in the course of his long career. He was not nearly as precocious as Rossini, and had to wait until 1842 for his first great success, the biblical opera *Nabucco*. This caught the public fancy not only because of the driving vigor of the music, but because one of its great choruses, "Va, pensiero," the lament of the Jews in exile, acquired adventitious meaning in the context of the struggle for Italian independence from Austrian rule, and the effort to unify Italy and make it a single nation-state.

After *Nabucco*, Verdi's career can be split into three periods, during each of which he wrote progressively less. During the first, which Verdi himself dubbed "The Years in the Galleys," he was incredibly prolific, and often rather crude. His operas were based on patriotic themes, but also on many of the standard Romantic sources, such as Hugo (*Ernani*, 1844); Byron (*I Due Foscari*, 1844); and Shakespeare (*Macbeth*, 1847). Throughout this period Verdi was experimenting with musical and dramatic forms, trying to discover the things that only opera could do.

During the next, middle, phase, Verdi was already a celebrated public figure. He became a deputy in the Italian parliament, and the phrase "Viva Verdi" became a patriotic slogan—an acrostic for "Viva Vittorio Emmanuele, Re d'Italia." His production during this period slowed down, and he produced increasingly elaborate operas in step with the public's developing taste for historical spectacle. The climax of this phase was reached with *Aida* (1871), an opera with an Ancient Egyptian theme written to celebrate the opening of the Suez Canal.

The final years of Verdi's life found him, like Rossini, more and more reluctant to compose, especially for the stage. He was eventually persuaded to create *Otello* (1887), which has completely displaced Rossini's opera based on the same play. Despite its late date it has frequently been de-

The Legend of Paganini

Romantic enthusiasm for exceptionally gifted performers easily became linked with the contemporary cult of the superhuman and the demonic. This can be seen in the extraordinary enthusiasm for the virtuoso violinist Niccolo Paganini (1782–1840), who enjoyed his greatest triumphs in the 1820s and 1830s. Born in poverty in Genoa, Paganini went on his first concert tour at the age of fifteen, first building up his reputation in Italy, then moving on, with even greater success, to northern Europe. The same phrases constantly recur in contemporary descriptions of his personality and art, in particular the assertion that his playing was "inexplicable." His extraordinary personal appearance, lean and cadaverous, linked to his musical gifts, insured that sulphurous legends gathered around him. Here is an extract from a letter written by someone who met Paganini in Venice in 1824 which gives a characteristic glimpse, not so much of the man himself, as of the legend surrounding him:

> Yesterday Messer Sorgo told us that Paganini was now playing every evening in the cemetery on the Lido. So we went over and found a big crowd sitting and standing round listening to Paganini play. Some people were amused but most of them—with tears in their eyes—said that it was touching that this great artist played every evening gratis for the dead. On the way home there was a Dominican monk in the gondola who said that Paganini had sold his soul to the devil, and the Bishop had given orders not to allow him in the cemetery any more. With that we threw him overboard . . .

> (G.I.C. DE COURCY, *Paganini, the Genoese*, Vol. I. University of Oklahoma Press, 1957.)

This letter seems to offer a good instance of Paganini's highly developed instinct for publicity.

Paganini's greatest triumph was probably the series of concerts he gave in Paris in 1831, very soon after the Revolution of 1830 which removed Charles X of France from the throne and replaced him with the much more liberal Louis-Philippe.

> It was a divine, a diabolic enthusiasm [one spectator at his first concert reported], I never saw anything to equal it in all my life. The people have all gone crazy and will make everybody crazy. They listened so intently that they lost their breath, and the necessary beating of their hearts disturbed and angered them.

> (G.I.C. DE COURCY, *ibid.*, Vol. II)

The audience at this concert included the cream of Parisian society, and many writers, musicians, and artists. One of the artists present was Delacroix (see page 381), who soon afterwards painted, apparently from memory, an oil-sketch of Paganini playing which perhaps gives the best impression of the impact he made on the Romantic sensibility. It accords perfectly with written descriptions of Paganini's physique, mannerisms, and personality.

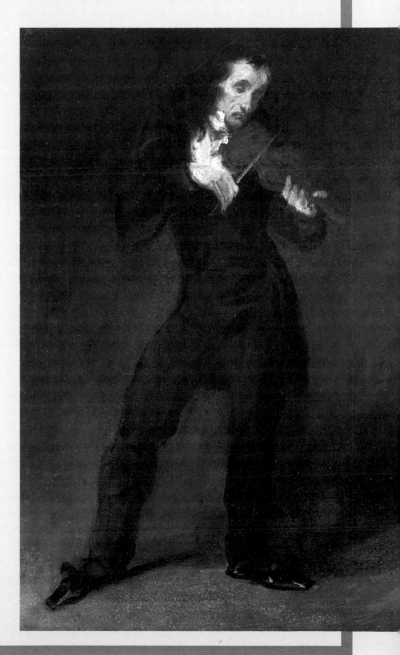

Eugene Delacroix, *Paganini* c. 1832. Oil on cardboard, 17⅝ × 11⅞ ins (44.7 × 30.1 cm). The Phillips Collection, Washington D.C.

scribed as the finest of all Italian Romantic operas. In *Otello*, the traditional components of opera (the solo aria, the duet, the chorus) are fully integrated into the melodic and dramatic flow. Verdi's last opera, *Falstaff* (1893), breaks free of conventional forms altogether, and finds music which follows the meaning of quick-flowing simple words as closely as possible. Because of its evident respect for the patterns of ordinary speech it stands on the threshold of a new operatic era, and is in many ways closer to Debussy's *Pelléas et Mélisande* (1902), in which speech patterns are paramount, than it is to Verdi's own operas of the early and middle phases of his career.

Richard Wagner

In northern Europe nineteenth-century opera was not content to remain simply a major popular genre—it aimed to be a fusion of all the arts, and also took on the overtones of a religious rite. The protagonist in this attempt to give opera a completely new role in Western culture was Richard Wagner (1813–83). By the beginning of the 1850s Wagner had elaborated his own theory of music and drama, stating his belief that opera should be a "total work of art" (*Gesamtkunstwerk*), which made use of all available theatrical resources. He referred this theory back to Ancient Greek drama (see page 68), which was a fusion of music, poetry, and dance, to which he proposed to add what he called "the ancillary aids of drama"—architecture, sculpture, and painting.

His most ambitious attempt to realize these theatrical ideals was the four operas of *The Ring* cycle—*Das Rheingold*, *Die Walküre*, *Siegfried*, and *Götterdammerung*. Wagner began writing the texts (in reverse order) in 1852, and the first complete performance of the cycle was given in 1876. *The Ring* is a full-scale epic, based on ancient Nordic legends concerning the old pre-Christian gods, but nevertheless essentially a parable for the composer's own time. Recent experimental productions have sometimes put the characters into nineteenth-century dress. The four operas tell the story of the working out of a curse. This has its origin in the dishonesty of the gods themselves, and especially of their ruler, Wotan.

One of the distinguishing characteristics of *The Ring* cycle is that Wagner understands how to give his characters the proper epic dimensions, but at the same time makes them complex and fully individual. This is especially true of Wotan, who begins as a bully and a cheat, henpecked by his wife Fricka. Yet he also shows a noble tenderness when he is forced to condemn his own daughter Brunnhilde.

A leading characteristic of Wagner's music is its overwhelming sensual power reinforced by a greatly enlarged orchestra and the use of special instruments, such as the Wagner tuba, made for the first performance of *The Ring*. For this very reason, his operas initially met with fierce resistance, and this was strengthened by their technical

novelty. Wagner, for example, uses *leitmotiven*—motto themes associated with personages, objects, and events—which recur in order to help to bind his immense musical structures together. One reason why they are necessary is that the composer was willing to loosen his grip on traditional tonality—the idea that music progresses either away from or toward fundamental pitches, which arrange all the musical notes available in a fixed hierarchy of importance—thus preparing the way for many characteristic developments in twentieth-century music.

Wagner gradually made his way with the help of distinguished and musically sophisticated admirers like his fellow composer Franz Liszt (1811–86). He also owed much to the support of King Ludwig II of Bavaria, who helped him to create the Bayreuth Festival as a showcase for his work. Ludwig, who became obsessed with Wagner's personality as well as his music, has some claim to be called the first Wagnerite—a word which became common currency in the last twenty years of the nineteenth century. In France, hostility was followed by the birth of a cult, and worship of Wagner's art became one of the tenets of the Symbolist movement (see page 424). A similar phenomenon occurred in England, though on a smaller scale. Throughout Europe Wagner's operas became an aesthetic touchstone, and their influence was not confined to the world of music alone.

The Romantic symphony

The instrumental symphony was transformed by Beethoven—in his hands it became a vehicle for weighty intellectual statements. Often symphonies were supplied with a program, which invited the listener to construe them, not just as abstract sound relationships, but as a series of pictures, or allusions to literature, or even as both. Mendelssohn's (1809–47) "Scottish" Symphony (1842) echoes the enthusiasm for Scotland which was so widespread at the time—it had also seized Italian opera-composers like Bellini and Donizetti. Schumann's (1810–56) Third "Rhenish" Symphony (1850) evokes a "Morning on the Rhine" in its scherzo, and a ceremony in Cologne Cathedral in its slow movement. Most ambitious of all is the *Symphonie Fantastique* (1830) by the French composer Hector Berlioz (1803–69). This is a five-movement work which tells a story of unrequited love. The movements are entitled 1. *Rêveries-Passions* (Daydreams-passions), 2. *Un bal* (A Ball), 3. *Scène aux champs* (Country scene), 4. *Marche au supplice* (March to execution), 5. *Songe d'une nuit de Sabbat* (Dream of a witches' Sabbath). Berlioz envisaged a young musician—himself—who is unable to drive from his mind the image of his beloved, and who attempts to poison himself with opium. In a delirium, he thinks he has murdered her, and is being led to the scaffold. Finally he dreams (like Faust) that he is present at the witches' Sabbath.

During the second half of the century, and in the early years of its successor, Romantic symphonies continued to

be written. The most conservative of these late nineteenth-century symphonists was Johannes Brahms (1833–97). No one was more keenly aware than Brahms of the problem posed for later composers by Beethoven's overwhelming personality. He began his first symphony when he was in his early twenties, but by the time he was thirty-eight he was denying that he would ever be able to complete such a work. "You have no idea," he said, "what a man such as I am feels like when he hears a man like that marching behind him." When he finally completed the project he had reached the age of forty-five. Compared with the symphonies composed by his contemporaries, Brahms's are more purely musical, less interested in extraneous literary or pictorial ideas.

The two other major symphonists of the nineteenth-century German and Austrian tradition were Anton Bruckner (1824–96) and Gustav Mahler (1860–1911). Bruckner began his career as a professional church organist, and remained a devout Catholic. Like Brahms, he only very gradually gained enough confidence to attempt the symphonic form, though eventually he wrote no fewer than nine. His music, unlike that of Brahms, was influenced by Wagner—his Seventh Symphony (1881–3) shows the impact made on him by *Parsifal*, Wagner's final opera, and the closing pages arc an elegy for Wagner himself. Even stronger in Bruckner's music, however, is the influence of traditional church music, and in particular the way in which material is usually laid out as if for the organ, in large blocks.

Mahler wrote ten symphonies in all (the Tenth was completed by another hand after his death), and many of these revert to the "literary" model of the first part of the nineteenth century—for example the First (1888), which is based on the novel *Titan*, by J. P. Richter.

The Eighth, the so-called "Symphony of a Thousand," is an example of the gigantism which overtook symphonic composition in the last years of the nineteenth century, and at the beginning of the twentieth. It has justly been said of this work, and of Mahler's other symphonies, that "it is possible to analyze [them] from the point of view of the Classical symphony, but this approach is not very useful. They are grand public statements of belief and feeling which, unlike Beethoven's, from which they ultimately derive, are not argued in musical terms."

The leading Russian symphonist of the nineteenth century (the epoch when Russian music first emerged as an independent force) was Pyotr Tchaikovsky (1840–93), who ranged himself, like Brahms, among the anti-Wagnerians, and therefore, in theory at least, saw the business of music as being music itself. Tchaikovsky complained of his own "want of skill in the management of form," but nevertheless completed six symphonies. The last three, the Fourth (1877), Fifth (1888), and Sixth (the "Pathétique," 1893), are concerned with the inexorability of fate. Tchaikovsky's pre-occupation with this has to be read as autobiographical: he was a homosexual, struggling to exist in a society which was extremely hostile to homosexuality.

realist painter produced by Russia was Ilya Repin (1844–1930), who originally trained as an icon painter, and later studied at the Imperial Academy of Arts in St. Petersburg. Like the other Russian painters of his generation, Repin responded to the call for a genuinely national art which would be an accurate reflection of the Russian people. Like the progressive Russian critics of the day who supported him, Repin had no doubts that an essential element in such an art was that what was shown should be immediately recognizable to the widest possible audience.

His epic canvas, *A Religious Procession in the Province of Kursk* 1880–3 (Fig. **24.7**), uses traditional skills to embody what for Russians were radical ideas. The procession is a never-ending, disorderly flow of people pressing forward through a drought-stricken land. The poor are thrust aside by the powerful and rich, and seem, all but one, to be in a kind of stupor. The exception is the little hunchback who hobbles along in the foreground—the embodiment of the "holy fool" who appears so often in Russian literature. In this instance he is the expression of individual determination and the right to free will. Repin's canvas prompts direct comparison with the novels of Dostoevsky. (see page 420).

The desire to embody a particular national consciousness is what links Repin to the leading American artists of his time. For example, the first artistic successes of Winslow Homer (1836–1910) were paintings inspired by the American Civil War, perhaps the most traumatic event in Ameri-

can history, and certainly one which led people to think about what it meant to be an American. These paintings show the influence of contemporary documentary photographers, such as Matthew Brady (1823–96). Homer's late paintings are mostly of marine subjects, and in these the difference between American and Russian attitudes is apparent. The Russian measured himself chiefly against society—the measure was the image of the Russian people as a whole. The Americans, still mastering the land, measured themselves against nature and the elements. Homer's late works have a different kind of grandeur from that of Repin's *Procession*. The starkest of them all, *The Gulf Stream* 1899 (Fig. **24.8**), focusses on the fate of a solitary individual. A lone black fisherman, in a dismasted boat already surrounded by sharks, watches the approach of the waterspout which may finally destroy him. Yet Repin's painting and Homer's have one important thing in common. Their method of focussing the collective consciousness is the same—they ask the audience to consider the fate of an outsider: the holy fool on the one hand, a member of a disadvantaged minority group on the other.

When asked to name the greatest American artist of his day, Thomas Eakins (1844–1916) chose Winslow Homer. Today many people would cite Eakins himself as the greatest American artist of the nineteenth century. One of the best known of his paintings, *The Swimming Hole* 1884–5 (Fig. **24.9**), encapsulates a mood which is almost completely the opposite of the one portrayed in *The Gulf Stream*. The

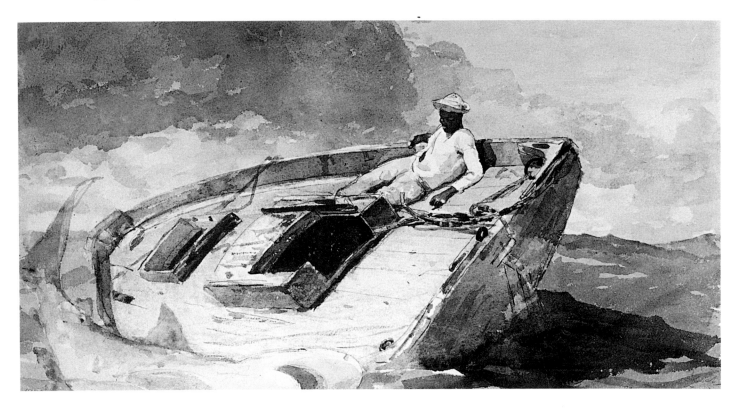

24.8 **Winslow Homer**, *The Gulf Stream* 1899. Watercolor, 11⅜ × 20 ins (28.9 × 50.9 cm). The Metropolitan Museum of Art, New York.

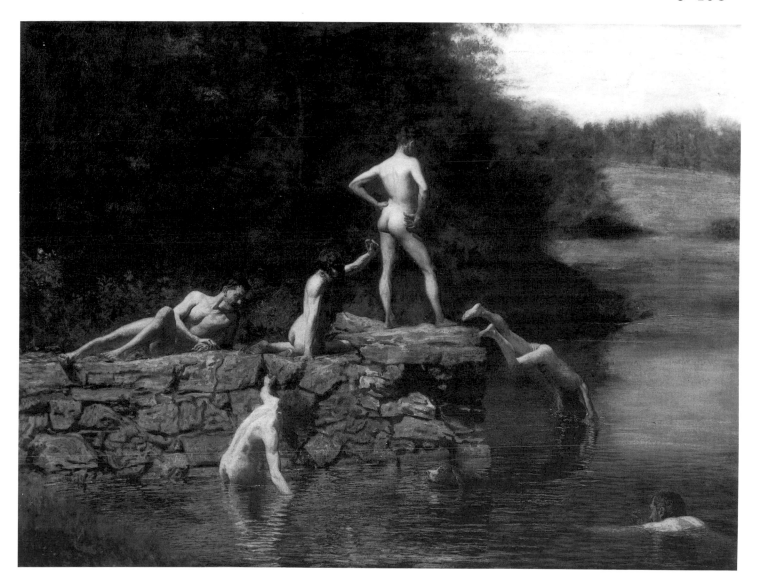

24.9 **Thomas Eakins**, *The Swimming Hole* 1884–85.
Oil on canvas, 27 × 36 ins (68.5 × 91.5 cm). The Modern Art
Museum, Fort Worth.

the veil which concealed what was real and true from the
spectator. This was the aim of nineteenth-century realist
and naturalist art in general.

Courbet and Millet

The investigation of the nature of reality which obsessed
French artists for most of the nineteenth century began with
Gustave Courbet (1819–77). Yet any study of Courbet's art
indicates the slipperiness of the term "realism." The ambi-
guity of the concept is well illustrated by what is perhaps his
most ambitious painting, *The Painter's Studio* (Fig. **24.10**)
of 1854–5. The artist subtitled this "a real allegory sum-
ming up ten years of my artistic life." Though impeccably
realistic in detail, it shows something which could obviously
never have occurred, either in Courbet's studio or anywhere
else. It is allegorical in the sense that it uses the studio
setting to provide a panorama of society as it existed in
France under Napoleon III. The emperor himself seems to

picture shows the artist (in the water, at the far right) dis-
porting himself with a group of his male pupils. All the
figures are nude—a gesture against the restrictive American
social conventions of the time. In this case, the work is
known to be based on real occasions of this kind, which
Eakins recorded in photographs. It also owes something to
more deliberately scientific photographs he made—studies
of the human figure in motion similar to those taken by
Eadweard Muybridge and Etienne-Jules Marey.

Despite all this, the actual composition is stringently
classical, with the figures grouped to form a pyramid. The
combination of formality and aggressive naturalism gives
the painting memorable force, and makes it an icon of atti-
tudes toward nature and the natural world which are also to
be found, though usually in more literary form, in Winslow
Homer's work. In both cases, the artists aimed to tear aside

Morisot and Cassatt

Impressionism was the first avant-garde art movement to attract female artists to its banner. The reason for reticence up to then had been understandable—it was so difficult for women to become successful artists (far more difficult than for them to become successful novelists, like Jane Austen) that women painters could not jeopardize the small successes they had been able to gain professionally.

Berthe Morisot (1841–95) and Mary Cassatt (1844–1926) had one important thing in common—they had independent means, and did not have to paint for a living. (Cassatt's family, in particular, would have been horrified at such a thought, as they had a substantial American fortune.) Their financial situations gave both women the freedom to experiment. They seized the chance because they were sincerely committed to the ideals of the Impressionist movement, but they were limited in what they could portray in their art by unspoken but very real constraints—limits imposed by class as well as by gender. Men could move freely in a number of different milieux, and could frequent bars, cabarets, and

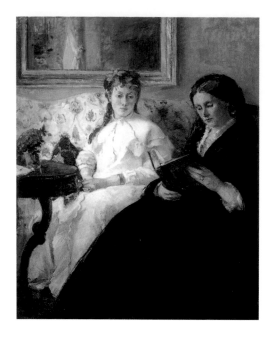

24.22 **Berthe Morisot**, *Mother and Sister of the Artist* 1870. Oil on canvas, 39½ × 32¼ ins (100.1 × 81.8 cm). National Gallery of Art, Washington, D.C., Chester Dale Collection.

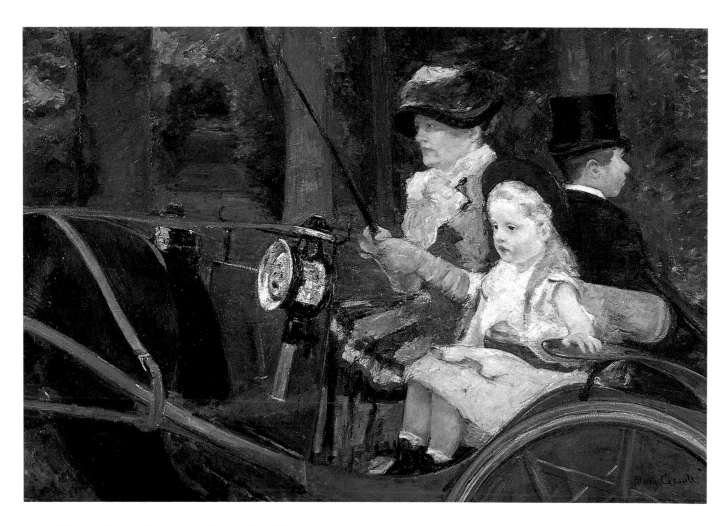

24.23 **Mary Cassatt**, *Woman and Child Driving* 1881. Oil on canvas, 35¼ × 51½ ins (89.3 × 130.8 cm). Philadelphia Museum of Art. The W. P. Wilstach Collection.

brothels as well as fashionable drawing rooms, all of which formed part of the Impressionists' subject matter. Morisot and Cassatt were more or less confined to their own domestic circles, using members of their immediate family as models. Neither, as it happened, was much interested in painting landscapes.

Both women were influenced by other Impressionist painters; Morisot by Manet, who painted several memorable portraits of her, and Cassatt by Degas, with whom she maintained a long and close friendship.

An active member of the Impressionist group, and treated on a par with her male colleagues, Morisot exhibited works of great sensitivity and observation in nearly all their shows. Manet's influence is perhaps particularly evident in her *Mother and Sister of the Artist* (Fig. **24.22**) of 1870, which was shown at the first Impressionist exhibition.

Degas professed great respect for the work of Mary Cassatt and it is easy to see why when looking at her *Woman and Child Driving* (Fig. **24.23**). This painting has much of the spontaneity and strength of observation associated with Degas, together with his preoccupation with arbitrarily cropped, snapshotlike compositions.

Seurat and Cézanne

Georges Seurat (1859–91) and Paul Cézanne (1839–1906) are not generally paired with one another. Nevertheless, they do have much in common. Both took the idea of the naturalistic—the passive acceptance of what was "given"—to its absolute limits, and both, as a result, found themselves returning toward a form of Classicism. For Seurat and Cézanne, Poussin (see page 280), that least naturalistic of artists, became an important exemplar.

Renoir, significantly, was utterly opposed to the work of Seurat, which he considered cold, mechanical, and industrialized. Yet Seurat is also Renoir's direct successor, both in the subjects he treated and in some, though obviously not all, of his attitudes toward them. For example, he remained deeply attached to the idea of a "realistic" depiction of everyday life, of the kind we see in Renoir's *Le Moulin de la Galette* (see page 409), though the precise nuance he gave to this approach was very much his own. In addition to his links with the art of Renoir, he owed much to Millet, and also to Degas.

In 1886, after a row which split the ranks of the Impres-

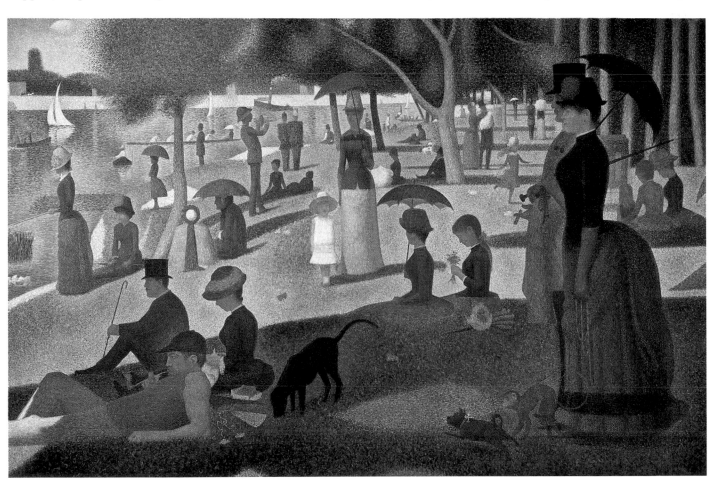

24.24 **Georges Seurat**, *A Sunday Afternoon on the Island of La Grande Jatte* 1884–6. Oil on canvas, 6 ft 9½ ins × 10 ft 8⅜ ins (2.05 × 3.05 m). Art Institute of Chicago, Helen Birch Bartlett Memorial Collection.

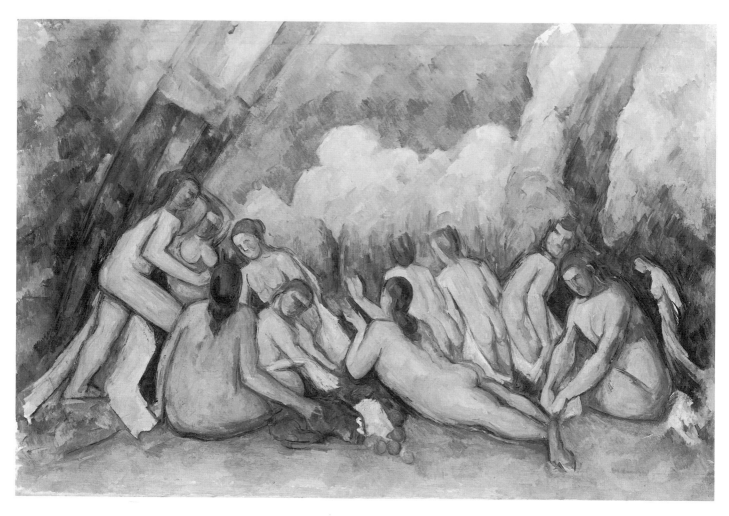

24.25 **Paul Cézanne**, *Large Bathers* 1897 (exhibited).
Oil on canvas, 50⅜ × 77⅛ ins (127.2 × 196.1 cm).
National Gallery, London.

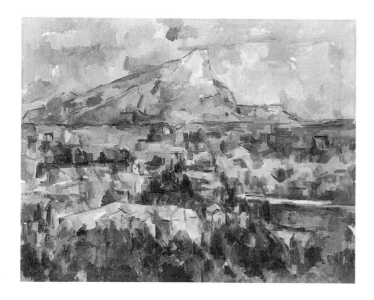

24.26 **Paul Cézanne**, *Mont Sainte-Victoire* 1904–6.
Oil on canvas, 27⅞ × 36⅛ ins (70.8 × 91.8 cm). Philadelphia
Museum of Art, George W. Elkins Collection.

sionist old guard, Seurat and a group of followers were admitted to the eighth and final Impressionist exhibition, where their work was hung in a room of its own. They owed this chiefly to the passionate advocacy of Pissarro, who had become converted to Seurat's methods. Seurat himself was represented, in addition to some other works, by a very large canvas, *A Sunday Afternoon on the Island of "La Grande Jatte"* (Fig. **24.24**). This was part of an ongoing attempt to create a new kind of monumental style. It was painted in Seurat's newly perfected divisionist technique, which consisted, in accordance with the writings of nine-teenth-century scientists and color theorists such as Eugène Chevreul, of innumerable little points or dots of color, evenly applied. The idea was that all these points of pure color would blend on the spectators' retina, provided that they stood at the correct distance from the painting, and would give a more luminous and vibrant effect than could be obtained by any other means. Thus far the composition was almost programmatically naturalistic—an extension of what Monet and others had long been doing.

The actual subject matter also fell within the boundaries of contemporary naturalism. The picture showed ordinary lower-middle-class Parisians enjoying an outing on the banks of the Seine.

However, Seurat had abruptly abandoned Impressionist

informality. The way in which his painting is constructed, using an elaborate grid of horizontals and verticals, shows Seurat's conscious debt to the classical tradition which the Impressionists scorned. Seurat once said that he could just as easily have painted a new version of David's *Oath of the Horatii* (see page 339). In fact he looked back beyond David's debt to the Greeks and Romans to still more ancient forms of art. His figures, mostly in profile to the spectator, are deliberately stylized. He took hints from the ancient Egyptian reliefs he saw in the Louvre, and also from popular prints by naïve artists—the *imageries d'Epinal*, so called from the French town which made a specialty of producing them.

Cézanne's definition of Classicism was somewhat more flexible than Seurat's. For many years he was intimately part of the Impressionist milieu, and he even found some of his few patrons among fellow painters in the Impressionist circle—both Renoir and Monet admired and bought his work. In the early 1870s he went to work with Pissarro at Pontoise and Auvers-sur-Oise, painting in the open air in the approved Impressionist manner, and in 1874 he was included in the first Impressionist exhibition, though only at Pissarro's insistence. It was at about this time that Cézanne began to come into his own as an original and independent talent. In 1875 he began work on a series of *Bathers* (Fig. **24.25**, for example), which he was to continue until his death. These compositions mark his espousal of his own version of Classicism, and demonstrate what he meant by his much-quoted remark that it was his ambition to "re-do Poussin from nature."

Many of Cézanne's mature paintings, in particular his still lifes and the many representations of Mont Ste.-Victoire near Aix (Fig. **24.26**, for example), can be thought of as meditations on the nature of reality itself, and also as attempts to find a precise equivalent, in paint on a flat surface, for the transformation which real things undergo when we look at them with maximum concentration. It has been observed, for example, that the mountain, as it appears in Cézanne's paintings, dominates the scene more assertively than it does in life. That is, it responds to the way the artist looks at it, and grows larger as an emblem of its subjective importance to him.

In this, as in some other respects—for example, the freedom of the actual brushstrokes—Cézanne crosses the frontier between realism and what was to become known as Expressionism (see page 455). Nevertheless Cézanne's life was dedicated to the problem of how to confront reality and absorb it into a highly personal art. The presence of the motif remained of crucial importance. His uniqueness springs from his insistence on finding precisely equivalent relationships, first within himself, and then upon the canvas, for what was in front of him.

Literature

One of the crowning achievements of the impulse toward realism in the arts was the nineteenth-century realist novel. This was the creation of a galaxy of great writers—in France, in Britain, in Russia, and in the United States. What they wrote still governs our ideas about the scope of narrative fiction.

The French novel

The movement toward realism in literature—the unvarnished depiction of contemporary or near-contemporary life—was at its most considered and self-aware in France. It was only there that "realist" became a definite stylistic label for a particular kind of novel writing. The two fathers of the realist movement in French fiction were Stendhal (Henri Beyle, 1783–1842) and Honoré de Balzac (1799–1850). Stendhal is notable for his pitilessly clear-eyed psychology. Balzac, viewing Stendhal's *The Charterhouse of Parma* (1839), was one of the first to call attention to the latter's merits. He called the book "the novel Machiavelli might have written if he had been exiled from Italy in the nineteenth century."

It is Balzac himself, however, who typifies a certain kind of nineteenth-century fiction. Perpetually in debt, he drove himself to produce one novel after another, often working on several at the same time. His literary rivals despised him, but the public read him eagerly. Because he worked under such pressure, Balzac was forced to write very directly, about what he knew and understood.

Nevertheless it was Gustave Flaubert (1821–80) who, with one book, *Madam Bovary* (1857), gave a new meaning to the term "realism" in fiction. Flaubert was the direct heir of Balzac, but a most unlikely one in terms of taste and temperament. Flaubert himself was always disconcerted by the resemblances between them. "What a man Balzac would have been, if he had known how to write!" he once remarked. "But that was the only thing he lacked. An artist, after all, would not have produced so much, would not have had such fecundity."

Madame Bovary, written over long years in stubborn provincial solitude in Normandy, differs from all its predecessors, and indeed from most of its successors, in Britain as well as in France, because it is a *self-consciously* realist work. It was written as a kind of corrective to its author's

Madame Bovary

In this famous scene from *Madame Bovary*, which Flaubert said was technically one of the most difficult passages he had to write, the growing attraction between Emma Bovary and Léon, who will become her lover, is shown through completely commonplace conversational exchanges.

"Are there any good walks in the neighbourhood?" inquired Madame Bovary of the young man.

"Hardly any!" he replied. "There's a place they call the Pasture, at the top of the hill, on the fringe of the woods. I go there with a book sometimes on Sundays, and lie there watching the sunset."

"I don't think there's anything as wonderful as the sunset," she observed. "Especially by the seaside."

"I adore the sea!" exclaimed Monsieur Léon.

"Don't you feel," Madame Bovary continued, "that your mind roves more freely over that measureless expanse? That just to gaze at it uplifts your soul, gives you glimpses of the infinite, the ideal?"

"Mountain scenery is like that, too," said Léon. "A cousin of mine toured Switzerland last year, and he says you can't form any idea of the magic of the lakes, the charm of the waterfalls, the gigantic spectacle of the glaciers. There are pine-trees, incredibly tall, growing across mountain torrents, huts hanging over precipices and when there's a break in the clouds you can see whole valleys spread out a thousand feet below you. How the sight must inspire you, move you to prayer, to ecstasy! I don't wonder any more at that famous musician who used to play his piano in sight of some magnificent piece of scenery, in order to stimulate his imagination."

"Are you a musician?" she asked.

"No, though I'm very fond of music," he answered.

"Don't you believe him, Madame Bovary," Homais interposed, leaning over his plate. "That's sheer modesty! Why, my dear boy, up in your room the other day you were singing the *Guardian Angel* beautifully. I heard you from my laboratory. You were rolling it out like a professional!"

Léon was the chemist's lodger; he had a little room on the second floor looking on to the square. He blushed at this compliment from his landlord, who had immediately turned back to the doctor, however, and was enumerating the leading inhabitants of Yonville, furnishing him with facts and anecdotes. The solicitor's fortune wasn't known exactly. . . . The Tuvache crowd gave themselves great airs. . . .

Emma resumed:

"What sort of music do you like best?"

"Oh, German . . . The sort that sets you dreaming."

"Do you know the Italian opera?"

"Not yet, but I shall go next year when I'm in Paris for my Finals."

"As I've had the honour of explaining to your husband," said the chemist, "speaking of this poor fellow Yanoda who's disappeared:—thanks to his extravagance you will find yourselves in possession of one of the most comfortable houses in Yonville. Its chief convenience for a doctor is that it has a door on to the lane, so that people can go in and out without being seen. And it's equipped with all the amenities—wash-house, kitchen and scullery, sitting-room, apple-loft, and so on. He was a lad who never counted his pennies! He had an arbour made at the bottom of the garden, by the river, just for him to drink his beer in the summer, and if Madame is fond of gardening, she'll be able . . ."

"My wife doesn't go in for that much," said Charles. "She's been advised to take exercise, but she'd sooner stay in her room all the time, reading."

"I'm the same," remarked Léon. "What could be better than a book by the fireside, with the wind beating on the window-panes and the lamp burning . . ."

"Yes! . . . yes!" she said, gazing at him with her great dark eyes wide open.

"You forget everything," he continued. "The hours slip by. You travel in your chair through countries you seem to see before you, your thoughts are caught up in the story, dallying with the details or following the course of the plot, you enter into the characters, so that it seems as if it were your own heart beating beneath their costumes."

"How true! how true!" she said.

"Have you ever had the experience," Léon pursued, "while reading a book, of coming upon some idea you have thought of vaguely yourself, some dim picture that returns to you from afar, and seems completely to express your subtlest feeling?"

"I have felt that," she answered.

"That is why I am fondest of poetry," he said. "I find it more tender than prose, and far more affecting."

"It palls in time, though," replied Emma. "In fact, nowadays I'm all for stories that rush you along breathlessly and make you frightened. I hate commonplace heroes and moderate feeling such as are to be found in life."

"Quite so," observed the clerk, "those books which do not touch the feelings seem to me to stray from the true end of Art. It is so sweet, amid the disappointments of life, to let the imagination dwell on noble characters, pure affections, pictures of happiness! For my part, living here far from the world, it's the one distraction I've got. Yonville has so little to offer!"

"Like Tostes, no doubt," Emma answered. "I always belonged to a library there."

"If you will do me the honour of making use of it, Madame," said the chemist, catching these last words, "my own library is at your disposal, comprising the best authors—Voltaire, Rousseau, Delille, Walter Scott, *The Literary Echo*, and so on. In addition I take various periodicals, among them the *Rouen Beacon*, for which I have the privilege of being correspondent for the area of Buchy, Forges, Neufchâtel, Yonville and roundabouts."

own incorrigible romanticism of temperament, fully expressed in other and very different books, such as the historical novel *Salammbo* (1862), which is full of the exotic ornamentation *Madame Bovary* shuns.

Flaubert's masterpiece was an attempt to see if a refined and exquisite work of art could be produced using only the most ordinary materials—the small change of French provincial life. The plot came from reality. A medical officer of health, who lived in Flaubert's own part of Normandy, took as his second wife the young daughter of a local farmer who, soon bored with her husband, became increasingly extravagant, then unfaithful, and finally poisoned herself.

On the face of it, Flaubert's heroine is not sympathetic. She is self-centered, self-deceiving, and self-dramatizing. At the first sight the author treats her harshly. The English critic Matthew Arnold called his attitude "cruel, with the cruelty of petrified feeling." Yet Flaubert often said that Emma Bovary was only a substitute for himself. The judgment he makes of her is less to do with her as an individual, and more to do with the society that deforms and destroys her.

Madame Bovary is a realist work, and it is also a naturalist one. When Emma and the man who is to become her lover meet, their attraction is entirely conveyed through what Flaubert himself called "trivial dialogue" (he also complained of the technical difficulty of achieving this).

In France the naturalist tendency reaches its culmination in the Rougon-Macquart cycle of novels by Emile Zola (1820–1902). These are not as coolly objective as Flaubert's work—there is much use of symbolic images and a continual heightening of physical experience. Zola's writing, however, offers a new approach to language. His novel *L'Assomoir* (1877) is written throughout in the earthy language of the working-class milieu it describes.

The English novel

French novelists were able to describe most aspects of contemporary life, though this freedom was occasionally threatened, as, for example, when *Madame Bovary* was prosecuted for indecency (the prosecution failed, however). In England, things were very different. Conventions concerning what was and was not permissible were rigorously enforced. This did not mean that English novels suffered from lack of passion—even directly sexual passion. But feelings of this kind were often expressed in a way which had little to do with any idea of "realism."

Two of the most striking novels of the early Victorian period were *Jane Eyre* and *Wuthering Heights*, both published in 1847. The books were the work of two sisters, Charlotte (1816–55) and Emily Brontë (1818–48), who were the daughters of a Yorkshire clergyman of Irish extraction. They lost their mother when very young, and were brought up in isolation, thanks to their father's difficult and gloomy

They had been sitting over the meal for two hours and a half. Artémise the serving-girl, listlessly dragging her carpet slippers over the flagstones, brought in the plates one at a time, failed to remember or understand anything she was told, and kept leaving the billiard-room door open so that the latch banged against the wall.

While he talked, Léon had unconsciously placed his foot on the bar of Madame Bovary's chair. She was wearing a little blue silk neckerchief which kept her goffered cambric collar as stiff as a ruff, and when she moved her head, the lower part of her face sank down into the linen or rose gracefully out of it. And side by side like that, while Charles chatted to the chemist, they entered upon one of those rambling conversations in which any remark may bring you back to the fixed centre of common sympathy. They discussed everything—Paris shows, names of novels, new dances, the world they had never known, Tostes where she had lived, Yonville where they now were:—so they went on till dinner was over.

Flaubert

temperament. Their childhood was marked by an intense imaginative life, shared with their brother, Branwell, and their other sister, Anne, also a novelist. They composed complicated sagas about imaginary countries and wrote poetry. Later, both had an unhappy time at boarding school, and experiences which were almost equally miserable when they earned their livings as governesses. Their two novels were therefore based on a very limited range of experience.

Charlotte Brönte's book, *Jane Eyre*, does begin in an apparently realistic way. Much of the first part is autobiographical, and offers a detailed picture of religious hypocrisy, and the slights suffered by penniless young women who were forced to go out to teach in private households. What changes the direction of the story is the appearance of its hero, Mr. Rochester, whom Jane meets when he has just taken a tumble from his horse:

Something of daylight still lingered, and the moon was waxing bright: I could see him plainly. His figure was enveloped in a riding cloak, fur-collared and steel-clasped; its details were not apparent, but traced the general points of middle height, and considerable breadth of chest. He had a dark face, with stern features and a heavy brow; his eyes and gathered eyebrows looked ireful and thwarted just now; he was past youth but had not reached middle age; perhaps he might be thirty-five.

(CHARLOTTE BRÖNTE, *Jane Eyre*. Penguin Books Ltd.)

Rochester, it soon appears, is a new variant of the "demon lover" of Gothic convention. Hidden away, and at first unknown to Jane, is his mad wife Bertha, who after a number of frightening events is burned to death in a fire. Rochester is maimed and blinded in the same conflagration, and Jane, summoned by mysterious instinct, returns to marry him. None of this has any semblance of reality, though the lack is concealed by the power and conviction of the writing. The novel is successful because it embodies a powerful myth about the relationship between the sexes and the nature of both male and female sexuality.

Wuthering Heights by Emily Brönte contains some of the same elements, but scarcely makes any pretence that it is dealing with the real world. It is set in the period 1780–1800, and the two chief characters are the heroine, Cathy, and the hero/villain, Heathcliff, whom Cathy's father brings back to the Yorkshire moors from a trip to Liverpool, and raises as a member of his own family. Heathcliff is Rochester's equivalent, but wilder, stranger, and more alienated. The core of the book is his peculiarly intense, somewhat sado-masochistic relationship to Cathy during their childhood and adolescence, and their inability to form more normal relationships, or to let go of one another once they have grown up.

Wuthering Heights has been the subject of many attempts at interpretation, all of which recognize its essentially symbolic character. One interpretation, possibly the most convincing, is that in essence the relationship between Cathy and Heathcliff is an incestuous one, though this is something which Emily Brönte probably concealed even from herself. In trying to deal with this most basic of taboos in a way acceptable both to the intended audience and to the author herself, the book develops extraordinary power.

The Brönte sisters were, however, exceptions. Their deviation from the realistic norms of the nineteenth-century novel can be explained by their own personal circumstances. Traces of the realist approach did in fact make themselves visible very early in the history of nineteenth-century English fiction. Realism seemed to spring as much from ingrained British pragmatism as it did from any change in aesthetic theory.

The most celebrated, and in many ways the most typical of the Victorian novelists, was Charles Dickens (1812–70), who made his début with *Sketches by Boz* (1836) and consolidated his success with *The Pickwick Papers* (1836–7). Like many of the great novelists of the nineteenth century, Dickens had a difficult time in youth and early manhood. His mature fiction draws heavily on the humiliations of these years, but his first successes were made as a humorous writer. *The Pickwick Papers* began as fodder for an illustrator who was much better known than the young author. After the illustrator committed suicide, Dickens seized the initiative, and developed the storyline and characters in response to public reaction as the story was published serially. The strong dramatic projection which Dickens gave to characters such as Sam Weller was the secret of his success with the contemporary public. Yet, as Dickens's rival, the novelist Anthony Trollope (1815–82), pointed out, these characters are realistic only in a very limited sense. "It has been the peculiarity and the secret of this man's power," Trollope said, "that he has invested his puppets with a power that has enabled him to dispense with human nature."

There was a practical reason for Dickens's characters' use of catchphrases, and for the emphasis which he put on various tics of physical behavior, and this was the appearance of his books over a period of time, in part form. Devices such as these helped to fix the various personages in the reader's mind, and enabled him to bridge the intervals between the appearance of one part and the next. There were other reasons as well. Dickens's grotesques supply the "scenery" through which some central figure, often himself only lightly disguised, passes on a voyage of self-discovery.

In constructing the plots of his novels, Dickens reverted again and again to the misfortunes and humiliations of his own youth. His books are full of the terror of debt, and the sadness of orphaned and alienated children. This personal mythology was linked to the great social issues of the time. *Oliver Twist* (1837–9) deals with the workhouses which were the result of the Poor Law Amendment Act of 1834.

David Copperfield (1849–50), published at the end of what were justly called the Hungry Forties, touches on the theme of emigration to Australia. *Hard Times* (1854), set in a northern industrial town, implicitly condemns Utilitarianism (see page 395). Despite this connection to the world of fact, Dickens's books, with their bizarre personages and their frequent evocation of an apocalyptic sense of evil (two aspects of his work which exercised a powerful influence over the Russian writer Dostoevsky), are less inherently realistic than the work of his chief contemporary rivals, William Makepeace Thackeray (1811–63) and George Eliot (Marian Evans, 1819–80).

Thackeray's greatest achievement is *Vanity Fair* (1847–8). Thackeray came from a higher social class than Dickens—he was born in India, where his father was a high-ranking civil servant. He lost much of his inheritance, became a journalist, and, like Dickens, established a reputation with humorous sketches. *Vanity Fair*, as its title suggests, reflects its author's characteristic world weariness. The events in the novel are deliberately distanced—the book is set in the period 1813–30. In this sense, as well as in its panoramic spread, it resembles Tolstoy's *War and Peace*. However, there is little that is heroic about Thackeray's characters, and their almost universal preoccupation with money suggests a comparison, not with Tolstoy, but with Balzac. The driving force in the book is a memorable female anti-hero, the "little adventuress," as Thackeray calls her, Becky Sharp. Typically, both in terms of his own temperament and of the constraints imposed by English literary convention, Thackeray equivocates about Becky's sexual peccadillos, even when he allows her to be discovered in a distinctly compromising situation. Essentially, as he tells us, the question of her guilt or innocence is irrelevant. What matters is that Becky has damaged her social credit, and thus her financial credit as well. Thackeray is a curious mixture: the indulgent worldliness of his tone half-conceals the severity of his moral judgments. Yet it is typical, too, that Becky Sharp survives, to assume a title to which she is not really entitled, and live a life of quasi-respectability in the fashionable spas of Bath and Cheltenham, where she goes to church accompanied by her footman.

Marian Evans, who assumed the masculine pseudonym George Eliot for literary purposes, was a more unorthodox figure in Victorian terms than either Dickens or Thackeray, and this may account for the unexpected modernity of some of her judgments. She was unorthodox not because she was female—writing novels was already an established profession for women—but because she lived in an irregular union with a fellow writer, George Henry Lewes. By temperament, she was more like a twentieth-century intellectual than any other Victorian novelist. In particular, her religious attitudes were skeptical, and the house in London she shared with Lewes was a meeting place for many of the savants who had been influenced by Darwin (see page 395). Her finest achievement was *Middlemarch* (1871–2), pub-

lished at a time when her reputation as a writer was already secure. Like *Vanity Fair*, the book is set at a period somewhat before the time of its publication—just before the First Reform Act of 1832, the initial step toward modern democracy in England. It is a study of English provincial life, and its most important character, Dorothea Brooke, later Casaubon, is a woman in search of a vocation, who is forced to acknowledge the constraints imposed by ordinary life: "She felt the largeness of the world and the manifold wakings of men to labour and endurance. She was a part of that involuntary, palpitating life, and could neither look out on it from her luxurious shelter as a mere spectator, nor hide her eyes in selfish complaining." Yet she ends, after a second marriage, with decisively narrowed possibilities—many who knew her previously think it a pity that "so substantive and rare a creature should have been absorbed into the life of another, and be known only in certain circles as a wife and mother."

This strikes a distinctly feminist note, and many other substantial issues find their places in *Middlemarch*. These issues range from the campaign for better sanitation to the social disruption threatened by the coming of the railway. In this sense the book is one of the most convincingly realistic—the most fully involved in tangible events—of all the great Victorian novels.

The Russian novel

Until the nineteenth century Russia was not regarded as a literary center by the rest of Europe, but then came the emergence of a series of great novelists. Tolstoy and Dostoevsky, most of all, came to be recognized as the peers of the major novelists working in France and Britain.

Leo Tolstoy (1828–1910) was an aristocrat and a great landowner. Two massive novels are his chief claim to fame in the pantheon of great writers: *War and Peace* (1869) and *Anna Karenina* (1876). The books are very different. *War and Peace* is set in the immediate past, and is a consideration of the events—the Napoleonic invasion in particular—that had created the Russia Tolstoy knew. One of the major links between recorded history and fiction in the book is the Russian commander-in-chief, General Kutuzov, an established historical figure. It is significant that Tolstoy uses him as a way of forcing home the idea that battles and other great upheavals develop a momentum of their own, and inevitably escape from those who are supposed to direct their course. The romantic superman is thrust aside; Kutuzov is great because he embodies the unconscious spirit of the Russian nation.

While *War and Peace* follows the fortunes of no less than five families, *Anna Karenina*, with its setting contemporary with Tolstoy himself, concentrates on one individual and those closest to her—husband, lover, brother, sister-in-law. The heroine has a good deal in common with Emma

Bovary: she is a woman who falls out of love with a dull husband and embarks on an extra-marital affair which leads her to such misery that she commits suicide, not by poison, as Emma does, but by throwing herself under a train.

The book is much wider in scope than *Madame Bovary*, and, unlike Flaubert, Tolstoy offers his characters many possibilities for change. For example, Anna's unsympathetic husband is kind and forgiving when Anna falls ill with fever after bearing her lover Vronsky's child. She momentarily rejects Vronsky because of this, and he shoots, but does not kill, himself. This attempted suicide once again shifts the pattern of the plot.

Tolstoy shows a perfect grasp of the aristocratic milieu in which the novel is set—it was, after all, his own. In contrast to *Anna Karenina*, *Madame Bovary* is a colder and more cerebral creation, since Flaubert constructs Emma's provincial bourgeois setting through observation and research, rather than having an instinctive grasp of it.

Of all the great Russian writers, it is Fyodor Dostoevsky (1821–81) who seems most in tune with the popular stereotype of the Russian character as melancholic, withdrawn, and potentially violent. He also had what was perhaps the most extraordinary career of any great Russian writer. His background was middle class—he was the son of a Moscow doctor. In 1849, just as he was starting to make a reputation as a writer, he was arrested for revolutionary activity, condemned to death, subjected to a mock execution, then sent to Siberia. He finally returned to St. Petersburg ten years later, to resume his literary career.

He came back not as a progressive but as an extreme Russian nationalist. He saw Russia as a unique force, a nation which had outstripped Western influences and was on the threshold of something new. Russia's salvation, Dostoevsky thought, lay in a mystic union of tsar and people, which would exclude both the aristocrats and the new class of intelligentsia.

All of these preoccupations are given full rein in *The Devils*, also known as *The Possessed* (1872). It is based, like so many other great realist novels of the nineteenth century, on an actual incident. In November 1869 a revolutionary student was murdered in Moscow by four others who were members of the same cell. The leader of the group was Sergei Nechaev, who preached destruction for its own sake, and who claimed to be connected with a worldwide network of conspirators which existed chiefly in his own imagination.

What makes the novel "realistic," though, in a special sense of that word, is the intensity with which characters and events are imagined. Dostoevsky has a special gift for "scandals"—elaborate, cumulative scenes involving many characters which move inexorably forward till a point of explosion is reached. In *The Devils* the most elaborate scene of this kind involves a disastrous charity fête. The ball with which the fête concludes is interrupted when the nihilists, or "devils" of the title, set fire to a suburb of the town where it takes place. Once the crisis is reached, Dostoevsky concludes the scene with a masterly diminuendo. Everyone hurries to go outside:

I don't think there was any theft, but it would not surprise me if in the disorder some people went away without their warm clothes because they were unable to find them, which gave rise to all sorts of legends, appropriately embellished, long afterwards.

(FYODOR DOSTOEVSKY, *The Devils*, translated by David Magarsheck. Penguin Books Ltd., 1953.)

In *The Devils*, as so often in the great nineteenth-century novels, we hear the voice of a writer who is completely sure of his power to create an alternative world.

Drama

Definitions of realism become especially difficult when we turn to nineteenth-century drama. What contemporary audiences accepted as "real" then do not seem in the least realistic to us today. From 1830 onwards (the date of the premier of Victor Hugo's *Hernani*), the European stage was dominated by extravagantly romantic plays in verse, or, at a lower level, by equally extravagant melodramas in prose. Some of these pieces paid tribute to the contemporary taste for the realistic through stage effects—waterfalls with real water, etc. In the second half of the century audiences transferred their enthusiasm to the "well-made play," thus

making the fortunes of playwrights such as Victorien Sardou (1831–1908) in France and Sir Arthur Pinero (1855–1934) in England. The well-crafted pieces produced by these writers sacrificed any profound exploration of character to a series of fundamentally implausible confrontations, filled with strong emotion. However, these confrontations took place within naturalistic stage settings.

Ibsen and Chekhov

This artificial dramatic world, full of characters who could

exist only in the theater, was challenged by two playwrights from outside the theatrical mainstream—first, the Norwegian Henrik Ibsen (1828–1906), and then the Russian Anton Chekhov (1860–1904). Ibsen's realistic plays belong to the middle period of his activity as a dramatist. His early works are plays in verse, based on old Norse folk ballads and legends.

One of his best-known prose plays is *A Doll's House* (1879). This has been recognized by feminists as one of the truly significant texts responsible for bringing aspects of the agenda of feminism to political prominence; it presents the most powerful statement in favor of women's rights since Mary Wollstonecraft's *A Vindication of the Rights of Woman* (see page 363), one all the more effective for being cast in dramatic form. Nora, the heroine, is trapped in a marriage where she is treated as little more than a wayward domestic pet, "scampering about like a little squirrel." She rebels not only against masculine control but against masculine duplicity. In the last scene of the play, she walks out, leaving husband and children behind her. Ibsen's audiences were duly shocked.

Anton Chekhov was a doctor in Moscow for whom writing was at first only a spare-time occupation. However, he rapidly made a reputation, and began to earn much-needed extra cash as a prolific writer of short stories. Chekhov's contemporaries expected him to move from the short story to the novel, but he never succeeded in producing a full-scale narrative of this sort. Instead he turned to playwriting.

His three mature plays, *The Seagull* (1896), *Three Sisters* (1902), and *The Cherry Orchard* (1904), all written when he was already ill with the tuberculosis from which he died, propose an entirely new kind of dramatic structure—apparently drifting, yet actually closely knit and symphonic. They were naturalistic in a completely new fashion, so much so that the Moscow Arts Theater, which presented all of his late plays, had to evolve a new acting style in order to deal with the texts.

The ambiguity at the heart of Chekhov's plays is perhaps most evident in the last of them, *The Cherry Orchard*. Chekhov insisted it was a comedy; Stanislavsky, the director of the Moscow Arts Theater, was convinced it was a tragedy. Even today, it is usually staged as an elegy for the feckless Russian gentry, already destroying themselves before the Revolution came to destroy them—the comic elements Chekhov insisted on are almost suppressed. Yet the play has an ironic cutting edge. When the gentry depart from their estate, now sold to a speculator, they abandon, forgotten in their hurry, the faithful old butler Fers. In the last moments of the play he lies down, perhaps to die, and it is then that the audience hears the first ax-blow, as the symbolic orchard starts to be felled.

Chekhov's plays demonstrate that a completely naturalistic surface and strong symbolic content are not incompatible. Indeed, the symbols are the bedrock—the drama evolves not through confrontations of the traditional kind but through the adroit manipulation of symbolic images. The seagull and the orchard of Chekhov's titles are simply among the most visible and potent of these.

Realism in music

It is a little difficult to describe any music as realistic—with the heavily qualified exception of certain forms of opera. During the nineteenth century composers often made use of effects taken directly from the world of natural sound. The commonest were the noises of wind and water, but to these one can add other, more specific sounds such as the whirring of a spinning wheel or the tolling of bells. The purpose of these effects was to evoke a context or a mood, or both together, and nearly all are recognizably Romantic in intention—because they summon reveries, and also because they conjure up the world of nature in which Romanticism rooted itself.

Opera, as opposed to purely instrumental music, could aim at realism in several different ways. Opera composers might, for example, give their work a contemporary setting, and make their characters credible human beings. The first opera to use a completely contemporary urban milieu was Verdi's *La Traviata* (1853), based on the novel (1848) and play (1852) *La Dame aux Camélias* by Alexandre Dumas the Younger. *La Traviata* startled the opera-going public of its day because it represented the mid-century Parisian demimonde. However, its melodramatic plot and outsize emotions are certainly not "realistic" in the sense given to this adjective by the plays of Ibsen, much less by those of Chekhov.

Another way in which opera could embrace the idea of realism was through the composer's actual handling of the voice. In the opera-house the cultivation of realism often went hand in hand with the growth of various national schools. Composers imbued with nationalist ideals tried to break away from the established way of doing things in order to express a particular cultural identity. Russian opera, in particular, was consciously different from its German and Italian counterparts, with an emphasis on the rhythms of actual Russian speech. This is especially the case in the operas of Modest Mussorgsky (1839–81).

Mussorgsky was a partly amateur composer whose musical procedures were not well understood by his contemporaries. His masterpiece, *Boris Godunov* (1874), is still frequently heard in the version re-orchestrated by Mussorgsky's more conventional colleague, Rimsky-Korsakov. Though *Boris* has a historical subject, it is realistic in almost every other way—in its use of continuous melodic recitative, without anything resembling an aria, which is closely linked to Russian speech patterns, and also in its powerful characterization. The guilty hallucinations of the usurping Tsar Boris make a telling contrast with the formalized "mad scenes" of early Romantic opera. The brilliance of characterization is paradoxical, because the emotional center of the work is to be found, not in any one individual, but in the composer's feelings about the Russian people as a whole. A direct comparison can be made with the content of some of Repin's paintings, such as *A Religious Procession in the Province of Kursk* (see page 401).

The *verismo* movement in Italy (which aimed at a vivid and realistic depiction of contemporary life, but which too often toppled over into melodrama) officially begins with *Cavalleria Rusticana* (*Rustic Chivalry*, 1884), a brutally effective one-act opera of Sicilian peasant life written by Pietro Mascagni (1863–1945), who in a long subsequent career produced nothing else which has remained in the standard repertoire. The greatest *verismo* composer, and by far the most successful with the public, was Giacomo Puccini (1858–1924)—though some of Puccini's major works, notably his last opera *Turandot* (1924), escape either completely or partially from the *verismo* category. Perhaps his most typical opera in this specialized version of realistic style is *Tosca* (1900), based on the drama of the same name by the boulevard playwright, Victorien Sardou. The plot follows the artificial conventions of the "well-made" play. It has strong confrontations, extremes of emotion, and a series of calculated theatrical effects—for example, the moment when the heroine places candles round the body of her would-be seducer, the evil police-chief Scarpia, whom she has just stabbed to death. What preserves *Tosca* is not plot, nor even characterization, but the power of the music, with its undulating declamatory line. Puccini entered the operatic scene late enough to learn a great deal from Wagner, especially his use of motto-like phrases to characterize people and situations, and also his skill in molding each scene into a single melodic statement. Yet within these great musical spans Puccini prudently found room for the seductive melodies which had always formed an essential part of the Italian operatic tradition.

Chapter 25

Symbolism

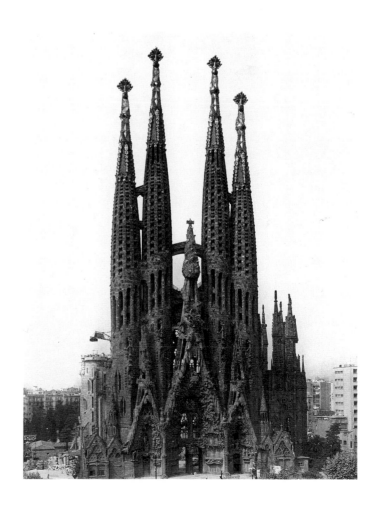

25.1 **Antonio Gaudí**, Church of the Holy Family (Sagrada Familia),
Barcelona, 1882–1926.

Philosophy

Symbolism and decadence

From the 1880s onwards, the European political climate was one of increasing nationalism, which expressed itself overseas in increasing competition for colonial empires which would both provide a market for European products and serve as a source of raw materials. In 1885 alone, for example, the Congo became the personal possession of King Leopold II of Belgium (whose agents mercilessly exploited its inhabitants), while Germany annexed Tanganyika and Zanzibar and Britain established protectorates over part of Bechuanaland, the Niger River region, and northern New Guinea.

At home, in Europe, at least in artistic circles, there was also an increasing impatience with the prevailing climate of rationalism and materialism, and a strong revival of Romantic attitudes. This impatience manifested itself in specific form in the international Symbolist movement, and in the associated cult of *fin-de-siècle* decadence. These movements emphasized the importance of what was intuitive and irrational in artistic creation; neither can be described as a fully-fledged philosophical system, yet between them they gave a very specific coloring to the art and literature of the closing years of the century.

The word "Symbolism," indicating a literary and artistic movement, achieved currency comparatively late. In the sense in which we now use the term, it was publicized in a manifesto issued by the minor French poet Jean Moreás which appeared in the Parisian newspaper *Le Figaro* on September 18, 1886. Moreás's text was concerned almost entirely with literature. It was an attempt to explain and systematize the new method of writing to be found in the work of the much more important poet Stéphane Mallarmé (see page 438). (To quote one of Mallarmé's aphorisms: "To *name* an object is to suppress three-quarters of the enjoyment to be found in the poem, which consists in the pleasure of discovering things little by little; *Suggestion*, that is the dream.")

The rules for Symbolism in the visual arts were elaborated on the basis of those already devised for poetry. The clearest statement of them is to be found in the French art-critic Albert Aurier's article on Gauguin, which was published in the *Mercure de France* in 1891. Aurier declared that the work of art should be:

1. *Ideative*, since its sole aim should be the expression of the Idea.
2. *Symbolist*, since it must express this idea in forms.
3. *Synthetic*, since it will express those forms and signs in a way which is generally comprehensible.
4. *Subjective*, since the object will never be considered merely as an object, but as an indication of the idea perceived by the subject.
5. (in consequence) *Decorative*, since decorative painting, properly speaking, as it was conceived of by the Egyptians, and very probably by the Greeks and the Primitives, is nothing other than an art at once synthetic, symbolist, and ideative.

The idea of decadence—the notion that civilization was in decline, coupled with a fascination for whatever seemed doomed or evil—was a revival and extension of the early Romantic fascination with death and suffering. In literature, it was popularized by several French writers. One was the poet Paul Verlaine (1844–96), whose book of essays, *Les Poètes maudits* (1884), put forward the notion that poetic genius was a mark of doom.

Still more influential in popularizing the notion of decadence were two novels by Joris Karl Huysmans (1848–1907), who had begun his career as a strict naturalist. These were *A rebours* (*Against Nature*, 1884) and *Là-bas* (*Down There*, 1891). The central character in *A rebours* is the last surviving member of an ancient noble family, Duc Jean des Esseintes. Exhausted both by heredity and thanks to his own excesses, he creates a life for himself which excludes anything ordinary or natural: "Artifice was in des Esseintes's philosophy the distinctive mark of human genius." Major themes in the novel are perverse sexuality and religion—des Esseintes, however, equates the latter with aesthetic aspirations. These, for him, amount "to the same thing as religious enthusiasms, aspirations toward an unknown universe, toward a far-off beatitude." But he combines this with a belief in human vileness and wickedness. Like Moreás and Verlaine, Huysmans stresses the importance of Mallarmé's poetry. For des Esseintes "the decadence of literature . . . the craving to leave a record of the most subtle pangs of suffering, was incarnate in Mallarmé in the most consummate and exquisite perfection." *Là-bas* restates the basic themes which Huysmans already used in *A rebours*, and adds an element of fashionable satanism.

Sigmund Freud

It is not usual to couple the name of Sigmund Freud (1856–1939) with those of the Symbolists and Decadents, yet there are good reasons for doing so. Freud, the inventor of psychoanalysis, presented himself as a scientist, and what he did as the beginnings of a new science. Throughout his life he remained a materialist and a determinist, thinking that all phenomena, even psychological phenomena such as thoughts, wishes, and fantasies, could be explained in terms

of what happened in the material world, through the principles of cause and effect.

He formulated a series of radical new theories. One of the most important concerned what he called the Oedipus complex—the childhood trauma caused because the male child is instinctively in love with his mother and jealous of his father, a situation which parallels that in Sophocles's play *Oedipus Rex*. Freud was to attribute many adult difficulties to this and similar traumas suffered in earliest childhood.

Another important area of exploration for him was the meaning of dreams. His pioneering study, *The Interpretation of Dreams*, was published in 1899. Freud's theory was once again linked to his basic conviction that neurotic problems originated in early childhood: "Our theory of dreams regards wishes originating in infancy as the indispensable motive force for the formation of dreams." The unacceptable and disturbing nature of these wishes meant that they had to be censored or disguised in some way, and this was the function of dreaming, which frequently, in the course of achieving this, fused together different ideas and images so as to make a single whole, or displaced one image by a less disturbing one, or else used some neutral object to symbo-lize what was innately threatening—usually some aspect of the dreamer's sexual life.

When one looks at Freud's theories, stated (as they have been here) in their simplest and most basic form, their connection with Symbolist doctrine in literature and art immediately becomes apparent. There was, too, in Freud's explorations of human sexuality, and the conclusions which he arrived at concerning it, a distinct element of intrusion into hitherto forbidden territory, which made a bridge between his researches and the Decadents' fascination with whatever was perverse, and with sexual perversion in particular. Most of all, Freud's pronouncement that "The interpretation of dreams is the royal road to a knowledge of the unconscious activities of the mind" sounds like basic Symbolist doctrine transposed into a different key.

Freud's explorations, in effect, are both an acknowledgment of the importance of the things which the Symbolists themselves thought valuable—images, indirections, and dreams—and a determined attempt to bring these back into consonance with the mechanistic determinism of nineteenth-century scientific theory. Romanticism was reconciled with scientific rationalism.

Art Nouveau architecture

Art Nouveau architecture represented a sudden release from the traditional, revivalist forms which had dominated building throughout the nineteenth century. It was an assertion of creative individuality, a liberation of forms (in terms of both planning and ornament), and it acknowledged the power of symbolic imagery in much the same way as Symbolist literature or painting. Its closest affinities were with the Gothic Revival, and some major Art Nouveau architects, such as the Catalan Antonio Gaudí (1852–1926), also built in the Gothic idiom. The sinuous vegetable ornament typical of the Art Nouveau decorative style in general did, of course, find exemplars in Gothic as well as in the Japanese art which was now becoming widely influential.

There is also another characteristic of Art Nouveau architecture which is worth noting. Its most intense manifestations are often to be found in cities where the inhabitants wanted to project ideas not only of modernity but of the special character of the local environment. Thus some of the chief masterpieces of Art Nouveau building are to be found in Barcelona, which was where Gaudí worked, and in Glasgow, with the architecture of Charles Rennie Mackintosh (1868–1928).

Gaudí's work sprang from two basic impulses—the desire to assert the existence of a genuine Catalan art and culture, separate from what was to be found in the rest of

25.2 Charles Rennie Mackintosh, School of Art (north front), Glasgow, Scotland, 1897–9 and 1907–9.

Spain, and the wish to make something whose novelty was immediately recognizable. The most memorable of all his buildings is the vast unfinished church of the Sagrada Familia (Fig. **25.1**), a commission which he took over from the original architect in 1882, and continued to work on for the rest of his life. The basic form is still Gothic, but the Gothic elements are overlaid and subverted by the swarming ornamentation which Gaudí devised as he progressed. The towers which cluster round the entrance portal are among his most extravagant creations. There is still at least an allusion to Gothic pinnacles and steeples, but the actual detail is far from being traditional—it has taken on a cartilaginous quality which makes it seem as if the whole building is turning into something organic—a weird vegetable growth. The emphasis in Symbolist literature on dreams and dreamlike states here finds architectural expression.

Mackintosh's work is less restless and fanciful than Gaudí's, in keeping with an aesthetically less permissive environment. His great masterpiece is the Glasgow School of Art (Fig. **25.2**), built in two phases, between 1897 and 1899, and 1907 and 1909. The building puts a much greater emphasis on function than Gaudí's characteristic structures. The asymmetrical façades are arranged so as to flood the painting studios with the greatest possible quantity of even north light. For the actual style of these façades Mackintosh has taken hints from Scottish vernacular architecture—this is particularly true of the looming west wing, which recalls Scottish tower houses of the late Middle Ages and Early Renaissance without actually copying them. The most typically Art Nouveau aspects of the structure are the wrought ironwork—screens and balcony railings—and the interior furnishings, meticulously designed by Mackintosh himself.

Painting

Gustave Moreau

The artists who receive most attention from leading Symbolist writers such as Huysmans and Henry James are not those who occupy pre-eminent positions in present-day art history. A good example is Gustave Moreau (1826–98). He was the link between Romanticism and Symbolism, and his early work shows the impact made on him by Delacroix (see page 382). His later admirations included early Italian art, Archaic Greek vases, early mosaics, and Byzantine enamels. What particularly fascinated Huysmans was Moreau's treatment of the Salome theme; in *A rebours* he dwells at great length on a version of what is still Moreau's most celebrated composition, *The Apparition* (Fig. **25.3**) of 1876, in which the severed head of John the Baptist appears in a vision to the depraved Judean princess. Moreau renders this sadomasochistic image with a wealth of exotic detail.

One of the secrets of Moreau's power is a reversal of expectations. With him, it is the male, not the female, who is languid, often effeminate, and doomed to destruction. Moreau's women, if not active destroyers, like Salome herself, are powerful, enigmatic beings whom it would be unwise to offend. Like much Symbolist literature, his art is a powerfully imaginative celebration of male fears of castration and impotence, of a kind identified and analyzed by Freud.

Paul Gauguin

In the years 1889–90, Symbolist art suddenly found a new hero in the person of Paul Gauguin (1848–1903). Typically,

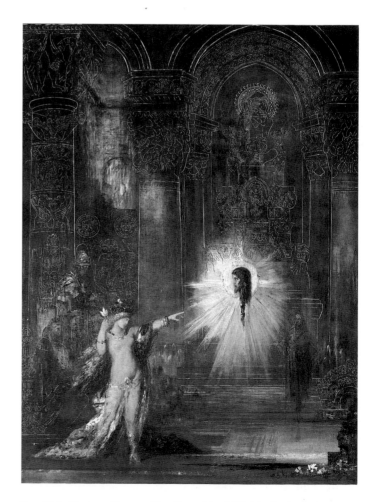

25.3 **Gustave Moreau**, *The Apparition* 1876. Musée Gustave Moreau, Paris.

the painter, suddenly elevated to a pinnacle of intellectual esteem, was inclined to mock his new admirers.

Gauguin was among the first of a new type of artist—one who came from outside the ranks of the old professional art world. He began as no more than a casual painter, working · on the fringes of the Impressionist movement, and did not become a full-time artist until 1882, when he lost his job with a stockbroking firm. His first truly independent period was spent in Brittany, in and around the village of Pont-Aven, which had become a magnet for painters of many different persuasions. It was here that he met a rebellious nineteen-year-old art student named Emile Bernard (1868–1941). Bernard was interested in all the intellectual fashions of the time—Symbolist poetry, the music of Wagner (see page 392)—always a touchstone for members of the Symbolist movement—and Schopenhauer's philosophy (see page 373). Contact with him suddenly crystallized Gauguin's ideas about what he wanted to do in art. These had already been influenced by other experiences—a childhood spent in Peru with his mother's family, and a period as a merchant seaman before he took up stockbroking.

The key moment in Gauguin's development came when he saw a picture which Bernard had just painted, *Breton Women in a Green Pasture* (Fig. **25.4**) of 1888. This inspired Gauguin's own *The Vision After the Sermon* (Fig. **25.5**) of 1888. The two pictures had much in common technically—a conscious reflection of perspective and modeling, plus flat color areas bounded by firm black outlines. These were symptomatic of a desire to synthesize visual perceptions—that is, to translate them into a new and coherent language peculiar to painting—instead of merely recording them, as the Impressionists did. Gauguin's work added another element. His Breton women have just come out of church, where they have been listening to a sermon about Jacob wrestling with the angel. What they still have in their mind's eye is placed on the same level of reality as the figures themselves.

Thanks to Emile Bernard, and still more to the enthusiasm of another young artist, Paul Sérusier (1863–1927) (see page 433), Gauguin was (though sometimes only reluctantly) recognized as the leader of a new and radical group of artists. In the summer of 1889 he was the central figure in an avant-garde show held in conjunction with the Universal Exhibition in Paris. Unfortunately this brought no increase in material success.

Gauguin had always been possessed by a restless desire to travel, and an impatience with the constraints of European civilization which was part of the intellectual climate of the time, but which may have stemmed in addition from childhood memories of Peru. Between visits to Brittany he had already made an expedition to Panama and Martinique. In 1891 he determined to travel still further and make a new life in Tahiti. The paintings produced during his two periods of residence in the South Seas are essentially those which now sustain his reputation both as a central figure in Symbolism and as an initiator of the Modern movement. *Primitive Tales* (Fig. **25.6**) of 1902 shows how complex his work became during this final epoch.

The picture is certainly not a direct transcription of anything Gauguin observed in Polynesia. Much of it consists of ideas and experiences which arrived there with him, as part of his mental baggage. The pose of the central figure, for instance, is borrowed from a Javanese temple sculpture which he knew only from photographs. What is going on is deliberately left vague—the figures exist in a kind of timeless trance. The "tales" of the title (the French word *conte* implies a kind of folk-story or fairy-story) flow around them, and also through each separate consciousness which comes in contact with them, always with a different meaning. This timelessness and ambiguity are the essence of Symbolist aesthetics. Meanwhile, the simplification of form points forward to more radical approaches to art.

Van Gogh and Munch

It is usual to pair Vincent Van Gogh (1854–90) and Paul Gauguin, because of their brief, violent personal association during a period of joint residence in Arles. In fact it makes more sense to link the Dutchman Van Gogh with the Norwegian Edvard Munch (1863–1944), with whom he had much more in common. Both men were deeply marked by fundamentalist Protestantism. Van Gogh's father was a minister of the Dutch Reformed Church; Munch's was a doctor who suffered from religious anxiety sometimes amounting to mania. Both men came to think of art as a route to personal salvation, and the Protestant imprint remained, even when formal religious belief had departed.

Van Gogh was the first fully-developed representative of a new type of artist. Romanticism had allowed the privilege of madness to poets, but clinical insanity continued to be a crippling disadvantage to creators working in other disciplines. Yet Van Gogh's chronic depression, his aggressive and suicidal impulses are all very much part of what he painted, and this was something new in European culture. Visual art had never before been the kind of intimate personal statement that Van Gogh made it—not even in the hands of his fellow countryman Rembrandt, Van Gogh's only rival as a self-portraitist.

Van Gogh came to painting late—he would never have been regarded as fully professional by the artists of an earlier generation. Before he decided that art was his true vocation, he had tried and failed to make a career as a Protestant missionary among the coalfield workers of the Borinage, the poorest part of Belgium. His artistic training was hit-and-miss.

During his student days in Antwerp Van Gogh's great personal discovery had been Japanese *ukioye* prints. He was not, of course, the first European artist to admire them, but their bold designs struck him with the force of a revelation. Later on, in Paris, he came into contact with the work of the

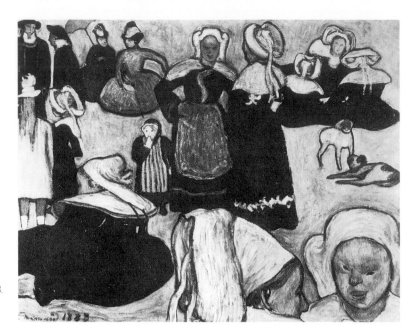

25.4 **Emile Bernard**, *Breton Women in a Green Pasture* 1888.
Oil on canvas, 29⅛ × 36¼ ins (74 × 92 cm). Denis Family
Collection, Saint-Germain-en-Laye.

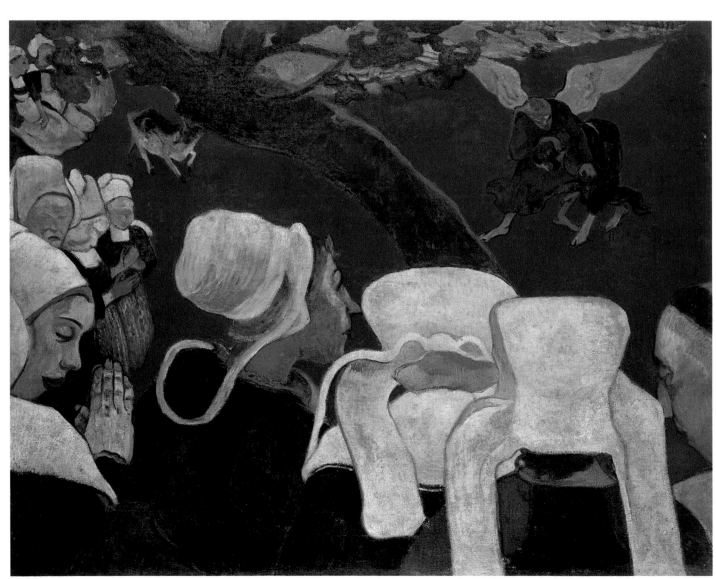

25.5 **Paul Gauguin**, *The Vision After The Sermon* 1888.
Oil on canvas, 28¾ × 36¼ ins (73 × 92 cm). National Galleries of
Scotland, Edinburgh.

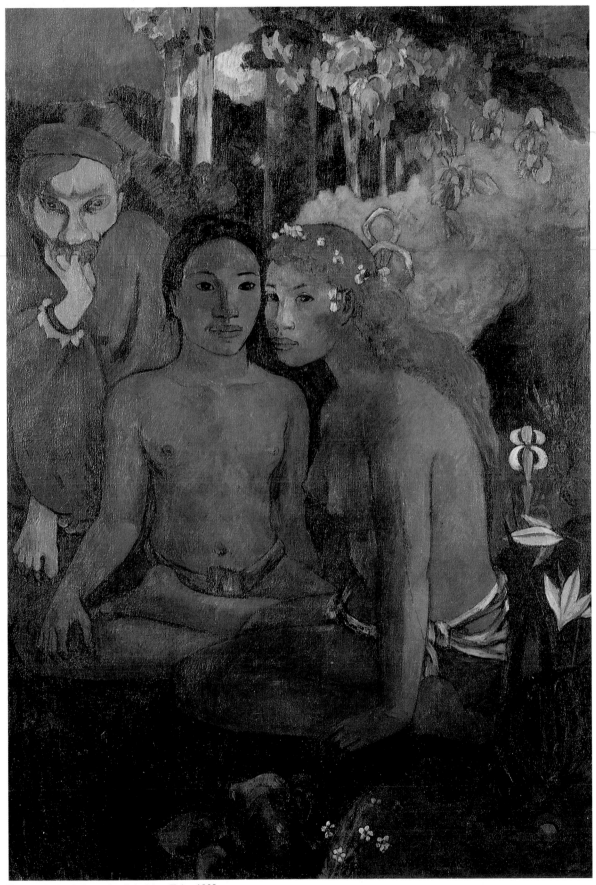

25.6 Paul Gauguin, *Primitive Tales* 1902.
Oil on canvas, 51¾ × 35½ ins (131.5 × 90.5 cm). The Folkwang
Museum, Essen.

25.7 Vincent Van Gogh, *Van Gogh's Chair* 1888. Oil on canvas, 36⅝ × 28⅜ ins (90.5 × 72 cm). National Gallery, London.

Impressionists, and also with newer artists, among them Emile Bernard and Toulouse-Lautrec (see page 436). By 1886 Van Gogh had finally reached a semblance of his mature style, though still with lingering traces of Impressionist influence. This style was marked by great boldness of brushwork, thick paint layered on the canvas, and explosive color. The originality of his technique strikes us favorably today, but was seen by most contemporaries as a short-coming.

His work reached a new pitch of intensity after he settled in Arles in February 1888. The pictures he painted before and after the arrival of Gauguin, with whom he hoped to found a community of artists, have a hallucinatory quality. They are not, however, Symbolist in the sense that Gauguin's Tahitian compositions are. Rather, they represent real objects, real places, real people, but all perceived with unique intensity. Any use of symbols is at a very simple level—for example, the still life of *Van Gogh's Chair* (Fig. 25.7), with the painter's pipe and tobacco resting on the seat, represents Van Gogh's aspirations toward a simple, unproblematic way of life, and the tranquility which he hoped (in vain) to achieve.

What is new about Van Gogh's art seems to be inadvertent—the inevitable product of a volcanic and at times uncontrollable temperament, rather than anything deliberately planned. It is this that gives a special pathos to some of the self-portraits, especially those which show the artist with his ear bandaged (Fig. 25.8), after he had made an attempt to slice it off during his first attack of mania. In these paintings Van Gogh seems completely estranged from himself, searching for a route back to his own personality. What they insistently call to mind is a phrase from one of Rimbaud's letters: "*Je est un autre.*"—"I is another."

Similar feelings can be found, though now projected with histrionic forcefulness, in certain paintings by Edvard Munch, particularly *The Scream* (Fig. 25.9). The most famous version dates from 1893 but Munch had in fact conceived the image earlier. In a diary entry for 1889 he

25.8 Vincent Van Gogh, *Self-Portrait with Bandaged Ear*.
Oil on canvas, 23¾ × 19¾ ins (60.5 × 50 cm). Courtauld Bequest,
1948. Courtauld Institute Galleries, London.

25.9 **Edvard Munch**, *The Scream* 1893.
Oil, pastel, and casein on cardboard, 35¾ × 29 ins (91 × 73.5 cm).
National Gallery, Oslo.

wrote: "One evening I was walking along a path, the city was on one side and the fjord below. I felt tired and ill. I stopped and looked out over the fjord—the sun was setting, and the clouds turning blood-red. I sensed a scream passing through nature; it seemed to me that I heard the scream. I painted this picture, painted the clouds as actual blood. The color shrieked."

Munch came from an even more provincial environment than Van Gogh; whereas a number of Van Gogh's relatives were connected with the international art trade, Munch had no such advantage. Nevertheless his professional training was a great deal more thorough, and he led a more cosmopolitan existence during the earlier part of his career—that is, until the serious breakdown of 1908, which marked a turning point, and the end of his most creative phase. The years from 1893 to 1908, the most important of his career, were spent largely in Germany.

Though he shares certain preoccupations with Gustave Moreau, Munch also shows new and more modern attitudes toward topics such as sexuality. In *Puberty* (Fig. **25.10**) of 1895, the subject is a young girl's discovery that she is no longer a child, but a woman. The theme is represented in a way which recalls the dramas of August Strindberg (see page 440), whom Munch knew in Berlin. However, underlying much of Munch's early work there still lies the typically Symbolist terror of sexuality.

Munch survived his breakdown of 1908, and lived on through a long and productive career, settling permanently in his native Norway in 1910. But the later work lacks the revolutionary intensity of what he had done earlier. Between them, Munch and Van Gogh are the true forerunners of twentieth-century Expressionism (see page 455).

The Nabis and Toulouse-Lautrec

In 1888 Gauguin was briefly in contact, during one of his visits to Brittany, with a young painter called Paul Sérusier (1865–1927). Under his tuition, Sérusier painted a small landscape using the new Synthetist technique just invented by Gauguin himself and by Emile Bernard. The lesson seems to have struck the young artist with the force of a revelation. He took his picture back to Paris, where it was promptly baptized *The Talisman* (Fig. **25.11**), and started preaching the new doctrine to a circle of friends of his own generation. Eventually he was to organize them into what amounted to a secret society. They called themselves the Nabis, *nabi* being the Hebrew word for prophet. Among their number were Maurice Denis (1870–1943), Paul

25.10 **Edvard Munch**, *Puberty* 1895.
Oil on canvas, 59¾ × 33¾ ins (151.5 × 85.5 cm).
National Gallery, Oslo.

Ranson (1862–1909), K.-X. Roussel (1867–1944), Pierre Bonnard (1867–1947), and Edouard Vuillard (1868–1940). It soon turned out, however, that the members of the Nabis group were very different from one another. Sérusier and Denis were serious, mystical, and philosophical, increasingly drawn toward the Neo-Catholicism which was increasingly influential at the time. Bonnard and Vuillard, on the other hand, were fascinated by the fashionable Symbolist milieu, and it is their early paintings which give us the best representation of it.

What Vuillard did with especial skill was to catch the overcrowded, hothouse quality of the domestic interiors then inhabited by rich and cultivated people. He was a master of pattern-on-pattern, and often chose such unex-

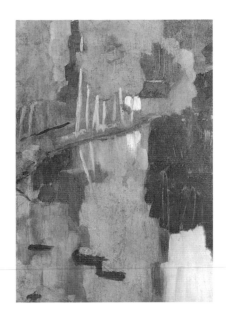

25.11 Paul Sérusier, *Landscape: The Bois d'Amour (The Talisman)* 1888. Oil on wood, 23⅝ × 17¾ ins (60 × 45 cm). Musée d'Orsay, Paris.

25.12 Edouard Vuillard, *After the Meal c.* 1890. Oil on cardboard, 11 × 14 ins (28 × 36 cm). Musée d'Orsay, Paris.

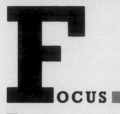

The Arts and Crafts Movement

The Arts and Crafts movement was a reaction against the excesses of nineteenth-century industrialism. It began in England, the cradle of the Industrial Revolution, and its father was the passionately eloquent critic and theoretician John Ruskin (1819–1900). Ruskin's writings, especially the chapter "On the Nature of Gothic" in his *The Stones of Venice* (1851–3), offered inspiration to generations of creative craftspeople. Ruskin laid down three rules for craft:

1. Never encourage the manufacture of any article not absolutely necessary, in the production of which *Invention* has no share.
2. Never demand an exact finish for its own sake, but only for some practical or noble end.
3. Never encourage copying or imitation of any kind, except for the sake of preserving records of great works.

(JOHN RUSKIN, *The Stones of Venice*. London, 1851–3.)

Mary L. McLaughlin, *Ali Baba Vase*, 1880. 37½ × 16½ ins (95.3 × 41.9 cm). Gift of the Rookwood Pottery. Cincinnati Art Museum, Ohio.

Ruskin did not himself practice a craft. It was the most important of his disciples, William Morris (1834–96), an ally and associate of the Pre-Raphaelite painters (see page 382), who took the first practical steps toward a craft revival, by founding a firm to manufacture decorative objects in accordance with Ruskin's prescriptions. Its products were first shown at the International Exhibition held in London in 1862. One of the novel features of Morris's activity was that, though brought up a gentleman, he was anxious to plunge into the business of making things himself. It was he who actually put into practice Ruskin's dictum that: "It would be well if all of us were good hand craftsmen of some kind, and the dishonour of manual labour done away with altogether ... In each several profession, no master should be too proud to do the hardest work." Despite this, few objects are directly attributable to Morris. What he is best remembered for are his brilliant wallpaper and fabric designs. He did, however, prove to be a brilliant propagandist and organizer.

In Morris's wake there sprang up a large number of craftspeople, who increasingly thought of craft as an activity which could rival the fine arts. Following the lead given by Ruskin and Morris, they tended to favor the medieval tradition, and also borrowed freely from traditional rustic crafts. By the 1880s, when a second generation appeared, their work had begun to accommodate itself to the so-called Aesthetic movement, a quite separate rebellion against the lavish over-complication of nineteenth-century bourgeois design.

It was in this form that the Arts and Crafts movement was carried to the United States. It made its first significant appearance in Cincinnati, where a women's china painting class, set up in 1871, led to the foundation of the Rookwood Pottery in 1880. Rookwood was the creation of a socially prominent young woman, Maria Longworth Nichols, and this was significant in itself, as women were to play a much more prominent role in the American branch of the Arts and Crafts movement than they did in Britain. One reason for this may have been that, during the pioneering period in the United States, many of the more ambitious handskills, such as quilt-making, were associated almost exclusively with women.

The pottery produced at Rookwood was decorated in Aesthetic style, often showing strong Japanese influence. This influence was to persist in American craft, reaching a climax in the work of two California-based architects, Charles Sumner Greene (1868–1957) and his brother Henry Arthur Greene (1870–1954), and in that of Louis Comfort Tiffany (1858–1933), who was responsible for domesticating the French Art Nouveau style (itself strongly influenced by Japan) on American soil.

Handwoven wool tapestry designed by William Morris in 1878.

pected viewpoints for his compositions that it is difficult, at first glance, to make out exactly what they represent. The more extreme examples, such as *After the Meal* (Fig. **25.12**) of *c*. 1890, are among the forerunners of twentieth-century abstract art.

Henri de Toulouse-Lautrec (1864–1901) frequented the same Symbolist circles, and sometimes portrayed their inhabitants. His preferred subject matter was Parisian nightlife in its more raucous and sordid aspects, especially the cabarets and dance halls of Montmartre. His portrayal of these helped to fix the image of the *fin de siècle* in the popular imagination.

In his prints and posters, even more than in his paintings, Lautrec, too, surrendered to the fascination of Japanese art. An example is his poster for *Le divan Japonais* (Fig. **25.13**). This also sums up a number of other characteristic themes. The singer Yvette Guilbert, one of his favorite models, appears in the background, recognizable by her trademark, long gloves. In the foreground sits Jane Avril, a dancer from the Moulin Rouge. Her escort is Edouard Dujardin, a well-known Symbolist critic.

Lautrec was far more than a mere chronicler of the passing scene. His radical attitudes toward the representation of reality and his original feeling for composition appealed profoundly to the young Picasso (see page 459). Through Picasso, Toulouse-Lautrec's innovations entered into the formation of Modernism.

25.13 Henri de Toulouse-Lautrec, *Le divan Japonais* 1892. Color lithograph, poster, 31¾ × 23⅞ ins (80.8 × 60.8 cm). Musée Toulouse-Lautrec, Albi.

Sculpture

Auguste Rodin

Sculpture, which almost throughout the nineteenth century had taken second place to painting, enjoyed a revival in the hands of the Frenchman Auguste Rodin (1840–1917). Perhaps because there was so much to unlearn as well as to learn, Rodin's art matured slowly. His early development incorporates a number of major tendencies to be discovered in nineteenth-century art. In his early career he was touched by the revival of eighteenth-century taste—some early sculptures are close to Rococo equivalents. The same impulse can be seen at work in many of Renoir's paintings. He was also the master of brilliant naturalism. As the *Gates of Hell* (Fig. **25.14**) demonstrate, however, Rodin's true place is with the Symbolists. The original inspiration was literary—Dante's *Inferno*—and places Rodin in the long and distinguished line of illustrators of Dante, including Botticelli and William Blake. Originally the *Gates* had a

practical purpose: they were to form part of a new Museum of Decorative Arts. Soon, however, the project became an end in itself. Rodin continued to work on it for the rest of his life, and the final version was not cast until 1926, some years after his death. The *Gates* led him in several directions: toward a swarming proliferation of images, and an intricate sinuosity reminiscent of Art Nouveau ornament; and toward ambiguity—as the basic images changed shape, or were put together in different combinations, they acquired new meanings.

Simply because he was a sculptor, not a painter, and because sculpture was still regarded as an appropriate vehicle for public statements, Rodin retained links with the official culture of his time. He could not brusquely turn his back on it, as the Symbolist poets and nearly all the Symbolist painters did. As a result his career was punctuated with a series of violent controversies about the public monuments which were commissioned from him. Public expec-

25.14 Auguste Rodin, *The Gates of Hell* 1880–1917.
Bronze, 250¾ × 158 × 33⅜ ins (636.9 × 401 × 84.8 cm). Musée
Rodin, Paris. Gift of Jules E. Mastbaum.

tations were usually flouted by the result. The most celebrated example is the monument to the great novelist Balzac (see page 415), commissioned from Rodin in 1891 (Fig. 25.15). When the finished result was shown at the Salon of 1898 it caused a public scandal, and the commission was withdrawn.

The paradox about the statue was that Rodin researched his subject in a way that should have produced a naturalistic result—he even went so far as to have a dressing gown made to the novelist's exact measurements, which he then set in plaster so as to create a three-dimensional object of the right size and form. Despite this, the statue became a powerful symbolic presentation of the idea of literary genius.

25.15 Auguste Rodin, *Monument to Balzac* 1897.
Bronze, 43 × 15¾ ins (109 × 40 cm). Musée Rodin, Paris. Gift of Jules E. Mastbaum.

Literature

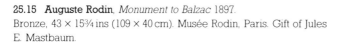

Poetry: Rimbaud and Mallarmé

The Symbolist approach to aesthetics was pioneered by poets, and made its deepest and longest-lasting impression upon literature. Symbolist poetry emphasized the power of imagery, the equivalence between words and the things they designated, and the status of the poem as an independent construct, something which was more than simply descriptive. These attitudes affected major writers throughout Europe, among them Rainer Maria Rilke (1875–1926), Stefan George (1868–1933), and W. B. Yeats (1865–1939), all of whom were Symbolists in one fashion or another. They were not, however, the creators of this new way of handling words. That was the joint responsibility of two French poets, closely allied in their approach to poetic problems if sharply contrasted in temperament.

The story of Arthur Rimbaud (1854–91) is one of the most astonishing in the history of European literature. A brilliant but rebellious schoolboy, he was already writing accomplished poetry by the age of fifteen. After running away to Paris from his native Charleville he found himself in contact with the dissolute but already well-established poet Paul Verlaine (1844–96). The two men began a relationship which alienated Verlaine from his wife, and scandalized the whole of literary Paris.

Rimbaud's chief works are *Les illuminations*, a collection of verses and prose poems written between 1872 and 1874,

and *Une saison en enfer*, a series of prose texts, written in 1873. Soon after the age of twenty, Rimbaud ceased to write. These books record two aspects of the same experience—Rimbaud's attempt to become a sage or seer (a *voyant*, as he himself called it) through the systematic "disordering of all the senses," and his disillusionment when these efforts did not produce the desired result.

Rimbaud's imagery and symbolism are often based on the study of alchemy, and everything about his work suggests that he saw poetry as a magical act through which poets hope to transform their whole personality and assume powers which will make them superior to their fellow humans. Both these preoccupations were to be passed onto many of the major poets of the twentieth century. Like Rimbaud, they came to believe that the poem must be more than a description or a narrative; it must be a ritual which the poet enacts. Equally, many of them came to share Rimbaud's conviction that these rituals were spiritually, and sometimes even physically, dangerous for poets, who are driven to sacrifice themselves on the altar of industrial civilization.

Stéphane Mallarmé (1842–98) lived a less disordered life (he was a teacher of English, and the center of a wide circle of literary and artistic friends), and his attitudes to language were more playful and experimental, and also much more detached, than Rimbaud's. One of his best-loved anthology pieces (less simple than it looks) gives a good idea of his

poetic methods. It needs to be quoted both in French and in English, since the actual sound of the words counts for so much:

Le vierge, le vivace et le bel aujourd'hui
Va-t-il nous déchirer avec un coup d'aile ivre
Ce lac dur oublié qui hante sous le givre
Le transparent glacier des vols qui n'ont pas fui?

Un cygne d'autrefois se souvient que c'est lui
Magnifique mais qui sans espoir se delivre
Pour n'avoir pas chanté dans la région où vivre
Quand du stérile hiver a resplendi l'ennui.

Tout son col secouera cette blanche agonie
Par l'espace infligée à l'oiseau qui le nie,
Mais non l'horreur du sol où le plumage est pris.

Fantôme qu'a ce lieu son pur éclat assigne,
Il s'immobilise au songe froid de mépris
Que vêt parmi l'exil inutile le Cygne.

The lively, lovely and virginal today
will its drunken wings tear for us with a blow
this lake hard and forgotten, haunted below
the frost with the clear glacier of flights not made?

A swan of past times remembers he's the one
magnificent but striving without hope
for not having sung a land where he could stop
when the ennui of sterile winter has shone.

All his neck will shake off this white death by space,
inflicted on the bird for whom it is not,
but never the horror of clay where his feathers are caught.

Phantom whose pure white dooms it to this place,
swathed in futile exile with a chill
dream of contumely, the Swan is still.

<div align="right">(STÉPHANE MALLARMÉ, Poems translated by
C. F. MacIntyre. Translation © 1957 C. F. MacIntyre.
University of California Press, 1957.)</div>

The central image of a swan frozen in ice represents the poet himself, immobilized by his own past history, and also by his own fastidiousness. The beat of "drunken wings" is the possibility of inspiration, which shatters (or may possibly shatter) the frozen surface of the lake of dreams. In the sestet (in form the poem is a conventional Petrarchan sonnet), the mood shifts and becomes darker—the poet is "swathed in futile exile" by his own sense of alienation, and despises himself because he cannot reach the highest pinnacles of art. The twin subjects of the poem are thus the special nature of the poet's vocation and this particular poet's sense of insufficiency and creative impotence.

Where Rimbaud asserted that the poet must take on a new role (or revert to a very ancient and primitive one), Mallarmé asked that the text itself should be read in a new way, fullest attention being given to what each line or phrase might imply, as well as what it actually says.

Fiction: Henry James

The pioneering Symbolist novels, such as Huysmans's *A rebours*, are important in the general cultural context but second-rate as fiction. They have little narrative thrust, and no interplay of character. Much of *A rebours*, for example, is made up of lists—the gems and exotic flowers which obsess its hero, des Esseintes. Yet Symbolist attitudes and recognizably Symbolist techniques came to permeate late nineteenth-century fiction in general.

A striking example is supplied by the work of the American Henry James (1843–1912). Born into a prosperous and cultivated family in New York, Henry James was educated there, and in Paris, London, and Geneva. In 1875 he moved permanently to Europe, spending a year in Paris and then settling in England for the rest of his life. Shortly before his death he became a naturalized British citizen.

James was the author of a long series of distinguished novels, many of which circle round the same issue—the problem of being an outsider in European society. The novella *Daisy Miller* (1878) was his first great fictional success, and introduces a type which James was to make peculiarly his own, the "mythically innocent" American woman who baffles the Europeans she moves among, and who is doomed to be misunderstood and misjudged by them. James clearly saw this as symbolic of the uneasy relationship between European and American culture.

Milly Theale, the heroine of the late novel *The Wings of the Dove* (1902), which many consider James's finest achievement, is a variation on the theme—an immensely wealthy young American heiress who arrives in Europe looking for something more than America has to offer, and discovers that she is doomed to die very soon from a mysterious and incurable illness. Surrounding her are Europeans of coarser fiber than herself.

James tells the story obliquely, constructing a web of hints and indirections. Important incidents are left obscure; important encounters and conversations are concealed from the reader. We never learn the exact nature of Milly's illness, and throughout the last quarter of the narrative she is allowed to fade from our consciousness, just as she is fading from life. The oblique nature of the narrative is well matched by James's intricate, circumlocutory style. Here is one sentence, chosen at random. Milly Theale has just visited a distinguished doctor, and the latter has hinted, rather than said openly, that there is something fatally wrong with her: "Stranger than anything for instance was the effect of its rolling over her that, when one considered it, he might perhaps have 'got out' by one door but to come

in by a beautiful beneficent dishonesty by another." The sentence is untypical only because it is fairly short.

In the late novels, James wraps his personages in a mist of speculation. Conclusions are never definitely arrived at; there is always an alternative, some further path to be explored. At the same time, he endows his characters with symbolic power. Milly is not simply good, she is goodness personified. And this goodness is fatal to corrupt thoughts and feelings when it comes into contact with them.

Drama

Maeterlinck, Wilde, and Strindberg

The most characteristically Symbolist plays, *Pelléas et Mélisande* (1892) by Maurice Maeterlinck (1862–1949) and *Salome* (1891) by Oscar Wilde (1854–1900), have not succeeded in holding the stage, though both survive triumphantly as operas. In every respect, their authors tried to mark them off from the realistic drama which had been the nineteenth-century norm. The events depicted were remote and legendary; the characters were deliberately distanced from the audience; the language itself was far from the colloquial rhythms of ordinary speech. *Salome* was written in French, and only afterwards translated into English. Both plays enjoyed their greatest early success in Germany.

Transposition into a different language from the one in which they were originally written, and into a different set of cultural circumstances, actually seems to have reinforced the effect which both authors aimed at, which was to turn their characters into archetypes, symbols of universal needs and passions.

The play of Wilde's which seems most vividly alive is the exquisite comedy *The Importance of Being Earnest* (1895). Historians of the drama generally compare this to English Restoration comedies, because of its airy wit and complete lack of sentimentality. The Symbolist connections are seldom mentioned. In fact, the play fits very well into the general framework of Symbolist aesthetics, because it creates a totally artificial world, whose artificiality is stressed at every turn. The universe the characters inhabit is as thoroughly enclosed as that of des Esseintes in *A rebours*. The great difference is that *Earnest* is illuminated by Wilde's irrepressible sense of humor.

The greatest dramatist of the period (apart from Chekhov—see page 420—who remained firmly within the realist tradition) was the Swede August Strindberg (1849–1912). Strindberg was in touch with many of the major artistic movements and personalities of his time. Gauguin asked him to write the preface for the exhibition of his work held just before his final return to Tahiti, and when Strindberg

ITERATURE

Miss Julia

This exchange between Jean the valet and the aristocratic Miss Julia takes place at the very end of the play, after she has given herself to him. She now recognizes (with the return of her father the count), and Jean acknowledges, that her lover's nature is irredeemably servile. This, in turn, makes both of them realize that what she really wants is not escape but self-destruction.

Miss Julia [*dully*]: Never mind the bird. Can you see any way out of this? Any end to it?

Jean [*thinking*]: I can't.

Miss Julia: What would you do in my place?

Jean: In your place? Let me think.... A woman of your class, who's gone wrong.... I don't know. Yes, I do, though.

Miss Julia [*she picks up the razor, and makes a significant gesture*]: Like this?

Jean: Yes. But *I* wouldn't do it, mind you—that's the difference between us.

Miss Julia: Because you're a man and I'm a woman? What difference does that make?

Jean: Just the difference that there *is* between man and woman.

Miss Julia [*with the razor in her hand*]: I wish I could.... I can't do it, though—any more than my father could—that time when he should have done it.

Jean: No, he shouldn't: he had to have his revenge first.

Miss Julia: And now my mother gets *her* revenge—through me.

Jean: Haven't you ever loved your father, Miss Julia?

Miss Julia: Yes—very much. But I must have hated him, too; I must have been hating him without realizing it. You see he taught me to despise my own sex—to be half woman and half man. Who's to blame for all this—my father, or my mother, or myself? Myself? I haven't a self; I haven't a thought that I don't get from my father, nor an emotion that I don't get from my mother. Even this last idea that all human beings are equal—that came from my fiancé—and then I call him a beast for his pains. How can I be to blame? Am I to put all the blame on Jesus, like Kristin? No, I'm too proud to do that—and too sensible, thanks to my father's teaching. As for the rich man not going to heaven, that's a lie; Kristin, with money in her savings bank, wouldn't get in. But who's to blame? Still, what does that matter? I'm the one who has to bear the blame and take the consequences.

Jean: Yes, but—[*There are two sharp rings on the bell.* **Miss Julia** *leaps to her feet*—**Jean** *slips on his other coat.*] That's the Count—he's home! [*Going*] Suppose Kristin has . . .

[*He goes to the speaking-tube, taps on it, and listens.*]

Miss Julia: Has he been to his desk yet?

Jean: It's Jean, my lord. [*He listens, but the audience do not hear the Count's reply.*] Yes, my lord. [*Listens*] Yes, my lord, at once. [*Listens*] Very well, my lord—in half an hour.

Miss Julia [*quite distraught*]: What did he say? Oh, God, what did he say?

Jean: He wants his boots and his coffee in half an hour.

Miss Julia: Half an hour! Oh, I'm so tired; I can't do anything: I can't repent, I can't run away, I can't stay; I can't live, I can't die. Help me now! Order me, and I'll obey you like a dog. Do this last thing for me: save my honour, save my name. You know what I ought to do if only I had the willpower. *Will* me to do it—and command me to obey you.

Jean: I don't know—I can't, now, either—I don't know why. It's just as if this coat stopped me. I can't order you now—not since the Count spoke to me—I can't explain it, it must be this livery I've put on my back. I really believe if the Count were to come down here now and order me to cut my throat, I'd do it on the spot.

Miss Julia: Then pretend you're the Count and I'm you! You could play the part quite well just now, when you were on your knees; you were the aristocrat then all right. Oh, haven't you ever seen a hypnotist on the stage? [**Jean** *nods*.] He says to his subject, "Take that broom", and he takes it. Then he says, "Sweep", and he sweeps.

Jean: He has to be in a trance, though.

Miss Julia [*ecstatic*]: I'm asleep already. The whole room seems full of smoke—you look to me like an iron furnace—a furnace that's like a man dressed in black, with a tall hat. Your eyes are glowing like coals when the fire sinks down, and your face is a white blur like ashes. [*The sunlight has reached the floor, and is now falling on* **Jean**.] Oh, it's warm and lovely—[*she rubs her hands together as if she were warming them at a fire*] and so light—and so peaceful.

Jean [*taking the razor and putting it into her hand*]: That's your broom. It's daylight now—go out into the barn and . . .

[*whispers in her ear.*]

Miss Julia [*rousing herself*]: Thank you—now I'm going to have peace at last. But before I go, tell me that the First can receive the gift of grace, too. Say it, even if you don't believe it.

Jean: The First can have . . . No, I can't say that! Wait, though, Miss Julia, I've got it! You're not the First any longer—you're among the Last!

Miss Julia: That's true; I'm among the very Last—I *am* the Last. Oh, but now I can't go. Tell me to go—tell me again!

Jean: I can't either, now—I can't!

Mis Julia: "And the First shall be Last"—

Jean: Don't think—don't think. You're taking away my strength and making me a coward. What's that! I thought the bell moved. No—let's stuff it with paper. Fancy being so afraid of a bell! Yes, but it's something more than just a bell—there's someone behind it—a hand that sets it moving—and something else that moves the hand. Stop your ears then—simply stop your ears! But then it rings more than ever; it rings and rings till you answer it—and then it's too late. The police come . . . and then . . . [*Two sharp rings from the bell.* **Jean** *shrinks for a moment, and then straightens himself.*] It's horrible—but there's no other way out. Go . . .

[*With a firm step,* **Miss Julia** *goes out through the door.*]

CURTAIN

Strindberg

refused, in a long and eloquent letter, Gauguin adroitly used this in its place. In Berlin during the 1890s, Strindberg was close to Edvard Munch. Everywhere Strindberg went he attracted notoriety—as much as a result of his personal character as the startling nature of many of his plays.

In his prolific and uneven output *Miss Julie* (1888) occupies a special place, and of all his plays it is perhaps the one which has been most widely translated and frequently performed. In a subtitle, Strindberg described it as "a naturalistic play," and added a long preface to the text, spelling out the difference between what he wanted and the artificial way in which drama was usually presented at the time *Miss Julie* was written. Yet, despite obvious affinities to Ibsen (who professed admiration for Strindberg's work and whom Strindberg rather carpingly criticized), it is very different in spirit. There is one set, a realistic country kitchen, and the drama consists of only one act, so that the flow of events is uninterrupted. The play contains just three characters—Kristin, a cook; Miss Julie, the daughter of Kristin's employer, who is a Swedish count; and Jean, the count's footman. The time is Midsummer's Eve—in Scandinavia,

the traditional moment for madness, and more especially sexual madness, to be unleashed. There is a servants' ball going on in the house.

The plot mechanism is very simple. Miss Julie seduces, or is seduced by, the upstart Jean, and then, unable to face the consequences, commits suicide. Strindberg uses this mechanism to explore attitudes about class and sex in a more unsparing fashion than had ever been attempted previously. His psychology is completely modern; at one point Jean recounts a symbolic dream which would certainly have interested Freud. What takes the play outside the "realism" of Ibsen, and even beyond the much more subtle psychological realism of Chekhov, is Strindberg's power to unleash long-suppressed emotion. His characters are archetypes—of sex and class—in a much more positive and terrifying sense than Maeterlinck's Mélisande, the personification of destructive innocence. For all its naturalistic surface, *Miss Julie* is deeply rooted in the world of the other great Symbolist writers and painters. In particular, it is situated on the frontier where Symbolism touches Expressionism (see page 455).

Music

Debussy and Richard Strauss

Wagner was for many Symbolists the presiding genius of their movement. The pilgrimage to the annual Wagner Festivals at Bayreuth was made by many French intellectuals, while fashionable Wagnerites in England were deftly caricatured by the English Art Nouveau draftsman Aubrey Beardsley (1872–98), who had a mercilessly accurate eye for the fads and fashions of his day (Fig. **25.16**). However, Wagner's final opera *Parsifal* was completed in 1882, before the Symbolist movement had properly established itself, and it was left to others to tease out the implications of his achievement.

Two composers who most deserve the title Symbolist are Claude Debussy (1862–1918) and Richard Strauss (1864–1949). It is significant that their work lags a little behind that of the main generation of Symbolist writers and artists. This time lapse tends to contradict the common assumption that music was the strongest and most typical expression of the Symbolist ethos.

Debussy scored his first decisive success with works inspired by Mallarmé (see page 438) and Maeterlinck. *L'Après-midi d'un faune* (1892) is a musical interpretation of one of Mallarmé's most ambitious poems, which was afterwards made into a ballet by Vaslav Nijinsky. *Pelléas et Mélisande*, composed between 1893 and 1895, is a word-for-word setting of Maeterlinck's play, with only four scenes

cut. The premier did not take place until 1901, but the opera then immediately changed the face of European music. Debussy took up techniques associated with Wagner, such as the use of *leitmotiven* and the role given to the orchestra as musical commentator, but used them to produce entirely new effects. The music of *Pelléas* is a shimmering reflection of evanescent moods and feelings, with not a trace of Wagnerian grandiosity. The rhythms of what is sung are close to actual speech, and thus hark back to the birth of opera—the work of Monteverdi and his contemporaries (see page 258).

Debussy's relationship to Wagner was one of love-hate, with dislike and mockery perhaps predominant. Richard Strauss's attitude was much more straightforwardly one of admiration, though he had been brought up in the anti-Wagnerian camp, to which his father, a trumpet player in the Munich Court Orchestra, belonged. Strauss began composing early, and was precociously successful, thanks in part to his father's musical connections, but achieved musical independence only in 1883 when he became assistant conductor with the Meiningen Court Orchestra. His first mature works were a number of tone-poems which followed in Wagner's footsteps. One, *Also Sprach Zarathustra* (1895–6), was a tribute to Nietzsche. Success on a much higher level, artistic and financial, came with two operas, *Salome* (1905), a setting of Oscar Wilde's play, then immensely popular in Germany; and *Electra*, a version of the bloody

legend used by Aeschylus written by the Austrian Symbolist poet Hugo von Hofmannsthal (1874–1929), who was then to become Strauss's regular collaborator. Both of these works have an orchestra elaboration which makes them paradigms of one aspect of Symbolist culture in general—the tendency to push the artistic techniques and discoveries of Romanticism to their furthest extreme. In addition, both operas have a violence which seems to pass beyond the limits of the subject matter. This almost hysterical violence is also present in the works of Munch (see page 432) and Strindberg (see page 440).

In the case of Munch and Strindberg emotional extremism was clearly an aspect of personal character. Strauss, on the contrary, was placid and level headed—a typical turn-of-the century *haut bourgeois* more interested in material success than in pandering to the imperious demands of the psyche. The third major work of his first and most successful creative phase was the opera *Der Rosenkavalier* (1911), which is very different in tone from either *Salome* or *Electra*. *Der Rosenkavalier* is an elaborate comedy set in eighteenth-century Vienna. It is about a mature but still beautiful woman who renounces a young lover so that he can marry the girl of his choice. Though the setting is the epoch of the Rococo, the music is still Wagnerian in technique—but Wagner's heroic ideals are subverted and the opera is full of calculated charm, and equally calculated irony. Under the elaborate Wagnerian textures pulse simple waltz themes, reminiscent not of the eighteenth century but of Richard Strauss's mid-nineteenth-century namesake, Johann Strauss the Younger (1825–99), composer of *The Blue Danube*.

The element of pastiche and Strauss's deft way of reconciling incongruous materials while still insisting on their

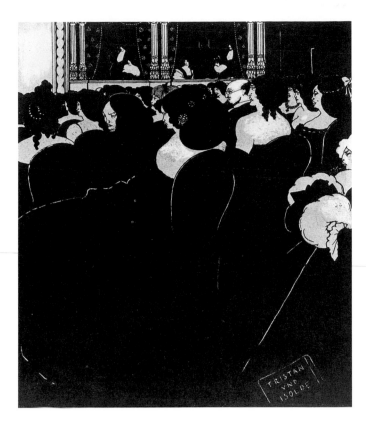

25.16 **Aubrey Beardsley**, *The Wagnerites* (Tristan and Isolde) 1894. Published in "The Yellow Book", vol. III (October 1894). Victoria and Albert Museum, London.

incongruity are typical of an important aspect of Symbolist art—the aspect which is prophetic of fully developed Modernism in its use of parody and deliberately mismatched elements.

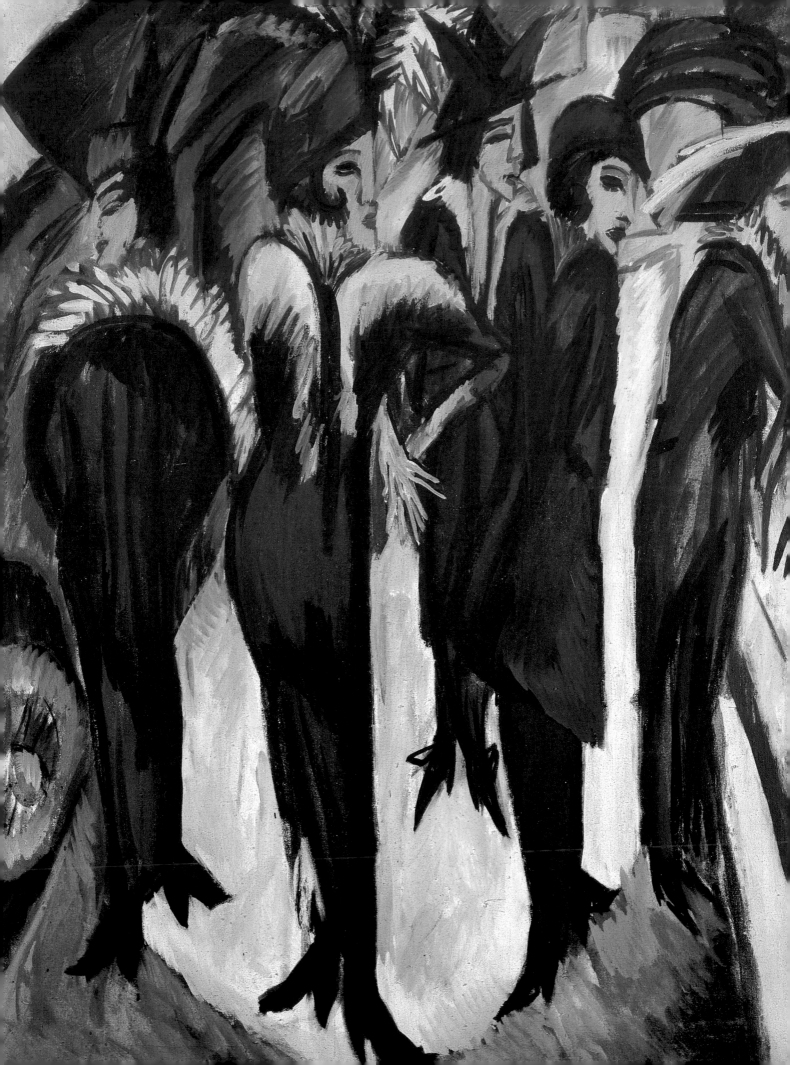

Part

8

The Modern Age

Chapter 26

The Birth of Modernism

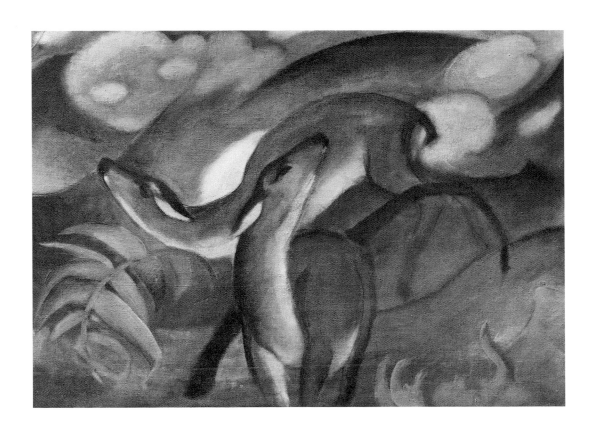

26.1 **Franz Marc**, *Red Roe Deer II* 1912.
Oil on canvas, 27½ × 39¼ ins (70 × 100 cm). The Bavarian State
Collection, Munich.

The political background of the Modern Movement

During the period 1905–14, which saw the birth of the Modern movement, the international situation became increasingly tense. The tensions were, however, either outside Europe or on its periphery.

In 1905 the Russians humiliatingly lost their war with the Japanese, which had broken out a year previously. One consequence of the disaster was a general strike in Russia. The saber-rattling Kaiser Wilhelm II of Germany paid a visit to Tangiers which provoked an international crisis. In 1906 the United States occupied Cuba. In 1908 Austria seized Bosnia and Herzegovina. In 1909 Sultan Abdul Hamid II of Turkey was deposed by a new nationalist movement, that of the Young Turks. In 1910 there was a revolution in Portugal, where the monarch fell and was replaced by a republic.

In 1911 Wilhelm II made a fiery speech, asserting Germany's right to a "place in the sun"—this was correctly interpreted as a direct challenge to the older and more established colonial powers; the Russian prime minister, Peter Stolypin, was assassinated, and the Manchu Dynasty (in power since 1644) fell in China. Italy went to war with Turkey, seizing Tripoli and Cyrenaica.

In 1912 Montenegro declared war on Turkey and the conflict soon involved Bulgaria and Serbia. In 1913 King George I of Greece was assassinated, and war broke out again in the Balkans, where Bulgaria, Turkey, Albania, Serbia, Russia, and Greece all became embroiled with one another. The outbreak of a general, Europe-wide conflict in 1914 therefore seemed to many people the inevitable climax to a long period of degeneration in international affairs.

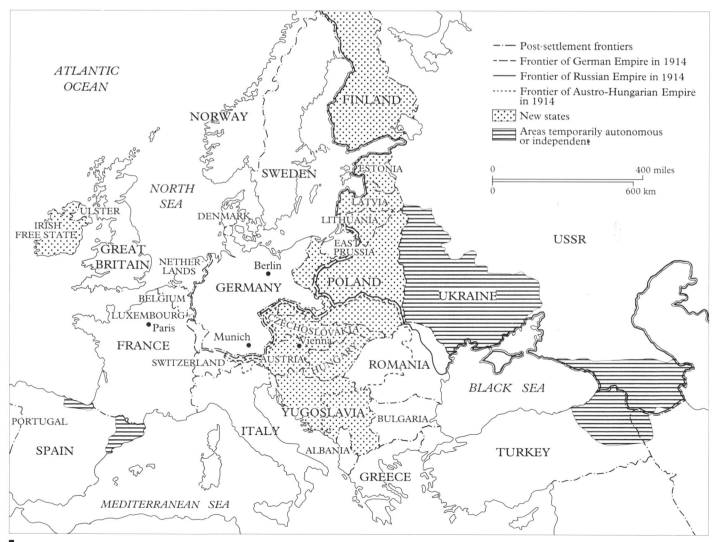

26.2 Europe in 1919.

Among avant-garde, as well as ultra-nationalist groups there was even a certain impatience for war, as the only thing which would clear the air. In 1909 Filippo Tommaso Marinetti (1876–1944), the leader of the Italian Futurists (see page 462), called for war as "our only hope, our reason for living, our only desire!" Significantly the tract in which this inflammatory phrase appears is called *Let's Murder the Moonshine*. It was directed against Symbolism.

There had been no universal war in Europe since the fall of Napoleon, and neither the eager avant-gardists or anyone else had the least idea of the social and economic dislocation the conflict would entail.

Philosophy

The makers of the twentieth century

It is a curious fact that the thinking of the twentieth century has been largely dominated by ideas formulated in the nineteenth. Marx and Freud have been especially influential. However, in the decade and a half which preceded the outbreak of World War I both remained little known, except to specialists. The great artistic innovations of the period had a curiously unstable—one could also say insubstantial—foundation in abstract thought.

For example, a major but now forgotten influence on the first wave of Modernists was occultism. Symbolism had brought with it a revival of interest in occult doctrines of all kinds. One of the most popular creeds was Theosophy, a movement with which many leading members of the avant-garde became involved. The classic formulation of theosophical teachings is *The Secret Doctrine* (1888), written by Mme. Blavatsky (1831–91). This mingles Western occult traditions with ideas borrowed from oriental religions and American spiritualism of the mid-nineteenth century. It places all these within a framework which owed a good deal to contemporary scientific ideas about evolution.

Another influence, better known at this stage in artistic and literary circles than either Marx or Freud, was Nietzsche. The image of the superman, as Nietzsche had envisaged him, found an important place in the personal mythology which sustained avant-garde artists.

One newly established philosopher who had an immedi-

	1890	1910	1930	1950	1970	1990
HISTORICAL BACKGROUND		Outbreak of World War I 1914 Russian Revolution 1917 Weimar Republic in Germany 1919–33	World War II 1939–45 Holocaust 1940–45 First atomic bomb dropped on Hiroshima 1945	Vietnam War 1959–73 First man on moon	Collapse of Communism in Eastern Europe	
PHILOSOPHY/ RELIGION	Bergson *Creative Evolution*	Wittgenstein *Tractatus* Dewey and pragmatism	Satre *Bang and Nothingness*			
ARCHITECTURE	Gaudí, Sagrada Familia (**25.1**) Wright, Robie House (**26.3**)	Le Corbusier, Villa Savoye (**27.2**)	Speer, Reichs Chancellery (**27.5**)	der Rohe/Johnson, Seagram Building (**28.2**)	Rogers/Piano, Pompidou Centre (**30.2**) Graves, Humana Building (**30.4**)	
VISUAL ARTS	Matisse (**26.9**) Mondersohn-Becker (**26.14**) Braque (**26.15**) Picasso (**26.16**)	Duchamp (**27.17**) Malevich (**26.23**) Tatlin (**26.24**) Foundation of Bauhaus 1918	Dali (**27.16**) Hopper (**28.6**) Gorky (**28.7**) Dubuffet (**29.6**) Balthus (**29.7**) Bacon (**29.8**)	Pollock (**28.9**) Rothko (**28.8**) Johns (**28.11**) Warhol (**28.13**) Rauschenberg (**28.10**) Beuys (**30.14**)	Freud (**30.1**) Kiefer (**30.7**) Baselitz (**30.6**) Long (**30.10**) Chicago (**30.12**) Sherman (**30.13**)	
LITERATURE/ DRAMA	Proust *Remembrance of Things Past* Apollinaire *Alcools*	Joyce *Ulysses* Eliot *The Wasteland* Woolf *To the Lighthouse* Kafka *The Castle* Faulkner *As I Lay Dying*	Robbe-Grillet Pasternak *Dr. Zhivago* Beckett *Waiting for Godot* Brecht *Mother Courage*	Celan *Death Fugue* Plath *Ariel*	Marquez *Love in the Time of Cholera*	
MUSIC		Schoenberg *Erwatuns* Stravinsky *Rite of Spring* Berg *Wozzeck*	Prokofiev *Romeo and Juliette*	Copland Stockhausen	Glass *Akhenaten* Cage	

ate impact on Modernist thought was Henri Bergson (1859–1941), thanks to his immensely popular book *Creative Evolution*, which appeared in 1907, and soon reached a wide public. One thing which made Bergson important to the Modern movement was his emphasis on the importance of time. For him, the notion of "time" involved both the accumulation of memory, which preserved the past without being itself in any way physical, and the non-existence of the future, which, by its very nature, stands outside time. The life of the universe was, for Bergson, a process of continuous creation, undetermined and unpredictable, but still the work of some kind of divine consciousness. The Bergsonian catchphrase was "*élan vital*"—this meant the "life drive," or original energy which, struggling with the resistance of matter, produced higher and higher states of intelligence and creativity.

Bergson also influenced the new generation of Modernists through the stress which he put on the value of intuition, as opposed to reason. This undermined the mechanistic nature of nineteenth-century scientific thinking, and challenged the determinism of much nineteenth-century philosophy. In Bergson's hands, reason became only one of the organs of life, and not necessarily the most important of them.

Bergson's doctrines were often taken up by avant-garde writers and artists in a much more exaggerated form than he himself was prepared to give to them. Despite their own refinement and subtlety of expression in Bergson's hands, they became linked to an enormous impatience with the refinement and preciosity of Symbolism, and, in a more general sense, with the burdensome elaboration of Western bourgeois society. Bergson's *élan vital*, must, it seemed to many of his followers, result inevitably in some kind of explosive catharsis. Many of the first generation of Modernists were rushing eagerly toward a catastrophe which they already partly foresaw.

The beginnings of Modernist architecture

Modernist architecture did not make as decisive a start as Modernist painting and sculpture. In some ways, however, the work done by the very earliest generation of Modernist architects was more prophetic than anything produced by the same generation of painters. It spoke, though sometimes only tentatively, about new life-styles, new materials and techniques, and the new building types which arose from the demands made by twentieth-century society.

Among the architects of the immediately prewar period, three are of major importance. They were the American Frank Lloyd Wright (1869–1959), the Frenchman Auguste Perret (1874–1954), and the German Peter Behrens (1868–1940).

Of these, Frank Lloyd Wright was incomparably the most original. Wright produced beautiful and innovative buildings throughout his long life. The designs of greatest historical importance, however, belong to the second phase of his career, after he left the office of Louis Sullivan in 1893. Wright, who had been born in Wisconsin, but who spent a part of his childhood in Massachusetts, moved to Chicago at the age of eighteen to begin a career as an architect, and in 1887 took a job with the most progressive architectural firm in the city, Adler & Sullivan. It soon fell to his lot to do the smaller jobs which Sullivan himself was too busy to handle—most of these were private houses.

Even before he set up on his own, Wright had begun to evolve a new type of domestic building—what he called the "prairie house." Its characteristic lines were long and low. The main rooms, instead of being separated, became interpenetrating areas spreading out from a central core, which contained the main fireplace, chimney stack and kitchen. One of the most fully developed of Wright's prairie houses is the Robie House of 1909 (Fig. **26.3**). This has the sweeping horizontal lines which Wright perfected, and the typical terraces which marry the building with its surroundings. In its studied simplicity, the building discards all historical elements. The main influence seems to come from Japanese architecture, which Wright began to study long before he first went to Japan in 1905. Wright's prairie houses, though they were designed for a prosperous middle-class clientele, seemed to call for a different, less formal, more relaxed way of living. This was one reason why his designs made such a profound impact in Europe when they were handsomely published by the German firm of Wasmuth in 1911.

Wright's European rivals were less isolated, but also less radically original than he was. Auguste Perret is important as a pioneer in the use of reinforced concrete construction—concrete was to become one of the preferred materials of the International Modernist movement in architecture. One of his most radical early buildings was a garage—a new building type which called for an untraditional solution. The Garage Ponthieu in Paris 1905–6 (Fig. **26.4**), uses a reinforced concrete framework whose nature is expressed by the skeletal façade. Perret employed the classical elements of

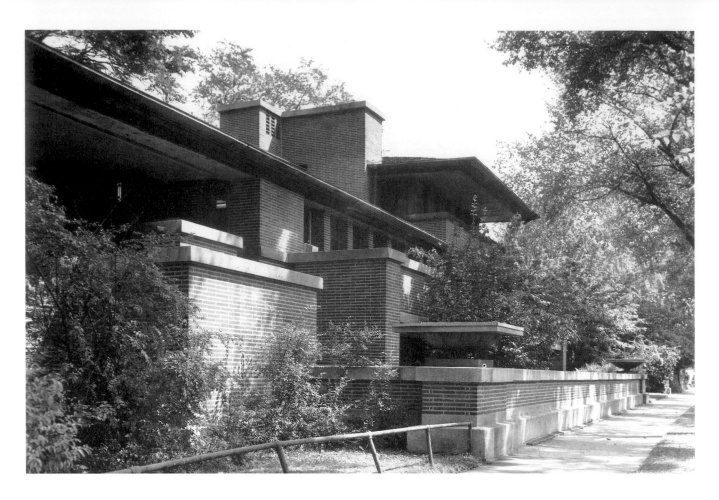

26.3 **Frank Lloyd Wright**, Robie House, Chicago, 1907–9.

26.4 **Auguste Perret**, Garage Ponthieu, Paris, 1905–6.

the Beaux-Arts architecture of the time—pillars, frieze, and cornice—but stripped them of traditional ornament and reduced them to their barest essentials. The only decoration is the rose-window-like glazing of the main central panel. This looks like a design for the kind of abstract painting which still lay some years in the future.

Peter Behrens was an inheritor of the tradition founded by the great Prussian architect Karl Friedrich Schinkel 1781–1841, (see page 375), which had continued to flourish throughout the nineteenth century in central Europe. He was important not only for his buildings, but because he carved out a completely new kind of architectural career. His most original work was done for the great German industrial firm of AEG (General Electricity Company). For AEG Behrens designed an enormous range of things—not only shops and factories, but industrial products of many types, and even the company stationery. He was the first architect to take on such a wide range of industrial responsibilities, and became the chief public representative of the

vigorous, innovative spirit which was shown by German industry in general in the years immediately before World War I. While his domestic buildings still make use of period allusions—their style has been described as "scraped classicism"—he did not think that such allusions were necessary in buildings which had a purely industrial function. Yet his industrial structures have a classical orderliness, a self-evident intellectuality and logic. All of this can be seen in the Turbine Factory (Fig. **26.5**) which Behrens designed for AEG in Berlin (1909–10).

It must be stressed that, unlike other Modernist manifestations in the arts, these new industrial buildings met with no opposition. They were immediately recognized in Germany as things which reflected the energy of modern life. Indeed, this early phase of Modernist architecture, taken as a whole, was not violently controversial in the way that Modernist art, literature, and music were controversial. The true controversy began only with the emergence of the Bauhaus in Germany (see page 476).

26.5 Peter Behrens, AEG Turbine Factory, Berlin, 1909–10.

Painting

The Vienna Secession

The Vienna Secession has often been pushed to the margin in standard histories of twentieth-century art. There were two reasons: it had a strong residual connection with the Symbolism of the immediately preceding epoch, and it was not based in Paris. In fact, the Secession, founded in 1897 and thus the predecessor of the various avant-garde movements which flourished in France, Germany, and Russia, contained many elements which were to be important to modern art in general.

The chief of these was that, far more than Fauvism or Cubism (see pages 454 and 458), this was a total art movement, as important for architecture and design as it was for painting. In this sense, it was the ancestor of the Bauhaus, and predicted what was to happen to Modernism in its period of fullest development.

The leading painters associated with the Secession were Gustav Klimt (1862–1918), Egon Schiele (1890–1918), and Oscar Kokoschka (1886–1980). Klimt, much older than the other two, was closely connected with the continuing International Symbolist movement in the 1890s, and often made use of favorite Symbolist themes—for example, as in *Salome* (Fig. **26.6**) of 1909. A powerful and rebellious personality, called *König* ("king") by his friends, he led the revolt against academic art in the Viennese milieu. His gift for pattern makes him one of the important predecessors of true abstraction in art.

The short-lived Schiele, who died in the great influenza epidemic of 1918, was a draftsman of genius, as can be seen from his *Self-portrait Drawing a Nude Model in Front of a Mirror* (Fig. **26.7**) of 1910. In his work, the Vienna Secession makes a significant shift. Much of Schiele's work is erotic—his drawings of female nudes, many of them pubescent or even pre-pubescent, are especially powerful, and link him to the Decadent strain within Symbolism. But they also strike an unmistakably personal note of anguish. In Schiele's drawings one finds reflected the neurasthenia of Viennese society—the qualities which are scientifically explored in the writings of Freud. In his art, and also in his conduct, Schiele constantly made the point that the artist's behavior could no longer be separated in any meaningful way from the work produced. This was to become one of the self-evident truths of the Modernist movement.

The early work of Oscar Kokoschka reiterated these attitudes. His affair with Alma Mahler, widow of the great composer, is celebrated in one of his best-known paintings, *The Bride of the Wind* (Fig. **26.8**), which shows the two lovers being swept away in the storm of their own passion. This painting, which dates from 1914, was painted after Kokoschka had already come into contact with the burgeoning Expressionist movement in Germany (see page 455).

Kokoschka's work, like Schiele's, demonstrates how many of the attitudes which came to be accepted as typical of the twentieth-century avant-garde were already latent within Symbolism.

26.7 Egon Schiele, *Self-portrait Drawing a Nude Model in Front of a Mirror* 1910.
Black chalk. Albertina, Vienna.

26.6 (*right*) **Gustav Klimt**, *Salome* 1909.
Oil on canvas, 70½ × 18⅛ ins (178 × 46 cm). Galleria d'Arte Moderna, Venice.

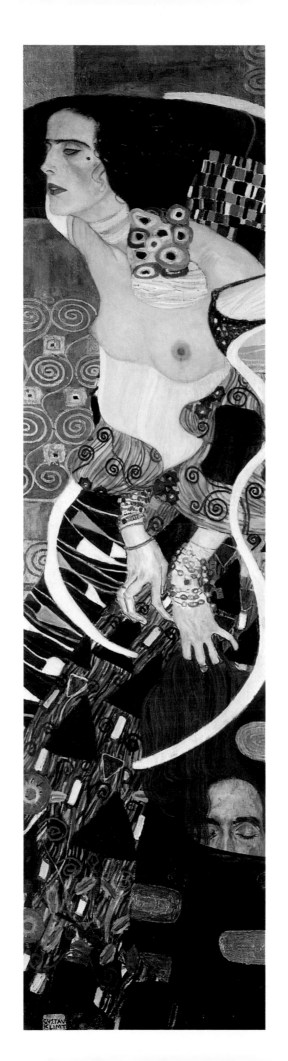

26.8 Oskar Kokoschka, *Bride of the Wind* 1914. Oil on canvas, 71¼ × 87 ins (181 × 221 cm). Öffentliche Kunstsammlung, Basle.

The Fauves

The definitive advent of Modernism is often dated from the dramatic appearance of the Fauves in the Paris Salon d'Automne of 1905. The group was led by Henri Matisse (1869–1954). Other members—soon to go their own way— included André Derain (1889–1954) and Maurice de Vlaminck (1876–1958). They owed their collective nickname to the critic Louis Vauxelles, who compared an anodyne sculpture placed in the room in which their works were hung to "Donatello among the *fauves* [wild beasts]."

The Fauves were influenced by Gauguin (see page 426) and Van Gogh (see page 427), and also by the Nabis—as

early as the 1890s, Vuillard (see page 432) had been producing small paintings which were as radical in their use of color as anything exhibited in 1905.

Fauvism was shaped by the temperament of Matisse, summed up in his remark that "Composition is the art of arranging in a decorative manner the various elements at a painter's disposal for the expression of his feelings." Significantly, Matisse's art, though violent in color, is very different from Van Gogh's, since he deliberately avoided autobiographical content. What he wanted to do was evolve a new kind of monumental decorative art.

The culmination of his early work is the large canvas *The Dance* (Fig. **26.9**) of 1910–11. It shows a ring of dancing figures against a boldly simplified background. These attempt to re-create the mood of Gauguin's Tahitian canvases in more intense, but also less specific, form.

Matisse drew inspiration from a number of traditions in both Western and European art. These included the work

of Ingres (see page 383), that of Delacroix (see page 381) and other nineteenth-century painters who portrayed "orientalist" scenes, and of Gustave Moreau (see page 426), who was his teacher. More exotic influences included Russian icon-painting, with its intense colors, firm outlines, and characteristic flatness; and, in particular, Islamic art. He paid three visits to North Africa before World War I, and made a careful study of Islamic works such as seventeenth-century Persian miniatures and Iznik (Ottoman Turkish) tiles. He thus built up a store of oriental and quasi-oriental motifs which he used for the rest of his career. He was especially affected by Islamic artists' use of simplified forms and areas of flat color—the qualities they had in common with Russian icon-painters. Their work had as decisive an impact on him as that made by Japanese prints on the European artists of an earlier generation, such as Van Gogh (see page 427) and Toulouse-Lautrec (see page 436).

The culmination of these tendencies came very late in his career. In 1941 he had an operation which permanently damaged the muscles on one side of his stomach. From then on he could hold himself upright only for short periods, and it became difficult, therefore, to stand or even sit at his easel. Matisse's solution was to abandon painting in favor of making brilliantly colored large-scale paper cutouts, using shapes cut from sheets he had colored himself. The best of these, such as *The Parakeet and the Mermaid* (Fig. **26.10**) of 1952, a mural decoration devised for his own studio in Nice, takes leave of Western traditions of pictorial composition almost completely. The parakeet and the mermaid of the title have no narrative relationship to one another; there is no perspective, not even any feeling of depth. Though some elements remain figurative—in the sense that the spectator can recognize immediately what they represent—they are used in an abstract, purely arbitrary way.

Expressionism

Fauvism was more directly influential in Germany than it was in France. Circumstances, however, insured that Matisse's deliberate avoidance of autobiography, and indeed of emotional extremes of all kinds, was subverted. The way was prepared by Edvard Munch, who held a violently controversial exhibition in Berlin in 1902, which prepared the way for the foundation of the Berlin Secession. In 1905 there was a major Van Gogh show in Dresden. This was the background against which the work of the Fauves was seen. Matisse's first one-man show in Germany took place in 1906 in Berlin.

By this date the first Expressionist group in Germany had already been founded. In 1905 a group of young artists came together in Dresden to form Die Brücke (The Bridge). This was followed, in 1911, by the foundation of Die Blaue Reiter (The Blue Rider), another radical art group, in Munich. Where Matisse saw brilliant color as a way of creating pictorial structure, for the new German artists painting was a way of projecting subjectivity, of imposing truths which they discovered within themselves on the world of appearances.

The leading members of Die Brücke included Ernst Ludwig Kirchner (1888–1938) and Emil Nolde (Emil Hansen, 1867–1958). Between them these two artists encompass most of the typical German Expressionist themes—frantic sexuality, the horrors and miseries of urban life, and mystical union with nature. Kirchner's *Five Women in the Street* (Fig. **26.11**) of 1913–15 is a characteristic Expressionist image, summing up the corruption of life in a great city. Equally characteristic, though in a wholly different fashion, is Nolde's *Tropical Sun* (Fig. **26.12**) of 1914. Representing a tribal dance, this is the product of a voyage Nolde made as part of an official expedition to the German territories in the South Pacific, newly acquired as part of the European race for colonial expansion. It shows the continuing interest in primitive cultures, present in European art ever since Gauguin's voyages to Tahiti. It also shows significant emphasis on the idea of the instinctive and the frenzied—something which was to be of great significance to twentieth-century art in general.

The Blaue Reiter group in Munich was more cosmopolitan than Die Brücke, thanks largely to the influence exerted by the Russian-born, but Munich-trained Vassily Kandinsky (1866–1944). Other members included the Swiss Paul Klee (1879–1940) and Franz Marc (1880–1916), who was killed in World War I. Perhaps because his development was so brutally cut short, Marc now seems the most typical figure in the group. He had a keen sympathy with the natural world, and his symbolic paintings of animals, such as his *Red Roe Deer II* (Fig. **26.1**) of 1912, show the continuation of a kind of nature mysticism which had already manifested itself in the German Romantic period.

Klee survived the war, and, like Kandinsky, became an important link between prewar Expressionism and the Bauhaus (see page 476), where he was an influential teacher. His work matured more slowly than that of fellow members of the Blaue Reiter, perhaps because the emotional violence of Expressionism was essentially alien to his quiet temperament. Yet he too was looking for a force which would liberate him. Like Matisse he found it in the culture of Islam. In 1914 he paid a brief visit to Tunis, where the light and color of North Africa had an overwhelming effect. He wrote in his journal:

> Color has taken hold of me; no longer do I have to chase after it. I know that it has hold of me forever. That is the significance of this blessed moment. Color and I are one. I am a painter.

(Quoted in EDWARD LUCIE-SMITH, *Lives of the Great Twentieth-century Artists*. Weidenfeld and Nicolson, 1986.)

This liberation is clearly evident in Klee's watercolor *Before the Gates of Kairouan*, painted during the visit (Fig. **26.13**).

26.9 Henri Matisse, *The Dance* 1910–11.
Decorative panel, oil on canvas, 102¼ × 125½ ins
(259.7 × 318.8 cm). The Hermitage, St. Petersburg.

26.10 Henri Matisse, *The Parakeet and the Mermaid* 1952.
Paper cut-out, 40½ × 30½ ins (102.8 × 77.4 cm).
Stedelijk Museum, Amsterdam.

26.13 Paul Klee, *Before the Gates of Kairouan* 1915. Watercolor on paper, 8¼ × 12½ ins (21 × 31.5 cm). Klee Foundation, Berne.

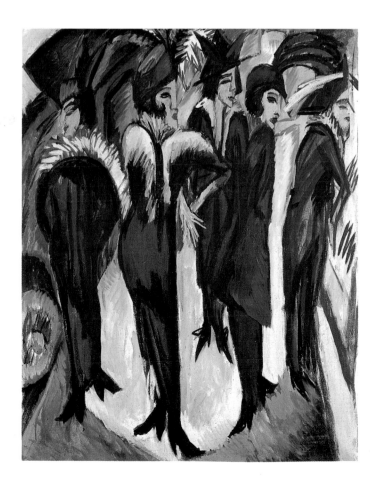

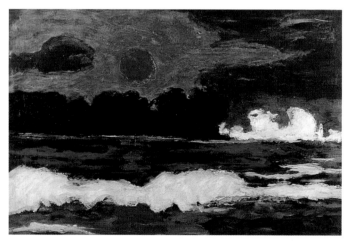

26.12 Emil Nolde, *Tropical Sun* 1914. Oil on canvas, 28 × 41 ins (71 × 104.5 cm). Emil Nolde Foundation, Sebüll.

26.11 (*left*) **Ernst Kirchner**, *Five Women in The Street* 1913–15. Oil on canvas, 47½ × 35½ ins (120.6 × 90.2 cm). Rheinischer Bildarchiv, Ludwig Museum, Cologne.

Paula Modersohn-Becker

The ideas and discoveries of German Expressionism were to some extent anticipated by the tragically short-lived Paula Modersohn-Becker (1876–1907). Trained in Berlin, Modersohn-Becker had her first real contact with "progressive" ideas in the Worpswede artists' colony—Worpswede is a small village about twenty miles north of Bremen. The resident artists, who included a number of women, painted in a semi-impressionist style and cultivated an interest in folk-culture. It was a tolerant, but at the same time provincial and limiting environment.

Unlike her contemporaries in Germany, Modersohn-Becker had the courage to break away from this. In 1900, flouting convention, she made an independent visit to Paris to work and study. Though she married a fellow Worpswede painter the next year, this was the first of a series of such visits. The fourth and last took place in 1906–7. In Paris, Modersohn-Becker got to know the work of Cézanne, Gauguin, Van Gogh, and the Nabis (see page 432). She also saw the work of the Fauves (see page 454) at the 1905 Salon des Indépendants.

Her preferred subject matter included representations of children, either alone or with their mothers, and self-portraits. A moving and remarkable *Self-Portrait on her Sixth Wedding Day* 1906 (Fig. **26.14**) shows her semi-nude and pregnant. The pregnancy is imaginary—she did not conceive her only child until about six months after it was painted; she died of a heart-attack shortly after giving birth to a daughter in November 1907.

This powerful painting seems to symbolize two things: on a personal level, her desire for a child; but on an artistic one her feeling that she was in the process of giving birth to something new, which was also entirely part of herself. The firm outlines and simplified boldness of form are typical of Modersohn-Becker's mature style, which goes beyond the simplifications of Gauguin and seems to challenge the work Matisse was producing during the same period. Where Matisse remains emotionally detached, Modersohn-Becker is full of subjective emotion—in this case tenderness, pride, and perhaps a touch of fear for the future. She was the first woman artist to establish an avant-garde style which was recognizably in advance of what was being produced by her male colleagues.

Cubism

Cubism enjoys a unique reputation among twentieth-century avant-garde styles. If the appearance of the Fauves

26.14 Paula Modersohn-Becker, *Self-Portrait on her Sixth Wedding Day* 1906. Oil on board, 40 × 27⅝ ins (101.5 × 70.2 cm). Ludwig–Roselius Sammlung, Bremen.

26.15 Georges Braque, *Houses at L'Estaque* 1908.
Oil on canvas, 28¾ × 23⅝ ins (73 × 59.5 cm). Kunstmuseum, Bern.
The Hermann and Magrit Rupf Endowment Collection.

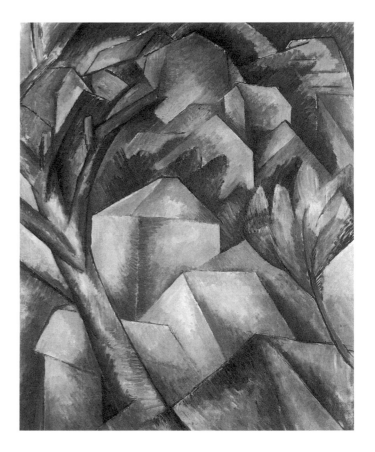

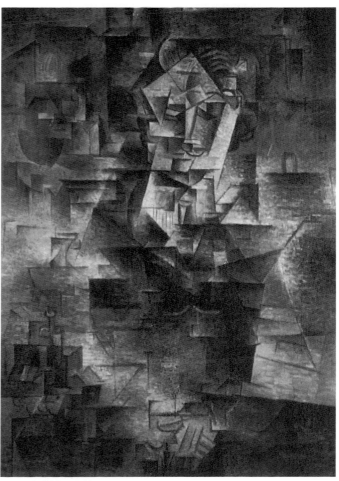

26.16 Pablo Picasso, *Daniel–Henry Kahnweiler* 1912.
Oil on canvas, 39⅝ × 28⅝ ins (100.5 × 72.6 cm). The Art Institute of
Chicago. Gift of Mrs. Gilbert W. Chapman.

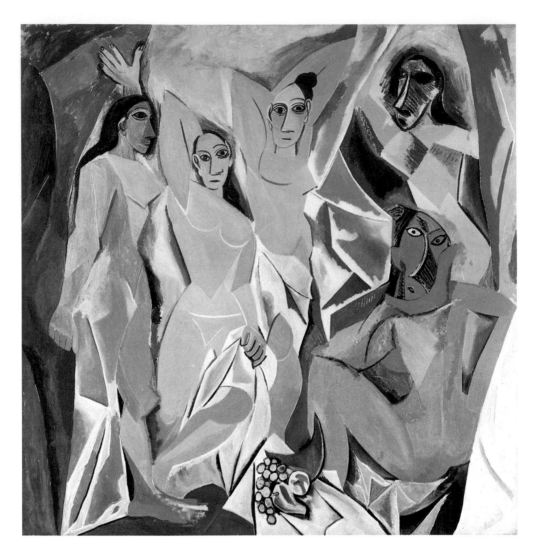

26.17 **Pablo Picasso**, *Les Demoiselles d'Avignon* (begun May, reworked July 1907). Oil on canvas, 8 ft × 7 ft 8 ins (243.9 × 233.7 cm). Collection, The Museum of Modern Art, New York. Acquired through the Lillie P. Bliss bequest.

in 1905 marked the official début of Modernism in the visual arts, Cubism has been ranked by most art historians as the central episode in the Modernist revolution. This reputation is only partly deserved.

Cubism, like Fauvism, owed its name to the jeer of a hostile critic, Louis Vauxelles, who, reviewing the Salon d'Automne of 1908, accused the young artist Georges Braque (1882–1963) of reducing "everything, landscapes and figures and houses, to geometrical patterns, to cubes." Vauxelles was referring to the landscapes which Braque had painted at L'Estaque, in the south of France (*Houses at L'Estaque*, Fig. **26.15**, for example), earlier that year. Braque, though he had originally been associated with the Fauves, was by instinct cool and classical, a painter in a direct line of descent from Nicolas Poussin (see page 278).

His closest colleague at this particular time, Pablo Picasso (1881–1973), was very different in temperament.

Picasso was a Catalan, precociously gifted, who had come to Paris to make his fortune, bringing with him most of the trappings of Symbolism, which flourished as mightily in Barcelona as it did in Paris and Brussels. The earliest episodes in Picasso's development, now called the Blue and the Rose periods, were essentially episodes in Symbolism's later development.

In 1906–7 Picasso reacted violently against the gentle melancholy and sentimentality of his own earlier work, and produced a revolutionary painting, *Les Demoiselles d'Avignon* (Fig. **26.17**). This combined a number of different influences—the late figure compositions of Cézanne, which Picasso had seen in a great retrospective exhibition held in 1906, African sculpture, especially masks, and the wild energy of the Fauves. Braque saw the painting and was profoundly impressed by it. This started the two artists on a joint adventure which lasted for several years.

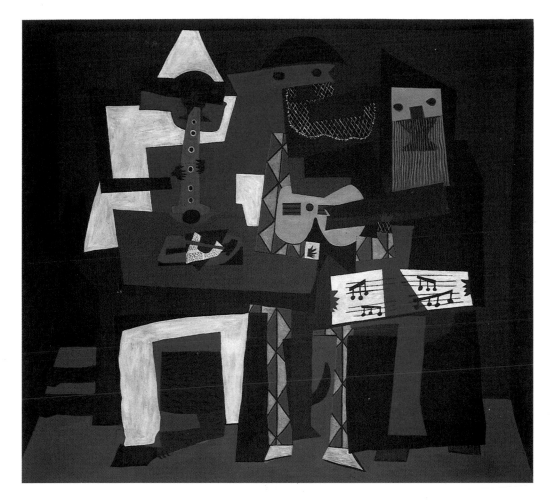

26.18 Pablo Picasso, *Three Musicians* summer 1921.
Oil on canvas, 6 ft 7 ins × 7 ft 3¾ ins (200 × 223 cm). Collection, The
Museum of Modern Art, New York. Mrs. Simon Guggenheim Fund.

When one looks at *Les Demoiselles* now, one can see how much of Picasso's later career is foreshadowed in it—not merely the power of formal invention but the energy, the demonic ferocity, and the element of misogyny. The most protean and changeable artist of the twentieth century, Picasso was to make constant use of formal ideas which first appear in this painting. One of the most obvious is the combination of full-face and profile views to be found in the lower figure on the right.

As Cubism originally developed, however, it took a more tranquil and classical line, closer to the temperament of Braque than to that of Picasso. In its first phase, now called Analytic Cubism, it was a system for analyzing form, derived chiefly from Cézanne. Braque and Picasso wanted to show the reality of what they perceived in a completer and profounder fashion than could be achieved by the academic painting of the official Salons, or, for that matter, by photography. Objects were shown in unfolding, overlapping views which gave spectators the feeling that they were actually walking round them, and seeing them from several different standpoints at once. The composition became a pattern of interlocking facets. The system reached its highest point of elaboration in a number of monumental portraits—for example, Picasso's likeness of his dealer, *Daniel-Henry Kahnweiler* (Fig. **26.16**) of 1912.

It soon became apparent that this way of painting imposed certain limitations. Picasso and Braque were forced to abandon bright color, or any attempt to represent texture. The latter problem was solved by the invention of an entirely new technique—collage. Instead of attempting to paint reality, the artist inserted an actual fragment of reality—a scrap of newspaper, or of wood-grained paper, or even a fragment of chair-caning, into the composition. This offered an indication of what the true color and texture of the object represented were. Not surprisingly, it worked best with still life, but still-life paintings were, in any case, the preferred genre of the early Cubists.

Collage, which detached texture from form, led to a further development of Cubism. The technique extended to produce compositions which, far from being fully three-dimensional, consisted of a series of planes floating one behind the other in a space much shallower than the

traditional box produced by using the established Renaissance system of perspective. It was discovered that these floating planes could be "coded" so as to produce not a representation of reality but an alternative reality. An impressive example is Picasso's *Three Musicians*, (Fig. **26.18**), which exists in two versions, both painted in the early 1920s. This style is now labeled Synthetic Cubism.

Long before *The Three Musicians* was painted, Cubism had passed from being the property of just two artists, working largely in private, to being a popular new visual language. This was because, first, it offered something complete and systematic, a grammar which could be learned, and secondly, it had such strong decorative possibilities. The two most important artists to adopt the new Cubist style were Fernand Léger (1881–1955) and Picasso's Madrid-born compatriot Juan Gris (1887–1927). In the 1920s both were prolific painters of the still lifes with which Cubism is now chiefly associated. After World War II, Léger, his Cubism now much modified, produced monumental figurative compositions, such as *La Lecture* (Fig. **26.19**) of 1924, which were conscious tributes to the art of Jacques-Louis David. These served to re-emphasize Cubism's basically classical roots.

Futurism

The Modern Movement acquired a public face with the emergence of Futurism, launched in February 1909. It was announced in a rhetorical manifesto published in a Parisian newspaper, *Le Figaro*, but the author was an Italian, Filippo Marinetti (1876–1944), a poet and novelist of only moderate talent, but a publicist of genius.

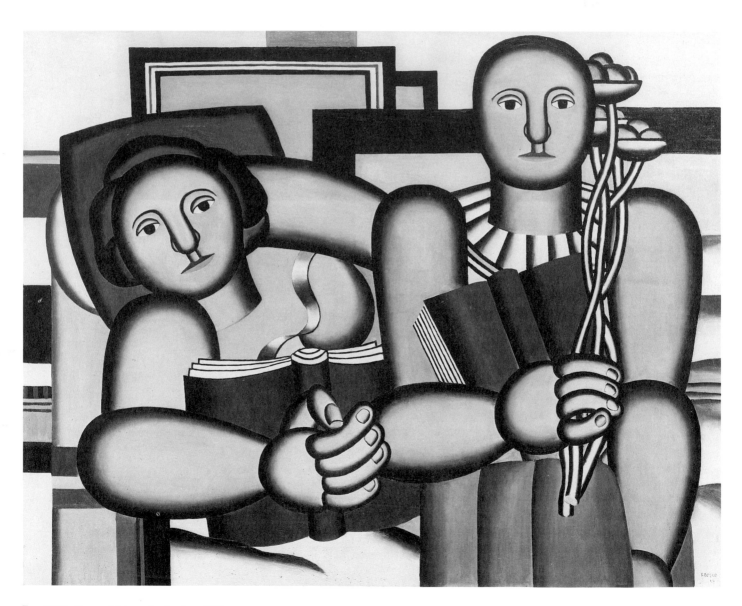

26.19 Fernand Léger, *La Lecture* 1924.
Oil on canvas, 44⅞ × 57½ ins (114 × 146 cm). Musée National d'Art Moderne, Centre Pompidou, Paris.

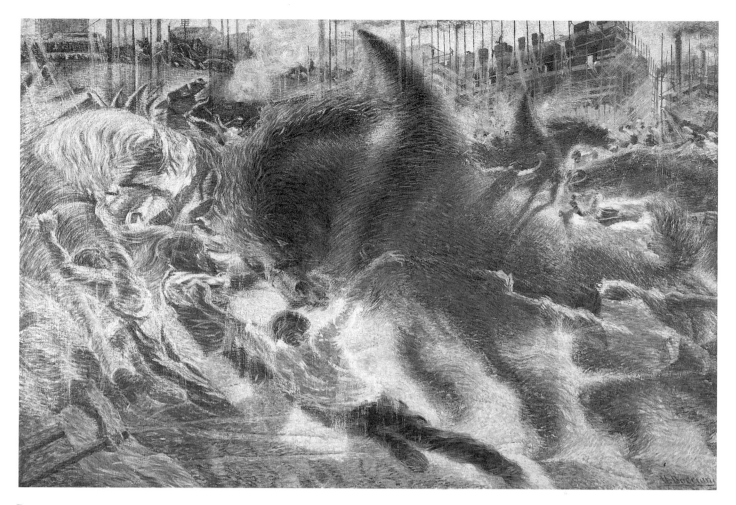

26.20 **Umberto Boccioni**, *The City Rises* 1910.
Oil on canvas, 6 ft 6 ins × 9 ft 10½ ins (199.3 × 301 cm). Collection,
The Museum of Modern Art, New York. Mrs. Simon Guggenheim
Fund.

Futurism was a mixture of national and international elements. The early members of the movement were all Italians, caught up in nationalist politics and obsessed by the overshadowing greatness of the Italian past. They wanted to break free of the trammels of the past, and yet at the same time to carry a newly united Italy to fresh glory. They were hostile to Symbolism, both because it was hermetic and apparently lacking in energy and also (paradoxically) because it now seemed to represent the ruling establishment in the arts. Additionally, they were in love with speed and the machine. It was the mixture of these feelings that inspired the Futurist Manifesto's most famous phrase: "A racing automobile . . . is more beautiful than the Victory of Samothrace!" (see page 61).

The Futurists were hostile to the heritage of the past, yet at the same time possessed by a very traditional kind of machismo. Clause 10 of the Futurist Manifesto pronounced:

We will destroy the museums, academies, libraries of every kind, will fight moralism, feminism, every opportunistic or utilitarian cowardice.

(*Marinetti: Selected Writings*, ed. R. W. FLINT.
Farrar, Straus and Giroux Inc., 1971.)

Marinetti soon recruited a number of talented artists to his cause. They included Umberto Boccioni (1882–1916), Giacomo Balla (1871–1958), and Gino Severini (1883–1966). Futurist painting owed much to Cubism in its use of transparent, overlapping planes, and it also borrowed from photographic experiments made in the late nineteenth century by Etienne-Jules Marey (see page 399), who devised a means of recording successive phases of movement (a man jumping a hurdle, for instance) on a single negative. Their concern was not merely to show unfolding aspects of the same static object or group of objects (as in a Cubist still life) but to find a way of representing the passage of time. Often the results were trivial, as in Balla's well-known painting of a little dog trotting along, its lead swinging in catenary curves, *Laughing Brush* (Fig. **26.21**) of 1918. Sometimes they took on genuine grandeur, as in Boccioni's studies of the restless movement of crowds, *The City Rises* (Fig. **26.20**) of 1910.

The Futurists aimed to be an ecumenical movement. They offered new initiatives in literature, music, theater, and architecture, though they proved to be less influential and successful in these areas than they were in painting. They were given to organizing noisy manifestations, which

FOCUS

African Art and Cubism

Sculpture from Africa and Oceania began to impinge on the consciousness of Europeans in the late nineteenth century, but as scientific specimens rather than as works of art. Temporary exhibitions were held in Paris during the 1870s, and in 1882 an Ethnographical Museum was opened at the Palais du Trocadéro. The first artist to take such sculptures

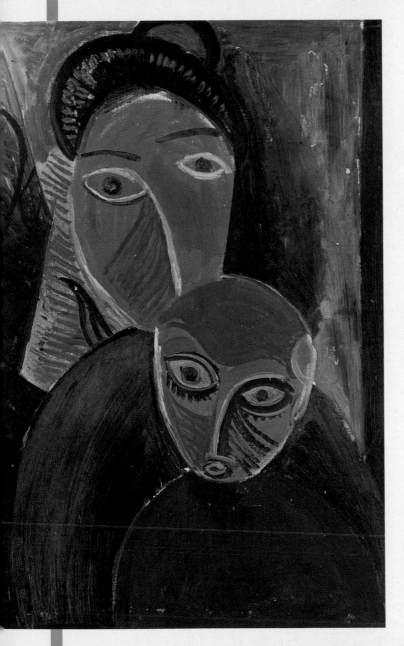

Pablo Picasso, *Mother and Child*, 1907. Oil on canvas. Musée Picasso, Paris.

Paul Gauguin, *Hina and Fatu*, 1892–3. Tamanu wood carving, 12⅘ ins (32.7 cm) high. Art Gallery of Ontario, Canada. Gift from the Volunteer Committee Fund, 1980.

seriously for their purely aesthetic qualities was also one of the few to have visited one of the places they came from. During his time in the South Seas, Paul Gauguin (see page 426) produced some woodcarvings based on Polynesian originals.

However, it was African, not Polynesian art which had a major impact on the next generation of avant-garde artists, and especially on the Cubists. In the early years of the twentieth century, before Cubism, Picasso was aware of the art of Gauguin and already interested in the idea of "primitivism." Immediately before his discovery of African art, he produced a series of paintings influenced by early Iberian stone carvings. The changeover of influence occurred while he was planning the *Demoiselles d'Avignon* (see page 460), where the heads of the figures show parallels with African masks. The African influence is even more marked in related but smaller works done at the same period, such as *Nude with Raised Arms*. Here the head can be directly linked to Kota reliquary figures in wood and brass from the Congo. Picasso had two of these in his own collection.

Picasso claimed that there was an important difference between his own appreciation of African art and that of Braque (see page 460). The latter, he said, "did not really understand '*art nègre*' because he was not superstitious." That is, he liked it for its formal qualities, while Picasso liked it for its "magic," or inner power.

In fact neither Picasso nor Braque knew much about the circumstances in which the sculpture they admired had been produced. They valued it because it stimulated their own creative faculties, and at the same time seemed to symbolize a rejection of the culture that surrounded them, which struck them as decadent and effete. What they admired was both the direct expression of the relationships between the various forms—the nose and the plane of a cheek, for example—and what seemed to them a certain roughness and brutality.

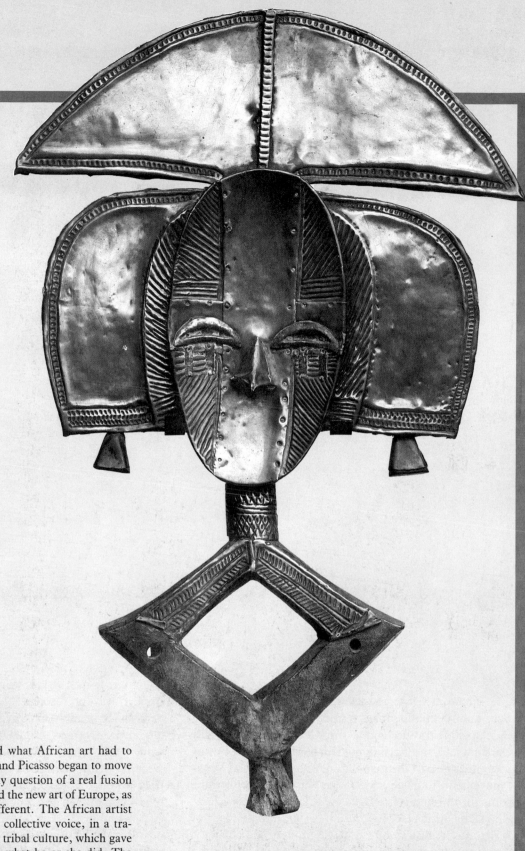

As soon as they had absorbed what African art had to offer them on this basis, Braque and Picasso began to move away from it. There was never any question of a real fusion between traditional African art and the new art of Europe, as the aims in each case were so different. The African artist spoke with what was primarily a collective voice, in a traditional way, on behalf of a whole tribal culture, which gave context and therefore meaning to what he or she did. The concept of originality had no place; the sculptor was often content to reproduce traditional forms as exactly as possible. The European artist was concerned above all to express his or her own individuality, and every work he or she produced had to be a new departure.

Ancestral figure of wood overlaid with copper and brass, late 19th century. Bakote, Ogowe district, French Congo. British Museum, London.

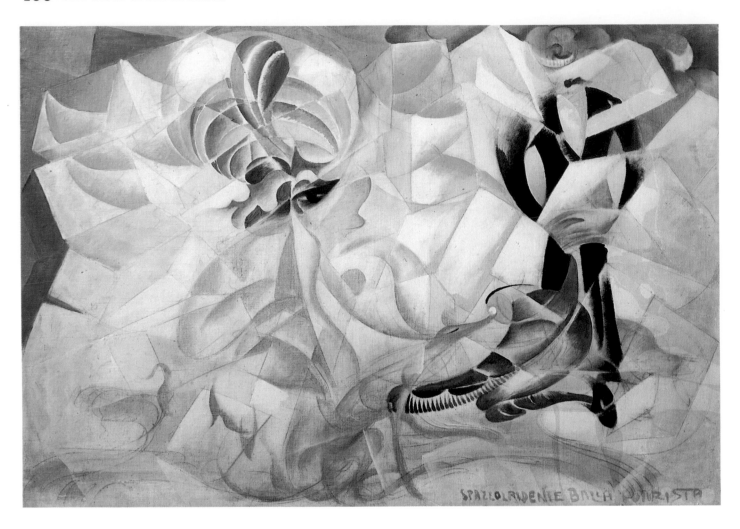

26.21 Giacomo Balla, *Laughing Brush* 1918. Oil on canvas, 27 × 40 ins (69 × 102 cm). Collection Jucker, Milan.

for the first time gave the new European avant-garde a recognizable public identity. Marinetti, in particular, was an indefatigable traveler and lecturer, carrying the Futurist gospel far afield, to England and Russia. In England Futurism was in large part the inspiration of the ephemeral Vorticist movement, founded in 1913. In Russia, it supplied the impetus for the emergence of a new Russian avant-garde.

The factor which has obscured the central importance of Futurism to the history of the whole Modern Movement is political: this was a movement of the radical right, not the radical left. In political terms, Marinetti was a right-wing nationalist in the same mold as Mussolini, and there was a brief period when the two men were rivals for the leadership of the nationalist cause in Italy. After Mussolini's triumph, Marinetti became assimilated into the new regime, and ended his life as a Fascist functionary.

Kandinsky and the birth of abstraction

For many years abstraction was considered to be the true hallmark of modern art, and despite the stubborn survival of figuration, something of this attitude still lingers. So does confusion about what is and is not abstract. Can it contain references to the external world, or must it be quite separate from it, with no recognizable imagery? One reason for the persistence of these controversies is that abstraction in art has always seemed exotic within the Western tradition, while it has been an integral part of non-Western culture—in India (with Tantric art in particular), in Muslim countries (where the depiction of the human figure is forbidden by Islam, though the rule was often enough broken), in Africa, and in Oceania.

Cubist and Futurist painting have often been described as abstract. In fact, this is not the case. Both are very much concerned with the world of appearances, but offer such an intricately coded version of it that the uninitiated viewer finds the image hard to construe.

True abstraction seems to have been introduced into Modernist art by a Russian artist working in Germany, Vassily Kandinsky, one of the founder-members of Die

Blaue Reiter (see page 455). In 1909 Kandinsky was painting pictures which combined Jugendstil (German Art Nouveau) elements with others which were linked to Expressionism. One day, at twilight, he came into his studio:

> Suddenly my eyes fell upon an indescribably beautiful picture that was saturated with an inner glow. I was startled momentarily and quickly went up to this enigmatic painting in which I could see nothing but shapes and colors the content of which was incomprehensible to me. The answer to the riddle came immediately: it was one of my own paintings leaning on its side against a wall.
>
> (Quoted in EDWARD LUCIE-SMITH, *Lives of the Great Twentieth Century Artists*. Weidenfeld & Nicolson, 1986.)

The experience prompted Kandinsky to try to produce pictures which would reliably re-create the sensations he had experienced as a result of this incident (*Composition 111* of 1913, Fig. **26.22**, for example). His explorations became linked in his own mind to Theosophy—he was a convert to the doctrines of Mme. Blavatsky—and also to the Russian Orthodox faith, which remained with him all his life. In the interwar years, when he held a professorship at the Bauhaus, he pursued the idea of abstraction in a more systematic way, by now influenced by the Constructivist doctrines so prevalent within the Bauhaus itself.

The Russian avant-garde

Russia saw a greater proliferation of avant-garde groups, and avant-garde theories to go with them, than any other country in the immediately prewar period. Their sources of inspiration were various. In St. Petersburg the new art was largely Symbolist-inspired, and gathered round the personality of Serge Diaghilev (1872–1929), founder-editor of the luxurious magazine *Mir Iskusstva* (*The World of Art*), founded in 1898, and later director of the Ballets Russes.

In terms of artistic innovation, however, this group was soon surpassed by artists and art movements associated with Moscow. Their art was at first a fusion of ideas borrowed from abroad—from Fauvism as well as from Cubism and Futurism—with others taken from Russian folk-art, particularly the brightly colored *lubok* prints popular with the Russian peasantry. Attention had already been directed toward this folk-art by a strong Russian Arts and Crafts movement.

The use of folk elements was an expression of Russian nationalism. With the foundation in Moscow of a group ironically called the Donkey's Tail, the newly self-confident Russian avant-garde sought to demonstrate its independence from the "decadence" of western Europe. Many of the contributors to the exhibition organized by the new group in March 1912 based their work on ideas borrowed from Russian peasant art—not merely traditional woodcuts, but peasant embroideries and painted trays.

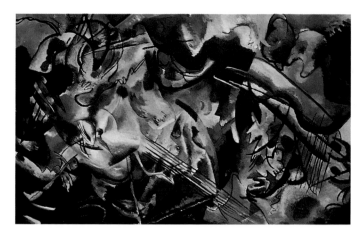

26.22 **Vassily Kandinsky**, *Composition III* 1913. Oil on canvas, 76¾ × 118 ins (195 × 300 cm). The Hermitage, St. Petersburg.

Two of the contributors to the exhibition—later arch-rivals—were Kasimir Malevich (1878–1935) and Vladimir Tatlin (1885–1953). Both were to move on from peasant-inspired primitivism to a new and radical form of abstraction. Though the abstract art they produced was in many respects very similar, they gave it diametrically opposed interpretations—an early example of the ambiguity and lack

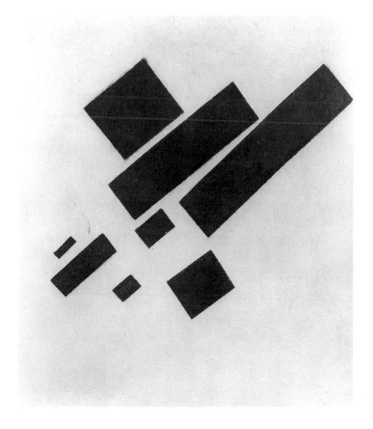

26.23 **Kasimir Malevich**, *Suprematist Painting, Eight Red Rectangles* 1915. Oil on canvas, 22⅝ × 19 ins (57.7 × 48.2 cm). Stedelijk Museum, Amsterdam.

of specific content which seem to be inherent in all abstraction.

By 1913 Malevich was producing completely abstract works using very simple geometrical forms, of a kind which he was later to label Suprematist. Some of these were so drastically simplified that they anticipated the Minimal Art of the late 1960s (see page 537). One painting consisted of a black square on a white ground, called simply *Black Square*. Another was an equal-armed cross, a third showed a plain black circle. To these designs, and the slightly more complex ones that followed (Fig. **26.23**), Malevich attached transcendental meanings. "At the present moment," he wrote in an essay of 1919, "man's path lies through space. Suprematism is the semaphore of color in this endlessness."

Tatlin, together with the new group of Constructivists who gathered round him, would have nothing to do with metaphysics of this kind. The Constructivist movement had to wait for its full development until after the outbreak of the Russian Revolution. It based itself on the paradoxical idea that purely abstract forms are also the most "concrete" ones. Because they represent nothing, and have no associations that would color our reactions to them, they become not reflections of a world which already exists, either externally or within our own minds, but entirely new objects added to the existing stock. The *Counter-Reliefs* (Fig. **26.24**) made of wood and metal done by Tatlin in 1915 (the originals have been lost, but reliable reconstructions have been made from old photographs) are concerned purely with the manipulation of space.

Constructivism was to go still further than this, however. Those connected with the movement were ardent partisans of the new political order in Russia, and this meant that they thought art should be an expression of Marxist dialectical materialism, and should fit the new patterns of society, the collectivism and the drastic social leveling, that the new regime aimed to bring about. This was one reason why they identified strongly with industry, to the extent that they

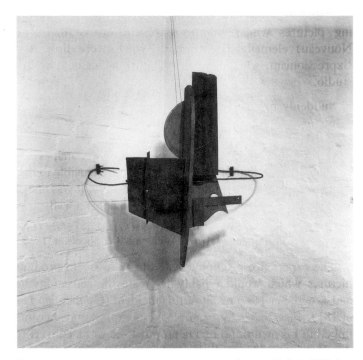

26.24 Reconstruction of Vladimir Tatlin's *Counter-Reliefs*, 1915, by Martyn Chalk, 1979. Wood, iron, wire, 31 × 31½ × 27½ ins (78.5 × 80 × 70 cm). Courtesy Annely Juda Fine Art, London.

soon made little distinction between art and industrial design.

Constructivist doctrines seized the imagination of a large part of the European avant-garde, as they became more widely known in the years after the end of World War I. Constructivism was transformed into an international movement whose influence was even more widespread than Futurism's had been, and its association with the Bolsheviks was largely responsible for giving the Modern Movement the left-wing image it possessed throughout the interwar period.

Sculpture and early Modernism

Sculptors found it much more difficult than painters to break out of the patterns set by society. They were also imprisoned by the method of working to which they had become accustomed. The nineteenth-century sculptor—even someone of the caliber of Rodin (see page 436)—was essentially a maker of monuments, and thinking about the

nature of monuments had not as yet been transformed, as it was to be by the Constructivists. In any case, because monuments had an audience much wider and less sophisticated than works of art intended for private contemplation, any departure from the expected became a focus for controversy.

Sculptural innovation came from two sources: leading painters of the time, especially Matisse and Picasso, and artists with access to alternative traditions, chiefly craft or folk-art.

Matisse came to sculpture, as he told an interviewer, not for its own sake but because it helped him to clarify his ideas. His starting point was Rodin, but he took Rodin in a new direction, simplifying and distorting the human figure. One source of ideas was Gallo-Roman statuary. The strange, elongated proportions of these primitive works fascinated Matisse, and he used them as the basis for a series of small bronzes.

His most ambitious work in sculpture are independent of this source, however. They are a series of four large reliefs, *The Back I–IV* (Fig. **26.25**). The first was made in 1910, the next two during World War I, and the last not until 1930. Matisse's point of departure seems to have been Cézanne—a desire to translate Cézanne's late nudes into fully three-dimensional form. The subject is a single female figure, seen from the rear. As the series progresses, the forms are gradually simplified, until only the main masses remain.

Picasso started where Matisse did, using established techniques—modeling and carving—to achieve unconventional results. With Cubism, he made a breakthrough. Cubist collages, which were flat, inspired works which were variants of the same technique but with the forms now realized in three dimensions. These fragile reliefs of tinplate, wood, and string were the start of a tradition of very free experimentation with materials which has been of immense importance to twentieth-century sculpture. Their rendition of solid volume by means of planes slotted together—for example, in *Guitar* (Fig. **26.27**) of 1912—anticipated the experiments made by Tatlin shortly afterwards in his *Counter-Reliefs*, though Tatlin's works are abstract while Picasso's sculpture, which he continued to make throughout his career, always retained elements of representation.

So too did that of Brancusi, though his work is often wrongly described as abstract. Brancusi came from Romanian peasant stock and in his youth was apprenticed to a cabinetmaker, though he also received a conventional training as an academic sculptor at the Academy of Fine Arts in Bucharest. In 1902 he left Romania and traveled on foot across Europe to Paris, a journey which took two years. Once there he started making sensitive sculptures in a Late Symbolist style which were admired by Rodin, who invited him to work as his assistant. The young sculptor wisely refused. Later he was to accuse Rodin—and Michelangelo too—of "working in beefsteak."

What he meant by this was demonstrated in 1908, when he produced his first fully mature work, *The Kiss* (Fig. **26.26**). Carved directly from a single block of stone whose original form is still evident, this represents two figures in a tight embrace. It has the economy and simplification of traditional folk-carving.

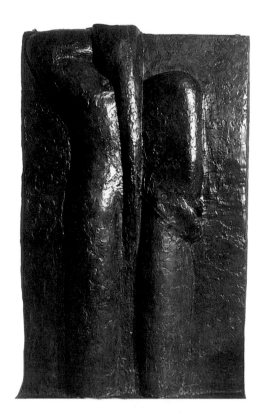

26.25 Henri Matisse, *The Back: No. IV* 1930. Bronze, 74¾ × 44 ins (190 × 112 cm). Tate Gallery, London.

26.26 Constantin Brancusi, *The Kiss* 1909. Stone, 35¼ ins (89.5 cm) high. Philadelphia Museum of Art, The Louise and Walter Arensberg Collection.

26.27 Pablo Picasso, *Guitar* Paris 1912–13.
Sheet metal and wire, 30½ × 13⅛ × 7⅝ ins (77.5 × 35 × 19.3 cm).
Collection, The Museum of Modern Art, New York. Gift of the artist.

Though Brancusi did make some sculptures in metal, direct carving now became his characteristic means of expression. He looked for the essence of whatever subject he wanted to represent—a bird, a fish, a crowing cock, or a newborn child. Each theme is painstakingly reduced to its simplest, densest form. Brancusi often made multiple versions of the same subject, each a refinement of its predecessor. Where Matisse and Picasso, the latter especially, opened up new possibilities for sculptural experiment, Brancusi tried to return sculpture to its original, primitive level—a means of producing objects filled with totemic power.

Literature

In France Baudelaire had been important not only as a poet but also as a gifted art critic, and Mallarmé had been a close ally of the most important artists of his time. This tradition, which made poets the analysts and publicists of new art, was continued by Guillaume Apollinaire (Wilhelm Apollinaris de Kostrowitzky, 1880–1918). After a childhood and youth spent mainly in the south of France, Apollinaire settled in Paris, where he soon became a central figure in the new avant-garde. While his chief ambition was always to be a poet, he busied himself defending the work of the painters who were his friends. His book *Les peintres cubistes* (1913) was the first major study of Cubism.

It was published in the same year as Apollinaire's first major collection of poems, *Alcools*. His verse has a lyrical charm, freshness, and gaiety which recall French poetry of the Late Middle Ages, Villon in particular (see page 167). One of the most substantial poems in the collection is "Le Chanson du Mal-Aimé," which can be compared with Villon's "Testament" in its mixture of lyricism, profound melancholy, mockery, and grossness.

The poem tells the story of the poet's ill-starred love for Annie Playden, an English governess whom he met while working as a tutor in Germany. Despite its connection with Villon, it has many features which are recognizably and defiantly modern. Apollinaire, like Rimbaud, is a poet of the modern city:

Soirs de Paris ivres du gin
Flambant de l'électricité
Les tramways feux verts sur l'échine
Musiquent au long des portées
De rails leurs folies de machines

Paris evenings drunk with gin
Ablaze with electricity
Green fires flashing on their spines
Tramways up and down their rails
Sing their madness of machines

(Translated by EDWARD LUCIE-SMITH.)

City imagery of this sort already had a place in French poetry—it had been in use since the days of Baudelaire. More important are other characteristics. One is the torrential flow of imagery, unchecked by punctuation, larded with neologisms. Apollinaire's literary technique anticipates the Cubist invention of collage (the poem seems to have been finished by 1904), and looks forward to more elaborate effects of the same sort in the poetry of Ezra Pound and T.

S. Eliot (see page 487). The poem is autobiographical, yet fluid, constantly in a state of transition or transformation. This combination was to be typical of Modernist literature as a whole.

Marcel Proust

Marcel Proust (1871–1922) conceived his great novel-sequence *A la recherche du temps perdu* (usually known in English as *Remembrance of Things Past*) as early as 1906, and started work on it in 1909. The first of the seven parts, *Swann's Way*, was published in 1913 (see page 472). Three more parts appeared before Proust's death, and the final three were published posthumously. Proust was an unlikely author for a major work of European fiction, the spoilt, snobbish, and deeply neurasthenic son of a wealthy Parisian doctor. Yet we owe to him the most convincing panorama of prewar Paris to have been written. The sequence is the culmination of one fictional tradition, which includes the novels of Balzac and Tolstoy, and the start of something new.

A la recherche occupies a territory half-way between autobiography and conventional, objectified fiction. In fact, Proust's novel depicts, in all its aspects, a process of becoming. The central character is not a stable entity, nor are those others who surround him; the view of human personality is something drastically new. We can catch a glimpse of something similar in Apollinaire's "Le Chanson du Mal-Aimé," where the protagonist is as much in a state of flux as Proust's narrator. He is also just as much of an egoist. It is no accident that Proust the novelist, like Apollinaire the poet, constantly asserts that love is unreciprocal. On their terms, it cannot be reciprocated—writers, because they try to analyze reality, rather than simply surrendering to it, are forever solitary.

Proust's narrative intricacy, which sometimes disturbs the expected time-sequence, his layering of physical sensations and inner associations, and above all his central theory of time and our perception of it—that is, of "involuntary" memory provoked by perhaps trivial sensations, such as the taste of a cake dipped in tea—were all to have an immense effect on subsequent fiction. Most important of all was his insistence on the primacy of subjective experience, a theme which was to run through the whole of twentieth-century literature.

Music and the new avant-garde

The revolution in music, between 1900 and 1914, matched the revolution in the visual arts. The composers who led it moved in the same milieu, and had many friendships with the leading avant-garde artists of the day. They were keenly aware that some of their work as revolutionaries had already been done for them. Wagner had begun a break-up in the structure of music, concealing the harmonic patterns within complexities of development and orchestration so that the old key signatures became difficult to perceive. Debussy attached rhythmic structure as well, sometimes making the rhythmic pulse almost imperceptible.

Three major composers rose to prominence in the years immediately before 1914. At the time, the most publicized was a young Russian, Igor Stravinsky (1882–1971). Stravinsky was a pupil of Rimsky-Korsakov (1844–1908), and therefore had his roots in the tradition of Russian nationalism. What gave his career its impetus was his association with Serge Diaghilev's Ballets Russes. Stravinsky's colorful scores for *The Firebird* (1910) and *Petrushka* (1911) were triumphantly successful with the sophisticated Parisian audience. It was his third major score for Diaghilev's company, *The Rite of Spring* (1913), which caused a major scandal. Stravinsky reversed the tendency of Debussy's music, and assailed the audience with violent and complex percussive rhythms.

The Rite of Spring can of course be related to the cult of primitivism in Russian art of the same period. This influence lingered in the work Stravinsky produced immediately after *The Rite of Spring*—*Renard* (1915–16) and *Les noces* (1914–23). These evoked Russian folk-lore and peasant life rather than the remote prehistoric past. Because they used modest musical forces, and were less massively violent, they did not cause the same stir. It was the very different music Stravinsky wrote postwar which re-established his reputation as an innovator.

Arnold Schoenberg (1874–1951) belonged to the Austrian-German tradition of Brahms (see page 392). He nevertheless began as a Symbolist, writing a symphonic poem on the theme of *Pelléas and Mélisande* (1902–3)—it is almost exactly contemporary with Debussy's opera of the same title. Schoenberg, who also became a talented if minor painter in the Expressionist style, then began to evolve toward a kind of music which would be an even closer equivalent of Expressionist art than Richard Strauss's opera *Electra* (see page 443). His two major works in this style are the monodrama *Erwartung* (1909), about a woman searching

Swann's Way

In this passage from the "Overture" to *Swann's Way*, the first volume in the novel sequence *The Remembrance of Things Past*, Proust gives a description of the theory of memory which is the mainspring of the whole work.

Many years had elapsed during which nothing of Combray, save what was comprised in the theatre and the drama of my going to bed there, had any existence for me, when one day in winter, on my return home, my mother, seeing that I was cold, offered me some tea, a thing I did not ordinarily take. I declined at first, and then, for no particular reason, changed my mind. She sent for one of those squat, plump little cakes called "petites madeleines," which look as though they had been moulded in the fluted valve of a scallop shell. And soon, mechanically, dispirited after a dreary day with the prospect of a depressing morrow, I raised to my lips a spoonful of the tea in which I had soaked a morsel of the cake. No sooner had the warm liquid mixed with the crumbs touched my palate than a shudder ran through me and I stopped, intent upon the extraordinary thing that was happening to me. An exquisite pleasure had invaded my senses, something isolated, detached, with no suggestion of its origin. And at once the vicissitudes of life had become indifferent to me, its disasters innocuous, its brevity illusory—this new sensation having had on me the effect which love has of filling me with a precious essence; or rather this essence was not in me, it *was* me. I had ceased now to feel mediocre, contingent, mortal. Whence could it have come to me, this all-powerful joy? I sensed that it was connected with the taste of the tea and the cake, but that it infinitely transcended those savours, could not, indeed, be of the same nature. Whence did it come? What did it mean? How could I seize and apprehend it?

I drink a second mouthful, in which I find nothing more than in the first, then a third, which gives me rather less than the second. It is time to stop; the potion is losing its magic. It is plain that the truth I am seeking lies not in the cup but in myself. The drink has called it into being, but does not know it, and can only repeat indefinitely, with a progressive dimunition of strength, the same message which I cannot interpret, though I hope at least to be able to call it forth again and to find it there presently, intact and at my disposal, for my final enlightenment. I put down the cup and examine my own mind. It alone can discover the truth. But how? What an abyss of uncertainty, whenever the mind feels overtaken by itself; when it, the seeker, is at the same time the dark region through which it must go seeking and where all its equipment will avail it nothing. Seek? More than that: create. It is face to face with something which does not yet exist, to which it alone can give reality and substance, which it alone can bring into the light of day.

And I begin again to ask myself what it could have been, this unremembered state which brought with it no logical proof, but the indisputable evidence, of its felicity, its reality, and in whose presence other states of consciousness melted and vanished. I decide to attempt to make it reappear. I retrace my thoughts to the moment at which I drank the first spoonful of tea. I rediscover the same state, illuminated by no fresh light. I ask my mind to make one further effort, to bring back once more the fleeting sensation. And so that nothing may interrupt it in its course I shut out every obstacle, every extraneous idea, I stop my ears and inhibit all attention against the sounds from the next room. And then, feeling that my mind is tiring itself without having any success to report, I compel it for a change to enjoy the distraction which I have just denied it, to think of other things, to rest and refresh itself before making a final effort. And then for the second time I clear an empty space in front of it; I place in position before my mind's eye the still recent taste of that first mouthful, and I feel something start within me, something that leaves its resting-place and attempts to rise, something that has been embedded like an anchor at a great depth; I do not know yet what it is, but I can feel it mounting slowly; I can measure the resistance, I can hear the echo of great spaces traversed.

Undoubtedly what is thus palpitating in the depths of my being must be the image, the visual memory which, being linked to that taste, is trying to follow it into my conscious mind. But its struggles are too far off, too confused and chaotic; scarcely can I perceive the neutral glow into which the elusive whirling medley of stirred-up colours is fused, and I cannot distinguish its form, cannot invite it, as the one possible interpreter, to translate for me the evidence of its contemporary, its inseparable paramour, the taste, cannot ask it to inform me what special circumstance is in question, from what period in my past life.

Will it ultimately reach the clear surface of my consciousness, this memory, this old, dead moment which the magnetism of an identical moment has travelled so far to importune, to disturb, to raise up out of the very depths of my being? I cannot tell. Now I feel nothing; it has stopped, has perhaps sunk back into its darkness, from which who can say whether it will ever rise again? Ten times over I must essay the task, must lean down over the abyss. And each time the cowardice that deters us from every difficult task, every important enterprise, has urged me to leave the thing alone, to drink my tea and to think merely of the worries of to-day and my hopes for to-morrow, which can be brooded over painlessly.

And suddenly the memory revealed itself. The taste was that of the little piece of madeleine which on Sunday mornings at Combray (because on those mornings I did not go out before mass), when I went to say good morning to her in her bedroom, my aunt Léonie used to give me, dipping it first in her own cup of tea or tisane. The sight of the little madeleine had recalled nothing to my mind before I tasted it; perhaps because I had so often seen such things in the meantime, without tasting them, on the trays in pastry-cooks' windows,

that their image had dissociated itself from those Combray days to take its place among others more recent; perhaps because of those memories, so long abandoned and put out of mind, nothing now survived, everything was scattered; the shapes of things, including that of the little scallop-shell of pastry, so richly sensual under its severe, religious folds, were either obliterated or had been so long dormant as to have lost the power of expansion which would have allowed them to resume their place in my consciousness. But when from a long-distant past nothing subsists, after the people are dead, after the things are broken and scattered, taste and smell alone, more fragile but more enduring, more unsubstantial, more persistent, more faithful, remain poised a long time, like souls, remembering, waiting, hoping, amid the ruins of all the rest; and bear unflinchingly, in the tiny and almost impalpable drop of their essence, the vast structure of recollection.

And as soon as I had recognised the taste of the piece of madeleine soaked in her decoction of lime-blossom which my aunt used to give me (although I did not yet know and must long postpone the discovery of why this memory made me so happy) immediately the old grey house upon the street, where her room was, rose up like a stage set to attach itself to the little pavilion opening on to the garden which had been built out behind it for my parents (the isolated segment which until that moment had been all that I could see); and with the house the town, from morning to night and in all weathers, the Square where I used to be sent before lunch, the streets along which I used to run errands, the country roads we took when it was fine. And as in the game wherein the Japanese amuse themselves by filling a porcelain bowl with water and steeping in it little pieces of paper which until then are without character or form, but, the moment they become wet, stretch and twist and take on colour and distinctive shape, become flowers or houses or people, solid and recognisable, so in that moment all the flowers in our garden, and in M. Swann's park, and the water-lilies on the Vivonne and the good folk of the village and their little dwellings and the parish church and the whole of Combray and its surroundings, taking shape and solidity, sprang into being, town and gardens alike, from my cup of tea.

Proust

(PROUST, *Remembrance of Things Past*, Vol. 1 *Swann's Way*, translated by Scott Moncrieff, revised by Terence Kilmartin. Reprinted by permission of Random Century Group and Random House Inc., on behalf of the Estate of Marcel Proust, the translators and publishers. Translation © 1981 by Random House Inc., and Chatto & Windus.)

a dark forest for the lover who has left her, and *Pierrot Lunaire* (1912). The latter calls for a reciter not a singer, and this performer is required to make use of *Sprechgesang*, a vocal production half-way between speech and song. This requirement was linked to Schoenberg's abandonment of conventional tonality. Both works are a cry for emotional freedom, for a situation in which content dictates form.

Atonality (or, as Schoenberg himself always preferred to call it, pantonality)—music which abandons the use of any key-center to which all the notes of a particular piece are related—is often hailed as the decisive break in the history of modern music. This is to forget what Wagner had already done. It is also to forget that, having decided to abandon the old system, Schoenberg and his disciples were immediately forced to search for a replacement. Otherwise they would have lacked the kind of moral justification within music which the Austrian-German tradition had demanded ever since Beethoven, and which was one of the chief reasons why Brahms and his supporters condemned Wagner. Their solution—the 12-tone or dodecaphonic system—will be discussed in Chapter 27.

Many people will feel that Erik Satie (1866–1925) does not deserve the label "major composer," not least because he himself so sedulously eschewed ambition. Satie began his career under the spell of Debussy, but rebelled against the demands of the Parisian musical world, earning a meager living as a café pianist in Montmartre. In 1898, he gave this up, and lived in self-imposed poverty for the rest of his life in the grimy Paris suburb of Arceuil-Cachan. He was now composing many brief pieces, in a mockingly simple, deceptively trivial style. Typical are the *Trois pièces en forme de poire*—*poire* is French slang for "idiot" or "fathead"—of 1903.

Later Satie experimented increasingly with either discontinuous or maddeningly repetitive forms, and with the use of non-musical noise as part of the composition. All of these features are present in his ballet-score *Parade* (1917), which is scored for, amongst other instruments, a typewriter and a revolver.

Many elements in Satie's music were important for the future, but most of all its use of bare-bones simplicity and of repetitiveness. For example Satie's *Vexations* consists of a single sheet of music—all the notes can be played in about 80 seconds. But the composer instructs that the whole thing is to be played again and again, no less than 840 times. If one looks at avant-garde or would-be avant-garde music today, it contains far more references to Satie than to either Stravinsky or Schoenberg.

There is another reason for taking Satie, the professional ironist, extremely seriously. Perhaps because of his profession as café pianist, he seems to have been the first to spot the growing rift between "serious" music on the one hand, and "popular" music on the other. The rift between the two genres was to become one of the distinguishing marks of twentieth-century culture.

Chapter 27

Armageddon and the Interwar Culture in Europe

27.1 Walther Gropius, Shop Block, The Bauhaus, Dessau, Germany, 1929–31.

Collapse and attempted reconstruction

World War I was perhaps the most important setback received by European culture since the Black Death of the fourteenth century (see page 134). The carnage was immense, the economic damage almost immeasurable. After the war political boundaries were redrawn and many new nation-states created, especially from the ruins of the old Austro-Hungarian Empire. In Russia, the October Revolution of 1917 abolished tsardom and dispossessed the Romanov dynasty which had ruled the country since 1613. Lenin (1870–1924) and his revolutionary colleagues set up a Communist state, an attempt to put into practice the doctrines of Karl Marx (see page 395). In Germany, Kaiser Wilhelm II was forced to abdicate, and a fragile republican government (the Weimar Republic) was set up in place of the old German Imperial one.

From the beginning of its existence the Weimar Republic suffered from almost overwhelming political and economic ills. The heavy financial reparations imposed by the victorious allies (a coalition headed by France, Britain, Italy, and the United States) bankrupted the country, and in the 1920s soaring inflation wiped out the savings of the old middle class. By 1923 one U.S. dollar was worth four million German marks. There was frequent political violence, much of it perpetrated by factions on the extreme right, unable to reconcile themselves to Germany's defeat in the war.

Despite all this the new German state became a focus for avant-garde experiment, usually linked to the political left. The climate was more daring than that which prevailed in France, which had been for a hundred years the traditional center for innovation in the arts. Rivaling Paris, Berlin developed a bizarre and decadent life-style which became notorious throughout Europe.

The gradual accession of the right wing to power started in Italy where Mussolini's March on Rome in 1922 was followed by the establishment of a Fascist government. The triumph of Nazism in Germany did not happen until the 1930s, when it was helped by the worldwide economic crisis which followed the American stockmarket crash of 1929. In 1932 the Nazis became the largest party in the German Reichstag, though they remained short of an absolute majority. Hitler became Chancellor at the end of January 1933, and in the election held on March 5 the Nazi Party was finally swept to power, and immediately started to dismantle the democratic institutions associated with the Weimar regime. In 1936, the Spanish Civil War broke out, a bitter, fratricidal struggle which polarized sympathies everywhere. Most creative artists were actively on the side of the Republican (legitimate) government. Despite this, the war ended with the complete triumph of General Franco's right wing and nationalist forces in 1939.

Philosophy

Dada and the new nihilism

One striking symptom of nihilism, in the narrow world of the avant-garde arts, was the birth of the Dada movement. Dada—the word is deliberately meaningless but may be derived from a childish German name for a hobbyhorse—had several focal points of activity, all of them situated on the fringes of the conflict rather than right in its midst. Two were New York and Barcelona, but the most important was Zurich, in neutral Switzerland, where a number of poets and artists of different nationalities gathered. The conflict had created acute personal dilemmas for many of these, which are reflected in some of the work they produced, but essentially Dada in Zurich was aggressive nonsense for its own sake.

Its most characteristic products were not paintings and sculptures, but manifestations and public performances. The main point about these was that they had no point— that they were meaningless and totally resistant to rational interpretation. Hugo Ball (1886–1927), the German poet who was one of the founder-members of the Zurich Dada group, did, however, have a profound concern with the purification of the word. "We must return," he wrote, "to the deepest alchemy of the word, and leave even that behind us, in order to keep safe for poetry its holiest sanctuary."

The somewhat transcendental tone of this statement would not have been sympathetic—or even, in his terms, meaningful—to the most important academic philosopher working at the time, but there is, nevertheless, something in common between Hugo Ball and Ludwig Wittgenstein

(1889–1951). Wittgenstein had studied philosophy at Cambridge University under Bertrand Russell (1872–1970), whose early work was heavily influenced by mathematics which seemed to offer a certainty and perfection of statement which could not be found in words. Mathematics led Russell to oppose the idealism which was characteristic of Schopenhauer, and Wittgenstein followed Russell's lead. During the war years Wittgenstein served as a volunteer in his native Austrian artillery, and found time to complete his first major philosophical work, the *Tractatus Logico-Philosophicus*, which was published in 1921.

The *Tractatus* consists of only 20,000 words, and many more than that have been expended on trying to interpret it. Its central concern, however, is very simple—what is the nature of language, and what is its relationship to the world? According to Wittgenstein, language literally "pictures" the world. This picture, logically, must have something in common with what it depicts, even if it shows it in many ways incorrectly. Wittgenstein called this shared minimum "logical form." For Wittgenstein, the tasks traditionally performed by philosophers were, because of the very nature of language, quite out of reach, and had always been so. He proposed a different job for the philosopher: clarifying propositions—that is, examining the fundamental nature of language, and how it works. The traditional idea that the philosopher was a moral or social lawgiver was for him inherently absurd. The *Tractatus*, which is divided not into chapters but into numbered paragraphs, many containing only a single sentence, begins and ends with two famous statements. Its first reads: "The world is all that is the case." The last reads: "Whereof one cannot speak, thereof one must be silent."

The silence Wittgenstein enjoined on himself and his colleagues left a great void at the center of Western culture. It was comparable to, and indeed probably identical with, the moral, social, and ethical void which the Dadaists had detected at about the same moment. The only difference was that the Dadaists believed it was a new phenomenon; Wittgenstein, more destructively, asserted that it had always been present.

Architecture

The avant-garde in architecture and design

Nihilism and withdrawal were not the only reactions produced by the conflict. One of the places where there was new and positive thinking was Holland which, like Switzerland, remained neutral. Here a new avant-garde group arose which called itself "De Stijl," and which published a magazine of the same name. Its moving spirit was Theo van Doesburg (C. E. M. Küpper, 1883–1931).

Van Doesburg was a painter, an architect, and an influential writer on art, and his associates included the architects J. P. Oud (1890–1963) and Gerrit Thomas Rietveld (1888–1964). Another member of the group was the painter Piet Mondrian (1873–1944).

Because of the war the members of the group had little opportunity to put their ideas into practice. They did, however, elaborate a body of theory which was to be extremely influential in the interwar period. For them the horrors of the world conflict were due to rampant individualism, and they wanted to produce an austere, impersonal architecture and art which rejected all forms of representation and relied on the simplest forms, based on the line and the right angle, and the three basic primary colors, red, yellow, and blue (to which could be added white, black, and grey), for their effect.

The ideas of De Stijl, like those of the Russian Constructivists, were to have a considerable impact on the Bauhaus. The Bauhaus was founded at Weimar in 1919, in the immediate aftermath of the German defeat and the political collapse that followed. It was unique for its time in bringing distinguished fine artists—among them Klee (see page 455) and Kandinsky (see page 467)—into what was basically a school of architecture and design. In Weimar Germany, devastated by war and deeply divided politically, the pressing need was to create a new and efficient industrial society, which would make the most of and further explore ideas which had already become current in Germany before the conflict, thanks to the activities of men like Peter Behrens.

In 1925, thanks to a political upheaval, the Bauhaus lost its base in Weimar, and was forced to move to Dessau. This at least offered an opportunity to create an exemplary new building to house its activities (Fig. **27.1**). It was designed by the director, the architect Walter Gropius (1883–1969). The building is asymmetrical, a combination of several "boxes," whose forthright rectangular forms echo the prescription of De Stijl. Through the use of a glass curtain wall to light four stories of studios in the main block, Gropius carried to the limit ideas which had already appeared in industrial buildings put up before the war. He also made full use of the possibilities offered by ferro-concrete, linking the two main parts of the building by a bridge at first-floor level. The bridge contained offices for the Bauhaus administrators.

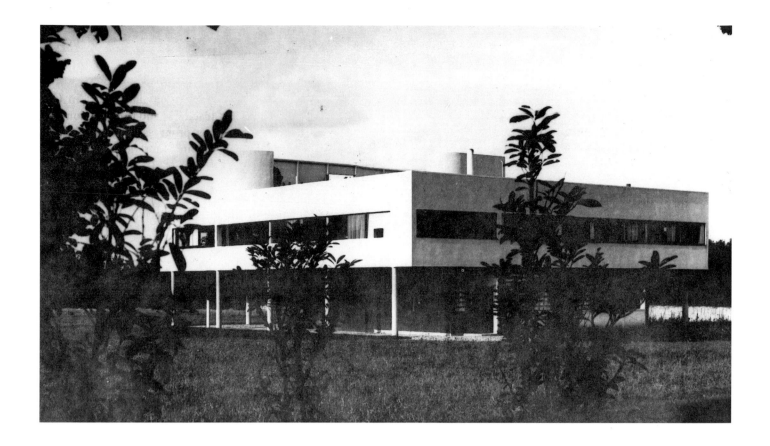

Bauhaus architecture found its equivalent in France in the work of Le Corbusier (Charles-Edouard Jeanneret, 1887–1966). Le Corbusier was Swiss, and received part of his training under Auguste Perret. He also worked briefly for Behrens in Berlin. After the war he became the most visible and also the most contentious figure in the new international movement in architecture. One reason for his high visibility was that he worked in Paris, still regarded as the focus for everything modern, though in fact Weimar Germany was now more generally experimental. Another was his much greater relish for architectural controversy.

Le Corbusier published, during the 1920s and 1930s, a number of visionary town-planning schemes—the best known is the Ville Radieuse of 1935 (Fig. **27.3**). These proposed that the cities of the future should consist of tall, symmetrically disposed skyscraper towers in park-like settings, with lower constructions and complex traffic routes to separate them. They had no chance of being implemented, but were to be widely influential after World War II.

Le Corbusier's most conspicuous practical achievement in the interwar period was a series of luxurious villas for private clients, notably the Villa Savoye at Poissy 1929–31 (Fig. **27.2**). Here the plan, unlike that of the Dessau Bauhaus, is kept within a defining rectangle, but this is nevertheless treated in a new and totally unconventional way, with the main floor raised on pilotis (stilts) and only a service core at ground level. One feature was the use of the continuous ribbon windows which were to become the signature of the new architecture; another was the obligatory

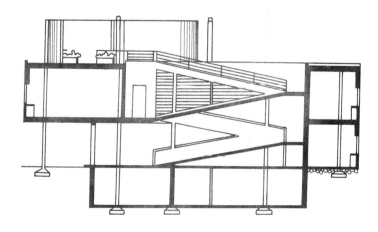

27.2 **Le Corbusier,** Villa Savoye, Poissy-sur-Seine, France, 1929–31.

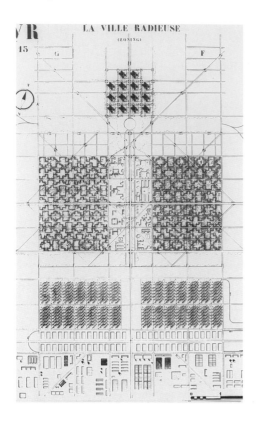

27.3 **Le Corbusier,** plan for la Ville Radieuse, 1935.

flat roof, which had already become a signature of the new architectural style.

Though the Bauhaus had an immediate effect in Germany, through its system of teaching, and through domestic articles created in its studios for progressive manufacturers, the new movement in architecture, there and still more so elsewhere, remained a minority taste. Its full consequences were felt only after World War II, and then more powerfully in the United States than in Europe. The truly characteristic architecture of the interwar period took a different path.

Interwar architecture: the classical style

The official architecture of a period rich in monumental buildings used a new version of traditional classical style. This was classicism stripped to its bare essentials, and monumentalized to meet new needs, political and practical. Our dislike of the political context should not lead us to underestimate the flair and ingenuity of the architects who served the totalitarian regimes. Their work can be seen at its most inventive, which is also its most austere, in the architecture of Fascist Italy—for example, University City in Rome 1935 (Fig. **27.4**), designed by one of Mussolini's favorite architects, Mario Piacentini (1891–1960).

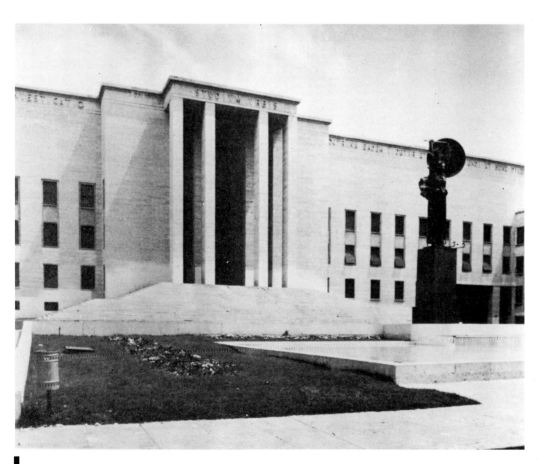

27.4 **Mario Piacentini,** University City in Rome, 1935.

27.5 **Albert Speer,** Reichs Chancellery, Berlin, 1938.

27.6 **Sir Edwin Lutyens,** The Viceroy's House (main façade). New Delhi, India, 1912–31.

Nazi architecture tended to be slightly more orthodox in its classicism. Hitler, who had a mania for building, did not have time to put many of his cherished plans into effect, but he did succeed in building the Reichs Chancellery in Berlin as a headquarters for himself (Fig. **27.5**). The building was the work of Albert Speer (1905–1981). Speer's buildings owed much to the great German classicist, Karl Freidrich Schinkel (see page 375), but also something to the French visionary architects of the eighteenth century, notably Etienne Boullée (see page 337).

Architecture of this type was not confined to the dictatorships, though it generally served as a symbol of authority. One of the most skillful and subtle exponents of the revised classical style was an Englishman, Sir Edwin Lutyens (1869–1944). Lutyens began his career in the wake of the English Arts and Crafts movement (see page 434), building delightful private houses in variants of traditional English vernacular modes. His transition to classicism came when public projects began to take up more and more of his time. First, there were memorials to the dead and missing of World War I, and finally there was his work at New Delhi.

The chief building for which he was responsible was the Viceroy's House 1912–31 (Fig. **27.6**). Austere and monumental, with principal fronts which are no less than 630 feet (192m) wide, this is much more than a simple habitation— it was meant to symbolize the permanence of British rule in India. The architectural framework is classical, but Lutyens made subtle use of local details, most of them Mogul rather than Hindu, since it was these which best evoked Delhi's imperial past. They included the *chujja*, a thin projecting cornice which threw deep shadows in India's dazzling light, and *chattris*, or little pavilions used to ornament the retaining walls of the forecourt and gardens. These, however, were only incidental touches: the building is an exotic variant of the great classical palaces of the past, fulfilling the same exemplary role.

Painting

The Classical style

The shock of World War I led avant-garde artists to reassess the nature of tradition. Many, like the leading architects of the time, started to re-explore Classical imagery. One of these, though only momentarily, was Picasso, whose painting entered a Classical phase in the early 1920s. One of Picasso's best-known images of this type is the monumental *The Pipes of Pan* (Fig. **27.8**) of 1923. This seems to evoke a nostalgia for Arcadian tranquility which can be found in the work of many other leading artists of the time. In Picasso's case, there was often an edge of satire to his essays in classicism, similar to the satiric impulse which can be found in much of the Neo-Classical music of Stravinsky (see page 490). Other artists took the classical revival more seriously.

The country where Classical influence was felt most strongly was Italy. The Novecento group, founded in 1922, received official encouragement from Mussolini, and leading artists associated with it, such as Mario Sironi (1885–1961), were honored with official commissions. Sironi's

simplified, rather heavy style of painting fitted well with the prevailing style of Italian architecture. He was asked to provide a mural for Mario Piacentini's university building in Rome, and for similar buildings elsewhere, such as the Court of Assizes in Milan (Fig. **27.7**).

The members of the Novecento were not, however, the only Italian artists to be caught up in the revival of Classicism. The most important convert was a loner, Giorgio de Chirico (1888–1978). De Chirico did, it is true, begin his career as a member of a group, the "Scuola Metafisica" founded by himself and a few associates, such as Carlo Carrà (1881–1966), who soon deserted to the Novecento. De Chirico's metaphysical paintings, featuring mannequins isolated in mysterious piazzas, have always been thought of as the precursors of Surrealism, and accorded enormous respect. Anything he produced later was ignored until recently.

De Chirico committed the crime of rebeling vocally against Modernism, and against his former associates in the Surrealist movement in particular. He proclaimed himself

27.7 **Mario Sironi**, *Justice Between Law and Strength* 1936. Mosaic, 137⁴⁄₅ × 222²⁄₅ ins (350 × 565 cm). Court of Assizes, Milan.

27.8 Pablo Picasso, *The Pipes of Pan* 1923. Oil on canvas, 80¾ × 68¾ ins (205 × 174.5 cm). Musée Picasso, Paris.

27.9 Giorgio De Chirico, *The Gladiators* 1928. Oil on canvas, 14 × 10½ ins (35.5 × 26.5 cm). Private Collection.

to be the last of the Old Masters. Among his later paintings are many with Classical themes—gladiators, Roman villas, what he called "mysterious baths." The long series of *Gladiators* (Fig. **27.9**, for example) is especially striking—it shows armed men struggling in claustrophobically enclosed spaces, an image which clearly meant a great deal to the artist, since it also features in his dreamlike novel *Hebdomeros* (1929).

It is tempting to give these scenes of combat an allegorical interpretation. De Chirico, like a number of his contemporaries, found himself armored yet confined by the memory of the Classical past. He was lucky enough to discover a truly striking trope with which to present his dilemma. The gladiators are suffused with a feeling of lassitude. Not only are they confined, but they look as if they are fighting in slow motion.

The Neue Sachlichkeit

The term Neue Sachlichkeit (New Objectivity) was coined by G. F. Hartlaub, director of the Mannheim Kunsthalle, who used it as the title of an exhibition which he organized in 1925. He thus gave an identity to a new kind of political art which had sprung up in Germany. It was a response both to the political and economic conditions of the time and to what artists had experienced in the war. "Objectivity" was often very far from their intentions.

The roots of the Neue Sachlichkeit were in prewar Expressionism. This can be seen clearly in the work of Max Beckmann (1884–1950). Beckmann had been a successful, rather conservative painter before the war, but he then turned to social and political themes. As he wrote in 1919, "My pictures are a reproach to God for all that he does wrong." What he meant can be seen from a painting done in the same year, *Die Nacht* (*The Night*, Fig. **27.11**). This shows a scene which is terrifying but at the same time unspecific—half field-hospital, half brothel. It is clearly meant to conjure up not a specific social evil but a general feeling of malaise.

Other artists were willing to be specific. They made direct attacks on what they saw as the evils of the time. The most effective of these satirists was George Grosz (1839–1959). Younger than Beckmann, he had no chance to establish himself before World War I. Despair and rebellion led him to join the Dada group in Berlin, which was an offshoot of the one in Zurich. In Berlin Dada rapidly took on political implications that had little to do with the pure nihilism of its origins. Grosz became one of the most celebrated draftsmen of the time, and by 1921 his portfolios of prints were being published in large editions. Not surprisingly, his work got him into trouble. One print, showing the crucified Christ on the Cross wearing a gas-mask (Fig. **27.12**), led to a celebrated trial for blasphemy.

Though Grosz also produced paintings, he was better

27.10 Otto Dix, *Portrait of the Journalist Sylvia von Harden* 1926. Mixed media on wood, 47¼ × 34⅝ ins (120 × 88 cm). Musée National d'Art Moderne, Paris.

known for his incisive drawings. The most typical of the Neue Sachlichkeit artists who made painting their central activity was Otto Dix (1891–1969). He emerged from the war with the declared ambition to produce what he called "anti-painting." His work, he declared, would be "objective, neutral, impassive." Among his most characteristic works from the 1920s is a series of incisive portraits of leading personalities of the time. Dix's likeness of the journalist Sylvia von Harden, her hair mannishly cropped, wearing a monocle, smoking, and with a cocktail in front of her (Fig. **27.10**), conjures up the notoriously decadent lifestyle of Weimar period Berlin, with its emphasis on sexual ambiguity.

It was this sensitivity to social and political events that seemed to pull the artists of the Neue Sachlichkeit away from the Modernist mainstream. Nazi detestation of their work was based more on its political content than on the experimental nature of its style. In its insistence on what was sordid and horrific, the Neue Sachlichkeit is a kind of mirror-image of the Arcadian Classicism which also flourished at the same period, but it was, nevertheless, a rejection of the élitist and esoteric side of prewar Modernism.

Neo-Plasticism and Surrealism

Most of the new developments in the visual arts during the immediate postwar years involved deviations from the Modernist doctrine of free experiment, without regard to tra-

dition, and also without regard to immediate social or political needs. There were two artistic movements which remained faithful to the old Modernist creed. One was a variant of Constructivism, but without Constructivism's link to Revolutionary Communism and its increasing emphasis on the purely practical nature of artistic activity. The other was Surrealism.

The variant of Constructivism which continued to pursue purely aesthetic ends was Neo-Plasticism. The label was invented by Piet Mondrian (1872–1944), and derives from his publication *Le Néo-Plasticisme* (1920). Mondrian himself was the chief practitioner of this style. His paintings from 1917 onward were composed strictly according to the principles laid down by De Stijl, the ideological grouping with which he had been associated in Holland. This meant that only primary colors, plus white and black, were used, and that all angles were right angles; the color areas were separated by thick black lines (see Fig. **27.13**).

The basis of Mondrian's early thinking was Theosophy (see page 448), a lingering allegiance to which prevented him from plunging into politics. As late as 1922, when his mature style was fully developed, he was prepared to say that Neo-Plasticism was "purely a Theosophical art." Yet his mature work also lacks the overt symbolic content that had appeared in earlier figurative or semifigurative paintings.

The Surrealists took a very different, indeed a diametrically opposed, view of the way in which art functioned. For them, single images and conjunctions of imagery were primary, and formal relationships were of minimal importance. Indeed, many Surrealists felt that it was better for the artist to disregard them altogether.

Surrealism, like Futurism, was the creation of a writer. André Breton (1896–1966) encountered the visionary poetry of Arthur Rimbaud (see page 438) during World War I. He worked as an orderly in a military hospital, and this familiarized him with the strange, disconnected, but often poetically resonant utterances of the mentally deranged. At the same time, because of this contact, he developed an interest in the doctrines of Freud.

Immediately after the war, Breton became involved with the Dada movement, which had now spread to Paris, but this did not have enough intellectual substance to satisfy him for long. So he proceeded to reformulate Dada, with substantial input from his own wartime experience. The result was the Surrealist Manifesto, issued in 1924. Here he offered a formal definition of Surrealism, a word Breton had borrowed from Apollinaire: "Pure psychic automatism, by which it is intended to express, verbally, in writing, or by any other means, the real processes of thought. Thought's dictation, in the absence of all control exercised by the reason or by aesthetic and moral preoccupations."

Surrealist painting is generally divided into two stylistic categories—Calligraphic and Veristic Surrealism. In the former the painter makes mysterious marks or signs, using a

27.11 **Max Beckmann**, *The Night* 1918–19.
Oil on canvas, 53¾ × 60½ ins (134 × 153.7 cm). Collection
Nordrhein-Westfalen, Düsseldorf.

technique akin to the process of automatic writing favored
by Breton and other Surrealist writers; paintings of Joan
Miró (1893–1983) are some of the best known (Fig. **27.14**,
for example). In the latter the painter records dreamlike or
paradoxical images in minute detail; one leading exponent
was Miró's fellow-Catalan, Salvador Dalí (1904–89).

27.12 **George Grosz**, *Christ with Gas Mask* 1927.
Crayon drawing, 17⅜ × 22¼ ins (44 × 56.5 cm). Wieland Herzfelde,
Berlin.

27.13 **Piet Mondrian**, *Composition in White, Black and Red* 1936. Oil on canvas, 40¼ × 41 ins (102 × 104 cm). Collection, The Museum of Modern Art, New York. Gift of the Advisory Committee.

Dalí developed a brilliantly polished realistic style, provocative in itself because it recalled the discredited Salon painters of the nineteenth century, and used this to depict disturbingly distorted imagery, often with erotic overtones. Dalí's aims were never simple. *The Enigma of William Tell* (Fig. **27.16**) of 1933 was described thus by the painter: "William Tell, a fatherly phantasm, has placed a mutton chop on my head, indicating the desire to eat the infant Dalí, whom he carries in his arms." This incestuous aspect is less obvious to the unprepared spectator than some others. The main figure is clearly a portrait of Lenin. He kneels, naked from the waist down, and one immensely elongated buttock is supported by a cleft stick.

This image of Lenin was designed to provoke Breton, whose often professed commitment to the absence of all aesthetic or moral control was in real life extremely limited. Dalí succeeded in highlighting Breton's blind attachment to Communism, and the authoritarianism with which he ruled the Surrealist Group. His long-term aim to unite Surrealism with the Communist Party, while still preserving total aesthetic independence, was never achieved. The Surrealist Group spent much time and energy on political quarrels, and Breton himself ended as an adherent of Trotsky, a communist outcast like himself.

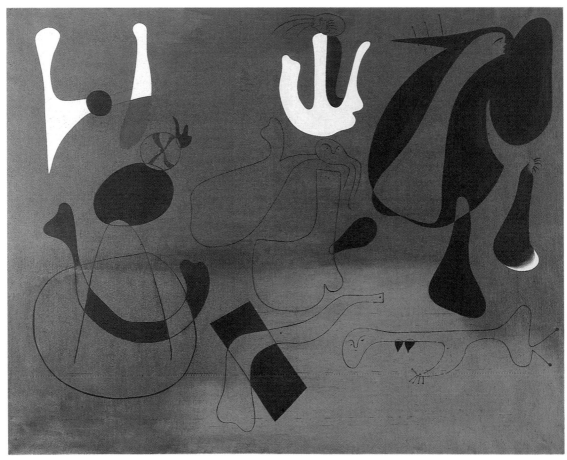

27.14 **Joan Miró**, *Painting* 1933. Oil on canvas, 51⅜ × 64 ins (130.5 × 163 cm). Wadsworth Atheneum, Hartford, Connecticut.

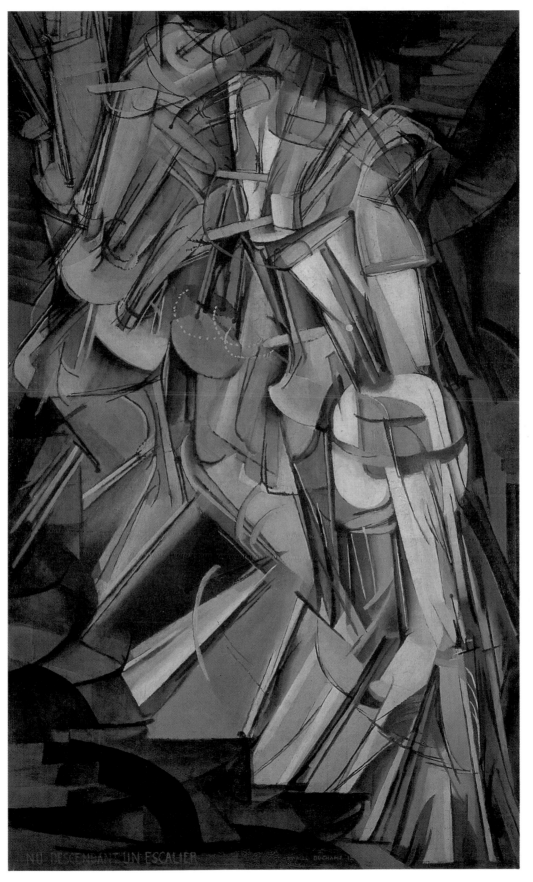

27.15 Marcel Duchamp, *Nude Descending A Staircase, No. 2* 1912.
Oil on canvas, 58 × 35 ins (147 × 89 cm). Philadelphia
Museum of Art.

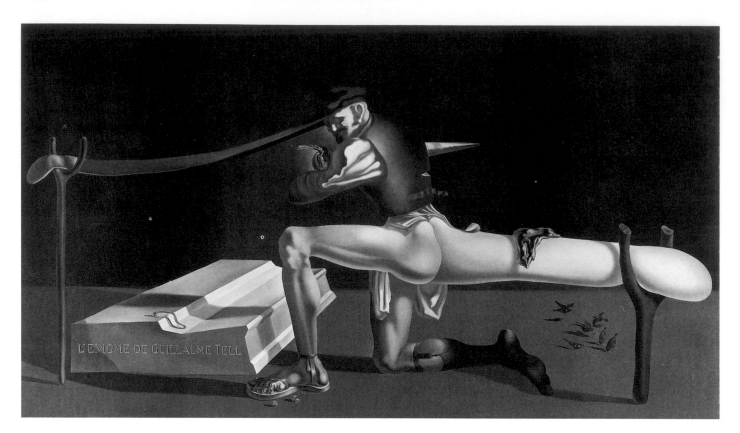

27.16 **Salvador Dali**, *The Enigma of William Tell* 1933.
Oil on canvas, 79⅜ × 136½ ins (201.5 × 346.5 cm). The National
Swedish Art Museums, Moderna Museet, Stockholm.

Sculpture

Duchamp and the "readymade"

Marcel Duchamp (1887–1968) first appeared on the prewar
avant-garde art scene as a minor Cubist. His painting *Nude
Descending a Staircase No. 2* (Fig. **27.15**) created a sensation
at the Armory Show, a gigantic survey exhibition of the
European and American avant-garde held in New York in
1913, thus catapulting him into a position of leadership.

His importance for twentieth-century art springs largely
from his invention of the "readymade." This was an
object—any object, however banal—taken by the artist
from an everyday context and designated a work of art. The
most notorious was a completely unaltered porcelain urinal.
Duchamp purchased this, signed it "R. Mutt," entitled it
Fountain (Fig. **27.17**) and submitted it to a non-juried exhi-
bition in 1917. Despite the absence of a jury it was, as
Duchamp intended, rejected. Gradually, however, the
readymades became the focus for a new theory of art, which
proposed that choosing or designating certain items as art
objects had the same validity as actually making art.

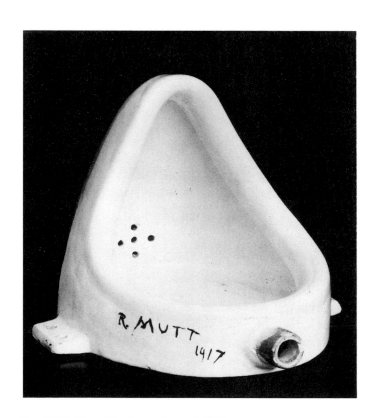

27.17 **Marcel Duchamp**, *Fountain* 1917.
Porcelain, height 24½ ins (62.5 cm). Arturo Schwarz Collection,
Milan.

Duchamp, a born ironist, always insisted that his own readymades were deliberately meaningless—a questioning of artistic ideas held by others, not positive statements made in their own right. The Surrealists, in direct contradiction to this—though they professed reverence for Duchamp—took up the notion that ordinary objects, combined in unexpected ways or in some way altered, could convey artistic meanings which had nothing to do with formal relationships. An example is the *Object* (Fig. **27.18**) of 1936 made by Meret Oppenheim, a leading Surrealist.

Objects of this type were undoubtedly three-dimensional, but they did not obey any of the traditional rules laid down for sculpture. Their power lay in the associations they evoked. The readymade and its Surrealist successor initiated a period of increasing confusion about how the word sculpture was to be defined. "Objects" and "assemblages" were sometimes considered to be quite different from sculpture and sometimes the same. This breakdown of categories heralded what was to happen to Modernist art after World War I.

27.18 **Meret Oppenheim**, *Object* 1936.
Fur-covered cup, saucer, and spoon: cup 4⅜ ins (10.9 cm) diameter; saucer 9⅜ ins (23.7 cm) diameter; spoon 8 ins (20.2 cm) long; overall height 2⅞ ins (7.3 cm). Collection, The Museum of Modern Art, New York (Purchase).

Literature

Eliot and Joyce

The year 1922 saw the publication of two works which summed up the impact made by the new Modernist ways of thinking on English writers. One was T. S. Eliot's poem *The Waste Land*; the other was James Joyce's novel *Ulysses*. Both writers were self-exiled. Eliot (1888–1965), born in the United States, chose to spend most of his adult life in England; Joyce (1882–1941), born in Dublin, lived in Trieste, Paris, and Zurich.

Eliot's poem is deliberately fragmentary. It is both a dramatic account of a personal crisis and a lament for the condition of European civilization. The poem contains a multitude of literary echoes—part of its structure is based on the *Divine Comedy* of Dante (see page 152), just as Dante had made use of elements in Virgil's *Aeneid*. There are quotations from many sources, often in their original languages. It is the paradox of the work that this massive apparatus of cultural reference is used to paint a picture of a world which is in a state of disintegration.

Eliot's method is Symbolist—allusions and direct quotations are allowed to resonate, and form their own patterns in the reader's mind. In general, each one stands for something which isn't fully spelt out. The whole structure is held together by Eliot's masterful lyricism. The lyric note is struck in the very opening lines:

April is the cruellest month, breeding
Lilacs out of the dead land, mixing
Memory and desire, stirring
Dull roots with spring rain.

Yet it also allows room for huge variations of tone:

When Lil's husband got demobbed, I said—
I didn't mince my words, I said to her myself,
HURRY UP PLEASE IT'S TIME
Now Albert's coming back, make yourself a bit smart

(T. S. ELIOT, *Collected Poems, 1909–1962*. Faber & Faber, 1963.)

Joyce's *Ulysses* is based on Homer's *Odyssey* (see page 65) even more obviously and firmly than Eliot's poem is based on Dante. The various sections of the novel, which tells the story of a day's progress through Dublin and its environs, are firmly linked, usually in a parodic way, to successive episodes in Homer. Eliot makes creative use of the great literature of the past, which echoes and re-echoes through his poem. Joyce, as the novel progresses, increasingly tends to reshape language itself. His two heroes are Stephen Dedalus, carried over from his earlier novel *A Portrait of the Artist as a Young Man* (1916), and Leopold Bloom. His heroine is Bloom's wife Molly. Stephen is a surrogate for Joyce himself, and also Odysseus's son, Telemachus; Bloom is Odysseus; and Molly is the long-suffering Penelope.

Bloom, though the main figure in the book, is by no means a conventional hero. He is an advertisement can-

vasser for a newspaper, the *Freeman's Journal*, and he knows his wife is going to cuckold him. He has introduced Molly to her seducer, Blazes Boylan, out of masochism and a sense of his own inadequacy. As the book progresses from episode to episode the language grows ever richer and denser, until finally it culminates in Molly Bloom's wonderful internal monologue, which ends with a memory of how she and Bloom courted one another in Gibraltar:

> . . . how he kissed me under the Moorish wall and I thought well as well him as another and then I asked him with my eyes to ask again yes and then he asked me would I yes to say yes my mountain flower and first I put my arms around him yes and drew him down to me so he could feel my breasts all perfume yes and his heart was going like mad and yes I said yes I will Yes.
>
> JAMES JOYCE, *Ulysses*. Penguin Books Ltd., 1985.)

As a convincing rendering of the character's subjectivity this is something new in literature, and remains unsurpassed.

Virginia Woolf

One of the writers crucially influenced by James Joyce's *Ulysses* was Virginia Woolf (1882–1941). Where Joyce was an outsider, who spent most of his life on the continent of Europe, far from influential literary circles in London, Virginia Woolf was the opposite. The daughter of Sir Leslie Stephen, the first editor of the British *Dictionary of National Biography*, she became one of the major figures in the so-called Bloomsbury Group, a circle of upper-middle-class friends who dominated literary and artistic life in London during the decade following World War I.

Virginia Woolf was an observant diarist, and a brilliant and unsparing literary critic who did not hold a high opinion either of her immediate predecessors in English literature—naturalistic novelists such as Arnold Bennett (1867–1931), whose books were in the mold created by Zola (see page 417); or of her contemporaries, though these included D. H. Lawrence (1885–1930) and E. M. Forster (1879–1970). In her own novels she sought to emphasize the difference between a male sensibility and a female one. Her ideas on this subject were quite clear:

> It would be a thousand pities if women wrote like men, or lived like men, or looked like men, for if two sexes are quite inadequate, considering the vastness and variety of the world, how should we manage with one only? Ought not education to bring out and fortify the differences rather than the similarities? For we have too much likeness as it is.
>
> (VIRGINIA WOOLF, *A Room of one's Own*. Hogarth Press Uniform Edition, 1931.)

Not surprisingly, though Virginia Woolf admired the "lightning flashes of significance" in *Ulysses*, she was repelled by much of it: "a queasy undergraduate scratching his pimples." Her own attempt to do better was *Mrs Dalloway* (1925), a novel which displays both her own strengths as a writer of fiction, and her weaknesses.

Like *Ulysses*, the book spans a single day. The main protagonist lives a far more restricted life than Leopold Bloom. She is a middle-aged but still attractive woman, the wife of a Conservative Member of Parliament. Her day is not particularly active or dramatic. She goes out to buy flowers for a dinner party, has an unexpected visit from a man she once almost married, engages in an undeclared and wordless tussle for the affections of her daughter with an embittered governess, and finally presides over the party itself, which is a great success.

Contrasted with this is the story of a young man, suffering from delayed psychological damage because of the war, who is driven to suicide by the insensitivity of his doctors—one of whom attends the party at Mrs. Dalloway's house. Just as Mrs. Dalloway reflects Virginia Woolf's upper-middle-class background, the young man Septimus Warren Smith reflects her own experience of madness.

Compared with *Ulysses*, *Mrs Dalloway* seems a minor achievement, as limited in scale as it is restricted in emotional range. The episodes dealing with madness are not fully integrated with the rest, and Virginia Woolf later wondered if she had been right to include them. The uniqueness of the book, and of Woolf's other mature novels—*To the Lighthouse* (1927), *The Waves* (1931), *The Years* (1937), and *Between the Acts* (1941)—is the finespun sensibility with which reality is rendered. This is Mrs. Dalloway moving through the London streets:

> . . . she felt herself everywhere, not "here, here, here", and she tapped the back of the seat; but everywhere. She waved her hand, going up Shaftesbury Avenue. She was all that. So that to know her, or anyone, one must seek seek out the people who composed them, even the places . . .
>
> (VIRGINIA WOOLF, *Mrs Dalloway*. Hogarth Press Uniform Edition, 1947.)

Her characters do not absorb the world, as those of Joyce tend to do; instead, they themselves are absorbed.

Franz Kafka

There is a great difference in intention and tone between James Joyce and Franz Kafka (1883–1924). Yet Kafka is perhaps the only one of Joyce's contemporaries to rank as his literary equal. Kafka himself would have been surprised by this verdict, since he left both his two major novels, *The Trial* and *The Castle*, unfinished, with instructions that they were to be destroyed. These instructions were, however,

disregarded and *The Trial* was published in 1925, *The Castle* in 1926.

Kafka, a Czech Jew who wrote in German, was doubly alienated—by his Jewishness and by his belonging to a minority culture within a larger, Slavic one. Both novels present a world of nightmarish uncertainty. In the first, *The Trial*, written between 1911 and 1914, the protagonist, Joseph K., is arrested for no apparent reason, and struggles vainly to extricate himself from the processes of the law. While always denying his guilt, he nevertheless seems tacitly to admit it almost from the beginning of the narrative. In *The Castle* the hero is called simply K. and it is clear that we are meant to identify him with the author.

K. arrives at a village, which remains nameless, to take up a post as land surveyor (there is a pun on this in German—the word for land surveyor is *Landvermesser*, while *sich vermessen* means "to commit an act of spiritual pride"). He is immediately faced by an intricate bureaucracy, and cannot obtain recognition from the castle, the local seat of power. His situation is summed up by the very topography of the place:

> ... for the street he was in, the main street of the Village, did not lead up to the Castle hill, it only made toward it and then, as if deliberately, turned aside, and though it did not lead away from the Castle it got no nearer to it either.

> (FRANZ KAFKA, *The Castle*, translated by Willa and Edwin Muir. Secker & Warburg, 1942.)

Drama

Bertolt Brecht

The career of Bertolt Brecht (1898–1956) falls into three well-defined periods. First, there was the Weimar Republic, when Brecht was a central figure in the experimental German theater of the day; then there was a long period spent in exile—in Austria, Switzerland, France, Denmark, Finland, and finally the United States—during which Brecht was largely out of touch with the German-speaking theater; lastly, there was his return to Europe and his decision to settle in East Berlin. Surprisingly, the most creative of these three phases was the middle one, when material conditions were most difficult for him.

With his first play, *Baal* (1918), Brecht set out to flout convention. The hero is, to some extent at least, a self-portrait—ugly, asocial, and amoral. But there is also an implied judgment—Baal is a man who pays the price for blindly following his own instincts. One of the reasons why the play found acceptance in Germany is its evident kinship with the German *Sturm und Drang* of the late eighteenth and early nineteenth centuries (see page 355) and also with prewar Expressionism (see page 455).

K. is soon reduced to being a janitor in a school that does not need one. His hopeless struggles lead to increasing exhaustion and eventually (so the author intended, had the book been finished) to his death. At the one moment when he seems to be offered a solution to his problems, by the minor official Bürgel, he is too tired and bewildered to understand.

Obviously a complex fiction of this kind can be read in many different ways. Admirers of *The Castle* have often insisted on interpreting it as a religious allegory. For example, they point to the fact that the self-appointed messenger of the Castle is called Barnabas. Barnabas was the man, who, though not one of the original Twelve Apostles, came to be ranked as one of them, and the biblical meaning of the name is "son of consolation." In Kafka's context, this gives it a fierce irony.

But to insist on the religious aspect as primary is to limit the book's meaning. Compared with a conventional nineteenth-century novel, or even with Joyce's *Ulysses*, *The Castle* is a work in which delineation and development of character play very small roles. What Kafka does is conjure up an atmosphere of threat and uncertainty which speaks for the nature not only of his own times but of what lay immediately in the future. It is not merely K. who feels threatened, but the reader, introduced to a world where all landmarks have been removed. In their own oblique way, *The Trial* and *The Castle* seem to predict the Holocaust (see page 525).

Brecht's greatest successes in his Weimar phase were his collaborations with the composer Kurt Weill (see page 490), most notably *The Threepenny Opera* (1928), a very free adaptation of John Gay's *The Beggars' Opera* (see page 332), with songs inspired by, among others, François Villon (page 167).

The best of Brecht's plays belong to the very late 1930s and early 1940s. They include *The Life of Galileo* (1938–9; first performed in Zurich, 1943), *The Good Woman of Setzuan* (1938–40; first performed in Zurich, 1943), and *Mother Courage* (1939; first performed in Zurich, 1941). *Mother Courage* is what the playwright called "epic theater;" it also demonstrates the basis of the much-discussed "alienation effect" (*Verfremdungseffekt*). Catchphrases though these are, they embody ideas central to Brecht's mature theory of drama, which was that human character must be understood as a "totality of all social conditions," and that the audience should be forbidden to identify with what they saw happening on the stage but should, instead, be helped to understand its deeper meanings in a spirit of objectivity, and thus form a balanced judgment.

The plot of *Mother Courage* is very simple. The central character, Anna Fierling, is an itinerant trader who makes

her living out of the vagaries of the Thirty Years War, which ravaged Germany in the seventeenth century. She lives by the war, and loses her three children to it, one after the other. The last to die is her dumb, mentally retarded daughter Katrin, shot for trying to warn a town which is about to be taken by stealth. Left alone, Anna is still determined to continue trading, and uses the last of her strength to pull her cart and catch up with the army.

For Brecht, Anna was a negative character, who sacrifices everything to commercial instinct, and never learns from experience. Contrary to his declared intentions, though, audiences tend to be moved by what happens to her, and by the never-failing resilience with which she meets successive blows of fate. They conjecture that Brecht was, in certain respects, still portraying himself, just as he had done in *Baal*.

Music between the wars

Music was offered a choice of directions during the interwar period, and composers remained hesitant as to which of these to take. The increasing complexity, and the harsh and unfamiliar sonorities of many Modernist compositions alienated a large part of the concert-going public. Music found itself split into three streams—the so-called "classical repertoire" (music from J. S. Bach to the tone-poems of Richard Strauss); "modern music," which nevertheless remained within the established framework of concert and opera performance; and music which attempted a reconciliation with popular mass-culture.

In Europe, the most striking examples of the third approach were to be found amongst the compositions of Kurt Weill (1900–50), and especially in his collaborations with the playwright Bertolt Brecht. The most important of these were *The Threepenny Opera* (1928), and *Rise and Fall of the City of Mahagonny* (1928–9). The first, a very free variation of John Gay's *The Beggars' Opera* (see page 332), is really a play with interpolated songs; the second conforms more closely to established operatic conventions. *The Threepenny Opera* is Weill's most striking score. Its sources are as eclectic as the sources Brecht used for his lyrics. Weill drew on the idiom of the Berlin satirical cabarets, but also on what he knew of American jazz. At that time in Germany, America was less a real place than a wonderful never-never land. *Mahagonny*, for instance, is set in a fantasy version of an American gold-rush town. Weill was so successful in blending these sources with more conventionally classical ideas that he succeeded in producing a series of genuinely catchy tunes, though with complexities of rhythm and harmonization which left the musically educated listener in no doubt that these sprang from a mind with full awareness of the historical tradition.

Many composers attempted to revive earlier musical traditions, thus aligning themselves with contemporary revivals of classicism in music and architecture. The most idiosyncratic of these attempts was made by Stravinsky, who now produced a series of anti-Romantic works written in variants of classical modes. These included his Violin Concerto in D (1931), his "Dumbarton Oaks" Concerto (1937–8), which is heavily indebted to Bach's Brandenburg Concertos, and the ballet *Apollo* (1927–8), which takes its theme from one of the most familiar of classical myths, that of Apollo and the Muses. This ballet, like *The Rite of Spring* before it, was written for Diaghilev. Also commissioned by Diaghilev was *Pulcinella* (1920), in theory an adaptation of various works by the Italian composer Giovanni Battista Pergdesi (1710–36) but in fact an ironic commentary on traditional forms which allows Stravinsky simultaneously to enhance classicism and to subvert it.

Stravinsky expatriated himself from Russia after the Revolution. Sergei Prokofiev (1891–1953) went back to Russia after a period in the West; Dimitri Shostakovich (1906–75) made his entire career in the Soviet Union. The music written by both was shaped by the demands of Stalinist aesthetic theory. Both composers had serious clashes with the cultural authorities—for example, Shostakovich's powerful opera, *The Lady Macbeth of the Mtensk District*, about the wife of a dull but wealthy merchant who poisons her bullying father-in-law when he discovers her with a lover, was hailed as a model of socialist realism at its Leningrad premiere in 1934, but after being condemned in 1936 in a violent editorial entitled "Chaos instead of music" inspired by Stalin's own negative reaction to the Expressionist qualities of the score, it was dropped from the repertoire. Shostakovich was able to recover from this setback without totally sacrificing his creative integrity. His Fifth Symphony (1937), subtitled "a Soviet artist's reply to just criticism," has the euphony his political masters demanded, but also genuine grandeur and nobility. Soviet composers, as opposed to post-Constructivist Soviet painters, demonstrated that there was still life in the nineteenth-century tradition.

Prokofiev's music is usually more percussive, more interested in irony and parody, than that of Shostakovich, and thus seems more modern in many senses, but his ballet score *Romeo and Juliet* (1935–6) was a conscious return to Tchaikovsky.

The musicians who challenged this tradition most directly, without exploring the alternative route offered by popular music, were Schoenberg and his two pupils, Anton Webern (1883–1945) and Alban Berg (1885–1935). From 1917 onward, Schoenberg had begun to work out his new technique of serial composition, in order to bring a new and different order to music after the chaos of atonality (see page 473).

Serialism was in many respects more rigid than traditional methods of composition. The twelve notes of the chromatic scale appear in a fixed order—called "the series"—which remains the same throughout the work. The notes can be manipulated in different ways—the series can be transposed, inverted, reversed, or both inverted *and* reversed. The main function of the note row is to replace the coherence given to music by the long-established values of tonality—the idea that certain tones harmonize naturally. In serial music, however, this coherence often appears more clearly in the score than it does in performance, where the presence of the series has no impact. In its more extreme forms, serialism can seem very arid. This is the case with much of Webern's music which shows a mania for symmetry. His *Symphony for Small Orchestra* (1928) has only two movements. One is a double canon, with one note row or series carried by the first and third "voices," another by the second and fourth. The other is a palindromic set of variations, where the second half is the first half read backward, moving in retrograde motion.

The member of the Vienna Group who best communicates a wide variety of emotional colorings in his music is Berg, and his music is not always strictly serialist. *Wozzeck* (1925) and *Lulu* (left unfinished at the composer's death) are powerful Expressionist operas, comparable with the German Expressionist theater of the time. The Violin Concerto (1935) is full of latent romanticism.

Despite the wide variety of moods in serialist or quasi-serialist works by members of the Vienna Group, the publicity given to the new technique of composition tended to convince the public that contemporary music of a "serious" sort had entered a new and difficult phase.

Chapter 28

The Rise of America

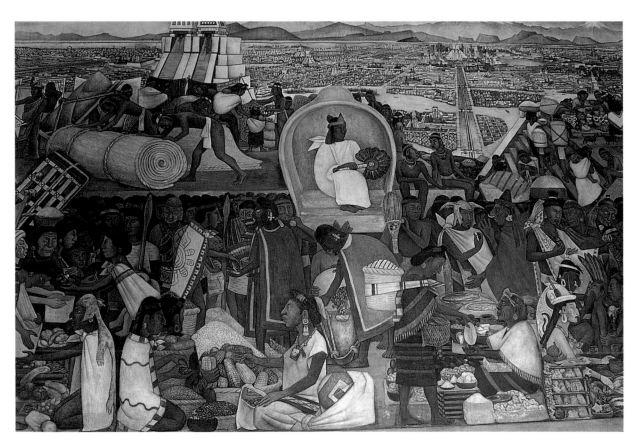

28.1 Diego Rivera, *Great City of Tenochtitlan* 1945. Mural, 193¾ × 382¼ ins (492 × 971 cm). The National Palace, Mexico City.

The rise of American culture

The United States already possessed a fully distinctive culture of its own in the nineteenth century, but its difference from the European cultures—to which it owed an incalculable debt—did not gain full recognition until the twentieth century. Something which contributed to this recognition was the United States' involvement in the two World Wars. Unlike that of Europe, the American economy benefited from the war in each case, rather than suffering from it. In 1945 the United States emerged as one of the most powerful nations, both militarily and economically. Between the wars, America had already become a major cultural exporter. Many parts of the world were influenced by American popular music and American films, and American literature was also making an impact. After 1945 it was the turn of the visual arts. With the rise of Abstract Expressionism, then of Pop Art, New York took over the position of leadership in the visual arts which had once belonged to Paris, and has retained it until now.

Philosophy

John Dewey and pragmatism

John Dewey (1859–1952) has had such widespread influence over twentieth-century American thought that he has, paradoxically, become an almost invisible figure, neglected and unfashionable because almost everyone agrees with him, even if they do not know the most immediate source of the ideas they espouse. Indeed, these ideas have become a kind of common ground, defended against professional philosophers and "intellectuals" in general. This provides another paradox, since Dewey was himself an exceptionally well-equipped professional philosopher.

Dewey's ideas are generally summed up in the word "pragmatism," though the pragmatic approach was not of course original to himself (see Locke, page 323). Few words have been more misused, and it seems prudent to offer a dictionary definition, taken moreover from a standard American work, rather than a British one. Funk & Wagnall's *New Practical Standard Dictionary* defines pragmatism as: "the philosophical doctrine that thought or ideas have value only in terms of action, and that results are the sole test of the truth of one's beliefs."

The implied amorality of this was not part of Dewey's credo, but his philosophy of practical use undoubtedly had great impact on his ideas about education. It is these ideas which, in turn, have affected the whole of American life, and helped to give twentieth-century American society and culture their particular tone.

Dewey's approach can be most easily summed up by giving a very brief sketch of his concept of "common sense."

Many philosophers and scientists have tended to see common sense not as the friend but as the enemy of rational inquiry—this is one of the things which separates them from the lay public. For them, it was simply a vague and contradictory group of beliefs whose general acceptance had nothing to do with accuracy. Dewey pointed out that all discovery, including science, must have a bedrock in what could plausibly be called common sense—that is, in a process of trial and error. In his terms, common sense was "a usable and useful name for a body of facts that are so basic that without systematic attention to them 'science' cannot exist, while philosophy is idly speculative apart from them because it is then deprived of a footing to stand on and a field of significant application."

The gulf between Dewey's attitude and that of Wittgenstein (see page 475) is self-evident. Dewey did not deny that philosophical propositions of a perfectly traditional sort can be meaningful. On the other hand, he tended to breakdown the distinction between philosophy and other modes of intellectual inquiry. It was the *pattern* of that inquiry which counted, not its subject matter. In this sense he looked back to Greek philosophers, such as Aristotle (see page 53), who also busied themselves with what we should now call science, and forward to the post World War II Structuralists (see page 516), who envisaged an overall "method" applicable to many disciplines—to anthropology on the one hand, or literary criticism on the other.

Another important aspect of Dewey's thought, especially significant in terms of its cultural context, is the emphasis he puts on the supremacy of practical experience. Anyone familiar with twentieth-century American culture and society will recognize the significance of these concepts. Even in cases where particular writers or artists seem to have rebelled against them, they still supply a framework for that rebellion.

Architecture

The triumph of the International Style

The United States began the twentieth century by producing an authentic architectural genius, Frank Lloyd Wright (see page 449). It was then inundated with successive waves of European influence. At first, it was European styles which were exported, and adapted for use on the other side of the Atlantic. Later, many foreign architects came to live and work in America. What they produced was strongly affected by local conditions, and by the demand for specifically American types of building, such as the skyscraper. Responding to these demands, certain leading architects were offered opportunities which probably never would have come to them in Europe, even if political conditions had been more favorable. They were able to build conspicuous monuments to themselves.

During the late 1930s, major architects who had once been connected with the Bauhaus began to arrive in the United States. Walter Gropius arrived in 1937, Mies van der Rohe (1886–1969) in 1938. Mies became Professor of Architecture at the Armour Institute (later the Illinois Institute) of Technology in Chicago. Opportunities to build were at first restricted by the continuing effects of the Slump, and then by World War II. As early as 1939, however, Mies started work on a new master-plan for the Institute of Technology, and by the later 1940s commissions for new buildings were flowing in. A number were for the skyscrapers which were now a long-established American building type.

Though the skyscraper had been invented in America, it had long excited the imaginations of European Modernist architects, but they had never been given the resources to realize their projects. During his years in Germany, Mies himself had prepared designs for buildings of this type— crystalline towers, making use of a steel skeleton, and enclosing, non-weight-bearing curtain walls of glass. In America he was finally given his chance, first building several such towers in Chicago and then the Seagram Building (1954–8) in New York, designed in partnership with the American architect Philip Johnson (born 1906).

The Seagram Building (Fig. **28.2**) is a single tall slab of bronze glass, set in a wide granite-paved plaza, with flowers and trees. The effect is somberly impressive. Commerce takes on the air of reticent nobility which architects once reserved for churches or governmental buildings. Mies's bronze tower became an icon of American architecture in the years following World War II, and American architects were content to follow the lead he offered. What had once been a revolutionary approach, to architecture itself and to the resources offered by twentieth-century technology, developed into a tight and rigid orthodoxy.

28.2 **Ludwig Mies van der Rohe** and **Philip Johnson**, Seagram Building, New York, 1954–58.

Painting

American realism between the wars

Americans had been introduced to the European avant-garde by the New York Armory Show of 1913. This awareness of what was going on in Paris was consolidated when the Museum of Modern Art opened its doors to the public in 1929. Would-be American avant-gardists in the European style nevertheless faced two very real difficulties in establishing themselves. One was the conviction that European work in the same vein was necessarily superior; the other was the strength displayed by a purely American realism.

During the interwar period, realist art in the United States was of several different sorts, and the artists pursued extremely different objectives. First in the field were the Precisionists. Precisionism began to emerge as a definable movement at the beginning of the 1920s. It had its roots in a number of different places—in European Cubism and Futurism, but also in photography. A number of the leading Precisionist painters, notably Charles Sheeler (1883–1965), were accomplished photographers, and their best-known compositions can often be traced directly to photographic sources. Sheeler's avowed aim was to "reduce natural forms to the borderline of abstraction, retaining only those forms which [he] believed to be indispensable to the design of the picture." His chosen subject matter was urban or industrial. Often, as in *Upper Deck* (Fig. **28.3**) of 1929, he used the kind of drastic cropping familiar from photography to make the chosen image seem alienated, and therefore closer to abstraction.

Related to the Precisionists in style, but not a member of the core group, was the most important American woman painter of the time, Georgia O'Keeffe (1887–1986). O'Keeffe was the protégée, and eventually the wife, of the leading photographer Alfred Stieglitz (1864–1946). She was therefore well aware of what the camera could achieve. She depicted New York cityscapes, very much in the Precisionist idiom, but also made paintings inspired by Lake George, and by New Mexico, where she was eventually to settle permanently. Her most memorable images are probably her close-ups of flowers (Fig. **28.4**, for example). These are sometimes seen from such a close viewpoint that they come, like Sheeler's machine-forms, very near to true abstraction. Despite this, they often retain strong sexual connotations, and can be read as feminist statements.

The objectives of the Precisionists were almost the opposite of those pursued by the American Regionalists, who rose to prominence in the late 1920s. Where Precisionism was detached, Regionalism was committed to a romantic vision of America. The leader of this group was Thomas

28.3 Charles Sheeler, *Upper Deck* 1929. Oil on canvas, 29 × 22 ins (74 × 56.3 cm). The Harvard University Art Museums, Massachusetts. Louise E. Bettens Fund.

Hart Benton (1889–1975). Part of Benton's inspiration came from the success of the muralist movement in Mexico. In 1921 the Mexican painter Diego Rivera (1886–1957), who had moved in Cubist circles in Paris, returned to his native country and began to paint enormous public murals (Fig. **28.1**, for example) illustrating the history of his country and the process of the left-wing revolution which was attempting to transform Mexican society.

Benton and his associates were not attracted by Rivera's Communism—their own political views were conservative. What did attract them was the element of nationalism, the fact that the new Mexican art was an art of public statement, and perhaps the idea that it involved a rebellion against the Modern Movement. Benton's views aroused a good deal of opposition from the New York art world, and in 1934 he decided to return to his native Midwest. He took up a post as director of painting at the Kansas City Art Institute, and in 1935–6 painted what was to be his most ambitious mural-cycle, *A Social History of Missouri* (Fig. **28.5**), for the Missouri State Capitol in Jefferson City. A skillfully orches-

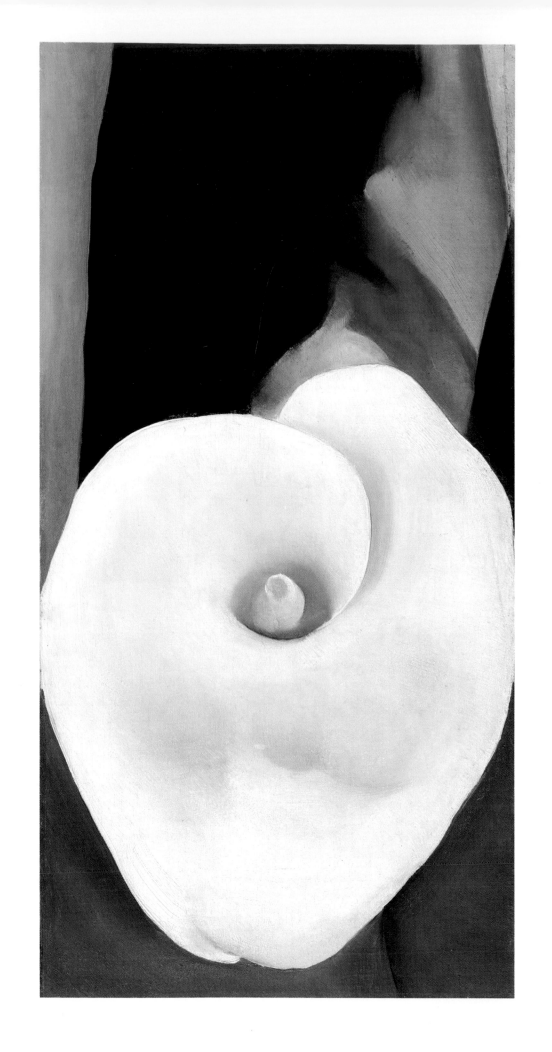

trated mixture of the historic, the realistic, and the symbolic, this has an energy which recalls Italian mural-painting of the late sixteenth century (see page 251). The details, such as the clearly recognizable portrait of the local political boss, Tom Prendergast, are more realistic than the effect made by the whole.

The work of Edward Hopper (1882–1967) does not speak with a collective voice, as Benton's tries to do. Its themes are rootlessness and loneliness. Hopper paints deserted street corners, hotel bedrooms and lobbies, offices, and railway cars. One of his most memorable paintings is *Gas* (Fig. **28.6**) of 1940, which shows a country filling station—a subject which had probably never before appeared in art. Evening is just beginning to fall; there is one man to tend the pumps and no automobile in sight. Hopper's blunt-edged technique is conventional for its time, but his actual choice of subject matter makes him look like a forerunner of Pop Art (see page 502). He can take what is absolutely banal, and make a positive and original statement about it.

28.6 **Edward Hopper**, *Gas* 1940.
Oil on canvas, 26¼ × 40¼ ins (66.7 × 102.2 cm). Collection, The Museum of Modern Art, New York. Mrs. Simon Guggenheim Fund.

28.4 **Georgia O'Keeffe**, *Lily—white with black* 1927.
Oil on board, 12 × 6 ins (30.5 × 15.2 cm). Estate of Georgia O'Keeffe.

28.5 **Thomas Hart Benton**, *A Social History of Missouri* 1935–36.
House of Representatives Lounge. Missouri state capital.

Abstract Expressionism

While the American artists who wished to create an avant-garde on the European model were ignored by the majority of their compatriots during the interwar period, and were neglected in addition by the few institutions who were in a position to offer them help—the Museum of Modern Art, for example, made no secret of their view that American art was provincial and imitative—they did have one unexpected and vital source of help. This was the Federal Art Project (FAP), set up by the Works Project Administration to alleviate the worst effects of the Depression as it affected American artists.

The FAP offered employment to substantial numbers of artists. When it was at its peak, almost 3,000 were able to work in comparative freedom in New York City alone. The stylistic range was wide—no official distinction was made between representation and abstraction—and room was found for many of those who were to become the leaders of American art in the postwar period. The FAP created a remarkable *esprit de corps* which carried over into the 1940s.

The other factor in the development of a new and more self-confident American avant-garde was World War II itself. Like Nazi persecution before it, it brought many European refugees to the United States. In particular, the French Surrealist group fled almost en masse to New York.

The first, vital link was formed between the Chilean painter Matta (Roberto Sebastiano Matta Echaurren, b. 1911), who had worked in Paris with the Surrealists, and the Armenian-born Arshile Gorky (Voganig Manoog Adoian, 1905–48). Gorky emigrated to the United States in 1920, and moved to New York five years later. His prewar work was a laborious recapitulation of European styles—Cézanne, Picasso, and finally Miró. His friendship with

28.7 **Arschile Gorky**, *The Liver is The Cock's Comb* 1944.
Oil on canvas, 72 × 98 ins (183 × 249 cm). Albright-Knox Art Gallery,
Buffalo, New York.

28.8 Mark Rothko, *Green on Blue* 1956.
Oil on canvas, 89¾ × 63¼ ins (228 × 161 cm). University of Arizona
Museum of Art. Gift of Edward Gallagher, Jr.

Matta, who was on the Calligraphic rather than the Veristic wing of Surrealism, encouraged him to explore more boldly, and he was further inspired by the recognition he received from André Breton.

What Gorky did was to take the technique used by Surrealists like Miró and André Masson (1896–1987) and loosen it still further, so that there was a constant proliferation of images. A typical example of the process is his painting *The Liver is the Cock's Comb* (Fig. **28.7**) of 1944.

Gorky, however, remained a forerunner, someone stranded between the European approach to painting and the American view. The first painter to win wide recognition for the new American art was Jackson Pollock (1912–56). Pollock was in many ways ideally equipped to become a new type of American hero. While Gorky and a number of other leading Abstract Expressionists were immigrants, Pollock was American-born. He spent his youth in the West—in Arizona and California—and in 1929 came to New York to study under Benton. In the succeeding decade, like many American artists of the same generation, he fell under the spell of Mexican muralism. He also began to take a keen interest in primitive art.

By 1947, Pollock had "broken through" to the manner for which he is now best known: free, informal abstraction, based on a technique of dripping and smearing paint on the canvas. If images are present in a painting like *One* (*Number 31 1950*) (Fig. **28.9**) of 1950, they are well disguised by Pollock's swirling calligraphy, which allows the composition no single center or focus.

"All overness," as it came to be called, was one of the salient characteristics of the new art. However, Abstract Expressionists evolved many different interpretations of the concept. Mark Rothko (1906–70) preferred a more tranquil, meditative version (Fig. **28.8**, for example). Floating rectangles of color—generally two or three, stacked one above the other—were shown against a ground of harmonizing hue. Their edges were blurred, so that they seemed to detach themselves from the canvas and float in space. The arrangement was almost always symmetrical, and there was no attempt at dynamic composition. What Rothko offered was an icon for mystic contemplation, while Pollock tried to involve the spectator in a kind of psychological labyrinth.

In American terms, Abstract Expressionism signaled a new mood of confidence in American creativity—though it was also, through a strange paradox, a mood of extreme introversion. The artist ignored all social considerations and gave free rein to the promptings of the ego. When they discovered the new American art after the war, Europeans were overwhelmed by its boldness and originality, and in particular by the ambitious scale on which the artists worked. New York abruptly replaced Paris as the focal point for visual experiment.

28.9 Jackson Pollock, *One (Number 31, 1950)* 1950.
Oil and enamel paint on canvas, 8 ft 10 ins × 17 ft 5⅝ ins
(2.69 × 5.31 m). Collection, The Museum of Modern Art, New York.
Sidney and Harriet Janis Collection Fund.

28.10 Robert Rauschenberg, *Crocus* 1962.
Oil and silkscreen on canvas, 60 × 36 ins (152.4 × 91.4 cm).
Leo Castelli Gallery, New York.

Neo-Dada

If there was one thing which Abstract Expressionism largely lacked, it was a sense of irony. This was to be supplied by two artists who took up Marcel Duchamp's ideas about the readymade (see page 486) and interpreted them in a new way—somewhat to the discomfort of Duchamp himself.

The Abstract Expressionist painter Robert Motherwell (b. 1915) had already begun to re-explore the history of Dada, which at that point had largely been forgotten, and in 1951 he published an important collection of Dada documents, *The Dada Painters and Poets: An Anthology*. But these explorations had little effect on his own art. The two artists who were to change the direction of American painting were Robert Rauschenberg (b. 1925) and Jasper Johns (b. 1930).

Rauschenberg's earliest paintings were flirtations with the Minimalism which was to surface again in the late 1960s. After this, he began to work on what he called "com-

bine paintings." These were an extension of the collage technique already used by the Cubists, the original Dadaists, and the Surrealists. A painted surface was combined with various objects. In the early 1960s, he took matters a little further and began to make increasing use of photographic silk-screens, which enabled him to fill the canvas with a mixture of readymade images. An example is *Crocus* (Fig. **28.10**) of 1962, which features a silk-screen image of a truck.

The philosophy behind these paintings seems to be borrowed from the experimental musician John Cage (see page 514), whom Rauschenberg met in North Carolina. Cage believes that the most creative and useful thing the creative artist can do is to "unfocus" the minds of the audience, so as to make them aware of the wash of images already passing thought their environment.

Johns made his reputation with art of a different but related type. His best-known early paintings are literal depictions of the American flag—for example, *Three Flags* (Fig. **28.11**) of 1958. He has since said that the image came to him in a dream. "Using the design of the American flag

took care of a great deal because I didn't have to design it." The flag, as Johns recognized, is for an American audience at once powerfully emotive and totally banal. He seizes on both these qualities as the basis for a magical transformation. The technique is wax encaustic (used by the ancient Egyptians for mummy portraits), which gives a uniquely seductive surface. The ordinary is transformed into the precious.

Like Rauschenberg's combine paintings, Johns's *Flags* are meditations on the nature of the everyday. The banal—which is the everyday in another and more pejorative guise—was to become the chosen territory of Pop Art.

Pop Art

The birth of Pop Art, at the beginning of the 1960s, was an important turning point for two reasons. It represented a recognition of cultural phenomena which were completely different from the traditional cultural inheritance of western Europe. At the same time it involved an enfeeblement of the power to create original images. The two things were closely

28.11 Jasper Johns, *Three Flags* 1958.
Encaustic on canvas, 31 × 45 ins (78 × 115 cm). Whitney Museum of American Art, New York.

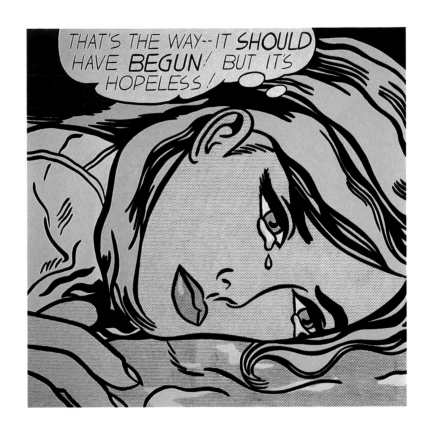

28.12 **Roy Lichtenstein**, *Hopeless* 1963.
Acrylic on canvas, 44 × 44 ins (112 × 112 cm).
Ludwig Collection, Kunstmuseum, Basel.

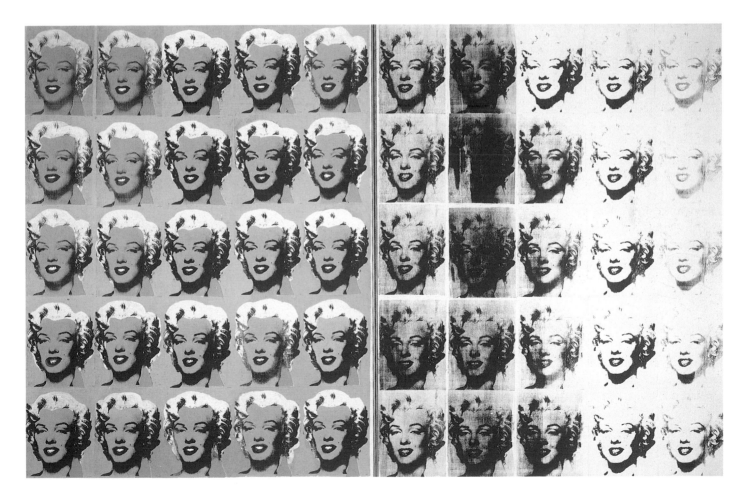

28.13 **Andy Warhol**, *Marilyn Diptych* 1962.
Oil on canvas, in two panels, 82 × 114 ins (208.3 × 289.6 cm). Tate
Gallery, London.

intertwined. One of the ways in which the new urban mass-culture differed from the traditional variety was through its power to generate a deluge of imagery which had no pretensions to be art. This tended to marginalize art itself. Pop tried to bridge the gap between the two realms, but at the price of becoming the junior, dependent partner.

The earliest notice accorded to the new urban mass-culture came not from the United States but from England. However, it did not take Americans long to seize the initiative in exploiting this new area of interest. The approach route was through the Neo-Dada of Rauschenberg and Johns. Two painters now seem especially typical of the style—Roy Lichtenstein (b. 1923) and Andy Warhol (1930–87). Lichtenstein made his reputation with paintings like *Hopeless* (Fig. **28.12**) of 1963, based on images taken from comic strips. He seemed to use what he selected quite literally, though in fact minute adjustments were made for compositional reasons. One prominent feature was the screen of dots—in the original this was part of the process of cheap color reproduction. The artist went on to apply the same visual language to a wide range of other subjects, making parodies of established Modernist masterpieces, and even of some of Monet's series paintings of the 1890s (see page 408).

Warhol did not merely imitate the effects of mechanical reproduction. He made use of up-to-the-minute reproductive processes, notably the silk-screens taken from photographic blow-ups which were also used by Rauschenberg. The way in which Warhol employed these screens was deliberately coarse and slipshod—he seemed to imply that the images were the mass-cultural environment imposing itself on the passive and almost helpless artist.

Warhol's work has commonly been interpreted as a celebration of mass-culture, and in particular of the way in which it projects certain personalities—Warhol called them "superstars"—into the public consciousness.

In fact, while Warhol's work may indeed be celebratory, it usually has little of the brash optimism which the public came to associate with Pop Art. For example, his well-known series devoted to the actress Marilyn Monroe (*Marilyn Diptych*, 1962, Fig. **28.13**) functions as a lament for something lost. The creative trigger for the series was the news of Monroe's suicide, and the point of the images seems to be the way in which our imagined image of a star (always a greatly coarsened version) conceals and eventually effaces the real person. Warhol's tribute to Marilyn is the vehicle for a sardonic sense of what stardom is.

Modernist sculpture

American Modernist sculpture is formidably difficult to categorize. The Pop Art movement, for example, offers work in three dimensions as well as in two, but this is more closely related to the Surrealist "objects" like Meret Oppenheim's teacup (see page 487) than to sculpture as it is traditionally defined. The works made by Claes Oldenburg (b. 1929) in vinyl stuffed with kapok often represented familiar items of food, such as hamburgers or ice-cream cones. They have close links with giant advertizing signs. When Oldenburg allowed the forms to flop and dangle, as he did in a series of *Eggbeaters* (Fig. **28.15**), the things he represents take on a slightly sinister sexual connotation, reminiscent of the soft objects found in some of Salvador Dalí's paintings (see page 486).

In general, American sculpture from the first sixty years of the century seems to be the product of a conflict between three not very easily reconcilable traditions. One, not unexpectedly, is folk-art. The culture which successive waves of European immigrants brought with them across the Atlantic was largely folk-culture; sophisticated high culture had to be self-consciously acquired. *Man in the Open Air* (Fig. **28.14**) by Elie Nadelman (1882–1946) shows clear evidence of his affection for the American folk artefacts he collected.

There is also folk influence in the mobiles (Fig. **28.17**, for

28.14 **Elie Nadelman**, *Man in the Open Air* c. 1915. Bronze, height 54³/₁₀ ins (138 cm), base 11¾ × 21½ ins (29.9 × 54.6 cm). Collection, The Museum of Modern Art, New York. Gift of William S. Paley, by exchange.

28.15 Claes Oldenburg, *Dormeyer Mixer Eggbeaters* 1965.
Vinyl, wood and kapok, 32 × 20 × 12½ ins (81.28 × 50.8 × 31.75 cm).
Collection, The Whitney Museum of American Art. Purchase with
the funds from the Howard and Jean Lipman Foundation, Inc.

28.16 David Smith, *Cubi XIX* 1964.
Stainless steel, 9 ft 4 ins × 4 ft ⅞ ins × 3 ft 4 ins (2.86 × 1.48 × 1.01 m).
Tate Gallery, London

example) of Alexander Calder (1898–1976). These delicately swaying confections of wire and flanges of painted tin had their origin in the playful toy circus which Calder constructed to amuse his friends in the Paris art world. The mobiles that followed owe something to windjacks and weathervanes, two favorite American folk-art forms, but are also indebted to the Surrealist Joan Miró (see page 484).

David Smith (1906–65), one of the most important American sculptors of the period after World War II, also owes much to painting, and indeed began as a painter. His most characteristic work, done at the end of his career, was

influenced by direct contact with American industry. His late sculptures, often very large, like *Cubi XIX* (Fig. **28.16**) of 1964, are welded together from sheet steel, I-beams, and other industrial materials. Despite their size and weight, Smith made them in an improvised way, laying out the parts in various experimental configurations, flat on the ground at his open-air studio, then putting them together in permanent form once he reached a design that satisfied him. For admiring Europeans, these sculptures symbolized the easy psychological relationship which seemed to exist between American culture and the modern industrial process.

28.17 Alexander Calder, *Lobster Trap and Fish Tail* 1939.
Hanging mobile, painted steel wire and sheet aluminum, about
8 ft 6 ins high × 9 ft 6 ins diameter (260 × 290 cm). Collection, The
Museum of Modern Art, New York. Commissioned by the Advisory
Committee for the stairwell of the Museum.

Literature

Hemingway and Faulkner

During the course of the nineteenth century, American writers produced great works of fiction, but only one novelist managed a consistently prolific career at the very highest literary level. This was the expatriate Henry James, whose work has already been discussed (see page 439). The major masterpieces written by writers who remained at home, chief among them *Moby Dick* (1851) by Herman Melville (1819–91) and *Huckleberry Finn* (1884) by Mark Twain (Samuel Langhorne Clemens, 1855–1910), are isolated phenomena which belong to no specific school.

If these two works do have anything important in common it lies in their concern to break down the barrier between fact and fiction—a recurrent concern with twentieth-century American novelists such as Truman Capote (1924–) and Norman Mailer (b. 1923). Melville does this through his detailed description of the processes of whale-hunting; Twain more directly through language—his concern is to offer a convincing version of American vernacular speech, in a book which is in many ways a direct descendant of Defoe's *Robinson Crusoe* (see page 330).

Though it is admiration for *Moby Dick* which has consistently fired the ambition of twentieth-century American writers to produce "the great American novel"—almost by definition a hybrid between prose fiction and traditional epic—*Huckleberry Finn* has been influential in more directly practical ways. Most of all, what Twain did was to establish the idea that communication with a popular, as opposed to an élite, audience remained possible without sacrifice of quality. James rejected this when he chose to expatriate himself, but the majority of important American novelists have chosen to believe otherwise.

In the earlier part of the twentieth century, the outstanding example of a writer who enjoyed both popular and intellectual success was Ernest Hemingway (1899–1961). His swift narrative and gift for describing violent physical action made him a major bestseller, and also a celebrity on a par with movie-stars and politicians. He was, nevertheless, a potent and original stylist, whose influence was felt among both his American contemporaries and European writers of stature. Eventually he was awarded the Nobel Prize for Literature in 1954.

Hemingway's prose, with its short, declarative sentences, avoidance of adjectives and complex syntactical structure, and cunning use of rhythmic repetition, had both popular and "high art" sources. He owed a great deal to his practical experience as a journalist, while his chief mentor in the literary avant-garde was the experimental writer Gertrude Stein (1874–1946), whom Hemingway met when he settled in Paris immediately after World War I.

Hemingway's novels all have foreign settings—only the short stories deal with Americans at home. These novels deal with the theme of manliness, and the necessity to obey the code—something Hemingway often defines in terms of sport. All-important is the question of "dignity"—stoic acceptance of whatever life chooses to hand out. These themes arise most naturally, and operate with greatest force, in two war novels: *A Farewell to Arms* (1929) and *For Whom the Bell Tolls* (1940). Both were based on Hemingway's personal experience of war—on the Italian Front as a Red Cross ambulance driver in World War I (which supplied material for the first book) and as a war-correspondent in the Spanish Civil War (which supplied material for the second)—and both are characteristic of major American fiction in that they consistently blur the line between fantasy and autobiography.

William Faulkner (1897–1962) was Hemingway's contemporary and his rival for literary esteem. He won the Nobel Prize for Literature four years before Hemingway, in 1950. Most of his twenty-odd novels deal with aspects of life in the fictional southern county of Yoknapatawpha, which bears many resemblances to the area of Mississippi where Faulkner spent most of his adult life. His books are thus, in contrast to Hemingway's, rooted in America, and, what is more, in a very particular region of America—the rural Deep South, which had never recovered from the defeat of the Confederacy in the American Civil War.

Faulkner has little of Hemingway's easy readability. On the other hand he is much more experimental in his use of literary forms. *As I Lay Dying* (1930) offers an index of his considerable powers. It tells the story of the death and burial of Addie Bundren, the wife of a poor sharecropper. When she dies, her family transport her body back to her home town, so she can be buried among her own folk. The narrative passes from voice to voice—her husband speaks, her four sons, her daughter, and her neighbors. There are violent events—one of the sons sets a barn on fire. All of this is told in dense, incantatory prose.

On the surface so different, Hemingway and Faulkner share important characteristics. Faulkner, like Hemingway, believed in a version of "the code," thinking "that man's free will functions against a Greek background of fate." In personal terms too, they were alike—both self-destructive alcoholics (Hemingway committed suicide). They offered a pattern which lesser authors were only too ready to follow and which in some ways has come to seem typical of American twentieth-century literature in general which has tended to fete writers for their personalities as much as their work.

Howl

This is the third and final section of Allen Ginsberg's *Howl* in which the poet addresses a friend who shared the experience of madness with him in the Columbia Presbyterian Psychiatric Institute ("Rockland") in New York. He remembers, among other things, the piano he and Carl used to bang on together until the doctors came running. He also recollects his mother, Naomi, who was mentally ill.

III

Carl Solomon! I'm with you in Rockland
 where you're madder than I am
I'm with you in Rockland
 where you must feel very strange
I'm with you in Rockland
 where you imitate the shade of my mother
I'm with you in Rockland
 where you've murdered your twelve secretaries
I'm with you in Rockland
 where you laugh at this invisible humor
I'm with you in Rockland
 where we are great writers on the same dreadful typewriter
I'm with you in Rockland
 where your condition has become serious and is reported on the radio
I'm with you in Rockland
 where the faculties of the skull no longer admit the worms of the senses
I'm with you in Rockland
 where you drink the tea of the breasts of the spinsters of Utica
I'm with you in Rockland
 where you pun on the bodies of your nurses the harpies of the Bronx
I'm with you in Rockland
 where you scream in a straightjacket that you're losing the game of the actual pingpong of the abyss
I'm with you in Rockland
 where you bang on the catatonic piano the soul is innocent and immortal it should never die ungodly in an armed madhouse
I'm with you in Rockland
 where fifty more shocks will never return your soul to its body again from its pilgrimage to a cross in the void
I'm with you in Rockland
 where you accuse your doctors of insanity and plot the Hebrew socialist revolution against the fascist national Golgotha
I'm with you in Rockland
 where you will split the heavens of Long Island and resurrect your living human Jesus from the superhuman tomb
I'm with you in Rockland
 where there are twenty-five-thousand mad comrades all together singing the final stanzas of the Internationale
I'm with you in Rockland
 where we hug and kiss the United States under our bedsheets the United States that coughs all night and won't let us sleep
I'm with you in Rockland
 where we wake up electrified out of the coma by our own souls' airplanes roaring over the roof they've come to drop angelic bombs the hospital illuminates itself imaginary walls collapse O skinny legions run outside O starry-spangled shock of mercy the eternal war is here O victory forget your underwear we're free
I'm with you in Rockland
 in my dreams you walk dripping from a sea-journey on the highway across America in tears to the door of my cottage in the Western night

Ginsberg

The Cinema

The cinema was the child of photography (see page 399). While several people can claim part of the credit for finding a way to project photographic images and make them move, the first practical camera and projector were the work of the Frenchman Louis Lumière, and it was Louis Lumière (1864–1948) and his brother Auguste (1862–1954) who opened the first public cinema in Paris in 1893. Films were, to begin with, simply naïve representations of what happened to be in front of the lens—the mere fact that the images moved was enough to fascinate the public—but they soon came to be used as a medium for fictional narratives. By 1909 Bronco Billy westerns were already popular in the United States.

One apparent drawback of the early cinema in fact helped to insure its universal popularity. There was no language barrier because films were at first silent and the action had to depend on mime, with inserted captions or subtitles. Sound arrived gradually. Experiments with it were being made throughout the 1920s, but they did not coalesce into a viable commercial product until the arrival of *The Jazz*

Still of Lillian Gish in *Broken Blossoms* 1919. British Film Institute, London.

Still from *The Battleship Potemkin* 1925. British Film Institute, London.

Singer, starring Al Jolson, in 1927. It was appropriate that this should be an American film, as the cinema was by this time inextricably linked in the public mind with the American way of life, the American movie-industry having secured a position of worldwide dominance over all its rivals.

The qualities which made the cinema unique were twofold: its technique of handling images, and its creations of personalities who enjoyed a mythic status within the context of popular culture. Film makers soon discovered that their medium had its own visual "grammar" and encouraged effects quite different from those which could be seen on the stage. Among the more important of these effects were the close-up, which intensified emotion by allowing the spectator to see a performer's reaction to a given situation in the minutest detail, or which called attention to a significant detail; the cut, which turned film-narrative into a collage of juxtaposed images; and the dissolve, where one image melted into another. The camera became more and more mobile as film techniques developed, and spectators were not confined to a fixed viewpoint, like spectators at the theater, but became part of the action.

During the silent film period the director who developed these new techniques to their fullest extent, and used them with the greatest degree of sophistication, was not an American but a Russian, Sergei Eisenstein (1898–1948), who had trained as an architect and engineer, and who was influenced by the aesthetic of Russian Futurism (see page 462). Eisenstein's film *The Battleship Potemkin* (1925) was a poetic reinterpretation of the unsuccessful Russian revolution of 1905, and was designed to present this as a heroic precursor of the

Still of Greta Garbo in *Queen Christina* 1933. British Film Institute, London.

revolution of 1917 which had brought the ruling Soviet regime to power. The film presents a mutiny on a Russian warship as a series of flashpoints. The most famous of these, the massacre on the Odessa steps, is presented by Eisenstein in a way which was to fascinate artists such as Francis Bacon (see page 521). Gigantic close-ups—such as one of a pair of shattered eye-glasses—involve spectators in the violence of the event, but do not allow them to see all of it. As a result the violence becomes internalized, part of themselves.

In its creation of personalities, film followed in the foot-steps of the theater of the Romantic period. Romanticism's worship of performers tended to deify certain actors and actresses, who were regarded as people who, even off the stage, were larger than, or even other than, life (see page 391). This process was now applied to performers in films. Thanks to the nature of the medium, however, these were as removed from the public in one sense as they were accessible to it in another. What the public saw were not living beings but shadows on a screen, and around these shadows power-ful fantasies were woven. The actor or actresses, in the public mind, became indistinguishable from the role, or from a series of similar roles, tailored to fit a particular personality. This was especially true of a series of screen goddesses—Lillian Gish in the silent era, Greta Garbo in the 1920s and 1930s, and Marilyn Monroe in the 1950s—whose public images were constructed and packaged to popularize different ideals of femininity.

The cinema, in addition to being a purveyor of myths, was also a conduit for information. In particular, films with contemporary subject matter projected American culture and attitudes into the collective consciousness. The cultural dominance achieved by the United States in the years immediately following World War II had been long prepared by what appeared on the cinema screens of the world, from the early 1920s onwards.

Still of Marilyn Monroe in *Some Like It Hot* 1959. British Film Institute, London.

Carlos Williams and Ginsberg

Twentieth-century America offers an exceedingly rich selection of poets, fully comparable to the European poetry of the nineteenth century, and challenged only in its own time by the poetry of Spain and Latin America. Though it may seem invidious to single out only two writers from so many, my choice is based on a search for what seems most truly American—for varieties of poetry which seemed to reflect the American experience.

William Carlos Williams (1883–1963) was, of all the poets of his time, the one who was most obsessively concerned with American subject matter, and, above all, with the nature of American language and its difference from other kinds of language. At the beginning of his career he was deeply involved in the Modern movement. He was aware of what was going on in the visual arts, and his poetry shows an attempt to offer parallels for Modernist styles in painting, particularly Cubism.

He was convinced that an American poet should use American idioms, and that the poems would then automatically take on an American speech rhythm. This speech must also have direct, vivid contact with the objects the poet encounters in the world. In the first part (1938) of his epic poem *Paterson*, Williams speaks of the need

To make a start
out of particulars
and make them general.

(WILLIAM CARLOS WILLIAMS, *Paterson*, complete edition. New Directions, 1963.).

Paterson, his most ambitious effort, is an attempt to sum up the life of an American city—a composite of Rutherford, where Williams actually lived, and nearby Paterson. Today Paterson's most celebrated product is the Beat poet Allen Ginsberg (b. 1926), who grew up there. Ginsberg's fame, however, began on the other side of the American continent, with the publication of his long poem *Howl* in 1956 by City Lights Books in San Francisco, a center for the new Beatnik culture, which took some of its ideas from jazz, and others from Zen Buddhism. The word "beat" had an extramusical connotation as the short form of "Beatitude." A remarkable amalgam, it owes something to Williams's example, but its roots are also in Whitman, in the Bible, in William Blake, and elsewhere. The poem is based on direct personal experience. Ginsberg had undergone psychiatric treatment, and *Howl* asserts the rights of madness:

I saw the best minds of my generation destroyed by
 madness, starving hysterical, naked,
dragging themselves through the negro streets at dawn
 looking for an angry fix,
angelheaded hipsters burning for the ancient heavenly
 connection in the starry dynamo in the machinery
 of night . . .

(ALLEN GINSBERG, *Allen Ginsberg: Collected Poems 1947–80*. (HarperCollins and Penguin Books, 1985.)

Howl was American in a different sense from Williams's poetry. Ginsberg's biographer Barry Miles notes that the poem is written "using the rhythms of speech from the American street, phrasings overheard on street corners and in bars—and the rhythms of bebop and jazz, of sports commentators and the cool DJs on all-night jazz programs."

In its insistence on the primacy of the psyche, it is linked to Abstract Expressionism in painting, but the actual materials used were similar to those of yet-to-be-born Pop Art (see page 502).

Drama

Eugene O'Neill

With Eugene O'Neill (1888–1953), America produced a playwright to rank with Ibsen, Chekhov, and Strindberg (see pages 420 and 440). These names are intended to give an idea not only of his stature as a dramatist but of the styles in which he wrote. He began his career as a naturalistic playwright, with the one-acter *Bound East for Cardiff* (1916), but by the early 1920s he was producing Expressionist plays, such as *The Emperor Jones* (1920) and *The Hairy Ape* (1922), which find their parallels in the work of Strindberg, and also in what leading German playwrights were doing at the same epoch. These experiments were followed by the trilogy *Mourning Becomes Electra* (first produced in 1931), which adapts the storyline of Aeschylus's *Oresteia* to the American Civil War period.

O'Neill's greatest achievements, however, are the plays of his final period, which appeared after a long interval when nothing of his had been seen on the stage. His two masterpieces are *The Iceman Cometh*, written in 1939 but not produced until 1946, and *Long Day's Journey into Night* (1939–41), staged only after his death.

The Iceman Cometh is set in a bar. Its characters seem to be suspended in a timeless void—the void of their own guilt

and despair. The naturalism of the play, mingled with a touch of melodrama, epitomizes the crucial difference between European and American twentieth-century culture.

More American still is the massive, autobiographical *Long Day's Journey into Night*. This recapitulates O'Neill's relationships with his actor father, his drug-addicted mother, and his dissolute elder brother. The vulnerability and psychic openness of this play recall the work of many other leading American writers.

Music

Popular music

Pop music, as something sharply divided from the main body of musical development is a twentieth-century phenomenon. The increasing complexity of nineteenth-century music, as exemplified by the operas of Wagner (see page 392), did of course, simply by reaction, lead to the development of a lighter repertoire. The operettas of Offenbach (see page 390) have already been mentioned. However, there was as yet no definite breach between the two forms of expression. The nationalist composers of the late nineteenth century were, in fact, especially keen to make use of simple folk-melodies, as things which were representative of the spirit and heritage of their own countries.

The breach between music as a "high art" and music as a popular form came when the popular form ceased to be indigenous. In other words when first ragtime, then jazz, began to be imported into Europe from the United States. These new forms immediately fascinated composers as different from one another as Stravinsky (see page 471) and Kurt Weill (see page 490), but the divorce between this imported popular music and what they made of it was always apparent, and the two worlds, "high" and "low," inexorably began to drift apart. The division was even re-exported to the United States, and it became permanent when industrialized urban mass-culture replaced folk-culture, which was largely rural.

American popular music has an especially complex history, something which is not surprising in view of the complexity of the American racial heritage. American popular music is the product of three major musical currents, sometimes in conflict with one another, and sometimes mingling. Two of these—jazz and the blues—are of black origin; the third, "hillbilly music," later to be called country and western was rural English folk-music, transported across the Atlantic, and transformed for American use.

American popular music would not have acquired the power it did without the rapid technological progress characteristic of the century. It was disseminated in two main ways: by means of the gramophone, and on the radio. The gramophone was invented in the late nineteenth century, and by 1916 most American homes had one. Later, it became public as well as private entertainment, when it was developed into the coin-operated juke-box. Radio stations began operating in Detroit, Pittsburgh, and Newark during 1919–20. In 1926, the NBC network made its inaugural broadcast, and this was followed by CBS in 1927.

Of all American musical forms, jazz has attracted the greatest degree of intellectual interest, and it also made the most immediate impact in Europe, where many leading composers made borrowings from it. Certain aspects of jazz—the use of syncopation, of driving rhythms, and of brilliant instrumental improvisation—remained important to American popular music as a whole. Yet it is certainly not the main source of pop music as it had developed since the mid-1950s. After a brilliant flowering in the interwar period jazz relapsed into being a specialist taste, as indeed it still is today. Even during its period of greatest creativity and brilliance jazz was never completely dominant in the popular field as there were always rivals—ballads and show-tunes of various kinds.

Today the mainstream popular idiom, in the United States and almost throughout the Western world, is rock, which arose from a fusion of rhythm and blues (a version, though a more emotionally positive one, of the blues lament, which in turn had its roots in the negro spiritual), and country and western—the narrative music of the white American working class. This fusion took place in the mid-1950s, when young white singers, such as Elvis Presley (1935–77), began to use their own version of the blues style formerly associated almost exclusively with blacks. The music expressed, not an increase in racial tolerance, nor a break up of the class system, but the rebellion of American youth against its elders. Its commercial success provided convincing proof of the purchasing power which was now in the hands of young people.

In purely economic terms, popular music and the movies were the two forms of cultural expression which enjoyed the greatest degree of success in twentieth-century America. They were also the only two art forms which reached a majority of the American nation.

"High" and "low" in American music

American "serious" (high art) music retained securer roots in popular forms than its European counterpart, simply

because these popular forms were in fact indigenous. The transition from folk influences to those which came from urban mass-culture was not as yet really apparent in the work of Charles Ives (1874–1954), since Ives wrote most of his music before 1918. What is apparent was his fascination with material which would have been dismissed as cheap or vulgar by all his peers. His artistic independence was the product of creative isolation. Though Ives studied composition at Yale, he spent most of his life pursuing a business career, and composing only in his spare time. Typical of one part of his output is his symphony *Holidays* (1904–13), parts of which are a dense collage of marches, hymns, and sentimental parlor songs.

George Gershwin (1898–1937) had already made a reputation as a composer of popular music before he began academic composition studies. His original field was the musical—the jazz-influenced transatlantic successor to European operetta. Among the shows for which Gershwin wrote songs (with lyrics by his brother Ira) were *Lady, Be Good!* (1924), *Oh, Kay* (1926), and *Funny Face* (1927). Gershwin was anxious to be recognized as more than a mere composer of popular tunes, and fused jazz and traditional musical structures in works designed for the concert hall. The best known is *Rhapsody in Blue* (1924), for piano and jazz orchestra.

Aaron Copland (1900–90) came, unlike Gershwin, from an academic, not a show business background, but he, too, felt a keen interest in making use of American popular material. This features most prominently in a series of ballet scores which he composed in the 1930s and 1940s—*Billy the Kid* (1938), *Rodeo* (1942), and *Appalachian Spring* (1944). Significantly, however, the themes are rural rather than urban. Copland's ballets can be seen as musical equivalents of the Regionalist paintings of Thomas Hart Benton (see page 495).

Gershwin's true successor was the composer-conductor Leonard Bernstein (1989–90), who managed a more successful mixture of "high art" and popular musical activity than any American of his generation. His greatest popular success was the musical *West Side Story* (1957), where Shakespeare's Romeo and Juliet story is transferred to a poor quarter of New York. The musical here seemed to reach its greatest possible degree of musical elaboration, without as yet weakening its roots in urban mass-culture.

Bernstein paid the penalty for crossing the line into something less obviously jazz-based, and more musically complex, with his operetta *Candide* (1956, several times revised), a failure when it was first produced. Nevertheless this is one of the most seductive and likeable of all twentieth-century American musical works. It retells the story of Voltaire's novella of the same title (see page 345) with a unique mixture of bravura, good humor, and real satirical bite.

John Cage

There was also a handful of American composers who turned their backs on the whole popular field and who allied themselves instead with the visual arts avant-garde. A notable example is John Cage (b. 1912), a pupil of Schoenberg (see page 491), who described him as "not a composer, but an inventor—of genius." However, Schoenberg's influence was less important for Cage than that of Erik Satie (see page 473), Dada (see page 481), and Zen Buddhism.

The essence of Zen is to be found in the belief that real knowledge can never be found through deliberate study, but only through an awakening to one's own nature. The emphasis is on achieving the immediate experience of ultimate truth. Cage has striven to put this doctrine into practice by choosing methods of composition which often look like a refusal to compose.

One of his more striking experiments was a brief piece called *Imaginary Landscape No. 4* (1954). Its duration is four minutes, and it is played on twelve radios, each of which is controled by two performers, one of whom uses the station selector, while the other employs the volume and tone controls. Cage meant this piece, and a number of others—one of which consists simply of four minutes and 33 seconds of uninterrupted silence (*4' 33"*, 1952)—to call attention to the importance of ambient sound. One ironic feature of both compositions is the fact that it would probably have been impossible to conceive of either of them without the immense growth of popular music, and its universal availability through the radio and other means of reproduction. Both, when performed as Cage instructs, are more likely than not to consist of a random collage in which pop music plays a preponderant role.

Chapter 29

Europe 1940–70

29.1 **Le Corbusier,** Unité d'habitation, Marseilles, 1946–52.

Postwar Europe

The intellectual and creative climate of the immediately postwar years in Europe was the product of World War II, and of the Cold War which followed between the capitalist and Communist system. World War II left behind it feelings of horror and emotional numbness which found frequent expression in the arts. There was a terror of atomic warfare. Despite successful political events in central and eastern Europe—the Hungarian Uprising (1956); the building of the Berlin Wall (1961); the crushing of the "Prague Spring" (1968)—many European intellectuals retained a stubborn sympathy not merely with Communist doctrine, but specifically with Communism as it manifested itself in Russia. At the same time there was a great fascination with America and the American way of life, and American artists, in particular, seemed to take over the leadership of the avant-garde from the prewar Ecole de Paris. A comparatively small number of major European artists, writers, and musicians emerged to fill the places left by the original leaders of the Modern Movement, who were now beginning to die off.

Philosophy

Existentialism and Structuralism

The Existentialism of Jean-Paul Sartre (1905–80) was the only philosophical system of the postwar period, and perhaps the only philosophical system of the twentieth century, to gain genuine popular currency. Many people were, or wished to think of themselves as "Existentialists," even if they had only a very skimpy knowledge of Sartre's doctrines. In this sense, Sartre could be thought of as the true successor to Jean-Jacques Rousseau (see page 348), who also initiated a pattern of life, a way of thinking and behaving in ordinary everyday circumstances, as well as a full-blown philosophical doctrine accessible only to the few.

Sartre's views on his own doctrine were most authoritatively set out in his long and complex philosophical treatise *Being and Nothingness*, first published in 1943. They can be summarized as follows:

1. Man is as he behaves, yet he can never be reduced to what he has done, except when he is dead. As such, he remains fundamentally a mystery.

2. Man is his situation, and cannot be separated from what his place and time have made of him. Yet he is responsible for what he is and for his environment.

3. Man's thought and behavior are determined by his original choice, which is similar to a Freudian determinism in that it is neither rational nor deliberate, and yet he is free.

4. Man's every action is subject to moral interpretation, and yet there are no objective moral principles.

5. Man's fundamental relationship with others is conflict, but he can find himself only by committing himself to others.

6. Man and his world have an irrational origin, but salvation lies in rational recognition of what he is—a sort of reverse Stoicism, the living by man of the life determined for him by his project.

(NORMAN N. GREENE, *The Existentialist Ethic.* University of Michigan Press, 1960.)

Of particular practical importance to Sartre and his followers was point 5 of this summary. The need to be engaged or committed to something, in order to be relieved of the burden of one's own non-existence, led to an intense, often rather factitious interest in social and political causes of various kinds, and an inexorable drift toward Marxism, in terms of practical political alignments, even though Sartre was, on the theoretical plane, the declared enemy of the Hegelian idealism from which Marx sprang (see page 395), and also of Marxist determinism.

In due course a challenge to Existentialism was mounted by a new doctrine, Structuralism. Structuralism and Existentialism were irreconcilable enemies because Structuralism declared that the one remaining fixed point in the already fluid Existentialist cosmos, the individual who acts, is a convenient fiction—an unstable, replaceable unit in an infinitely extensible system.

The Structuralists, like Wittgenstein before them (see page 476), proposed a *method* of approaching reality rather than a philosophical system (an apprehension of reality itself) of a more traditional kind.

The chief Structuralists came from many different disciplines. Claude Lévi-Strauss (b. 1908) was an anthropologist. Jacques Lacan (1901–81) was a psychiatrist and psychoanalyst engaged in reinterpreting the doctrines of Freud. Other important members of the movement—all of them Frenchmen—are Roland Barthes (1915–80), Michel

Foucault (1926–84), and Jacques Derrida (b. 1930). All Structuralist thinking is ultimately based on the work of the Swiss linguist Mongin-Ferdinand de Saussure (1857–1913). Saussure thought that language was like a game of chess. At any given point in the game, the potential of any piece depends not on what it is in itself but on the relationship it has with other pieces. Structuralists therefore believe that what matters in a given system of meanings are the contrasts between the various elements, and not the elements themselves. Language itself is equated with thought, and instead of looking *through* it, Structuralists invite us to look *at* it. The difference of approach between the Structuralists and Wittgenstein is that Wittgenstein seems to have thought of linguistic forms as having a content, even if it was one that remained elusive. For Structuralists, the constantly changing form (changing as other forms exert pressure, or change themselves in relationship to it) is in fact the content.

Derrida, the youngest of the leading Structuralists, is of particular importance because of his association with the idea of "deconstruction." That is, he is hostile to all philosophical systems, and seeks to dismantle them by exposing their own inherent contradictions. He does not seek to replace them by anything else. For him, every exercise in language or thought involves the speaker or thinker in paradoxes which cannot be resolved. Every explanation involves a falsification. Derrida thus reflects the essential negativity of much late twentieth-century thought. "Deconstruction" has increasingly become a catchphrase in all the arts.

Postwar architecture

Architecture after World War II was necessarily preoccupied with the reconstruction of war-damaged Europe. It also, in the hands of social democratic governments, became the instrument of new ideas about the nature of society itself. Architectural planning became more important than the forms taken by single buildings.

Sometimes, however, architectural planning and architectural form were fused into a single, indissoluble whole. This was the case with one of the most influential of all postwar constructions, Le Corbusier's *Unité d'habitation* 1946–52 (Fig. **29.1**) at Marseilles. The building was a summary of the ideas Le Corbusier had put forward about urban living during the interwar period. It is a single vast slab, 450 feet (137.16 m) long, 66 feet (20.16 m) thick, and 200 feet (60.96 m) tall. In it are nearly 340 apartments designed to house around 1,600 people. Incorporated into the buildings, about a third of the way up, is a two-story shopping street, and there is a communal roof-garden. This is a complete small town which also happens to form a single structure.

The conception of the *Unité* was extremely influential—to architects and planners throughout Europe it seemed to offer the possibility of a new, healthier, more rational environment, less greedy for valuable building land. It was only later that the miseries of tower-block apartment living, and the social evils they engendered—isolation and crime—began to make themselves apparent.

The method of construction used for the *Unité* was also influential. There was a postwar shortage of skilled labor, and Le Corbusier chose the simplest, most direct form of building he could find. The basic material is *béton brut*—concrete poured into roughly made wooden formwork, which gave its own texture to the finished result. The result was in stark contrast to the kind of effects which Mies van der Rohe and his followers were achieving in America, using metal frameworks and glass curtain walls (see page 494). There smoothness and precision of finish were crucial. At the *Unité*, roughness was part of the final effect. This method of construction became part of a moral statement about the architect's relationship to society.

Outside of Le Corbusier's orbit, the most influential European architect of the immediately postwar period was the Finn, Alvar Aalto (1898–1976). The architectural historian Charles Jencks has succinctly described Aalto's personality and work as "the inverse of Le Corbusier's: relaxed and flowing rather than violent and tempestuous and patient rather than outspoken." A typical late building by Aalto, Säynäisalo Town Hall at Säynäisalo, Finland, 1959 (Fig. **29.2**), carefully avoids any hint of the overbearing or the monumental. It is careful to signal conformity with the Scandinavian tradition of democratic cooperation, and with the Scandinavian creed of unity with nature. It is also a building which is full of small surprises—some come from the plan, some from details of the construction. These make it continuously interesting to inhabit.

Aalto's architecture has been criticized for what has been called "soft paternalism;" for imposing mutuality and cooperation and allowing no escape from them. But it is at any rate much less dictatorial in its statement of social ideals than the postwar work of Le Corbusier and his followers, and it has not aroused the hostility and indeed the outright rejection which have been the more recent fate of many of Le Corbusier's ideas. Even on the physical plane Aalto's architecture has survived the passage of the years more successfully. Much Corbusian architecture in concrete now looks stained and shabby, and radical faults of construction have not been slow to appear.

29.2 **Alvar Aalto,** Säynäisalo Town Hall, Finland, 1959.

Painting

Postwar Europe

There was an expectation in postwar Europe that Paris would retain the dominance it had enjoyed in the visual arts ever since the birth of Modernism. It was also thought that art would arrange itself neatly as a series of groups or movements, each with a dialectical relationship to what preceded it. However, when new European movements did appear, they seemed no more than pale shadows of their American counterparts.

An exception might perhaps be made for the short-lived Op and Kinetic Art movements, which arose in the 1960s as a kind of challenge to American Pop Art. Op Art explored optical effects and apparent movement produced by violent contrasts of color and form. It has its roots in the old International Constructivist movement of the interwar period (see page 482). One of its chief practitioners is the British artist Bridget Riley (b. 1931). Her paintings (Fig. **29.3**, for example) make use of moiré patterns and other optical devices to give spectators the impression that the whole surface is in motion. Essentially this movement is the result of the reactions of their own retina when faced with some visual paradox.

29.3 **Bridget Riley**, *Movement in Squares* 1961.
Tempera on board, 48 × 48 ins (122 × 122 cm).
Mayor Rowan Gallery, London.

29.4 **Yves Klein**, *Blue Sponges* 1960.
90½ × 60¼ ins (90 × 143 cm). Moderna Museet, Stockholm.

Kinetic Art was three-dimensional, and made use of real, not apparent, movement. Often these works were demonstrations of simple physical properties. The Greek-born artist Takis (Takis Vassilakis, b. 1925) made numerous sculptures exploiting the properties of magnets. In his *Magnetic Ballet* (Fig. **29.5**), for example, two magnets were suspended on threads from the ceiling. An electromagnet on a base switched itself on and off in a regular rhythm. When it was on, it attracted the positive pole of one magnet, and repelled the positive pole of the other. When it was off, the two magnets sought each other. The alternation of the two conditions was responsible for the "ballet."

Op and Kinetic Art enjoyed major if ephemeral success, and well-attended exhibitions devoted to them did much to implant the idea that contemporary art was now legitimized, both on the old terms, as something for individual contem-

plation, and as a form of public spectacle.

A more direct response to American Pop—though rather less to Pop Art, then barely in its infancy, than to the widely felt impact of American mass-culture—was the Nouveau Réaliste group, formed by the French critic Pierre Restany in 1960. Its members were heterogeneous, but one of the main influences was Dada. The most important member of the group was a gifted maverick, Yves Klein (1928–62). His work combines ideas taken from Dada with others borrowed from Zen Buddhism. He was a forerunner of the notion, which was to become prevalent in the 1970s, that artists' personalities and physical actions were more important than any work of art they might produce. Among his characteristic works are monochrome canvases painted an intense shade of blue (he patented this color, dubbing it International Klein Blue, see Fig. **29.4**), and others in

29.5 Takis, *Magnetic Ballet* 1986.
Musée National d'Art Moderne, Centre Pompidou, Paris.

which he used nude girls as brushes. They covered themselves in paint, and at the artist's direction flung themselves across the canvas.

Balthus, Dubuffet, and Bacon

The character of postwar European art was set not by art movements or groups but by certain isolated, highly individual artists. In France there were Balthus (Balthasar Klossowski de Rola, b. 1908) and Jean Dubuffet (1901–85). In England there was Francis Bacon (1910–92).

Balthus's career as an artist began in the 1930s, and his work, even postwar, showed many of the influences common at that time—for example, an instinctive Classicism, expressed, in Balthus's case, through a lifelong fascination with the work of Piero della Francesca (see page 181). Yet Balthus can also be seen as something very anti-Classical, a belated Symbolist. His constant theme is sexuality—specifically, the sexuality of pubescent girls. This is powerfully expressed, for example, in his *Nude with a Cat* (Fig. **29.7**) of 1949. The main figure—an adolescent girl—lies back on a chair, in an attitude that can speak only of sexual desire. A subsidiary figure, also female and apparently very young, stands with her back to us at the window. The atmosphere is full of unspoken secrets.

The smooth, Classical forms of this painting, firmly based on the Old Master tradition, make a striking contrast with a typical figure-painting by Dubuffet, such as *Joë Bousquet in Bed* (Fig. **29.6**) of 1947. Dubuffet's aim in this, as in most of his paintings, was to use modes of representation, and indeed actual techniques of making art, which completely subverted conventional aesthetic frameworks. Major sources of inspiration were children's art, the art of the insane, and the untutored graffiti to be found on city walls—specimens of what Dubuffet called *art brut* or "art in a raw state." Normal artistic values are inverted, so as to freshen spectators' perceptions. Dubuffet's grotesque personages soon begin to seem more lifelike than life itself.

Bacon transforms "found images" in a different way, and uses a very different range of sources. One of his most celebrated series of paintings (Fig. **29.8**) is based on Velasquez's *Portrait of Pope Innocent X* (see page 259), combined with a still from the Russian director Sergei Eisensteins's film *Battleship Potemkin* (1925). Thanks to this, the pope is shown screaming like the wounded nurse who appears in the "Odessa Steps" sequence of the film. The combination works because it reflects something the artist has found within himself, and which he has found no other means of exteriorizing. He constantly deals with extreme feelings and situations, but never quite directly. This evasiveness adds to the fascination of his art, but eventually calls Bacon's constant insistence on horror and terror into question. The fact that extreme emotion seems here to be valued and cultivated for its own sake tells us something about the nature of the European cultural climate.

29.6 Jean Dubuffet, *Joë Bousquet in Bed*. From the *More Beautiful Than They Think* Portrait series, 1947. Oil emulsion in water on canvas, 57⅝ × 44⅞ ins (146.3 × 114 cm). Collection, The Museum of Modern Art, New York. Mrs. Simon Guggenheim Collection.

David Hockney

Compared with Bacon another well-known British artist of the postwar period, David Hockney (b. 1937), seems a lightweight. Where Bacon insists on horror, Hockney's territory is hedonism. In his earliest and best works, such as *We Two Boys Together Clinging* of 1961 (Fig. **29.9**), one sees how a study of Dubuffet led this naturally gifted draftsman toward an exploration of the values to be found in child art. Later, having settled in Los Angeles, Hockney produced conventional figurative images which reflected the easy-going Californian life-style. Later still, Hockney seems to have fallen in love with prewar French Modernism in a rather naïve and provincial way, and has produced a series of paintings which look like didactic demonstrations of some of Picasso's more familiar post-Cubist techniques (see page 481).

29.7 Balthus, *Nude With a Cat* 1949.
Oil on canvas, 25⅝ × 31¾ ins (65.1 × 80.5 cm). National Gallery of Victoria, Melbourne, Australia. Felton Bequest 1952.

29.8 Francis Bacon, *Pope II* 1951.
Oil on canvas, 78 × 54 ins (198 × 137 cm). Mannheimer Städtische Kunsthalle.

29.9 David Hockney, *We Two Boys Together Clinging* 1961.
Oil on canvas, 48 × 60 ins (121.9 × 152.4 cm).
Arts Council Collection, Great Britain.

Sculpture

Moore and Giacometti

The most important European sculptors of the immediate postwar period seem as isolated as the painters who have just been discussed. One is Henry Moore (1898–1986) and the other is Alberto Giacometti (1901–66). At the beginning of their careers both were in contact with the interwar Surrealist movement, though Moore was always less committed to it than Giacometti.

The growth of Moore's reputation was not a postwar phenomenon. In the 1930s he was already accepted as the most important Modernist sculptor working in Britain. A number of the major themes in his work were well established—the mother and child, and the reclining female figure—and so was a very important basic metaphor—the idea that a figure could also be a landscape.

Moore emerged onto the postwar stage as an artist of international rather than purely national repute. The succeeding years saw the creation of a long series of sculptures, monuments both in size and in intention, which made him

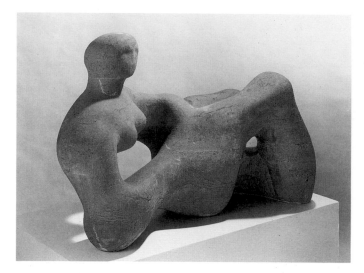

29.10 **Henry Moore**, *Recumbent Figure* 1938. Stone, 35 × 52 × 29 ins (88.9 × 132.7 × 73.7 cm). Tate Gallery, London.

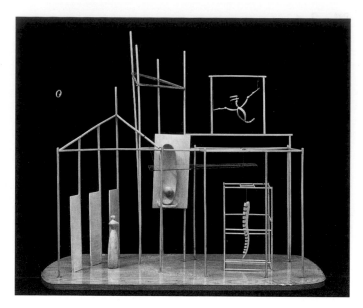

29.11 **Alberto Giacometti**, *The Palace at 4 a.m.* 1932–33. Construction in wood, glass, wire, string, 25 × 28¼ × 15¾ ins (63.5 × 71.8 × 40 cm). Collection, The Museum of Modern Art, New York. Purchase.

the pre-eminent sculptor of his day. This development involved losses as well as gains. He ceased to be a direct carver, working in isolation or perhaps with a single assistant, and became the master of a large workshop, making bronze and stone sculptures which went through the process of enlargement—from small maquette to full-scale finished product—that had been commonplace in the nineteenth century and against which Modernists like Brancusi (see page 469) had rebelled.

The Classical—or, rather, the Neo-Classical—element in his work, hidden earlier but always present from the beginning, became more obtrusive. Nevertheless, his best sculptures, such as his *Recumbent Figure* (Fig. **29.10**) of 1938, served their purpose well as public symbols. The meanings offered were less specific than those offered by the allegorical sculpture of the past, but spectators were able to find in Moore statements which still seemed relevant, especially about the relationship between humans and nature.

If Moore relapsed somewhat into the academic formulae of the past, so too did Giacometti. During the prewar period he made a series of remarkable sculptures, some of which owed a good deal to ancient and primitive artworks—Cycladic marbles and Oceanic carvings—but others, such as the well-known *The Palace at 4 a.m.* (Fig. **29.11**) of 1932–3, are Surrealist "dreamworks" very much on a par with paintings being done at the same time by Miró (see page 484).

Eventually Giacometti became extremely dissatisfied with this method of working, and began to make studies from nature, an act of heresy which led to excommunication by his Surrealist colleagues. During the war he continued to wrestle with the problem. His new work was not ready to be exhibited until 1948, when he had a show in New York. The exhibition catalog preface was written by Sartre, and the immediate assumption was that Giacometti was now to be thought of as an artistic child of Existentialism (see page 516).

In fact, Giacometti's figures and busts, though strikingly attenuated, had little to do with a sense of human isolation in the world. They were, rather, about the mechanics of perception, and signaled the difficulty of fully grasping any form, and the untrustworthiness of the senses, most of all sight. Each sculpture (Fig. **29.12**, for example) offered no more than an armature of roughened bronze, something around which air and light could accumulate and offer a kind of provisional solidity and presence. Giacometti had more in common with Samuel Beckett (see page 528) than with Sartre.

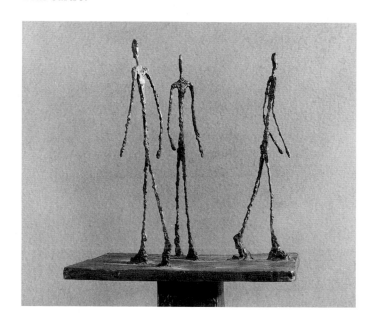

29.12 **Alberto Giacometti**, *Three Men Walking* 1948. Bronze, 28¼ × 17 × 16¼ ins (72 × 43 × 41.5 cm). Alberto Giacometti-Stiftung, Kunsthaus, Zurich.

Literature

Poetry: Paul Celan and Sylvia Plath

World War II did not produce poetry on a level with that written by the soldier poets of World War I. The full impact of the war was felt only later, when a shattered Europe was trying to rebuild itself psychologically as well as physically. The great, daunting subject which seemed to confront poets was the Holocaust. The crime committed by the Nazis against the Jews, gypsies, Slavs, homosexuals, and others was so huge and so terrible that it continued to obsess sensitive minds. And because it was so huge and so terrible, few poets succeeded in dealing with it satisfactorily from a literary point of view.

Poetry inspired by the Holocaust can be divided into two separate bodies of work. The first—much the smaller by its very nature—was written by poets who had been in direct contact with the Nazi attempt at a Final Solution. The second was written by those who use the experience of the Jews during the Holocaust as a metaphor for their own private anguish.

Of the poets who wrote from direct experience, the greatest was Paul Celan (1920–70). Celan, like Kafka (see page 488), was a German-speaking Jew who grew up outside Germany—in his case, in a part of Romania which was occupied by the Soviet Union in 1940, and then taken over by German and Romanian troops the following year. Celan's parents were sent to a concentration camp and died, but he himself survived. Most of his postwar years were spent in Paris; he committed suicide in 1970.

Celan once said that for him the central themes in poetry were absence, death, and non-being; the contemporary poem, he declared, "has a strong tendency to fall silent . . . it constantly calls and recalls itself from the no-longer-existing into the only-just-existing." His late work can be extremely difficult to penetrate, but a number of immediately postwar poems are powerfully eloquent, especially those in which the Holocaust is directly re-enacted. The most celebrated of these is the lament "Todesfuge" ("Death Fugue,") which contrasts the fates of Margarete, the ideal German girl, and Shulamith, the Jewess who dies in the camps:

Black milk of daybreak we drink you at night
we drink you at noon death is a master from Germany
we drink you at sundown and in the morning we drink and
 we drink you
death is a master from Germany his eyes are blue
he strikes you with leaden bullets his aim is true
a man lives in the house your golden hair Margarete
he sets his pack on us he grants us a grave in the air
he plays with the serpents and daydreams death is a master
 from Germany

your golden hair Margarete
your ashen hair Shulamith

> (*Poems of Paul Celan*, translated by Michael Hamburger.
> Anvil Press Poetry Ltd, 1988.)

This has a lulling as well as terrifying quality. It speaks out of a dream world in which, as Celan said—quoting the Russian poet Marina Tsvetayeva (1892–1941)—"All poets are Jews."

It is interesting to contrast Celan's poetry with that of another suicide, Sylvia Plath (1932–63). Plath is generally claimed for American poetry, not only because of her American birth but because of her close affinities with the American "confessional" school, which also includes poets such as Robert Lowell (1917–77) and John Berryman (1912–72). She did, nevertheless, spend most of her creative life in England. Her situation, as a cultural exile, was thus in some ways not unlike that of Paul Celan.

Plath's best-known poems come from her posthumous collection *Ariel* (1965). In "Daddy," she specifically compares herself to a concentration camp victim:

An engine, an engine
Chuffing me off like a Jew.
A Jew to Dachau, Auschwitz, Belsen.
I began to talk like a Jew,
I think I may well be a Jew.

> (SYLVIA PLATH, *Collected Poems* [ed. Ted Hughes]. Faber &
> Faber, 1981.)

Here the equation has been drastically simplified—"Jew" equals victim.

The French "New Novel"

Truly ambitious fiction-writers in postwar Europe had two basic alternatives available to them. They could commit themselves completely to the avant-garde, and allow themselves to become marginalized, leaving the way clear for prose narratives with no particular artistic impetus behind them but which would continue to feed a surviving appetite for naturalistic storytelling. Or they could try and find a way of reoccupying the middleground, which fiction had lost since the nineteenth century, when it was the recreation of the whole educated class.

Writers of the so-called "New Novel," which appeared in France after the war, opted for the first choice. The New Novelists were closely linked to developments in French philosophy. Nathalie Sarraute (b. 1902) launched the vogue for a new kind of fiction with her *Portrait of a Man Unknown* (1948), which was duly equipped with a preface by Sartre in

Waiting for Godot

Samuel Beckett here employs the music hall crosstalk which appears throughout *Waiting for Godot*, but uses this "low" theatrical form to address very serious issues. There are coded references to the Holocaust ("like billions of others . . . like ashes"), and a terror of inertia and the void which echoes the Existentialist philosophy of Jean-Paul Sartre (see page 516).

Silence. Vladimir sighs deeply.

Vladimir: You're a hard man to get on with, Gogo.
Estragon: It'd be better if we parted.
Vladimir: You always say that, and you always come crawling back.
Estragon: The best thing would be to kill me, like the other.
Vladimir: What other? (*Pause.*) What other?
Estragon: Like billions of others.
Vladimir: (*sententious*). To every man his little cross. (*He sighs.*) Till he dies. (*Afterthought.*) And is forgotten.
Estragon: In the meantime let us try and converse calmly, since we are incapable of keeping silent.
Vladimir: You're right, we're inexhaustible.
Estragon: It's so we won't think.
Vladimir: We have that excuse.
Estragon: It's so we won't hear.
Vladimir: We have our reasons.
Estragon: All the dead voices.
Vladimir: They make a noise like wings.
Estragon: Like leaves.
Vladimir: Like sand.
Estragon: Like leaves.

Silence

Vladimir: They all speak together.
Estragon: Each one to itself.

Silence.

Vladimir: Rather they whisper.
Estragon: They rustle.
Vladimir: They murmur.
Estragon: They rustle.

Silence.

Vladimir: What do they say?
Estragon: They talk about their lives.
Vladimir: To have lived is not enough for them.
Estragon: They have to talk about it.
Vladimir: To be dead is not enough for them.
Estragon: It is not sufficient.

Silence.

Vladimir: They make a noise like feathers.
Estragon: Like leaves.

Vladimir: Like ashes.
Estragon: Like leaves.

Long silence.

Vladimir: Say something!
Estragon: I'm trying.

Long silence.

Vladimir: (*in anguish.*) Say anything at all!
Estragon: What do we do now?
Vladimir: Wait for Godot.
Estragon: Ah!

Silence.

Vladimir: This is awful!
Estragon: Sing something.
Vladimir: No no! (*He reflects.*) We could start all over again perhaps.
Estragon: That should be easy.
Vladimir: It's the start that's difficult.
Estragon: You can start from anything.
Vladimir: Yes, but you have to decide.
Estragon: True.

Silence.

Vladimir: Help me!
Estragon: I'm trying.

Silence.

Vladimir: When you seek you hear.
Estragon: You do.
Vladimir: That prevents you from finding.
Estragon: It does.
Vladimir: That prevents you from thinking.
Estragon: You think all the same.
Vladimir: No, no, impossible.
Estragon: That's the idea, let's contradict each other.
Vladimir: Impossible.
Estragon: You think so?
Vladimir: We're in no danger of ever thinking any more.
Estragon: Then what are we complaining about?
Vladimir: Thinking is not the worst.
Estragon: Perhaps not. But at least there's that.
Vladimir: That what?
Estragon: That's the idea, let's ask each other questions.
Vladimir: What do you mean, at least there's that?
Estragon: That much less misery.
Vladimir: True.
Estragon: Well? If we gave thanks for our mercies?
Vladimir: What is terrible is to *have* thought.
Estragon: But did that ever happen to us?
Vladimir: Where are all these corpses from?
Estragon: These skeletons.
Vladimir: Tell me that.
Estragon: True.

Vladimir: We must have thought a little.
Estragon: At the very beginning.
Vladimir: A charnel-house! A charnel-house!
Estragon: You don't have to look.
Vladimir: You can't help looking.
Estragon: True.
Vladimir: Try as one may.
Estragon: I beg your pardon?
Vladimir: Try as one may.
Estragon: We should turn resolutely towards Nature.
Vladimir: We've tried that.
Estragon: True.
Vladimir: Oh, it's not the worst, I know.
Estragon: What?
Vladimir: To have thought.
Estragon: Obviously.
Vladimir: But we could have done without it.
Estragon: Que voulez-vous?
Vladimir: I beg your pardon?
Estragon: Que voulez-vous?
Vladimir: Ah! que voulez-vous. Exactly.

 Silence.

Estragon: That wasn't such a bad little canter.
Vladimir: Yes, but now we'll have to find something else.
Estragon: Let me see.

 He takes off his hat, concentrates.

Vladimir: Let me see. (*He takes off his hat, concentrates.*
 Long silence.) Ah!

 They put on their hats, relax.

Estragon: Well?
Vladimir: What was I saying, we could go on from there.
Estragon: What were you saying when?
Vladimir: At the very beginning.
Estragon: The beginning of WHAT?
Vladimir: This evening . . . I was saying . . . I was saying
 . . .
Estragon: I'm not a historian.
Vladimir: Wait . . . we embraced . . . we were happy . . .
 happy . . . what do we do now that we're happy . . . go
 on waiting . . . waiting . . . let me think . . . it's coming
 . . . go on waiting . . . now that we're happy . . . let me
 see . . . ah! The tree!
Estragon: The tree?
Vladimir: Do you not remember?
Estragon: I'm tired.
Vladimir: Look at it.

 They look at the tree.

Estragon: I see nothing.
 Beckett

which he hailed the birth of the "anti-novel." Further contributions to the genre were made by Alain Robbe-Grillet (b. 1922) and Michel Butor (b. 1926). These writers concerned themselves with what Sarraute christened "tropisms." In biological terms, a tropism is the automatic reaction of an organism to some stimulus—for example, the presence of light. Sarraute defined the word further by saying that tropisms, as she presented them, were "inner movements . . . hidden under the commonplace . . . the secret source of existence."

The kind of fiction which results borrows elements from the detective story. The writer offers minute descriptions of places and things, and the reader is invited to use these as clues, in order to try and puzzle out a narrative which is carefully kept half-hidden. A typical example of the genre is Robbe-Grillet's *Les Gommes* (*The Erasers*, 1955), in which the Oedipus theme is adapted to a modern setting: a detective called Wallas kills the supposed victim (who happens to be his father) of a murder he has been asked to investigate. There are many minute descriptions of significant objects—the eraser of the title, a paperweight, a slightly imperfect tomato. There is much emphasis on the idea of alternative realities—scenes which are imagined and thus, though described, do not really take place. The New Novelists, on principle, eschewed consistency of plot or character and emphasized what Henri Bergson (see page 449) called "the immediate data of consciousness." There is also much which was borrowed from the German philosopher Edmund Husserl (1859–1938), who related all states of mind to either real or imaginary objects.

Lampedusa and Pasternak

The typical New Novel was interesting for its technique rather than its plot, which was invariably conventional and unambitious—only thus, indeed, could the reader understand what was being attempted. Major postwar novels which sought to do more than this, and especially those which tried to rival the epic scale of nineteenth-century fiction, were generally the work of writers who in one way or another could be described as outsiders. Two of the most impressive fictions of the period fit this description exactly, even though they come from opposite ends of Europe. One is *The Leopard* (1958) by Giuseppe Tomasi di Lampedusa; the other is *Dr. Zhivago* (1958) by Boris Pasternak.

Lampedusa (1897–1957) was a Sicilian prince who died the year before his novel appeared. Previously he had published only a small handful of articles. Outwardly the book conforms to a long-established pattern—it is a loving re-creation of aristocratic society in Sicily at the time of the Risorgimento. Despite the fact that it is set in the nineteenth century, many elements in the book are clearly autobiographical, and others are taken from Lampedusa's own family history.

Boris Pasternak (1890–1960) was one of the best-known Russian poets of his generation. What fiction he had written previously had been short stories; one, *The Childhood of Lyuvers* (1922), is known to be the surviving fragment of a lost novel. Like *The Leopard, Dr. Zhivago* is a deeply personal book, set within a historical framework. The hero is clearly intended to be a kind of self-portrait, and to sum up Pasternak's own experiences. On the other hand, the author makes strenuous efforts to dissociate himself from his creation, giving him a different appearance, a profession (medicine) which Pasternak never practiced, and an early death. The basic message, one of disillusion with the Russian Revolution and its consequences, indicates why the book could not be published in Russia, and had to be smuggled out and published in translation (an edition in the original Russian appeared in western Europe at the same time).

At first sight both books look like fairly traditional historical narratives, conforming to a pattern already created by Tolstoy and others (see page 419). However, a closer examination shows that this is not the case. *The Leopard* and *Dr. Zhivago* have one very important characteristic in common. Both are fragmentary—the narrative is full of gaps. Some episodes are treated in great detail, others are skimmed over, still others are omitted entirely. The reader learns about them through brief allusions. In structure, therefore, they resemble the episodic, fragmentary, long poems already written by T. S. Eliot and others (see page 487).

In fact, the method used by both authors is poetic and subjective to a degree which would not have been tolerated in nineteenth-century fiction. Episodes exist for their emotional impact, far more than for their narrative value.

Drama

Samuel Beckett

The plays of Brecht (see page 489) reached the peak of their popularity in the immediate postwar period, and his type of political drama found many imitators, especially in Germany. The approach to the theater he represented was at the same time challenged by something very different—the minimalist drama of Samuel Beckett (1906–89).

Beckett was Irish-born, and began his career as a disciple of James Joyce—he was one of the twelve disciples chosen by Joyce to attempt an official explanation of *Finnegans Wake*, then still in its early stages. Beckett was by this time (1929) already in close contact with avant-garde circles in Paris, and in 1936 he settled there permanently.

Immediately after the war (during which he worked with the French Resistance) Beckett had an astonishing burst of creativity. He wrote a trilogy of novels, *Molloy, Malone Dies*, and *The Unnamable*, a play which remains unpublished called *Eleuthéria*, and another play, *Waiting for Godot*. All of these were composed not in English but in French. *Godot*, written in 1948, had to wait for its first performance until 1953. It immediately made Beckett's reputation, and still remains the most important single item in the Beckett canon.

The play is at one and the same time extremely opaque and very simple. Two men, Vladimir and Estragon, dressed as tramps, are waiting on a lonely road, near a tree. They hope for the arrival of Godot, who will in some way reward them for being there to meet him (see page 526). After a while someone does arrive—a bullying local landlord called Pozzo, accompanied by his slave Lucky. Pozzo makes Lucky dance, and then think aloud. Soon after Pozzo leaves, a small boy appears, with the news that Godot "won't come today but surely tomorrow." The two men briefly contemplate suicide, then decide to depart, but have not moved when the curtain falls.

The second of the two acts repeats the pattern of the first, with minor variations. The tree, once bare, has now put out a few leaves. Pozzo and Lucky reappear, but Pozzo is now deaf, and Lucky dumb. Pozzo and Lucky exit once again, and the boy also reappears, to deliver the same message as before. Once again the two tramps contemplate suicide, but fail to do anything about it. Once again they decide to leave, but have made no move to do so when the curtain falls.

The energy of the play is not to be found in the plot or the action, but in the dialogue. Much of this springs from popular sources. Vladimir and Estragon often use standard comic routines, borrowed from the tradition of the music hall. There is also a good deal of sharp-eyed—or, rather, sharp-eared—naturalistic observation. Beckett demonstrates the way in which people constantly misunderstand one another, and go off at different tangents.

Though these features add greatly to the viability of the play as a theatrical event, they are certainly not the main point. Indeed, one of the things Beckett gradually teaches the audience, as the play proceeds, is that what they are seeing and hearing has *no* specific point. *Waiting for Godot* is not an allegory—Godot is not God. It is not a Symbolist drama, in the manner of Maeterlink (see page 440). Its dramatic inertia is of a different kind, and Beckett is manifestly not interested in inculcating moral and political lessons after the manner of Brecht.

What he does, essentially, is to focus on the "tropisms" which interested the New Novelists who were emerging in Paris at the same moment. But he treats them in a much subtler way. He narrows the focus down to the bare facts of human existence. In doing so, he demonstrates how uncertain our grasp of reality really is. Vladimir and Estragon find they have imperfect memories, and an unreliable sense of connection with the physical world. They are constantly disorientated, and are forced at each moment to reinvent themselves. Their surest possession is their rather reluctant connection with each other.

With *Godot*, Beckett began a whole new dramatic tradition, sometimes labeled the Theatre of the Absurd. He contributed to this with further plays of his own, and a number of other playwrights—the list includes Eugène Ionesco (b. 1912) and Harold Pinter (b. 1930)—were aligned with him by the critics. But the main point was not the birth of a new movement; it was the liberty being offered to playwrights of all persuasions to invent a new, non-naturalistic theater, entirely separated from the sort of territory now dominated by film. The effect of Beckett's ideas and discoveries soon began to be felt even in production of accepted classics, such as the plays of Shakespeare and Chekhov. He gave new life to the theater as a whole.

Postwar music

In postwar Europe, "serious" music met the same competition from pop that it had already encountered in America. The European development of rock—the most vital and creative form of pop—was however delayed by the fact that many people regarded it as alien. In Britain, this situation was abruptly changed by the emergence of the Beatles in the early 1960s—the group made its first record for a major recording company in 1962. The appearance of the Beatles was followed by that of the Rolling Stones. Both groups scored an unexpected success in the United States, which seemed to confirm the view that rock was now an international phenomenon. Despite this, rock never achieved total dominance on the continent of Europe. Though the Beatles had a success in Hamburg immediately before they reached the bigtime in Britain, and then in America, they and all the rock groups who followed remained an exotic import, competing with local styles of music. In France, singers like Yves Montand continued to use a style which looked back to that of the cabaret singers of the early 1900s. Though European pop was not unified, it nevertheless drove other kinds of music, related to the nineteenth-century concert tradition, into a specialist ghetto.

Some of this music was still very much in touch with the music-making of the nineteenth century. Benjamin Britten (1913–76), the success of whose opera *Peter Grimes* (1945) made him the dominant figure in British music in the immediate postwar period, was a belated "nationalist" composer, very much on a par with his Russian contemporary, Shostakovich. He did not suffer from the political constraints imposed upon the latter, but he was subject to the innate conservatism of British musical taste.

Composers who did not wish to follow the path taken by Britten tended to develop an accentuated avant-garde identity, perhaps in compensation for their culturally isolated situation. The most discussed experimental composer of the time was the German Karlheinz Stockhausen (b. 1928). There are two major strands in Stockhausen's work. The first is what he was able to take from the serialists of the Vienna School, and also from the French composer, Olivier Messiaen (1908–92). The second came from experimentation with electronics and with aleatory techniques, on parallel lines to those followed by John Cage (see page 514). Electronics gradually gained the upper hand, and it is pieces like *Kontakte* (1958–60), wholly electronic in character, which have established Stockhausen's identity and made him one of the best-known post World War II composers.

Kontakte shows an exploration of timbre which involves the abandonment of the strict formal structures essential to true serialism. Though certainly suggested by the nature of the medium itself, Stockhausen's interest in timbre is also part of his legacy from Messiaen, who, after being regarded for many years as a marginal figure, now seems ready to assume a central place in postwar music taken as a whole.

What is significant about Olivier Messiaen is the lack of forward rhythmic impulses in his music, which accumulates more and more complicated sonorities rather than moving forward, so the listener's sense of time is annihilated. The obsession with nuances of sonority and timbre is something inherited from Debussy. Far more than either Debussy or the Romantic composers of the nineteenth century, Messiaen is also a practitioner of musical naturalism. For example, his *Réveil des oiseaux* (1953) is transcribed almost directly from birdsong. All these characteristics were to influence Messiaen's numerous disciples; the family tree of his musical descendants is now perhaps the most important kinship structure in contemporary music.

Chapter 30

1970–90

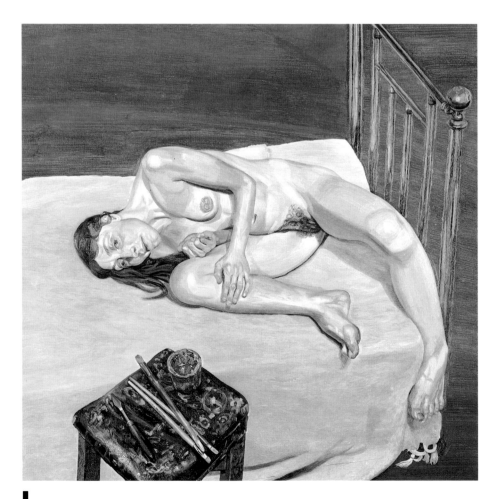

30.1. Lucian Freud, *Naked Portrait* 1972–73.
Oil on canvas, 24 × 24 ins (61 × 61 cm).
Tate Gallery, London.

The end of the twentieth century

The last decades of the twentieth century have witnessed a decline in established ideologies. Neither Marx (see page 395) nor Freud (see page 424) enjoys the status he once had. The reputation of Marxism has been especially severely damaged by the rapid collapse of Communism, first in the satellite republics of eastern Europe, then in the Soviet Union itself. What has discredited Marxist philosophy is the economic inadequacy as well as the political tyranny of the regimes which were based on it, now revealed for universal inspection by revolutionary changes of government. Yet these changes were not brought about by the challenge of a

new philosophy. For the first time since the appearance of Jean-Jacques Rousseau (see page 348), Western civilization faces an ideological void.

This disappearance of once-powerful ideologies has also brought to the surface behavior which is far from reassuring, chiefly the playing out of old religious and national animosities. Nationalism, which used to be described as a disease of the nineteenth century, and a symptom of the old bourgeois culture, is now seen to be an enduring and, because it is irrational in nearly all its aspects, perpetually threatening force.

Philosophy

The revival of Islam

This new nationalism has often united itself with religious revivalism. One aspect of this is the reappearance of fundamentalist Islam, no different in any respect from the creed which successfully withstood the crusaders in the twelfth century (see page 133), which not only offers a major challenge to the West but forces Western historians to

reconsider the idea, deeply rooted in traditional Western historiography, that all cultures will gradually and inevitably become Westernized.

In many ways the last twenty years are still too close for there to be any possibility of singling out the major achievements of the period. The sections that follow, however, offer a tentative cultural overview.

Architecture

Since the decline of the International Modern style, which rapidly lost vitality after the death of its greatest exponent, Mies van der Rohe, in 1969, two main strands of development have been visible. One is architecture which flaunts its alliance with high technology. The second is a renewal of interest in traditional classicism. Rather confusingly, both of these developments have been labeled "post-modern," though it is generally the new classicism which is colloquially referred to as Post-Modernism. It resembles the musical and to some extent the artistic Neo-Classicism of the 1920s, rather than the kind of architecture favored by Hitler and Mussolini (see page 479). Like Stravinsky's *Pulcinella* (see page 471), for example, it contains a strong dose of sardonic

irony. The standard classical elements—columns, entablatures, pediments—are often used in a disjointed way, which stresses the fact that they are non-functional ornaments, not an integrated part of the structure.

The most celebrated high tech building is undoubtedly the Pompidou Centre in Paris. This is the work of the English architect Sir Richard Rogers (b. 1933), working in partnership with the Italian Renzo Piano. The building was completed in 1977 and is very much a new design for a new age (Fig. **30.2**). It was intended to house a wide range of activities associated with contemporary art and design, and its immediate and stunning success was a tribute to the shrewdness with which the architects had judged the situ-

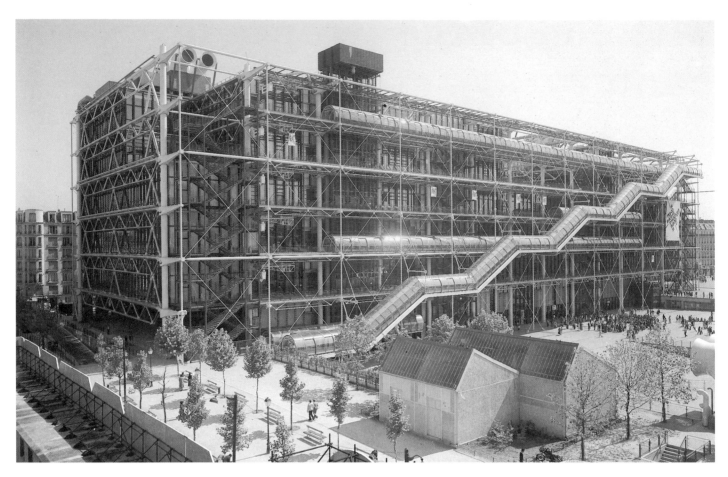

30.2 **Renzo Piano** and **Richard Rogers,** The Pompidou Centre, Paris, 1971–77.

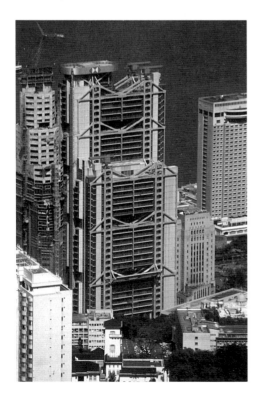

30.3 **Norman Foster**, Hong Kong and Shanghai Bank, Hong Kong, 1979–86.

ation, and also to the way in which the visual arts avant-garde had moved from the cultural periphery to the center. As if to symbolize this new situation, all the services which are usually kept hidden have been moved to the outside of the building, and deliberately emphasized by the use of contrasting paintwork. Rogers and Piano achieved their two main objectives, which were to create a building which the public would like and respond to, and which would offer great flexibility in the use of space. The disadvantages of their design, now increasingly apparent, are the lack of internal circulation for the staff, and problems with maintenance.

Also British is another major practitioner of high tech architecture, Norman Foster (b. 1935). It is Foster who was responsible for the most ambitious of all the buildings in this style, the gigantic headquarters of the Hong Kong and Shanghai Bank 1979–86 (Fig. **30.3**). The building has a number of symbolic messages to deliver, chief among them the bank's continuing commitment to Hong Kong after the takeover by mainland China in 1997. Foster took the opportunity to reinvent the traditional skyscraper office-block, using the very latest in engineering techniques. The steel structure of the building is fully expressed on the exterior,

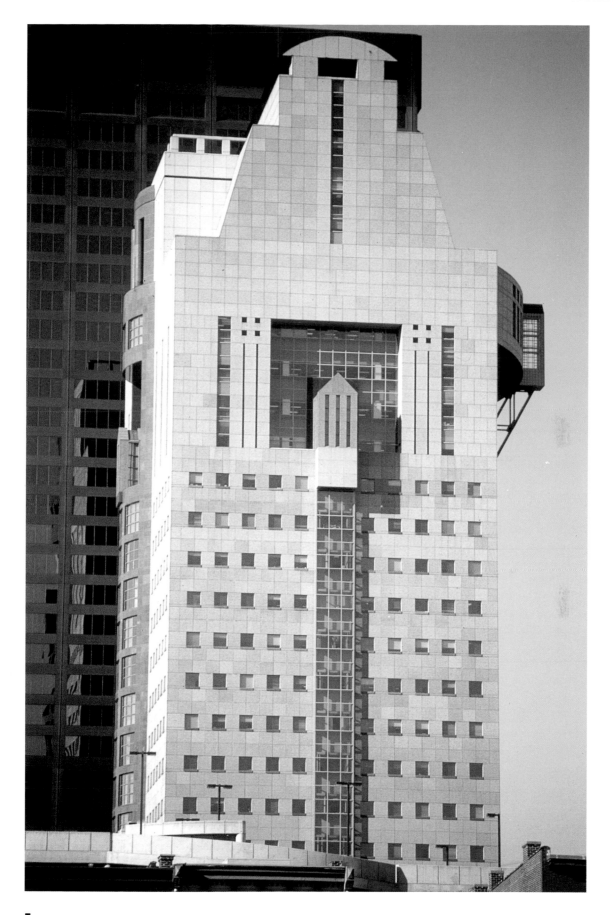

30.4 **Michael Graves**, Humana Building, Louisville, 1982–85.

as a kind of cage containing the habitable volumes. The 100-feet (30.48 m) clear spans of this cage allowed Foster to manipulate the distribution of internal spaces in a much freer way than would have been possible with a more conventional mode of construction. Foster's architecture, like that of Rogers, deliberately avoids all references to the past.

The name most closely associated with the Post-Modernist use of classical forms is that of the American architect Michael Graves (b. 1934), whose work has been tirelessly publicized by the leading theorist of Post-Modernism, Charles Jencks (Jencks did not invent the term, but he did give it wide currency with his book *The Language of Post-Modern Architecture*, published in 1977). Graves, as Jencks points out, is much more than a simple classical revivalist.

In Jencks's words, "Graves suggests all sorts of historical references, but leaves them abstract or incomplete so that his work has a resonance of meaning that cuts across time and culture." An example is his corporate headquarters for Humana Inc. (1982–5), in Louisville, Kentucky (Fig. **30.4**). This is a "prestige" job, like Norman Foster's Hong Kong and Shanghai Bank, but treats the problem of the tall building in a totally different way, splitting the structure into a base loggia, a middle section of offices, and a belvedere at the top. There are vestigial classical details and also anthropomorphic references—the river frontage has a cantilevered "brow," with suggested eyes and nose beneath.

Painting

Post-Modernism

Not surprisingly, attempts have been made to link the emergence of Post-Modernist architecture with some kind of parallel movement in painting. In fact, the chief effect of this has been to redirect interest toward certain artists working independently and in isolation from the artistic mainstream.

An outstanding example is Lucien Freud (b. 1922). His work carries no Classical overtones; it has been compared to the German Neue Sachlichkeit, Dix in particular (see page 482). He is a pitiless realist who deliberately omits any references which would deflect the spectator from what is actually being shown. Freud's nudes (Fig. **30.1**, for example) and his portraits proclaim that the narrow world of the studio is literally the only thing left to the painter, the only territory where painting remains valid. All those things which were part of the painter's subject matter in the past—myth, allegory, religion, the recording of social status as well as of individual appearance—have now been stripped away.

Another variant of the Post-Modern theme is provided by the work of the French artist Jean Rustin (b. 1928). Rustin's work has strong links to the Classical French tradition, which in his case means not the art of Greece and Rome but that of the mid-seventeenth century. The route he has taken in order to reach his present style has been circuitous. He began as as abstract artist very much in tune with what was happening in French art in the immediate postwar years, and only became a fully-figurative painter at the beginning of the 1970s.

Rustin's figures—like Freud's, they are often nudes—are not painted from life. They come directly from the artist's imagination, but nevertheless have a convincing naturalism (Fig. **30.5**, for example). Their aspect is not reassuring; they have been compared to concentration-camp victims and the inhabitants of lunatic asylums. Yet there is also something grand and dignified about many of them; they confront the spectator like the peasants of Louis Le Nain (see page 280). Like Le Nain's peasants they are emblematic, but the message is negative, not positive. For Rustin, men and women are beings whose possibilities are increasingly limited, whose hopes draw ever closer to extinction.

It is significant that Freud and Rustin are both artists whose work has been known for a long time but who have only now begun to be thought of as central rather than marginal figures.

Neo-Expressionism

There has been only one really significant development in European art during the past twenty years, and that is the revival of Expressionism. Though publicized at its inception as a West German phenomenon, its roots were in what was then East Germany—the regime there favored a revival of the old Expressionist art which had flourished before the rise of Nazism but, because of its own intolerance, failed to hold onto gifted younger artists.

The true founder of the Neo-Expressionist movement was Georg Baselitz (Georg Kern b. 1938). He was already exhibiting in the 1960s—a show held in Berlin in 1963 attracted the attention of the police, who confiscated two paintings because of their supposed obscenity. However, he achieved real fame only in the 1970s. By this time he had left Berlin, and had begun the practice for which he is now most famous—that of painting all his images upside down (Fig. **30.6**, for example). Painting in this manner was part of an obsessive search for a style which would break through the boundaries imposed by pictorial habit. Baselitz has de-

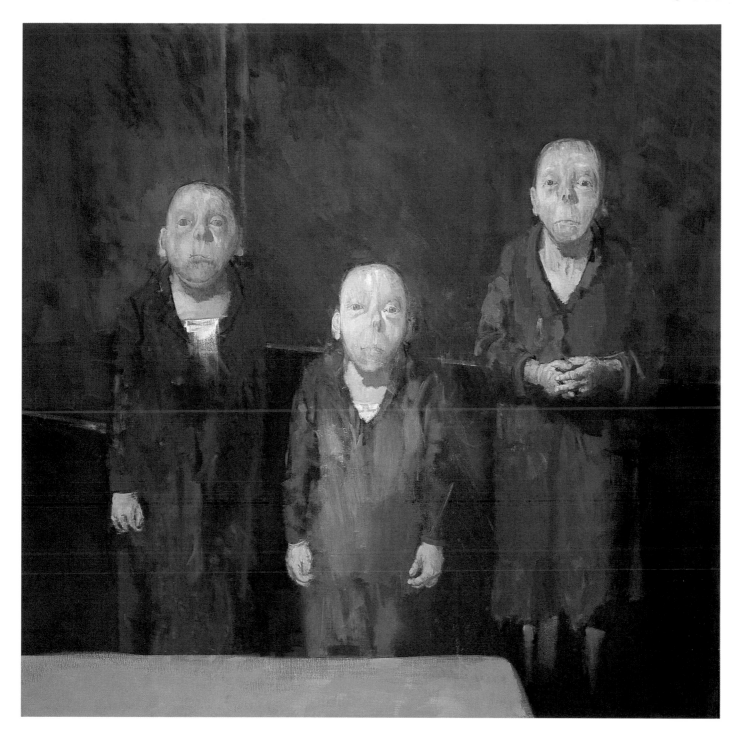

30.5 Jean Rustin, *Father, Mother and Son* 1990.
Acrylic on canvas, 59 × 59 ins (150 × 150 cm). Marnix Neerman Art
Gallery, Bruges.

scribed his own paintings as "being organized methodically
by an aggressive and dissonant reversal of the doctrine of
ornament."

This was certainly to form an important part of the
general Neo-Expressionist credo, but so too was a return to
specific content, political and social. This, on the whole, is
something which Baselitz himself has avoided, after his
initial outbursts of rage and disillusionment as a young man.

The avoidance has set him a little apart from the rest of the
German Neo-Expressionist group.

More typical is Anselm Kiefer (b. 1948). His work is a
meditation on German myth and history. Among his
sources are Wagner's operas, "Death Fugue," and other
poems by Paul Celan (see page 525), the architecture of
Albert Speer (see page 478), and also various battleplans
drawn up by the Nazi High Command during World War
II—for example, Operation Sea Lion, the plan for the
invasion of England. The planners experimented with toy
ships in a bathtub, and Kiefer's paintings employ this
image.

30.6 Georg Baselitz, *Schuhe vor dem Fabriktor!* 1989.
Oil on canvas, 98⅜ × 78¾ ins (250 × 200 cm). Courtesy, Anthony
D'Offay Gallery, London.

He often makes use of a mixture of materials to give form to his conceptions, thus linking himself, though in a very oblique way, with the Cubist and Surrealist tradition of collage, and in a more direct way with the Neo-Dadaist Robert Rauschenberg's use of mixed media (see page 501). In Kiefer's case his favorite substance is straw, which he has used as a metaphor for Margarete's golden hair in Celan's poem "Death Fugue."

In historical terms Kiefer's work is a curious compromise. By using materials for their symbolic qualities as much as their physical appearance, he comes close to the sculptor Joseph Beuys (see page 542), who employs substances like fat and felt in the same way. Yet Kiefer's paintings—vast, desolate landscapes, looming interiors—seem to have a close relationship to the great rhetorical statements attempted by late eighteenth- and early nineteenth-century artists. *Midgaard* (Fig. **30.7** of 1980–1 offers a reminder that Fuseli (see page 353) tackled the same theme; and the paintings which commemorate the Nazi regime and the Holocaust are directly comparable to Géricault's *Raft of the "Medusa"* (see page 380), which tried to give the same kind of tragic resonance to a contemporary event.

Minimalism

The official opponent of Neo-Expressionism has been Minimalism. This is less a style in its own right than a recurrent theme in the history of Modernism. In its present form it has its roots in the American art of the late 1960s, when a new kind of sculpture appeared as part of the reaction against Pop.

Minimal art was at first a gallery art, like its stylistic rivals. By the mid-1960s artists like Carl Andre (b. 1935) and Donald Judd (b. 1928) were making sculptures which consisted either of simple, boxlike forms or repetitions of equally simple, totally characterless readymade units. In one notorious instance, Andre made a sculpture out of a group of white firebricks, arranged to make a regular solid (Fig. **30.8**). Minimal art can be summed up in a statement made about his own work by Judd:

A shape, a volume, a color, a surface is something itself. It shouldn't be concealed as part of a fairly different whole. The shapes and materials shouldn't be altered by their context. One or four boxes in a row, any single

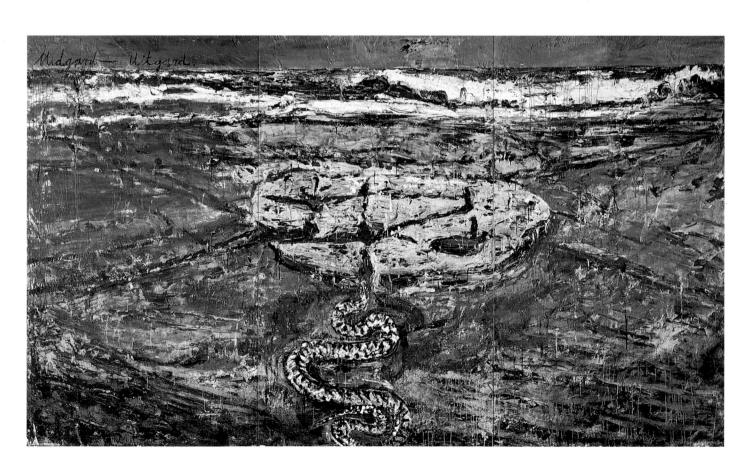

30.7 **Anselm Kiefer**, *Midgaard* 1980–85.
Oil and emulsion on canvas, 142 × 237¾ ins (360 × 604 cm). The Carnegie Museum of Art. Museum Purchase. Gift of Kaufmann's, the Women's Committee and the Fellows of the Museum of Art, 85.62.

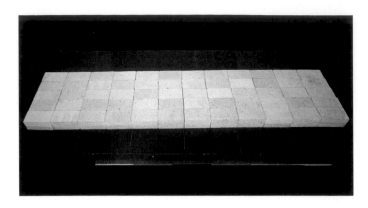

30.8 **Carl Andre**, *Equivalents* 1966.
120 Firebricks, 5 × 106½ × 22½ ins (12.5 × 274 × 57 cm). Courtesy
Saatchi Collection, London.

thing or such a series, it's local order, just an arrangement, barely order at all, the series is mine, someone's, and clearly not some larger order. It has nothing to do with either order or disorder in general. Both are matters of fact.

(DONALD JUDD, in the *Yale Architectural Journal*,
New Haven, Connecticut, 1967.)

In the early 1970s this extremely rigorous approach began to loosen, with the appearance of Earth Art or Land Art. One of the most spectacular examples of this was created by Robert Smithson (1938–73), whose *Spiral Jetty* (Fig. **30.9**) of 1970 on the shores of the Great Salt Lake in Utah became a kind of cliché image of its time. There were three basic elements in Earth Art. One was Minimalism— the forms were deliberately kept very simple and basic. Another was rebellion against the increasing commercialism of the avant-garde art world, brought about by the success of Pop Art. A third was a romantic idealization of the primitive. *Spiral Jetty* is an invented archeological site, an attempt to re-create Stonehenge (see page 25) in twentieth-century terms.

From Earth Art sprang a broader interest in working with the physical environment, but still with its roots in Minimalism and Conceptualism. One of the most admired artistic figures of the 1970s and 1980s was the British artist Richard Long (b. 1945). Though Long has made work which can be shown in galleries—for example, loose arrangements of stones chosen from a particular site—his most characteristic form of expression is a small alteration made in a remote and lonely landscape, whose existence is then verified by the camera (Fig. **30.10**, for example).

30.9 **Robert Smithson**, *Spiral Jetty* 1970.
Earth, mud, water, soil, and volcanic rock. 15,000 ft (457.2 m) long.
Courtesy John Weber Gallery, New York.

The New Russian Avant-Garde

The Russian avant-garde of the 1980s grew increasingly fashionable in the West, and at the same time seemed to come closer and closer to formal reconciliation with, and recognition by, the Soviet authorities. One symbolic event was the auction organized by Sotheby's in Moscow, in July 1988, at which astonishingly high prices were reached for recent works by Russian avant-garde artists. This was in marked contrast with attitudes toward an exhibition of *Unofficial Art from the Soviet Union*, seen at a number of western European venues in 1977. The critical reaction to this was one of condescension mixed with pity.

In fact, the Soviet avant-garde transformed itself in less than a decade. The artists included in *Unofficial Art* wanted to distance themselves from Socialist Realism, the Soviet official style, and, in addition, made little direct reference to the realities of Soviet life. In the 1980s Soviet artists were in constant dialogue with the reality surrounding them. Many, such as Erik Bulatov (b. 1933), produced work which made ironic reference to the official style, parodying its icons, such as the ever-present portraits of Lenin. Other artists, such as Ilya Kabakov (b. 1933), created poetic evocations of daily life in Russia, often in the form of environmental works and "actions," or happenings. In this new art there were constant references not only to Socialist Realism but to avant-garde styles influential in the West. John Cage (see page 514) was an especially pervasive influence. But there was also an intermingling of stylistic categories which in the West continued to be kept separate. No dividing line existed in Bulatov's work, for example, between Conceptualism and what in the West would have been described as Pop Art.

One of the best ways of evoking this phase of Russian art is to quote something written in the late 1980s by Kabakov, not least because Kabakov's work makes little, if any, distinction between image and text:

First and foremost I would like to speak about a peculiar psychic mold, a psychological condition of those people born and residing in emptiness. As if fully penetrating emptiness itself, each of these people's experiences and sensations is included in every reaction and deed, it is combined with each task, word and desire. Every person living here lives, consciously or not, in two dimensions—whether in relation to another person or to emptiness. Moreover these two dimensions are opposed, as I stated earlier, to one another. The first is "construction", organization; the second, the destruction and annihilation of the first. On the everyday, worldly level this separation, bifurcation and fatal disconnection of the first and the second dimensions is experienced as a feeling of the universal destruction of everything that man would do, the uselessness, groundlessness and senselessness of what he would have built and undertaken.

Eric Bulatov, *Happy New Year*, 1990. 102 × 75 ins (259 × 190.5 cm). Phyllis Kind Gallery, New York.

(ILYA KABAKOV, "On Emptiness," translated by Clark Troy, in *Between Spring and Summer: Soviet Conceptual Art in the Era of Late Communism*. Boston, Mass: Institute of Contemporary Arts, 1990.)

As this seems to hint, one of the peculiarities of the Russian avant-garde art of the 1980s was that it was completely dependent on the system it opposed. On a bedrock of Soviet images and Soviet slogans it erected an elaborate structure of ironic commentary. This commentary is likely to seem less meaningful now the system it mocked has disappeared.

30.10 **Richard Long**, *Summer Circle* 1991.
Delabole slate, 29 ft 6 ins (9 m) diameter. Anthony D'Offay Gallery,
London.

30.11 **Donald Judd**, *Untitled (Perforated Steel Ramp)* 1965.
Perforated steel, 119¼ × 8¼ × 65¾ ins (303 × 21 × 167 cm).
Collection Giuseppe Panza di Biumo-Varese.

It will be evident from this that Long's work differs from the original Minimalism of Judd (Fig. **30.11**, for example) and others in at least two fundamental ways. It is filled with the transcendental spirit of the Romantic movement (a comparison can be made with the paintings of Caspar David Friedrich, see page 378). At the same time, it enforces a shift of focus, from what is made to the personality of the maker. Art is where Long himself happens to be, in his progression across a landscape.

Feminist art

In the 1970s and 1980s, Minimalism, where the subject of art was essentially art itself, found itself opposed by art which embraced specific causes, and put great emphasis upon content. Examples were Afro-American and Hispanic art, which explored minority experience in the United States, often making use of imagery drawn from non-Western cultures, and feminist art. Feminist art had a number of characteristics, quite apart from its actual con-

tent, which marked it off from the kind of work which was being produced simultaneously by artists who were not in touch with the feminist movement.

Far more than other kinds of contemporary art, it saw itself as the expression of a system of ideas—that is, feminist art and feminist criticism (which included art criticism) were tightly bound together to form a single intellectual structure. This noun has been carefully chosen, as it was in fact the ideas of the European Structuralist philosophers (see page 516) which affected this criticism. The work of art became a complex "sign," whose meaning was modified by the context in which it was placed.

Part of the meaning of these signs came, not from the image itself, but from how it was made, and even from the actual materials used. The most ambitious feminist art projects of the period were the work of Judy Chicago (Judy Cohen Gerowtz, b. 1939). *The Dinner Party* 1973–9 (Fig. **30.12**) was designed as a homage to 39 women whom the artist considered to be major figures in Western history, plus 999 others. The final work consists of a triangular table accommodating 39 place settings, each with a different, specially designed plate, goblet, and runner. The place settings are arranged thirteen to a side, so that the complete work is the image of a triple Last Supper, as this is usually shown in Christian art (for example, the *Last Supper* of Leonardo da Vinci, see page 193). All the details are of feminist significance—for example the designs for the plates are often based on a combination of the vagina and the butterfly. The techniques used, chief among them stitchery and china painting, are forms of expression used traditionally by women rather than men.

The Dinner Party was a collaborative project—though designed and supervised by Judy Chicago, it was brought into existence by a large number of people, both women and men. Coming together in this way, they were able to explore

30.13 **Cindy Sherman**, *Untitled No. 216* 1989.
Color photograph, 95 × 62 ins (241.3 × 162.6 cm). Saatchi Collection, London.

their own feelings about the position of women in contemporary Western society. An artist who works on her own, and spends much of her time obsessively exploring her own identity, is Cindy Sherman (b. 1943). Sherman's medium is photography, and much of her work consists of self-portraits in which she plays various roles. In early examples, the portraits were modeled on movie-stills—that is, Sherman measured herself against the various female stereotypes created by the movie industry. This, she seemed to say, was how women were expected to look and behave. More recently, she has disguised herself to resemble various Old Master paintings (Fig. **30.13**), familiar masterpieces of different epochs, portraying men as well as women. The form of questioning here is subtly different. Sherman seems to ask herself how she, as a modern woman, measures up when confronted with the images which have created our vision of the past. The fact that the results are usually grotesque makes a didactic point—that a woman living in a modern society has a range of possibilities open to her which are quite unlike those which were available in the past (and by implication, much wider).

30.12 **Judy Chicago**, *The Dinner Party* 1973–9.
Mixed media, 48 × 48 × 48 ft (14.6 × 14.6 × 14.6 m). Copyright Judy Chicago, 1979. Photo Donald Woodman.

Sculpture

Joseph Beuys

The most significant and broadly influential figure in the art world of the 1970s and 1980s was the German sculptor Joseph Beuys (1912–86). Beuys's work was in part conditioned by his experience during World War II, during which he served as a Stuka pilot; he was shot down over the Crimea and his Tartar rescuers saved his life by wrapping him in felt and fat. Beuys later attached powerful symbolic meanings to these materials.

By the mid-1960s Beuys had established a reputation for performances, or, as he himself called them, "actions." One of the best-known of these is *How to Explain Paintings to a Dead Hare* (Fig. **30.14**), performed at the Schmela Gallery in Düsseldorf in 1965. Beuys, with his head covered in a mixture of honey and gold leaf, wearing an iron sole on his right foot and a felt sole on his left, carried the dead hare round the gallery from picture to picture. He talked to the hare as he carried it, and let it touch each artwork with its paw. Later, he sat down on a chair and began a more thorough explanation. Beuys described the performance as follows:

> A complex tableau about the problem of language, and about the problems of thought, of human consciousness and the consciousness of animals. This is placed in an extreme position because this is not just an animal but a dead animal. Even this dead animal has a special power to produce.

> (Quoted in Caroline Tisdall, *Joseph Beuys*. The Solomon R. Guggenheim Museum, 1979.)

In the late 1960s Beuys, in response to the changing political situation in Germany, which had led to an increasing polarization between the forces of conservatism and law on the one hand, and those of rebellion and sometimes terrorism on the other, shifted his position and became an overtly political figure. He founded the "German Student Party as Metaparty," which was later transformed into the "Organization for Direct Democracy through Referendum." This, despite the political gestures indulged in by the Italian Futurists (see page 462), was probably the first political party to operate almost entirely through the structures and institutions of the avant-garde art world. Asked in 1972 why it seemed appropriate to mix politics with art in this way, he replied: "Because real future political intentions must be artistic. This means they must originate from human creativity, from the individual freedom of man."

Throughout the 1970s, and until his death in 1986, Beuys was a peripatetic sage, prophet, and performer—a

30.14 Joseph Beuys, *How to Explain Paintings To A Dead Hare*. Performed at the Galerie Schmela, Düsseldorf, 1965. Photo courtesy Walter Vogel.

Pied Piper to the radical young throughout western Europe. His activity suggested that the artist's personality, rather than what was produced, had now become the true artwork. Beuys also went further than this. He thought that art (as he defined it) could redeem the modern world. He saw himself as a shaman, helping people to come into intense psychological contact with the realities of the physical world and thus sense its energies, which, he believed, had the power to transform and heal.

Whether or not he accomplished this task, he altered public perception of what an artist was, and did something to return art to its most primitive origins.

Literature

Gabriel García Márquez

In 1982 the Colombian writer Gabriel García Márquez (b. 1928) was awarded the Nobel Prize for Literature. The prize was chiefly an acknowledgment of the worldwide influence exerted by García Márquez's best-known book, *One Hundred Years of Solitude* (1967, English translation 1968). This novel chronicles the fortunes of the Buendía family in the imaginary Colombian town of Macondo, from independence in the nineteenth century to the early decades of the twentieth (see page 544). The book is the supreme example of what has been called "the fantastic" in Latin American literature and art. Latin American reality, it is argued, breaks all the bounds of reason, without losing touch with the solidity of the real world.

One Hundred Years of Solitude combines the tragic and the comic—it is an endless succession of tall tales, each linked to the next, so as to form a kind of burlesque epic. As such it has deep roots in western European literature. Among its ancestors are Ariosto's *Orlando Furioso* (see page 206) and Cervantes's *Don Quixote* (see page 236). In a narrower context, it confirms what was already becoming visible in works like Pasternak's *Dr. Zhivago* and Lampedusa's *The Leopard* (see page 527). Nineteenth-century fictional forms are now showing an increasing tendency to

fragment, and prose fiction is showing an increasing tendency to revert to its remote origins in the folk-tale and the verse epic.

This process can also be seen at work in an equally brilliant but slightly more conventional later novel by García Márquez, *Love in the Time of Cholera* (1985, English translation 1988). This has a more narrowly focussed setting—the location is clearly the colonial seaport of Cartagena, on the Caribbean shore of Colombia—and a less ambitious time scale. Nearly all the incidents recounted are individually plausible, but the total effect is very much like that made by *One Hundred Years of Solitude*. This combination of the plausible and the implausible is typical of the atmosphere generated by the new Latin American literature.

Long before the appearance of García Márquez, Latin America had been making a major contribution to twentieth-century literature. The great writers of the region include the Peruvian poet César Vallejo, his Chilean contemporary Pablo Neruda (1904–73), and, from the same generation, the Argentinian short-story writer Jorge Luis Borges (1899–1986). *One Hundred Years of Solitude* and *Love in the Time of Cholera* form the culmination of a movement which has affected Western literature as a whole—the migration of creativity from the center to the periphery, to situations where it is "Western" only by courtesy.

Music

Minimalism and multiculturalism

In the 1970s and 1980s, serious and popular music, hitherto so thoroughly estranged from one another, showed signs of coming together. At the same time, all forms of Western music showed a tendency to absorb ideas from non-Western cultures—from India, from Indonesia, and from Africa.

One of the things which tied these developments together was the so-called Minimalist movement in music. This, though it stems directly from some of the experiments of John Cage (see page 514), uses means which are by no means "minimal" by most people's standards. The adjective therefore, in musical terms, takes on a paradoxical quality which it does not possess when applied to the visual arts, where the avoidance of complex forms is self-evident.

The two best-known Minimalist composers are Steve Reich (b. 1936) and Philip Glass (b. 1937). Both have been influenced by non-European music—Reich by West African drumming and Hebrew cantillation; Glass by immer-

sion in Indian music. In Glass's case, this interest goes back to the 1960s. He met the sitar player Ravi Shankar during a period of residence in Paris, then went to India to study in 1966.

In the early 1970s, Reich and Glass made substantial avant-garde reputations with extremely repetitive compositions, with changes which were at first imperceptible because stretched over prolonged periods. Since then their paths have diverged. Reich has written increasingly complex orchestral pieces, and his work has gradually been absorbed into the "classical" mainstream, putting him on the same footing as other twentieth-century classical composers, such as Shostakovich (see page 490) and Britten (see page 529). Amongst the major orchestras which have performed compositions by Reich are the San Francisco Symphony and the New York Philharmonic.

Glass has enhanced his reputation with a series of major performance works. The first of these was *Einstein on the Beach* (1976), a collaboration between Glass and the artist

One Hundred Years of Solitude

This passage from Gabriel García Márquez's *One Hundred Years of Solitude* is a coded denunciation of capitalism and colonial exploitation. These ills are represented by "the chubby and smiling Mr. Herbert" who insinuates himself almost unnoticed into the life of the town of Macondo.

Dazzled by so many and such marvellous inventions, the people of Macondo did not know where their amazement began. They stayed up all night looking at the pale electric bulbs fed by the plant that Aureliano Triste had brought back when the train made its second trip and it took time and effort for them to grow accustomed to its obsessive *toom-toom*. They became indignant over the living images that the prosperous merchant Bruno Crespi projected in the theatre with the lion-head ticket windows, for a character who had died and was buried in one film and for whose misfortune tears of affliction had been shed would reappear alive and transformed into an Arab in the next one. The audience, who paid two cents apiece to share the difficulties of the actors, would not tolerate that outlandish fraud and they broke up the seats. The mayor, at the urging of Bruno Crespi, explained in a proclamation that the cinema was a machine of illusions that did not merit the emotional outbursts of the audience. With that discouraging explanation many felt that they had been the victims of some new and showy gypsy business and they decided not to return to the movies, considering that they already had too many troubles of their own to weep over the acted-out misfortunes of imaginary beings. Something similar happened with the cylinder phonographs that the merry matrons from France brought with them as a substitute for the antiquated hand organs and that for a time had serious effects on the livelihood of the band of musicians. At first curiosity increased the clientele on the forbidden street and there was even word of respectable ladies who disguised themselves as workers in order to observe the novelty of the phonograph from first hand, but from so much and such close observation they soon reached the conclusion that it was not an enchanted mill as everyone had thought and as the matrons had said, but a mechanical trick that could not be compared with something so moving, so human, and so full of everyday truth as a band of musicians. It was such a serious disappointment that when phonographs became so popular that there was one in every house they were not considered objects for amusement for adults but as something good for children to take apart. On the other hand, when someone from the town had the opportunity to test the crude reality of the telephone installed in the railroad station, which was thought to be a rudimentary version of the phonograph because of its crank, even the most incredulous were upset. It was as if God had decided to put to the test every capacity for surprise and was keeping the inhabitants of Macondo in a permanent alternation between excitement and disappointment, doubt and revelation, to such an extreme that no one knew for certain where the limits of reality lay. It was an intricate stew of truths and mirages that convulsed the ghost of José Arcadio Buendía under the chestnut tree with impatience and made him wander all through the house even in broad daylight. Ever since the railroad had been officially inaugurated and had begun to arrive with regularity on Wednesdays at eleven o'clock and the primitive wooden station with a desk, a telephone and a ticket window had been built, on the streets of Macondo men and women were seen who had adopted everyday and normal customs and manners but who really looked like people out of a circus. In a town that had chafed under the tricks of the gypsies there was no future for those ambulatory acrobats of commerce who with equal effrontery offered a whistling kettle and a daily régime that would assure the salvation of the soul on the seventh day; but from those who let themselves be convinced out of fatigue and the ones who were always unwary, they reaped stupendous benefits. Among those theatrical creatures, wearing riding breeches and leggings, a pith helmet and steel-rimmed glasses, with topaz eyes and the skin of a thin rooster, there arrived in Macondo on one of so many Wednesdays the chubby and smiling Mr Herbert, who ate at the house.

No one had noticed him at the table until the first bunch of bananas had been eaten. Aureliano Segundo had come across him by chance as he protested in broken Spanish because there were no rooms at the Hotel Jacob, and as he frequently did with strangers, he took him home. He was in the captive-balloon business, which had taken him halfway around the world with excellent profits, but he had not succeeded in taking anyone up in Macondo because they considered that invention backward after having seen and tried the gypsies' flying carpets. He was leaving, therefore, on the next train. When they brought to the table the tiger-striped bunch of bananas that they were accustomed to hang in the dining-room during lunch, he picked the first piece of fruit without great enthusiasm. But he kept on eating as he spoke, tasting, chewing, more with the distraction of a wise man than with the delight of a good eater, and when he finished the first bunch he asked them to bring him another. Then he took a small case with optical instruments out of the toolbox that he always carried with him. With the suspicious attention of a diamond merchant he examined the banana meticulously, dissecting it with a special scalpel, weighing the pieces on a pharmacist's scale, and calculating its breadth with a gunsmith's calipers. Then he took a series of instruments out of the chest with which he measured the temperature, the level of humidity in the atmosphere, and the intensity of the light. It was such an intriguing ceremony that no one could eat in peace as everybody waited for Mr Herbert to pass a final and revealing judgement, but he did not say anything that allowed anyone to guess his intentions.

Márquez

(MÁRQUEZ, *One Hundred Years of Solitude*. Reprinted by permission of Jonathan Cape Ltd. and HarperCollins Publishers Inc., 1970.)

and dramatist Robert Wilson. This was the "performance art" of the visual arts world blown up to a gigantic scale. Though lacking in anything resembling a conventional plot, the work was a sell-out when it was given two performances at the Metropolitan Opera in New York. It divided professional musical opinion completely. Some of the audience found it wildly exciting, others intolerably pretentious.

Glass's third and now best-known opera, *Akhenaten* (1984), provoked a similar reaction, even though, as a theatrical event, it is much more tightly knit. The work's retelling of the story of the Ancient Egyptian "heretic pharaoh" (see page 37) was sung in a mixture of ancient languages, but this should not have troubled audiences well accustomed to hearing operas sung in languages they do not understand.

One reason for *Akhenaten*'s considerable success with the lay public, as opposed to the critics, was the fact that it neatly combined the fascination of the extremely ancient with that of the extremely modern, and at the same time offered an opportunity for spectacular visual effects. Similar effects are now also demanded in the world of rock music, which has recently tended to compensate for loss of creative vitality by increasingly ambitious modes of presentation.

Meanwhile opera, until very recently regarded as a hopelessly outmoded musical form, continues to attract the attention of other Modernist composers. A recent challenge to Glass's pre-eminence in this sphere was mounted by *Nixon in China* (1987), a musical retelling of history—but contemporary rather than ancient—by the second generation Minimalist, John Adams (b. 1947). The musical language used was far more accessible than that of *Akhenaten*. Yet even this latter work is now sufficiently entrenched in the popular repertoire for excerpts to be used (1990) as musical material for an ice-show.

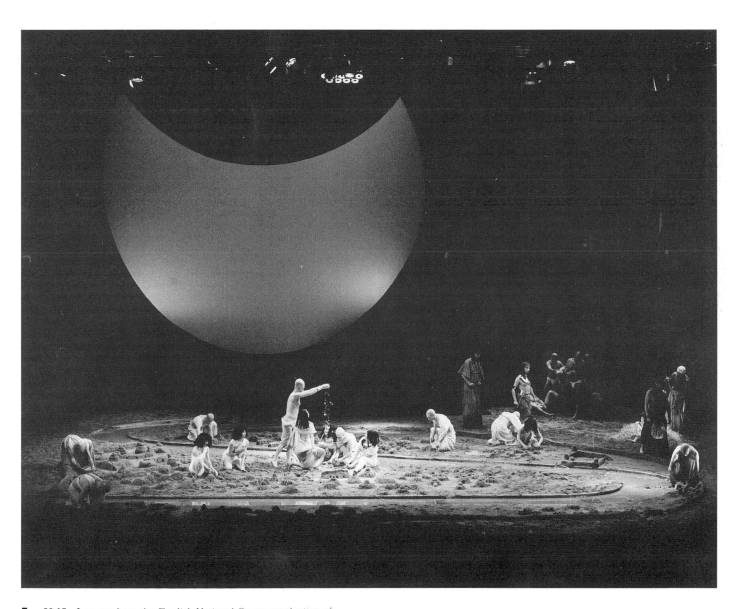

30.15 A scene from the English National Opera production of *Akhenaten* in London in 1985.

Glossary

abacus, the flat upper part of the CAPITAL of a column.

abstract, art that is non-representational, having no reference to an exterior world but being purely autonomous.

Abstract Expressionism, the term applied to a specifically American but diverse style of painting which emerged in New York in the mid 1940s and with which the United States replaced France as the leading arena for experimentation in art.

the Absurd, the notion that the world is neither designed nor predictable, but essentially meaningless, elevated to a philosophical doctrine by certain postwar thinkers and writers, amongst them Camus and Beckett.

academies, institutions of art which flourished in the 18th and 19th centuries providing comprehensive training in the received theory and techniques of art to aspiring artists.

aerial or atmospheric perspective, the suggestion of distance in painting through the use of light and atmosphere; a device used particularly by landscape artists from the 16th century onward (Fig. **16.4**).

aesthetic, (adj.) derived from the Greek *aisthēsis*, meaning "feeling," and used to refer to something judged by its beauty or taste rather than its practical value.

aesthetics, the philosophy of the beautiful.

aisle, (Fr. "wing") the parts in a church parallel and flanking the nave and generally divided from it by an arcade of piers or columns.

alabaster, a fine-grained stone widely used in small-scale carvings in Europe from the medieval period onwards.

alexandrine, in French prosody a line of 12 syllables used frequently by poets and dramatists from the Renaissance on and reaching perfection in the verse tragedies of Corneille and Racine in the 17th century.

allegory, (Gk, *allēgorein* "to speak otherwise") a work of art or fiction that presents a double meaning; both a superficial literal meaning and a deeper secondary meaning.

altarpiece, a devotional work of art set above or behind the altar.

ambulatory, the passageway surrounding the choir and the chancel in a church.

Analytic Cubism, the earliest stage of CUBISM in which, inspired by Cézanne, Picasso and Braque abandoned conventional perspective and sought to depict a richer, more complex sense of form, often for example, by showing different aspects of an object simultaneously (Fig. **26.15**).

anamorphosis, an image or drawing distorted so as to only become recognizable when viewed in a specified manner (Fig. **12.9**).

antiphonal, music in which two or more choirs sing alternately or echo each other.

apse, the vaulted semicircular or semipolygonal recession usually situated at the eastern end of a church and within which the altar is usually housed.

arabesque, (Fr. "in the arab style") intricate linear decoration with curves and flowing lines (and originally based on plant forms).

arcades, a linked series of arches placed side by side.

Archaic, the term used to describe Greece from the 8th to the 6th centuries B.C. during which the Greek city or poleis was established; also applied to the art of that period, characterized by crisp, somewhat stylized, forms (Fig. **3.7**).

aria, an air or song for solo voice with accompaniment and usually part of an OPERA or ORATORIO.

Ars Nova, (It. "new art") the new, more complex style of music which emerged at the beginning of the 14th century surplanting the *ars antiqua*; its most representative exponent was Guillaume de Machaut.

Art Brut, (Fr. "raw art") the term coined by the French artist Dubuffet to describe art which emerges from a crude, untutored artistic impulse, such as that which a child might have.

Art Nouveau, a lush decorative style that flourished in the final years of the 19th century, and characterized by the use of stylized natural forms (such as flowers and leaves) and of undulating flowing lines.

baptistery, a building or part of one in which the sacrament of baptism takes place.

barbarism, the term originally applied by the Greeks to non-Greek speaking races, imputing both lack of culture and intellectual as well as material inferiority.

Baroque, a European style in architecture, art, and music which developed in the 17th century from late Renaissance and Mannerist works, and characterized by an often florid emotionalism and the use of rich and complex forms.

basilica, originally a Roman administrative building with a large rectangular central NAVE with AISLES on each side and an APSE at one end. The early Christian and medieval church developed from this construction.

bel canto, (It. "beautiful singing") a style of singing in Italian opera in which the voice is used to display its tonal beauty rather than for its dramatic power.

Bronze Age, a technological stage between the Stone and Iron Ages beginning in the Middle East about 4500 B.C. and during which weapons and tools were made from bronze.

buttress, a support (usually an exterior projection of masonry or wood) for a wall, arch or vault.

calotype, (from Gk. *kalos* "beautiful" and "type") the earliest practicable negative-and-positive photographic process on paper, developed by Fox Talbot.

capital, the uppermost member of a Greek column.

capriccio, in music a short freely-composed instrumental piece. Also a peculiarly Venetian genre in the visual arts: a study of imaginary architecture, or of real architecture in an imaginary setting.

catharsis, (Gk. "purgation") the term first used by Aristotle in his *Poetics* and central to his definition of tragedy: "Tragedy through fear and pity effects a purgation of the same emotions." His exact meaning is contested but the general sense is that tragedy having incited powerful emotions in an audience has also, finally, a therapeutic effect.

cella, (Lat. "room, shrine") the inner body of a classical temple as distinct from its portico or COLONNADES, and by extension the inner sanctuary in which the cult-figure of the deity was held.

chiaroscuro, (It. "clear-obscure") in painting the manipulation of passages of light and dark paint to suggest three-dimensional form.

chorus, (Gk. "dance") originally a group of performers at a religious festival. Later it became an essential part of Greek drama, acting as protagonist, commentator or lyric interlude.

Classical, strictly used of the art and architecture of Greek and Roman antiquity, and especially of Greece in the 4th and 5th centuries B.C. Also used to describe art which aspires to imitate such models. More generally art which aspires to a state of emotional and formal equilibrium, rationally rather than intuitively constructed.

collage, (from Fr. *coller* "to stick") a technique developed by Picasso and Braque who, as part of their CUBIST experiments, introduced fragments of newspaper and other printed matter into their compositions.

colonnade, a series of columns, generally supporting an ENTABLATURE and one side of a roof.

composition, "the art of arranging in a decorative manner the various elements at the painter's disposal for the expression of his feelings." (Matisse)

Constructivism, an international movement in art which originated in Russia shortly before the Revolution. The Constructivists aimed to make art a detached, scientific, investigation of abstract properties (picture surface, composition, line and color). They also wished to apply this art to the industrial and social needs of the time, breaking down the divisions between art, architecture, and design.

contrapposto, (It. "placed against") a way of representing the various parts of the body so that they are obliquely balanced around a central vertical axis.

corbelling, in masonry the method of constructing a wall, arch or dome by means of a step-like series of projecting stones.

Corinthian order, (from the Greek city-state, Corinth, in the Peloponnese) the most slender and most ornate of the three Greek orders of Classical architecture, characterized by a bell-shaped capital decorated with two rows of leaves, which are a stylized representation of an acanthus plant growing out of a basket.

cornice, in Classical architecture the third and uppermost section of the ENTABLATURE which rests upon the frieze.

Cubism, a revolution in the visual arts led by the experiments of Braque and Picasso in the early years of the 20th century, which overturned

conventional systems of perspective and ways of perceiving form. See ANALYTIC CUBISM and SYNTHETIC CUBISM.

cuneiform, a script system developed in Mesopotamia in which nail-shaped wedges (Lat. *cunerus* "wedge") were pressed into wet clay.

Dada, a nihilistic and anti-art movement founded by Hugo Ball and others in Zurich in 1916 which encouraged artists to dump the inheritance of the past and start afresh. In its exploration of the irrational and the spontaneous it was an important influence on the Surrealists.

daguerrotype, the first practical photographic process invented by L. J. M. Daguerre and patented in 1849 whereby a positive image was fixed on a silver-coated positive metal plate.

Deposition, the taking down of Christ's body from the Cross and its representation in art (Fig. **13.6**).

diptych, a devotional picture or relief on two hinged panels.

distemper, a water-based paint with glue as a binder and chalk as a filler.

divisionism, a synonym for Pointilism in which small marks, sometimes dots, of pure, unmixed color are juxtaposed on a white ground so that from a distance they fuse optically into the appropriate immediate tones (Fig. **24.24**).

dome, an architectural form based on the principles of an arch in which space is defined by a hemisphere used as a ceiling.

Doric order, (from the Greek Dorian tribe whose most important state was Sparta) the simplest and the sturdiest of the Greek orders characterized by a column with a simple square-slab capital.

echinus, a convex projecting molding between the shaft and the ABACUS in a Doric column.

elegy, (Gk. "lament") typically a poem which mourns the death of an individual or laments a tragic event.

enamel, a colored glass in powdered form which is fused on to a metal surface.

Enlightenment, the term used to describe a philosophical and literary movement in Europe from the last quarter of the 17th century until the last quarter of the 18th, and characterized by a profound belief in human reason and a devotion to the CLASSICAL.

ensemble, a small group of performers; part of an opera or large choral work for two or more solo singers.

entablature, the upper part of one of the orders of architecture.

entasis, (from the Greek *enteini*, "stretch") the slight convex curvature of the shaft of a classical column without which the column would appear concave.

epic, a long narrative poem on the heroic deeds of warriors and heroes.

Epicureanism, the philosophy of Epicurus (341–270 B.C.), which asserted that the purpose of philosophy was to make life happy through intellectual pleasure or serenity.

etching, a print from a metal plate on which the design has been etched or eaten away by acid.

Expressionism, the term originally applied by the German art critic Herwarth Walden to all modern art—FAUVISM, CUBISM, FUTURISM and so on—in opposition to IMPRESSIONISM. Later it was applied to a specific art movement which emerged in Germany in the early part of the 20th century and which attempted to express in simple powerful forms the artist's inner responses to reality.

Fauvism, (Fr. *fauves* "wild beasts") the name given by an art critic to a group of young painters who exhibited together for the first time at the Salon d'Automne in 1905, because of their aggressive use of color. The leader of the group was Matisse who maintained that Fauvism emerged from "the courage to return to the purity of means."

fête galante, a genre of early ROCOCO painting in which groups of courtly lovers are shown in an idyllic setting (Fig. **18.5**).

figurative, art which seeks to depict, in any manner, the visible world.

flying buttress, an exterior arched support designed to resist lateral thrust in a building.

foreshortening, the technique of depicting an object lying at an angle to the picture frame by means of perspective devices (i.e. by making it narrower and paler as it recedes). During the Renaissance it was widely used as a means of virtuosic display.

found object, an object taken from life and presented as an artwork.

fresco, a very durable method of wall-painting in which WATERCOLOR is applied to wet plaster ("buono fresco") or with less durable results to dry plaster ("fresco secco"), (Fig. **8.17** and Fig. **11.4**).

Futurism, a movement which erupted in Italy at the beginning of the 20th century and which sought to glorify modernity, aggression, and the beauty of speed.

genre, a category of artistic expression characterized by a particular style form or content, i.e. the novel as opposed to poetry or history as opposed to landscape painting. In terms of Dutch painting it denotes a kind of picture which depicts everyday domestic life (Fig. **17.10**).

Gnosticism, (Gk. *gno*) Christian and Jewish sects who maintained that behind the religion of the ordinary believers there lay another, higher one accessible only to those who know.

Gothic, an architectural style dominant in the late medieval period, which found its most complete expression in the great cathedrals of the period. These were characterized by pointed arches, FLYING BUTTRESSES and a gradual reduction of walls to luminous expanses of stained glass.

Gothic novel, a type of romance popular in Europe from the 1760s onwards and dealing with mystery, terror and the sensational.

graphic arts, Fine or applied visual arts based on drawing or the use of line as opposed to color or relief, and thus including everything from drawing through printmaking to typography.

hedonism, (from Gk. "pleasure") strictly, the doctrine that pleasure constitutes the good.

Hellenistic, the term used to describe the Greek culture throughout the Mediterranean from the conquests of Alexander the Great in the late 4th century B.C. to the incorporation of the region into the Roman Empire in the 1st century B.C.

hieroglyphs, (Gk. "holy carving") an Egyptian script first attested in the late 4th millennium. In it pictorial signs were used to stand for words or syllables forming parts of words.

humanism, applied to the Renaissance period it refers to the revival of interest in classical thought and literature and more broadly a belief in human dignity, apparent for example in the work of writers such as Erasmus and Montaigne.

icon, (Gk. "image") a Byzantine painting on a panel depicting a traditional image of Christ, the Virgin Mary, or a saint.

iconoclasm, a movement in Byzantium history which sought to suppress and destroy icons and other figurative religious art, and which became official policy in the period 730–843 A.D. By extension any attack on traditional and received ideas.

iconography, the systematic study of subject matter in painting.

ignudo, (pl. ignudi) in art, a male nude, in particular those of Michelangelo on the Sistine Chapel ceiling (Fig. **11.9**).

illumination, the brilliantly colored illustrations and decorations found in medieval manuscripts.

Impressionism, a term deriving from Claude Monet's painting *Impression: Sunrise* (first exhibited Paris 1874) and applied, originally derisively, to a group of artists who, abandoning academic techniques, developed a more spontaneous, more luminous style, and who dealt exclusively with contemporary subjects.

International Gothic, the elegant courtly style which spread throughout Europe from 1400 onwards—it was in origin a fusion of the Italian naturalism of Giotto and Duccio and the grace of French medieval style (Fig. **9.5**).

Ionic order, (from the Ionians—Greek people of the islands off what is now the coast of Turkey, and Athens) order of architecture characterized by its scroll-like CAPITAL.

jamb, the upright piece forming the side of a doorway or windowframe, sometimes decorated.

Jansenism, the doctrine of Cornelis Jansen in the 17th century who maintained salvation was restricted to those already chosen. In France the movement had an important center at Port-Royal from where it exerted a considerable influence on contemporary French writers, such as Pascal and Racine.

kouros, (Gk. "youth" pl. *kouri*) the sculpture of a nude youth typical of Greek art of the ARCHAIC period (Fig. **3.7**).

leitmotiv, (Ger. "leading motif") the term coined by a German critic to designate the recurring musical themes in a Wagner opera, each being associated with a particular character, object or emotion. Used in consequence to designate any recurrent theme or motif in a musical or literary work.

linear perspective, (artificial perspective), perspectival system in which the apparent size and shape of an object in space is established by real or apparent lines converging on the horizon.

lintel, the horizontal structural member across an opening such as a door.

lyric, originally, in ancient Greece, a song to be sung to the lyre; now used

LITERATURE
Anderson Winn J., *John Dryden and His World*. New Haven and London: Yale University Press, 1987.
Carey J., *John Donne, His Life, Mind and Art*. London: Faber and Faber, 1981.
Carey J., *Milton*. New York: Arco, 1970.

Chapter 18: The Rococo
ART AND ARCHITECTURE
Hitchcock H. R., *Rococo Architecture in Southern Germany*. London: Phaidon Press, 1968.
Kalnein W. G., and Levey M., *Art and Architecture of the Eighteenth Century in France*. Harmondsworth: Penguin Books Ltd., 1972.
Levey M., *Rococo to Revolution: Major Trends in Eighteenth Century Painting*. New York: Oxford University Press, 1977.
Wakefield D., *French Eighteenth Century Painting*. London and Bedford: The Gordon Fraser Gallery Ltd., 1984.
DRAMA
Richards K., and Richards L., *The commedia dell'arte, a documentary history*. Oxford: Blackwell, 1990.

Chapter 19: The Middle Class
Dunn J., *Locke*. Oxford and New York: Oxford University Press, 1984.
Guyer P., *Kant and the Claims of Knowledge*. Cambridge: Cambridge University Press, 1987.
Phillipson N., *Hume*. London: Weidenfeld and Nicolson, 1989.
Raphael D. D., and Daiches D., *Adam Smith*. Oxford and New York: Oxford University Press, 1985.
ART AND ARCHITECTURE
George Stubbs 1724–1806. Catalogue of an exhibition held at the Tate Gallery, London 1984–5, and at the Yale Center for British Art, New Haven, 1985.
Links J. G., *Canaletto*. Oxford: Phaidon Press, 1982.
Nicolson B., *Joseph Wright of Derby*, 2 vols. London: Routledge and Kegan Paul, 1968. New York: Pantheon Books, 1968.
Wilson M. I., *William Kent, architect, designer, painter, gardener, 1685–1748*. London: Routledge and Kegan Paul, 1984.
LITERATURE
Bell I. A., *Defoe's Fiction*. London: Croom Helm, 1985.
Thomas D., *Henry Fielding*. London: Weidenfeld and Nicolson, 1990.
DRAMA
Pugh A. R., *A Critical Commentary on Beaumarchais' "Le mariage de Figaro"*. London: Macmillan, 1968.
MUSIC
Landon H. C., *Handel and His World*. Boston: Little Brown and Co., 1966.

Chapter 20: The Enlightenment
Furbank P. N., *Diderot: A Critical Biography*. London: Secker & Warburg, 1992.
ART AND ARCHITECTURE
Arnason H. H., *The Sculptures of Houdon*. London: Phaidon, 1975.
Honour H., *Neo-classicism*. Harmondsworth: Penguin Books Ltd., 1968.
Schnapper A., *David*. New York: Alpine Books, 1982.
LITERATURE
Foster M. P., *Voltaire's "Candide" and the Critics*. Bellmont, California: Wadsworth Publishing Company Inc., 1962.

Chapter 21: The Cult of Nature and the Cult of Feeling
Ayling S., *Edmund Burke, his Life and Opinions*. London: John Murray, 1988.
Green F. C., *Jean-Jacques Rousseau: A Critical Study of his Life and Writings*. Cambridge: Cambridge University Press, 1956.
ART AND ARCHITECTURE
Henry Fuseli. Catalogue of an exhibition held at the Tate Gallery. London: Tate Gallery, 1975.
Baillo J., *Elizabeth Vigée Le Brun 1755–1842*. Fort Worth: Kimbell Art Museum, 1982.
Hinde T. *Capability Brown*. London: Century Hutchinson, 1986.
Novotny F., *Painting and Sculpture in Europe 1780–1830*, rev. edn. London and New York: Penguin Books Ltd., 1978.
Perouse de Mantclos J. M., *Etienne Boullée (1728–1798), Theoretician of Revolutionary Architecture*. London: Thames and Hudson, 1974.
Wilton-Ely J., *The Mind and Art of Giovanni Battista Piranesi*. London: Thames and Hudson, 1978.
LITERATURE
Darbishire H., *The Poet Wordsworth*. Oxford: Clarendon Press, 1950.

Hatfield H., *Goethe: A Critical Introduction*. Cambridge, Mass.: Harvard University Press, 1964.
King J., *William Blake, His Life*. London: Weidenfeld and Nicolson, 1991.
MUSIC
Dent D. J., *Mozart's Operas: A Critical Study*, 2nd edn. London: Oxford University Press, 1947.

Chapter 22: The French Revolution
Ayer A. J., *Thomas Paine*. London: Secker and Warburg, 1988.
Lorch J., *Mary Wollstonecraft: The Making of a Radical Feminist*. Oxford and New York: Berg, 1990.
ART AND ARCHITECTURE
Bayly C. A., ed., *The Raj: India and the British*. London: National Portrait Gallery Publications, 1990.
Boime A., *The Academy and French Painting in the Nineteenth Century*. New York and London: Phaidon Press, 1971.
Licht F., *Goya: The Origins of the Modern Temper in Art*. New York: Harper and Row, 1970.
Middleton R., and Watkin D., *Neo-classical and 19th Century Architecture*. London: Faber and Faber/Electa, 1987.
Stroud D., *Sir John Soane, Architect*. London: Faber and Faber, 1984.
LITERATURE
Fergus J., *Jane Austen, a Literary Life*. Basingstoke: Macmillan, 1991.
MUSIC
Abraham G., ed., *The New Oxford History of Music Vol VIII: The Age of Beethoven 1790–1830*. London: Oxford University Press, 1982.

Chapter 23: Romanticism
Singer P., *Hegel*. Oxford and New York: Oxford University Press, 1983.
ART AND ARCHITECTURE
Clark K., *The Romantic Rebellion*. New York: Harper and Row, 1973.
Honour H., *Romanticism*. Harmondsworth: Penguin Books Ltd., 1979.
Vaughan W., *Romantic Art*. London: Thames and Hudson, 1978.
LITERATURE
Graham P. W., *"Don Juan" and Regency England*. Charlottesville, Virginia: University Press of Virginia, 1990.
Pichois C., *Baudelaire*. London: Hamish Hamilton, 1989.
DRAMA
Dieckmann L., *Goethe's "Faust": A Critical Reading*. Englewood Cliffs, New Jersey: Prentice Hall Inc., 1972.
MUSIC
Budden J., *The Operas of Wagner*, 3 vols. London: Cassell, 1973–81.
Dahlhaus C., *Richard Wagner's Music Dramas*. Cambridge: Cambridge University Press, 1971.

Chapter 24: Realism
Carver T., ed., *The Cambridge Companion to Marx*. Cambridge: Cambridge University Press, 1991.
ART AND ARCHITECTURE
Clark T. J., *The Painting of Modern Life: Paris in the Art of Manet and His Followers*. New York: Alfred A. Knopf, 1985.
Gernsheim H., and Gernsheim A., *The History of Photography, 1685–1914*. New York: McGraw-Hill Book Company, 1969.
Giedion S., *Space, Time and Architecture: The Growth of a New Tradition*, 5th edn. Cambridge, Mass.: Harvard University Press, 1967.
Goodrich L., *Thomas Eakins*, 2 vols. Cambridge Mass., and London: Harvard University Press for the National Gallery of Art, Washington D.C.
Hitchcock H. R., *Architecture 19th and 20th Centuries*. Harmondsworth: Penguin Books Ltd., 1977.
Rewald J., *The History of Impressionism*, 4th edn. New York: New York Graphic Society for the Museum of Modern Art.
Scharf A., *Art and Photography*. Baltimore: Penguin Books Ltd., 1968.
LITERATURE
Bayley J., *Tolstoy and the Novel*. New York: Viking Press, 1967.
Cortland P., *A Reader's Guide to Flaubert*. New York: Hollow Books, 1968.
Hingley R., *Doestoevsky, His Life and Work*. London: Paul Elek, 1978.
Hobsbaum P., *A Reader's Guide to Dickens*, 2nd edn. London: Thames and Hudson 1988.
DRAMA
Marker F. J., and Marker L. L., *Ibsen's Lively Art*. Cambridge: Cambridge University Press, 1989.

Chapter 25: Symbolism
Neu J., ed., *The Cambridge Companion to Freud*. Cambridge: Cambridge University Press, 1991.

Robinson R., *Poetry, Paintings and Ideas, 1885–1914*. London: Macmillan, 1985.

ART AND ARCHITECTURE

Cabanne P., *Van Gogh*. London: Thames and Hudson, 1963.

Chassé C., *The Nabis and their Period*, trans. by Michael Bullock. London: Lund Humphries, 1969.

Cooper J., ed., *Mackintosh Architecture: The Complete Buildings and Selected Projects*. London: Academy Editions, 1989. New York: St. Martin's Press, 1989.

Lucie-Smith E., *Symbolist Art*. London: Thames and Hudson, 1972.

de Sola-Morales I., *Gaudi*. London: Academy Editions, 1987.

LITERATURE

Ahearn E. J., *Rimbaud: Visions and Habitations*. Berkeley and Los Angeles: University of California Press, 1983.

Fowlie W., *Mallarmé*. Chicago: University of Chicago Press, 1953.

Tanner T., *Henry James: the Writer and his Work*. Amherst, Mass.: University of Massachusetts Press, 1985.

DRAMA

Meyer M., *Strindberg, A Biography*. London: Secker and Warburg, 1985.

Chapter 26: The Birth of Modernism

Kolakowski L., *Bergson*. Oxford and New York: Oxford University Press, 1985.

Wintle, J., *Makers of Modern Culture: A Biographical Dictionary*. London: Routledge and Kegan Paul Ltd., 1981.

ART AND ARCHITECTURE

Blake P., *Frank Lloyd Wright: Architecture and Space*. Harmondsworth: Penguin Books Ltd., 1969.

Goldwater R., *Primitivism in Modern Art*, rev. edn. New York: Vintage, 1982.

Osborne R., *The Oxford Companion to Twentieth Century Art*. London and New York: Oxford University Press, 1981.

Nikos Stangos, ed., *Concepts of Modern Art*, 2nd edn. London: Thames and Hudson, 1981. New York: Harper and Row, 1981.

Windsor A., *Peter Behrens: Architect and Designer*. London: The Architectural Press, 1983.

LITERATURE

Howe I., ed., *Literary Modernism*. Greenwich, Conn.: Fawcett Publications Inc., 1967.

Little R., *Guillaume Apollinaire*. London: University of London, The Athlone Press, 1976.

Painter G. D., *Marcel Proust: A Biography*, 2nd edn. New York: Random House, 1989.

MUSIC

Salzmann E., *Twentieth Century Music: An Introduction*, 2nd edn. Englewood Cliffs, New Jersey: Prentice Hall Inc., 1974.

Chapter 27: Armageddon and the Interwar Culture in Europe

Ayer A. J., *Ludwig Wittgenstein*. Harmondsworth: Penguin Books Ltd., 1986.

ART AND ARCHITECTURE

Borsi F., *The Monumental Era: European Architecture and Design 1929*. New York: Rizzoli, 1987.

Cowling E., and Mundy J., *On Classic Ground: Picasso, Leger, de Chirico and the New Classicism 1910–1930*. London: The Tate Gallery, 1990.

Nadeau M., *The History of Surrealism*, trans. by Richard Howell. New York: Collier Books, 1967.

Richter H., *Dada: Art and Anti-Art*. London: Thames and Hudson, 1965.

Willett J., *The New Sobriety: Art and Politics in the Weimar Period 1917–1933*. London: Thames and Hudson, 1976.

Wingler H. M., *The Bauhaus*. Cambridge, Mass.: Harvard University Press, 1978.

LITERATURE

Attridge D., ed., *The Cambridge Companion to James Joyce*. London and New York: The Cambridge University Press, 1992.

Bergonzi B., *T. S. Eliot*, 2nd edn. London: Macmillan, 1978.

Bishop E., *Virginia Woolf*. London: Macmillan, 1991.

Heller E., *Franz Kafka*. New York: Viking Press, 1975.

DRAMA

Esslin M., *Brecht: A Choice of Evils*, 4th rev. edn. London and New York: Methuen, 1984.

Chapter 28: The Rise of America

Tiles J. E., *Dewey*. London: Routledge, 1988.

ART AND ARCHITECTURE

Geldzahler H., *New York Painting and Sculpture 1910–1970*. London: Pall Mall Press in association with the Metropolitan Museum of Art, New York, 1969.

Rose B., *American Art since 1900*, rev. edn. New York: Praeger, 1972.

Russell J., and Gablik S., *Pop Art Redefined*. London: Thames and Hudson, 1969.

Sondheim A., *Individuals: Post-Movement Art in America*. New York: E. F. Dutton & Co. Inc., 1977.

Whiffen M., and Koeper F., *American Architecture 1607–1975*. London: Routledge and Kegan Paul, 1981.

LITERATURE

Dowling D., *William Faulkner*. Basingstoke: Macmillan Education Ltd., 1989.

Meyers J., *Hemingway: A Biography*. London: Macmillan, 1988.

Miles B., *Ginsberg: A Biography*. New York: Simon and Schuster, 1989.

FILM

Rhode E., *A History of the Cinema, from its Origins to 1970*. Harmondsworth and New York: Penguin Books Ltd., 1978.

MUSIC

Gillett C., *The Sound of the City: The Rise of Rock and Roll*, rev. edn. London: Souvenir Press Ltd., 1983.

Griffiths P., *Cage*. Oxford and New York: Oxford University Press, 1981.

Oliver P., Harrison M., and Bedcon W., *The New Grove: Gospel, Blues and Jazz*. London: Macmillan, 1986.

Chapter 29: Europe 1940–1970

Cooper D. E., *Existentialism, a Reconstruction*. Oxford: Blackwell, 1991.

Sturrock J., ed., *Stucturalism and Since: from Lévi-Strauss to Derrida*. Oxford and New York: Oxford University Press, 1979.

ART AND ARCHITECTURE

Jencks C., *Late Modern Architecture*. London: Academy Editions, 1980.

Jencks C., *The Language of Post-Modern Architecture*, 2nd rev. edn. London: Academy Editions, 1978.

Lucie-Smith E., *Movements in Art Since 1945*, rev. edn. London: Thames and Hudson, 1985.

LITERATURE

Celan P., *Poems*, trans., and with an intro. by Michael Hamburger. London: Anvil Press Poetry, 1988.

Hingley R., *Pasternak: A Biography*. London: Unwin Paperbacks, 1985.

Wagner L. W., ed., *Sylvia Plath: the Critical Heritage*. London: Routledge, 1988.

DRAMA

Fletcher J., and Spring J., *Beckett, the Playwright*, 3rd edn. London: Methuen, 1985.

Chapter 30: 1970–90

ART AND ARCHITECTURE

Ecker G., ed., *Feminist Aesthetics*. Boston: Beacon Press, 1986.

Krens T., Govan M. and Thomson J., eds., *Refigured Painting: the German Image 1960–1988*. New York: Prestel in association with the Solomon R. Guggenheim Museum.

Lucie-Smith E., *Art in the Eighties*. Oxford and New York: Phaidon Press, 1990.

Stackelhaus H., *Joseph Beuys*. New York: Abbeville Press Ltd., 1991.

Sudjic D., *New Architecture: Foster, Rogers, Stirling*, exhibition catalogue. London: Royal Academy of Arts, 1986.

LITERATURE

Martin G., *Journeys through the Labyrinth: Latin-American Fiction in the Twentieth Century*. London: Verso, 1989.

MUSIC

Schaefer J., *New Sounds: The Virgin Guide to New Music*. New York and London: Harper and Row and Virgin Books/W. H. Allen, 1987.